ART THEMES

ART THEMES

CHOICES IN ART LEARNING AND MAKING

MARJORIE COHEE MANIFOLD

INDIANA UNIVERSITY PRESS

This book is a publication of

Indiana University Press
Office of Scholarly Publishing
Herman B Wells Library 350
1320 East 10th Street
Bloomington, Indiana 47405 USA

iupress.indiana.edu

This book is printed on acid-free paper.

Manufactured in China

Names: Manifold, Marjorie Cohee, author.
Title: Art themes : choices in art learning and making /
 Marjorie Cohee Manifold.
Description: Bloomington, Indiana : Indiana University
 Press, 2017. | Includes bibliographical references.
Identifiers: LCCN 2017020278 | ISBN 9780253022929 (pr)
Subjects: LCSH: Art—Technique.
Classification: LCC N7433 .M26 2017 | DDC 700—dc23
LC record available at https://lccn.loc.gov/2017020278

2 3 4 5 6 25 24 23 22 21

Contents

4. Art and Narrative Imagination 363

5. Exploring Self and Others through Art 461

6. Media Play

ART THEMES

Introduction and How to Use This Book

This textbook is designed for those who are interested in art making for pleasure or who need to develop a few basic art making skills in order to achieve specific goals. The text introduces a variety of art themes, genres, materials, and processes that interest novice or casual art makers. Often those who have had little previous experience in art education assume that making artistic images and products requires a certain genetic disposition, or a talent bestowed at birth like a gift from a magical fairy godmother. Nothing could be further from the truth. All healthy human beings have a psychological need to express deep feelings and profound thoughts about the meaning of life in ways that go beyond words. We all seek to celebrate our loved ones and our belonging to community. We wonder about what came before us and what will remain when we are no longer conscious of life. We seek to mark transitions of joy and sorrow in our journey through life as an affirmation of our being. These needs are the foundations and motivations for creating in the arts.

Another common misperception is that to be an *artist* one must be able to draw realistically. Yet because we all see life from differing perspectives and understandings, the notion of what constitutes realism is something of a moving target. For example, both of these artistic renderings are easily recognizable representations of a dog, yet neither looks exactly true to life. Each artist has simplified the texture, form, color, or lines that describe a dog; nevertheless, each image is realistic insofar as it conveys the idea of *dog* with clarity.

Young children tend to use drawing to symbolically communicate ideas that are not dependent on photographic realism. We may be familiar with stick-figure drawings of humans and recognize these to be the typically unsophisticated, albeit delightful, renderings by children. Yet many artists who seek to express tacit qualities of humanness have found that realism actually masks or challenges their abilities to describe such essences. Some have studied the works of children to rediscover how to communicate such ideas eloquently through symbols that could scarcely be called realistic.

Of course, if you are using this text as a guide for learning to draw realistically, there are themes and lessons that can help you become more observant of what you see. This is crucial to drawing realistically. Additionally, there are physical tools and laws of science and mathematics that can be used to create

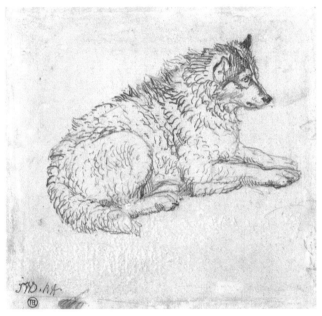

Below, James Ward (1769–1859), *Arctic Dog, Facing Right,* undated. Graphite on medium, slightly textured, cream wove paper, 6¾" × 7¼" (17.15 × 18.4 cm). Paul Mellon Collection, Yale Center for British Art, New Haven, CT.

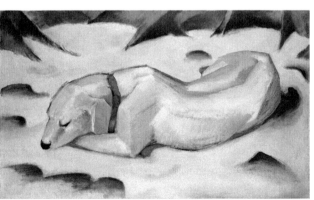

Above, Franz Marc (1880–1916), *Dog Lying in the Snow,* 1911. Oil on canvas. 24" × 41 ⅓" (62.5 × 105 cm). Städel Museum, Frankfurt, Germany.

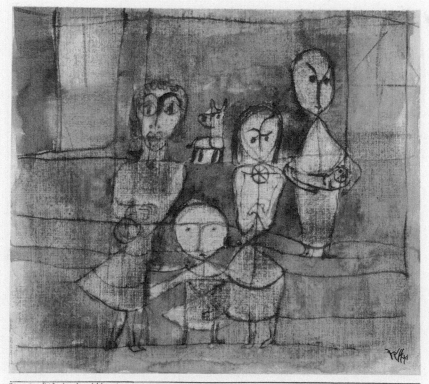

Paul Klee (1879–1940), *Children and Dog (Kinder und Hund)*, 1920. Watercolor, pen, and ink on paper, 6¾" × 7 ⅜" (16.3 × 18.7 cm). Private Collection.

impressive artworks. As you work through the lessons in this text, focus on what it is you wish to communicate and consider the most effective ways of visually presenting your feelings, thoughts, and ideas. In some cases, this may require that you practice techniques such as mathematically accurate depiction of aerial perspective or proportion, but there also are many ideas and experiences that can be articulated visually without relying on photorealism or great technical skills in realistic drawing.

My hope is that through practice and experimentation with the lessons in this text, either working independently or guided by an instructor in an actual or virtual community of fellow learners, you will develop basic technical skills of art making and an enhanced ability to engage with ideas about art. Through exploring and completing one or several thematic units, you will also

· experience pleasure experimenting with art making;
· recognize your ability to replicate what is seen in a visually coherent way;
· recognize your ability to communicate ideas coherently through visual symbols;
· develop basic skills in a medium of choice;
· recognize your ability to successfully make artworks that achieve personal goals;
· be able to visualize how your personal art making might be useful or pleasurable to everyday life or in a future non-art-specific career.

Brian Cho, *Gangham Station*, 2015.
Pencil on paper, 9½" × 12".
(Courtesy of the Artist)

Anonymous, *Portrait*. Graphite
and colored pencils, 18" × 11".
Created by a student of Ritók Nóra,
Director of Igazgyöngy Alapítvány-
Berettyóújfalu, Hungary (Pearl
Foundation Abu Dhabi), http://
www.igazgyongy-alapitvany.hu.

Unlike many books that present art instruction in conventionally structured sequences, this text offers users numerous entry points for progressing through lessons. The hypertext-like organization of lessons is informed by observations of how art is learned in extracurricular settings among adolescents and adults of like-interested communities. Such observations tell us that art making is experienced more positively when individuals are allowed control in terms of thematic topics they choose to address, and are invited to make images or artifacts that are deemed useful, relevant to personal interests, important to future goals, or are in accord with hobbies in which they already engage. People who voluntarily create art also tell us they like to learn in holistic ways, obtain information and advice on a "need to know" basis, and receive affirmative support from peers and instructors.

Thus the design of the textbook provides considerable flexibility in selecting the thematic content, art forms, media, and processes with which you will engage. Lessons are organized by *themes* of general subject matter or media. As you look through the book, you will see some themes that appeal to you more than others. When you have identified such a theme, look next at the four *strands* of lessons presented in that thematic unit and select one lesson from each consecutive strand and complete that lesson.

Any of the lessons in the first (far left) strand will introduce you to the thematic topic and present opportunities to develop simple art products that challenge critical thinking skills. The lessons in strand one will prepare you to attempt more complex projects. After choosing and completing one of the lessons from this first strand, move to the next strand to the right and choose a new lesson that interests you. Lessons of the second strand are designed to build upon the skills and knowledge developed by successfully completing a lesson of the first strand. Next, move to the third strand and select one lesson with which to engage. Finally, select a lesson from the fourth strand (on the far right) and complete that lesson.

Because each lesson builds upon previously presented knowledge and developed skills, as you progress through four lessons, one from each strand, you will grow in your understanding of art concepts, meanings, and processes, while also improving your art making skills. A spiraling development of thematic knowledge and skills may result from repeating the thematic unit, in which case a new sequence of lessons could be selected and completed with each repetition of the theme. However, you may prefer to choose a different theme for attention and begin work on the new thematic unit rather than repeating a theme. Either way of working through the themes is acceptable.

If you are using this textbook as curriculum for a formal studio art class, I recommend that three themes be completed during a semester. This pacing provides optimum time for brainstorming, critical thinking, making, sharing, and receiving feedback on in-progress work, and then revising, completing, and reflecting upon your work. You are advised to complete one project at a time, so you can focus on specific issues involved in creating that work and

Theme #11: Fantastic Worlds

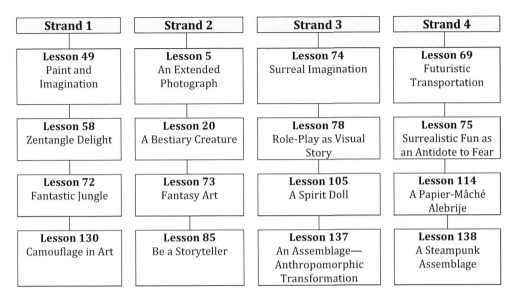

Strand 1	Strand 2	Strand 3	Strand 4
Lesson 49 Paint and Imagination	**Lesson 5** An Extended Photograph	**Lesson 74** Surreal Imagination	**Lesson 69** Futuristic Transportation
Lesson 58 Zentangle Delight	**Lesson 20** A Bestiary Creature	**Lesson 78** Role-Play as Visual Story	**Lesson 75** Surrealistic Fun as an Antidote to Fear
Lesson 72 Fantastic Jungle	**Lesson 73** Fantasy Art	**Lesson 105** A Spirit Doll	**Lesson 114** A Papier-Mâché Alebrije
Lesson 130 Camouflage in Art	**Lesson 85** Be a Storyteller	**Lesson 137** An Assemblage—Anthropomorphic Transformation	**Lesson 138** A Steampunk Assemblage

experience a sense of satisfaction at your progress in completing lessons in a sequential order. For every completed artwork, be prepared to reflect on the problems you encountered during the creation process, the solutions you arrived at for solving these difficulties, the final project outcome, and what you learned from the project.

If you are using this textbook in a formal or informal setting with small groups of peer students, it is important that you share your in-progress work with others of the class, even when they are working on entirely different themes and lessons or when they exhibit differing levels of skill or knowledge. Your peers may provide ideas and insight about your work and offer encouragement in addressing conceptual difficulties. Your instructor can provide individualized instruction, technical advice, and suggestions for improving your work. Your peers or group can benefit from hearing the advice your instructor gives you about your work, and you can benefit from the advice the instructor gives to others. Sharing, seeking, and receiving feedback supports efforts of art making as a communal interaction between makers and viewers and will assure more conceptually and technically successful results for all participants of the group. Therefore, whether you are using this text in a formal or informal, actual or virtual art learning group, it is important that you actively participate in conversations and constructive critiques about your own and others' work.

A theme consists of several thematically related lessons, organized in strands of progressing complexity. Having selected a theme of interest, choose and complete one lesson from each strand, moving sequentially from left to right. When four lessons in total (one from each strand) have been completed in consecutive order, a second thematic unit may be selected or the original theme repeated, using different lessons from the sequenced strands. (Created by the Author)

Materials Needed

For each lesson, a list of materials needed to successfully complete it is provided. In looking through these lists, you will notice that drawing and watercolor papers are frequently mentioned. Drawing and watercolor papers come in pads or packets. Drawing paper is used for sketching and drawing (i.e., *dry* media). Watercolor paper should be used as a foundational material for watercolor

paintings, glued collages, and all other *wet* media. Printing, construction, or drawing papers are not an appropriate backing for wet media because these lightweight papers warp and quickly disintegrate when moisture is put to them. All art projects should be done using the kinds of paper, media, and materials described in the project instructions. These materials will ensure the best results in completing your work. Using materials other than those suggested can adversely affect the completed work.

The majority of the materials required to complete the lessons can be purchased inexpensively from craft or discount stores. It is not necessary to purchase expensive supplies from professional art supply stores. However, a box of drawing pencils of various soft and hard leads is a necessity. Drawings having near-black values are impossible to achieve with typical No. 2 drawing pencils. Also, if you are planning to use watercolor or tempera, you will want to purchase a tray of watercolors or a boxed set of tempera paints and a couple of good brushes (a large and a medium or small brush). Brushes that come with watercolor sets are generally poor in quality and should be replaced with separately purchased, better quality brushes.

Rubber cement or glue sticks are preferred adhesives for working in collage and cut-paper projects. Wet glues (i.e., white glue, craft glue, or gels) will wrinkle your paper. Wet glues are useful for fastening together heavy porous materials like pieces of cardboard. Non-porous materials, like plastics or metals, require special types of glues or epoxies, as suggested in the Materials Needed sections of lessons where adhesives are to be used.

Exceptions to the materials instructions may be made in terms of overall sizes of artworks or choices of collage papers and found materials. Additionally, many of the lessons may be adapted to include the use of new digital media in order to correct, modify, or enhance an artwork. When in doubt about the propriety of alternative materials or processes, ask your instructor's advice. He or she can give technical suggestions as well as guidance regarding material choices and uses.

Vocabulary

For those who are unfamiliar with art, art terms are highlighted throughout the book. Definitions of these vocabulary words are given in the text and at the end of the book.

Extensions

Suggested extensions are provided for many lessons. These are intended for those who desire to be more deeply challenged by the possibilities of art making presented in the lesson. Additionally, those who are repeating a theme can look to extensions for ideas about increasing their knowledge and skills beyond what was learned or acquired the first time a lesson was completed.

Tips for Teachers

Generalist elementary teachers face challenges in working with students who learn in different ways. Visual and hands-on learning opportunities in art support learning across various disciplines. If you are planning to be a generalist elementary teacher, or if you are teaching art in a community setting, the Tips for Teachers presented throughout this text will provide suggestions for how to increase interdisciplinary learning through art.

Evaluation Criteria

If you are using this textbook as curriculum for a formal studio art course, you will want to discuss the due dates of completed lessons, how these works are to be submitted, and how you are to be evaluated with your instructor. Your evaluation will be based on whether or not you demonstrate growth in technical drawing skills as well as on your ability to develop ideas and concepts about works of art. Rarely can great skills of drawing be acquired in a short period of time, but you should be able to demonstrate some slight growth in skill from one lesson to the next. Other evidences of thinking and learning, such as sketches, notes indicating attention to group feedback, and written essays frequently will be requested. These provide concrete as well as subjective learning evidences that can be evaluated.

The following rubric may be used to identify benchmark expectations of knowledge and skill acquisition.

Art Production The student should be able to
- *demonstrate craftsmanship:* show increased control over the elements, principles, and materials of visual arts (such as shading, perspective, control of watercolor, etc.);
- *pursue growth:* display increased efforts in working through problems over time and in depth;
- *be inventive:* show increased interest and willingness to experiment with materials, solve assignments in imaginative ways, and/or initiate ideas for projects;
- *be expressive:* create works that are inspired by deep feelings and images that are increasingly powerful, sensitive, or evocative.

Perception The student should be able to
- *be aware of sensuous aspects of experience:* converse about what inspired his or her work, and express awareness of the visual world and sensory and emotional responses to his or her experiences and the environment;
- *be aware of qualities of materials:* become increasingly aware of uses and limitations of materials, and discriminate among similar types of materials;
- *make distinctions and connections about art:* begin to notice the technical, functional, and aesthetic properties of art from a wider canon of genres.

Reflection The student should be able to
- *assess his or her own work:* demonstrate an increased ability to articulate and defend judgments about his or her artworks;
- *take on the role of critic:* demonstrate an increased ability to articulate, discuss, and defend judgments about others' works;

- *use criticism and suggestions:* demonstrate receptiveness to positive criticism and use that criticism to improve;
- *articulate artistic goals:* recognize a role for art in his or her life or career, such as (for generalist elementary teachers) recognizing the importance of art in the teaching and learning of elementary students.

Approach to Work The student should be able to

- *engage:* work hard, carry projects through to completion, pay attention to details, and meet deadlines;
- *be receptive:* actively seek advice from the instructor on in-progress works, and use the instructor's advice to improve his or her work;
- *use visual resources:* make use of resources for art making (e.g., books, museums, online resources) beyond those provided in the text or by the instructor.

Participation and Improvement

- If this text is being used in a formal studio environment, whether real or virtual, your instructor will take into consideration your *active and engaged participation* during the course, your willingness to share your work with others and encourage them in their efforts, and your efforts to improve your skill, knowledge, and understanding of art from lesson to lesson.

An Alternate Way of Using This Text

The lessons of this book have been organized into chapters that broadly describe categories of art making based on concepts, art genres, or materials used to create artwork. This organization is intended to assist readers in finding types of art projects that might be of further interest. Those wanting to explore art making independently rather than in a formal or informal studio setting may find this organization useful to selecting topics of interest. Additionally, teachers may look through these chapters to find lessons that address specific cross-disciplinary concepts.

Basics of Creating Works of Art

Perhaps you recall learning about Principles of Art from instruction you received in elementary- or secondary-level art classes. Just as it is necessary to memorize the alphabet and understand sentence constructions when learning to read text, the Elements and Principles of Art should be memorized, for these represent a kind of artistic alphabet and language primer that permit us to read images. Look over the following definitions of these terms so you will understand and be able to participate in conversations about your work and the work of others. If there are additional terms that you do not know, look up their meanings or ask your instructor to explain them to you.

The Elements of Art

LINE

· Lines may be drawn or implied. When creating a two-dimensional work of art, we often begin by drawing lines around objects that will be represented in the image. Additionally, lines may be drawn to suggest movement, shadows, and textures. Because lines have to describe so many details of a subject, the quality or characteristics of a line are flexible. That is, lines can be thick, thin, feathered, smudged, crisp, faint, solid, overlapped, or hatched. Differences in line may describe visual characteristics of the subject being drawn, suggest mood, and direct a viewer's eye through the image.

· An implied line is not drawn but is suggested by a shape (or gaze) that points the viewer's eye in a certain direction. Implied lines may also result when two or more objects within an image suggest a line, as the viewer's eye moves from one shape or space to another.

SHAPE AND FORM

· Lines create shape by outlining or otherwise establishing the inside and outside (i.e., there/not there) of an object. Shapes may be geometric (e.g., circles, squares, triangles) or organic, like the shape of a human figure, flower, or butterfly.

· Form describes a three-dimensional shape. Besides height and width, a form has depth. Therefore, form refers to sculptural objects, or to the illusion of depth that is created in two-dimensional images by use of shading and highlighting.

VALUE

· In order to create an illusion of a form, it is important to include variations of value (or light and dark) in an artwork. This is because we are able to see objects in space by the way light falls upon them. If all objects were of the same value (lightness or darkness) we could not distinguish

one from another, just as we might not see a black-clothed figure in the dark of night or a white-clothed figure in a whiteout snowstorm.

SPACE

- This refers to the distances between or area around things. Artworks created by artists of Euro-American traditions use certain conventions that allow viewers to see flat images as representing space. Objects that are closer are shown with greater detail, brighter colors, are larger in size, and placed lower on the page than objects that are further away. Additionally, closer objects may overlap more distant objects and may be foreshortened as they move backwards from the viewer.
- Western art traditions describe "things" in an image as the positive spaces of an image, while empty areas around objects are considered the negative spaces of an image. When drawing, we tend to focus on the positive spaces of things and often overlook the importance of negative or empty space. Yet to create a pleasing composition, both are important. The negative space around an object must be just as interesting and full as the space occupied by an object, and because both have visual weight (i.e., light areas appear lighter in weight than dark areas), there must be a balance of negative and positive spaces if the completed composition is to be aesthetically harmonious.

VISUAL TEXTURE

- Although brushstrokes or collaged materials may present actual texture, two-dimensional images cannot present texture as a tactile experience in the same way that a sculptural piece does. Nevertheless, an artist describing objects that have form and texture must find a way to visually suggest texture. This is done by thoughtful use of light and dark values.

COLOR

- Color is a complex element. We perceive colors as changing when they interact in particular ways with one another. For example, each of two complementary colors may appear more vibrant when placed side by side, but when complementary colors are combined the result is a muted or neutral color. Primary colors may be mixed together to create secondary and tertiary colors. Colors have value (degrees of light or dark), suggest visual temperatures ranging from cool to hot, and convey visual weight. Because of atmospheric perspective, objects that are closest to the viewer are often brighter than objects that are further away, which tend to be both duller and imbued with bluish coloration. These and other discoveries about how colors function in the visual world constitute color theories, which incorporate or overlap with the Principles of Art.

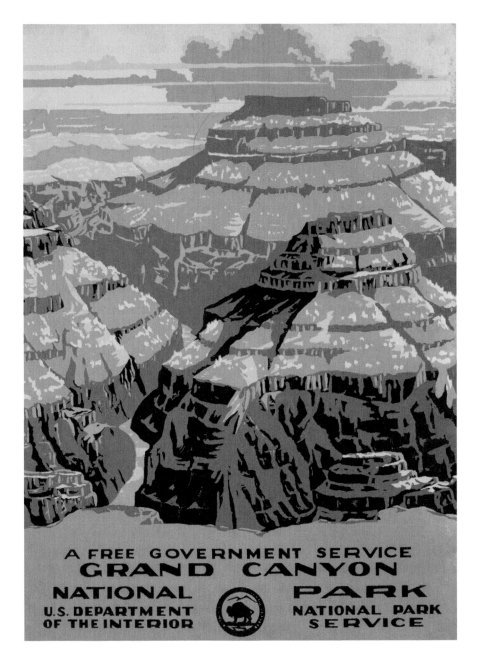

In this poster, the artist has skillfully created a balance of light and dark monochromatic tones. We instinctively know that those colored shapes toward the top of the poster are further away. This tells us we are looking at the representation of a landscape. However, we also can enjoy the balanced coloration, the play of light and dark patterns and positive and negative space as an abstract composition. The result is an effective poster that grabs the attention of viewers, serving as both an informational poster and a pleasing work of art. *Grand Canyon National Park, A Free Government Service*, 1938. Screen print, 18¾" × 14⅛" (48 × 36 cm). Work Projects Administration Poster Collection, Prints and Photographs Division, Library of Congress, Washington, DC.

Principles of Art

HARMONY

· Human beings seek harmony in the visual environment. Harmony is achieved when there are elements that relate to or repeat one another logically. Harmony invites the viewer's eye to flow from one area to another with fluidity, and permits various parts of the visual field to connect with one another.

MOVEMENT

· Harmony may be achieved if the viewer's eye is allowed to move gracefully through the image and come to see it as an interconnected whole.

Movement refers to the path taken by the eye as it makes this journey. Color, shape, value, scale, and proportion assist in moving the eye in this way. Similar colors and shapes may be placed in such a way as to form implied line connections from one to another. Values may change gradually from light to dark or dark to light in such ways as to move the eye along.

VARIETY

· While an artist's task is to manipulate the Elements of Art in ways that move the eye smoothly through the image, viewers also need variety (in use of line, shape, color, etc.) and a point of emphasis. Humans have an intuitive need for visual excitement as well as rest. With too little visual stimulation we become bored; on the other hand, we can also experience overstimulation from the visual environment and need some visually quiet spaces.

EMPHASIS

· Emphasis refers to the focal point—where the viewer's eye comes to rest, linger, and reflect upon the artwork. Emphasis also refers to how the artist arranges an image so the viewer may quickly and easily grasp the point (i.e., meaningful subject) of the image. Emphasis can be achieved by combining elements such as directional lines, brighter colors, a weightiness of light and dark values, or with more detailed visual textures within a specific section or sections of the artwork.

PROPORTION

· Viewers of artworks typically look to proportion for important information about how to perceive parts of an image in relation to one another or as objects in space. For example, viewers look for conventional human proportions when judging the accuracy of a drawn figure. When objects are significantly larger or smaller than the proportional norm for that object, or when one object is larger or smaller than it would usually be in relation to other nearby objects, the subject is recognized as a distortion of reality.

PATTERN

· Pattern refers to the repetition of certain elements or motifs throughout an image. There might be regularity of pattern, such as repeated oval shapes in a sequence of red, yellow, and blue. An irregular pattern would be achieved by suggesting similar oval shapes that are randomly placed, differently sized, or arranged in a varied sequence of colors, values, or textures.

- Balance often is a misunderstood principle. Novices frequently will describe an image as "balanced" without understanding there are many different types and ways of achieving a harmonious or pleasing sense of balance within an artwork. Balance may be formal or informal, symmetrical or asymmetrical, or radial. Balance may be achieved by pitting a few dark and highly detailed (visually heavy) objects against a larger area of light, slightly out-of-focus (visually light) objects. It may be achieved by placing warm- and cool-colored objects adjacent to one another or by organizing elements into groups equipoised with one another.

- Different kinds of balance suggest different moods or interpretations of artworks. Generally speaking, formally or symmetrically balanced artworks may seem solid, regal, ceremonial, artificially constructed, and unmoving. Informally and asymmetrically balanced images may suggest movement, change, naturalness, and casual or lyrical concepts. Recognizing the type of balance used within an artwork assists viewers in deciphering the purpose and meaning of a work.

UNITY

- Unity is achieved when all the parts of an artwork function harmoniously together to create a compositional whole. One can think of the various Principles of Art as parts played by different instruments in an orchestra. Unity is achieved when each instrument plays its role in sync with all the others, thus moving the musical piece from beginning to end in an aesthetically pleasing way.

Selecting an Interesting Composition

Once you have decided upon a subject for your artwork, you will want to arrange the various parts of the image into an interesting composition. A composition is a grouping of objects (or lines, shapes, colors, and textures) that make up the subject of an image. Simply lining up objects in a row or scattering them randomly on a page rarely results in an interesting or effective composition. Objects should relate to one another in such a way that they can be taken in all at once as a harmonious unit. This requires you to think about the point of view from which you will look at the subject, or how you will arrange the various parts in relation to one another.

One of the most frequent problems artists face in this regard is determining how much of the subject will be shown compared to its background. This is an issue of balancing positive and negative spaces of the image. Too much negative space dwarfs positive space and makes it seem weak, lifeless, and uninteresting. Having more positive space than negative space can make an artwork more interesting to look at, but too much positive space can be visually overwhelming.

Using a viewfinder.
(Created by the Author)

When working with digital images, it is fairly easy to use cropping tools to select the most interesting part of a large subject and cut away excess or unnecessary background areas. Usually, you can adjust the size of a crop and move the tool around to find just the amount and area you wish to keep. When working in traditional (non-digital) media, you can use a homemade viewfinder to help you find and select interesting compositions.

Take a sheet of watercolor or cover weight paper and cut it into a 6" square, or 6" × 8" rectangular size. Then, using a ruler and pencil, carefully measure off a 3" square or a 3" × 5" rectangle in the center of the paper and cut out the centered square or rectangle. Hold the paper in front of you at about arm's length, with part of the subject you wish to draw or paint visible through the small opening. Move the viewfinder around until you find an interesting part of the subject. Quickly make a thumbnail sketch of what you see.

THUMBNAIL SKETCHES

A thumbnail sketch is a small sketch, usually around 3" × 4" in size, so that several sketches can fit on a single sheet of drawing paper. These are visual ideas that represent your thinking processes as you move objects around or explore different points of view or compositional arrangements before committing

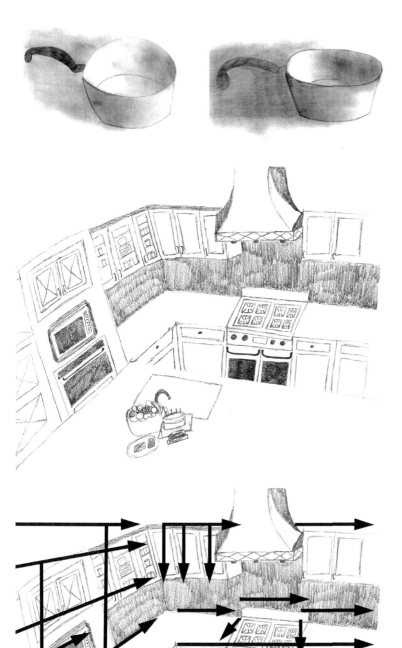

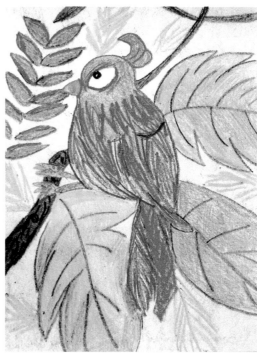

Top left, Bethany Gross, *Two Views of a Saucepan,* 2012. (Courtesy of the Artist)

Above, Megan Van Pelt, *Practice Drawing of a Bird for Fantastic Jungle,* 2013. Crayon on paper, 12" × 9". (Courtesy of the Artist)

Middle left, Victoria Seidman, "Sketch of Kitchen," from *Sketchbook Drawings of One-Point Perspective,* 2013. (Courtesy of the Artist)

Bottom left, After selecting the sketch she liked best, Victoria received feedback on how to correct errors in her use of one-point perspective. This helped her develop the sketch into a larger, finished artwork. Instructor-added lines of perspective overlay on "Sketch of Kitchen," from *Sketchbook Drawings of One-Point Perspective,* 2013. (Courtesy of the Artist and the Author)

yourself to the intensive time and effort needed to complete a finished composition. In nearly all the projects suggested in this textbook, you will benefit from making many small sketches, then deciding on the best one for enlarging into a finished work.

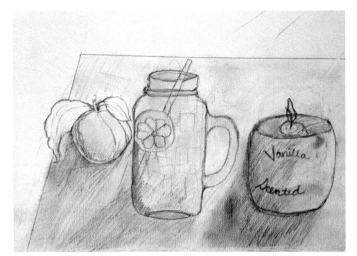

Left, Savannah Michel, *Still Life Grouping #1,* 2013. (Courtesy of the Artist)

Below left, In a first drawing, still life items were placed in a straight row on a table. In the second drawing, we see the same items arranged according to the Rule of Thirds. Savannah Michel, *Still Life Grouping #2,* 2013. Pencil on paper, modified in Photoshop. (Courtesy of the Artist)

Below right, Here you can see the nine equal-sized sections of the drawing. A piece of fruit rests in square B, very near the intersections of squares B-E-F-C. The light of the candle rests in square H, near its intersection with squares E-H-I-F, and the top of the fruit jar rests in square D, with the handle meeting the body of the jar in square G. Thus the strongest focal point meets at intersections of squares D-G-H-E. Focal point overlay on *Still Life Grouping #2,* 2013. (Courtesy of the Artist and the Author)

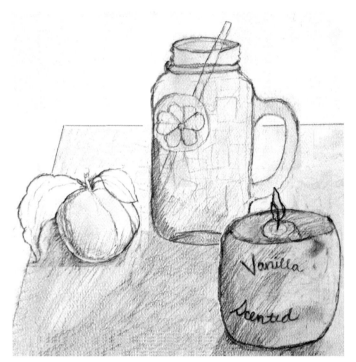

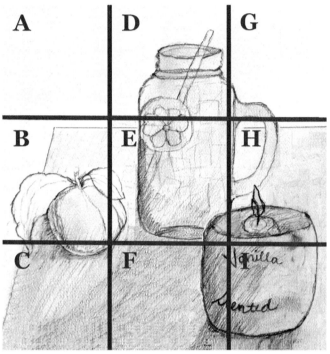

RULE OF THIRDS

Novice artists can employ a few basic conventions to assist them in producing pleasing compositions. One convention is known as the Rule of Thirds: the sheet of paper on which the image is to be drawn is "imagined as divided into nine equal parts by two equally spaced horizontal lines and two equally spaced vertical lines. . . . [I]mportant compositional elements should be placed along these lines or their intersections."[1] As a result, the important features of the artwork will be connected by implied lines that form a triangle. To use this simple compositional technique, with a ruler and very lightly penciled guidelines, divide your drawing or watercolor paper into nine equal parts. Draw your composition so that the focal point and two supportive features of the artwork fall on or very near three intersections of the guidelines. The resulting

image will be more interesting than if subjects were lined up in a straight row or randomly placed in the image.

OUTLINING NEGATIVE SPACE

Another way of thinking about how to make an interesting composition is to look at sketches you have made in planning your finished drawing and visually divide the sketched composition into quarters. Look closely at the negative space of each quarter; you might draw outlines around these negative spaces in order to help focus upon them. Are the negative spaces interesting? If the negative spaces are not interesting, the positive spaces will be less interesting than they might otherwise be. Rearrange your image or your point of view, or crop your image differently so negative and positive spaces are equally interesting.

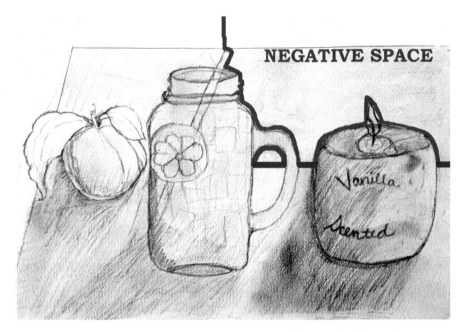

Divide sketches into quarters and draw around the negative space of each quarter. Which negative spaces are more visually interesting? *Still Life Grouping #1*, 2013. (Courtesy of the Artist and the Author)

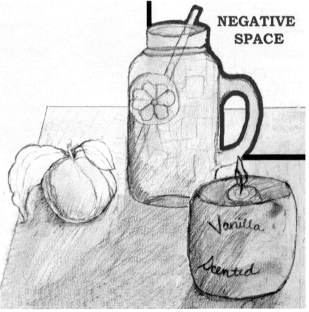

Notice that the objects in this still life differ in size and shape, adding interest to the overall composition. *Still Life Grouping # 2*, 2013. (Courtesy of the Artist and the Author)

Practice, Practice, Practice!

Becoming competent at art making, like gaining competency in any skill area, takes practice. First, it requires practice in observation. Because we see with such ease and seem to intuitively process what we see, we forget that intuitively "knowing" what a visual object is is not the same as really "seeing" that object. While you may only aspire to learn very basic skills that can be practically applied to some other (non-art-related) purpose, observation is a skill that will benefit many, if not most people, in their everyday and professional lives.

Practice in drawing or creating works of art is more likely to be productive if you choose a subject that greatly interests you. For example, if you are a fan of a particular televised series or popular story, such as *The Hunger Games* or *Game of Thrones*, perhaps you would find practice more rewarding if it involved copying images of your favorite characters and exploring the fashions worn by those characters, or drawing the architectural features or furnishings associated with the show. There is nothing wrong with copying as a way of learning basic skills. Once you have some confidence in your ability to adequately replicate through copying, you will want to move on to create original and improvisational illustrations of the subject.

Perhaps you are interested in becoming a musician, doctor, auto mechanic, botanist, or farmer. Observing the forms of musical instruments, organs of the human body, internal parts of an engine, or various seeds and plant forms stimulates the neurons of the brain that increase abilities to physically perform activities and cognitively process information about the observed subject.[2] Observing and creating art in response to observation is, therefore, as relevant and useful to goals that are not related to art as it is to goals that are. This textbook was created with this in mind. Those who aspire to become visual artists can find a plethora of resources for developing their skills; however, this text is intended as a resource for people who may not aspire to art-based careers but need or want to develop basic art skills and knowledge to support them in a variety of other goals.

NOTES

1. "Rule of Thirds," Wikipedia, last modified April 7, 2017, https://en.wikipedia.org/wiki/Rule_of_thirds. Also see explanation of the rule of thirds in B. F. Peterson, *Learning to See Creatively* (New York: AmphotoPress, 2003), 96–97.

2. See S. H. Johnson-Frey, F. R. Maloof, R. Newman-Norlund, C. Farrer, S. Inati, and D. T. Grafton, "Actions or Hand Object Interactions? Human Inferior Frontal Cortex and Action Observation," in *Neuron* 39 (2003): 1053–1058.

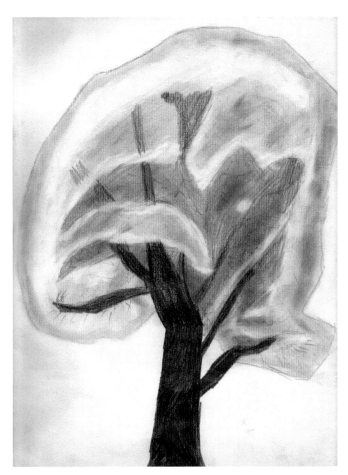
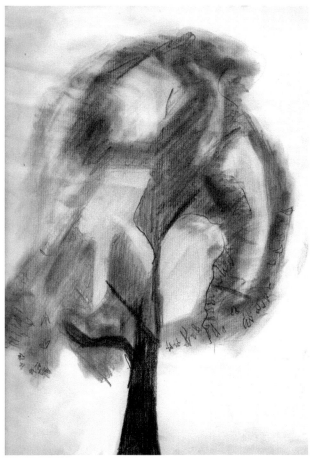

In a series of drawings of one tree, student William B. Kennedy demonstrates his increasing understanding of the tree's proportions and the way masses of foliage catch or hide light from above. "I think the most important thing that I came across from trying to draw trees was the idea of being very specific with my shading but not very specific at all with the actual material that is being shaded. I realized after a few failed attempts at trying to put great detail into drawing each leaf and each twig that I could possibly make out that that just wasn't possible. I just wasn't going to be able to get any resemblance of a tree if I attempted that. Therefore, I thought about what I was actually seeing when I looked at this tree. I realized that all the leaves were the same color up close but there were so many shades of green in the tree's leaves that I thought it would be important to show how the shadows lay across the tree and how, when there was an empty spot, you could see the inside of the mass of leaves was significantly darker than the outside. So I used a lot of eraser work to try to lighten up the places where the tree was being struck by the most light. Then, regarding the proportions of the trees, I suppose I have never really thought about how the trunk of the tree is not as tall as I would've guessed. In the first few drawings I tried the trunk took up half of the page! Hopefully I've now described a more accurate proportion of trunk to leaf mass." William B. Kennedy, *Studies of a Tree*, 2014, from student sketchbook. Pencil on paper, 12″ × 9″. (Courtesy of William Bixby Kennedy)

The Thematic Units

In the following section, you will find descriptions of the 22 *themes* or thematic units. These thematic units organize groups of lessons, which address the theme in such a way as to encourage gradual development of art skills and knowledge.

Each theme presents four *strands* of lessons. After looking through the themes and finding one that interests you, look through the lessons contained within that thematic unit. Beginning with the first strand of the theme, select and complete one lesson from each successive strand. When you have completed four lessons, one from each strand, you may move on to another theme and repeat this process, or return to the original thematic unit and complete a second sequence of lessons.

Theme #1: The Art of Drawing People

Few subjects are more fascinating to draw than people, and being able to produce a drawing of oneself or another person with competence gives satisfaction to the artist as well as to the person represented. Because we see ourselves in mirrors and interact with others nearly every day of our lives, it would seem that people would be the easiest subjects to draw, but this is rarely true. When we speak with or interact with people, we tend to focus on their eyes and mouth and don't look at the face as composed of shapes and forms that can be objectively viewed and drawn. We don't see our own or others' faces and bodies as being composed of mathematically ordered units of proportion, even though we intuitively respond to a well-proportioned face or body as physically attractive and notice when there are disconcerting errors of ideal proportion.

Looking at yourself or others from an artistic point of view requires that you see the person being drawn as a mathematical construction of proportional relationships. For instance, you could use a subject's head as a measurement unit for determining his or her height, and the eye as a ruler against which other features of the face can be measured. Close observation reveals that the law of Fibonacci applies to human proportions and motion. For example, look at how the fingers of the hand curl into a fist that mimics the Fibonacci spiral.

Theme #1: The Art of Drawing People

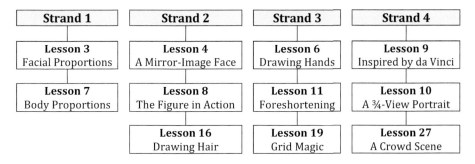

Strand 1	Strand 2	Strand 3	Strand 4
Lesson 3 Facial Proportions	**Lesson 4** A Mirror-Image Face	**Lesson 6** Drawing Hands	**Lesson 9** Inspired by da Vinci
Lesson 7 Body Proportions	**Lesson 8** The Figure in Action	**Lesson 11** Foreshortening	**Lesson 10** A ¾-View Portrait
	Lesson 16 Drawing Hair	**Lesson 19** Grid Magic	**Lesson 27** A Crowd Scene

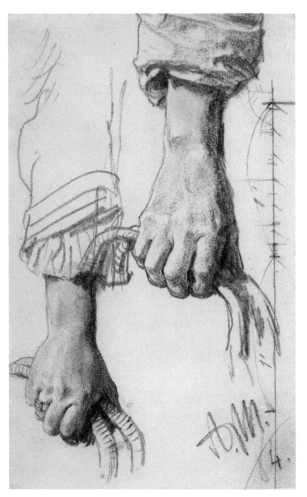

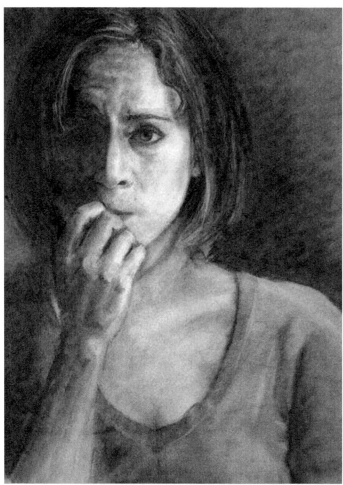

Adolph von Menzel (1815–1905),
Two Studies of a Right Hand, 1884.
Carpenter's pencil with stumping,
7 1/8" × 4 ⅜" (18.1 × 11.11cm). Los
Angeles County Museum of Art,
Los Angeles, CA.

Samantha Petry, *Worried*, 2014.
Charcoal on paper, 22" × 17".
(Courtesy of the Artist)

This thematic unit provides practice in rendering human forms. It begins with a look at basic facial or bodily proportions, and concludes with exercises in observing and drawing more complex aspects of the human body. To complete this theme, select and complete one lesson from each column, in order from left to right.

ELEMENTARY CLASSROOM APPLICATIONS

Very young children have their own delightfully symbolic ways of drawing human figures, with which we would not want to interfere. As children grow toward adolescence, they become more interested in the way things actually appear, and they want to draw objects realistically rather than as symbols of the things they represent. For example, it may no longer be sufficiently satisfying to draw a hook shape for noses; the young artist wants to know how a particular individual's nose actually looks as it comes out of the flat surface of the person's face.

As children voluntarily practice drawing, adolescents may look to adult models of art or copy drawings of muscular comic heroes, beautiful actresses, or other popular figures. This copywork is evidence that the young artist admires these characters, but it also reveals the adolescent's desire to feel competent in his or her abilities to draw human forms in action. Therefore, students in upper elementary grades appreciate learning strategies for drawing human faces and bodies more realistically. One such strategy is suggested in Lesson 118: Art of Ancient Egypt (see Theme #14). By

looking at examples of drawings that the viewer perceives as intuitively wrong (e.g., because of asymmetry, distorted proportion, or other inaccuracies of representation) and comparing these to realistic images that do not exhibit irregularities, students may determine for themselves what must be done to correct certain drawing errors. Of course, this understanding may be more quickly and effectively acquired with the assistance of an instructor who can focus the students' attention on correcting errors of drawing human forms.

Teaching about human proportions has an interdisciplinary advantage for students of all ages, even those who are too young to care about realistic drawings of people. The proportions of the human body are in accord with proportions in all of nature. Teaching students to use one part of an organism to determine the approximate size of its other parts is both a mathematical and scientific objective. Learning to *see* the faces and bodies of people with proportional accuracy (even if there is no subsequent desire or need to draw the human figure realistically) is an important bit of knowledge acquisition.

Theme #2: Drawing Objects Realistically

Many people think of an artist as a person who is able to create images that look as realistic as if taken by a photograph. While we hope that people will expand their understanding of authentic artworks to include a range of abstractive to realistic representations, the desire to reproduce images with realistic accuracy is a valid goal.

Being able to produce a convincing drawing of an object requires keen observation of details, such as careful attention to contours of form, proportion, light and shadow, and visual textures. In this thematic unit, you will begin to explore these object attributes, with particular attention to light and dark values and visual texture.

IMPORTANT TIPS

Realistic drawings are most compelling and interesting if they reveal the hand of the maker. Otherwise, why not simply take a photograph rather than draw at all? Works by the greatest artists throughout history are known because of some characteristic style or manner of representation, demonstrated intentionally or unintentionally by the artist. Looking carefully at drawings by a variety of master artists will reveal differences in style that render each uniquely aesthetically pleasing.

Drawing tools are important to success in art making. Without proper tools and materials, even the best efforts are wasted, and the artist can be quickly become discouraged because the end results are not as he or she intended. Besides the paper you choose to draw upon, the pencil is the most important tool for drawing. Before you begin this theme, be sure you have the proper drawing tools. The choice of drawing pencils can help create line variations and shading in your drawings. Hard lead pencils can be used if you want to produce only very soft shadows. Soft pencils can create very, very dark shadows with little pressure. You can obtain excellent inexpensive sets of pencils, such as Derwent Academy Sketching Pencils, from craft stores or by ordering online from Amazon.com.

Mabel Dwight, *Backyard*, 1938. Lithograph on paper (edition of 25 printed by the Federal Art Project), 14" × 10". Prints and Photographs Division, Library of Congress, Washington, DC.

Theme #2: Drawing Objects Realistically

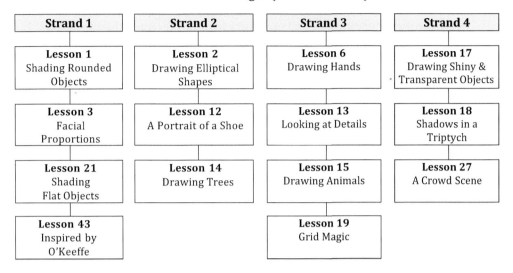

Strand 1	Strand 2	Strand 3	Strand 4
Lesson 1 Shading Rounded Objects	**Lesson 2** Drawing Elliptical Shapes	**Lesson 6** Drawing Hands	**Lesson 17** Drawing Shiny & Transparent Objects
Lesson 3 Facial Proportions	**Lesson 12** A Portrait of a Shoe	**Lesson 13** Looking at Details	**Lesson 18** Shadows in a Triptych
Lesson 21 Shading Flat Objects	**Lesson 14** Drawing Trees	**Lesson 15** Drawing Animals	**Lesson 27** A Crowd Scene
Lesson 43 Inspired by O'Keeffe		**Lesson 19** Grid Magic	

ELEMENTARY CLASSROOM APPLICATIONS

The vast majority of children born during the twenty-first century will have been exposed to virtual images via the internet and gaming software by the time they enter kindergarten. These technologies encourage the development of particular visual literacy skills related to reading man-made or computer-generated icons and cues, and moving through hyperspace. Unfortunately, however, these children may not have keen perceptions about the natural world. How many of us can name the types of trees that grow in our yards or are aware of the direction where evening shadows fall? What can we assume about the appearance of the hips and legs of an animal that weighs one ton and walks slowly, compared to the hips and legs of an animal that weighs 150 pounds and runs very quickly? An ability to *see* things in the visual world is a crucial literacy for lifelong learning and a particularly important interdisciplinary component for learning in the biological and natural sciences. To find out more about the importance of using images in teaching, and of being able to see and create visual images in learning, see

· Gangwer, T. *Visual Impact, Visual Teaching.* 2nd ed. Thousand Oaks, CA: Corwin Press, 2009.

Theme #3: Explorations in Color

Crayons, color markers, and paints are so omnipresent in the educational and play experiences of children today that it is hard to imagine that just over a century ago, materials used for teaching and learning in schools were almost entirely black and white. Crayons were invented in 1903, and color markers were invented 50 years later, although it took a few years more for either item to become commonly used by schoolchildren. Today, we are accustomed to working with color in the classroom; colors have become a mode of visual communication in their own right. Colors convey moods, discriminate and distinguish differences in information, and provide cues as to what to focus on or ignore. In this thematic unit, you can explore technical information about how color works in paintings and images, how we experience color in works of art, and how artists of the last century have used color to convey philosophical ideas about the world. Wet (i.e., paints and inks) and dry (i.e., crayon, marker, pencil, and colored paper) materials are included as possible media for explorations of color.

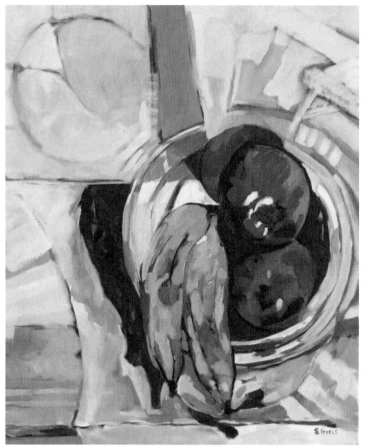

Sharon Geels, *Plantains and Pomegranates*, 2014. Acrylic on canvas, 24" × 20". (Courtesy of the Artist)

Theme #3: Explorations in Color

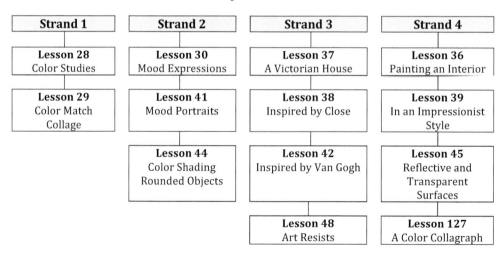

Strand 1	Strand 2	Strand 3	Strand 4
Lesson 28 Color Studies	**Lesson 30** Mood Expressions	**Lesson 37** A Victorian House	**Lesson 36** Painting an Interior
Lesson 29 Color Match Collage	**Lesson 41** Mood Portraits	**Lesson 38** Inspired by Close	**Lesson 39** In an Impressionist Style
	Lesson 44 Color Shading Rounded Objects	**Lesson 42** Inspired by Van Gogh	**Lesson 45** Reflective and Transparent Surfaces
		Lesson 48 Art Resists	**Lesson 127** A Color Collagraph

PAINTING IN THE ELEMENTARY CLASSROOM

Although watercolors are commonly marketed as an appropriate art media for elementary students, watercolor painting is challenging. Children need instruction and practice in order to produce effective watercolor paintings with brushes. If packaged watercolor trays are to be used, demonstrate how brushes must be gently rinsed in water before being dipped in a new color. This helps keep colors clean and bright. The bristles of brushes should never be squeezed dry; instead, dripping brushes can be gently touched against the inside rim of the water container or touched to a paper towel to remove excess water. Brushes should never be left standing in water containers, as this not only causes the bristles to become permanently bent but also increases the risk of accidental spills.

This thematic unit could provide an opportunity for young students to have successful experiences in working with color and paint without having necessarily mastered sophisticated skills in watercolor painting. Other techniques appropriate for young children include using watercolors to create resist paintings, wet-on-wet paintings of backdrops for under-the-sea scenes or spring and autumn landscapes, and simple monoprints. When creating any watercolor painting, however, children will find the painting experience more successful if they begin using lighter, more transparent colors first (i.e., yellow, pink, or turquoise) and apply the darker, less transparent colors (i.e., purple, brown, and black) last. Likewise, the backgrounds of paintings should be painted before foregrounds or details.

If your art supply budget is limited, you might consider tempera paints as an alternative to watercolors. Tempera can be diluted with water to create the consistency of transparent watercolor or left in its normal consistency for opaque painting. Small amounts of tempera can be squirted into paint trays or large amounts can be poured into cups, in order that the paint be applied with tiny or large brushes. Also, tempera paints come in a wide variety of colors, and they are economical, easy to clean up, and easy to store. See the Tips for Teachers section in Lesson 28: Color Studies for information about selecting appropriate tempera colors (hues) for teaching elementary students about mixing colors.

Occasionally one finds that the use of wet media such as tempera or watercolor paint is not convenient or practical. If this is the case, using watercolor pencils may be an option. These allow color to be applied as if by colored pencils and afterwards, a damp brush is daubed over the color, which causes the colors to melt and flow more like paint. Inexpensive Staedtler Watercolor or Derwent Inktense Pencils work excellently as dry/wet art making materials.

Theme #4: Visual Music, Light, and Movement

The previous theme offered opportunities to experience functions of colors in visual images as they are exposed by light or hidden by darkness, blended to create color harmonies, or placed in competition to arouse passionate sensations of joy, suspense, or profound sorrow. In this theme, you are invited to explore how color and light serve as visual music. Additionally, you may explore how the sensation or impression of movement is produced by the ways that Elements and Principles of Art are presented within a composition. Movement that is created by rhythmic tempos of music or the swaying of a human body in dance is suggested in visual art by the way one's eyes are guided to move like music through the work of art.

This thematic unit begins by inviting a visual translation of music into composition. Further lessons encourage visual interpretations of mood, resonance with music and poetry, movement through time, or metaphoric connection.

Kate Gessling, *Mardi-Gras Matisse*, 2013. Collage and Photoshop CS6 manipulation, 12" × 9". (Courtesy of the Artist)

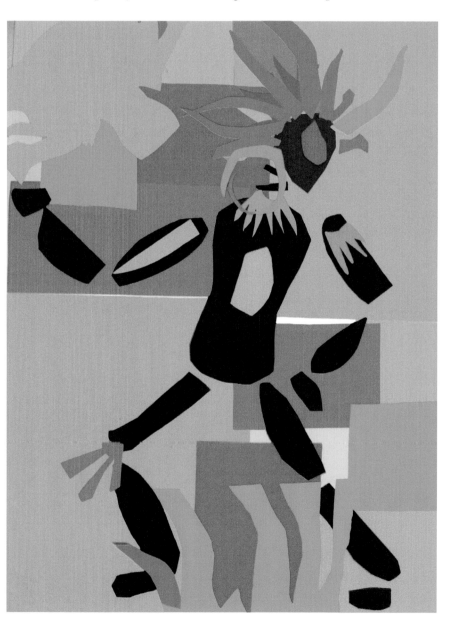

Theme #4: Visual Music, Light and Movement

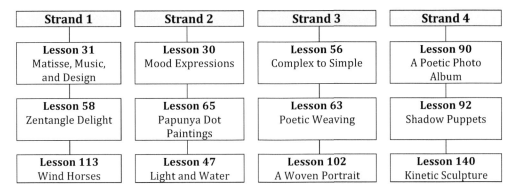

Strand 1	Strand 2	Strand 3	Strand 4
Lesson 31 Matisse, Music, and Design	**Lesson 30** Mood Expressions	**Lesson 56** Complex to Simple	**Lesson 90** A Poetic Photo Album
Lesson 58 Zentangle Delight	**Lesson 65** Papunya Dot Paintings	**Lesson 63** Poetic Weaving	**Lesson 92** Shadow Puppets
Lesson 113 Wind Horses	**Lesson 47** Light and Water	**Lesson 102** A Woven Portrait	**Lesson 140** Kinetic Sculpture

CLASSROOM APPLICATIONS

Visual art, music, and movement are three sensual languages of learning. Perhaps you have observed children in classrooms who sing or chatter to themselves, sway or swing parts of their bodies as they work. These may be children who need the stimulation of images, music, or movement in order to organize and make sense of information input. Permitting these children opportunities to express their knowledge or understanding through various artistic media may offer insights into learning that is tacit and cannot be adequately measured through traditional didactic modes of assessment.

Art making invites play, and play is a critical component of learning. Play exercises reasoning skills and an ability to organize information in logical ways. It compels players to push through challenges and persevere in quests for answers and solutions to problems. It requires social integration with others. Play is fun, and so is art making.

There are a multitude of educational resources that present interdisciplinary information in artistic ways. Many demonstrate connections between art and music or poetry, art and science, math, literature, or social studies. Two classic examples include

· *Fantasia.* Directed by J. Agar, S. Armstrong, and F. I. Beebe. DVD. Walt Disney Studios, 1940/2000.
· *Schoolhouse Rock!* Special 30th anniversary edition. Directed by T. Warburton. DVD. Walt Disney Studios, 2010.

Theme #5: The Human Condition

While Theme #1 offered opportunities to practice drawing the human figure as a physical form, in this thematic unit you are invited to explore the emotional and meaning-seeking worlds of human beings through visual stories, rhythms, and art. We respond to popular stories and compelling music because these modes of expression appeal to universal archetypes of being and feeling. All humans experience the heights and depths of emotion these arts inspire, but each person experiences these emotions in response to unique circumstances and as a result of social enculturation. The lessons of this thematic unit offer opportunities to explore who and how you uniquely are in the world, and how all people are connected through empathetic resonance with others of past and present traditions.

Brian Cho, *Filtered*, 2015.
Acrylic on canvas, 43½" × 50".
(Courtesy of the Artist)

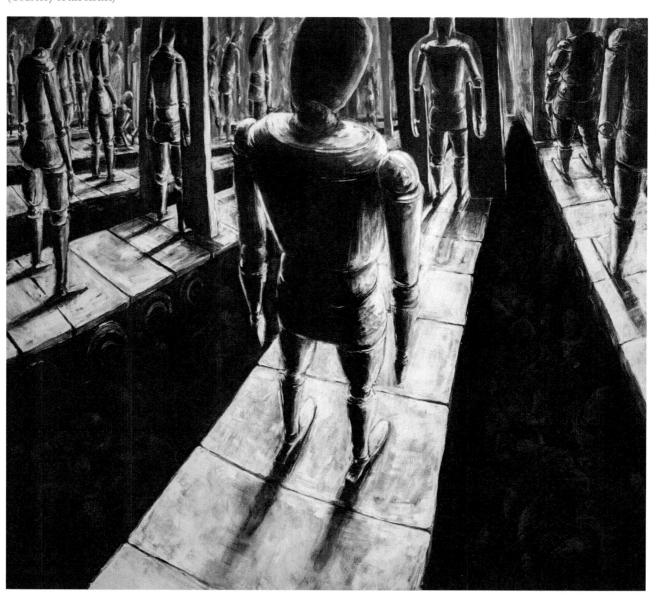

Theme #5: The Human Conditions

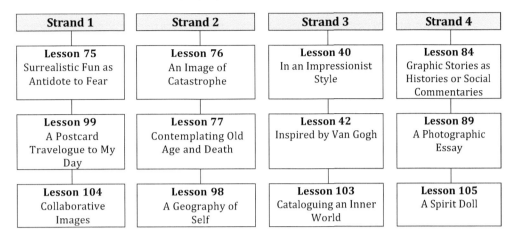

Strand 1	Strand 2	Strand 3	Strand 4
Lesson 75 Surrealistic Fun as Antidote to Fear	**Lesson 76** An Image of Catastrophe	**Lesson 40** In an Impressionist Style	**Lesson 84** Graphic Stories as Histories or Social Commentaries
Lesson 99 A Postcard Travelogue to My Day	**Lesson 77** Contemplating Old Age and Death	**Lesson 42** Inspired by Van Gogh	**Lesson 89** A Photographic Essay
Lesson 104 Collaborative Images	**Lesson 98** A Geography of Self	**Lesson 103** Cataloguing an Inner World	**Lesson 105** A Spirit Doll

ELEMENTARY CLASSROOM APPLICATIONS

Recent discoveries of how the brain processes and organizes information have revealed an important connection between cognitive and emotional processes. Frustration, despair, anxiety, sorrow, and shame obstruct the ability to learn and remember information. The arts have been found to release these hindering emotions, calm the spirit, and sooth individuals into a reflective state, from which they can begin to make sense of or re-order chaotic emotions. Not only can the arts heal individual emotional wounds, they also help develop empathy for others—which is essential to forming caring human beings. Viktor Lowenfeld, an extraordinary educator of the mid-twentieth century, asserts that as a child is involved in creating art, "he learns to use his imagination in such a way that it will not be difficult for him to visualize the needs of others as if they were his own."[1] The lessons in this thematic unit focus on feelings that are not given space in the general curriculum. They provide an opportunity for tacit expression of things that cannot be mentioned insofar as these have been deemed irrelevant to academic disciplines, are controversial, or otherwise considered inappropriate to dwell upon during school hours.

The opportunity to express one's feelings freely in a supportive learning environment is not without academic benefit, for while expressing these feelings, students also must negotiate processes of art making which are learning experiences in and of themselves. Yet the most profound benefit of arts that consider the human condition is simply that they address the most fundamental questions and problems of life, such as Who am I? What is the purpose of my existence? and How must I be in the world?

Theme #6: The Beautiful Arts of Math and Science

Among the general population, there is sometimes a perception that the cognitive processes required for mastering math and science are opposite to those required for appreciating and mastering art. Yet this is a vast misconception, for those "scientific rules" that order mathematics and the sciences also order art. Pattern, proportion, symmetry, and transformation are fundamental concepts to both disciplines. Furthermore, the intellectual characteristics of artists and scientists/mathematicians are remarkably similar. In the words of noted physicist F. David Peat, "Both are motivated by a high degree of intellectual curiosity and in their respective ways are constantly asking questions in the pursuit of truth."[2] Additionally, both are inspired by randomly abstract or highly structured forms. The lessons of this thematic unit provide opportunities to see the world around us from new perspectives, explore a fundamental pattern in nature—the law of Fibonacci—as well as basic geometric functions or random accident in service of creating something of great beauty.

Theme #6: The Beautiful Arts of Math and Science

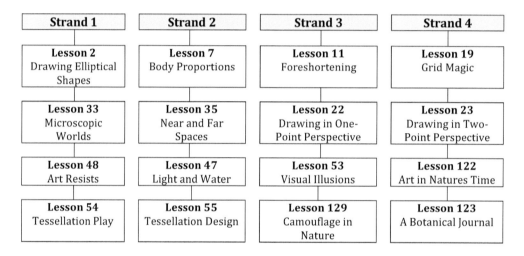

Strand 1	Strand 2	Strand 3	Strand 4
Lesson 2 Drawing Elliptical Shapes	**Lesson 7** Body Proportions	**Lesson 11** Foreshortening	**Lesson 19** Grid Magic
Lesson 33 Microscopic Worlds	**Lesson 35** Near and Far Spaces	**Lesson 22** Drawing in One-Point Perspective	**Lesson 23** Drawing in Two-Point Perspective
Lesson 48 Art Resists	**Lesson 47** Light and Water	**Lesson 53** Visual Illusions	**Lesson 122** Art in Natures Time
Lesson 54 Tessellation Play	**Lesson 55** Tessellation Design	**Lesson 129** Camouflage in Nature	**Lesson 123** A Botanical Journal

CLASSROOM APPLICATIONS

A classic resource for seeing connections between math and art is the Disney-produced film, *Donald in Mathmagic Land*.[3] Recognition of powerful relationships between science, math, and art also has been acknowledged by those who suggest the Science, Technology, Engineering, and Mathematics (STEM) curriculum movement be modified to incorporate the arts (STEAM) as an integral and inseparable part of science education. Adding art as a component of STEM acknowledges the arts as ways of knowing by recognizing

· the role of creative thinking in scientific research
· the role of design in successful engineering
· the role of visualization in empowering mathematical reasoning
· how all sciences and maths are ultimately grounded in the delicate balance between order and disorder
· how visual metaphor and archetypal figures function in cognitive thinking, meaning making, and healthy human psychology

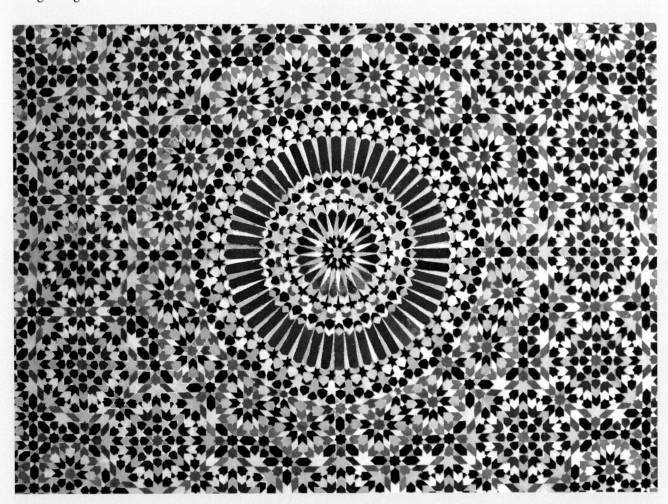

The Grand Mosque was constructed by the French people in 1926 in appreciation of the 100,000 Muslim fighters who died in support of France during World War I. *Grand Mosque of Paris (Grande Mosquée de Paris)*, detail of mosaic, 1926. (Photograph by Marc Cooper. CC by 2.0)

Theme #7: The Space around Us

Early in the artistic development of children, they become concerned with objects in their environment and wonder how to indicate where these object are located in space. In early attempts at describing space, all objects may be presented on a flat ground line, with no overlapping objects. Eventually objects may appear to float in space, or be placed high on the page as indication of their distance from the viewer. Placement on the page and other ways of suggesting space that are typical of young children are attempts to express concepts rather than actualities of space. Of course, this is not to say that young children do not see space accurately, for they obviously do. Furthermore, even very young children can be guided to observe and reproduce the details they see in objects of their environment.

Félix Vallotton (1865–1925), *Honfleur in the Mist (Honfleur dans la brume)*, 1911. Oil on canvas. 32¼" × 34 2/3" (82 × 88 cm). Musée des beaux-arts de Nancy, France. (Photograph by Ji-Elle. CC by 3.0)

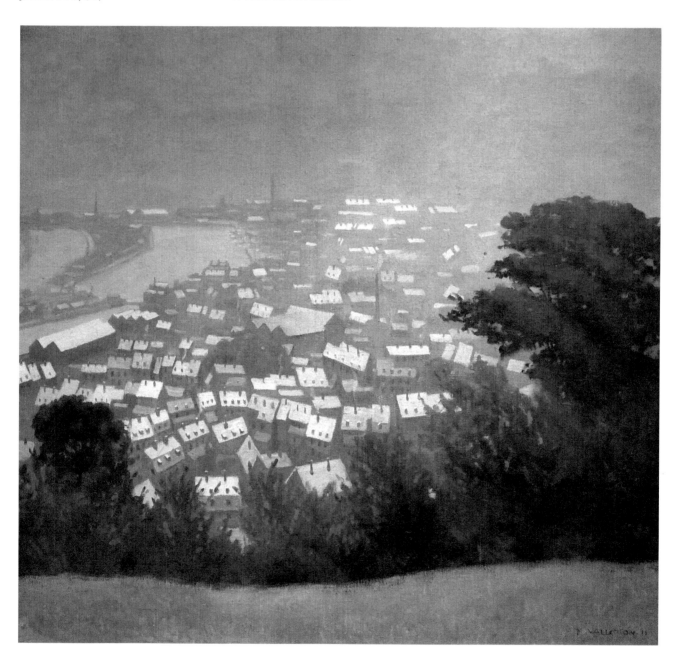

Once children begin to express interest in realistic portrayals of objects in space, they may be guided to notice and draw linear perspectives and create images that convey depth and volume. They also can understand space as a metaphoric concept, or as something that we do not inhabit so much as we *experience* as an extension of self.

Being aware of distance and space is important to movement through one's environment. Weather effects can change one's orientation and movement through space. The use of GPS (Global Positioning System) devices has removed the necessity of reading maps, but has also freed us to think of novel ways of perceiving or using maps. The strands of this thematic unit are arranged to move from observing objects closely to depicting them in linear space or remembered time.

Theme #7: The Space Around Us

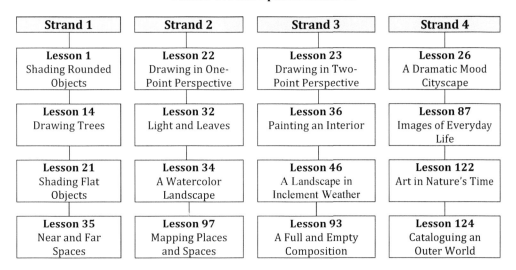

Strand 1	Strand 2	Strand 3	Strand 4
Lesson 1 Shading Rounded Objects	**Lesson 22** Drawing in One-Point Perspective	**Lesson 23** Drawing in Two-Point Perspective	**Lesson 26** A Dramatic Mood Cityscape
Lesson 14 Drawing Trees	**Lesson 32** Light and Leaves	**Lesson 36** Painting an Interior	**Lesson 87** Images of Everyday Life
Lesson 21 Shading Flat Objects	**Lesson 34** A Watercolor Landscape	**Lesson 46** A Landscape in Inclement Weather	**Lesson 122** Art in Nature's Time
Lesson 35 Near and Far Spaces	**Lesson 97** Mapping Places and Spaces	**Lesson 93** A Full and Empty Composition	**Lesson 124** Cataloguing an Outer World

Theme #8: Tales of the Imagination

Imagination is more important than knowledge. For knowledge is limited to all we now know and understand, while imagination embraces the entire world, and all there ever will be to know and understand.—Albert Einstein

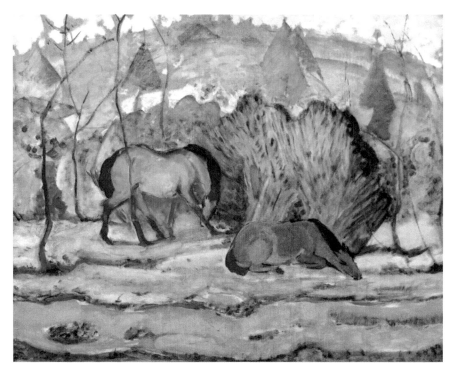

Franz Marc (1880–1916). *Horses Grazing (Chevaux au pâturage)*, 1910. Tempera on paper, 24⅛" × 32¼" (61.5 × 82 cm). Musée des beaux-arts de Liège, Belgium.

We are born into a world of mystery and enigma, assaulted by a confusion of sights, sounds, and other sensations. We begin to order and make sense of that world through narrative and story. The stories others tell serve as archetypal models of how we might effectively conduct ourselves as we maneuver through the landscape of our personal narratives. Stories can function in this way because we are gifted with great powers of imagination.

This thematic unit invites you to explore imaginative story as told through visual imagery, and consider how visual stories inform understandings of self and the world.

Theme #8: Tales of the Imagination

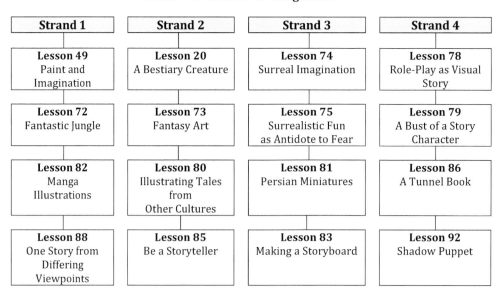

Strand 1	Strand 2	Strand 3	Strand 4
Lesson 49 Paint and Imagination	**Lesson 20** A Bestiary Creature	**Lesson 74** Surreal Imagination	**Lesson 78** Role-Play as Visual Story
Lesson 72 Fantastic Jungle	**Lesson 73** Fantasy Art	**Lesson 75** Surrealistic Fun as Antidote to Fear	**Lesson 79** A Bust of a Story Character
Lesson 82 Manga Illustrations	**Lesson 80** Illustrating Tales from Other Cultures	**Lesson 81** Persian Miniatures	**Lesson 86** A Tunnel Book
Lesson 88 One Story from Differing Viewpoints	**Lesson 85** Be a Storyteller	**Lesson 83** Making a Storyboard	**Lesson 92** Shadow Puppet

Theme #9: Symbolic and Visual-Textual Communication

As people who speak different world languages and dialects increasingly interact and exchange information through the internet, verbal languages are giving way to a common cross-linguistic language of visual images. Images as symbols or icons allow us to maneuver our way through a cyberworld with ease and competence, even when we do not share one another's verbal languages.

Symbols can be manipulated by artists to convince or persuade viewers to think or act in particular ways. Imagic symbols stimulate desires, evoke memories or emotions, and open understanding about things that are real but tacit and cannot be expressed with words. Artistic images have always been features of human language, but being able to read and write in the language of art is now a crucial literacy for living competently in a twenty-first-century world.

In this thematic unit, you are invited to explore art as a visual language, and consider what and how you might effectively communicate in that language.

Laurie Gatlin, *Untitled Sketchbook Pages*, 2013. Mixed media, 11" × 8 ½". (Courtesy of the Artist)

Theme #9: Symbolic & Textural Communication

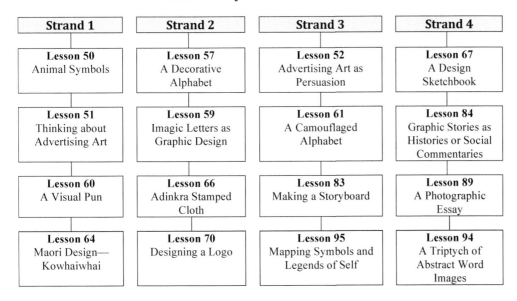

Strand 1	Strand 2	Strand 3	Strand 4
Lesson 50 Animal Symbols	**Lesson 57** A Decorative Alphabet	**Lesson 52** Advertising Art as Persuasion	**Lesson 67** A Design Sketchbook
Lesson 51 Thinking about Advertising Art	**Lesson 59** Imagic Letters as Graphic Design	**Lesson 61** A Camouflaged Alphabet	**Lesson 84** Graphic Stories as Histories or Social Commentaries
Lesson 60 A Visual Pun	**Lesson 66** Adinkra Stamped Cloth	**Lesson 83** Making a Storyboard	**Lesson 89** A Photographic Essay
Lesson 64 Maori Design— Kowhaiwhai	**Lesson 70** Designing a Logo	**Lesson 95** Mapping Symbols and Legends of Self	**Lesson 94** A Triptych of Abstract Word Images

CLASSROOM APPLICATIONS

Many classroom teachers prepare newsletters for parents of their students. Try having the students be creative directors of their class newsletter. Invite them to create a classroom logo, decorative motifs, and layouts for the news, or otherwise participate as reporters, editors, layout artists, and designers. Use the newsletter as a source of discussion about how texts and images are used for persuasive purposes.

Theme #10: Art of the Built Environment

How often do you notice the external shapes of buildings and wonder at differences of architectural styles and types? Some differences are striking, as when comparing a 20-story glass-walled skyscraper to a four-story jewel-box-like limestone office building, whose facade is decorated with intricate Art Deco carvings. We can assume these buildings were built at different times and, perhaps, for different purposes. Yet some architectural forms are so familiar to us that they seem natural, and we may not consciously question or wonder about them. For example, county courthouses and other government buildings that imitate classical Roman or Greek architecture are clearly distinguishable from ordinary homes, which tend to reflect characteristics of the

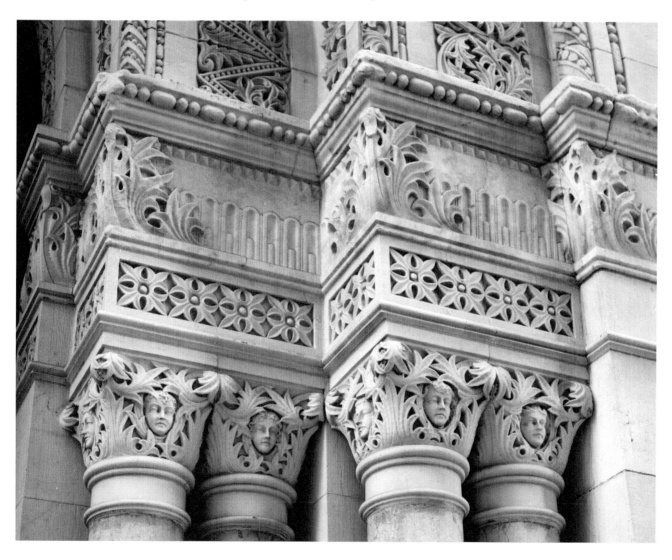

Burnham and Root/D. H. Burnham Company (Architects), *Detail, Capitals and Entablature at Entrance to Mills Building*, San Francisco, CA, 1892. Photograph taken ca. 1933, 4" × 5". Prints and Photographs Division, Library of Congress, Washington, DC.

local regions and climates where they are located. Homes in arid hot regions may be made of adobe with flat roofs, while homes in the wintry north often feature steep roofs and windows facing the south to capture as much sun as possible. Homes and buildings can be fascinating subjects for artists. Certain homes capture our imagination as quaintly romantic, or elegant and stately.

Children may dream of living in castles, while adults imagine homes tucked away in secluded places surrounded by manicured lawns and luxurious flower gardens. How would one draw representations of these buildings? What kinds of buildings do we imagine for ourselves and what do the buildings we imagine tell us about ourselves?

In this thematic unit, you will explore techniques of rendering buildings in art, monuments and public sculptures, and assemblages. Then you may follow your imagination to envision a built environment of your dreams.

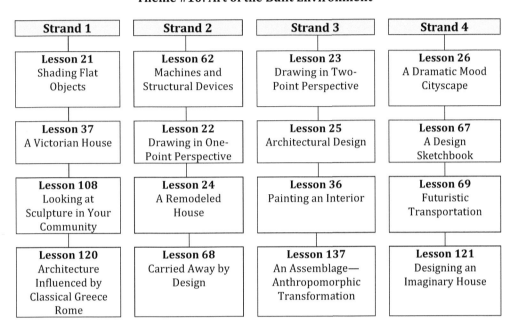

Theme #10: Art of the Built Environment

Strand 1	Strand 2	Strand 3	Strand 4
Lesson 21 Shading Flat Objects	**Lesson 62** Machines and Structural Devices	**Lesson 23** Drawing in Two-Point Perspective	**Lesson 26** A Dramatic Mood Cityscape
Lesson 37 A Victorian House	**Lesson 22** Drawing in One-Point Perspective	**Lesson 25** Architectural Design	**Lesson 67** A Design Sketchbook
Lesson 108 Looking at Sculpture in Your Community	**Lesson 24** A Remodeled House	**Lesson 36** Painting an Interior	**Lesson 69** Futuristic Transportation
Lesson 120 Architecture Influenced by Classical Greece Rome	**Lesson 68** Carried Away by Design	**Lesson 137** An Assemblage—Anthropomorphic Transformation	**Lesson 121** Designing an Imaginary House

CLASSROOM APPLICATIONS

Art instruction that features architecture or the built environment integrates well with units that focus on history and historic places. It becomes an assessment tool of learning in other disciplines as students put to work their knowledge of climate, geography, natural resources, and needs for public and private spaces. Also, when students make models of the drawings they imagine, they practice math and engineering skills in pleasurable ways. Resources to assist in teaching the art of built environments include

· MDOE. *It's Elementary: Architecture*. Curriculum guide, Michigan Department of Education, n.d.

National Park Service. 2011. http://www .k5architecture.org/pdf/g5%20-%20Grade%205 .pdf. 2.

· *Teaching with Historic Places*. Web resource. https://www.nps.gov/subjects/teachingwith historicplaces/index.htm.

· Teach Engineering. "Lesson: Architects and Engineers." *Teach Engineering Curriculum for K–12 for Teachers*. Regents of the University of Colorado, 2006. http://www.teachengineering .org/view_lesson.php?url=collection/cub _/lessons/cub_intro/cub_intro_lesson03.xml.

Theme #11: Fantastic Worlds

Like Theme #8: Tales of the Imagination, this thematic unit combines narrative and image as powerful tools for helping us make sense of the world around us, and for visualizing what might be. Fantasy and science fictions may begin in playful imaginings, then inspire us as adults to invent that which once existed only in our dreams or offered a pleasurable escape from mundane experience. Such dreams satisfy deeply intuitive needs for sensual delight. In this theme, you need not worry about what might be "realistically" in the future; rather, you can and should focus on what exists purely in the wonderfully present realm of the imagination.

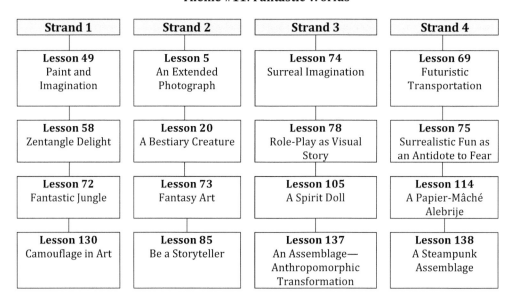

Theme #11: Fantastic Worlds

Strand 1	Strand 2	Strand 3	Strand 4
Lesson 49 Paint and Imagination	**Lesson 5** An Extended Photograph	**Lesson 74** Surreal Imagination	**Lesson 69** Futuristic Transportation
Lesson 58 Zentangle Delight	**Lesson 20** A Bestiary Creature	**Lesson 78** Role-Play as Visual Story	**Lesson 75** Surrealistic Fun as an Antidote to Fear
Lesson 72 Fantastic Jungle	**Lesson 73** Fantasy Art	**Lesson 105** A Spirit Doll	**Lesson 114** A Papier-Mâché Alebrije
Lesson 130 Camouflage in Art	**Lesson 85** Be a Storyteller	**Lesson 137** An Assemblage— Anthropomorphic Transformation	**Lesson 138** A Steampunk Assemblage

CLASSROOM APPLICATIONS

Children learn best when knowledge is wrapped in sensual delight. For this reason, much of children's literature—even when it aims to convey factual information about the world—is expressed through fiction, fairytale, and fantasies that feature talking animals, wizards, fairies, and other purely imaginary beings. Invite children to invent their own characters and stories as they work out or work through frustrations and confusions in their lives.

Erithe (Erin McChesney),
Erithe in Hogwarts, 2003; *Long Ago and Far Away*, 2003. Digital media.
(Courtesy of the Artist)

Theme #12: Domestic Arts

When we hear the term "domestic arts" we tend to think of women's traditionally assigned work, even though many women are no longer solely tied to the chores of domestic life, and men as well as women can—and do—work in media typically associated with the home. Some domestic art products are made for use by other family members rather than for exhibition display in sanctuaries of "high art" such as museums. Dissanayake described the impulse to create artifacts for loved ones or objects to be shared in social situations as a "making special" of the ordinary.[4] How might the purpose for which an artifact is made alter people's perceptions of its value or place in the hierarchy of art? How might knowing who made the artifact influence perceptions of its value? When the same processes are used to create objects for display in galleries or museums as are used to supply needed items for loved one, does this render such artistic products more or less socially valuable? This thematic unit begins with an investigation of either a woman who creates art in your immediate vicinity or famous women artists in history. It ends with invitations to create artistic works in textile media.

Theme #12: Domestic Arts

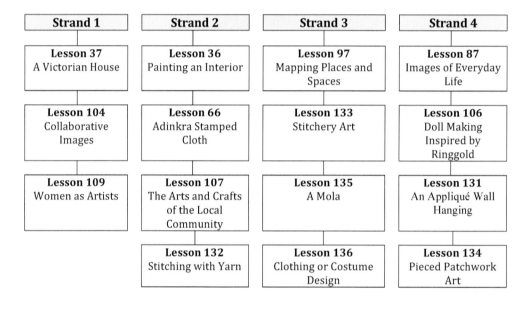

Strand 1	Strand 2	Strand 3	Strand 4
Lesson 37 A Victorian House	**Lesson 36** Painting an Interior	**Lesson 97** Mapping Places and Spaces	**Lesson 87** Images of Everyday Life
Lesson 104 Collaborative Images	**Lesson 66** Adinkra Stamped Cloth	**Lesson 133** Stitchery Art	**Lesson 106** Doll Making Inspired by Ringgold
Lesson 109 Women as Artists	**Lesson 107** The Arts and Crafts of the Local Community	**Lesson 135** A Mola	**Lesson 131** An Appliqué Wall Hanging
	Lesson 132 Stitching with Yarn	**Lesson 136** Clothing or Costume Design	**Lesson 134** Pieced Patchwork Art

CLASSROOM APPLICATIONS

With what kinds of art are your students familiar in the context of their communities? Who makes that art, and where do the students experience it? Do others of the community value this type of art or art making? If so, how is it valued or experienced? Is it considered as art or something else? Look to your students for answers to these questions. If possible, invite a member of the community who is recognized as an expect in a locally appreciated art form to share her or his work and the processes of making it with students of your class.

Quilt Top, "M. B. 1807," England, 1807. Pieced and appliquéd cotton quilt, 71½" × 62¼" (181.6 × 158.1 cm). Los Angeles County Museum of Art, Los Angeles, CA.

Theme #13: Traditions of Fine Arts and Artists

Ever since human beings appeared on the face of the earth, people of every culture in every time and place have created art. Expression through art is instinctual, evolutionary, and a uniquely human need. This thematic unit invites you to take a brief glimpse at some of the cultural artifacts one might find housed and displayed in a museum, as representing some of the expressions of diverse peoples and cultures through time and place.

Ohara Shoson (Kosan), (Japan, 1877–1945), *Egrets in Snow*, 1927. Color woodblock print, 14¼" × 9 11/16" (36.2 × 24.6cm). Los Angeles County Museum of Art, Los Angeles, CA.

Theme #13: Traditions of Fine Art and Artists

Strand 1	Strand 2	Strand 3	Strand 4
Lesson 107 The Arts and Crafts of the Community	**Lesson 31** Matisse, Music, & Design	**Lesson 43** Inspired by O'Keeffe	**Lesson 80** Illustrating Tales from Other Cultures
Lesson 108 Looking at Sculpture in Your Community	**Lesson 109** Women as Artists	**Lesson 101** Yin and Yang	**Lesson 81** Persian Miniatures
Lesson 110 Visiting a Museum	**Lesson 111** Native American Artists	**Lesson 112** Visual Poetry in Myth	**Lesson 119** A Cultural Fusion Mandala
Lesson 116 Out of Africa	**Lesson 120** Architecture Influenced by Classical Greece and Rome	**Lesson 118** Art of Ancient Egypt	**Lesson 128** Multicolor Block Printing

CLASSROOM APPLICATIONS

Set up a mini-museum exhibition space in your room. Invite students to bring artifacts from their homes and the community that represent something unique or remarkable about their families or community. Urge students to think carefully about the items they select for display. What worldviews do they convey? Will they stand the test of time? What do they tell us about the individual student families and their cultural communities? Is there an art guild or art community in your local area? What types of art or crafts are displayed there? Who made those items? Are art fairs held in your community? What kinds of art are displayed, exhibited, or sold at these fairs? Who makes these items, and who buys them?

Artworks may be made by individuals for personal reasons or by groups of people who share common interests, but the ultimate purpose of all works of art is social. Art is made to communicate with, be shared with, or experienced by others. On an individual level, artworks may function to express or heal the "self" in the world. On a public level, art conveys understandings of who we are or how we should or might be in the world. Discuss ideas of art as civic participation with your students.

If there are exhibit spaces or events in your community that are open to student works, negotiate for your students' work to be displayed—or, set up a class website of student works. Have students participate in selecting appropriate subject matter, themes, and types of work that might be displayed. You could also involve the community by inviting parents to assist your students in preparing their works for display. Guide your students to recognize the special cultural and communicative value of their art and the art of others.

Theme #14: Global Traditions and Cultures

When we travel as tourists to unfamiliar countries or regions of the world, we are bound to see sights and encounter people whose ways of life are different from our own. It is difficult to assimilate all the subtle differences we see. Therefore, we tend to group these differences into broad categories, with the result that we may construct stereotyped impressions of the peoples and life worlds we encounter. In order to avoid stereotypes, it is important to acknowledge from the beginning that what we will see is not representative of all of the nation or region visited. It represents only a snapshot, a tiny picture from a particular (and often picturesque or romanticized) vantage point. That does not mean we are viewing the culture wrongly; it just means we will want to recognize our perceptions of other cultural groups as being quite narrow. In this thematic unit, you will look at collected art that has been housed in a museum setting or created by artists from specific cultural groups, and you will challenge yourself to learn more about these geographic or cultural realms through research explorations. You may also look at and consider yourself in the context of your own cultural background.

Facing left, Glengarry Cap, Haudenosaunee, 1860s. Cloth and glass beads. Glenbow Museum, Calgary, AB. (Photograph by Daderot, via Wikimedia Commons)

Facing right, Shirt with Tadpole Design, Kainai, early 1900s. Elk hide, porcupine quills, natural dyes, and weasel pelts. Glenbow Museum, Calgary, AB. (Photograph by Daderot, via Wikimedia Commons)

Theme #14: Global Traditions and Cultures

Strand 1	Strand 2	Strand 3	Strand 4
Lesson 50 Animal Symbols	**Lesson 101** Yin and Yang	**Lesson 39** In an Impressionist Style	**Lesson 114** A Papier-Mâché Alebrije
Lesson 110 Visiting a Museum	**Lesson 111** Native American Artists	**Lesson 40** In an Expressionist Style	**Lesson 115** A Retablo
Lesson 116 Out of Africa	**Lesson 113** Wind Horses— Tibetan Prayer Flags	**Lesson 81** Persian Miniatures	**Lesson 117** A Mardi Gras Mask
	Lesson 118 Art of Ancient Egypt	**Lesson 112** Visual Poetry in Myth	**Lesson 119** A Cultural Fusion Mandala

CONSIDERATIONS AND CLASSROOM APPLICATIONS

When we talk of traveling to unfamiliar places, we often speak of meeting people from other cultures or having different cultural experiences. In other words, we use the term "culture" as a noun in reference to a general concept or as an adjective when describing that human quality (i.e., the cultured person) that is the goal of culturally sensitive educational practices. Generally, culture is used in reference to any group whose members hold similar beliefs, histories, customs, mores, and values, and whose members communicate with one another in a common language or symbol system.[5]

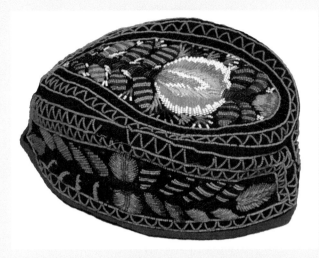

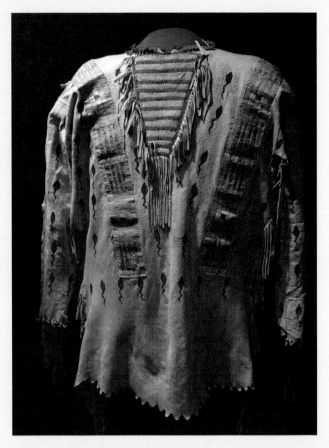

According to this broad definition, various cultures may be defined by commonalities of religion, nation, race, and/or socio-economic condition. For example, people may be born, raised, live among, and identify with members of Islamic, Romanian, Hispanic, English-speaking, rural middle-American, or working-class cultures. Culture defined in generalities implies no evaluative judgment of the political correctness or social value of any particular group perspective or expression. To describe a collective organization of people as a culture simply acknowledges group adherence to a particular paradigm of life. This already is recognized and addressed in value-neutral social studies and art curriculum presented to students in American public schools.

Culture also may refer to a community of people who are drawn together by local geographies of interest and who participate with others in ways that shape and influence perceptions of all group members. These groups might be better understood as subcultures, because they exist as smaller components within overarching cultures and attract members who come together for varying periods of time in order to share limited common interests. Examples of subcultures include fans of a particular personality or narrative of popular culture, video gamers, soccer players, or people who dress, behave, share attitudes, and embrace identities as goths, jocks, or artists. The members of these subcultural groups exemplify specific characteristics in terms of how they communicate their interests with one another and express themselves within these small cultural communities.

As a classroom application and engagement, invite students to talk about the different "cultures" there are within the school, such as those who live in the country versus those who live in town, those who enjoy playing video games versus those who would rather spend their time reading.

- How are these cultural groups different and the same?
- Compare these mini-cultural groups with larger cultural groups, such as people who live in a particular neighborhood of a city with people who live along the ocean on the West Coast.
- What kinds of art traditions, styles, and media might be used by gamers to create art versus the kinds used by book readers, or by East Coast versus Midwestern peoples?

Looking at how different cultural groups (including their own) express themselves aesthetically and in art making can help students come to honor their own cultural identities, while also developing tolerance and empathy for others with whom we all share similarities as well as differences.

Theme #15: Design

Art is more than paintings or sculptures; it exists all around us in our everyday, natural and man-made world. Human beings, who are endowed with the senses of sight and touch, are stimulated by intricate patterns and textures. When patterns or textures are applied to objects and artifacts with the intention of making these things more beautiful, they are forms of applied art or design. In this thematic unit, you will look at and practice drawing, painting, or printing visual patterns as design.

Theme #15: Design

Strand 1	Strand 2	Strand 3	Strand 4
Lesson 33 Microscopic Worlds	**Lesson 55** Tessellation Design	**Lesson 61** A Camouflaged Alphabet	**Lesson 25** Architectural Design
Lesson 58 Zentangle Delight	**Lesson 57** A Decorative Alphabet	**Lesson 66** Adinkra Stamped Cloth	**Lesson 67** A Design Sketchbook
Lesson 59 Imagic Letters as Graphic Design	**Lesson 65** Papunya Dot Paintings	**Lesson 71** Package Design	**Lesson 130** Camouflage in Art
Lesson 70 Designing a Logo	**Lesson 132** Stitching with Yarn	**Lesson 135** A Mola	**Lesson 134** Pieced Patchwork Art

An interesting extension to this thematic unit might be to select a single large subject and capture it in a photograph. Then revisit the subject, search for, and create a composite photograph of many smaller visual textures, patterns, and designs within the larger subject. Arrange the images in an aesthetically pleasing montage.

Tracy Rivers, Images from *Sampled Spaces Series*, 2008. Digitally manipulated photograph, 12½" × 30". (Courtesy of the Artist)

Theme #16: Self-Identity

From the moment we as infants first see our fingers and toes as extensions of our bodies, or see our reflections in mirrors and recognize these as images of ourselves, we become interested in knowing about ourselves. The external self (i.e., what we look like) is easier to know than the internal self. We may know the color of our eyes, skin, and hair, and whether we are short or tall compared to others. But knowledge of what we look like does not satisfy more profound questions, such as Who am I? Why am I here? What is my familial and cultural background? What can I be or become?

These are not superficial questions; they are critical to self-efficacy and empowerment within society and the world. Those who develop positive self-identities are far more likely to be successful students and contribute positively to society as adults than those who are not guided to know and experience a sense of value in self.

In this thematic unit, you will explore how you feel, who you are, and the trajectory of your possible future self. Images must convey more than the surface appearance of things, and in this thematic unit, more than physical appearance is explored.

Audrey Walton, *End of Pain*, 2007. Tissue paper and watercolor paper collage, 12" × 12". (Courtesy of the Artist)

Theme #16: Self-Identity

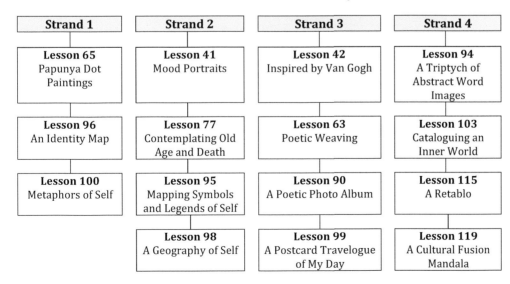

Strand 1	Strand 2	Strand 3	Strand 4
Lesson 65 Papunya Dot Paintings	**Lesson 41** Mood Portraits	**Lesson 42** Inspired by Van Gogh	**Lesson 94** A Triptych of Abstract Word Images
Lesson 96 An Identity Map	**Lesson 77** Contemplating Old Age and Death	**Lesson 63** Poetic Weaving	**Lesson 103** Cataloguing an Inner World
Lesson 100 Metaphors of Self	**Lesson 95** Mapping Symbols and Legends of Self	**Lesson 90** A Poetic Photo Album	**Lesson 115** A Retablo
	Lesson 98 A Geography of Self	**Lesson 99** A Postcard Travelogue of My Day	**Lesson 119** A Cultural Fusion Mandala

Theme #17: Art of the Natural Environment

We are familiar with beautiful paintings and drawings of local landscapes and scenes of exotic distant places, but understandably less familiar with the changing patterns of growth in a single plant, the hidden beauty of natural shapes and forms camouflaged within their surroundings, or the many intricate shapes and forms that are microscopically hidden from the naked eye. In this thematic unit, you are invited to look closely at and notice the intimate natural world.

Theme #17: Art of the Natural Environment

Strand 1	Strand 2	Strand 3	Strand 4
Lesson 14 Drawing Trees	**Lesson 13** Looking at Details	**Lesson 35** Near and Far Spaces	**Lesson 122** Art in Nature's Time
Lesson 33 Microscopic Worlds	**Lesson 15** Drawing Animals	**Lesson 46** A Landscape in Inclement Weather	**Lesson 123** A Botanical Journal
Lesson 43 Inspired by O'Keeffe	**Lesson 32** Light and Leaves	**Lesson 47** Light and Water	**Lesson 129** Camouflage in Nature
	Lesson 34 A Watercolor Landscape	**Lesson 93** A Full and Empty Composition	

Cassidy Young, *Tide Pools*, 2014. Watercolor, 24" × 32". (Courtesy of the Artist)

Theme #18: Media Explorations

While other thematic units of this text focus on ideas that may be expressed through art, this unit invites you to experiment with various materials and processes of art making. In order to express ideas competently in art media, you will need to know how to employ these media with a basic level of skill. The lessons of these strands give instructions for sculpting in wire and papier-mâché, and for working with two-dimensional printmaking, collage, paint, cardboard, fabric, and photographic materials. Each medium requires a different way of thinking through the process, a specific type of eye-hand coordination, and knowledge of how materials interact with one another. In this thematic unit, you may explore a selection of art making media.

Theme #18: Media Explorations

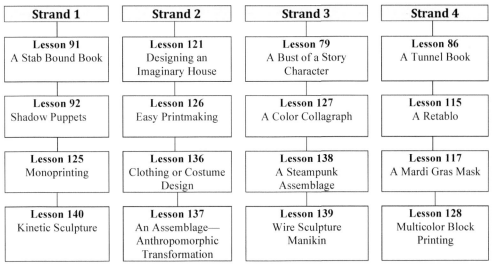

Strand 1	Strand 2	Strand 3	Strand 4
Lesson 91 A Stab Bound Book	**Lesson 121** Designing an Imaginary House	**Lesson 79** A Bust of a Story Character	**Lesson 86** A Tunnel Book
Lesson 92 Shadow Puppets	**Lesson 126** Easy Printmaking	**Lesson 127** A Color Collagraph	**Lesson 115** A Retablo
Lesson 125 Monoprinting	**Lesson 136** Clothing or Costume Design	**Lesson 138** A Steampunk Assemblage	**Lesson 117** A Mardi Gras Mask
Lesson 140 Kinetic Sculpture	**Lesson 137** An Assemblage— Anthropomorphic Transformation	**Lesson 139** Wire Sculpture Manikin	**Lesson 128** Multicolor Block Printing

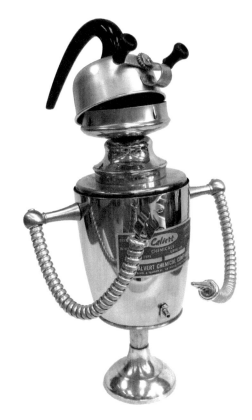

Laurie Gatlin, *Assemblage*, 2015.
Found objects, 15" × 10" × 8".
(Courtesy of the Artist)

51

Theme #19: Working on Details

This thematic unit will be particularly helpful to those who have practiced basic skills of drawing objects and figures in proportion, and now want to concentrate on developing observational skills and techniques for realistically drawing the finer details of a subject or describing the complex relationships of objects in a composition. This thematic unit is suggested as an appropriate follow-up to Theme #1 or #2.

Theme #19: Working on Details

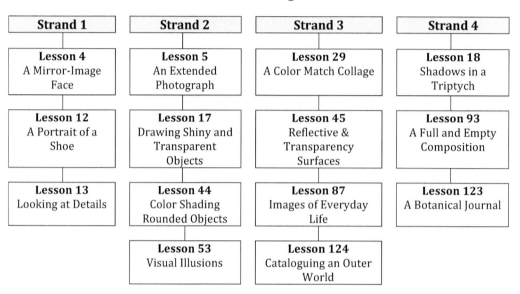

Strand 1	Strand 2	Strand 3	Strand 4
Lesson 4 A Mirror-Image Face	**Lesson 5** An Extended Photograph	**Lesson 29** A Color Match Collage	**Lesson 18** Shadows in a Triptych
Lesson 12 A Portrait of a Shoe	**Lesson 17** Drawing Shiny and Transparent Objects	**Lesson 45** Reflective & Transparency Surfaces	**Lesson 93** A Full and Empty Composition
Lesson 13 Looking at Details	**Lesson 44** Color Shading Rounded Objects	**Lesson 87** Images of Everyday Life	**Lesson 123** A Botanical Journal
	Lesson 53 Visual Illusions	**Lesson 124** Cataloguing an Outer World	

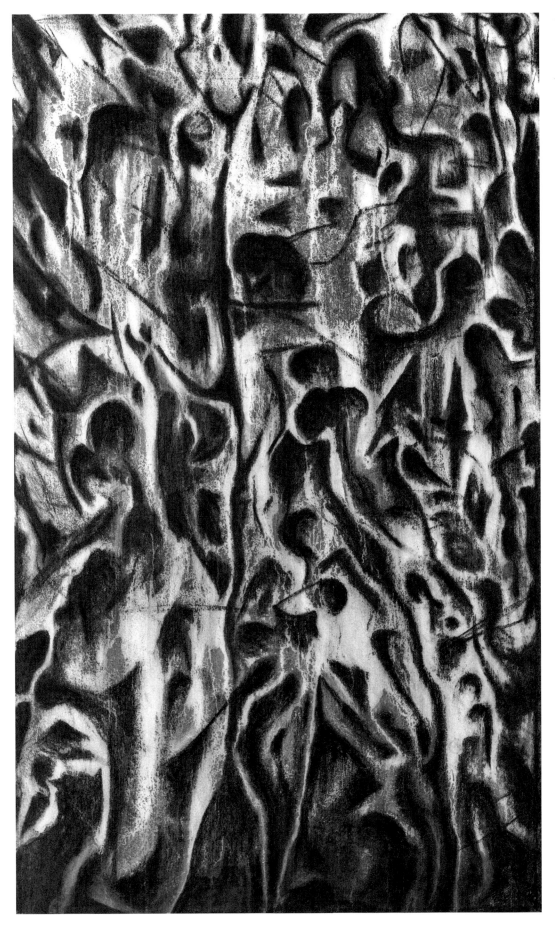

Linda Helmick, *Rock Detail*, 2015. Charcoal on canvas, 5' × 3'. (Courtesy of the Artist)

Theme #20: Engineering

Art and engineering work hand in hand in the production of tools and functional objects and machines. Human beings have a psychological need to surround themselves with beautiful objects in pleasant environments. Innovative devices may have the benefit of making life easier but are most desirable when they also delight the senses. This thematic unit invites you to explore these harmonious interactions of form and function.

Charles Bombardier, creator, and Boris (Borka) Schwarzer, designer, *Mirage Snowmobile Concept*, 2013. Supplied by copyright holder Charles Bombardier. (CC BY-SA 3.0 US)

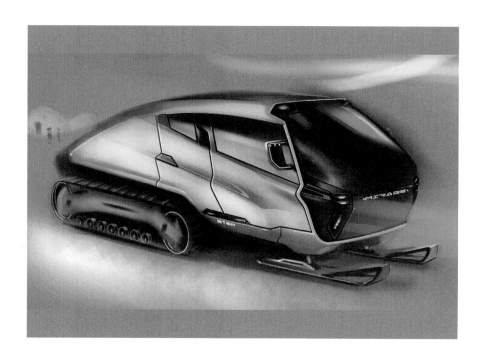

Theme #20: Engineering

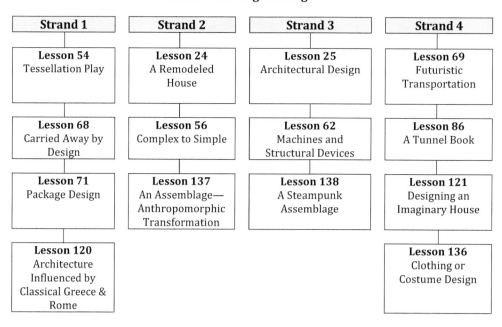

Strand 1	Strand 2	Strand 3	Strand 4
Lesson 54 Tessellation Play	**Lesson 24** A Remodeled House	**Lesson 25** Architectural Design	**Lesson 69** Futuristic Transportation
Lesson 68 Carried Away by Design	**Lesson 56** Complex to Simple	**Lesson 62** Machines and Structural Devices	**Lesson 86** A Tunnel Book
Lesson 71 Package Design	**Lesson 137** An Assemblage— Anthropomorphic Transformation	**Lesson 138** A Steampunk Assemblage	**Lesson 121** Designing an Imaginary House
Lesson 120 Architecture Influenced by Classical Greece & Rome			**Lesson 136** Clothing or Costume Design

Theme #21: Visual Metaphors

Metaphoric understanding is a critical cognitive ability that allows human beings to make meaning of the world. Metaphor is a word or phrase in spoken or written language, image, or gesture that literally indicates or describes one thing, yet diverts or directs attention to an entirely different phenomenon in an abstractive way. Images can communicate in a language that goes beyond speech. Thus, the tacitness of imagery may carry or convey metaphoric meaning. The lessons of this theme provide opportunities to express and explore metaphor through art.

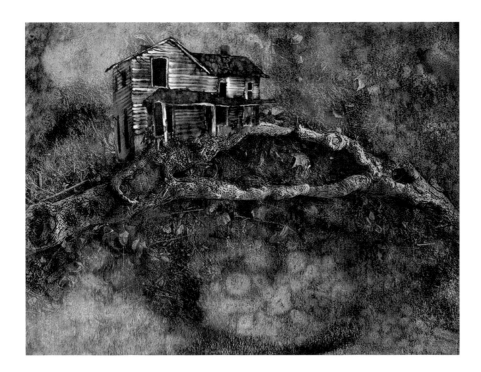

James Huntley, *Family Roots*, 2014. Digital, 18" × 24". (Courtesy of the Artist)

Theme #21: Visual Metaphor

Strand 1	Strand 2	Strand 3	Strand 4
Lesson 50 Animal Symbols	**Lesson 53** Visual Illusions	**Lesson 30** Mood Expressions	**Lesson 94** A Triptych of Abstract Word Images
Lesson 64 Maori Design— Kowhaiwhai	**Lesson 76** An Image of Catastrophe	**Lesson 101** Yin and Yang	**Lesson 102** A Woven Portrait
Lesson 65 Papunya Dot Paintings	**Lesson 88** One Story from Differing Viewpoints	**Lesson 103** Cataloguing an Inner World	**Lesson 105** A Spirit Doll
	Lesson 100 Metaphor of Self		**Lesson 112** Visual Poetry in Myth

Theme #22: Customized Theme

The field of art making encompasses far more varieties of media and subject matter than can possibly be covered by the 140 lessons organized in 22 thematic units that are provided in this text. Therefore, the last thematic option is for customized work. Is there a special topic you would like to address, or a medium you would like to explore? Discuss your interests with your instructor and decide upon the topic, media, and assessment criteria for four sequential projects you would like to do that are relevant to your interests.

Besides coming to an agreement with your instructor about the parameters of the work, you should submit the following:

1. An outline of the projects for each strand
2. Evidence of your in-progress work
3. Four completed pieces or parts of the work
4. A reflection essay that addresses each piece of the work separately and provides an overall reflection on the thematic unit

While your customized theme will be unique to you and your needs, you may gain some ideas by considering the varieties of customized works that were successfully completed by other students, such as Hank Powell, who aspires to one day own his own sound production company. He developed a series of company logos and signs that he hopes to use in advertising and promoting his future business.

Paul Vasich is a computer programmer whose work was inspired by a nineteenth-century Japanese woodcut print. He made several digital copies of the chosen image, opened them with a text editor, and corrupted them by running them through a program for audio files. Finally, he selected the most aesthetically appealing images and arranged them in a triptych. "Depending on their order, the images can tell a new story, or put the skeleton [central panel] in an introspective sandwich," he explained.

Left, Utagawa Kuniyoshi (Japan, 1797–1861), Center panel of triptych: *In the Ruined Palace at Sōma, Masakado's Daughter Takiyasha Uses Sorcery to Gather Allies (Sōma no furudairi ni Masakado himegimi Takiyasha yōjutsu o motte mikata o atsumuru),* ca. 1844. Color woodcut triptych, 14" × 28 ³⁄₈" (35.56 × 72.1 cm). Los Angeles County Museum of Art, Los Angeles, CA.

Right, Paul Vasich, triptych panels, left: *Mitsukin Anatomizing the Skeleton,* 2012. Computer manipulation. (Courtesy of the Artist)

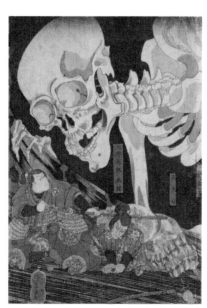

The panels are "Mitsukini Anatomizing the Skeleton," "Untitled," and "Fact and Fantasy."

Kathleen McShea has a special interest in world religions and was fascinated by the process of Zentangles. She completed a series of four large images in pen and ink that represent the creation stories of Hindu, Iroquois, Zulu, and Buddhist religions. Each image is accompanied by a narrative of the creation story that inspired her image.

Left, Paul Vasich, triptych panels, center: *Not Applicable*, 2012. Computer manipulation. (Courtesy of the Artist)

Right, Paul Vasich, Triptych panels, right: *Fact and Fantasy,* 2012. Computer manipulation. (Courtesy of the Artist)

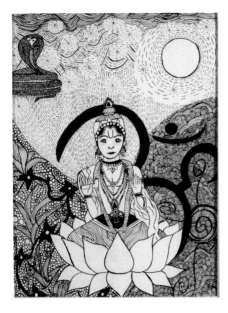
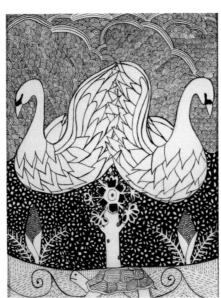

Left, Kaitlynn McShea, *Hindu Creation Story,* 2012. Sharpie ink on watercolor paper, 18" × 12". (Courtesy of the Artist)

Right, Kailtynn McShea, *Iroquois Creation Story,* 2012. Sharpie ink on watercolor paper, 18" × 12". (Courtesy of the Artist)

Shown here are images for "Hinduism" and "Iroquois," whose story is as follows.

> Before this world came to be, there lived in the sky-world an ancient chief. In the middle of his land was a beautiful tree. The tree was uprooted, and in the hole where the tree used to be, the ancient chief's youthful wife fell, grabbing the seeds of the tree as she fell. As she fell, the animals of the Earth tried to find

land for her. The turtle got dirt from the bottom of the waters and put it on his back, where it grew and grew until it became the whole world. Two swans caught her in between their wings. As she was flown to the earth, she dropped the handful of seeds she'd brought from the sky-world. (Iroquois Creation Story)

Kara Busche was fascinated by the look of rain splattering on her window at night. She developed works based on her observations of nature and experimentations of media.

Kara Busche, *Rain on the Window at Sunset*. Tempera on wood, 10¼" × 16". (Courtesy of the Artist)

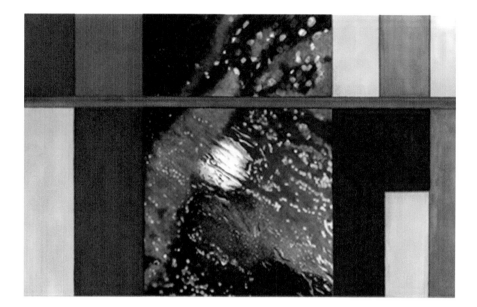

One day, a couple weeks ago, I was sitting at home and it started raining heavily. I looked out the window. I noticed how weird and nonobjective rain looks on glass with the sunset behind it. This design represents the abstract way rain hits glass. I used tempera paint and to recreate the colors and textures, I used different sizes of brushes, to get a glossy textured look on a piece of wood that my mom had lying around. This design represents the abstract way rain hits glass. (Kara Busche)

NOTES

1. Viktor Lowenfeld, *Creative and Mental Growth,* 3rd ed. (New York: Macmillan, 1964), 39.

2. F. David Peat, "Report on the Art and Science Meeting" (1999), Pari Center for New Learning, http://www.fdavidpeat.com/pcnl/octreports.htm#report1.

3. *Donald in Mathematic Land* (animated film), directed by H. Kuske. J. Meador, J. Clark, and W. Reitherman and produced by Walt Disney (Burbank: Walt Disney Studios, 1959/2009).

4. Ellen Dissanayake, *What Is Art For?* (Seattle: Washington University Press, 1990).

5. Christopher O. Adejumo, "Considering Multicultural Art Education," *Art Education* 55, no. 2 (2002): 33–39.

1 · Lessons in Drawing Realistically

Very young children typically are free and open about the process of art making. For these young artists, art making is an act of gestural play, an exploration of media, and an expression of immediate emotions and ideas. There is little concern for or attempt at realism; a child's art making is expressive, idiosyncratic, individually and socially symbolic.

When adolescents or adults return to art making, much of the playfulness has been forgotten. Older would-be artists have been conditioned to experience visually realistic representations as *art*. Therefore, older students who return to art making after a hiatus of several years may want to learn basic rules of creating realistic art in order to develop or re-awaken confidence in their artistic abilities. The lessons in this section offer choices of subject matter, techniques, and traditional media for realistic drawing. Students are introduced to ways of observing real objects in space and are provided instructions on how to translate what they see into competent visual images or artifacts. Through the stimulation of ideas that spark emotional expression and invite experimentation with traditional approaches, the lessons in this section will encourage students to rediscover art making as a playful adventure.

FEATURED ARTIST: BRIAN CHANGRAI CHO

Brian Cho's interest in art making, which evolved from early childhood experiences of doodling on paper, was honed by art classes in elementary school while living in South Korea, then through high school art classes in Charlotte, North Carolina. Eventually he received a Bachelor of Fine Art (BFA) degree from the School of Visual Arts in New York and both a Master in Fine Arts (MFA) degree and a K–12 Visual Art teaching certificate from Indiana University, Bloomington. Several works by his students are included in this text.

In his work, Cho attempts to create a visual reflection of a narrative situation or context. Once an idea or story comes to mind, he begins to transfer the conceptual imagery in his mind to canvas.

> When I am painting, I ask myself two questions. First, I ask, "Is my image effectively representing the idea intended?" Since my paintings are visual narratives, it's important that viewers are able to determine what the painting is about. I would like viewers to read the dialogue of my paintings from studying the imagery without relying on any verbal or textual explanations. Second, I ask, "Is my painting aesthetically appealing?" Creating a visually appealing artwork is just as important for me as creating a conceptually interesting work.

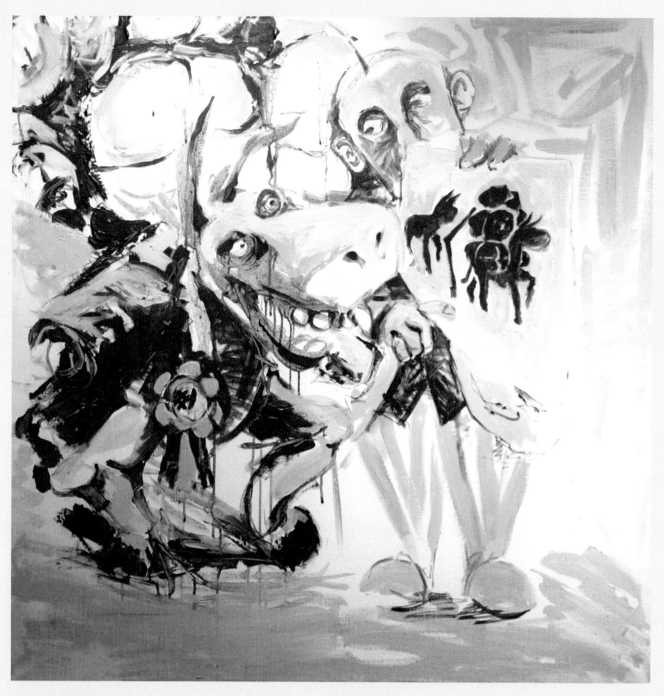

Brian Cho's painting describes an overworked donkey receiving praise and pampering from an owner, who keeps him working under unreasonable conditions by assuring him that he is a "superior donkey" for doing such hard work. *Dumb Ass*, 2015. Acrylic and gesso mixed media on canvas, 30" × 30". (Courtesy of the Artist)

Lesson 1: Shading Rounded Objects

Have you ever tried to draw a ball, cylinder, or human body? These shapes have surfaces that are **concave** (curved inward) or **convex** (curved outward); their surfaces are rounded rather than flat. Light and shadows define the **three-dimensional form** of rounded objects. When light hits a curved surface two effects result: the part closest to the light source will be very bright, while the part farthest from the light source will be darkened. Unlike a flat-sided object, where **shading** may change sharply from one angle to another, on a rounded surface the shading seems to change gradually. In this lesson, you will look closely at a group of rounded objects to examine how light falls on these kinds of surfaces. Additionally, you will notice how shadows fall when an object closest to the light **overlaps** and blocks light from falling on another object. You will describe what you observe by drawing those areas of light and shadow that define a **still life**.

Left, William Kennedy, *Rounded Objects,* 2012. Pencil on paper, 12" × 9". (Courtesy of the Artist)

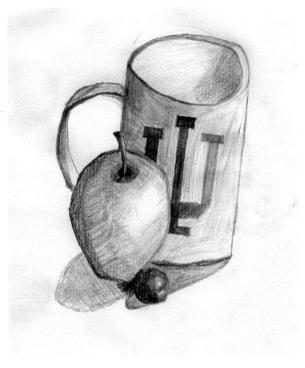

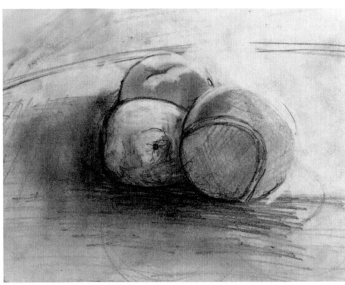

Above, Megan Newcomer, *Drawing of Rounded Objects,* 2015. Pencil on paper, 9" × 12". (Courtesy of the Artist)

INSTRUCTIONS

1. Arrange a group of curved or round objects into a still life **composition**. Some objects should be placed in front of others to create a visual overlap.
2. Make sure the light illuminating the objects comes from a strong single source, such as a floodlight, flashlight, or reading lamp. Dim all other lighting and pull shades or curtains to block diffused daytime lighting.
3. On a 9" × 12" sheet of white drawing paper, draw the **contour** shapes of the objects in the grouping you have arranged.
4. Check your drawing for correct **proportions** of one object to another.

5. In order to show clearly what happens when the rounded objects are lit by a single light source, note the following:
 a. Use various soft and hard lead pencils to show gradations of light to dark.
 b. The small section of the rounded object that directly faces (and is therefore closer to) the light source will be lighter than the parts of the object that fall away from this point.
 c. Very few parts will be completely black (no reflected light) or white (maximum reflected light).
 d. Most surfaces will reflect some lesser or greater **gradations** of shading.
 e. Pay attention to shadows under the rounded objects and to places where shadows overlap each other.
6. Draw objects that are close to you in greater detail than those that are farther away.

Materials Needed

white drawing paper, 9" × 12"
drawing pencils with soft and hard leads
eraser
assorted found objects with rounded forms

Vocabulary

Composition	Form	Shade/Shading
Concave	Gradation	Still Life
Contour(s)	Overlap	Stippling
Convex	Proportion	Three-Dimensional
Cross-Hatch(ing)	Scrumbling	Visual Texture

WHAT TO SUBMIT FOR EVALUATION

· a drawing of a group of rounded objects with overlaps, lit from a single light source, with gradations of shadows

LESSON EXTENSION

Study how shadows affect dark- or light-colored objects and reflective or matte surfaces differently. As a lesson extension, try drawing a still life of objects with dark and light or matte and reflective surfaces. After completing the drawing, add touches of color to some of the darkest areas of the drawing with colored pencils or watercolors. Does color alone change your perception of depth and volume? If so, how? What role do light and dark play when combined with color?

TIPS FOR TEACHERS

Applications for Teaching Pre-K–6 Students

The shading of rounded objects is demonstrated by the relationship of planets to the sun. When a planet or moon is facing the sun, it is illuminated. Its opposite side is unlit and thus dark. When our planet faces the sun, we experience daytime; when it turns away from the sun, we experience night. Planets that have atmospheres, such as the earth, will move somewhat gradually from light to dark, because the atmosphere diffuses the light along the edge of the earth that is moving into darkness. This also happens to objects we view here on earth. Students may begin to understand how rounded objects are shaded if they are invited to create images of planets in the solar system as these might be seen from space.

At night, when we see the side of the moon that is lit by the sun, the reflected glow of moonlight casts a pale light on objects below. Students can study this effect by drawing pumpkins or other rounded objects as they would appear in the light of a full moon.

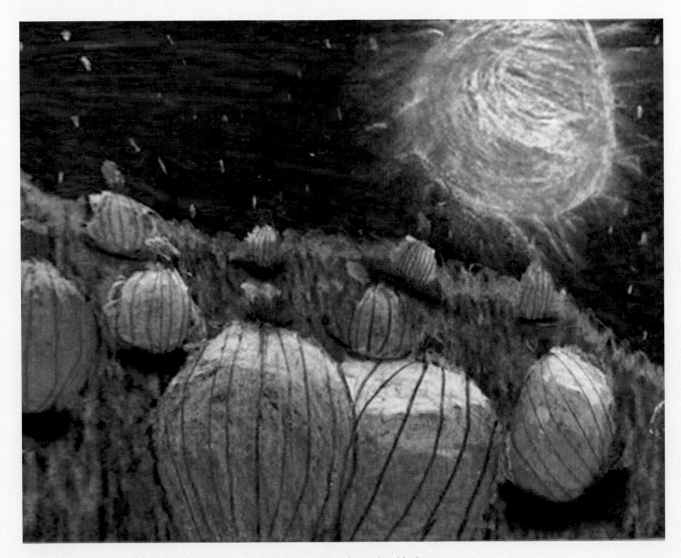

Anonymous, *The Pumpkin Patch at Midnight with a Full Moon*, 1992. Oil pastel on black paper, 18" × 14½". (Child Art Collection of Marjorie Manifold)

Paul Cézanne (1839–1906), *Three Pears*, 1888–1890. Watercolor, gouache, and graphite on cream laid paper, 9½" × 12 3/16" (24.2 × 31cm). The Henry and Rose Pearlman Collection, Princeton University Art Museum, Princeton, NJ.

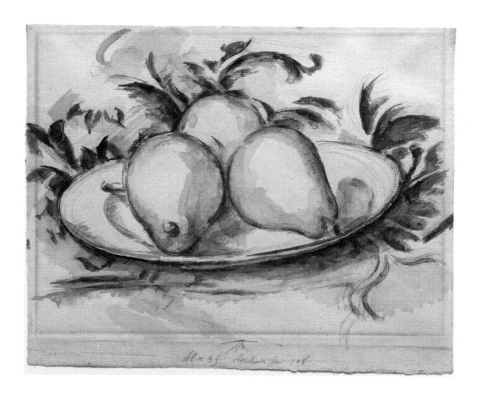

TIPS FOR TEACHERS

Your choice of pencils can help create shading in your drawings. Hard lead pencils can be used if you want to produce very light shadows. Soft pencils can create very dark shadows with little pressure. The grade (i.e., hardness or softness) of a drawing pencil lead is indicated by the initials H or B and numbers, as follows:

extremely hard	7H to 9H
very hard	4H to 6H
hard	3H to 4H
medium hard	H to 2H
medium	HB
medium soft	B to 2B
soft	3B to 4B
very soft	4B to 6B
extremely soft	7B to 9B

You can create shade by gently rubbing the drawing paper with the side of the pencil rather than the tip. Lines made by **scrumbling**, **cross-hatching**, or **stippling** in a variety of hard and soft pencil leads can also be used to create both shading and **visual texture**. Search online for examples of these techniques.

Lesson 2: Drawing Elliptical Shapes

Flat circular shapes are common in our environment. We see them in dinner plates, coffee cups, manhole covers, buttons, and hubcaps and wheels of various vehicles. We are so accustomed to what round-shaped objects are that we are often unaware of how they really look when seen from differing positions. Drawing compels us to look carefully at these objects. A circular shape with a flattened top and bottom, such as a plate or bottle cap, only looks perfectly round when the circular side is seen at a right angle to you. If the circular side is tilted, it appears as an **ellipse**. The greater the tilt away from the viewer, the flatter the ellipse. This lesson is an introduction to drawing **elliptical** shapes; it should help you draw rounded, circular, or **cylindrical** objects in visually convincing ways.

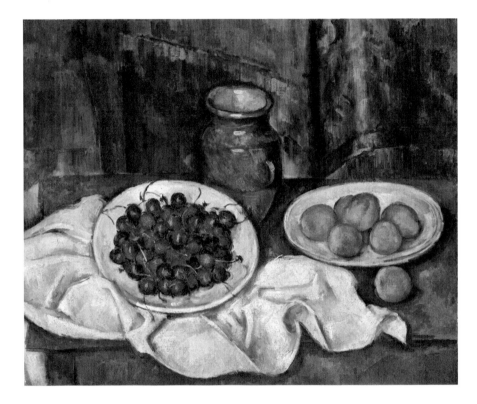

Paul Cézanne (1839–1906), *Still Life with Cherries and Peaches*, 1885–1887. Oil on canvas, 19¾" × 24" (50.165 × 60.96 cm). Gift of Adele R. Levy Fund, Inc., and Mr. and Mrs. Armand S. Deutsch, Los Angeles County Museum of Art, Los Angeles, CA.

INSTRUCTIONS

1. As practice for your finished drawing, from three different viewpoints sketch the outline of a cylindrical object or an object that is both round and has flattened sides, such as a plate, a wheel, or a fry pan. The task is to draw different ellipses that you see as the objects are tilted away from you. You may have some difficulty drawing evenly shaped ellipses because this takes practice with eye-hand coordination, but the greater difficulty is stopping yourself from *thinking* of the object as circular in order to *observe* how it changes from a circle to ellipse as you move the object. Notice that as the object is moved, both the top and bottom of the object simultaneously will appear elliptical.

2. Now for a finished drawing, arrange a group of five to eight food cans, **opaque** bottles, or cylindrical objects of varied sizes, such as soft drink cans, ceramic vases, or paper cups, into an interesting **still life** grouping.
 a. Some of the cans, vases, or cylindrical objects should partially overlap others.
 b. The arrangement should expose the ends of the rounded forms.
 c. Do not use transparent glass or plastic objects, as the appearance of an ellipse may be distorted when viewed through transparent objects.
3. Dim overhead lights and pull the blinds or curtains to darken your room as much as possible, then set up a strong light source near the still life.
 a. This strong light source should cause parts of the rounded forms to appear shaded.
 b. Objects also should cast distinct shadows on the table or surface where they are resting.
4. On heavy white 9" × 12" drawing paper, draw the main contours or outline shapes of the elliptical forms. Use a variety of soft and hard lead pencils to create strong and soft outlines.
5. Add areas of shade. **Shading** helps you see the cans, vases, or cups as curved rather than flat objects.
 a. Draw any shadows that are cast by objects overlapping and/or blocking light from falling directly on parts of other cylindered or rounded forms.
6. When all the shapes have been drawn as accurately as possible and the curved sides have been shaded to show where shadows create a sense of rounded form, look at where shadows fall on the table or surface that the cylindrical objects are resting upon.
 a. What shapes do you see in these shadows?
 b. How do they help you recognize that the objects drawn are curved forms rather than flat objects?
 c. Add these shadows to your drawing.

Materials Needed

white drawing paper, 9" × 12"
drawing pencils with soft and hard leads
eraser
assorted **found objects** with rounded and cylindrically shaped forms
(*avoid selecting glass or transparent objects*)

Vocabulary

Cylindrical	Opaque
Diameter	Perspective
Ellipse/Elliptical	Shade/Shading
Found Objects	Still Life

Elena Jeon, *Still Life*, 2013. Pencil on paper, 9" × 12". (Courtesy of the Artist)

Savannah Michel, *Still Life*, 2012. Pencil on paper, 9" × 12". (Courtesy of the Artist)

WHAT TO SUBMIT FOR EVALUATION

· three preliminary sketches of a round object from three different viewpoints
· a finished still life drawing
· a brief written explanation of how objects with circular or cylinder shapes change appearance as the angle from which they are viewed changes, and how shadows help us *see* the objects in the drawing as being rounded

TIPS FOR TEACHERS

An ellipse is a circle viewed at an angle or in **perspective**. The axis of the ellipse is constant, and it is represented as a straight centerline through the longest part of the ellipse. When we look across the face of a circle, it is foreshortened and we see an ellipse. The major axis (the longest part) of the ellipse is constant to the **diameter** of the circle.

It may be difficult for young children understand the concept of ellipses or to see and draw them in familiar objects. This is because we tend to draw what we *know* rather than what we *see*. This is why it is important to closely observe objects that we are drawing. Help your students understand ellipses as a geometric and art concept by taking digital photographs of a common cylindrical object from several angles. Blow up the images and invite students to trace the ellipses seen from these differing angles.

Above, Elliptical example 1.
(Created by the Author)

Right, Elliptical example 2.
(Created by the Author)

Lesson 3: Facial Proportions

From birth, humans are attracted by and attentive to faces. Perhaps it is because faces are so important to recognition that we are both fascinated by and anxious about drawing identifiably accurate faces. There are simple tools of **proportion** that can be used to help draw faces realistically. In this lesson, you will use a reflection of your own face as a model in learning to draw the proportions of a face.

INSTRUCTIONS

1. Sit in front of a mirror that is large enough for you to be able to see your whole face and neck. Notice that the shape of the human face, when viewed straight on, is somewhat egg (**oval**) shaped.
2. Draw an oval shape on a sheet of 9" × 12" white drawing paper. Make the oval large, so that it fills the center of the drawing paper.
3. Now notice that if you were to draw a line **vertically** down the center of your face, your facial features would appear rather **symmetrical**; that is, the right and left halves are mirror images of each other. Lightly draw a vertical line down the center of the oval on your paper.
4. Notice that your eyes are located on a horizontal line that is halfway between the top of your head and the bottom of your chin.
 a. You may be surprised to see that the components that make up the face (eyes, nose, mouth, chin, ears) are *all* located in the bottom half of the oval, below this horizontal line.
 b. The eyebrows and hairline are the only features above the imaginary halfway line.

Left and right, The eyes fall halfway between the crown of the head and bottom of the chin. The corners of the mouth fall just below the center of the eye. Notice other approximate placements of the nose, lower lip, eyebrows, and hairline. Peter Paul Rubens, *Rubens's Daughter Clara Serena*, ca. 1623. White chalk, black chalk, and sanguine paper, 13¾" × 11 1/12" (35.3 × 28.3 cm). Albertina Museum, Vienna, Austria.

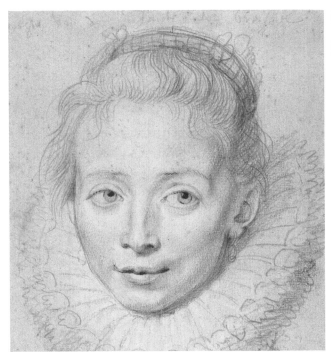
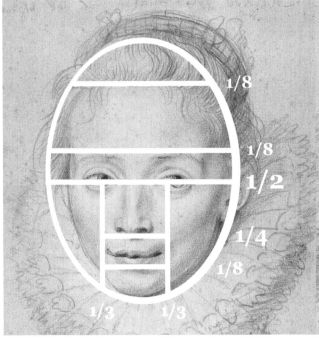

 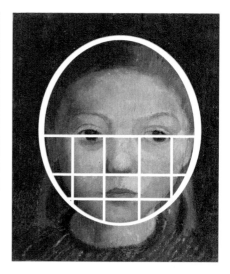

Although there are slight proportional differences between the head of a child and that of an adult, the eye can be used as a basic measurement unit for all. Eyes will always fall halfway between the crown and chin. There is approximately one eye's width between the two eyes, and the nose is about one eye's width long from bridge to tip. What other features of the face can be measured in comparison to the width of the eye? Paula Modersohn-Becker (1876–1907), *Head of a Girl*, 1906. Oil on canvas, 9 ⅔" × 8¼" (24.5 × 21 cm). Städel Museum, Frankfurt am Main, Germany.

5. Place the eyes on the **horizontal** line. The head is about four eye widths wide, with one eye width between the two eyes and half an eye width from the outside corner of the eye to the side of the head.

6. The tip of the nose is about halfway between the center horizontal line (where the eyes are located) and the bottom of the chin. The width of the bulbous part of the nose depends on the person.

 a. The bottom of the nose is often as wide as the inside corners of the eyes. So you can draw two lines down from the inside corners of the eyes, to mark the width of the nose.

7. Draw another line halfway between the tip of nose and bottom of the chin. The mouth is placed just above this line.

 a. The corners of a mouth will line up with the center of the eyes.

Materials Needed

white drawing paper, 9" × 12"
drawing pencils with soft and hard leads
eraser
mirror

Vocabulary

Horizontal/Horizontally Symmetry/Symmetrical
Oval Vertical/Vertically
Proportion

WHAT TO SUBMIT FOR EVALUATION

· a facial proportion drawing that includes features and details of hair
· a list of books and/or URLs to online tutorials used to assist in completion of this lesson

TIPS FOR TEACHERS

Now that the proportions of the face have been determined, attention can be given to drawing specific features of the face. Provide your students with small mirrors so they may study the features of their faces.

· Beginning with the eyes, notice that the shape of the eye is not a perfect oval. The eye tucks into a tear duct near the nose. Soft folds from the eyelid frame the upper part of the eye. The iris (colored part) of the eye tucks under the eyelid. Look at your face in the mirror and consider how your eyes differ from these shapes.

Below, Drawing of Eye. (Created by the Author)
Right, Drawing of Eye, Nose, and Mouth.
(Created by the Author)
Bottom, Drawing of Mouth. (Created by the Author)

· A nose is difficult to draw with lines only. Shading the bridge of the nose helps define its shape, but lines can help describe the nostrils and the bulbous part of the nose.
· Study the shape of your mouth. Your mouth is described by softly curves lines; it is shaded where the lips meet and beneath the lower lip. There is also shading where the lips curve into the cheeks. This shading becomes more pronounced as the corners of the mouth form creases with age.

Many tutorials online and in how-to-draw books provide further tips for drawing facial features. Providing students with a variety of how-to-draw books will encourage them to develop drawing skills.

1. The instructions above give proportions for frontal face drawings. There are also rules of proportion that apply to side views of faces. As a lesson extension, practice drawing the proportions of the head from the side.

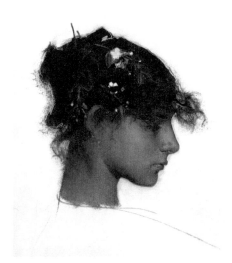

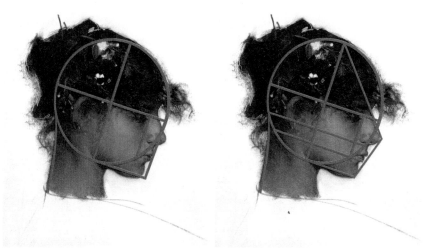

Above, Notice how, as in a front facial view, the eyes, nose, mouth, and chin occupy only one-quarter of the entire skull. The ear sits in the center of the adjoining lower quartile. Notice that the upper portion of the ear aligns with the upper eyelid, and the lower portion approximately aligns with the tip of the nose. John Singer Sargent (1856–1926), *Rosina Ferrera, Head of a Capri Girl,* 1878. Oil on cardboard, 19½" × 16¼" (495.3 × 412.75 cm). Denver Museum of Art, Denver, CO.

Right, An interesting characteristic of the ear is that it is placed at a slant on the upright head. Its prominent divisions fall in thirds. (Created by the Author)

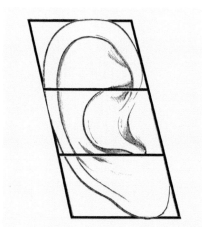

2. Manga and comics present popular artistic styles that are often employed by illustrators in drawing human faces and forms. If you are a fan of a particular manga or comic style of drawing, study how the preferred proportions of manga/comic characters differ from realistic human forms.
 · Make a chart showing these differences.
 · Create a second drawing of your face using the proportions of your favorite manga or comic style.
 · Compare it to the original, realistic drawing. How are they similar or different? Which looks most like you? Which was easiest to draw? Why?

Lesson 4: A Mirror-Image Face

Many times artists refer to photographs to help them complete their drawings. Artists also may use parts of real photographs or commercial images in collage creations. This lesson uses a photographic **collage** to assist in drawing a realistic face. You will attach half of a photographic image of a face to a drawing surface, then you will complete the missing half of the photograph by drawing, thus combining two **media** in one project.

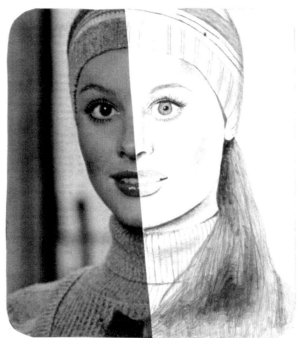

Student example of a mirror-image face. (Courtesy of the Artist)

INSTRUCTIONS

1. Select a large black and white magazine photograph of the full front view of a person's face and head. The image should be of the full frontal face and may range in size from about 6" × 8" to 8" × 10".
 a. If you find a color photograph you would like to use, make a black and white photocopy of it before you begin the project. You may download an image off the internet, if the downloaded image is of sufficiently high quality to allow the accurate reproduction of shading or copying of fine details.
2. Cut the photograph exactly in half vertically (i.e., down an imaginary center line through the nose and between the eyes.) Each half will be approximately the same because faces are almost **symmetrical**, that is, the same on both sides of the center line.
3. Use rubber cement to attach one half of the photograph in the center of a sheet of white drawing paper. Clean off the excess rubber cement with a rubber cement eraser.
4. Keep the remaining half of the photograph for reference.
5. Use the cemented half of the picture as a guide to help you draw the missing half accurately. The unused half of the photograph can be studied to see how the features, hairstyle, shape of the head, and so on are formed. Draw the missing half of the picture with a soft lead pencil, so you can easily correct or adjust lines and shaded areas of the face.
 a. Observe the **contour** (outline) of the shape of the face as accurately as possible.
 b. Refer to Lesson 3 to review facial **proportions**.
 c. Pay attention to light and dark areas. Use shading to make the face look solid.

Materials Needed

white drawing paper, 9" × 12"
scissors
rubber cement

rubber cement eraser
a magazine or photocopied frontal face image
(approximately 6" × 8" to 8" × 10")
drawing pencils with soft and hard leads
eraser

Vocabulary

Collage
Contour(s)
Medium/Media
Proportion
Symmetry/Symmetrical

WHAT TO SUBMIT FOR EVALUATION

· a brief essay (300–400 words), in which you
 define symmetry in reference to facial portraiture
 explain why it was easier to draw an image of a face when half of it
 already was provided as a guide
 reflect upon your observations and drawing of a portrait
· a drawn facial portrait created by matching a photographic image, in
 which you demonstrate the use of accurate proportion, contour, and
 shading

TIPS FOR SHADING

This exercise aims to help students see variations in shading from light to dark. A helpful tool that assists in observing degrees of shading differences is a value scale. To create a value scale (gray scale), draw a 1" grid along the length of a 12" strip of white drawing paper. Leave the first square blank (white). In the last square, use your softest lead pencil and fill the square in, pressing very hard to create a black shade. Starting from the lightest and moving toward the darkest, shade each square slightly darker than the previous one. Continue checking the squares as you progress to be sure the transitions from one shade to the next are gradual. Use this scale to help you see value differences in images and drawings.

Hold the scale up to a black and white photo or image you would like to reproduce. You might, for example, be surprised to discover that things we assume to be white, like teeth or the whites of an eye, are not really white. Likewise, things we know to be dark, like hair, may include a range of values from light to dark.

Gray scale. (Created by the Author)

TIPS FOR DRAWING HAIR

1. Look at the dark and light areas that you see in the hair on the photograph. Notice that not every strand of hair needs to be articulated; hair can appear as broad masses with a loose strand here and there.

2. Start your drawing of hair by making light pencil lines to create the main outline of the hair mass. Do not press hard with the pencil. In some pictures you will notice that when the background of a picture is pale and light hits hair that is silhouetted against the background, the contour of the hair seems to blend into the background.

3. Begin to darken in the darkest areas of the hair, using a pencil with a soft lead. Use lines that follow the direction of the hair.

4. Continue to draw lines that follow the direction of the hair. Use lines to create light and dark areas of the hair by making lines that are denser in some areas and less dense in others. Use pencils with medium leads to add visual texture. Use an eraser to add highlights to lighter areas.

5. Remember that it is not necessary to try to draw in every strand of hair!

6. Several online sites feature tutorials that may help you draw convincing-looking hair.

LESSON EXTENSION

Rather than drawing to recreate a portrait or magazine image of a face, try using pieces of magazine or newspaper text to correspond to light and dark values of a photograph or drawn facial image. Strips of magazine text or images can be laid and matched on a portrait that has been photocopied to an enlarged 8" × 12" size. As in the original instructions for this assignment, it may be helpful to complete one half of the image at a time, so as to have a reference guide for your work. Tack the strips with a dot of rubber cement or glue from a glue stick. When you are satisfied that the collage image is complete, tack down any lose ends of text with rubber cement and carefully clean excess dried cement from the image.

Jay Rosen, *Self Portrait—Text Collage*, 2010. Magazine collage, 13" × 8½". (Courtesy of the Artist, http://silent-pea.deviantart.com/art /Self-Portrait-Text-Collage-181641747)

Lesson 5: An Extended Photograph

In many drawings, paintings, advertisements, and photographs, people are depicted in a specific setting such as a garden, museum, or living room. Without the background setting, it may be difficult to understand a person's actions. Backgrounds and surrounding objects add important information. They

help us make sense of an image by placing it in context. What goes on beyond the space of that which is shown in a picture can add meaning or change the meaning of what we think we are seeing. For example, if you see a picture of a person who is dressed in a baseball outfit posed as if to throw a ball against a background of people seated in rows of seats similar to those of a baseball stadium, you might assume that the scene is of a pitcher throwing the ball to a batter during a baseball game. But what if the image were extended to show that the pitcher is throwing a ball at a stack of wooden milk bottles? This would change the meaning of the picture.

Likewise, what if a section of an image is missing? We can assume certain things might fill the missing portions of the image—for example, if a picture includes the lower trunk of a tree and the upper branches of the tree, we can assume the missing portion of the image includes the main trunk of the tree. Yet the assumption might be very wrong. The missing portion of the image may contain some very surprising element, such as a circus strongman standing on a stump of the tree and holding the severed upper portion of the tree over his head.

In this lesson, you will use your imagination and draw additions around or within a photograph to tell a story that extends the meaning beyond what is obviously seen, in a way that might surprise your viewers!

INSTRUCTIONS

1. Find a black and white photograph in a magazine or newspaper that contains people or animals in action, or includes an otherwise interesting environment. For example, you might find a picture of a basketball player on a basketball court, a dog catching a Frisbee, or a dancer on a stage. The more unusual or mysterious the image the better! If the photograph you would like to use is in color, make a black and white copy of it before you begin working.

2. Decide what part of the image you will extend or remove. If you decide to remove a portion of the image, carefully tear or cut that section away.
3. Use rubber cement to adhere the photograph to a larger sheet of white 9" × 12" drawing paper and clean the excess rubber cement off. If you are going to extend the photograph outside the frame of the image, leave at least 2" around each edge of the photograph.
4. Your additions should tell a larger or different story than the one that is shown in the original photograph, or surprise us with a twist to the story.
5. Match the **light and dark values** and **visual textures** with the original photograph.
6. Write a brief essay (300–400 words) in response to the following:
 a. List characteristics of your extensions that best match the original photograph.
 b. Describe any difficulties you encountered while working on this project. How did you resolve the difficulty?
 c. Explain how your extension tells a more complete story or changes the original story conveyed by the photograph.

Materials Needed

white drawing paper, 9" × 12"
a black and white photograph or image
that is smaller than the drawing paper
drawing pencils with soft and hard leads
eraser
scissors
rubber cement
rubber cement eraser

Vocabulary

Light and Dark Values Value(s)
Neutral/Neutral Color Visual Texture

WHAT TO SUBMIT FOR EVALUATION

· the original black and white photograph (or photocopy of a color photograph) used as basis for your artwork
· your extended photographic drawing
· a written essay response, as outlined in Instruction #6

LESSON EXTENSION

Combining photographs with drawn manipulations can result in humorous or fanciful images. As a lesson extension, select a familiar image or picture, trim it out of its original setting and situate it in an incongruous, humorous, or fantastic environment. When doing so, you could either try to match the **neutral** darks and lights of the original photograph to mask the fact that the image has been relocated to a new environment, or use color to emphasize the fantasy of the new setting.

Facing, "The original photograph for this assignment came from a *National Geographic* article about the Kayapo indigenous tribe in Brazil. The man shown is a tribal chief. The article was about how this man's tribe was effectively combating attempts to take their tribal land and the loss of culture his tribe was experiencing, despite their success at retaining their land. When I saw the tribal chief's picture, I immediately noticed that without the parrot-feather headdress and body paint, this man could easily be a businessman. His strong, sincere look comes across as both intimidating and accessible. I felt that, for this man's tribe, he was actually a superhero waging battle against evil. That is how I decided to put a dress shirt on him with a Superman suit showing beneath. I felt that it sums up the various roles the chief truly is playing in his tribe: that of superhero, business negotiator, and cultural archaeologist." Shelly Gerber-Sparks, *Tribal Superman,* 2014. Magazine collage with pencil, 12" × 9". (Courtesy of the Artist)

Dorian Villaneuva, *Photographic Extensions with Photoshop Alteration*, 2012. Mixed media, 9" × 12". (Courtesy of the Artist)

Samantha Parillo, *Photographic Extension*, 2007. Mixed media, 9" × 12". (Courtesy of the Artist)

Lesson 6: Drawing Hands

The hand is considered by many artists to be one of the most difficult parts of the human body to draw. Every day we observe hands moving, flexing, grasping, caressing, or relaxing, yet the sheer varieties of positions and postures a hand might achieve suggest it as too complex a feature to be easily represented. Recognizing that hands are structured and move in accordance with the law of **Fibonacci** may help to overcome hesitance about the difficulty of drawing them and awaken wonder at the beauty, grace, and versatility of the human hand.

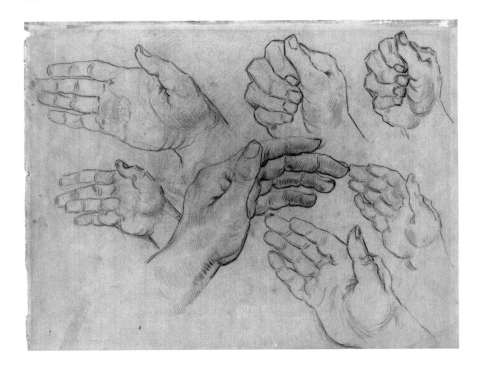

Vincent van Gogh (1853–1890), *Studies of a Hand*. Chalk on paper, 9 ⅜" × 12 9/16" (23.8 × 31.8 cm). Van Gogh Museum, Amsterdam, the Netherlands.

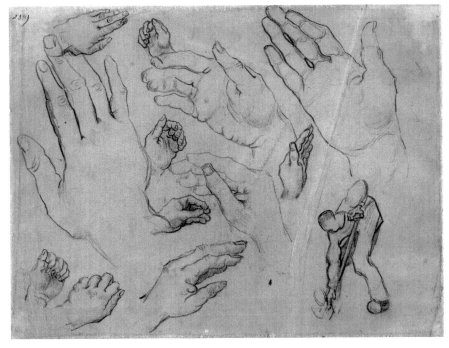

Vincent van Gogh (1853–1890), *Studies of a Hand and a Digger*. Pencil on paper, 9 ⅜" × 12 9/16" (23.8 × 31.8cm). Van Gogh Museum, Amsterdam, the Netherlands.

Although all human hands follow the law of Fibonacci, there are slight differences in the hands of one person to another. Generally speaking, for example, a young woman's hands may have graceful knuckles, slender and tapered fingers, and an overall more delicate appearance than the angular hands of a man. The surfaces of some hands are blistered and rough, while others are soft and smooth; an elderly person's hands may be highly wrinkled. It is easier to see these variations after you have looked at drawn examples of hands that distinctly follow the law of Fibonacci. Look at the diagrams below to see these basic hand proportions. In addition, search online to find helpful tutorials about drawing hands.

INSTRUCTIONS

1. Examine your hand in a variety of positions. Look closely at how the fingers bend.
2. Compare the proportions of the digits to the length and width of the palm, and compare the length of the first digit to the second and third. See if you can find correlations to the Fibonacci series in these dimensional comparisons.
3. On a sheet of 9" × 12" drawing paper, do a series of three sketches of your hand in three different positions.
4. After trying to draw three positions of your hand from observation alone, search online for tutorials about drawing hands. After studying a tutorial, draw your hand three more times in approximately the same positions as before.
5. Search online for a close-up of a hand in a position that you find interesting and somewhat challenging. If possible, find a black and white photograph that shows the hand in great detail.
6. Draw a final picture of the hand you have selected. Add shading as it appears in the photograph.
7. Write a very brief essay (250–400 words) in response to the following:
 a. What did you notice after studying a tutorial about drawing hands that was different than what you had observed while drawing your hand the first time? Explain.
 b. How did you apply what you had learned from the tutorial to your final drawing?

Materials Needed

white drawing paper, 9" × 12"
drawing pencils with soft and hard leads
eraser

Vocabulary

Fibonacci

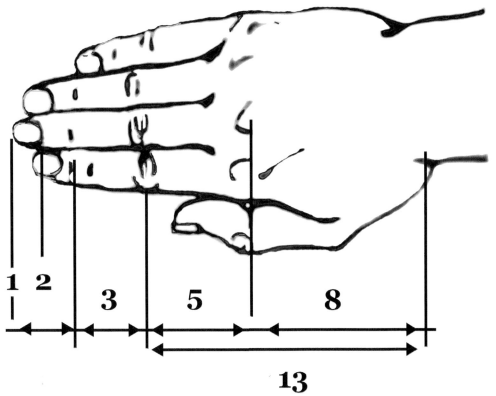

1 2 3 5 8

13

Above, Hand proportions.
(Created by the Author)

Left, Fibonacci hands.
(Created by the Author)

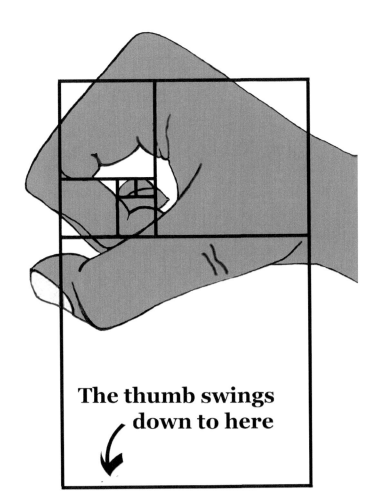

**The thumb swings
down to here**

TIPS FOR TEACHERS

Just as hands are difficult for adults to draw, they present drawing challenges for very young children who are just beginning to notice distinctions in human bodies. One way to help young children notice how many fingers (or toes) people have is to compare their own hands with the hands of cartoon characters, which often are depicted with three fingers and a thumb. While three fingers and a thumb are easier to draw than the full four fingers plus a thumb, cartoonists find fewer digits can still be expressive elements of their characters. As an expressive symbol, hands drawn by young children may have many fingers, especially if the child wants to show actions that involve using hands and fingers. The logic young children use to draw is not a logic of realism; they use images as symbols of objects, actions, and ideas.

As children grow older and strive to draw things more realistically, they may use visual devices to mask an inability to draw hands (or feet) realistically. People may be shown with their hands stuffed in pockets, in mittens, or hidden behind bouquets of flowers. These conventions of drawing suggest the child is aware of his or her inability to draw what he or she sees. You can help children draw hands more realistically by pointing out the proportions of the hand, and how the hand relates in size to other parts of the body. For example, the length of the hand, from the tip of the longest finger to the base of the palm, is about the same length as the face, from the bottom of the chin to the beginning of the hairline. There are one and a half hand lengths from the base of the palm to the elbow. If you open and splay the fingers of your hand as widely as possible, you will find that the distance between the tip of the little finger to the tip of the thumb is about the same as the length of the hand from the tip of the longest finger to the base of the palm. Ask children to measure various parts of their hand with a rule. Compare these measurements to other parts of the body.

WHAT TO SUBMIT FOR EVALUATION

· three observational sketches
· three sketches from the tutorial
· your final drawing of a hand, with a citation to the source or link to the photograph from which you took inspiration for the drawing and the tutorial that assisted you
· a written essay response, as outlined in Instruction #7

LESSON EXTENSION

As a lesson extension, study images of bare feet in various positions. How do human feet adhere to the law of Fibonacci? From the internet or a magazine, select a drawing or clear photograph of a foot seen from the side. Download or photocopy two copies of the image.

· On one copy, overlay a diagram of the Fibonacci spiral.
· Use the second copy as a guide to be copied, studying the shape, dimensions, and proportional relationships of the ankle, heel, arch, instep, ball of the foot, and toes. Draw these parts of the foot.
· Sitting with your legs stretched out in front of you, sketch an image of the tops and toes of your own feet.

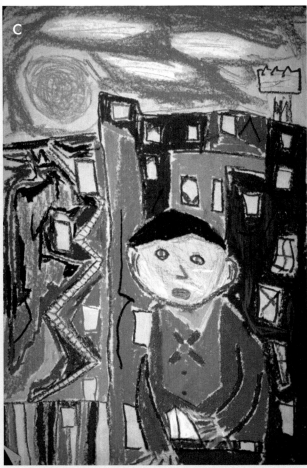

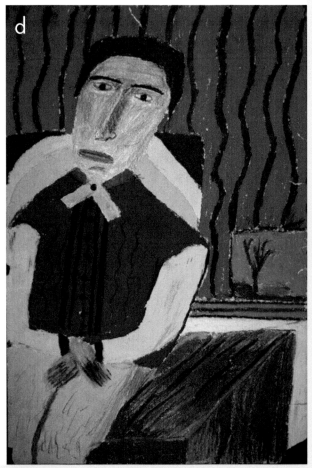

Very young children draw symbolically. Realism is not important at this age, so hands may appear to have many fingers or lack fingers at all, as in figures a and b. As children become more interested in drawing realistically, the difficulty of drawing hands becomes more apparent. In figure c, they have been drawn almost as afterthoughts emerging from sleeves. Another young artist has begun to see the division of fingers on the hands, but the hands are drawn much too small in proportion to the face (figure d). *Children's Depiction of Hands.* (Child Art Collection of Enid Zimmerman)

Lesson 7: Body Proportions

Leonardo da Vinci's **Vitruvian Man** drawing famously described the ideal **proportions** of a human being using geometric principles. The drawing depicts a man with outstretched arms and legs in two positions. The man is enclosed within a circle and a square in such as way that the arms, legs, and head all touch either the circle and/or the square. In his notebooks, da Vinci also wrote out the ideal geometric ratios of human bodies. His notes compare parts of the body as proportional measures of one another and conclude that the ideal height for a man is $7\frac{1}{2}$ "heads" high. Da Vinci also observed that

· the length of the outspread arms is equal to the height of a man;
· the maximum width of the shoulders is a quarter of the height of a man;
· the distance from the elbow to the tip of the hand is a quarter of the height of a man;
· the length of the hand is one-tenth of the height of a man; and
· the distance from below the foot to below the knee is a quarter of the height of a man.

We still look upon da Vinci's notions of the ideal male body as valid, even though real bodies will always vary slightly from this model. The measurements also hold true for adult female bodies; however, children's growing bodies may vary from the adult model. Consider the next example. How are the proportions of these figures similar yet different from da Vinci's Vitruvian Man? When drawing human figures, recognize that these body proportions remain the same even when bodies are in motion, although foreshortening (see Lesson 11) may make it appear that parts of the body that are close to us are larger.

INSTRUCTIONS

1. Study Leonardo da Vinci's Vitruvian Man to understand proportions of the body and how these fill space as the body moves.
2. Look through images in magazines or online and select an image that shows a full-body view of an adult person. Try to find a front, back, or side view that shows movement but does not include a lot of foreshortening. In other words, avoid images that have an arm or leg of the body pointed toward the viewer in a way that makes the arm or leg seem shortened.
3. Using a ruler or other measuring tool, measure the height of the figure's head. Compare this measurement to other parts of the figure's body (upper arm and lower arm with hand, or head to overall height of the body, etc.). How many heads high is this person? What other measurements are similar to or different from the ideal body measurements described by da Vinci?

Facing, Leonardo da Vinci (1452–1519), *Vitruvian Man,* ca. 1492. Drawing, ink, and wash on paper, $13\frac{1}{2}$" × 9 3/5" (34.3 × 24.5 cm). Gallerie dell'Accademia, Venice, Italy.

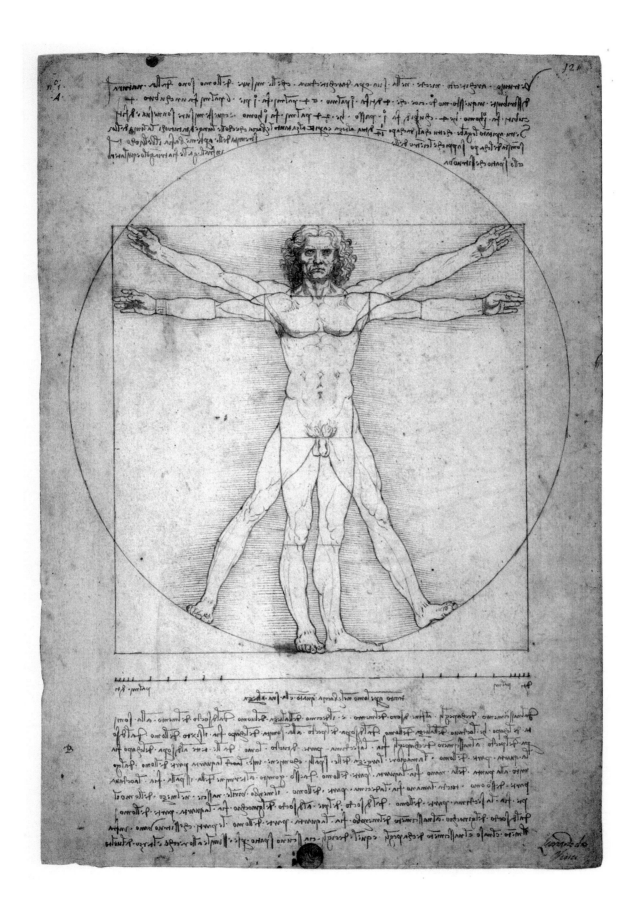

Proportions of typical male and female adults. Notice the larger head-to-body proportion of the infant, who is only 4 heads high. Examine full-sized photographs of children at different ages to see how the ratio of head size to body changes as we grow into adulthood. (Created by the Author)

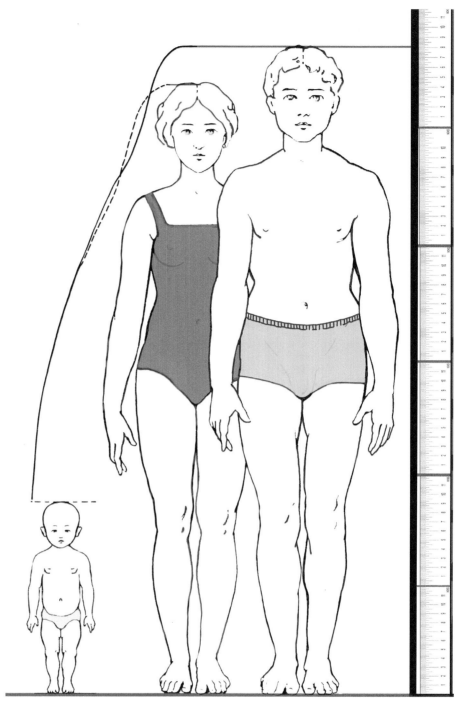

ART THEMES

4. With a drawing pencil, mark these relationships on the magazine photograph.
5. Draw a sketch of the person in the image. Use stick-figure lines or circular guidelines to help you see how bones of the skeleton fit together and allow the body to move.
6. Keep a copy of the sketch by scanning it or capturing a digital photograph of it.
7. Turn the sketch into a finished image by drawing over the circles and lines to add flesh and clothing.
8. Use shading to add a sense of volume.
9. Write a very brief essay (250–400 words) in response to the following:
 a. Explain how the proportions and movement seen in da Vinci's Vitruvian Man are similar to or different from the proportions considered ideal for fashion models and ordinary humans today.
 b. What difficulties did you encounter when creating this work? Were the primary issues technical, or related to the concept of proportions? Explain.
 c. To what extent (and how) did you resolve these problems?

Materials Needed

white drawing paper, 9" × 12"
drawing pencils with soft and hard leads
eraser
ruler

Vocabulary

Fibonacci
Proportion
Vitruvian Man

WHAT TO SUBMIT FOR EVALUATION

· a copy of the image that inspired your drawing
· your sketches of that image
· your completed drawing of a person that demonstrates accurate body proportions
· a written essay response, as outlined in Instruction #9

LESSON EXTENSION

Because aesthetic tastes change with time, ideals of beauty in one era may not be the most pleasing or preferred bodily proportions for another era. For example, contemporary fashions are (unrealistically) designed for women who are 8½ (rather than 7½) heads high. What parts of the body do illustrators of women's fashion elongate in order to make models appear to be 8½ heads high or higher? Are models of men's fashions also illustrated to be taller than 7½ heads high?

Compare images of a person drawn in realistic proportions with a fashion illustration. Draw the outline of a figure that is 8½ to 10 heads high and a figure that is 7½ heads high. On the taller outline, design an outfit, include patterning of fabric and other details. Then draw the same outfit, including all details, on the realistically proportioned figure, or scan the taller drawing and insert into Photoshop. Then use the scale feature to shorten the drawing to 7½ heads high.

- What differences do you notice?
- What is your felt response to these differences?
- Do you consider one image prettier than the other? (If so, which one?)

Think critically about your reaction. Is one figure truly more beautiful that the other, or does your response suggest that you have been socialized or persuaded by media images to accept an unrealistic perception of human bodies?

TIPS FOR TEACHERS

Body Proportion, Biology, and Math

As an interdisciplinary connection to biology or health, encourage students to search for information online about how the bodily proportions of infants and children differ from the bodily proportions of adults. What would account for these differences?

At the upper elementary level, students begin to be concerned with how things *look*, as opposed to simply providing representations of the *idea* of things. Lessons in ideal bodily proportions are especially helpful to students at this grade level. Consider how information about body proportions might be of assistance to students' math learning, while also informing those who are eager to draw human beings with convincing visual realism.

TIPS FOR TEACHERS

Socially Contrived Notions of Appropriate Body Proportions

Body image is of concern to students even at the elementary level. Media images can inculcate children with notions of beauty that are often quite unrealistic. Looking at ideals of proportion found in nature as relationships of parts to the whole or as the law of **Fibonacci** allows open discussions about issues of beauty. Have students examine images of people who do and those who do not live up to popular expectations of beauty in contemporary society. Regardless of whether or not an adult person is overweight or underweight by contemporary socially determined standards, and regardless of the ethnicity of the person or factors of gender, all the images are probably approximately 7½ heads high. What does this tell us about how we should think about the ideal body? Encourage students to openly explore and discuss this topic.

To assist students in understanding how mass media distorts our perceptions of ourselves as less than physically *ideal*, invite students to compare the average *real* height of adults—as demonstrated by Leonardo da Vinci's Vitruvian Man—with fashion illustrations. Designers create fashion illustrations by drawing models that are from one to four heads higher than the ideal proportional height of real human beings! These impossible proportions are also used in the creation of fashion dolls that are popular with children. No wonder many children grow up with unrealistic expectations of what they should look like!

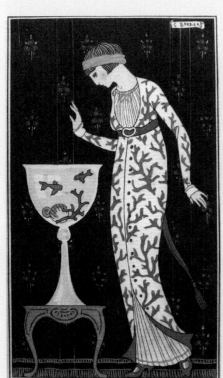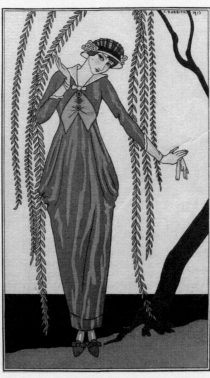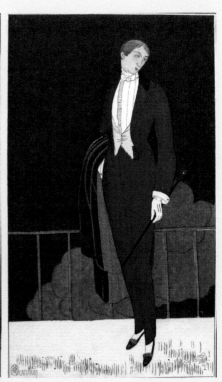

These fashion illustrations were created by designers over 100 years ago. Compare the height of the figures with da Vinci's *Vitruvian Man*. Then compare them to the height-of-fashion illustrations by contemporary designers. What do fashion illustrations tell us about changing beauty ideals over the past 100 years? "Costumes Parisiens," fashion illustration No. 86, *Riding Habit*, by Kriegck; illustration No. 91, *Robe of Gray Taffeta*; illustration No. 61, *Brocaded Silk Housecoat*, by George Barbier (1882–1932). *Journal des dames et des modes*, 37 (1913). (via Wikimedia Commons)

Lesson 8: The Figure in Action

In a drawing, the tilt of a torso, the angle of a hip, or the bend of an arm or leg can all convey some human action or tension. Very seldom do we see real-life humans who are stiff or absolutely still. Therefore, if an artist wishes to draw a realistic image of a person, it is important to suggest some movement or gesture. It is also important to show the person in accurate proportion. When drawing a person in motion, this can include using the principle of **foreshortening**. In this lesson, you will have the opportunity to use a photograph to help you draw an accurately proportioned human figure in an action **pose**, which may also require that a portion of the body be seen in a foreshortened position.

George Bellows (1882–1925), *A Stag at Sharkey's*, 1917. Lithograph, 18 9/16" × 23 15/16" (47.2 × 60.7 cm). Gift of Mrs. George Ball, Indianapolis Museum of Art, Indianapolis, IN.

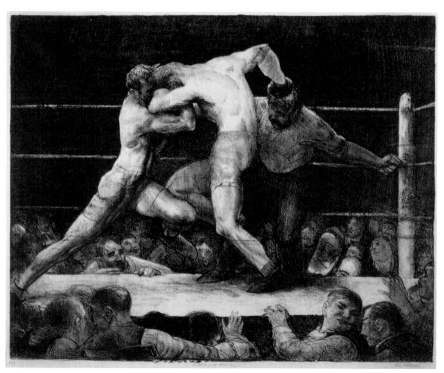

INSTRUCTIONS

1. Find a photograph in a magazine or newspaper that depicts a person in a strenuous action. It could be a picture of a sprinter, dancer, swimmer, basketball player, or gymnast. The picture should show the entire body of the person.
2. Remember that a body part such as an arm or leg coming toward you will appear shortened, because its full length is masked. This is called foreshortening.
3. Using a colored pencil or marker, draw stick-like shapes that describe the underlying structure of the movement. You can think of these as the skeleton or as connecting rods and joints. Notice where foreshortening occurs, as in the shoulder area of this side view of a running baseball player.

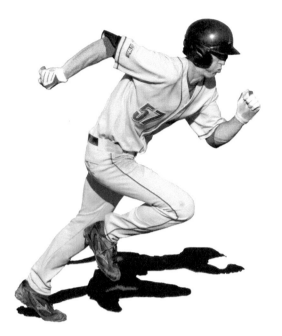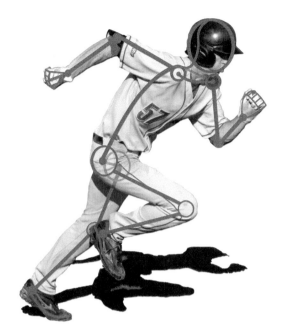

Stick action figure and slightly modeled stick figure. (Created by the Author)

4. Make two quick outline sketches on each of two sheets of 9" × 12" white drawing paper. Start with very lightly drawn stick shapes that show the basic skeleton of the moving person and the proportions of the body. Draw the main angles. At this point, do not try to draw the picture in detail. The drawing should try to show the **gesture** of movement.

5. Choose the sketch that you think best captures the action of the pose. Draw the pose again on another sheet of 9" × 12" white drawing paper. This time draw it so that the image fills most of the page.

6. Flesh out the stick figure to show the volume of the body. Use a very light touch of the pencil, so you can easily erase and correct your work.

7. Continue fleshing out the figure. Add **shading** to show how light would affect the form. Add clothing and details.

8. Write a brief essay (300–400 words) in response to the following:
 a. Describe how foreshortening changes the appearance of human proportions.
 b. Describe how you went about drawing your finished work.
 c. How did you describe the gesture as a stick figure and then flesh out the form?
 d. Explain any problems you had drawing the action figure. How did you think/work through each problem?
 e. Indicate what additional information would have helped you solve the problems of drawing a person in a position that demonstrated foreshortening.

Materials Needed

white drawing paper, 9" × 12"
drawing pencils with soft and hard leads
eraser

photograph or picture from magazine of a person
with a foreshortened body part

Vocabulary

Foreshorten/Foreshortening	Shade/Shading
Gesture	Stop Motion
Pose	Zentangle

WHAT TO SUBMIT FOR EVALUATION

- a photograph from a magazine (or downloaded from the internet) that has been overlaid with a colored sketch of the underlying skeleton
- four sketches (two each on two sheets of 9" × 12" white drawing paper)
- a finished action drawing that demonstrates action gesture, accurate proportion, shading, and foreshortening
- a written essay response, as outlined in Instruction #8

Sketches of Figures in Action. Pencil on paper, 10" × 8 ⅛". (Child Art Collection of Enid Zimmerman)

ART THEMES

1. Fill a page with sketches of people in action; try to capture the overall form of the movement. Notice the effects of foreshortening.

2. Templates are helpful for learning the proportions of the body and seeing how parts of the body move in relation to one another. As a lesson extension, cut template pieces of black or colored construction paper, using the template pieces shown below. Arrange these against an interesting background that has been created in collage, watercolor, or digitally, or create an abstract arrangement of colors and shapes or **Zentangles** (see Lesson 58) as background and details.

Cut 1 Head, Torso, and Hip

Cut 2 Upper and Lower Arms, Thighs, Calves, Hands and Feet

Top, Template for an action figure. Cut one of the head shape and one each of the upper and lower torso. Cut two of each upper and lower arm, thigh, calf, and foot pieces. These may be used as templates or patterns. The two hand pieces may be cut from scraps. (Created by the Author)

Below left, Zoe Cradick, *Mardi Gras Dancer,* 2013. Color paper collage with template pieces, 12" × 9". (Courtesy of the Artist)

Below right, Joan Lancing, *Running before Jugglers* (Courtesy of the Artist). Lancing has placed a template-made figure on top of a digitalized photograph of a Paul Klee painting. Paul Klee (1879–1940), *Arrival of the Jugglers (Llegada de los juglares),* 1926. Oil on incised putty on cardboard mounted on cardboard, 6 7/8" × 10¾" (17.46 × 27.3 cm). Phillips Collection, Washington, DC. Acquired 1939, © 2015 Artists Rights Society (ARS), New York, NY. (Photograph by Miguel Hermoso Cuesta. CC BY-SA 4.0)

3. Turn action figures into a **stop motion** film. Place the template pieces in an arrangement against a separately made background that has been tilted at about a 30° angle. Affix a camera onto a tripod in such a way as to have the background and figures parallel to the camera lens. Take stop action photographs of the figure, moving the template pieces slightly with each photograph to create a complete action, such as a figure kicking a soccer ball or diving into a pool. Edit the film into a short animated sequence, using one of several apps or available software programs.

TIPS FOR TEACHERS

Using Templates to Create Action Figures

As children develop in their abilities to draw the human body, they become concerned about bodily proportions and how arms, legs, and heads "look" when in motion. Often, in an attempt to show action, students overlook the joints of the body that are crucial to movement. As a result, figures may appear to have rubber arms and legs. While this may be a charming childlike way of depicting figures, using templates allows students to recognize the function of joints while also permitting more sophisticated ways of visually describing action. This method of creating people-in-action pictures helps young students understand human anatomy and proportion.

The template above can be enlarged on a scanner to a size of your choice and used as a pattern for making students sets of templates. Invite them to arrange these shapes on drawing papers in interesting action positions. Try different variations of this technique: black forms can be left as silhouettes against decorated backgrounds; or forms cut from white cover weight paper can be colored with crayon or marker to add clothing and features.

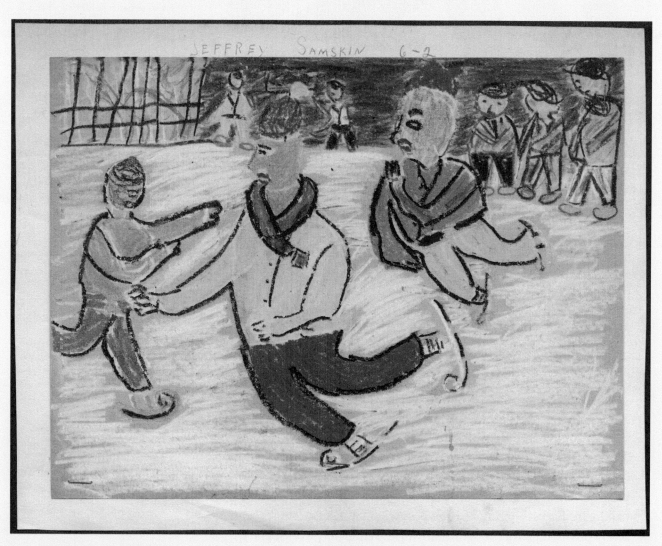

Ice Skating. Crayon on manila paper, 9" × 12". (Child Art Collection of Enid Zimmerman)

Lesson 9: Inspired by da Vinci

Leonardo da Vinci (1452–1519) lived during a period when people were emerging from the **medieval** era and rediscovering the arts of Classical Greece and Rome that had been ignored or forgotten for hundreds of years. Da Vinci personified the spirit of insatiable curiosity that characterized great thinkers and artists of the **Renaissance**. As a painter, sculptor, inventor, biologist, astronomer, engineer, architect, and mathematician, da Vinci made unique contributions to the culture of his time. His drawings of portraits and figures are of a remarkable quality that still holds appeal for people today.

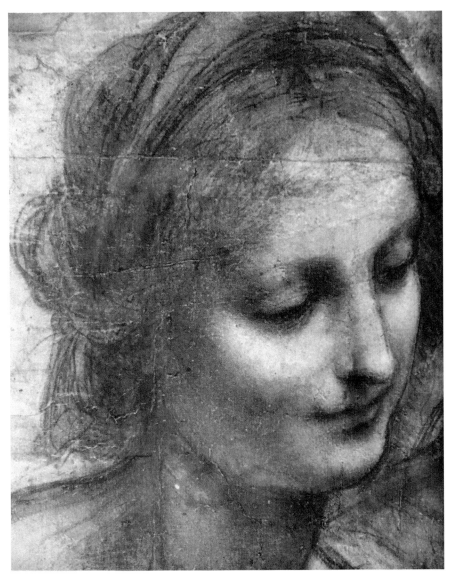

Leonardo da Vinci (1452–1519), *The Burlington House Cartoon: The Virgin and Child with St. Anne and St. John the Baptist*, detail of Virgin Mary, 1499 and 1500. Charcoal black and white chalk on tinted paper mounted on canvas, 55 3/5" × 41 1/8" (141.5 × 104.6 cm). National Gallery, London, UK. (F. Zöllner and J. Nathan, *Leonardo da Vinci: The Graphic Work* [Paris, France: Taschen, 2014])

INSTRUCTIONS

One way to learn about drawing is to go through processes similar to those other artists went through when they drew. Da Vinci made many realistic portrait and full-length drawings of people. For this assignment, look at many examples of drawings by Leonardo da Vinci.

1. Select a drawing of a person (either a portrait or a full-length figure) by da Vinci. Make a photocopy of the drawing.
2. Carefully study the body **planes**, **contours**, **proportions**, **shading**, and **details** in the da Vinci drawing.
3. Make a drawing of the da Vinci artwork you have chosen to study. Your drawing should be on 9" × 12" white drawing paper with several pencils having soft and hard leads. Do not trace!
4. **Render** all contours, proportions, shading, and details as accurately as possible.
5. Write a very brief (200–250 words) response to the following:
 a. Describe how da Vinci personified the spirit of the Renaissance in Italy.
 b. Explain why da Vinci's drawings are excellent examples for the study of portraits and human figures.

Materials Needed

white drawing paper, 9" × 12"
pencils with soft and hard leads
eraser

TIPS FOR TEACHERS

Leonardo da Vinci was a scientist as well as an artist. He seems to have understood **Golden Numbers** or the **Golden Ratio**, which is proportionally similar to the law of **Fibonacci**, and he used mathematical relationships to help draw realistic images of people and objects in nature. The characteristic of the Fibonacci series is that each number consists of the sum of the two numbers before it: 0, 1, 1, 2, 3, 5, 8, 13, 21, 34, 55, 89, 144, 233, 377, 610

The Golden Ratio helps us know how to draw the proportions of the human face (see Lesson 3), the overall proportions of the body, and every part of the body. Have students use a ruler or tape measure to test the proportions of their own bodies. Have students pose for one another to measure the following pairs of features:

· length of face / width of face
· distance between the lips and where the eyebrows meet / length of nose
· length of face / distance between tip of jaw and where the eyebrows meet
· length of mouth / width of nose
· width of nose / distance between nostrils
· distance between pupils / distance between eyebrows
· the distance between the fingertip and the elbow / distance between the wrist and the elbow
· the distance between the navel and knee / distance between the knee and the end of the foot

Students should write down these measurements, then draw facial or full-length portraits of one another based on the measurements. Refer to the relationships of one measurement to another as a guide assisting them in determining if their drawings are accurate.

WHAT TO SUBMIT FOR EVALUATION

· a photocopy of a drawing by Leonardo da Vinci
· the completed drawing that you made as a copy of da Vinci's drawing
· a written response to Instruction #5

LESSON EXTENSION

Michelangelo di Lodovico Buonarroti Simoni (1475–1564), who is better known simply as Michelangelo, was a contemporary of Leonardo da Vinci, and for a time the two great artists worked in the same region of Italy. While Leonardo was known as a painter, Michelangelo was primarily a sculptor, even though one of his greatest accomplishments was the painting of the Sistine Chapel in Rome. Comparing works by the two men, you may notice some distinctive differences in their styles of work. For example, Michelangelo carefully studied, explored, and described the heavy muscular structures of the human face and body, while Leonardo was concerned with the sensuousness of flesh and soft tissues over muscle and bone. As an extension of this lesson, select an image of a sculpture or painting by Michelangelo and practice drawing it. Compare it to your drawing of a work by Leonardo da Vinci. Do your drawings capture some of the differences you see between works by Leonardo and those by Michelangelo?

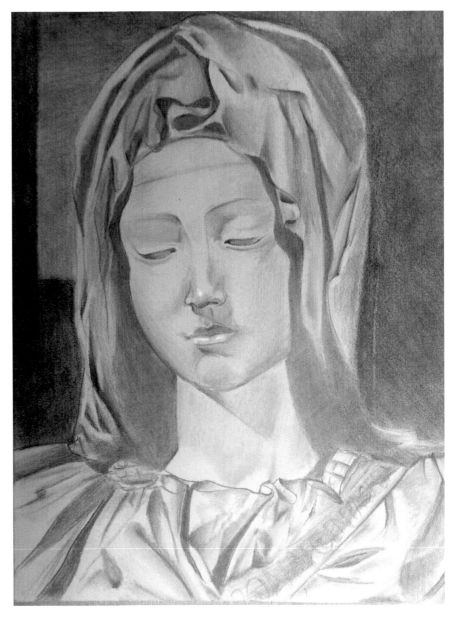

Student drawing of Michaelangelo's *Pietà*, detail, head of Mary. Pencil on paper, 12" × 9". (Courtesy of the Artist)

Lesson 10: A Three-Quarter-View Portrait

A full-face view of a person usually appears **symmetrical**. Side views are **asymmetrical**. A face that is partially turned to the side is described as a three-quarter view, because we see aspects of the front and side view simultaneously. A good three-quarter view is balanced, but it is more asymmetrical than symmetrical. This kind of portrait work is more difficult than drawing a front or side view, but results also may be more interesting. This lesson offers you an opportunity to draw a three-quarter front-view portrait.

Albrecht Dürer (1471–1528), *Head of an African*, 1508. Black chalk, 12½" × 8½" (31.8 × 21.7 cm). Albertina Museum, Vienna, Austria.

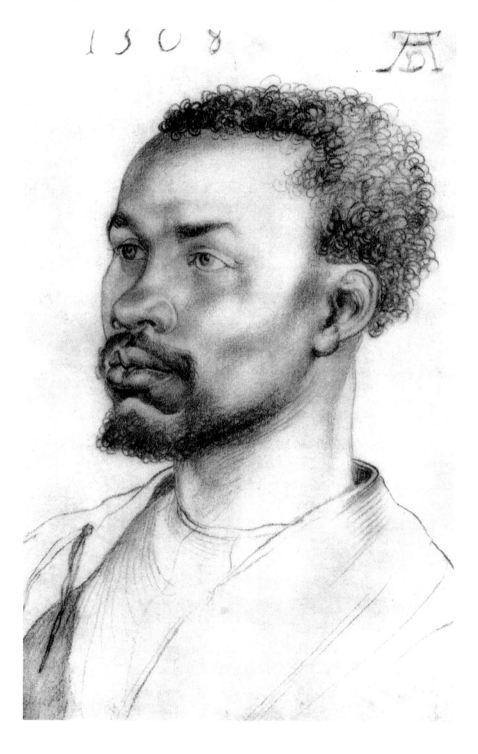

1. Ask a friend to pose for a portrait drawing.
 a. Sit so that your eyes are on the same level as the person posing for you. Also sit as close as possible, so that you can see all of the important details.
2. Use a strong light source, such as a lamp, that casts strong shadows on the face. This will help you see the **planes** of the face and how light falls on these planes.
3. On white drawing paper, either 9" × 12" or 12" × 18", lightly sketch the generalized oval shape of a head. Use a very light vertical line to show where the center of the face will be and use vertical lines to mark where the eyes, nose, and mouth will fall. Refer to information about **facial proportions** in Lesson 3, Use these as guidelines throughout your drawing,
4. Go over the oval shape and redraw it into a shape that more accurately describes the actual head of your subject. Begin to sketch the shapes of the subject's eyes, nose, mouth, hairline, and the one ear you can see. Be sure to check and re-check the positioning of these against what you actually see when looking at your subject and the faint guidelines you have provided for yourself on the drawing paper. Always use light lines with a soft pencil as you draw these early parts of the portrait. This will allow you to easily erase mistakes and correct the drawing until you have all the parts drawn in to your liking.
5. Draw the neck and shoulders.
6. Begin adding **shading**—darker areas that are the result of shadows falling on the face. Go over the features and hair to add shadows and **visual texture**.
7. Before concluding your drawing from life, ask your subject to hold his or her position just a little longer and take a photograph of that person in the position you describe in your drawing.

Left, Erithe (Erin McChesney), *Self Portrait*. Watercolor and digital manipulation. (Courtesy of the Artist)

Right, Kevin Potter, *A ¾ View Portrait,* 2012. Charcoal on paper, 11½" × 8". (Courtesy of the Artist)

8. Write an essay (300–400 words) in response to the following:
 a. Compare the photograph to your drawing. Did the camera see things that you did not? Did you see details that the camera did not?
 b. Describe basic facial proportions and explain how you visualized the head turned at an angle.
 c. Describe how light from a single source casts shadows on the planes of the face when the face is turned slightly toward or away from the light.

Materials Needed

white drawing paper, 9" × 12" or 12" × 18"
drawing pencils with soft and hard leads
eraser

Vocabulary

Asymmetry/Asymmetrical	Plane
Facial Proportions	Shade/Shading
Gradation	Symmetry/Symmetrical
Gray Scale	Visual Texture

WHAT TO SUBMIT FOR EVALUATION

· the photograph you took of your subject
· a completed drawing of the subject
· an essay response to the questions posed in Instruction #8

TIPS FOR TEACHERS

Shading Faces

Shading is very important to creating a realistic drawing of a face. Because you are creating a three-quarter drawing, it may be helpful to have the stronger light fall on the side of the face that is turned toward you. This will cast the part of the face that is farther from you in shadow.

Sketch the outline shape and features of the face. Then, look at the shadows around the eyes, under the nose and mouth, and under chin. Identify the basic blocks of shadow.

After you have identified basic dark and light areas, look at areas that may need special attention in terms of shading. For example:

· Shade the eyelid fold above the eye to create depth.
· Shade the side of the nose that is farther from you, around the nostrils, and at the bottom edge of the nose. (Keep the shadow under the nose subtle, so it doesn't look like a moustache.)
· There may be subtle shading around the cheekbones, beneath the eyes, beneath the mouth, and on the neck under the chin.

If you have difficulty determining how light or dark one shadow is in comparison to another, try using a **gray scale** measuring device (see Lesson 4) until these differences in **gradation** become familiar to you.

Lesson 11: Foreshortening

In order to create a realistic impression of objects in space, artists draw objects that are closest larger than those that are at a distance. This visually distorts the appearance of things that we know to be of particular proportions. In a drawing of a person who is standing parallel to the artist, accurate **proportions** of the body are evident, but when a part of the body is extending toward the artist, that part will appear larger than those parts of the body that are receding away from the artist. This effect is known as **foreshortening**, because the space between the closest portion of the body and the furthest portion appears to be greatly shortened. In this lesson, you will practice drawing an effect of foreshortening.

Left, Canadian Sports Publishing Company, *Hurdlers,* 1910. 7 2/3" × 9 1/4" (19.5 × 23.5 cm). From "Picturing Canada Project," British Library, London, UK.

Above, (Erin McChesney), *Bright Morning Light: Cerion,* 2014. Pencils and Photoshop CS5. http://erithe .deviantart.com/art/Bright-Morning -Light-Cerion-448193773. (Courtesy of the Artist)

1. Ask a friend or family member to pose with one of his or her limbs extended out toward you. Take a digital photograph of the person in this position. Check the photo to see if it truly captures an effect of dramatic foreshortening; if not, take pictures of several such poses until you find one that presents this interesting phenomenon.

2. Crop the photo so the foreshortening effect is emphasized as the subject of the image, print out the photo in a large size and use as a hard-copy reference while working.

3. Carefully sketch the foreshortened image onto a sheet of 9" × 12" drawing paper.

4. Begin by drawing the largest portion of the body; then draw the smallest portion while looking closely to compare the visual size of this area in relation to the largest portion. How does ideal proportion seem distorted?

5. Look at the areas that connect the largest to the smallest section of the body. Don't allow yourself to be confused by thinking of the connective areas as body parts (i.e., as the leg or arm) but simply examine these as shapes. This will help you *see* what foreshortening looks like.

6. Using soft and hard lead drawing pencils, add shadow and value to the drawing so as to emphasize the foreshortening effects.

7. Write a very brief essay (250–400 words) in response to the following:
 a. Describe the visual appearance of a foreshortening that occurs when viewing a body with a limb or section extended toward the viewer.
 b. How did you use shading to increase or emphasize the foreshortening effect?

Materials Needed

white drawing paper, 9" × 12"
pencils with various soft and hard leads
eraser

Vocabulary

Foreshorten/Foreshortening
Kraft Paper
Proportion

WHAT TO SUBMIT FOR EVALUATION

· the photograph you took of foreshortening
· the drawing you created of the foreshortening effect
· a written essay response, as outlined in Instruction #7

TIPS FOR TEACHERS

Foreshortening is a visual illusion. Young students are fascinated by visual illusions, especially when the illusions involve the human body. Working with human foreshortening as a visual illusion has the benefit of teaching about space and illusions of visual distortion. An easy way to teach the concept is to ask students to stand on large pieces of **kraft paper** and have friends help them trace around their feet and/or hands. Then draw their faces and the trunks of the bodies in the center of the paper, with their limbs decreasing in size as they recede from the enlarged hands and feet and the trunk of the body. What visual illusion does this suggest?

Parachuting! 1989. Crayon on manila paper, 12" × 9". (Child Art Collection of Marjorie Manifold)

Lesson 12: A Portrait of a Shoe

Artists recognize all manner of objects as potentially interesting subjects for finished drawings. Teapots, Coke bottles, car seats, as well as articles of clothing may be interesting subjects because of their unique forms and functions in everyday life. Also, because such objects are made and used by human beings, they may be perceived **metaphorically** or physically as representative portraits of their human makers and users. Everyday objects that intentionally or accidentally appear to combine elements of inanimate form while visibly referencing humans may be described as **anthropomorphic** or anthropomorphized forms. For example, as shoes are worn and become formed to the shape of a wearer's feet, they present as anthropomorphic forms. Additionally, the warped shape of a ragged shoe metaphorically references the life and activities of its wearer. In this lesson, you will carefully observe and draw the **contour**, details, and **visual texture** of a worn shoe as a referential portrait of its owner.

Elena Jeon, *Portrait of Shoes*, 2013. Pencil on paper, 8½" × 11". (Courtesy of the Artist)

TECHNIQUES FOR ADDING TEXTURE

Adding visual texture to a drawing is similar to adding **shading**. Use of hard and soft pencils to create lines can help create the effect of texture. Also, techniques like **hatching** (the use of fine lines laid side by side), **crosshatching** lines (lines that cross), **stippling** marks (dots placed close together), and **scrumbling** (scribble lines laid close together) can be used to create the effect of texture. Here are some examples of the effects that can be created by using these techniques. Try inventing a few techniques of your own!

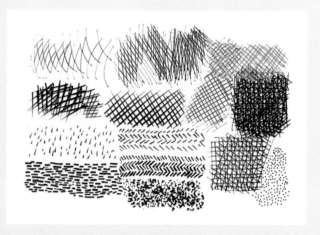

Where do you see examples of scrumbling, hatching and crosshatching, and stippling in this notebook page of sample lines? What additional techniques could you use to create a sense of visual texture in your drawing? (Created by the Author)

1. Begin this project by practicing drawing a variety of lines. On a sheet of 9" × 12" white drawing paper, practice drawing wavy lines, short repeated lines, and cross-hatching (crisscrossed lines) with pencils of different lead types. Notice how the soft leaded drawing pencils create a darker effect than the hard leads. Try drawing wavy lines that stretch from one side of the paper to another, while alternately pressing down firmly and then lightly on the drawing pencil. This should create thin and thick lines. Try drawing some lines with the tip of a sharp pencil lead and other lines with the side of the lead.

2. Select a worn shoe from your closet, or ask a member of your family to allow you to use a worn shoe as the subject of your drawing. Place the shoe on a table in front of you. Turn or tilt it so that you have an interesting view.

 a. It will be helpful if you place a strong light source, such as a reading lamp, near the shoe, so the light will cause strong shadows to be cast by the shoe.

3. On a 9" × 12" sheet of white drawing paper, carefully draw the contour of the shoe. Draw the contour so it fills the largest area of the drawing paper. Try varying the line to create thin and thick contour lines.

4. Now carefully observe the details of the shoe. Notice things like worn heels, frayed shoelaces, missing eyelets, bent tongue, or scuffs on leather or canvas.

5. Using a variety of drawing pencil leads and line types, sketch details of the shoe. In doing so, try to capture the shoe's anthropomorphic *personality.*

6. Add shading to the shoe by looking for areas that are in shadow.

7. Write an essay (300–400 words) in response to the following:

 a. Describe variations of line in your practice drawing; explain how you created that line variation.

 b. Explain why a drawing of an inanimate object might serve as a metaphor of a person or people.

 c. Describe how this drawing of a shoe presents the shoe as having an anthropomorphic personality. How would you describe the personality?

Materials Needed

white drawing paper, 9" × 12"
drawing pencils with soft and hard leads
eraser

Vocabulary

Anthropomorphic	Hatching	Shade/Shading
Contour(s)	Metaphor/Metaphoric	Stippling
Cross-Hatch(ing)	Scrumbling	Visual Texture

WHAT TO SUBMIT FOR EVALUATION

· a sheet of drawn line experiments
· a detailed drawing of a shoe
· a written essay response, as outlined in Instruction #7

LESSON EXTENSION

Add color to your drawing with a medium of your choice. The color should not take the place of drawn textures but should enhance the effect of visual texture. Color might also give further description, as in this image of the repaired sole of a worn shoe.

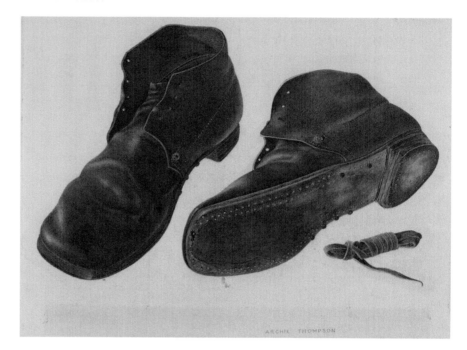

TIPS FOR TEACHERS

Drawings of shoes can reveal something of the wearer in terms of the shape of the foot, how the person walks, his or her interests, work, and status. Shoes also reveal the basic cultural milieu of the wearer. For this reason, shoes are excellent visual resources for studying social history and geography.

Historically, the materials from which shoes were made reflected available raw materials and addressed the needs of a people arising from their environmental conditions and life contexts. Thus, sturdy but lightweight willow or poplar wood of the Netherlands was carved into shoes that protected feet from damp, swampy ground. Inuit peoples of the Artic made soft lightweight boots or *kamik* of reindeer or sealskin lined with fur that kept their feet warm and allowed them to move quickly over snow and ice. Native peoples throughout North American wore *moccasins* of deerskin, caribou, moose, or sometimes with buffalo hide to protect feet from rough or hot terrain. Additionally, decorations on shoes reflected the regions where peoples lived and tribes or cultural groups to which they belonged. Natives of woodland tribes preferred

decorative floral motifs, while Natives of plains of deserts covered their moccasins with geometric motifs made of flatted and dyed porcupine quills, and shell or glass beads.

Shoes reflect the status and working roles of their wearers. In some circumstances they are understood as symbols of beauty and wealth. Among women of ancient China, for example, it was considered quite beautiful to have extremely tiny "lotus" feet. Mothers would tightly bind the feet of their young daughters to prevent the feet from growing normally. Cone-shaped shoes or *jin lian* were made of elaborately embroidered silk intended to highlight the fragility of the wearer rather than to support walking. During the Italian Renaissance, aristocratic women and boys wore *chopines* or shoes attached to high cork platforms to keep their heavy velvet and brocade dresses or cloaks from dragging in the mud and mire of city streets. Eventually these stilt-like shoes became fashion statements in themselves and were elaborately brocaded, embroidered, trimmed in silver, or adorned with precious jewels.

Have students examine images of shoes that were worn by people from many cultures and positions in society, and invite them to use visual cues to categorize these shoes into ones worn by peasants, the middle class, or the elite of their societies. What might have been the environmental or geographic origin of the shoe and its wearer? What other information might children glean from examining shoes from diverse cultural and historic eras?

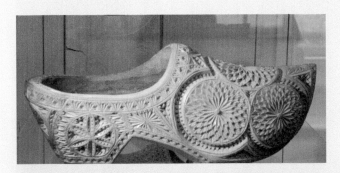

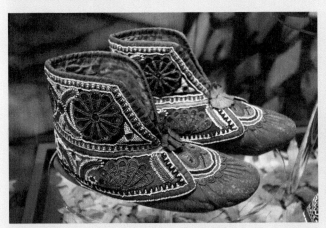

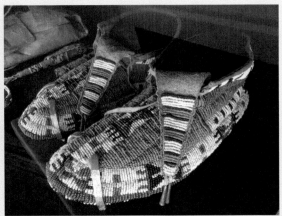

Lesson 13: Looking at Details

Have you ever looked at a small object through a magnifying glass? Details that you cannot normally see become clearly visible. Even without a magnifying glass, the human eye often takes a long time to notice rather obvious details of an object. This is because we are so accustomed to looking quickly at objects to see *what* they are that we do not examine details of objects carefully. The purpose of this lesson is to exercise the magnification powers of your eyes by having you examine and draw a natural object in great detail.

Ernst Haeckel (1834–1919), *Artforms of Nature (Kunstformen der Natur)*, 1904, Plate 53: Prosobranchia. (via Wikimedia Commons)

1. Select an object from nature such as a plant, piece of tree bark, small seashell, flower, or leaf. Examine the object for several minutes. If you have access to a magnifying glass, you can explore the very small details of the object.

2. When you are confident that you *know* the object visually, draw its contour with a pencil on a sheet of 9" × 12" white drawing paper. Draw the object so that it fills up a large section of the drawing paper. This enlargement is possible by keeping the **details** and **contour** of the object in **proportion** to one another.

3. Use a variety of drawing pencils with soft and hard leads to create the illusion of **three-dimensional** form by indicating **light and dark values** or **shading** observed in the object.

4. Add details and visual texture of the object.

5. When you think nothing more needs to be added to the drawing, take a fresh look at the object. You will probably discover details that you had not seen before. Include these newly discovered details.

6. In a brief essay (300–400 words), write about the following:

 a. Describe something you noticed when looking closely at your subject that you had not noticed before.

 b. List at least three reasons why it might be beneficial to or important to study an object carefully before making a detailed drawing, and consider why these might be important to you in your professional or everyday life.

Left, Linda Helmick, *New Birth*, 2015. Graphite on paper, 30" × 20". *Right, Rose in Black and White*, 2015. Charcoal on canvas, 5' × 3'. (Courtesy of the Artist)

Materials Needed

white drawing paper, 9" × 12"
drawing pencils with soft and hard leads
eraser
magnifying glass

Vocabulary

| Contour(s) | Light and Dark Values | Shade/Shading |
| Detail | Proportion | Three-Dimensional |

WHAT TO SUBMIT FOR EVALUATION

· the object you drew from nature
· a finished detailed pencil drawing of that object
· a written response, as outlined in Instruction #6

LESSON EXTENSION

As a lesson extension, notice the color details of a small object or objects and describe these in a color medium of your choice.

Albrecht Dürer (1471–1528), *Tuft of Cowslip*, 1526. Gouache on vellum, 7 5/8" × 6 5/8" (19.3 × 16.8 cm). The Armand Collection, National Gallery of Art, Washington, DC.

Lesson 14: Drawing Trees

Trees included as realistic features of a landscape painting help viewers identify general information about the geographic region being described or portrayed in the painting. Some types of trees are indigenous to a wide variety of geographic environments; others have limited ranges of habitation. Thus, we can identify a landscape of palmetto trees as describing a tropical region near the sea, while a forest of tall fir trees would more likely indicate a northern latitude or high altitude.

Regardless of their geographic region, forested environments tend to make us feel calm. There is a biological reason for this: leafy trees produce oxygen, which makes the air around them easier to breath. Being in the presence of woodlands also has the psychological effect of relieving stress and alleviating mental fatigue. When it is not possible to spend time in nature, simply looking at lovely landscape images of trees can calm the mind and spirit.

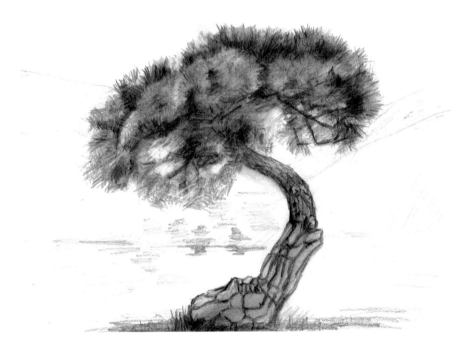

Elena Jeon, *Tree*, 2013. Pencil on paper, 8½" × 11". (Courtesy of the Artist)

Besides general tree variants, such as conifer, deciduous, and palm types, there are differences among trees within each of these categories. Particular trees have distinguishing trunk and limb shapes, bark textures, and leaf constructions. Focusing on trees as the main subject of landscape art gives an opportunity for the artist and viewer to observe these distinctive features. Look at the tree images in this collection of vintage postcards. Notice differences in the **silhouettes**, **visual textures** of bark, shapes of leaves, and appearance of seeds specific to each. Notice also various tree proportions. When standing near trees, we first notice the size of the trunk; as a result, novice observers tend not to notice that in many tree types, the foliage extends much higher than the length of the trunk. When drawing deciduous and fir trees, a general

Horse Chestnut	Oak Tree	Ash Tree
Silver Birch	Elm Tree	Beech Tree

Tree silhouettes from vintage postcards. (via Wikimedia Commons)

rule of thumb is to consider the length of the visible trunk as only one-quarter the height of a tree in full foliage.

If you are drawing a deciduous tree in later fall or winter, you can clearly see how branches of the tree taper as they split off from the trunk, and how these give way to switches and twigs. If this were not so, even the thickest trunk could not support the weight of branches that extend up to three times the height of the trunk.

The first step in this lesson will be to show the main silhouette or overall shape of a tree. Since silhouettes only show outer **contours**, you will also need to practice drawing trunks, branches, and foliage. You are to study a tree from the area where you live and attempt to draw it accurately.

INSTRUCTIONS

Part I

1. Look around you for a tree that you can see from a distance and that has an interesting overall shape. Using a digital camera, take a photograph of the tree. If a digital camera is not available to you, or if you live in an urban area where trees cannot be viewed from a distance, find a clear photographic image of a tree that shows the complete trunk and foliage. The photo image should be in high resolution and show the tree clearly in profile from top to bottom.

2. **Crop** the image so only the tree, with few superficial elements, is visible.

3. Enlarge the tree photograph to at least 9" high. This can be done on a scanner by uploading the image to an image modification software program. A large picture is easier to work from than a small one.

4. Study the photograph before you begin your drawing. Notice the **proportions** of the trunk to the limbs and branches. Generally, the trunk of a tree before the branches begin will be around one-quarter of the total height of the tree.

5. Draw the contour of the tree on a sheet of 9" × 12" drawing paper. Be careful to draw the contour in correct proportion.

6. Add the details of visual texture and shading to the drawing.

Part II

7. Next, you are to draw a real tree, without the assistance of a photograph. This is called a **plein air** (in the open air) drawing.

8. Attach a sheet of 9" × 12" drawing paper to a hard surface to keep the wind from blowing the paper as you work. Take extra paper and pencils with you.

9. Select a tree to draw and walk around it to find the most interesting view. Sit as close to the tree as you can without having to move your head to see all of it in one glance. The drawing should be at least 9" high on your paper.

10. First draw the proportions of the general silhouette quickly and check them for accuracy. Then show the main branches. On most trees the foliage appears as masses of light and dark areas. Show the placement of these masses against the general silhouette.

11. You are now ready to draw in greater detail. Shade the trunk and branches to show visual texture and the curvature of the trunk and branches.

12. Since you cannot draw every leaf, create visual textures that represent the various masses of leaves. These leafy masses are

three-dimensional, so some parts will be lighter or darker than others. Some of the leafy masses that are closest to you may appear more detailed and textured than those that are further away or in deep shadow.

13. If you are drawing a deciduous tree in winter, the tree will be leafless. In this case, you can focus your attention on the branches. The branches that project toward you might be drawn in greater detail or visual texture and shading than those that extend away from you.

14. Identify the tree by searching "tree identification" online. Examine the silhouette of the tree and compare it to a chart of silhouette types. Then look at the leaf structure and arrangement, bark texture, and color to determine the tree name. Write your conclusions as to the identity of the tree you have drawn, along with answers to the following questions about the tree:

 a. What is the average height of this type of tree when it is full grown?
 b. What is its average lifespan?
 c. How is it especially useful to humans or animals?

Materials Needed

white drawing paper, 9" × 12"
drawing pencils with various soft and hard leads
eraser

Vocabulary

Contour(s)	Plein Air	Three-Dimensional
Crop/Cropping	Proportion	Visual Texture
	Silhouette	

WHAT TO SUBMIT FOR EVALUATION

- two drawings of trees:
 - one from a photograph showing the tree's contour with shading and visual texture
 - one from an actual tree drawn in plein air, with emphasis on accurate proportions and foliage drawn with shading and/or texture to distinguish which parts are near or far
- the identification of each of the trees you drew
- written responses to Instruction #14
- also, provide a written explanation of some techniques you learned about drawing trees, and what you observed about the proportions of trees in your local area

LESSON EXTENSION

1. Having looked carefully at the form of a tree, with its trunk, branches, and tree masses, and having studied the proportions of the tree's trunk to its limbs, move to a single leaf as a subject of study. Carefully draw the leaf in as much detail as possible, considering these questions as you do so:

- Are the leaves *single* or *compound? Symmetrical* or *asymmetrical?*
- What is the shape of the leaf? Are its edges *smooth* or *serrated?*
- How do the veins fan out? Do they branch out from a large center vein or fan out like fingers of a hand?
- Turn the leaf over. How can you tell the front of the leaf from the back?

2. Now study the bark and other detailed features of the tree. How is the bark different from or similar to the bark of other nearby trees? Sketch a small section of the bark, showing its texture.

3. Other details to consider: Why do some trees bear blossoms in the spring while others do not? What does this tell you about the tree? Does the tree you drew bloom in the spring? If you are drawing a tree that is in bloom, sketch a blossom in detail.

4. Trees produce seeds of some kind in order to replicate themselves. What kind of seeds does this tree produce? If you are drawing a tree that has developed seeds, draw a seed in detail.

5. What color(s) do the leaves of this tree turn in the fall? If you are drawing the tree in autumn, use colored pencils or watercolors to add color to the tree's foliage.

TIPS FOR TEACHERS

Research has shown that young children can readily identify a host of brand name logos but are virtually illiterate about the names and varieties of trees and plants that grow in their immediate environments. In an effort to help students become more attuned to their natural habitat, invite students to make postcard-sized drawings of specific trees and plants in the local community. One set of cards might feature the silhouettes of various trees, another might illustrate leaf shapes and coloration, another set show details of bark and seedlings, and a fourth set include the names of the tree types. Then suggest that students play rummy-like games that require players to match appropriate features of a tree in order to create a set. An additional challenge would be to have students identify where a particular tree can be seen in the area, such as "in front of the courthouse" or "near the sidewalk by the playground."

Lesson 15: Drawing Animals

Animals, as living creatures that share our natural world, have fascinated people throughout history. Early examples of animals as subjects of art date back 35,000 years to the dynamic forms painted on walls of caves in France, Spain, and Romania, and on the sides of cliffs in Africa, Australia, Asia, and North America. From antiquity to the modern day, animals have been subjects of paintings, sculptures, and illustrations. At some time, you too may want to draw pictures of animals and include them in designs. Before doing this successfully, you need to study the appearance of the animal you will draw by looking carefully at living animals and/or photographs of animals.

INSTRUCTIONS

1. Use a family pet or livestock animal as subject of your drawing, or find a large, clear photograph of an animal. Make sure you can see the entire body of the animal, from nose to tail and from back to paw or hoof.
2. You are to make two outline sketches of the animal. Each should be on a separate sheet of 9" × 12" white drawing paper.
3. When drawing the complex form of an animal, it may be helpful to begin by looking for the simple shapes that compose the animal. After choosing a picture of an animal that you would like to draw, look for the basic geometric shapes that make up the animal's form.

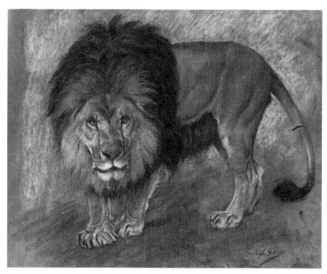 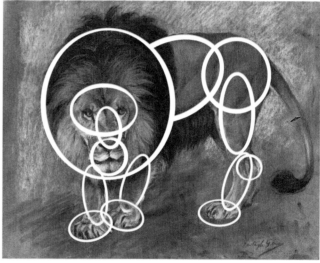

Notice the basic underlying structure of the lion can be recognized if visualized as a set of interconnected circles, ovals, and lines. Geza Vastagh (1866–1919), *A Lion (Schreitender Löwe)*. Gouache and pastel on cardboard, 16 ¹⁵/₁₆" × 21" (43 × 53.5 cm). Private Collection. (via Wikimedia Commons)

4. Once you have identified these, look at the **proportions** of the **shapes** to one another.
 a. How large are the legs compared to the body?
 b. Is the oval shape of the body one-half or one-third as thick as the legs are long?
 c. Is the length of the back about as long as the legs?
 d. How large is the head in comparison to the body and legs?
 e. What are the proportions of other features?

5. Once you have identified the basic shapes and their proportions and have sketched these shapes on your drawing paper, go back to the drawing and consider the position of the major skeletal structures of the animal.

 a. How does the head and neck move into the spine, and how does the tail come off the spine?

 b. Where do the shoulder blades or hipbones attach to the spine and support the limbs?

 c. How do the legs bend at the knees and into the paws or hooves?

 d. Notice how strong musculature supports the body and facilitates movement.

6. Lightly sketch these lines to help you see how the skeleton supports the animal form.

7. Share your drawn sketches with your peers and instructor for feedback.

8. Based on feedback and your own preferences, select the better of the two sketches and complete it by fleshing out the form and adding fur or feathers over the structural form you have created.

9. Observe that even animals appearing to be comprised of rather simplistic shapes will stand, move, or rest in ways that are expressive. Look at these examples of a penguin, rabbit, and duck, which all are animals posed to show simple body forms. Notice how the upward tilt and exaggerated size of the penguin's beak, the curve of the rabbit's back, and the shading of the duck's breast result in very expressive body contours. Now look at your own drawing to see if you have captured the expressive form of the animal. If not, adjust your drawing.

Left, Kevin Potter, *Drawing of Penguin,* 2012. Charcoal on paper, 12" × 9". (Courtesy of the Artist)

Middle, Paul Robinson, *Indian Running Duck.* Charcoal on paper, 14" × 11". (Courtesy of the Artist, http://www.paulrobinsonanimalart .co.uk/indian-runner-duck)

Right, Paul Robinson, *Hare Study.* Charcoal on paper, 28½" × 21½". (Courtesy of the Artist, http://www .paulrobinsonanimalart.co.uk /hare-study)

10. Continue working on this drawing by adding details and shading. Many animals have interesting markings, but these details should enhance, not obscure the drawn solidity of the animal's body. For

Albrecht Dürer (1471–1528), *Hare*,
1502. Watercolor with white gouache,
9 15/16" × 8 15/16" (25.1 × 22.6 cm).
Albertina Museum, Vienna, Austria.

example, if an animal is covered with fur or feathers, draw the markings
by using lines that match the direction that the fur or feathers lie on the
body.

Materials Needed

white drawing paper, 9" × 12"
drawing pencils with soft and hard leads
eraser

Anthropomorphic

Foreshorten/Foreshortening

Gesture

Proportion

Shade/Shading

Shape

Visual Texture

WHAT TO SUBMIT FOR EVALUATION

- the photographic image that inspired your drawings
- an accurately sketched contour of an animal from a photograph, using correct proportions of the body parts
- a completed drawing of an animal that clearly shows the solidity and details of the animal's body form through use of **shading**, **visual texture**, and representation of specific body features

Paul Robinson, *Maggie*. Giclée print, 20" × 16". (Courtesy of the Artist, http://www.paulrobinsonanimalart.co.uk/)

Animal Foreshortening

When viewing animals from the side, parallel to us, we can see relatively accurate proportions of one animal part to the whole, but animals rarely will stay still and remain in a parallel position to the viewer. Therefore, you will want to explore how animals appear from **foreshortened** positions, that is, when one part of an animal's body is much closer to than another. The part closest to you will appear larger than the part that is most distant. You can see this effect in Robinson's drawing of *Maggie*. Study the animal you chose to draw for this lesson. How might the animal be depicted with a part of its body foreshortened? Try drawing a foreshortened version of the animal.

TIPS FOR TEACHERS

Children have natural affinities for animals. In children's literature, movies, and animations, animals are frequently assigned **anthropomorphic** or human-like qualities. Invite students to look through children's books that feature animal characters expressing anthropomorphic thoughts, feelings, or actions. Determine whether illustrations of these characters present them in ways that take advantage of **gestures** and movements that would be consistent with the actual anatomy of the animal, or if the gestures and movements have been distorted to emphasize more human-like behaviors. For example, you can ask students to compare animal examples from texts such as the following:

- Andrae, G., and G. Parker-Rees. *Giraffes Can't Dance*. New York: Cartwheel, 2012.
- Bishop, W., and M. Martin. *The Crow and the Feather: A Tale of the Oak Woodlands of California*. Lafayette, CA: Cupola Press, 2015.
- Broach, E., and D. Catrow. *Wet Dog!* New York: Puffin Books, 2007.
- Pinkney, J. *Aesop's Fables*. New York: Chronicle Books, 2000.
- Willems, M. *The Pigeon Has Feelings Too*. New York: Disney-Hyperion, 2005.
- Zagarenski, P. *The Whisper*. New York: HMH Books for Young Readers, 2015.

Lesson 16: Drawing Hair

Human hair is a challenging subject to draw, often complicated by the artist's awareness of hair as comprising thin independent strands. However, because there are hundreds of thousands of strands, hair visually appears as a fluid mass. Once the artist begins to think of hair as a mass, the subject becomes easier to draw. In this lesson, which is a natural follow-up to Lesson 3, you will practice drawing hair.

INSTRUCTIONS

1. On a 12" × 18" sheet of drawing paper, or on several 9" × 12" sheets of drawing paper, make at least six practice sketches of hair details. These should serve as warm-up exercises that encourage your ability to *see* hair as mass.

Left, Dante Gabriel Rossetti (1828–1882), *Woman Combing Her Hair, Fanny Cornforth,* 1864. Pencil on paper, 14 ⅔" × 15 ⅛" (37.3 × 38.5 cm). Birmingham Museum and Art Gallery, Birmingham, England.

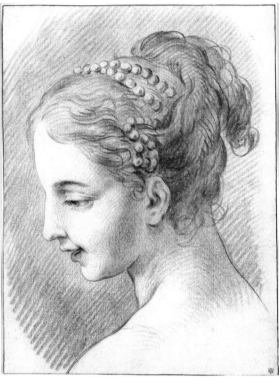

2. Because the focus of this lesson is on hair, rather than a face or head, you are to add the best example of hair from your drawings to the self-portrait you drew for Lesson 3 or to a blank head shape on a sheet of 9" × 12" white drawing paper.

3. Block out an outline of the hair shape. Look in the mirror at your own hair or study a high-resolution photograph of hair.

4. Don't try to rely on your imagination or memory of what hair looks like. Observe the way hair really looks and try to see how it appears as an entire form rather than as individual strands.

Above, Charles-André van Loo (1705–1765), *Head of a Young Woman in Profile Facing Left (Kopf einer jungen Frau im Profil nach links),* pre-1765. Red chalk on textured paper, 15" × 11½" (38 × 29.2 cm). (via Wikimedia Commons)

5. The cap of hair begins about one-eighth of the way down from the top of the head and curves to the top of the ears. Because of this bulk, it stands out from the scalp.

6. Continuing to think of hair as mass, sketch the planes of any clumps of hair that catch and reflect light or recede into darkness.

7. Carefully darken those spaces that fall back into shadow, adding pencil strokes as these dark areas begin to pull out into the light.

8. Look for the middle tones and, using a medium soft leaded pencil, add value with very light, closely placed pencil strokes, without succumbing to the temptation to think of these as individual hairs.

9. Remember: all pencil strokes should correspond with the direction hair would naturally flow, arising from the scalp and submitting to gravity by falling down away from the crown of the head,

10. Use a smudging tool, such as a **tortillon**, to gently blend pencil strokes of the mid- and dark-toned areas.

11. A very few carefully placed directional lines can give the illusion of hair in areas where light bounces off sections of the hair facing the light source.

12. For very long or curly hair, add two or three wispy strands of hair at the ends or to the side of the hair mass.

13. You are encouraged to study tutorials about drawing hair. *Study but do not copy exactly the examples given in the tutorial.* These are some excellent tutorials:

 Maery. "Drawing Hair in Graphite Pencil." http://www.instructables.com/id/Drawing-Hair-in-Graphite-Pencil/?ALLSTEPS.

 Prokopenko, Stanislav. "How to Draw Hair." *Stanislav Prokopenko Fine Art Painter* (blog). http://www.stanprokopenko.com/blog/2010/03/draw-hair/.

 Timon. "Hair Drawing Tutorial." *Stars Portraits* (tutorials). http://www.stars-portraits.com/en/tutorial/hair.html.

14. Complete a body of hair as it would appear on the head. You do not need to complete the features of the face, but the hairline and body of hair should be considered and demonstrate awareness of the proportions of hair to the head.

Materials Needed

drawing paper, 9" × 12" or 12" × 18"
drawing pencils with soft and hard leads
eraser
pencil smudge stick (tortillon)

Vocabulary

Additive/Additive Method
Scratchboard
Subtractive/Subtractive Method
Tortillon

- six detailed sketches of hair as evidence of practicing the drawing of hair
- the URL for any tutorial used to study the appearance of hair
- a finished drawing of hair on the model of a head. *Your work should not be an exact copy of the tutorial.*

LESSON EXTENSIONS

Drawing Fur or Feathers

Drawing fur and feathers are challenging features of animal and bird drawings. Like drawing hair, these are more easily illustrated by treating fur and feathers as masses of shape, with details limited to a few highlighted areas. Fur, hair, and feathers have directional grain and should be drawn with lines that describe that grain. Search online for a tutorial about drawing fur or feathers. As a lesson extension, practice drawing an animal with fur or the feathers of a bird as suggested by an online tutorial. Provide a link to the tutorial you used to study drawing of fur and/or feathers.

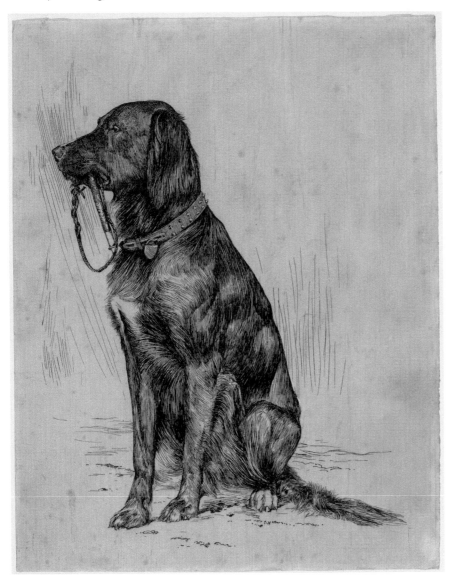

Arthur B. Davies (1862–1928), *Aldrich's Dog*, late 1880s. Pen and black ink touched with white on paper, 10½" × 8¼" (26.6 × 21 cm). John Davis Hatch Collection, National Gallery of Art, Washington, DC.

Cornelius Visscher (1629–1662). *The Large Cat*, ca. 1657. Engraving on paper, 5 11/16" × 7 5/16" (22.1 × 31.4 cm). Alisa Mellon Bruce Fund, National Gallery of Art, Washington, DC.

Scratchboard Drawing

We tend to think of drawing as an **additive** process, that is, as applying dark lines to a light surface. However, drawing can also be a **subtractive** process. One medium that permits drawing by removing color is the **scratchboard**. A scratchboard is a small white plate that has been covered by a black surface. Using a sharp tool, lines are cut into the black, revealing the white undersurface. This is a particularly effective means of showing highlights on dark surfaces, like the dark hide or fur of an animal, or the reflected light on a shiny wet surface such as an eye. Thinking of fur or feathers as described by the removal of dark value rather than by adding it may help you see how fur is related to the muscular and skeletal structures beneath. Artists who are particularly adept at drawing detailed images of animals in scratchboard are Stephanie Ford and Cathy Sheeter, whose works can be viewed online:

Stephanie Ford Fine Art. http://stephaniehford.com/workszoom/1736264/the-itch

Cathy Sheeter Fine Arts: Wildlife and Western Artwork. http://www.cathysheeter.com/artwork.html

As a lesson extension, try creating a detailed drawing of an animal using the subtractive method of scratchboard. Try focusing on the textures of the animal's coat that help define the form beneath.

Lesson 17: Drawing Shiny and Transparent Objects

Drawing shiny objects challenges an artist's ability to see and reproduce the abstractive shapes of highlights and reflections on the surfaces of objects. These are often difficult to see because there is a distracting tendency to want to draw what you *know* the shiny object to be rather than how it looks. Thus, we may be aware that the object is shiny but fail to notice what makes it look that way.

Drawing **transparent** objects contributes an additional challenge to the artist's ability to see, because objects seen through a transparent glass of water, for example, are distorted by **refraction**. Also, if you are drawing a rounded object such as a bottle, glass, or globe, the edge turning away from the viewer will appear thicker and **opaque**—either very light in value (if the edge faces the light) or very dark (if it faces away from the light), because you are seeing through the widened edge of the glass. Look at how artist Sharon Geels shows light passing through glass and how Kathrine Lemke Waste describes reflected light on shiny metal.

Left, Sharon Geels, *It's about a Fish*, black and white detail. Acrylic on canvas, 36" × 36". (Courtesy of the Artist)

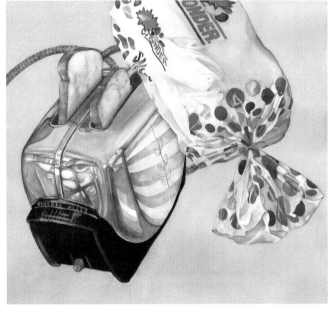

Shiny objects will include a full range of light and dark values, from pure white to deep black. Shiny objects cast reflected light on objects and surfaces near them. Because of complicating factors related to drawing shiny or transparent objects, it is helpful to study works by artists who specialize in describing these effects. Janet Fish is an **American Realist** artist who is especially skilled in capturing light reflections bouncing off shiny surfaces or distorted by transparencies. Do an online search for artworks by Fish and study differences and similarities in drawing light as it is affected by transparent objects and how it is reflected by shiny surfaces. In this lesson, you will practice drawing **still life** objects that are shiny and those that are transparent.

Above, Kathrine Lemke Waste, *Out of the Blue*, black and white detail. Watercolor, 18½" × 20½". (Courtesy of the Artist)

Begin practicing drawing shiny and transparent objects by studying how skilled artists have captured these effects. Then progress to drawing from a photograph or image that you select, so as to spend time *seeing* the **highlights**, distorted reflections, and range of dark to light values from different angles.

1. Search online for additional art images by Kathrine Lemke Waste and Janet Fish. Download two examples of each artist's work. One downloaded image must include a shiny metallic object, and one must include a transparent object.

2. Crop and download a small section of each image so the image focuses on one object with its nearby environment.

3. Carefully sketch reproductions of these four cropped images on a single 9" × 12" sheet of paper. Use drawing pencils with soft and hard leads to capture a full range of values from white to black.

4. Now arrange a group of three objects that includes one shiny and one transparent object, and take a high-resolution photograph of the still life. Or, select a photographic image of shiny and transparent objects from the internet. The image must be in high resolution so that fine details can be studied. Choose an image that shows a full range of tones from white to black.

5. Sketch the outlines of the still life objects on a sheet of 9" × 12" drawing paper.

6. Using soft and hard leaded pencils, begin adding values to the image. Work from the darkest areas of the objects to the lightest.

7. If awareness of what the object *is* distracts you from being able to see accurate reflections and transparencies, try turning the photo image sideways or upside down, so you can focus only on the abstractive darks and lights you see. Notice also how glass refracts shapes of things placed behind them, but try to see these as patterns of light and dark, not as *things*.

 a. *Drawing the shiny object:* Add sharp-edged white highlights to the surface of the object that is closest to the light source. The shape of the highlight will generally reflect the shape of the light source distorted by the surface shape of the object. Other white highlights may fall upon parts of the rim or edges facing the light. Objects near the reflective object also will be seen, but distorted by the curvature of the object's shape and by the reflective object itself.

 b. *Drawing the transparent object:* If you are drawing a rounded object such as a bottle, glass, or globe, the edge turning away from the viewer will appear thicker and opaque—either very light (if the edge faces the light) or very dark (if it faces away from the light), because you are seeing the thickness of the glass's width.

8. Continue working until you have a full range of gray-scale tones from black to white and have accurately described the reflections on the

shiny surface, transparencies, and light-bouncing effects within shadows around these objects.

9. Write an essay (300–400 words) in response to the following:

 a. Describe something you learned about reflected light from observing artworks by Sharon Geels, Janet Fish, and Kathrine Waste that surprised you because you had not noticed or previously been aware of this visual effect.

 b. How are reflections distorted by curved or bent surfaces of the reflecting object?

 c. What is refraction? How do transparent objects refract light from object placed behind them?

Materials Needed

white drawing paper, 9" × 12"
drawing pencils with soft and hard leads
eraser
found objects with shiny and/or reflective surfaces

Vocabulary

American Realist/	Opaque
American Realism	Prism
Concave	Refract/Refraction
Convex	Still Life
Highlights	Transparent/Transparency

WHAT TO SUBMIT FOR EVALUATION

· four cropped reproductions (two Janet Fish artworks, and two by Kathrine Lemki Waste)
· sketches you made of these images
· the photo image of a still life that inspired your final drawing

Left, Sharon Geels, *It's about a Fish,* detail. Acrylic on canvas, 36" × 36". (Courtesy of the Artist)

Right, Kathrine Lemke Waste, *Out of the Blue.* Watercolor, 18½" × 20½". (Courtesy of the Artist)

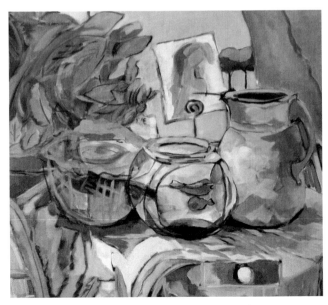

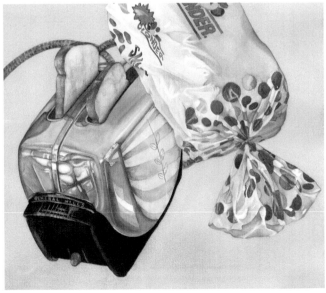

- a completed drawing of a still life that includes a shiny and a transparent object
- a written essay response, as outlined in Instruction #9

LESSON EXTENSION

Once an artist has mastered the ability to see and describe values of light in a drawing, he or she is less likely to become confused by how colors function similarly to light and dark in transparencies or reflective surfaces. Try reproducing a color still life photograph in a color medium of your choice. Compare the black and white versions of Geels's and Waste's images with these color versions of the images.

TIPS FOR TEACHERS

Examinations of reflections and transparencies introduce scientific concepts about how light waves function as they are interrupted by **concave** or **convex** objects, transparent objects, and **prisms**. Invite students to explore what happens to images that are reflected off curved images from various distances. Look for examples that show objects appearing upside down on the reflected surface. Invite students to research scientific knowledge about light and reflection that explains this phenomenon.

Lesson 18: Shadows in a Triptych

In earlier lessons of still life drawing, you explored how shadows were cast by objects as they blocked light between its source and another surface. However, in those studies you may have been working in daylight with an additional lighting source that you intentionally aimed at the subject of your drawing. When both direct and indirect sources light an object, the effect of shadowing is subtle. When there is only one highly concentrated light falling upon an otherwise totally darkened object, the effect is extreme and dramatic. This result is called **chiaroscuro** or extreme shadowing. Chiaroscuro often results in distortions of size and appearance that can alter viewers' perceptions and elicit strong emotional responses.

Artists of still and motion images use chiaroscuro techniques to affect a viewer's sense of fear, establish emotional tension, or suggest impending doom about to befall the protagonist of a story. Attention may be focused on the highlighted object or objects, or attention may be focused upon the shadow. In some cases light and shadow work together to create the foreboding mood. For example, either the evil *thing* may be lit and the innocent victim hidden in shadow, or vice versa. Look at the screen shots presented in this lesson and consider how light and shadow are used in each to tell a story of innocence, villainy, or what is about to occur to whom.

Extreme lighting can create patterns that suggest ambiguity or a discomforting sense of confusion. In each of these screen shots from *film noir* movies, falling shadows are intended to heighten these feelings in the viewer. What ominous possibilities await the young woman about to enter the darkened house? Will she go in, or sense danger and flee? What does a shadow across the face of a clock, which is set to just before midnight, suggest? Are the man and woman in the upper and lower left victims or villains? Screen shots from *Shadow of Doubt* (Skirball and Hitchcock, 1943), *Rebecca* (Selznick and Hitchcock, 1940), and *The Letter* (Wyler, 1940).

How are shadows used to create sense of suspense or evil in these screen shots? *Touch of Evil* (Zugsmith and Welles, 1958).

Yet patterns created by extreme lighting need not always establish feelings of imminent danger. Patterns can surprise, intrigue, and delight. Examine photographs taken when the sun is just coming up in the morning or about to set in the evening. Observe that sunlight hitting objects at such an angle results in very intense or pronounced shadows.

Right and facing, Look carefully at these images to determine the source of light and the objects casting shadows. Can you estimate the time of day based on the length of the shadows? *Sunrise Camel Shadow in the Morocco Desert,* 2009. (Photograph by Lahoriblefollia. Copyright holder published under Creative Commons Attribution-Share Alike 3.0 License Unported) *Chicago Skyline Shadows,* 2010. (Photograph by Evojim. CC BY-SA 3.0 US)

In this lesson, you will create three images of extreme lighting from three angles or points of view and arrange them as a **triptych**. You may either draw the images in soft lead drawing pencils or use photography as a medium.

INSTRUCTIONS

1. Think about whether the subject of your artwork will be a still life setting or a human subject.
2. Using a flashlight in a darkened room, examine the effects of lighting your subject from various angles, such as from below, above, or to the side. Explore the effects of a streetlight shining through a window,

through venetian blinds, sheer curtains, or from behind branches of a tree.

3. Select three different perspectives that you find most intriguing. Then continue with instructions for either drawing or photographing your images, below.

Drawing

1. For each of the three perspectives, draw a square area of about 5″ × 7″ in the center of a 9″ × 12″ sheet of drawing paper. You will produce the chiaroscuro drawing in this section of the paper. Attach drawing paper to a drawing board with tape, and prop the board in front of your subject in such a way as to be able to see the light and dark shadows from the most interesting angle. You may need to attach a small book light to your drawing board so you can see your work without interfering with the lighting you have set up for your subject.

2. Use a very soft leaded drawing pencil to get very dark shadows. Because soft lead smudges easily, you may need to place a sheet of paper over areas that you are not working on in order to keep them clean.

3. Change the lighting setup and repeat this process for each of the next two drawings. Then continue with Instruction #4, below.

Photography

1. Photographs can be more easily managed if you have a camera that has an adjustable speed mechanism and lens aperture. Mount the camera on a tripod in front of your subject and try taking several shots with slow speeds, with the lens opened to its widest aperture, until you find a speed and lens opening that result in the most dramatic (very dark and very light) values and chiaroscuro effects. Record this speed and lens opening to use when taking the next two photos, but check each time to see if any slight adaptions are needed for these shots.

2. If your camera does not have an adjustable timer and aperture, you might still be able to capture extreme dark and light effects, depending on the sensitivity of the setting adjustments on your camera. Mount the camera on a tripod and play around with different settings to get the captured image to replicate what you actually see as closely possible.

3. Print out the image to about 4" × 5½" or 5" × 7." You also may upload the images into Photoshop CS6 or some other image modification software to modify the images to your further satisfaction. Continue with Instruction #4, next section.

Drawing or Photography

4. Lay the three chiaroscuro drawings or photos in front of you and decide how they should be arranged to create an interesting triptych. How does the dark or light area of each image lead your eye from one drawing or photo to the next. Having decided on the best **layout**, center the images on a sheet of 12" × 18" cover weight paper or cleanly cut black poster board. Use a metal-edged ruler to mark off the area so the images are centered with a ¼" to ½" space between their outside edges.

5. Attach the images carefully with rubber cement and clean the excess rubber cement with a rubber cement eraser. If you are attaching drawings, it might be helpful to place clean pieces of paper on top of the drawings while you are gluing them down. This will help prevent them from being smudged during this process.

6. (*Optional*) Trim the backing to a pleasing size if it seems disproportionate to you, but leave at least 1½" border on all sides.

7. You may leave the triptych flat, or **score** two grooves between the three images that will permit the two sides to bend forward and allow the triptych to stand.

Materials Needed

drawing paper in various sizes up to 9" × 12"
drawing pencils with soft and hard leads
eraser

strong light setup

poster board (white or black), 12" × 18"

metal-edged ruler

rubber cement and rubber cement eraser

Photography Method

camera with adjustable timer and aperture

camera tripod

Photoshop or other image modification software

Vocabulary

Chiaroscuro	Score
Layout	Triptych
Medium/Media	

WHAT TO SUBMIT FOR EVALUATION

- three small drawings or photographs of a subject from three different perspectives that demonstrate an understanding of chiaroscuro effects
- a completed triptych that demonstrates sensitivity to the aesthetic relationship of three separate images with one another
- a written response (300–400 words) to the following:
 - provide an explanation of the chiaroscuro effect
 - explain how you arrived at the effect in each of your three triptych images
 - describe your thought processes in deciding upon the layout of the three triptych images

Morning Greeting: A Triptych.
(Created by the Author)

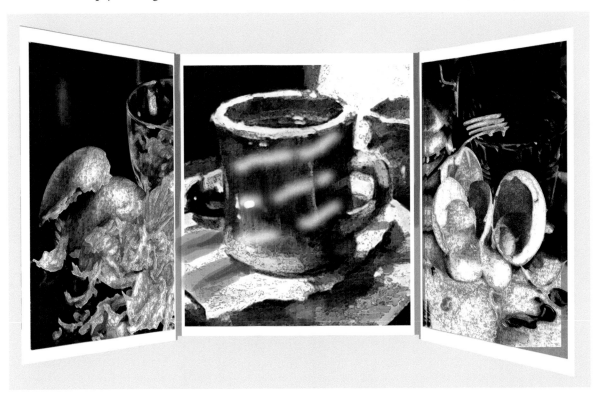

Repeat this project using one of these different techniques:

1. Paint three chiaroscuro pieces using washes of black paint. Draw the images on watercolor paper and use black paint, thinned with water, to create layers of value from light to extremely dark.

2. Try mixing it up a bit by creating each of the three images in a different **medium**, such as charcoal, soft lead drawing pencil, photography, or black wash paint, or select three related objects and place them side by side.

3. For a more challenging project, try painting chiaroscuro in color. As a reference for how color might be used, study these Renaissance paintings by Italian artist Michelangelo Merisi da Caravaggio (1571–1610).

Caravaggio (1571–1610), *The Calling of St. Matthew*, 1599–1600. Oil on canvas, 127" × 130" (322 × 340 cm). Contarelli Chapel, Church of St. Luigi dei Francesi, Rome, Italy.

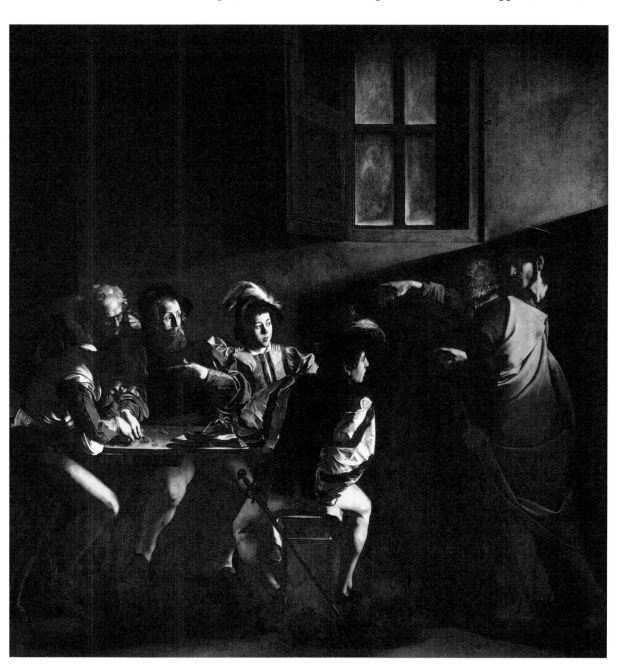

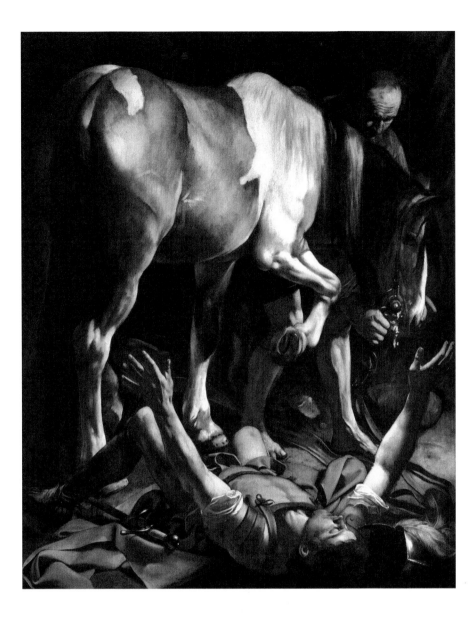

Caravaggio (1571–1610), *The Conversion on the Way to Damascus*, ca. 1600–1601. Oil on canvas, 68 7/8" × 90 9/16" (175 × 230 cm). Santa Maria del Popolo, Rome, Italy.

In an age prior to the introduction of electric lights, fires, torches, lanterns, or candles were the only options for artificial lighting. These methods of lighting were used after sundown. People relied on sunlight alone during the day. As a result, people were accustomed to seeing dramatic effects of chiaroscuro. Artists used the effect to create emotionally powerful stories. Notice how in the *Calling of St. Matthew* by Caravaggio, light falling from an upper window on the pointing hand and expectant faces of the men seated at a table help us read the story.

Another example of chiaroscuro by Caravaggio is seen in a painting of *The Conversion on the Way to Damascus*, which refers to a biblical New Testament account of an event from the life of the Apostle Paul. From what direction is the light falling on these figures, and what is its implied source? How might Caravaggio have set up the lighting in his studio in such a way as to cause this visual effect? If his studio was darkened except for the chiaroscuro light falling upon his models, how could he see to paint these images? How would you have resolved this dilemma?

Lessons in Drawing Realistically

Lesson 19: Grid Magic

Mathematics and art come together when artists use the **grid** method of enlarging an image with exact fidelity to its reference source. This method has been used for centuries. There is evidence that it was used by ancient Egyptian painters, by medieval artists of stained glass windows, by Renaissance artists such as Leonardo da Vinci, and by contemporary artists like Chuck Close (see Lesson 38). The grid method involves drawing a grid over your reference image and a grid of a corresponding **ratio** on a sheet of drawing paper, then drawing what you see in each grid section of the referenced image in the corresponding squares of your drawing paper.

This grid-made portrait, created by a high school student, was inspired by her relationship with her grandparents, who both have dementia. Amy Sweaton, *Grid Portrait of Grandmother.* Student of Emily Morris, Pontefract, UK. (Courtesy of the Artist)

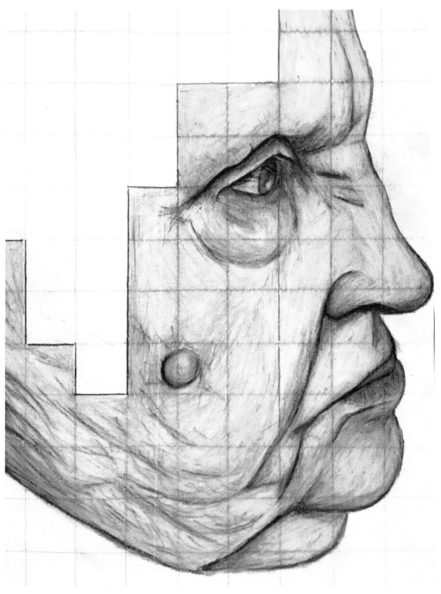

To draw an image that is exactly the same size as the reference image, you will create a grid that has a 1:1 ratio. That means the grid you draw on your drawing paper will be exactly the same size and have exactly the same number of spaces as the grid you draw over your reference image. For example, if you

want to reproduce a 5" × 7" photo of yourself at the same size, you would place a ruler at the top and bottom of the photo and make tiny marks at 1" intervals across the top and the bottom. Using the ruler again, draw lines **vertically** that connect the top and bottom marks. Repeat this on the right and left sides of the photo, drawing **horizontal** connective lines. You will have five 1" squares across and seven 1" squares from top to bottom, or 35 equal 1" squares. Now, using the ruler again, make a grid on the drawing paper that is 5" across and 7" from top to bottom. If you are concerned about losing your place when copying what you see on the image to the drawing paper, you can number the squares as in the illustration below.

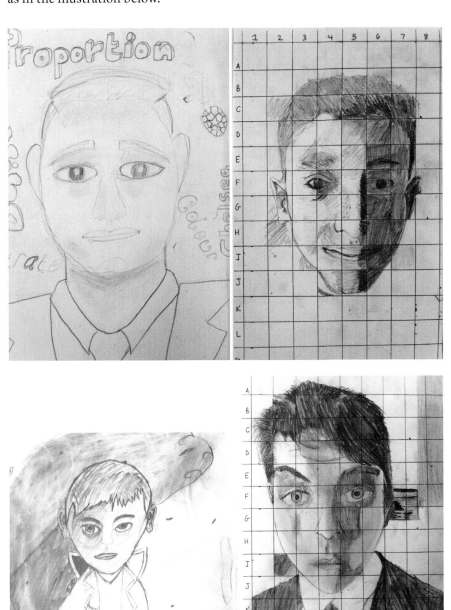

Compare drawings done freehand by these students with their subsequent drawings done using the grid method, as described in this lesson. Gridded drawings by students of Eleanor Langton, Amersham School, UK. (Courtesy of the Artists)

The grid method also can be used to enlarge (or reduce) images, because it relies upon exact ratios. So for example, you can enlarge a 5" × 7" photo by a ratio of 1:2 to 10" × 14", or by a ratio of 1:3 to 15" × 21". Decreasing sizes works according to a reverse ratio. A decreasing ratio of 3:1 would result in a 15" × 21" image being reduced to 5" × 7", while a 2:1 ratio applied to a 10" × 14" image also would reduce it to 5" × 7".

Enlarging a 5" × 7" photo to 10" × 14" means each square of the larger grid would be 2" × 2". For many artists, this is too large a size, since any error in copying the original image would be magnified. Thus, when enlarging images most prefer to work with a smaller original grid, such as a ½" grid, which when enlarged to twice its original size would create a grid of 1" squares.

INSTRUCTIONS

1. Find a clear photograph of an interesting but rather simple object. The photo may be from a magazine or may be downloaded from an online site. If downloaded, select an image of high resolution.
2. Trim this reference image to 4" × 5", 5" × 7", or 8" × 10" in size.
3. Decide if you would like to redraw the image at the same size (recommended if your image is 8" × 10") or double the original size (recommended for original images that are either 4" × 5" or 5" × 7").
4. Using a ruler and sharp hard lead pencil, mark the picture into equal-sized squares.
 a. If you are going to reproduce the image in the same size, draw a grid of 1" squares. For a picture that is 8" × 10", there will be eight 1" squares across the top and ten 1" squares up and down, or 80 equal-sized squares in total.
 b. If you are enlarging a 4" × 5" image, you will draw a grid of ½" across and ½" up and down. There will be eight ½" squares across and ten ½" squares going up and down, that is, 80 equal ½" squares in total.
 c. If you are planning to enlarge a 5" × 7" image, divide it into ten ½" squares across and fourteen ½" squares from top to bottom, or 140 equal-sized ½" squares in total.
5. On a sheet of white drawing paper that is 9" × 12" or 12" × 18" in size and using a ruler, draw a grid of 1" squares that matches the number of squares on the original image—remembering that if your original picture is either 4" × 5" or 5" × 7", the image will be enlarged to twice the original size. (An enlargement of the 4" × 5" picture will be 8" × 10". An enlargement of the 5" × 7" picture will be 10" × 14".) If you are reproducing an 8" × 10" image, the reproduction will be exactly the same size as the original.
6. Draw the lines, shapes, shading, and details of what you see inside each of the squares on the original image in the corresponding squares on

the white drawing paper. Use pencils of soft and hard leads in order to capture the values of the original image in its reproduction.

7. Insofar as possible, erase the grid lines of the finished drawing.

Materials Needed

picture or photograph, 4" × 5", 5" × 7", or 8" × 10" in size
white drawing paper, 9" × 12" or 12" × 18"
18" ruler
drawing pencils with various soft to hard leads
eraser

Vocabulary

Distort/Distortion	Horizontal/Horizontally
Elongate	Ratio
Emphasis	Vertical/Vertically
Grid	

WHAT TO SUBMIT FOR EVALUATION

- the original image with grid lines, and a completed drawing as instructed in the lesson
- a demonstrated attention to lines and shapes in each section of the original image by reproducing them exactly in the completed drawing
- indicate the ratio of the reproduction to the original (i.e., an exact 1:1 or an enlarged 1:2 ratio)

LESSON EXTENSION

Deliberate distortion has always been present in art. Even the most realistic-looking art may not be true to life. Contemporary artists distort images to create **emphasis**, exaggerate a form, create special effects, or suggest emotionally powerful or humorous points of view.

By altering the ratio of your drawing to the original grid, image distortions may be made. Try playing with distortions of figure. The distortion can show stretching or collapsing of an image, or random distortions. Working from the already gridded original image as a reference, draw a distorted grid on a 9" × 12" sheet of drawing paper. There are several ways of doing this, but here are two possible ways of accomplishing the distortion.

1. Draw ½" measurements across the top of the grid. Match the number of grid spaces to the number of squares across the top and bottom of your original image and connect these lines vertically. Then draw 1" spaces from side to side and connect these horizontally, matching the number of spaces on your original image. Fill in these spaces as you did before. The result, however, will not be an exact reproduction or enlargement of the original but a greatly **elongated** image.

2. Draw a grid that has uneven measurement across the top and/or across the sides of the grid. Although the grid marks will vary in distance from one another, there must be the same number of "squares" horizontally and vertically as in the original image. Use either a ruler to connect the grid marks from top to bottom and side to side, or draw these connection lines freehand, curving them as they are drawn. Fill in the spaces as you did in the lesson above. The result will be a highly distorted image.

TIPS FOR TEACHERS

A popular app for iPad allows users to distort images by placing a figure on one section of a picture and dragging the image around on the screen. If students understand that digital images are made up of square pixels (i.e., a grid), ask them to surmise how moving the grid changes the image by **distortion**. Even when distortion within the image occurs, does the overall size of the image remain the same? Why or why not? What would have to be true in order for the overall area of the image to remain the same?

Lesson 20: A Bestiary Creature

Science fiction and fantasy writers describe extraordinary and imaginary creature whose bodies and features seem to be combinations of many familiar creatures. Fantastic creatures have appeared in the art images of people in ancient as well as modern times. Historical examples of this kind of creativity in Greek and Roman art, for example, include the flying horse Pegasus, human-horse centaurs, snake-haired Medusa, winged-lion griffins, mermen and mermaids. In the medieval era, fanciful animals were described in handmade books called **bestiaries**. The more popular animals also appeared in sculptures or decorative items and became subjects of stories, songs, and performances at celebrations or onstage.

Right, and bottom left, Some bestiary creatures may have been animals that had been briefly glimpsed but not closely studied, like the sawfish shown in this bestiary. Others may have been imagined mythical creatures that were composites of two better-known animals. Unknown Artist, *Sawfish and Sail,* 1187. Paint on parchment, 6 1/10" × 8½" (15.5 × 21.5 cm). The Morgan Library and Museum, New York, NY. Roger von Helmarshausen (fl. 12th century), *Water Pitcher in the Form of a Griffin,* 1120–1130. Gilded bronze, silver, inlay, and garnets. Kunsthistorisches Museum of Vienna, Austria. (via Wikimedia Commons)

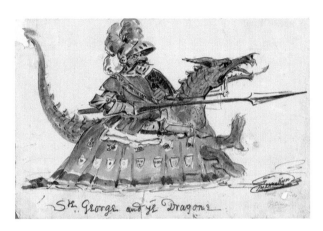

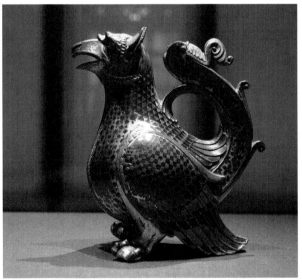

This lesson provides you an opportunity to work in this artistic tradition and create your own fantasy bestiary images by selecting different animals and combining them to create an imagined life form.

Top left, Among the most popular bestiary subjects was the dragon. Richard Wynne Keene (1809–1887), *St. George and ye Dragons,* Designs for the Theater, ca. 1850. Ink and watercolors. *2006MT-209, Harvard Theatre Collection, Houghton Library, Harvard University.

141

1. Look through magazines or on the internet to find clear photographs of two interesting but different animals. Make photocopies or download these two images.
2. On each of two sheets of 9" × 12" white drawing paper, draw a pencil sketch of each animal.
3. Carefully draw each animal's contour so it fills most of the paper.
4. Add **shading** to create **visual texture** and to help suggest the roundness or solidity of the creature.
5. Be sure to show a full range of shading, from almost white to very dark. Visually describe as many details as possible.
6. On another sheet of 9" × 12" white drawing paper, lightly sketch a new creature whose features include parts of each of the two animals you drew previously. You may also include human body or facial features in the drawing. This makes the animal seem more **anthropomorphic**, that is, with human-like appearance or gestures.
7. As you draw, give attention to how the underlying structures must work and/or fit together. For example, if you wish to add wings to an elephant, realize that the bones and muscles attaching the wings to the body must be very thick, strong, and provide a wide enough wingspan to get such a heavy creature off the ground. The whole creature must fit together as if the parts were logically connected.
8. Add visual texture and shading to the sketch to show features and details. The viewer should be able to get a good sense of whether your drawn animal is covered with feathers, scales, or fur.
9. Write an essay (300–400 words) in response to the following:
 a. Describe at least three examples of bestiary creatures from historic traditions or cultures.
 b. Explain how the creatures you selected for study might fit together. For example, what would be the necessary structural changes if cows were to have chicken feet, or if elephants were to have wings for flying?

Materials Needed

white drawing paper, 9" × 12"
drawing pencils with various grades of soft and hard leads
eraser

Vocabulary

Anthropomorphic
Bestiary
Shade/Shading
Visual Texture

WHAT TO SUBMIT FOR EVALUATION

· two photocopies of animal images as references for your drawings
· two practice drawings based on these images
· a finished drawing of an imaginary creature that combines the two referenced animals and uses appropriate visual texture and shading to describe the new animal's body form and details
· a written essay response, as outlined in Instruction #9

Brandon Ragains began with a sketch of a pig and added features of an ape to arrive at his "pigape" bestiary creature. Brandon Ragains, *Sketch of Pig, Gorilla, and Bestiary Pigape*, 2013. Pencil on paper, 8½" × 11" each. (Courtesy of the Artist)

TIPS FOR TEACHERS

Imagination in Art and Science

Imaginary animals, such as dragons, are popular art forms. Throughout the Middle Ages in Europe, and in many cultures around the world, artists and storytellers have told tales and drawn illustrations of dragons, griffins, and other imaginary creatures. Artists and illustrators who represented mythic creatures in paintings and sculpture throughout history may not have fabricated the beasts out of nothingness. The discoveries of folklorist Adrienne Mayor[1] have led scientists and academics to propose that these imaginary creatures were inspired by viewing the fossilized bones of ancient dinosaurs, mastodons, saber-toothed tigers, or rhinoceroses. Unable to imagine how the fossil remains would have fit together accurately, ancient peoples who viewed these bones envisioned the many mythic creatures of their bestiaries.

In the present day, artist scientists still struggle to reconstruct the way various now-extinct creatures might have looked and behaved in real life. Imagination and scientific observations of living creatures compared to fossil remains provide information that artists rely upon to help them create realistically probable illustrations of extinct animals. Encourage students to learn more about how myths may have their origin in ancient observations of living creatures. Invite them to see how early scientists and storytellers imagined these creatures to be, and compare that to how modern day scientists are discovering them to be. Resources include the following:

WEBSITES

· Bryner, Jeanna. "Science World: Mythical Creatures Revealed." *Science World*, May 8, 2006, Scholastic. http://www2.scholastic.com/browse/article.jsp?id=11846.
· "Reconstructing Extinct Animals." Smithsonian National Museum of Natural History, 2015. http://www.mnh.si.edu/exhibits/backyard-dinosaurs/reconstructing-animals.cfm.

Mastodon skull on display at The Children's Museum of Indianapolis. Indianapolis, IN. (Photograph by Chris Howie. CC BY-SA 3.0 US)

BOOKS

· Conway, John. *All Yesterdays: Unique and Speculative Views of Dinosaurs and Other Prehistoric Animals.* Raleigh, NC: lulu.com, 2012.
· Milner, Richard, and Rhonda Knight Kalt. *Charles R. Knight: The Artist Who Saw through Time.* New York: Abrams, 2012.
· Trusler, P., P. Vickers-Rich, and T. H. Rich. *The Artist and the Scientists: Bringing Prehistory to Life.* New York: Cambridge University Press, 2010.
· White, S. ed. *Dinosaur Art: The World's Greatest Paleoart.* London: Titan Books, 2012.

Because many contemporary films, games, and literatures feature imaginary creatures, those skilled in creating believably real imaginary creatures can look forward to very lucrative careers. These artistic fantasies must adhere to basic laws of animal structure. For example, drawings of heavy mammals must acknowledge the need for strong shoulder and pelvis bones to support their body weight on thick, muscular legs. The wing muscles of an enormous flying creature must attach to a powerful back, shoulder, and rib cage. Rules of proportion apply, whether the creature is a real living animal or an animal concocted from imagination. Invite students to explore the realm of fantasy art through these resources:

· Banducci, G., ed. *Animals Real and Imagined: Fantasy of What Is and What Might Be.* Culver City, CA: Design Press Studios, 2010.
· Hunt, J. *Illuminated Alphabet of Medieval Beasts.* New York: Simon and Schuster Children's Publishing, 1998.
· Larios, J., and J. Paschkis. *Imaginary Menagerie: A Book of Curious Creatures.* New York: Harcourt Children's Books, 2008.
· O'Connor, W. *Dracopedia the Bestiary: An Artist's Guide to Creating Mythical Creatures.* Atascadero, CA: IMPACT, 2013.

In their play, children may pretend they exemplify certain traits of animals. For example, in *Where the Wild Things Are*,[2] author Maurice Sendak tells the story of a little boy who imagines himself as a frolicking "wild thing" as an expression of his angry, rebellious mood. In our language, we use animal analogies to describe physical, emotional, or intellectual conditions, such as "strong as an ox," "hungry as a bear," "proud as a peacock," or "smart as a fox."

Think of a mood you've recently experienced and imagine an animal trait that you associate with that mood. Then create a simple drawing of your face with the animal features overlaid or integrated with your portrait. You may add color with a medium of your choice.

Grant Sarber, *Leonid Me*, 2003. Pencil drawing, 9" × 12". Kelli Johnson, *Self-Conflict*, 2007. Colored pencil and watercolor, 12" × 9". (Courtesy of the Artists)

Lessons in Drawing Realistically

Lesson 21: Shading Flat Objects

Realistic drawings of three-dimensional objects that have flat sides require an understanding of both light and shadow and the basic rules of perspective. Light rays travel in straight lines until interrupted by an object in their path. Rays bounce off hard **opaque** surfaces or **planes**, moving away at the opposite angle from which they hit. So if the side of a flat object is directly facing a light source, it reflects a maximum amount of light. If a flat-sided object, such as a cube or box, is placed at an **angle** so that a corner is facing the light source, surfaces that are turned away from the light will reflect less light and therefore appear darker or **shaded**. Light and shadows help us see the volume or three-dimensionality of objects.

Linear perspective also assists us in conveying volume in three-dimensional forms. You will observe that the sides of flat objects appear somewhat diagonal as they recede in space. Other lessons in this chapter provide opportunities to learn technical rules of drawing in **one-point perspective** or **two-point perspective**. In this lesson, however, you are to rely on observation alone in describing the visual effects created by light striking or being blocked by objects, and in describing the appearance of the receding sides of flat three-dimensional objects.

Below left, Student drawing, *Shaded Flat Object Drawing,* 2006. Pencil on paper, 12" × 9". (Courtesy of the Artist)

Below right, Emma Rauch, *Drawing of Flat Objects,* 2013. Pencil on paper, 12" × 9". (Courtesy of the Artist)

1. Arrange a group of solid, flat-sided objects into a **still life** arrangement. Some objects should be placed in front of or **overlap** with others. At least one object should be set at an angle.

2. Make sure that the objects in the grouping are lit from a single direct light source, such as a floodlight, flashlight, or reading lamp.

3. On a 9" × 12" sheet of white drawing paper, lightly draw the **outlines** of the objects in the grouping you have chosen or set up. Check your drawing for **perspective** (see Lessons 22 and 23) and the **proportion** of one object to another.

4. Shade all the planes to show the amount of lightness and darkness that is reflected by each. Surfaces facing the light source will be lighter than those facing away. Very few parts will be completely black (no reflected light) or white (maximum reflected light). Most surfaces will reflect some, but not the maximum possible light.

5. Pay attention to shadows under objects and to places where shadows overlap each other.

6. Observe and draw how the receding edges of objects seem to slant away from the object.

7. Draw objects that are close to you in greater detail than those that are farther away.

8. Write an essay (300–400 words) in response to the following:
 a. Define a plane in reference to a flat surface.
 b. Explain how surfaces facing a light source appear different than those that are turned away from the light source.
 c. What observations did you make about the appearance of planes that are placed at an angle to you?
 d. How did you describe this phenomenon in your drawing?

Materials Needed

white drawing paper, 9" × 12"
drawing pencils with soft and hard leads
eraser

Vocabulary

Angle	Outline	Proportion
Linear Perspective	Overlap	Shade/Shading
One-Point Perspective	Perspective	Still Life
Opaque	Plane	Two-Point Perspective

WHAT TO SUBMIT FOR EVALUATION

· the completed drawing of an arrangement of flat-sided objects in correct perspective, with accurate detail, proportion, and shading
· a written essay response, as outlined in Instruction #8

1. Add color to your drawing.

Alexander Lyon, *Drawing of Flat Objects with Color*, 2010. Pastel on gray construction paper, 11 ⅛" × 12". (Courtesy of the Artist)

2. Now that you have experimented with shading flat objects in a still life, expand your knowledge to shading more complex arrangements of objects, such as buildings in an urban setting. Study photographs or black and white line drawings of cities and see how sunlight falls from the same angle onto the sides of all buildings.
 · Create a line drawing.
 · Make a copy of the line drawing.
 · Use a pencil to fill in black and white shadows on the copy.
 · Use color crayons, pencils, or markers to finish the original in colors that also illustrate shadows.
3. Explore how flat planes can be layered to give the impression of depth. What role could light and dark or color play in increasing the illusion of depth, or in contributing to a sense of "flatness" of the image?

Left, Helicopter and New York Skyline, from the East River. (Photograph by Alex Proimos, 2011. CC BY 2.0)

Below, Collaborative Cityscape Collage. Cut construction papers and color markers, 24" × 9½". (Child Art Collection of Marjorie Manifold)

TIPS FOR TEACHERS

Learning Math Concepts through Still Life Drawing

This lesson combines concepts important to understanding art and math. When sketching the various objects of the still life, you must attend to mathematical relationships of measurement and proportion. Questions to consider could include the following:

- Is this box half or two-thirds as tall as its neighbor?
- Is the space between the two objects 5" or 4"?
- Is that also about the distance from the top of the box to the table?

These are questions an artist intuitively asks and answers in sketching various still life forms. Intuitive mathematics and measurements also figure in decisions about shading. Is this light area twice as dark as the shadow it casts? Proportions of size, value, and shade are critical aspects of observational drawing and scientific investigations. In the education of elementary students, consider how observational drawings of still life objects might assist students' understanding of other mathematic and scientific concepts.

Lesson 22: Drawing in One-Point Perspective

When you look down the middle of a street or corridor, everything appears to get smaller as it recedes into the distance. If you could see far enough down the street, or if the corridor were long enough, you would notice that all the receding edges of things converge and disappear into a single point on the **horizon**, called a **vanishing point**. This effect is due to a visual illusion called **one-point perspective**. To test this illusion, find a clear photograph that shows objects receding in space. Hold a ruler along the edges of objects that seem to recede. Do they all seem to converge on the same spot, while all the edges of objects that are exactly parallel to you remain either exactly horizontal or vertical?

Joseph Pennell (1857–1926), *Down and Up the Hills to the Bay San Francisco*, 1912. Etching. The Rosenwald Collection, National Gallery of Art, Washington, DC.

In order to draw realistic scenes, you will need to learn the rules of one-point perspective. This lesson will help you practice these rules and apply them to a real setting that you observe in your daily life.

Before you choose the scene you wish to draw, try to remember these rules:

· **Vertical** lines will remain vertical.
· **Horizontal** lines that are directly in front of you will remain horizontal.
· Horizontal lines that are moving away from you into the direction you are looking will seem to converge at an equal rate into a vanishing point in the distance.

This vanishing point is an imaginary point on the horizon where all the receding parallel lines appear to come together.

Top, Leonardo daVinci has balanced this painting of the disciples and Jesus gathered together for the Last Supper in such a way that all receding lines converge at a point on the horizon that would be exactly behind the head of the Christ. In this way, da Vinci has created an image that combines technical aspects of linear perspective with religious iconography to heighten emotional response of the viewer to the image. Leonardo da Vinci (1452–1519), *Last Supper,* 1495–1498. Tempera on gesso with pitch and mastic, 181" × 346" (460 × 880 cm). Convent of Santa Maria delle Grazie, Milan, Italy. (High resolution scan by http://www .haltadefinizione.com, in collaboration with the Italian Ministry of Culture)

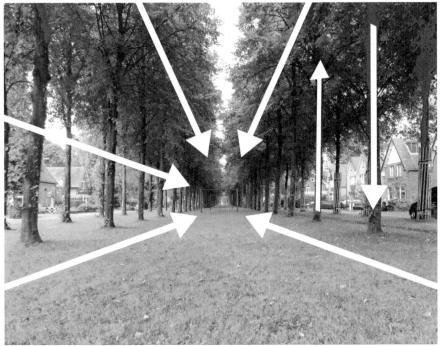

Bottom, Trees and lawn with directional lines pointing to a single location on an unseen horizon line. Central median of the Kaz King Avenue to Apeldoorn, the Netherlands. (via Wikimedia Commons)

1. Find three *outdoor scenes* that demonstrate one-point perspective and take photographs of the scenes to be used as reference. These should be scenes *based on observations* in your actual community, *not imaginary scenes or images from the internet.*
2. Make three quick sketches of the outdoor scenes, showing one-point perspective.
3. Use white drawing paper that is 9" × 12" in size.
4. For the sketches, do not bother with details of objects at first; try to describe the large shapes and how these recede into space.
 a. Concentrate on making sure the main horizontal and vertical lines are drawn correctly. The horizontal lines that are facing (or parallel) to you remain horizontal, while horizontal lines of things moving away from you recede toward the vanishing point.
5. Compare what you see in your photographs with what you have sketched. Use a ruler to compare the verticals of your sketches with the verticals in the photographs.
 a. Are they similar, or has something changed?
 b. What might account for the changes between the photographs and your sketches?
 c. Share your sketches and photographs with your peers and instructors. Discuss differences between drawing **linear perspective** that is observed and the digitally captured scene. Seek feedback about the more interesting of your sketches.
6. Based on the feedback you receive and your own preferences, select one of the sketches and redraw it as a finished drawing on a sheet of white drawing paper that is about 12" × 18" in size.
7. Add details, making sure that these also follow the rules of perspective.
8. Add **shading** to the planes that are facing away from the light source. This will help make your drawing look realistically **three-dimensional**.

Materials Needed

white drawing paper, 9" × 12" and 12" × 18"
drawing pencils with various soft and hard leads
eraser
18" ruler

Vocabulary

Horizon Line Three-Dimensional
Horizontal/Horizontally Vanishing Point
Linear perspective Vertical/Vertically
One-point Perspective
Shade/Shading

· the digital photograph you took of a one-point perspective scene
· two sketches of that scene
· a finished one-point perspective drawing of the scene, with details and shading
· a written explanation of at least three rules for drawing scenes in one-point perspective, and a description of how a vanishing point is used in one-point perspective drawings

LESSON EXTENSION

Some exercises in one-point perspective ask that the artist draw a railroad track with receding telephone poles or a street with buildings on either side. Such views might seem less interesting than sweeping landscapes or expansive interiors shown as two-point perspective scenes. Yet street scenes can be quite interesting if additional attention is given to architectural features, human street activity, or slight variations of receding forms, such as a gentle bend in the street or a building that protrudes into view.

Left, Hirose M., *Perspective Drawing,* 2015. Pencil and pen on paper, 8½" × 12". Student of Brian Cho. (Courtesy of the Artist)

Also interesting are one-point perspective landscapes that are painted from unusual positions, such as looking down from a high vantage point, or from a low point looking upward. These require close observation of what happens when the line of vision dips below the horizon and then reappears or curves as it recedes toward the horizon.

Study how one-point perspective is used to describe depth in these images. As an extension of this lesson, try drawing a one-point perspective composition from an unusual vantage point. Then as an additional challenge, add color with a medium of your choice.

Above, Ben H., *Perspective Drawing,* 2015. Sharpie pen on cream paper, 9½" × 12". Student of Brian Cho. (Courtesy of the Artist)

Lessons in Drawing Realistically

Right top, Joseph Pennell (1857–1926), *Le Puy,* 1894. Etching. The Rosenwald Collection, National Gallery of Art, Washington, DC.

Right bottom, Vincent van Gogh (1853–1890), *Field with Poppies,* 1889. Oil on canvas, 28" × 35 13/16" (71 × 91 cm). Kunsthalle Bremen, Bremen, Germany.

Facing left top, Fisheye Panorama at the Intersection of Wall Street and Broad Street, New York, 2008. (Photograph by Martin St-Ament. CC BY-SA 3.0 US)

Facing left middle, Tree, 2014. (Photograph by Nevit Dilmen. CC BY-SA 3.0 US)

Facing left bottom, This dramatic view of the *Space Shuttle Atlantis* taken in 1996, looking directly down onto the shuttle stack atop the Mobile Launcher Platform (MLP) and crawler-transporter, was taken from the Vehicla Assembly Building (VAB) roof approximately 525 feet (160 meters) above the ground. Kennedy Space Center, United States National Aeronautics and Space Administration (NASA).

Facing right top, Field of Pumpkins, 1989. Watercolor collage, 8" × 12". (Child Art Collection of Marjorie Manifold)

Facing right bottom, A collaborative work by mixed-ability students. *Princess and the Frog,* 1991. Mixed media, 12" × 8". (Child Art Collection of Marjorie Manifold)

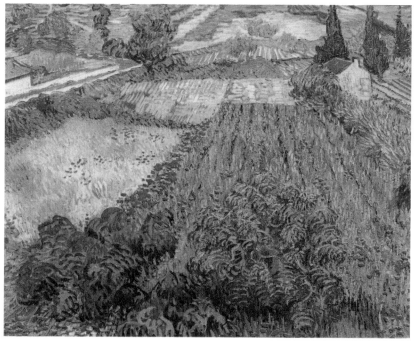

TIPS FOR TEACHERS

Until children are around 12 years of age, it is difficult for them the grasp the technical notions of true (linear) one-point perspective. However, they can grasp a general idea of linear perspective if it is couched in an unusual, casual, fanciful, colorful, or imaginary way. One way of doing this is to create a theme of high interest to children and invite them to explore how linear perspective works in extreme circumstances.

Where are the horizon lines in these examples? Does the horizon line have to lie on the actual earth horizon, or is a horizon line a *place* that is dependent on the gaze of the viewer? Does the horizon line move every time you change the position of your eyes?

Ask students to consider where the horizon line would be if they were looking down into a deep well or up from the ground toward the top of a skyscraper. Explore what shadows look like as the sun is setting with its light falling on tall objects. Notice how tall shadows seem to grow thinner as they recede into the distance. Inviting students to draw a one-point perspective drawing from an unusual position encourages observation of the laws of perspective at work. For example, suggest that students imagine the world from a frog's- or worm's-eye view, or from an eagle's point of view.

Allow students to use a ruler in drawing receding, vertical, and horizontal lines, but also encourage them to include objects that do not require the use of a ruler.

For example, if drawing from a worm's-eye view, try adding bugs or other worms along with tall blades of grass reaching to the sky. If drawing a field of pumpkins, consider how the pumpkins would appear smaller as the rows recede toward an imaginary vanishing point. Remember too that although vertical lines will remain vertical, it is not always necessary that the lines of recession be exactly straight. Combining the exactitude of a vanishing point with casualness of other features encourages students to grasp important ideas about perspective in a playful way. Allowing the use of alternate media, such as oil pastels or collage, also makes this learning more pleasurable.

Lesson 23: Drawing in Two-Point Perspective

If a box is placed in front of you so that one corner is closest to you, each side of the box will appear to recede away from you. If you imagine the top and bottom edges of the box as lines that extend into the distance, you can see that the lines of each side would converge and disappear into two points along a single **horizon line**. This effect is due to a visual illusion called **two-point perspective**. In order to draw realistic scenes, you need to understand basic rules of two-point perspective. This lesson will help you practice these rules.

Student example of two-point perspective drawing. Pencil and paper, 8" × 12". (Courtesy of the Artist)

BEFORE YOU BEGIN

Before choosing the scene you wish to draw, remember these rules:

- **Vertical** lines will remain vertical.
- **Horizontal** lines that are moving away from you will seem to converge into distant vanishing points on either side of the corner of the rectangular building or object.
- These **vanishing points** are imaginary points on the horizon where receding parallel lines appear to come together. The lines described in the previous point slope down if they begin above your eye level, and slope up if they begin below your eye level.
- These rules apply to the edges of objects that are above as well as below your position in space.

INSTRUCTIONS

Many lessons about two-point perspective ask that students draw buildings within a cityscape. However, the many details of a block of buildings may overwhelm and confuse an understanding of the essential techniques of two-point perspective drawings. It is generally much easier to comprehend these technical issues by observing and drawing simple objects within an uncluttered space. Therefore, for this lesson you are to do the following:

1. Arrange a still life of flat but three-dimensional objects, such as books, small boxes, building blocks, or a structure made from Lego® structure. Situate these objects so you can view them from a corner angle.

2. Take a digital photograph of the arrangement and place it beside you or clip it to the side of your drawing paper; compare what you observe before you in the actual still life with the photo. This will allow you to double-check your drawing as you proceed with the lesson.

3. In the center of a 12" × 18" of white drawing paper and using a ruler, lightly sketch a horizon line. Draw a vertical line to represent the corner of the structure you are drawing.

4. Very lightly sketch the angles that you think you see at the top and bottom of each side. Are these lines steeply or gently angled?

5. Place the ruler along the top edge of one receding edge the structure. Redraw the sketched top lines of the receding edges, extending the lines to a vanishing point on the horizon line.

6. Repeat this with the opposite side of the structure.

7. Having established two vanishing points on a single horizon line, straighten the bottom edges of the structure to align with the vanishing points.

8. Continue drawing the structure, making sure all receding edges of the structure align with one of the two vanishing points.

9. Draw the back vertical edges of the structure and erase the lines that extend beyond this edge.

10. Use the ruler to help keep the vertical lines vertical.

11. Add details, making sure that these also follow the rules of perspective.

12. Add **shading** to the **planes** that are facing away from the light source. This will help make the drawing look realistically **three-dimensional**.

Process of drawing a two-point perspective. (Created by the Author)

House photograph with directional lines to horizon lines. (Lines added by Author).

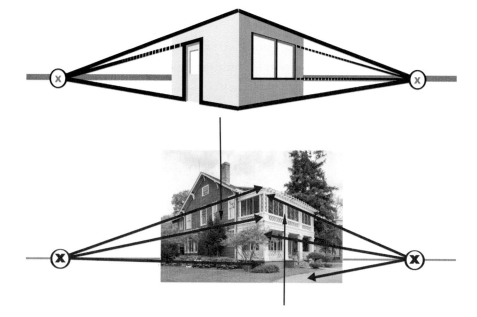

ART THEMES

Materials Needed

white drawing paper, 12" × 18"
drawing pencils with soft and hard leads
eraser
18" ruler

Vocabulary

Horizon Line	Three-Dimensional
Horizontal/Horizontally	Two-Point Perspective
Plane	Vanishing Point
Shade/Shading	Vertical/Vertically

WHAT TO SUBMIT FOR EVALUATION

- a photograph of the still life that inspired your drawing
- a finished, detailed, and shaded drawing of a still life arrangement in two-point perspective

LESSON EXTENSION

Once you are sure you understand the principles of two-point perspective drawing, try drawing a more challenging subject, such as a complex structure or angled view of city streets. Perspective drawings of cityscapes require attention to the verticals of doors and windows as well as to the proportions of doors and windows. Drawing cityscapes also requires that you notice how distances between doors and windows appear progressively closer as the planes of buildings recede into the distance. Look at these student-made examples of buildings or cityscapes that adhere to laws of two-point linear perspective.

Left, Annie H., *Perspective Variation Drawing,* 2015. Sharpie pen on paper, 9" × 12". Student of Brian Cho. (Courtesy of the Artist)

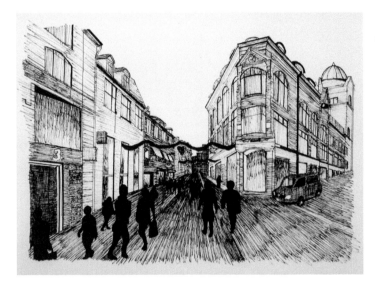

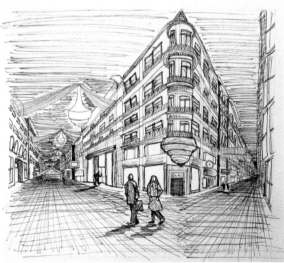

Above, Hailey Adams, *Perspective Variation Drawing,* 2015. Pencil on paper, 10¾" × 12". Student of Brian Cho. (Courtesy of the Artist)

Follow these instructions to create your building or cityscape drawing in two-point perspective:

1. Find a small photograph in a magazine or online that shows an interesting but simple building with one corner near the viewer. The photograph should be no smaller than 3" × 4". It must be large enough and of high enough resolution that you can see the details clearly.

2. Place the edge of a ruler along the top edges and bottom edges of the building. Notice how, if the edges of these buildings were extended, the edges would converge at points, called vanishing points, along the horizon line.

3. In the center of a 12" × 18" white drawing paper and using a ruler, lightly sketch a horizon line. Draw a vertical line to represent the corner of the building in your photograph.

4. Use the ruler to lightly sketch the top and bottom edges of each side of the building. Extend these lines to converge at a vanishing point.

5. Draw the back corner of each side of the building. Erase the lines that extend beyond this corner.

6. Draw in the doors and windows of the building. Use the ruler to help keep the vertical lines vertical. Edges should all recede toward the appropriate vanishing points.

7. Add details, making sure that these also follow the rules of perspective.

TIPS FOR TEACHERS

Depicting Linear Perspective

Even young students can gain a basic *sense* of two-point perspective, which opens them to develop understanding of the subject. Two-point perspective can be recognized through playful art projects that rely on a sense of whimsy. Invite students to draw imaginary castles, turn an initial into a block letter that adheres to two-point perspective, or create an object in Lego® bricks and use it as a model from which to draw. Alternatively, focus on a fantasy house or castle, the corner of a backyard fence, or an unconventional structure such as a tree house, birdhouse, mailbox, or treasure chest. Finish the drawing with colored pencils or markers.

Depicting Receding Objects in Space

Recognizing that objects become smaller as they recede into space could help children address a common problem in spatial depiction. By combining the idea of decreasing size as objects move off into the distance and the concept of a horizon line, you can assist young students in addressing ordinary problems of representation. For example, students may benefit from being shown ways to make roads grow smaller and disappear toward the horizon, or from observing how flowers or large vegetables appear to grow smaller, are higher on the page, and may be overlapped by nearer objects as they recede in space.

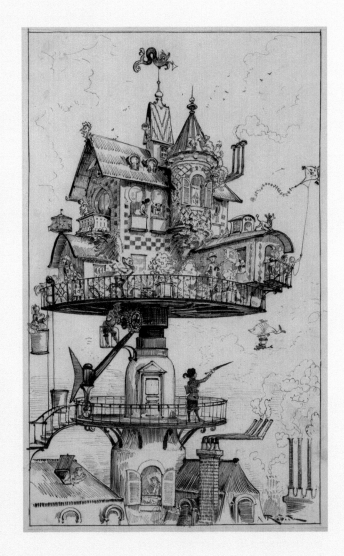

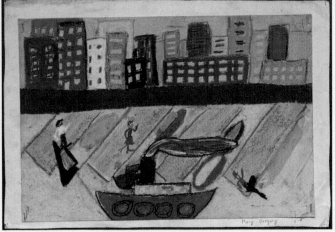

Lesson 24: A Remodeled House

Do you ever imagine a house you would like to own and live in? Perhaps you have examined or collected ideas from magazines that show beautifully designed homes. A no less imaginative but practical task is to visualize modifications that could be made to an existing house so that it becomes more functional and attractive, or to imagine an old and dilapidated house as it once was when newly built. Drawing these ideas and sharing them with others will be the task for this lesson.

Owen Staples (1866–1949),
Mercer Andrews House, Wellington Street West, south east corner Bay Street, 1880.
Pen and ink drawing, 5 5/8" × 11 3/16"
(14.3 × 28.7 cm). Toronto Public
Library, Toronto, ON.

INSTRUCTIONS

1. Search your neighborhood for a home that needs external renovation, or use a photograph of a house that could be modernized, remodeled, or adapted into an entirely new form. The question you might ask yourself is: What changes to the external appearance would be desirable or would give the home more curb appeal?

2. Using a pencil, on a 9" × 12" sheet of white drawing paper draw the original house you have selected as accurately as you can. For the purposes of this drawing, place yourself so that one corner of the building is closest to you. You should then be able to see two sides of it clearly. The experience with **two-point perspective** drawing in Lesson 23 will prove useful as you draw.

3. Check that the **proportions** of the house, windows, doors, and other features are accurate and all details are included. Do *not* shade this drawing.

4. Share the drawing with your peers and instructor to receive feedback about the accuracy of perspective and proportion on the drawing. Discuss modifications that you are considering.
5. Based on feedback, make alterations to the sketch.
6. Transfer or redraw the drawing to another 9" × 12" sheet of paper.
7. Change various aspects of the house to reflect an updated, modernized, or remodeled version of the original.
8. Complete your drawing with shading, visual texture, and details.

Left, Bethany Gross, *Photograph of Deserted House,* 2013. Student work. (Courtesy of the Artist)

Above, Bethany Gross, *Sketch of Remodeled House,* 2013. Student work. Pencil on paper with digital manipulation, 9" × 12". (Courtesy of the Artist)

Materials Needed

white drawing paper, 9" × 12"
drawing pencils with soft and hard leads
eraser
18" metal-edged ruler

Vocabulary

Proportion
Two-Point Perspective

WHAT TO SUBMIT FOR EVALUATION

· a photograph of the house that served as reference and inspiration for your drawings
· a drawing of the house using two-point perspective, showing proper proportion and including all the details of the original
· a drawn modification of the house demonstrating how it might be transformed into a more desirable or attractive house
· a written list and explanation of changes you made to the original building when you remodeled it into a dream home

Lesson 25: Architectural Design

The purposes for which a building is made will dictate basic requirements of the structure. For example, a barn must be large enough to provide housing for farm animals, with storage areas for their food and fodder as well as shelter for farm equipment. An economical house for a young couple may be very small and include only a kitchenette, a bathroom, and a combination living, dining, and sleeping area. Beside these requirements, factors to consider could include the geographic location of the building and the climate of the region where it will be built. A home in a tropical region may have walls that open up to allow cooling breezes to flow through the structure. A barn in upper Midwest America would need to be built with sturdy materials that protect animals against harsh cold winters with deep snows. A home in the Southwest desert might be made of adobe, while a tree house could make a delightful home for someone living in the Northwest rain forest.

Beyond acknowledging what a building must do and how it must fit into its environment, where do architects get their designs for new structures? There are stylistic traditions of architecture that may inform the design. We can easily recognize influences of ancient Greek architecture in the slender columns of national monuments and public buildings. Elements of medieval cathedrals may be present still in the spires of churches, while picturesque Renaissance-era arches and balconies may be used in modern apartment buildings in European cities. Architect Frank Lloyd Wright's Prairie House style house evolved into the highly popular ranch-style homes that can be seen throughout suburban America. In some areas of the American Midwest, round barns became practical and beautiful additions to the countryside.

Left and middle, Tamzin Ann Harris, *Venice Houses,* 2015. Watercolor on paper. (Courtesy of the Artist)

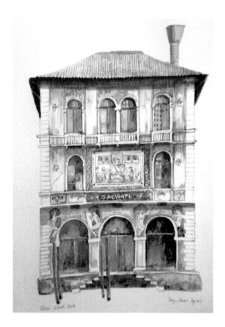
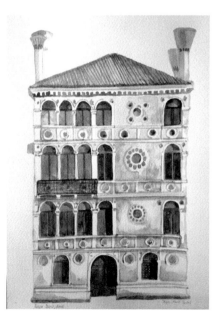
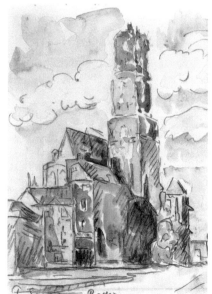

Right, Paul Signac (1863–1935). *Rodez,* detail, 1923. 8 ⅔" × 9¼" (22 × 23.5 cm). Albertina Museum, Vienna, Austria.

164

Architecture is like sculpture in that it should be interesting to look at when viewed from several different positions. To help a prospective owner of a building or home understand how the completed structure will look, an architect may prepare drawings that show the structure from different points of view or highlight its particularly interesting details.

INSTRUCTIONS

Part I

1. Search through several books and/or magazines of architectural design. Make photocopies of at least three different buildings of the same **genre**, that is, that have the same function—for example, three churches, barns, sports arenas, office buildings, museums, factories, or homes.

2. Gather as much information as you can about the buildings you selected. Try to determine the **architectural style** of the building and the architect who designed it. For example, one building might be an elegant Southern plantation house with a columned porch that resembles an ancient Greek temple, another an adobe home from Tucson, an Arts and Craft style home in Indianapolis, or a Prairie Style house designed by architect Frank Lloyd Wright.

3. Make photocopies or printout images of the three building examples, and write down (on the back of each photocopy) relevant information about the genre, style, architect, and location of the house. If some of this information is not available, record as much information as possible that will help determine something of the style of the house, such as date of creation and place or culture where it is located.

4. Select one of the images you downloaded, and on a sheet of 9" × 12" drawing paper, draw an image of the structure. Try to reproduce the building with attention to those features that you find to be more interesting. Draw features of the building, such as windows and doors, in correct proportion to one another and to the overall form of the building. Also describe fine details and visual textures of the materials used to create the building **facade**.

Part II

5. On sheets of 9" × 12" white drawing or watercolor paper, sketch portions of each of the downloaded structures that you find most interesting.
 a. Use drawing pencils with soft and hard leads and color media of your choice to highlight important or prominent features of the buildings.

6. Do not worry about describing these features with exact realism, although you should attend to the overall proportions of the structures and the relationships of one part to another.

7. Share your sketches with your peers and instructor. Consider how the architectural features might be combined or how some parts might be extended or added on to create a more interesting structure.

Color sketches of buildings by
students of Claire Cooper.
(Courtesy of the Artists)

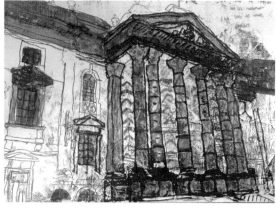

8. Based on feedback and your own preferences, on a sheet of 9" × 12" or 12" × 18" watercolor paper, imagine and draw a design for a building that has been inspired by your sketches and the images you downloaded.

9. Add additional features or changes based on your imagination or on pictures of similar or different buildings.

10. Finish the drawing as accurately as possible, with as many details as you like. You may want to include such things as balconies, windows, steps, doors, etc.

11. Add a color medium of your choice to finish the drawing.

12. Write a brief essay (300–400 words) in response to the following:
 a. Describe the genre (function) and style of the three photocopied building examples.
 b. Indicate what architectural features suggest this architectural or cultural style.
 c. Explain what ideas inspired your sketch of an original structure and where/how you used references to the photocopied buildings.
 d. Explain how the color medium you used to complete the drawing enhances or contributes to the interest and harmony of the composition.

Materials Needed

white drawing paper or watercolor paper, 9" × 12" or 12" × 18"
drawing pencils with soft and hard leads
eraser
18" ruler
markers, Sharpie pens, or other color medium of choice

Vocabulary

Architectural Style
Facade
Genre

TIPS FOR TEACHERS

Playing with blocks, Lego® bricks, or other construction toys are typical ways children begin to comprehend simple principles of engineering. These materials invite hands-on ways of learning. Additionally, when instructional diagrams are included with construction toys, children can learn to follow construction plans in order to build structures.

Envisioning a structure in a drawing or blueprint, then testing the hypothesis of the plan by attempting to construct what has been imagined is an important engineering task. Students can be encouraged to create a plan for a construction, using materials that also could be used as media of the construction. For example, students might use gears, blocks, Lego® bricks, dowel rods, plastic tubing, cardboard squares, and other construction materials as printmaking tools for creating an image of a structure. Once the print is complete, encourage students to use their artwork as the plan for a construction. How feasible is it as a plan? Why or why not? How could improbable or seemingly impossible plans be transformed into achievable results? What materials could be used to create the structure in three dimensions? How could parts of the structure be connected, made flexible, tilt, or hover? By moving alternately between visual ideas and hands-on experimentation, students gain a firmer grasp of engineering possibilities.

Alexander M., *Houses for Superheroes* (2015). Alexander, aged 6, used plastic stickers, blocks, bottlecaps, and cardboard with white printing ink on blue kraft paper to create a scene of imaginary houses. (Courtesy of the Artist)

WHAT TO SUBMIT FOR EVALUATION

· three photocopied images of buildings with identification information, as indicated in Instruction #3
· a sketch of one of these buildings
· a finished color drawing of a building design
· a written essay response, as outlined in Instruction #12

Lesson 26: A Dramatic Mood Cityscape

Drawing an urban scene or **cityscape** can be challenging, because it is difficult to observe the forms of buildings and details of architecture from a distance. This often results in having to practice drawing extremes of perspective in order to describe the features of your image. Rather than avoiding the difficulties of capturing cityscapes, many artists take advantage of these perspective extremes to add a sense of excitement to their compositions. Looking down from a balcony or from windows of a tall building as the sun is rising or setting, or at night when the activities of the streets are bathed with glaring artificial lighting, artists notice how dramatic the combined effects of extreme perspective and shadows appear. Alternatively, by standing on a sidewalk and looking up toward tall buildings, an artist can describe the looming awe of urban architecture.

General View, Bush Street Side, Mills Building, 220 Montgomery Street, San Francisco, California. Photograph, 4" × 5". Prints and Photographs Division, Library of Congress, Washington, DC.

The dramatic **one-point** and **two-point perspective** views seen below are examples of **vanishing points** on **horizon lines** that are above or below the frame of the photograph or drawing paper. Photographs and drawings that show such extreme perspectives contribute a sense of foreboding or drama to cityscapes. This moody effect is made even more pronounced when artists take advantage of light that adds strong shadows to the scenes. Would these images have been as interesting if the buildings and people were portrayed at eye level with the viewer? What moods do the images evoke? Would they have seemed as appealing if the light had been directly overhead and thus cast less pronounced shadows?

INSTRUCTIONS

This project will be easier to do if you live in an urban area. Find a high point from which to view the cityscape, perhaps a balcony or upper floor of a highrise building with a good view of the streets and rooftops below, or find a view from the street looking up toward tall buildings.

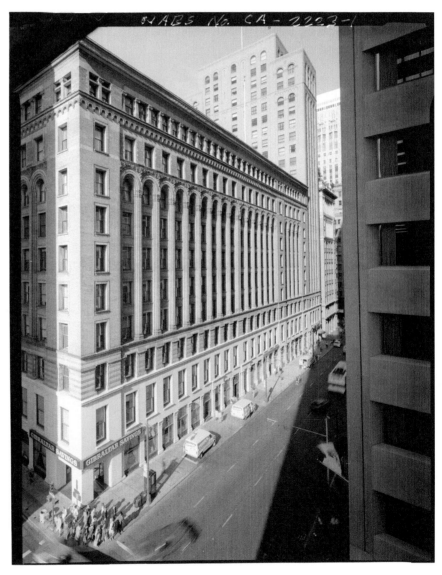

Left, Perspective View of Rear Elevation, Detail of Upper Floors—Tudor City Complex, Hotel Tudor, 304 East Forty-Second Street, New York, NY. Photograph, 4" × 5". Prints and Photographs Division, Library of Congress, Washington, DC.

Right, Earl Horter (1881–1940), *The Dark Tower,* 1919. Etching, 12¼" × 18" (33.7 × 45.7 cm). Reba and Dave Williams Collection, Gift of Reba and Dave Williams, National Gallery of Art, Washington, DC.

1. Select a view that demonstrates either one- or two-point perspective.
2. Wait until early morning or late afternoon, when shadows are most pronounced, then take several photographs of what you see. Take at least six photos from multiple viewpoints.
3. Using these photos as guides, sketch a scene on a 12" × 18" sheet of watercolor paper.
4. Use a large ruler to draw the horizon line if it falls within the space of your paper frame.
 a. If the horizon line or vanishing point would fall beyond the surface of your paper, tape your paper to a table or other hard surface. Use a strip of masking tape to indicate where the horizon line would be and mark the exact locations of the vanishing point(s).
5. As you draw the cityscape, use a ruler to help align the edges of buildings with the vanishing point(s) on your horizon line.
6. Add details with soft and hard leaded pencils. *Remember*: all **vertical** lines in the photo will remain vertical in your drawing.
7. With pencils, lightly indicate areas that are in partial shade or full silhouette due to the extremes of light.
8. Use black watercolor washes to add mid-range and dark values to describe shadows and visual textures.

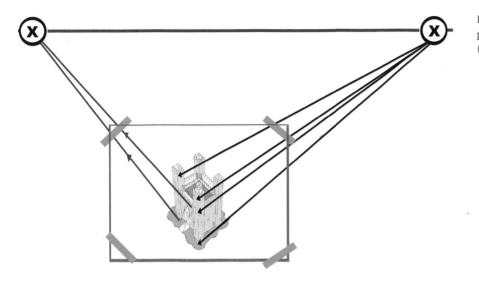

Example of laying out perspective past the frame of the drawing. (Created by the Author)

Materials Needed

watercolor paper, 12" × 18"

drawing pencils with soft and hard leads

eraser

18" metal-edged ruler

masking tape (*optional*)

black watercolor paint

brushes with large and small bristles

water container and water

paper towels for cleanup

Vocabulary

Cityscape

Horizon Line

One-Point Perspective

Two-Point Perspective

Vanishing Point

Vertical/Vertically

WHAT TO SUBMIT FOR EVALUATION

- six photographs of an urban scene taken from an extreme perspective and in extreme lighting situations such as early morning or late evening
- a sketch of one of the photographs done with drawing pencils and completed with additions of a watercolor wash to emphasize shadows

LESSON EXTENSION

Dramatic effects can sometimes be achieved by drawing with white oil pastel or white tempera paint on black paper. This is especially effective for night scenes. As an extension of this lesson, on heavy black paper with a white medium, create a drawing of a cityscape from an extreme perspective, with dramatic lighting cast by artificial night lighting. For night scenes with rain or reflective lights, add touches of yellow and orange to describe how light is reflected by wet pavements.

Lesser Ury (1861–1931), *Bülowstraße
Elevated Station (Hochbahnhof
Bülowstraße)*, 1922. Oil on canvas,
27½" × 39½" (70 × 100.5 cm).
Private collection.

Brian Cho, *Star Junction*, 2017. Acrylic,
46" × 30". (Courtesy of the Artist)

From the perspective of the child living in or visiting a city, skyscrapers may seem especially dauntingly tall and, when viewed close-up, shadows may lose their true definitions. Encourage students to describe their impressions of looming city structures by inviting them to stand close to large buildings, bridges, or towers and look upward. How does the structure look from this position? What do they notice about its apparent shape as it ascends toward the sky? How do the colors of the building change as shadows from other structures fall upon it? How do windows appear in size, shape, or color as one looks toward upper floors? What reflections can be seen in windows that are near the ground and those that are higher up? If the structure being observed is a bridge or scaffolding, what visual effects do its combinations of wires, beams, or struts create?

After examining tall structures in this way, provide students with large sheets (12" × 18" or 18" × 24") of drawing paper. Invite students to turn the paper portrait style and, using a medium such as oil pastels, describe their impressions of the experience as a work of visual art. Encourage students to draw large, using a full range of motion of their bodies and filling the entire page with their drawings.

Skyscrapers. Crayon and oil pastel on manila paper, 18" × 12". (Child Art Collection of Enid Zimmerman)

Lesson 27: A Crowd Scene

When drawing a single figure or a small group, an artist can concentrate on **gestures** and features of the face and body that describe personality traits or physical characteristics of the subjects. Drawing large groups of people requires that these traits be either simplified and exaggerated or ignored altogether, so that only a suggestion of people is provided. Notice how artist Brian Cho has simplified and **exaggerated** facial features in one crowd scene but relied more heavily on bodily gesture to describe a second scene. Crowds are the central subjects in both of these artworks, yet crowds are frequently presented as secondary or supporting features of an artwork. For examples of crowds as secondary subject matter, look at *A Stag at Sharkey's* by George Bellows in Lesson 8 or the illustration *Hurdlers* in Lesson 11. Bellows and the illustrator of *Hurdlers* have presented the physical and facial expressions of a few spectators as representative of a larger crowd, whose individual members have been reduced to a mere line or dab of color.

Brian Cho, *Untitled*, 2009. Charcoal on paper, 60" × 40". (Courtesy of the Artist)

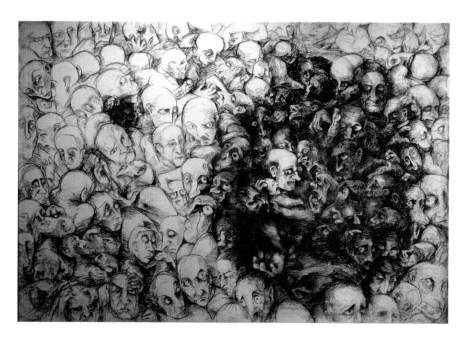

How would you describe members of a crowd in a work of art that focuses on the crowd as subject matter? In this lesson, you will have an opportunity to make decisions about aspects of human form, gesture, or expression that are important to describing your subject.

INSTRUCTIONS

1. Look through images in magazines or online to find examples of large crowd scenes, or visit a location where many people gather and take several photographs of gatherings of people. For example, you might photograph people walking through a shopping mall, waiting to board a bus or plane, sitting on bleachers at a sports event, riding a subway, sitting in pews at a church, or mingling at a party.

2. Decide what features of the crowd to highlight and what aspects to ignore or minimize.

3. On sheets of 9" × 12" drawing paper, create at least three sketches describing what your finished work might look like.

4. Share your work with peers and your instructor for feedback. Are features of the composition arranged in such a way that we visually read the scene as a crowd, without empty or dead spaces in the scene?

5. Based on feedback and your own aesthetic sensibilities, select the best of your sketches and make adjustments and/or notes on the drawing.

6. Redraw the best sketch on a new sheet of 9" × 12" or 12" × 18" watercolor paper.

7. Use light and dark values of shading to create three-dimensional effects or intensify sense of tension and drama in the viewer.

8. Use drawing pencils, black watercolor paint and brushes, or pen and ink to finish the drawing.

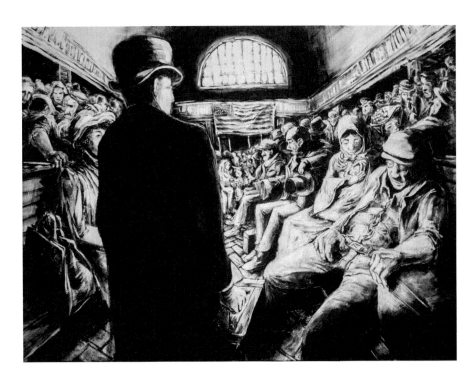

Brian Cho, *Huddled Masses of Tired and Poor*, 2013. Acrylic on paper, 40" × 30". (Courtesy of the Artist)

9. Write an essay (200–250 words) in response to the following:

 a. Explain what features of the human form you decided to highlight as descriptive of your crowd scene.

 b. Why did you consider these features most appropriate?

 c. Did you show distinctive features of all the subjects in the crowd, or single out a few people of the crowd and describe their features?

 d. What prompted this decision?

Materials Needed

drawing paper, 9" × 12"
watercolor paper, 9" × 12" or 12" × 18"
drawing pencils with soft and hard leads
black ink or watercolor and brushes or pens (*optional*)

Vocabulary

Exaggerated (Features)
Gesture

WHAT TO SUBMIT FOR EVALUATION

· the photograph or image you used as a guide for your drawing
· three sketches for a crowd scene with notes about feedback received from your peers and instructor
· a finished drawing or painting of a crowd scene
· a written essay response, as outlined in Instruction #9

LESSON EXTENSION

The term "frenzied mob" conjures visions of a turning, twisting, surging mass of people. Mobs can form when persuasive orators whip the collective emotions of crowds into action, or crowds may spontaneously erupt in response to outrageous injustices enacted upon a person or group of people. Artists throughout history have been inspired to portray mobs of people caught up in political or religious frenzy. Often these works have become influential statements about the times in which they were created. As a lesson extension, convey the fury of a mob in a work of art. The idea is not to condemn or take sides with or against the mob, but to capture its character pictorially.

· Search for examples of mobs as portrayed in print or online news stories. Your topic could be a political demonstration, an unorganized protest, a military clash, civil rebellion, a sporting event, or a rock concert. Notice how body angle, gesture, and facial expression communicate emotion. Also, pay attention to overlapping, closer and more distant figures, and group movement.
· Download or photocopy some of the photographs you have found. Crop, cut, and trim out superfluous visual or textual information. Assemble the photographs into a collage that demonstrates a harmoniously integrated composition. Rubber cement the pieces to a sheet of 9" × 12" or 12" × 18" drawing paper.
· Use the collaged composition as the basis of a drawing or painting about the frenzy of a mob. Use drawing pencils with soft and hard leads, watercolors, or an ink wash to create your finished artwork. The picture will be finished when it communicates the drama of mob behavior through overlapping, varying the size of figures that are closer or further away, gestures that describe the overall mood of the group participants, and actions of several prominently placed individuals. Because all the

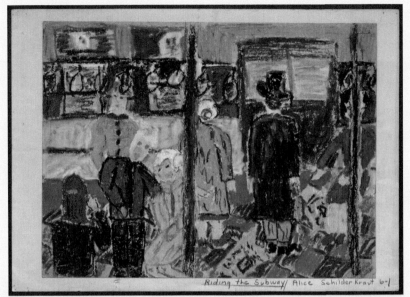

Children are exposed to many settings where crowds of people are present. Because primary-age children draw symbolically, describing large groups may be challenging for them. It is difficult to maintain the integrity of a symbolic human form when it must be distorted or overlapped to describe many people. Encourage students to focus on a few people in a scene and then add others, challenging students to consider where and how the additional figures might be inserted, simplified, or overlapped to highlight, accompany, or serve as background to more central characters.

Top, Riding the Subway. Crayon and oil pastel on manila paper, 9" × 12". (Child Art Collection of Enid Zimmerman)

Left, Crowd Scene. Crayon on manila paper, 12" × 18". (Child Art Collection of Enid Zimmerman)

people are experiencing a single driving emotion, the picture should exhibit strong rhythmic movements.

· Create a title for the work.

NOTES

 1. A. Mayor, *The First Fossil Hunters: Paleontology in Greek and Roman Times* (Princeton, NJ: Princeton University Press, 2001).

 2. M. Sendak, *Where the Wild Things Are* (New York: HarperCollins, 1967/2012).

2 · Lessons in Color and Paint

We live in a world of light and color, both virtually and in reality. Brilliantly colored images blend into a landscape of live colors. Yet well into the twentieth century, color reproductions of artworks were expensive and therefore rare. Unless they lived near a museum or gallery where they could see great works of arts in bright colors, ordinary people rarely had access to color reproductions of a wide array of famous artworks. This does not mean artists avoided making art in bright colors. In fact, some very important nineteenth- and early twentieth-century artistic movements of the Western world prized exploration and experimentation with color. In this chapter, you are invited to explore color in art. You will observe how colors of a painting interact with one another to produce new colors or illusions of colors. You may explore how color reveals the emotion of the artist or effects the emotion of a viewer.

FEATURED ARTIST: SHARON GEELS

Sharon Geels is a featured artist in this chapter. Her active life as an artist began when she gave up her corporate job, with its stress and long commute, to live in the small mountain town of Georgetown, Colorado. There she was determined to devote herself to her interest in art making. Initially she considered painting very realistically and says, "I began painting as tightly and classically as I could; but about half an hour into painting, I said this is tedious. So, I let loose and had fun the rest of the ride."

Geels is an example of a *self-taught* artist, because she did not receive a degree in fine art from a school of fine art or design. "I never took a course on shading, or shapes, or perspective," she says, "but my paintings work. What makes them work? I think it's honesty. The viewer sees my work and recognizes a truth." Her paintings are exuberant, with colors and forms that splash across her canvases and tumble into one another in celebratory dances. They describe recognizable objects and spaces in unexpected ways. She believes "art should be fun to make and fun to see, no matter what the subject may be.

Art is, first and foremost, a conversation between the artist and the viewer."

Geels's technique is simple. She uses only the primary colors of red, blue, and yellow, plus white to mix all the colors for her paintings. While there are many additives for acrylic paints that might give design and textural qualities to a piece, she prefers to stay with water and occasionally a matte medium. The greatest insight Geels has about painting is that any given artwork is about more than the subject depicted. Many times, she explains, the purpose of each painting is a mystery, even to her. She often doesn't know what it is about until a viewer shares with her a feeling or insight from a work. Yet she hopes that her art brings a breath of fresh air to viewers and points to something beautiful, knowable but unknown, and slightly above the fray.

Geels's intriguing works are sold at shows and in galleries throughout the southwestern United States, as well as through social media sites on the internet. Visit her online galleries at https://www.facebook.com/SharonGeelsFineArt.

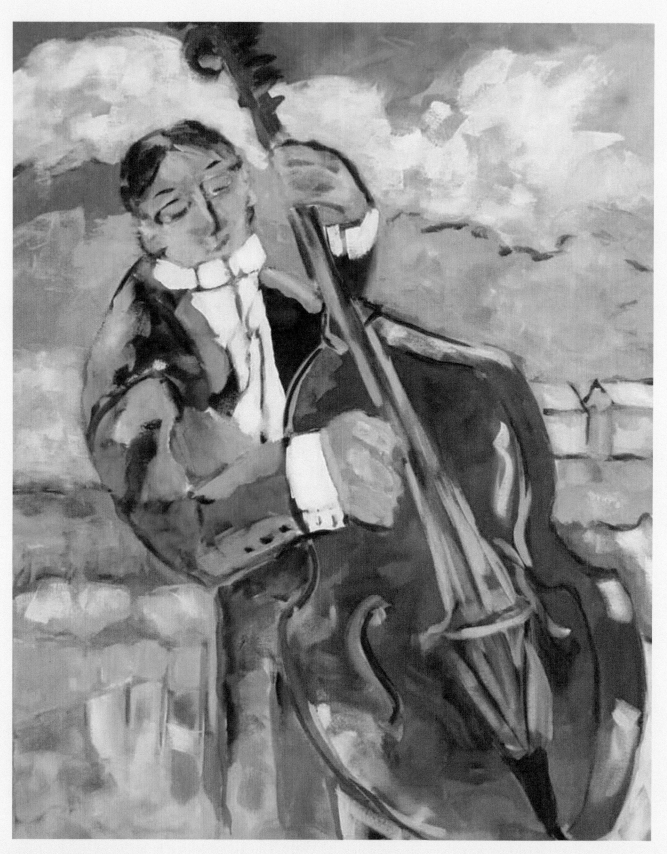

Sharon Geels, *Virtuoso*, 2015.
Acrylic on canvas, 24" × 30".
(Courtesy of the Artist)

Lesson 28: Color Studies

The **color wheel** is a chart of colors of the visible spectrum that is used to show how colors relate to each other. It is made up of three **primary**, three **secondary**, and six **tertiary** or **intermediate colors**. Primary colors (red, blue, and yellow) are colors that cannot be created by mixing any other colors. Mixing two primary colors together forms a secondary color. Combining a primary color with an adjacent secondary color forms a tertiary color. In this lesson, you will create a color wheel by mixing the primary colors in appropriate proportions in order to make secondary and tertiary colors, then practice mixing colors in ways that result in new colors.

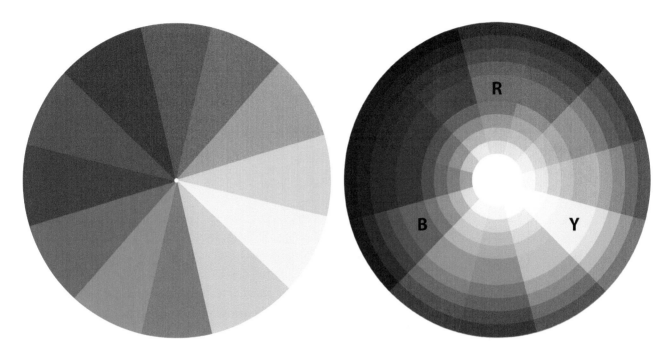

DEFINITIONS

A color wheel demonstrates the spectrum of visible colors in the order they would appear if they were bent into a circle. It is a useful tool for organizing colors and describing the relationships between colors. It is laid out so that any two primary colors are separated by the secondary colors. The tertiary or intermediate colors provide gradual transitions from the primary to secondary colors. Here are some important things to know about colors:

- Primary colors (red, yellow, blue) are hues that can be mixed to create all other colors.
- Primary colors are basic and cannot themselves be mixed from other elements. They are to color what prime numbers are to mathematics.
- Mixing two primary colors will produce a secondary color. Yellow and blue will result in green. Yellow and red will produce orange. Red and blue will result in violet.

The first color wheel seen here presents the primary, secondary, and tertiary colors as they would be arranged in a prism. Violet, which has the shortest wavelength on the spectrum of visible light, is adjacent to red, which has the highest wavelength among colors visible to the human eye. In the second color wheel, tints and shades have been added at the same graduated rate from the inner to outer perimeter of the wheel. (via Wikimedia Commons)

- There are six tertiary or intermediate colors: red-orange, red-violet, blue-violet, blue-green, yellow-green, and yellow-orange. Mixing a secondary color with one of its primary parents creates these colors.
- **Complementary** colors are colors located across from each other on the color wheel. Violet and yellow are complementary, blue and orange are complementary, and red and green are complementary.
 - Color complements are color opposites. These colors contrast each other in the most extreme way possible. They also excite the eye and therefore suggest activity.
- **Hue** refers to a pure primary, secondary, or tertiary color that has no white or black added.
- **Value** is the lightness or darkness of a color. When white is added to a hue, the results are called **tints**. Adding black results in **shades** of the color.
- The color wheel can be divided into **warm colors** and **cool colors**.
 - Warm colors are hues, tints, and shades of reds, yellows, and oranges. These colors suggest warmth and refer to things that we perceive or experience as warm.
 - Cool colors suggest feelings or things they we experience or describe as cool or cold; they are hues, tints, and shades of blues, greens, and violets.

INSTRUCTIONS

Part I

1. Using a compass, ruler, and pencil, draw a large circle in the approximate center of a 12" × 18" sheet of watercolor paper. Within the circle, place an equilateral triangle whose points touch the circle. The three points of the triangle will mark the location where you will place the three primary colors: red, yellow, and blue. Look at the example of the twelve-color color wheel to show how you might further divide the areas of the wheel.

2. Using only the three primary colors of paint, create the secondary and tertiary hues needed to complete the wheel. In order to mix a secondary color, place a dab of each of the primary colors from which it is made on a clean section of the palette. Mix these two primary hues with the brush. Paint the appropriate section on the wheel. Now clean the brush and begin working on a tertiary shade.

3. Test your colors before you apply them.
 a. Notice that the color labeled and sold as blue is often an indigo rather than a true blue. As a result, mixing indigo with red will produce a very dark, almost black purple. Mixing indigo with yellow will result in a deep forest green. Mix a sample of color and apply it to a scrap of paper before adding it to the color wheel. If the blue is too intense or appears to be indigo, look for a truer blue hue. It might be labeled light blue or cerulean (sky) blue.

b. You will be more successful if you think of the proportion of primary colors needed to make any given mixed hue. For example, mixing equal parts of each of two different primary hues makes a secondary color. A tertiary color is created by mixing two parts of one primary color with one part of another. Using this system of color mixing, paint in all the appropriate sections of the wheel.

4. When mixing colors, always *add the darker color to the lighter*, one *tiny bit at a time*.

5. Always clean your brush when switching from one color to another.

Part II

6. Draw several circles, squares, triangles, or other geometric shapes on a sheet of 9" × 12" watercolor paper. You may trace a circular object, such as a compact disk or empty glass, or trace a small square, rectangular, or triangular object to get even shapes. Try to select several objects with interesting shapes. Place the shapes so that some overlap others.

7. Select only one primary hue of paint and with water, dilute the color to a transparent wash. Using only this hue, paint a few of the shapes and allow the color to dry.

8. Select another primary hue and repeat the instructions given in Instruction #7. Allow some of the color to overlap the previous hue.

9. Select the third primary hue and repeat the instructions given in Instruction #7. Notice what happens when two colors overlap. What happens when three colors overlap?

Madison Wise, *Mixing Transparent Primary Colors*. Watercolor on cream paper, 9" × 12". (Courtesy of the Artist)

Part III

10. Draw a second arrangement of geometric shapes on a second sheet of 9" × 12" watercolor paper. Focus on the general overall shapes of the objects rather than on small details.

11. Select only two hues that are complementary colors to one another and add water to each in a separate compartment of your mixing tray. Adding more water will make the colors transparent.

12. Using only these two colors, paint places where the complementary colors overlap with one another.

13. If you wish the colors/hues to remain pure and bright, allow the wet sections of one color to dry before adding the complementary color.

 a. Mixing wet complementary colors together will produce neutral colors (i.e., grays, tans, or browns).

 b. Does the same thing seem to happen when a wet color is painted over or overlaps with its dry complement?

A neutral brown hue appears in places where a transparent turquoise (bluishgreen) color has been laid atop its near complement, yellow orange. *100 Watercolors by Easel Artists of the New York City WPA Art Project*, detail of poster, 1940. Silkscreen. Work Projects Administration Poster Collection, Prints and Photograhs Division, Library of Congress, Washington, DC.

Materials Needed

watercolor paper, 9″ × 12″ and 12″ × 18″
watercolor or tempera paints in red, yellow, blue, white, black
brushes with thick and thin bristles
water containers and water
mixing trays

Vocabulary

Color Wheel	Intermediate Color	Tertiary Color/Hue
Complementary	Monotone	Tint
Colors	Primary Color/Hue	Value
Cool Color(s)	Secondary Color/Hue	Warm Colors
Hue	Shade	

WHAT TO SUBMIT FOR EVALUATION

- an accurately painted color wheel
- a still life painting using transparent primary colors that shows what happens when transparent primary colors overlap
- a still life painting using transparent complementary colors that shows what happens when transparent complementary colors overlap
- a brief written description of any problems you encountered when creating this project, and an explanation of how these might be avoided in the future

LESSON EXTENSION

The Impressionist painters discovered that the use of black to create shadows was unnecessary, since placing complementary colors atop one another serves this purpose, whereas adding black to a hue results in a dulled shade or lifeless color. Nevertheless, many still use black to produce powerful effects in paintings.

As a lesson extension, try mixing and using tints and shades in a painting. Using tempera paints, select only *one hue* of paint and pour a small amount on the mixing tray. Also place a small amount of white and black in sections of the tray. Add a *tiny* amount of the main hue to a clean section of the

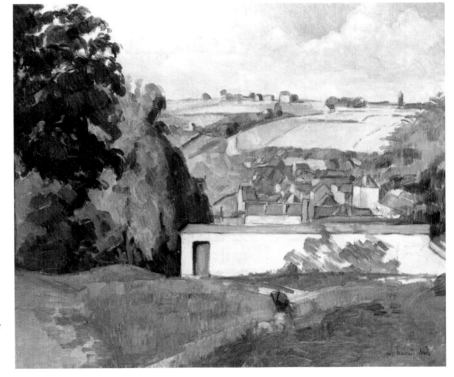

The artist has created a full range of light to dark values in this painting without using any black pigment. Instead, shadows and dark shades have been created by laying complementary colors atop one another. Émile Bernard (1868–1941), *Young Girl on a Hill (Jeune Fille sur la colline)*, 1904. Oil on canvas, 25″ × 30 3/16″ (63.5 × 76.8 cm). Gift of Harry William and Diana Vernon Hind, Fine Art Museums of San Francisco, San Francisco, CA. (The Amica Library)

tray and add increasing amounts of white to it in order to produce several tints of the color.

Repeat this, adding a *tiny* amount of black to some of the main color and add increasing amounts to create a range of shades. Paint a **monotone** composition that uses only one color together with its tints and hues. Compare the shades with the neutral colors created by mixing complementary colors. Which colors are more vibrant?

Remember: when mixing colors, always *add the darker color to the lighter,* one *tiny* bit at a time.

TIPS FOR TEACHERS

Mixing Colors—The Problem with Blue

Learning to mix colors is a basic skill for elementary school students. Selecting the right paint media is important to students' success. Tempera is one of the most commonly used paints. The advantages of this media include ease and flexibility of use—although it is normally opaque, it can be thinned to the consistency and transparency of watercolor. Liquid and cake forms of tempera are inexpensive to purchase, store easily, and clean with soap and water. However, the many different manufacturers of tempera label their colors differently.

This is especially problematic when selecting a good primary blue. Many manufacturers sell as "blue" a color that is actually indigo or navy blue. When mixed with red or yellow, the result is not a pleasant purple or green, but a harsh acidic hue that may frustrate students who do not see their teacher's instructions that "blue and red make purple" or "blue and yellow make green" replicated in practice. Look carefully at the labels of colors marketed as blue. Primary blue may actually be labeled as "cerulean blue," "light blue," or "primary blue." Let your eyes be your guide in selecting primary red, yellow, and blue paints that will produce predictable results when mixed with one another.

Lesson 29: A Color Match Collage

Some colors are bright and brazen. Others are much more subtle and sophisticated in their impact and include deep vibrant tints and soft tones. When different colors sit side by side or in close proximity, each affects the way we perceive the other. In some cases, this may result in our assuming we see a color as being brighter, duller, more yellow, blue, or red than it really is.

Paint can be mixed fairly easily to make subtle colors and gradual changes, because we are mixing colors separately before adding them to the painting. To deconstruct colors and determine what colors are present within a picture, when other hues may be interfering with our perception, can be a much more challenging task. This lesson requires that you study colors in a work of art more carefully than you may otherwise do. You are to find exact colors from magazines or colored papers that match those present in a work of art, then create a **collage** reproduction of the artwork.

INSTRUCTIONS

1. Select a color reproduction of a painting, illustration, or mural.
 a. A composition of large simple shapes will be easier to work from than one with small details.
 b. The reproduction should be large enough that you can clearly see color divisions and subtleties.
 c. Make a color copy of the painting by scanning a picture from an art book or by downloading a color image from the internet.
 d. If selected from the internet, the picture must be of high resolution
2. Print the image as large as possible on a normal-sized sheet of copy paper.
3. Collect colored papers similar to the colors in the painting. Good sources of colored papers include magazines, commercially made scrapbook papers, wrapping and construction papers.
4. When you have an adequate collection of colored papers, make a line drawing of the picture you have chosen on a 9" × 12" or 12" × 18" sheet of watercolor paper.
5. Tear or cut small pieces of colored paper and organize the torn or cut pieces according to color family (yellows, oranges, blues, greens, etc.).
6. Hold up small pieces of color to the reproduction until you find the pieces that match the color that actually appears in the reproduction.
7. Arrange these correct colors on the line drawing and carefully attach them in place with rubber cement.
8. You may overlap colors or lay them very close together in mosaic fashion. If you mosaic them, do *not* leave noticeably large gaps of space between individual pieces.
9. When all the pieces of paper have been attached in a correspondingly correct position, carefully clean off all the excess or exposed rubber cement with a rubber cement eraser.

10. Write a brief essay (250–400 words) in response to the following:
 a. Explain why you selected this particular painting or illustration for reproduction.
 b. Describe any difficulties you had matching the colored papers to the color reproduction, and explain how you resolved the problem.

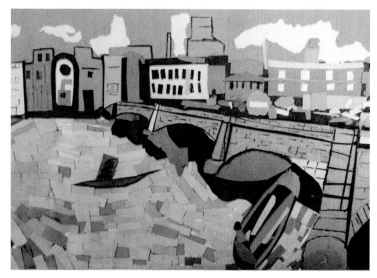

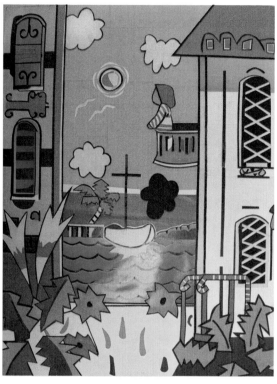

Above, In this example, a student has created a collage to match the colors of *London Bridge,* 1906, a painting by André Derain (1880–1954) in the Museum of Modern Art (MoMA), New York, NY. (Courtesy of the Artist)

Right, Student-created color collage from a magazine illustration. (Courtesy of the Artist)

Materials Needed

watercolor or construction paper, 9" × 12" or 12" × 18"
pieces of colored paper from many sources
pencil

eraser
scissors
rubber cement
rubber cement eraser

Vocabulary

Collage
Picture Books

WHAT TO SUBMIT FOR EVALUATION

· the color image reproduction that is referenced in your collage
· a completed cut-paper color match collage
· a written essay response, as outlined in Instruction #10

TIPS FOR TEACHERS

Picture Books: Harmonizing Story and Images

Several illustrators of children's books use collage as a medium for their illustrations. Some well-known collage artists include Eric Carle, Bryan Collier, Lois Ehlert, Leo Leonni, Ezra Keats, and Ellen Stoll Walsh. Whether an artist uses paint, collage, photography, or some other medium to produce illustrations for **picture books**, the artist's and author's main consideration is that the images and story blend together to create a unified whole. "Illustrations are more than background for the authors' words," writes Catherine Prudhoe, "they act to engage the reader cognitively and emotionally."[1] Pictures provide contextual cues to help children cognitively understand the moods and meanings of stories. They permit children to check the accuracy of words they are learning to read. By engaging emotions, they assist memory development and a kind of "cognitive stickiness" that is critical to learning.

When you select picture books for use in the classroom, without being consciously aware that you are doing so, you are very likely basing your choice on the book's visual appeal as well as on its narrative content. The illustrations and narrative content must harmoniously relate in order for the story to be satisfying. Children also need opportunities to tell their own stories visually, and to practice making relationships between the stories they wish to tell and the way those stories can best be conveyed so that others might understand and respond to them. Cutting or tearing paper and reorganizing these shapes into illustrations helps young students understand order and sequencing as a component of storytelling and as a principle of composition in art. They must consider the most important elements of the story or picture and make choices about details that contribute richness to the tale.

Invite your students to tell their stories in collage. Students could illustrate one part of the story, then write about what came before and/or what came after the illustrated section of the tale. Students could collaborate on a story, with each student illustrating one aspect, event, or progression of the story. Look online for other ways to incorporate storytelling and illustration. Websites of children's book publishers are excellent places to begin the search. Most publishing sites of children's literature feature links to teacher resources, with information about authors and illustrators of their most popular books. Lesson plans for art and language arts provide ideas for integrating art and literacy acquisition.

Lesson 30: Mood Expressions

Colors can be effective metaphors for **moods**. If you close your eyes and imagine the emotional *feel* of the color gray, you might experience a physical sensation of gray rolling over you like a silent and eerie fog, or the cold of a snowless winter dawn. If shapes, colors, and **visual textures** are combined, altogether different emotions might come to mind. Imagining sharp jagged gray shapes rather than a foggy organic gray could change your mood from listless melancholia to frenetic apprehension. Likewise, bright blue and brilliant white could evoke moods of exhilaration, pleasant relaxation, or apprehensive mystery. When elements of line, shape, and visual texture are added, these colors can evoke memories of the warm white sand and blue skies of a tropical beach, the rushing sensation of rafting on a wild river, or the disquieting flash of white lightening during a thrashing rainstorm.

Using a variety of media, artists arrange colors, along with shapes and visual textures, to express mood. In this lesson, you will use a color medium with which you feel comfortable as you explore and express emotion through formal elements of shape, color, and visual texture. Among the media you might use are watercolor or **collage**. To stimulate memories or sensations of emotions, you are to encourage and enhance feeling through focusing on the words of a poem or sounds of music.

What mood is suggested by Van Gogh's painting? Vincent van Gogh (1853–1890), *Starry Night over the Rhône (Nuit* étoilée *sur le Rhône)*, 1888. Oil on canvas, 28½" × 36 ³⁄₁₆" (72.5 × 92 cm). Musée d'Orsay, Paris, France.

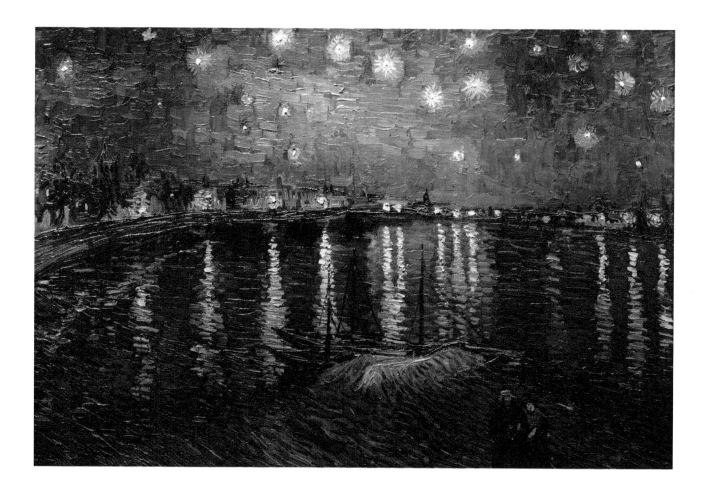

1. Think about art media you have used in the past and consider which types allow you to express yourself freely. Recommended media for this project are watercolor or tempera and collage, but you might prefer to use oil pastels or colored pencils. It is important that you feel comfortable using a medium, because the focus should be on expressing feeling rather than struggling to control the materials.

 a. If creating with watercolor or tempera, paint directly onto watercolor paper without pre-drawing an image. Once you are satisfied with the colors, you may go back into the painted image with color markers or ink to highlight or create additional features.

 b. If creating with collage, prior to beginning the work make a collection of many varieties of paper, including shades of colored construction paper, newspaper, plain and patterned wrapping paper, colored tissue papers, slick-surfaced pages from magazines, brown paper bag paper, spongy paper towels and paper napkins, wallpaper swatches, rice paper, and other interesting kinds of paper.

 c. If creating in dry color media such as colored pencils, pastel, or oil pastels, thoughtfully select a type of paper that will complement the medium. Papers to consider would include rough watercolor paper, rice paper, scrapbooking paper, construction paper and kraft paper or opened paper bags.

2. Choose a poem, passage from a literary work (or your own diary), or a piece of music that appeals to you—such as a folk song, a Beethoven symphony, a jazz piece, or a hip-hop rhythm.

3. Lay a sheet of 12" × 18" paper in front of you, then close your eyes and allow the words of the selected text or sounds of the music to flow through your mind. When you are comfortable and feeling attuned to a resonating mood, begin your work.

4. Communicate the mood you have chosen through colors, textures, and patterns with paint, sheets of your collected papers, or a dry color medium.

 a. Recognize as you work that different kinds of moods have **rhythms** that vary throughout a particular piece. Some rhythms are more pronounced than others. The main part of your design should focus on one strong rhythm that clearly articulates the mood you want to achieve. For example, you might use sweeping rounded shapes, small geometric shapes, or combinations of large and small shapes to depict the strong rhythm of martial pride felt when hearing the beat of drums and music of a piccolo while watching a Fourth of July parade.

 b. This dominant rhythm should be the **focal point** of your work, while also taking your eye on a journey through the composition.

c. The predominant design of your work should be **nonobjective**, that is, it should focus more on colors, lines, and shapes than objects.

5. The entire surface of this backing should be covered with your composition.

 a. If working in collage, attach pieces of the work with rubber cement and clean the excess rubber cement when the work is finished.

6. Write a brief essay (300–400 words) about the process of creating this work:

 a. Indicate why you chose to work with the medium you did.

 b. Describe any connections between that which inspired your composition (i.e., poem, literary passage, or music), you and your experiences in life, and the mood you described in your work.

 c. Describe and explain the emotions elicited and expressed.

 d. Explain how rhythm was expressed through the paint or collage medium.

 e. How was the medium appropriate to you and the emotions you expressed?

 f. Were you able to manipulate the medium to express what you wanted to say through your artwork?

Materials Needed

Painting Method

watercolor or tempera paints
heavy watercolor paper, 12" × 18"
drawing pencils in soft and hard leads
eraser
brushes
water container

Collage Method

Bristol board or heavy drawing paper, 12" × 18"	scissors
	rubber cement
pieces of colored paper from many sources	rubber cement eraser
	dry color medium of your choice
pencils	an appropriate textured paper,
eraser	12" × 18"

Vocabulary

Collage	Nonobjective/Nonobjective Art
Focal Point	Rhythm
Mood	Visual Texture

WHAT TO SUBMIT FOR EVALUATION

· a finished artwork that expresses your mood as encouraged by a poem, passage from a literary work, or movement from a piece of music

- a title for your artwork
- a written essay, as outlined in Instruction #6
- a link to or citation of the text or musical choice used as inspiration for this piece

How does this student-created collage composition reflect the mood of George Gershwin's musical composition? Zoe Cradick, *Collage of Rhapsody in Blue by George Gershwin*, 2013. Collage with Photoshop manipulation. (Courtesy of the Artist)

LESSON EXTENSION

In her artwork, student Zoe began by creating a collage from magazine and downloaded images as a background to her work. Then she scanned the collage and opened it in Photoshop, where she added design pieces from clip art and additional internet images. As a lesson extension, combine a nonobjective painting or collage with an image manipulation software program, such as Photoshop. If you are familiar with another program, such as Illustrator, and would prefer to use that program, you may do so.

1. Think of a theme or idea you would like to explore and a piece of music that conveys that theme. Allow the music to play softly in the background while you work on this project—it will help set the mood for your explorations of art and technology.
2. Create a nonobjective painting in a fluid medium like watercolor, finger paint, or monoprint.
3. Scan the artwork and open in Photoshop or Illustrator.
4. Clean up the image to your liking by using one of the image adjustment features.
5. Alter the image by overlaying it with other images selected from the internet, or use one of the program's filters—or both.
6. Consider: Does working with a digital medium interfere with, enhance, or otherwise modify your own mood as you work toward finishing the artwork?

TIPS FOR TEACHERS

Music and Poetry Inspired by Art

While this lesson invites the creation of art that integrates with internal mood and music, many musicians, poets, and authors have been inspired to create music in response to art. Examples of music that refer to artists or artworks include "Mona Lisa" sung by Nat King Cole, Seal's "Mona Lisa Smile," Mussorgsky's *Pictures at an Exhibition*, and Don McLean's "Vincent" as sung by various artists.

Invite students to explore artworks exhibited in a gallery or museum, then write poetry and create their own work based on what they see and how the artwork makes them feel. Allow them to create PowerPoint presentations or YouTube videos that combine music with artworks. Time a series of artworks to resonate with the mood and rhythm of the musical selection.

What emotional and cognitive skills are honed by researching and working in this way? What can be surmised about artists, their artworks, and/or the subjects of art by combining these art forms?

Abstractive Impressions of Special Events

Students can be introduced to the idea that artworks can capture moods in abstractive ways. Ask students to close their eyes and remember a special event in their lives along with the feeling that the event elicited. Having experienced a memory with its accompanying feeling, students can be invited to describe that experience in paint. Allow them to consider how the entirety of an event/feeling experience might be described as an abstract impression.

A child's boldly painted and oil pastel–drawn image of *Animals* abstractly suggests the frenzied excitement and activity elicited by parading circus animals, while *Candles*, done in soft chalk pastels, suggests the celebratory glow of birthday candles on a cake. (Child Art Collection of Enid Zimmerman)

TIPS FOR TEACHERS

Cultural Differences in Color Moods

Although colors convey mood, the specific mood a color induces is not universal. Color moods are largely culturally defined. For example, in Western cultures red conveys a sense of warmth, excitement, passion, and possibly danger. It is associated with fire and fire trucks, stop signs, and red flag warning signals. For many people all over the world, it is associated with the Christmas holiday. In China and several other Eastern cultures, red is the color of good luck; brides are often dressed in red. In India red is the color of purity, and in South Africa it is the color of mourning. In Egypt yellow is the color of mourning, while the Japanese consider it a color of courage. In the United States, yellow is used as a warning sign and to signify cowardice, but it also is understood as a bright, sunny, happy color.

If you plan to teach young children about the moods and meanings of colors, do some research and find out the meanings of colors among several other cultural groups. Why might colors mean different things to different people? Ask students to consider why one color might have different meanings among different peoples. Could the same color suggest both happiness and danger, or courage and mourning within the same culture? How and why?

Lesson 31: Matisse, Music, and Design

Henri Matisse (1869–1953) was regarded as one of the most important French painters of the twentieth century. Early in his career, he was the leader of a style of painting that focused primarily on color and design. Many of these early works were inspired by music and dance. Following surgery for cancer at the age of 70, Matisse was confined to a wheelchair. This made it difficult for him to paint with brushes on canvas, so he turned to cut paper **collage** as a medium of art making. He described working with paper cutouts as a liberating experience. These new explorations of patterned compositions seemed to depict shapes dancing in rhythmic formations. Matisse described these boldly colored paper cutout compositions as "visual counterparts of jazz music." To read more about Matisse and his work, see Henri Matisse: Paper Cut Outs, at http://www.henri-matisse.net/cut_outs.html, or search in books and online for examples of his work.

Student-created example of a collage inspired by Matisse. Construction paper collage, 12" × 18". (Courtesy of the Artist)

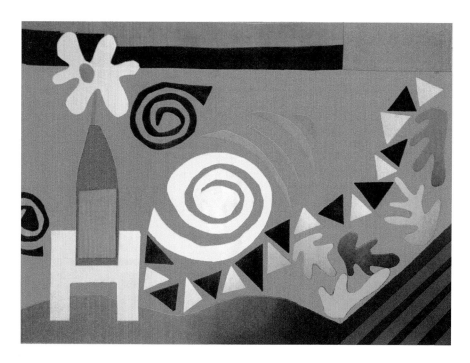

INSTRUCTIONS

1. Study the life of Henri Matisse and look at several examples of his art, until you are familiar with his artistic style and the kinds of subjects and themes that appear in his work.
2. When examining his works, pay special notice to his later paper cutout compositions.
3. Select three examples of artwork by Matisse that demonstrate **repetition** of simple **organic shapes** and colors. At least two of the examples should be of his paper cutout collages.
4. Make color photocopies of the three works by Matisse. Set these beside you to serve as inspiration while you continue to work through this lesson.

 a. If you are selecting images from a book, scan each image into a color printer and print it out.

 b. If you download images from the internet, make sure the images are of high resolution and show good color reproduction.

5. Select a piece of music that you find interesting and pleasurable. Listen closely to the music until a particular rhythm or melodic refrain is impressed upon you.

6. Close your eyes and imagine what this repeated sound *looks like*. What colors and visual textures does it suggest?

7. Select scrap pieces of paper that recall the colors and textures of the musical rhythm or refrain.

8. Draw shapes on the *reverse side* of these paper pieces that reflect the sounds you heard.

9. Cut out the shapes, turn them right side up and arrange them on a sheet of 12" × 18" white watercolor paper or heavy black construction paper.

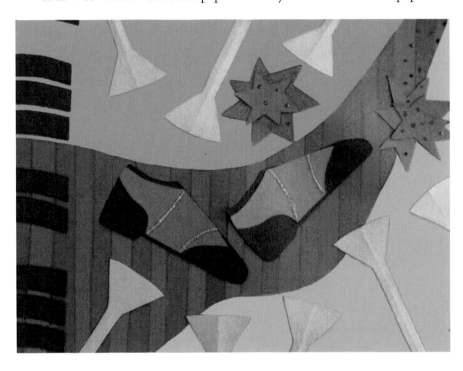

Katie Nail, *Untitled Matisse-Inspired Collage*, 2012. Construction paper collage mounted on silk fabric and manipulated in Photoshop CS6. (Courtesy of the Artist)

Move the pieces around until they describe the progression of the music you have selected and also create a pleasing composition. You may overlap shapes if this contributes to the description of the music and/or the visual **composition**.

10. Attach the cut paper shapes to a backing with rubber cement. Clean the excess rubber cement from the finished artwork.

11. Write an essay (300–400 words) in response to the following:

 a. Describe what you learned about the work of Henri Matisse. What interested him aesthetically and what inspired his later artworks? Cite your sources of information.

Shelly Gerber-Sparks, *Music Dance*,
2014. Cut paper collage, 9" × 12".
(Courtesy of the Artist)

b. Explain what the music you selected inspired, and how it influenced your choice of a repeated organic shape, color, and/or texture for your collage.

Materials Needed

white watercolor paper or black
 construction paper, 12" × 18"
scraps of colored paper
 (construction paper, wallpaper,
 magazines, etc.)

pencil
scissors
rubber cement
rubber cement eraser

Vocabulary

Collage
Composition
Organic/Organic Shape
Repetition

WHAT TO SUBMIT FOR EVALUATION

- three color photocopies or reproductions of art works by Henri Matisse
- a finished artwork, as instructed in this lesson
- a link to or citation of the music that added inspiration to your artwork
- a written essay response, as outlined in Instruction #11

LESSON EXTENSION

A famous painting by Henri Matisse is *La Danse* (1909), located in the Museum of Modern Art, New York. Search online for an image of this painting. Notice how Matisse creates an illusion of space in the center ring of dancers. This subject fascinated Matisse and he painted several versions, seeking to find new ways of simplifying shapes and applying colors while still maintaining an illusion of empty space amid the ring of dancers. Search online for other versions of Matisse's subject and examine how he has arranged dance forms differently in each to produce greater or lesser visual impressions of space and movement.

1. As a lesson extension, cut several construction paper copies of the figure template given in Lesson 8. Arrange the template pieces to describe a ring of dancers. Use overlap and move the template pieces to exaggerate bodily movements of the dancers.

2. Try playing a favorite piece of music while you arrange these forms. Does the music affect the way you see the figures moving in your mind's eye? Change the music to something with a different rhythm and mood. Does this influence how you might arrange the figures of a dance? Choose the visual arrangement you like best and rubber cement the template pieces to a backing. Give your composition an appropriate title.

3. As another extension, create a stop animation of the figures dancing to the rhythm of the music.

Lesson 32: Light and Leaves

You may have completed an earlier lesson in which you were invited to examine trees in your local environment and notice the silhouettes, bark details, and leaf shapes of different types of trees (see Lesson 14). Another challenge to depicting trees convincingly is to capture the effects of light and air that flow through leafy structures of the tree. From a distance, the foliage of a tree may appear as a solid mass of leaves. Yet when you stand beneath a tree and look upward, you will notice there are many gaps and airy spaces among the branches and clusters of leaves. In some spaces, you can see bits of sunlight streaming through, along with patches of blue sky. Describing both the mass and airiness of a tree might be less daunting if you imagine being a bird living within the spaces of leaves and branches. To a small bird, these delicate spaces would seem huge, and the openings where sky is visible would seem as large as picture windows.

Light and Leaves, Students of Battyeford Primary School. Natalie Deane, art teacher, West Yorkshire, UK. (Courtesy of the Artists)

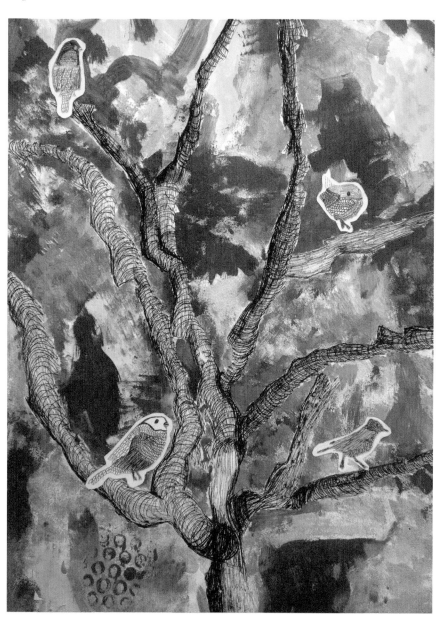

In this lesson, you are to consider what a tree might look like from within the spaces of its leaves and branches. To do so, you will need to do a little research into a type of tree you might like to depict, consider the geographic range of its growth habitat and the kinds of birds that might frequent its branches for food or as shelter for a nest.

INSTRUCTIONS

What types of trees and birds are commonly found in your geographic area? If you have never paid attention to variations of these natural features, spend an early morning outside in your yard or take a walk in a nearby park. What types of trees and birds do you see?

1. Make at least five sketches of a bird or birds, with side notes about the type of bird, the color of its feathers, and structure of its beak.
 a. Notice the birds' general sizes in comparison to one another and to the branches upon which they may rest.
 b. If you cannot identify the types of birds you observe, check your notes and sketches against images and descriptions of birds in a birdwatcher's guide or on a bird identification website.
 c. What are the habits and peculiarities of the bird(s)?
 d. Make notes of this information in your sketchbook or on your drawing paper.
2. What types of trees can be found in your local area?
 a. Are these trees in which a bird might find shelter or build a nest?
 b. Notice the typical shape of the tree's leaves. Are they large and single, or small and arranged in alternate rows as compound leaves?
 c. Are the leaves typically a very dark green, medium green, or yellow green?
 d. If you do not recognize the types of trees you see, look for information about the tree type in a tree identification guide or online site.
 e. If you are observing trees in autumn, what color do the leaves become as they change? Notice that some types of trees turn yellow and others turn orange or red. What determines the color a leaf will become as it turns?
 f. Add these notes to your sketchbook or drawing paper.
3. Prepare blue watercolor paint for a background color by placing about a tablespoon of water into one of the sections of a clean empty egg carton or the cup section of a muffin tin.
 a. Dip the tip of a large brush into the blue watercolor and add color to the water.
 b. Continue adding color until the blue is the light blue tint of sky.
4. Prepare a sheet of 12" × 18" watercolor paper as a background for your work by quickly painting large areas of the paper with washes of the light blue watercolor. *Use a large brush.*

5. Allow the blue to dry completely while you prepare several hues and shades of green, blue green, and yellow green, and place these in sections of the egg carton of muffin tin. These colors should be less diluted than the blue.

6. When the blue paint is dry, use small sponges to dab splotches of greens, yellow green, and blue green hues to the background. Layer the colors. If you do not want these colors to blend into one another, allow each layer of color to dry before adding the subsequent layer.

 a. If you are creating a tree in autumn, mix appropriate yellows, oranges, or reds, depending upon the type of tree you are describing.

 b. Do not cover all the sky with leaf colors; allow the patches of the sky to show through sections of green.

7. While the background is drying, begin working on the tree branches and bird or birds that will inhabit the tree.

8. On a sheet of watercolor paper that is oriented **vertically** (portrait style), draw a single tree branch and several long switches with twigs.

 a. Remember that you are describing the light and spaces within the foliage of the tree, therefore you will be drawing slender branches and twigs coming off the branches. All will **taper** and become increasingly thinner as they reach toward the top of the paper.

 b. Some limbs may bend as if to become hidden in patches of leaves.

 c. Add color to the branch with colored pencils, markers with thin nibs, or pens.

9. On scraps of paper draw three birds of a type that are common to your local area and inhabit trees similar to the one you have described in your background.

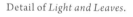

Detail of *Light and Leaves*.

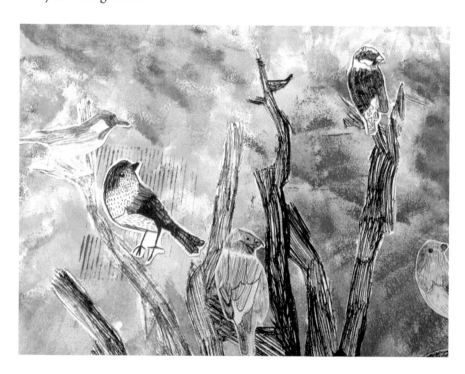

a. Keep proportion in mind: How large would each bird be in relationship to the branches and twigs? How large would the birds be in relation to one another?

b. Use a variety of pencils with soft and hard leads.

c. Add color with colored pencils, markers with thin nibs, or pens.

10. Carefully cut out the drawing of branches and twigs, and rubber cement this structure to your background. Clean off the excess rubber cement, being careful not to tear the branch and twig structure.

11. Cut out the birds and add them to the scene with rubber cement. Clean off any excess rubber cement.

Materials Needed

watercolor paper, 12" × 18"	pencils with soft and hard leads
watercolor paints and water	eraser
large watercolor brush	colored pencils, markers with thin nibs, or pens
one clean empty egg carton or muffin tin	rubber cement
one soft sponge, cut into 1" strips	rubber cement eraser

Vocabulary

Taper

Vertical/Vertically

WHAT TO SUBMIT FOR EVALUATION

· sketches and research notes about trees and birds that are common to your area, as indicated in Instructions #1 and #2

· a list of sources you consulted for information about the trees and birds of your area

· a completed artwork, as indicated in this lesson

LESSON EXTENSION

This project might be completed in a software program as a digital montage rather than a traditional collage. Create a background and drawings of a branch with twigs and birds, as in the original lesson.

1. Scan the completed background, drawing of the branches and twig structure and the birds, and save on your desktop as jpegs.

2. Using Photoshop or Illustrator, upload these as different layers, with the background sheet serving as the background layer of the program.

3. Reduce the white areas around the branches and twigs and around the birds to transparencies, and arrange the remaining elements into a pleasing composition, then flatten the scene.

4. Add another layer of leaves from a drawn and scanned page of paper, or create this layer digitally. Allow some of these leaves to overlap branch and bird features of the scene.

Teacher Natalie Deane of Battyeford Elementary School in West Yorkshire, UK, designed a process-based project that invited students to study the trees and birds they observed from their playground.

> Pupils worked in pairs to create an observational masking tape drawing depicting one of our playground trees. Over the top of the masking tape we daubed, printed and brushed a variety of painted and printed textures (using a limited color palette) to create an atmosphere for our further drawing work.

Once we peeled off the masking tape from the painted surfaces, we revealed a white (formerly observed) tree shape in which we then drew with a biro [ball-point pen] to form tree textures, bark, branches etc. The effect of this drawing activity created quite a surprisingly strong 3D effect. We talked about how curved lines suggest form and how to develop light and dark, tonal approaches of cross-hatching to developing the tree image.

Next came tracing around British bird photographs and transferring these images on to [scraps of heavy paper]. Bird outlines were then drawn into with illustrative effects. We added a variety of line and pattern in to the birds to create interest.

Finally we cut out the birds (leaving a small white outline around the bird image) and arranged these images onto our tree backgrounds to form our final compositions.[2]

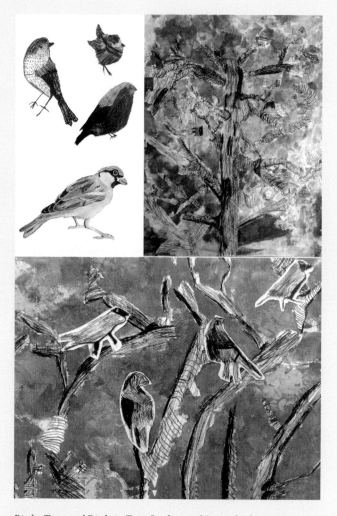

Birds, Tree, and Birds in Tree, Students of Battyeford Primary School. Natalie Deane, art teacher, West Yorkshire, UK. (Courtesy of the Artists)

Lesson 33: Microscopic Worlds

Beauty often lurks in hidden and unexpected places. Looking through a microscope, you can see amazing forms and patterns that are otherwise invisible to the eye. **Microscopic** views of nature reveal pattern as potential for **nonobjective** compositions. Nonobjective compositions are arrangements of color, shape, line, value, form, and texture that have no recognizable subject matter. Examining the microscopic structures of natural forms reveals surprising patterns and designs of tiny internal structures. In this lesson, you will enlarge a microscopic image as a nonobjective composition or pattern.

Left, Susan Stroman, *Elodea,* 2013. Graphite and colored pencils with pastel on paper, enhanced in Photoshop. (Courtesy of the Artist)

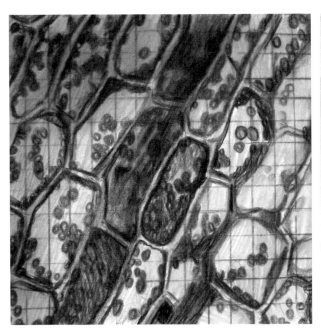

INSTRUCTIONS

1. Search in books or online for an image of plant or other living cells as seen with a microscope. Make sure that you would not be able to determine what structural form is being observed without information provided by the publisher of the image, other than it being an interesting pattern or design.
2. Make a color photocopy or download a color copy of the image. It is important that the image be of very good resolution.
3. Trim the reproduction to a 4" square and rubber cement it to a larger piece of drawing paper.
4. Using a ruler, mark a ½" grid along all four sides of the reproduction.
5. Draw a 1" grid on a piece of white drawing paper cut to 8" × 8" exactly.
6. Reproduce the colors and shapes seen in each square of the image grid on the corresponding square of the larger paper.
 a. Use colored or watercolor pencils to copy colors and textures of the original grid onto the drawing paper grid.

Right, Pamela Cherisha, *Plant Cell,* 2013. Colored pencils on paper, enhanced in Photoshop. (Courtesy of the Artist)

b. Layer colors if necessary to re-create the color and texture seen in the original image. Use soft light layers of colored pencils to achieve soft gradations and different colors.

c. Always start with the lightest colors first and then go to the darker ones.

d. Colorless blenders may be used to help blend layers together.

e. Practice the colors you need in the borders of the paper.

7. On the back of the finished design, indicate the source of this pattern. For example, indicate if this is the pattern of fish scale or rose petal cells as seen under a microscope.

8. Write a response to the following:

a. Explain what is meant by nonobjective composition and describe how your finished artwork might be considered nonobjective. Could your artwork also be **figurative**? Why or why not?

b. Tell what your design represents and explain how you created your finished project.

c. How did you use your colored pencils to recreate the colors and textures of the image?

"My design represents the cross section of a tree trunk. If someone chopped a tree in half, this is what the inside would be like. I never would've known what the inside of a tree looked like had it not been for this project. It's actually a very interesting and visually pleasing design. I was instructed to leave some of the design untouched because the contrast was interesting with the paper. I did this and am happy with how it looks." Gretchen Childers, *Cross-Section of Wood*, 2009. Colored pencil on paper, 8" × 8". (Courtesy of the Artist)

Materials Needed

white	pencil
drawing	colored or watercolor pencils
paper, cut or	rubber cement and
measured to	rubber cement eraser
8" × 8"	ruler

Vocabulary

Fibonacci	Macroscopic
Figurative	Microscopic
Fractal	Nonobjective/Nonobjective Art
	Topography

WHAT TO SUBMIT FOR EVALUATION

· a photocopied or downloaded image of the microscopic form referenced in your artwork

· a finished nonobjective composition based on the microscopic form

· a written essay response, as outlined in Instruction #8

LESSON EXTENSIONS

Macroscopic Worlds

Macroscopic views are those that can be seen with the naked eye. All the people, natural objects, and things we interact with in our everyday physical environment are macroscopic in relation to us. But when an object is seen

from a very great distance, beyond our physical reach, its detailed features may become less distinct or invisible to the eye. Features of once-distinguishable objects can merge into a collection of colors, shapes, and lines that form non-objective patterns. For example, when the earth is viewed from outer space, features such as roads, houses, forests, fields, rivers, and mountain ranges lose their individualizing details and become elements of an overall pattern. In fact, sections of the earth seen from outer space may bear resemblance to the nonobjective patterns of microscopic views.

As an extension of the Microscopic Worlds assignment, find an aerial image of the earth taken from space. Such images are available online at NASA: Visible Earth, http://visibleearth.nasa.gov. Follow the instructions given for creating a gridded image of a microscopic pattern to create a nonobjective reproduction of a macroscopic view of the earth.

In this satellite image of West Fjords in northwestern Iceland, flowing ice fields and a jagged coastline resemble branch coral. Earth Resources Observation and Science Center, U.S. Geological Survey, U.S. Department of the Interior.

Compare the resulting images of microscopic and macroscopic views and address the following questions:

· What similarities or differences do you observe?
· To what extent and/or how does each image demonstrate the law of Fibonacci?
· Look up the definition of **fractals**. To what extent and/or how does each image demonstrate evidence of a fractal?

Topographies and Microbes

Search for examples of textile art by Leah Evans, who combines textile and needlework processes to create compositions inspired by satellite images of earth **topographies** or microscopic images of microbes. According to Evans,

> Both scales deal with the translation of scientific information into visual form. At times, these separate bodies of work merge. The overlap is seen in vessel-like arteries of water, tundra pools that look cellular, and microbes that swim through topographic lines.[3]

As a lesson extension, try combining satellite and microscopic imagery into a single composition. Use any media of your choice, including textile or needlework.

TIPS FOR TEACHERS

Law of Fibonacci

Drawing from nature is an important strategy for learning about the world through careful observation. Plants and animals grow and develop in accordance with law of **Fibonacci**. The characteristic of the Fibonacci series is that each number consists of the sum of the two numbers before it: 0, 1, 1, 2, 3, 5, 8, 13, 21, 34, 55, 89, 144, 233, 377, 610.

These ratios and patterns apply to the development and growth of plants and animals from microscopic to macroscopic levels. Can you see this pattern in the microscopic image that you reproduced? If you accept that the law of Fibonacci functions at micro- and macroscopic levels, why might it not be apparent in the small microscopic (or macroscopic) section that you copied?

To learn more about the law of Fibonacci, look online for information about these scientific phenomena, or explore some of the following texts:

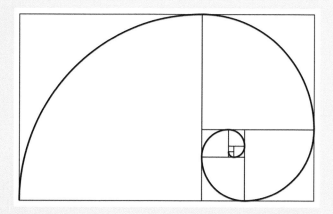

Translated visually, the progression of numbers in the Fibonacci series unfurl like a spiral in ever-increasing size. (via Wikimedia Commons)

- Campbell, S. C. *Growing Patterns*. Honesdale, PA: Boyds Mills Press, 2010. (Ages 5–11)
- Elam, K. *Geometry of Design: Studies in Proportion and Composition*. New York: Princeton Architectural Design, 2001. (Ages 16+)
- Garland, T. H. *Fascinating Activities with Intriguing Numbers*. Upper Saddle River, NJ: Dale Seymour Press, 1997. (Ages 10+)
- Garland, T. H. *Fascinating Fibonaccis*. Upper Saddle River, NJ: Dale Seymour Publications, 1990. (6th grade and high-ability elementary students)
- Sidman, J., and B. Frommes. *Swirl by Swirl: Spirals in Nature*. Boston: HMH Books for Young Readers, 2011. (PK and primary grades)
- Wahl, M. *Mathematical Mystery Tour: Higher-Thinking Math Tasks*. Austin: Prufrock Press, 2008. (Ages 5 and up)

The law of Fibonacci can be seen in the growth spirals of flora and fauna, as seen here. (a) Romanesque broccoli (photograph by Jon Sullivan. CC BY-SA 3.0 US); (b) red cabbage (photograph by Ian Alexander. CC BY-SA 3.0 US); (c) a cactus (photograph by I. Opuntia. CC BY-SA 3.0 US); (d) a nautilus shell cut in half to show chambers arranged in a logarithmic spiral (photograph by Chris73/Wikimedia Commons); and (e) a sunflower (photograph by Chiswick Chap. CC BY-SA 3.0 US).

TIPS FOR TEACHERS

Consider how the law of Fibonacci assists in understanding how basic structures in the natural and man-made worlds are put together and function. Could it also apply to other aspects of science, such as population growth or weather changes caused by global warming? How could the law be used in social sciences research, such as in tracking the influence of word-of-mouth information about a product or political candidate? How could it apply to other aspects of everyday life in meaningful ways? How could the law be presented to K–12 students in graspable ways? Consider:

1. In what artworks could you involve your students that would help them better understand this mathematical law?
2. In what artworks could you involve your students to help them understand the law as it applies to science or social studies?
3. How could you apply the law of Fibonacci to create more interesting and harmonious artworks?
4. Present students with the concept of fractals. Have students consider how fractals are similar to or different from the law of Fibonacci
5. Do fractals demonstrate the law of Fibonacci? Explain.

Lesson 34: A Watercolor Landscape

Communication of mood and feeling are basic functions of poetry and prose. Images also may communicate sensual information. Consider, for example, how the crimson colors of a sunset behind bare branches of winter trees or the blue-gray tints of a misty foggy morning not only convey information about time of day, season, and temperature, but also metaphorically suggests mood. Landscape images may evoke mood by layering information about the artist, subject, and viewer in relation to space.

To make landscapes more interesting to viewers and present an overall mood within the landscape, an artist selects a focal point of the scene. Through the arrangement of various Elements of Art, a viewer's eyes are guided through the composition to rest at this location. The focal point may be in the **foreground** or area closest to the viewer. In looking at an artwork with a focal point in the foreground, the viewer experiences intimacy with landscape features, since nearby things can be seen in great detail. Details become muddled as portions of the scene move into middle distance or **middle ground**, which allows the viewer to enter into the scene or experience the expanse of the scene. A landscape with a focal point in the **background** allows the viewer to sense the grandeur of a scene. Look at these examples of focal points that are placed respectively in the foreground, middle ground, or background space, and consider how each suggests a different overall mood.

Watercolor is an art medium that is particularly suitable for creating **landscape** paintings. Because watercolor can be manipulated to produce light pastel tints or very intense hues, it can describe the crisp details of objects in the foreground or suggest the faint coloration of objects in the distance.

In this lesson, as you experiment with watercolor and create a landscape painting with a focal point in the foreground, middle ground, or distant background space, you are

Kathleen O'Connell, *Raven and the Bristlecone Roost*, 2013. Watercolor. (Courtesy of the Artist)

Vincent van Gogh (1853–1890), *Bridge Landscape with Bridge across the Oise*, 1890. Graphite and gouache on brown paper, 18 ⅔" × 24¾" (473 × 629 mm). Tate Gallery, London, UK.

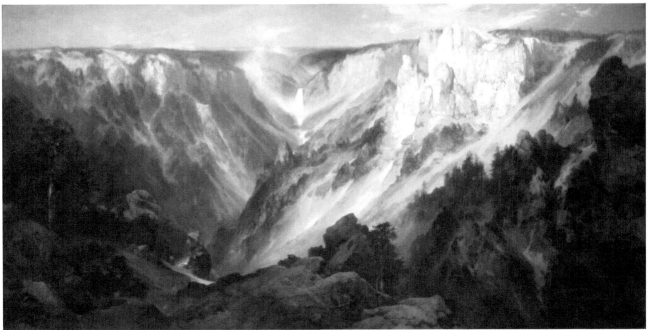

Thomas Moran (1837–1929), *Grand Canyon of the Yellowstone*, 1872. Oil on canvas mounted on aluminum, 84" × 144¼" (213 × 266.3 cm). Smithsonian American Art Museum, Washington, DC.

to keep in mind a mood such as feeling close and intimate with the environment, being an observer of the scene, or experiencing a sense of awe at the landscape before you.

INSTRUCTIONS

1. Begin by experimenting with the medium of watercolor. Fill at least two sheets of 9" × 12" watercolor paper with the experiments.
2. On one, wet the paper with the side of a brush that has not yet been dipped in color. Then touch the tip of the dry brush to the paint, draw

lines of color atop the wet paper. Notice how the color feathers or spreads out into the wet areas of the paper.

3. On another watercolor paper, dip the brush in water first, then touch it lightly to the paint. Use this very wet brush to create thin and thick lines. This can be done by pressing down on the brush and dragging it along the paper (creating a thick line) or using the tip of the brush (creating a thin line).

4. On both experimental paintings, explore the effects created by the use of various quantities of water and paint, from dry brushes dipped in paint to very wet brushes touched to the paint.

 a. Instead of using white to lighten watercolor paints, use more water to produce washes of pale tints.

 b. Use layers of watercolor **wash** of a hue over a dried wash of the same color to produce more intense hues.

 c. Add washes of complementary colors to produce shades or muted hues.

5. When you have developed an understanding of watercolor techniques, search for a photograph of a landscape that includes a foreground, middle ground, and background in the image.

 a. Search for scene that has intriguing points of interest, such as clumps of flowers or grass, a brace of trees or house in the middle ground, or distant light and dark effects that create or support a **focal point**.

 b. Look for a scene that describes (or has the potential to describe) a mood that is emphasized by the use of space within the composition.

6. Lightly draw a real landscape scene on a piece of watercolor paper that is about 12" × 18" in size.

7. Begin your painting, while remembering the following:

 a. Always paint the background areas first.

 b. Paint lightest areas first, using light washes of color.

 c. Build darker areas up by layering washes of **transparent** color.

 d. To avoid colors smearing into one another, allow the background to dry before adding watercolor to the middle ground, and allow the middle ground to dry before adding the detailed foreground.

8. Thinking about color application and how intense, muted or pale hues, or shades or tints of colors could be used to emphasize or evoke a particular mood, complete the watercolor landscape to convey the appropriate mood of the scene.

9. Write an essay (250–400 words) describing the watercolor techniques that you used to create a mood in a landscape painting:

 a. What mood did you create?

 b. Explain your choices of watercolor techniques to create this mood.

 c. How does the use of color support the mood?

 d. Where did you place your focal point (foreground, middle ground, or background), and why did you place it there?

TIPS FOR TEACHERS

Looking at Landscapes

Young children develop a variety of ways to describe space in their artworks. They learn many techniques from one another, while other ways of showing distance are intuitive attempts to use art as a schematic language. In the following examples of children's art we see combinations of placement on the page, multiple ground lines, overlapping, and variations in pattern and size as ways of indicating where things are in relationship to one another.

In these respects, the works of children resemble the art of David Hockney; or rather, Hockney imitates the ways children depict space in his landscape paintings. Additionally, he plays with patterns and visual textures in a stunning way. Look up these child-pleasing examples of Hockney's work and share them with your students.

· *Nichols Canyon* (1980)
· *The Road across the Wolds* (1997)
· *The Road to York through Sledmere* (1997)
· *Garrowby Hill* (1998)

Notice how Hockney resolves the visual problem of describing how rivers and roads recede into the distance. How can young students who struggle with the concept of one-point perspective be guided to depict these features more convincingly?

Notice the playful moods that are created by Hockney's use of design-like space. Compare the mood suggested by these spaces with the moods created by combining close and far spaces, as in Kathleen O'Connell's work, or in deep spaces of Vincent van Gogh or Thomas Moran. Invite students to identify and discuss how the use of space in these images influences the viewer's perceptions and interpretations of mood.

Top, In these examples of child art, we can see a variety of ways children symbolically resolve the problem of depicting three-dimensional space in a two-dimensional medium. Having drawn an art room with a ground line and ceiling, this child proceeds to add students working at easels. Figures further toward the back of the room are placed higher on the page, until the child farthest away is shown standing on the ceiling line, as if it were a second ground line. (Child Art Collection of Enid Zimmerman)

Bottom, A circus scene is shown with a number of activities taking place simultaneously, each within its own designated space. Although the animals are not reduced in size as they move back into space, placing one higher on the page than the other suggests three-dimensional space. High-wire artists walk on a rope that also serves as a plausible ground line. The man in the lower-left foreground overlaps the whip of a lion tamer. Acrobats ascending a ladder overlap the animal forms, suggesting space and also flatness as they blend into the decorative motifs of the circus tent. (Child Art Collection of Enid Zimmerman)

Materials Needed

watercolor paper, 9" × 12" and 12" × 18"	mixing tray
	paper towels
watercolor paints and brushes	water and water container

Vocabulary

Background	Middle Ground
Focal Point	Transparent/Transparency
Foreground	Wash
Landscape	

WHAT TO SUBMIT FOR EVALUATION

· two watercolor experiments on 9" × 12" sheets of watercolor paper

· a photocopy of the image used as inspiration for your final work, with an identification of the landscape's location and a link to or citation of the site where the image was found

· a completed watercolor landscape painting that demonstrates foreground, middle, and background spaces, and describes a specific mood that is highlighted by the use of space in the composition

· a written essay response, as outlined in Instruction #9

Lesson 35: Near and Far Spaces

How do we perceive our physical relationship to spaces around us? If you are lost in an unfamiliar city without a GPS (Global Positioning System) device and a helpful stranger tells you to go about a mile straight ahead, turn left to the east at the stoplight, then south at the next intersection, can you visualize what this kind of maneuver would look like on a map? Could you find your destination by relying only on a map for directions? What if the entirety of information you had about a location was a photograph or painting? From a photograph alone, could you estimate the distance to a hill or mountain in the distance? What influences how we see closeness or distance in the physical world?

If the earth were perfectly flat, we might be able to judge distances according to linear perspective, but landmasses are not flat, which means it is not always practical to use linear perspective (one- or two-point perspective) in describing distances. Fortunately, we are able to perceive distance in other, visually intuitive ways:

- Objects that are closest to us appear larger than those that are further away. We see this effect in landscapes when, for example, a clump of flowers that is near to us may seem as tall as or taller than a mountain in the distance.
- Objects that are farthest from us appear to be higher on the **plane of vision** or page than objects that are near to us.
- Objects that are closest to us appear much more detailed than objects that are farther away.
- Objects that are closer may **overlap** objects that are further away.
- Land is rarely completely flat, and so there may appear to be multiple **ground lines** or planes between near and distant spaces.
- Because the earth is covered by an atmosphere that includes water particles and dust, things that are distant from appear to be lighter or less brilliantly colored than nearby things. In fact, if the air is full of many water particles, a mist or fog may actually obscure things that are at a distance. This is called **aerial perspective**.

For this lesson, you are to use at least three of the principles listed above in the creation of a landscape image. To assist in understanding how we perceive space in a two-dimensional image, it is necessary to observe these visual cues in the real world. Therefore, for this project you are to use a reference photograph as you practice drawing and painting a landscape.

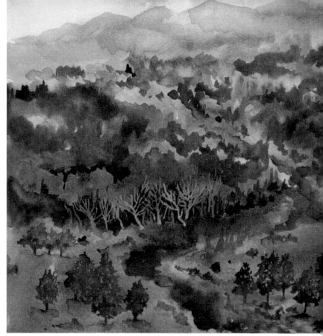

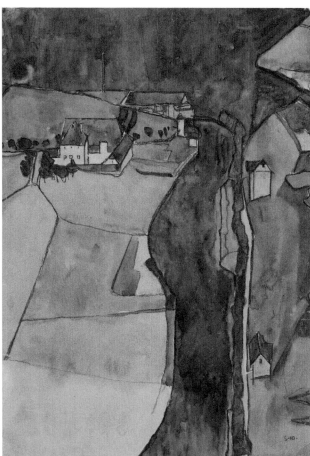

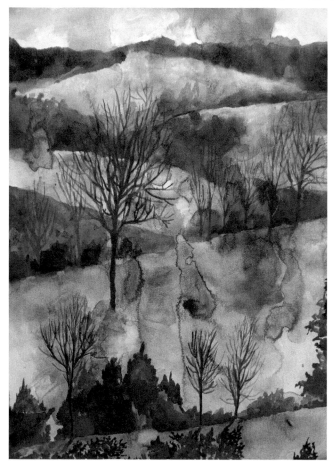

INSTRUCTIONS

1. Search online, in books, or through your collections of postcards and photographs from places that you have visited. Find several landscape images that each clearly display at least three of the distance markers indicated above.

2. On separate 9" × 12" sheets of drawing paper, sketch at least three landscape variations.
 a. Simplify the more complex features of the photographic images if necessary in order to focus on the features you have determined to be most important descriptors of space within the drawing.
 b. Consider where visual textures or pattern might make the space more interesting and suggest natural features. Make notes of these on your sketches.
3. Show your sketches to your peers and instructor for feedback and discuss the best option for the completed work.
 a. It is suggested that you complete the artwork using watercolor, tempera, or acrylic paints, or oil pastels. *You may enhance the work in a digital software program, but this is not required.*
4. Select from the best of your sketches, based on feedback and your own preferences, and draw a landscape on a sheet of 12" × 18" heavy weight watercolor paper.
5. Complete a finished version of the work in a color medium such as watercolor, tempera, or acrylic paints, or oil pastels.
6. Write an essay (300–400 words) in response to the following:
 a. Describe the three or more distance indicators used in your finished artwork. Explain why you used these indicators rather than others. Why were these the most effective ways of showing distance in this particular case?
 b. Describe how you altered the sketches to emphasize distance.
 c. Explain why you believe the medium used to complete this project was an effective means of producing a landscape image.

Materials Needed

white drawing paper, 9" × 12"	drawing pencils in soft and hard leads	brushes
watercolor paper, 12" × 18"	eraser	water container
	watercolor, tempera, or acrylic paints	oil pastels (*optional*)
		printmaking or digital software (*optional*)

Vocabulary

Aerial Perspective	Overlap
Ground Line	Plane of Vision
Multiple Ground Lines	

WHAT TO SUBMIT FOR EVALUATION

· photocopies of three images used to inspire your drawing
· a sketched landscape that makes reference to one or more of the photocopied images
· a written essay response, as outlined in Instruction #6

Facing top left, Objects that are close to us appear larger and brighter than objects that are farther away; close objects may seem to overlap objects that are farther away. Eduard Tomek (1912–2001), *Poppy Field (Pole máku),* 1969. Watercolor on paper, 16½" × 13 13/16" (42 × 35 cm). (Public domain, granted by David Tomek, son of Eduard Tomek, CC BY-SA 3.0 US)

Facing top right, Because of aerial perspective, objects that are close appear in greater detail and with crisper colors than objects that are far away. James Huntley, *Colorado Spring,* 2015. Watercolor and tempera on paper. 24" × 23¾". (Courtesy of the Artist)

Facing bottom left, The farther away an object is, the higher on it will appear on the plane of vision or within the picture frame. Egon Schiele (1890–1918), *The Blue River, Cesky Krumov Town (Stadt am Blauen Fluss, Krumau),* 1910. Gouache, watercolor, metallic paint, and black Conté crayon on paper, 17¾" × 12 3/8" (45 × 31.4 cm). Private Collection.

Facing bottom right, Multiple ground lines define a sequence of spaces from nearest to farthest. James Huntley, *Appalachia Series, Hills in Kentucky,* 2014. Watercolor and tempera on paper, 24" × 18". (Courtesy of the Artist)

TIPS FOR TEACHERS

Teaching Social Studies with Landscape Art

Landscape art can assist students' understandings of social studies concepts. Landscape paintings present images of various world geographies over time and may reveal cultural beliefs about the relationship of humans to nature. Grant Woods is an artist whose work may be of special interest to young children. In his work he provides a view of rural life and community during the early twentieth century and the Great Depression. Besides making reference to a historical figure, his artworks are filled with visual puns. For example, notice the shapes of the trees. What do they suggest? Why do you think he created them to look this way? What other playful manipulations of form does Wood include in his painting?

Search online for study guides about Grant Wood and his artwork for teaching social studies topics about community, life in the 1920s and '30s, and the Great Depression. You can also explore visual resources and study guides for teaching a variety of social studies topics through the Smithsonian American Art Museum's website, at http://www.americanart.si.edu/education/resources/guides/rtf_guides.html.

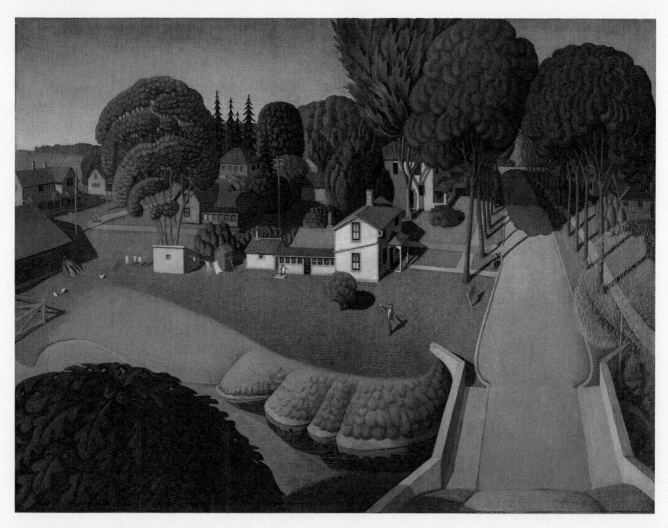

Grant Wood (1891–1942), *Birthplace of Herbert Hoover, West Branch, Iowa*, 1931. Oil on Masonite, 29 2/3" × 38 3/4" (75.2 × 101 cm). Minneapolis Institute of Arts, Minneapolis, MN.

TIPS FOR TEACHERS

Watercolor or Tempera?

Although watercolors are commonly marketed as an appropriate art media for elementary students, watercolor painting is challenging. Children need instruction and practice in order to produce effective watercolor paintings with brushes. If packaged watercolor trays are to be used, demonstrate how brushes must be gently rinsed in water before being dipped in a new color. This helps keep colors clean and bright. The bristles of brushes should never be squeezed dry; instead, dripping brushes can be gently touched against the inside rim of the water container or touched to a paper towel to remove excess water. Brushes should never be left standing in water containers, as this not only causes the bristles to become permanently bent but also increases the risk of accidental spills.

This lesson could provide an opportunity for young students to have successful experiences in watercolor painting without having necessarily mastered more sophisticated skills in that medium. Other techniques appropriate for young children include using watercolor to create resist paintings, wet-on-wet paintings of backdrops for under-the-sea scenes and spring or autumn landscapes, and simple monoprints. When creating any watercolor painting, however, children will find the painting experience more successful if they begin by using lighter, more transparent colors first, like yellow, pink, or turquoise, and apply the darker, less transparent colors like purple, brown, and black last. Likewise, the backgrounds of paintings should be painted before foregrounds or details.

If your art supply budget is limited, you could consider tempera paints as alternatives to watercolors. Tempera can be diluted with water to create the consistency of transparent watercolor or left in normal consistency for opaque painting. Small amounts of tempera can be poured into the paint trays, while large amounts can be poured into cups, allowing the paint to be applied with tiny or large brushes. Also, tempera paints come in a wide variety of colors, are economical, easy to clean up, and easy to store. See the Tips for Teachers section after Lesson 28 for information about selecting appropriate tempera colors for teaching elementary students about mixing colors.

Lesson 36: Painting an Interior

The rooms and objects of indoor environments offer readily available subject matter for artists. Interiors can serve as interesting subjects or backdrops for artistic compositions. In such a confined space, items necessary to telling a story or creating an interesting composition must be judiciously placed. **Cropping** a scene will force viewers to focus on details within a room or space that the artist intends to highlight. Additionally, interior views challenge artists to address extreme angles of linear perspective; an artist may choose to tilt or skew the perspective of a space to direct the viewer's attention. For example, in this painting, artist Sharon Geels shows a section of a room from a very close perspective. She has tilted the checkered floor tiles beneath the table in order to help us both see the depth of space and keep our focus on the chair in the foreground.

In Édouard Vuillard's painting *Women Sewing*, the angle of the wall to the left shows how the tight space of an interior may force an extreme perspective. The same effect is demonstrated by the side of the sofa in *The Sofa*. **Foreshortening** causes the portion of the sofa closest to the viewer to seem much larger than the opposite side where a woman is reclining. In Stanislav Zhukovsky's room, one-point perspective has a much more subtle effect because most of the shown portion of the room is parallel to the viewer. The wall and windows stop the viewer from perceiving strong depth.

In each of these images, the scarcity of space or pressing together of objects depicted is enlivened by brilliant colors and visual patterns, making each work of art more visually engaging. In this lesson, you are to use all that you have learned about drawing rounded or flat objects and perspective in describing an interesting interior scene that also presents vibrant color.

Above, Sharon Geels, *The Hiding Place*, 2015. Acrylic on canvas, 24" × 18". (Courtesy of the Artist)

Right, Édouard Vuillard (1868–1940), *The Sofa (The White Room)*, 1890–1893. Oil on cardboard mounted on panel, 12 ⅝" × 14 ¹⁵⁄₁₆" (32 × 38 cm). Pushkin State Museum of Fine Art, Moscow, Russia.

Far right, Stanislav Yulianovich Zhukovsky (1898–1944), *Joyful May*, 1912. Oil on canvas, 12 ⅝" × 51 ⅔" (95.3 × 131.2 cm). Lviv National Art Gallery, Ukraine. (via Wikimedia Commons)

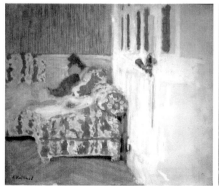
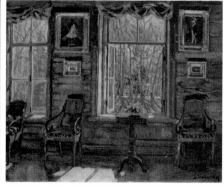

1. Look around your dwelling place to identify several corners, sections of rooms, or arrangements of objects that would make interesting compositions. Use a viewfinder to help you select the area to be included in each composition. (Instructions for making a viewfinder are given in the section Basics of Creating Works of Art, near the beginning of this book.) Try to identify compositions that would present a harmonious or surprising combination of colors, visual textures, lines, and shapes.

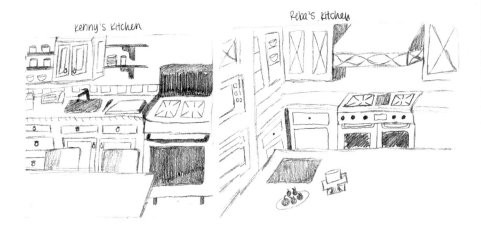

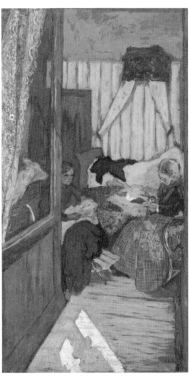

Above, Édouard Vuillard (1868–1940), *Women Sewing,* ca. 1912. Glue on paper on canvas, 70 $^{13}/_{16}$" × 37¾" (179.9 × 95.9 cm). Collection of Mr. and Mrs. Paul Mellon, National Gallery of Art, Washington, DC.

Left, Victoria Seidman, *Sketches,* 2013. (Courtesy of the Artist)

2. On 9" × 12" drawing paper, draw at least six thumbnail sketches of areas or subjects that attract your attention.
3. Share your sketches with peers or the instructor for feedback about which one might result in the most engaging finished composition. What elements could be added or eliminated from the sketch to improve its visual appeal?
4. Based on this feedback, select the most aesthetically interesting of the sketches and draw that scene in a larger size on a sheet of heavy watercolor paper that is 9" × 12" or 12" × 18" size.
5. Using either watercolor or tempera paints, finish painting the scene.
 a. Remember to paint the background areas first.
 b. If there will be objects overlapping background features, use layers of transparent wash. Layers of wash also should be used to build up intense hues, shades, and shadows in the painting.
 c. Consider using colors and patterns to enliven the scene.
6. Write a brief essay (300–400 words) describing how you decided upon this scene as a subject of your painting:
 a. What considerations did you take into account when looking around your room or home for an interesting subject to paint?
 b. What did you include in your composition? Did you leave anything out? If so, why?
 c. What advice did you receive from peers and the instructor about modifying your composition? To what extent was this feedback taken into account in your final product?

d. Describe any techniques of perspective, foreshortening, light and shading, overlapping, color, or pattern you used in the work and why you consider these to have been appropriate and effective.

Sharon Geels, *My Kitchen in Georgetown*, 1981. Acrylic on canvas, 34" × 30". (Courtesy of the Artist)

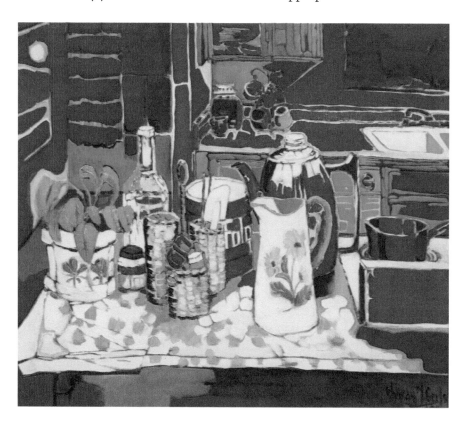

Materials Needed

several sheets of drawing paper, 9" × 12"
drawing pencils with soft and hard leads
eraser
watercolor paper, 9" × 12" or 12" × 18"
watercolor or tempera paints
brushes with thick and thin bristles
water containers and water
mixing trays and palette

Vocabulary

Crop/Cropping
Foreshorten/Foreshortening

WHAT TO SUBMIT FOR EVALUATION

· six thumbnail sketches of interior subjects that show evidence of selective cropping through use of a viewfinder
· a finished painting of an interior subject that presents a harmonious combination of colors, visual textures, lines, and shapes
· a written essay response, as outlined in Instruction #6

Lesson 37: A Victorian House

During the mid-nineteenth century, elaborate, elegant forms of home architecture became popular throughout North America. Made possible by an abundance of wood as a natural resource, a growing and affluent middle class, and new technologies that permitted wood to be sawn into elaborate forms and designs, **Victorian** and **Queen Anne** style houses were built as city homes, townhouses, and farmhouses throughout North America. The most decorative styles often sported rounded **turrets**, leaded windows, balconies, or wraparound porches. Exterior details of the houses often featured fish-scale or latticed shingles, decoratively spindled columns, and **gingerbread** patterns as trim along roof eaves and porches. Although earlier versions were painted in muted natural pigments, by the 1880s the development of synthetic house paints permitted exuberant color choices for these ornate structures, the most intricately painted examples of which became known as **Painted Ladies**. Even so, instructions given to housepainters of the era warned against the use of primary and secondary **hues** as being *too* gaudy.

House colors, in order to exhibit good taste, could be of any hue so long as they were not pure red, yellow, blue, orange, green, or purple. All colors were to be muted, tinted, or shaded to reduce the jarring effects of the pure primary and secondary colors. Once a basic color family was selected (perhaps brick red, forest green, or plum purple), the second most prevalent color used should be the same color in its 30 percent lighter or darker form (e.g., a deep burnt brick red, pale forest green, or lilac). To make these colors really "pop," homeowners were advised to use a **complementary color** to the basic color as a trim on **grillwork** or ornamental eaves. But how does one decide what the exact complementary color is to brick red, forest green, or plum? The author of a nineteenth-century handbook of Victorian house **color schemes** suggested the following:

> A good and simple way of determining the complementary or any color whatever is to take a piece of paper about two-inches square, tinted with the color whose complementary it is desired to find; lay it down on a piece of white paper and look fixedly at it for a moment or so; then withdraw the colored piece, still continuing to look at the place where it lay and the complementary color will appear on the white paper, whether as a fringe of the color around the edges of the square where the color lay or a solid square of color occupying the same position of the white that the original color had. This simple method may be found of use in determining those colors which cannot be easily analyzed. . . . This experiment, it may be well to note, is a good practical illustration of the intimate relations of colors to each other, and of the way they mutually affect each other.[4]

In this lesson, you will look at examples of Victorian and Queen Anne style homes in North America. Carefully study the proportions of various parts of these houses and examine the various color palettes used, then draw a house, adding textural and color details.

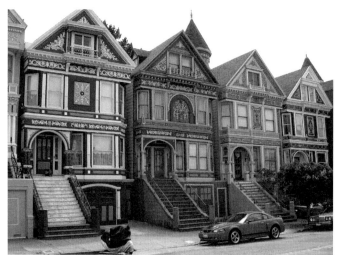

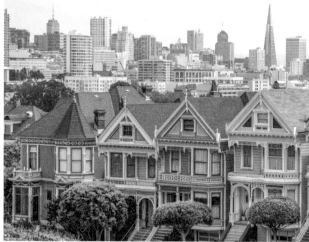

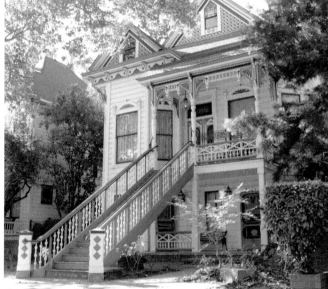

Top left, Painted Ladies of Haight Ashbury, San Francisco, CA. Victorian and Edwardian style houses built between 1849 and 1915. (via Wikimedia Commons, CC BY-SA 3.0 US)

Top right, Painted Ladies near Alamo Square, San Francisco, CA. Houses built between 1892 and 1896 by developer Matthew Kavanaugh. (Photograph by Alex Proimos. CC BY 2.0)

Bottom left, Machell-Seaman House, 1888. Architect unknown, Queen Anne style Victorian house, Los Angeles, CA. (Photograph by Los Angeles, via Wikimedia Commons. CC BY-SA 3.0 US)

Bottom right, Winters House, 1890. Victorian era Queen Anne–Eastland style wooden residence, Sacramento, CA. (Photograph by Irneh. CC BY-SA 3.0 US)

INSTRUCTIONS

1. Look through books or online resources for examples of Victorian or Queen Anne style houses that are highly decorative in wood detail and paint. Examine the proportions of doors and windows to the whole.

2. Look for geometric features—rectangles, squares, triangles, curved arches, circles. How are these interrelated proportionally and as architectural features?

3. Look for examples of Painted Ladies.
 a. What colors are used?
 b. How many colors are used?
 c. Where is the color applied?

4. Select one example that you find most appealing. Copy or download the image in color. To be sure you can see most of the architectural features, avoid using a model that is hidden by shrubs, trees, or other buildings. Also download any enlarged images of the **facade** that might assist you in creating a detailed drawing of the structure's decorative aspects.

5. Refer to these downloaded images while working on your artwork.

6. On a 12" × 18" sheet of watercolor paper, draw an outline of the house and sketch in its various larger features.

7. Using pencils with soft and hard leads, fill in the woodworked details of the facade.

8. You may add additional details if you do not think the example you chose is sufficiently decorative.

9. To finish the drawing, you will need to add color. You do not need to copy the color of your model exactly, but may use it to inspire your color choices.

10. Carefully select a color scheme of three colors that includes a basic color, its **tint** or **shade** at about 30 percent, its complement, plus white. Remember not to select a pure **primary** or **secondary color** as the basic hue. Your basic color may be a **tertiary hue** or a shade or tint of a primary or secondary color.

 a. To determine what a 30 percent difference might be, visit a paint store and ask for color swatch strips. After selecting a basic color that you like for the house, skip three spaces up or down the strip to find the difference.

11. Using watercolors, complete the drawn house by painting it with watercolors. *To achieve white, leave any white areas unpainted.*

12. Write a brief essay (300–400 words), explaining how your watercolor painting is consistent with 1880s instructions for decorating Painted Ladies. Also, describe any difficulties you encountered in the painting process and explain how you resolved those difficulties.

Materials Needed

white watercolor paper, 12" × 18"
drawing pencils with soft and hard leads
eraser
18" ruler
watercolor paints
watercolor brushes with small- and medium-width bristles
water container, water, and mixing trays

Vocabulary

Color Scheme	Hue
Complementary Colors	Painted Lady (Architecture)
Facade (Architecture)	Primary Color/Hue
Gingerbread (Architecture)	Queen Anne (Architecture)
Grillwork (Architecture)	Secondary Color/Hue

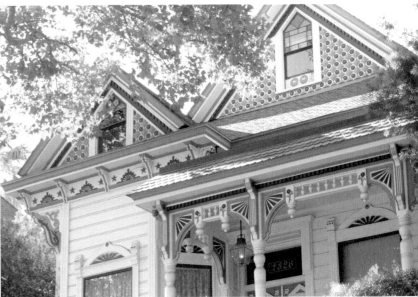

Grillwork detail, Winters House.
(Photograph by Irneh.
CC BY-SA 3.0 US)

Shade
Tertiary Color/Hue
Tint

Turret (Architecture)
Victorian (Architecture)

- a downloaded image or images of architecture that inspired your artwork
- a finished Victorian or Queen Anne style house painting that
 - demonstrates recognition of the proportionate relationships of doors and windows to the overall structure of a house
 - demonstrates awareness of the relationships of parts of the exterior geometric elements (i.e., rectangles, squares, circles, triangles, etc.) to the whole of a house structure
 - demonstrates ability to mix tertiary colors and/or tints and shades, and find the complementary color
- a written explanation of how your color scheme is consistent with the rules of Painted Lady coloration and how you addressed difficulties encountered in your work, as outlined in Instruction #12.

TIPS FOR TEACHERS

House drawings provide excellent opportunities for teaching math skills of geometry (recognizing squares, rectangles, triangles, etc.) and proportions. Fractions and percentages also can be explored in terms of color. Ask your local paint dealer to provide sample strips of color gradation by percentage. Invite students to examine what percentages of light and dark look like. Eventually, ask them to guestimate percentage differentiations in color. This encourages deeper understandings of the mathematics of percentages, while also honing students' observational skills and sensitivities to color in the environment.

Lesson 38: Inspired by Close

Photorealism is a style of painting that results in images so realistic in appearance as to closely resemble photographs. Chuck Close is a photorealist artist who builds enormous portraits of his friends by placing small bits of colors in the squares or **pixels** of a **grid**. Viewed up close, the images look like colorful mosaics, yet from a distance the portraits look like high-resolution photographs. For this reason, his works have been considered more realistic that real life; art critics have described them as examples of **hyperrealism**.

If you are familiar with the way digital images are constructed, you will recognize that Close's method of constructing portraits is similar to the way digital photographs are created, with the exception that digital images may be constructed of hundreds of **microscopic** pixels per square inch, while Close paints large (**macroscopic**) pixels that do not resolve into images unless seen from afar. In this lesson, you will explore the work of Close and practice making a photorealistic or hyperrealistic image by building a portrait out of pixels colored within a grid.

INSTRUCTIONS

Begin this lesson by researching the life and work of Chuck Close. Why does he focus on enlarged faces as subjects of his paintings? You will find that among his early works, photorealistic paintings were created without the use of a grid or pixilation. Among the early works that demonstrate his use of the grid are *Linda/Pastel* (1977), *Stanley (Large Version)* (1980–1981), and *Self Portrait* (1986). In Close's grid work from the late 1980s, you may notice stylistic changes beginning to appear. He now adds decorative flourishes to each grid section. Pixels of enlarged images include washes of a **complementary color** before a circle of the main color is laid down. Concentric circles of complementary or monochromatic colors also are used to give the overall effect of a computerized photograph in low resolution. Search for examples of this style in Close's portraits of Lucas Samaras, *Lucas I* (1886–1887), *Self Portrait* (2000), *Emma* (2002), and *Lyle* (2003). What major life event might have resulted in changes to his style of pixelated work?

1. Scan, download, or make color photocopies of two examples of Close's portraits, one showing a simple pixilation style and one showing his more decorative grid work. Keep these images near you while you work on this assignment and turn them in with your finished work for evaluation.
2. Consider the following questions:
 a. What is photorealism and how are Close's huge portraits photorealistic?
 b. Why might they also be considered hyperrealistic?
 c. Is one of Close's grid work styles more photorealistic or hyperrealistic than the other? Why or why not?

d. When and how does Close use complementary or **monochromatic** colors in the grids of his portraits? What is the resulting effect?

3. Select a portrait or photograph of a face of a friend or relative that has high contrast (strong areas of light and dark).

4. Reproduce the photograph with a color copier (or use a high quality magazine or digital image) so that the size of the image is 5" × 8".

5. Measure a **grid**, using ruler markings at ½" intervals on the top, bottom, and sides of the copied photograph. Using a ruler, connect marks that are exactly opposite one another to form a ½" grid on the image.

6. Mark a 1" border all around a 12" × 18" sheet of watercolor paper. (This will leave a center space of 10" × 16"—which is exactly twice the size of the portrait you will be copying.) Measure grid marks at 1" intervals along the top, bottom, and sides of the paper. Using a ruler, connect marks that are exactly opposite one another to create a grid. Be careful to ensure that lines are straight and exactly 1" apart.

7. Using either one of the styles of grid work employed by Close in his portraits, begin to reproduce the photograph you have chosen as a photorealistic (or hyperrealistic) portrait.

8. Concentrate on the color of a square in the photograph and replicate the color's **hue**, **tint**, or **shade** in the corresponding square on your drawing. You may use felt tip markers, watercolor pencils, or colored pencils to create the color.

9. This is an exercise in seeing and perception. Try to see the color in each square and not get lost in a line or object. Think of each grid as a small work of art. Do *not* try to blend the colors from one square to another.

10. Be sure to study your work from a distance from time to time as you work. How does your work compare to the work of Chuck Close?

Materials Needed

a 5" × 7" color portrait image showing high contrast
watercolor paper, 12" × 18"
colored markers (a wide selection of colors),
 or watercolor pencils (with brushes and water)
18" ruler

Vocabulary

Complementary Colors	Monochromatic Color/Hue
Grid	Photorealism
Hue	Pixel/Pixelate
Hyperrealism/Hyperrealist	Shade
Macroscopic	Tint
Microscopic	Zentangle

- two downloaded or photocopied images of works by Chuck Close, with an indication of which of the examples most informed your work
- a 5" × 8" portrait or photograph marked with a ½" grid
- a completed artwork that replicates the photograph in a stylistic manner similar to one demonstrated by Chuck Close
- written responses to the questions outlined in Instruction #2

LESSON EXTENSION

Breaking an image up into pixels and then filling each pixel with color to construct a facial image does not require that colors be used to produce the result. Values of light and dark, patterns, and visual textures can also result in a realistic reproduction. Repeat this lesson using black and white **Zentangle** patterns to create values from black to white to fill in pixels of a portrait. See Lesson 58 to read about Zentangles.

Fiona Makowski, *Portrait of Julie Roberts*, 2013. Pencil and oil pastel on paper, 12" × 9". (Courtesy of the Artist)

TIPS FOR TEACHERS

Enlarging images from small to larger grids (or vice versa) helps students acquire a basic math skill while also coming to recognize how images might be constructed of pixels. For more information about using grid drawings to strengthen students' mathematical understandings about ratios, see Lesson 19.

Lesson 39: In an Impressionist Style

During the late nineteenth century in France, a group of artists became interested in how man-made and natural lighting affects how we see the world. It was a time of scientific progress, innovative thinkers were exploring ways of producing electric lights, and buildings were being constructed with large stained glass windows that made colors dance as sunlight flooded into rooms. Along with being interested in artificial forms of lighting, young people were fascinated by how the appearance of solid objects changed under different weather conditions or at different times of the day. Artists tried to capture the appearance of seascapes and cityscapes by working outdoors in **plein air**, where they could see observe the effects of sun, fog, or rain on the subjects they were painting. Most importantly, they painted the real world of their local environment as they actually saw it rather than as contrived scenes or imagined landscapes.

These artists painted very quickly, dabbing bright colors onto their canvases before the light could change and create new highlights or shadows on the subject. Because they worked so quickly, in order not to lose the momentary character of the scene before them, some details were captured only as impressions. For this reason, the group of artists became known as the **Impressionists** and their artworks were considered impressionistic in style.

One of the most famous of the French Impressionists was Claude Monet. However, the French were not the only nationality of artists who painted in this style. Artists all over the world who were inspired by French culture and art began painting impressionistic works. For this lesson, you are to explore examples of Impressionist art that were painted by artists from your own region of the world, and sketch a scene from your local environment in an Impressionist style.

INSTRUCTIONS

First, look at these examples of Impressionist style art that were painted by two French artists who were among the founders of **Impressionism**. Claude Monet attempted to describe light and water as it appeared at a brief moment in time. The subject matter of Gustave Caillebotte's painting is also a momentary event in nature. One can see drops of rain falling and forming concentric circles in water for only a split second. Study how these fleeting visual

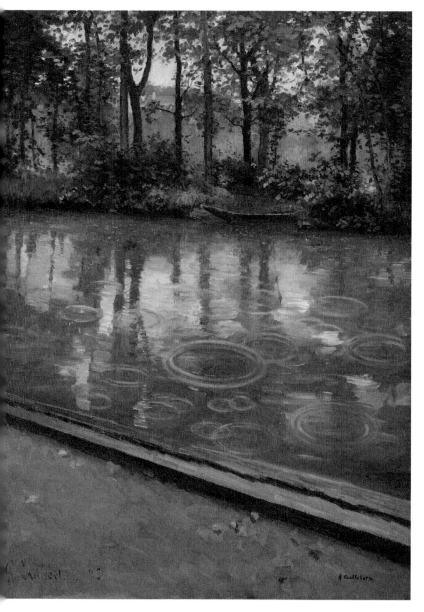

Gustave Caillebotte (1848–1894), *Verres, Effects of Rain*, 1875. Oil on canvas, 31 ⅝" × 23" (80.3 × 59.1 cm). Gift of Mrs. Nicholas H. Noyes, Eskenazi Museum of Art, Indiana University, Bloomington, IN. (Photograph by Kevin Montague)

effects are described in paint. Consider why the results might have been described as impressionistic.

In the late nineteenth century, artists from North America considered artists of Europe to be the most forward-thinking or **avant-garde** in the world. When possible, they traveled to Europe to meet and study with artists such as the French Impressionists. Upon returning to the United States or Canada, they brought ideas about how to paint in impressionistic styles but were obliged to paint scenes within their own local environments. Thus American artists painted scenes that described locally specific environments. Examine the following images by artists of the United States.

Theodore Clement Steele (1847–1926) was born and raised in southern Indiana, where he painted portraits and landscapes, eventually setting up a studio near Nashville, Indiana, in picturesque Brown County. Other artist friends, attracted by the natural beauty of the location, joined him to eventually form the Brown County Art Colony, which continued for many years and attracted young artists who could not or did not wish to study from European masters but were eager to learn the Impressionist style of painting. The impressionistic artworks of Brown County artists predominantly describe the wooded hills and valleys of the southern Indiana. In *The Bloom of the Grape*, Steele captures a late autumn day, as light filters through an overcast sky to cast a hazy glow on the landscape.

In Canada, a group of artists who became known as the Group of Seven painted local landscapes in styles that could be considered Impressionist while remaining true to their own unique styles. Franklin Carmichael, for example, created scenes with strong outlines, broad brush strokes, and vivid flat patches of colors rather than with small specks of color laid side by side, as was typical of Monet and many others of the Impressionist movement.

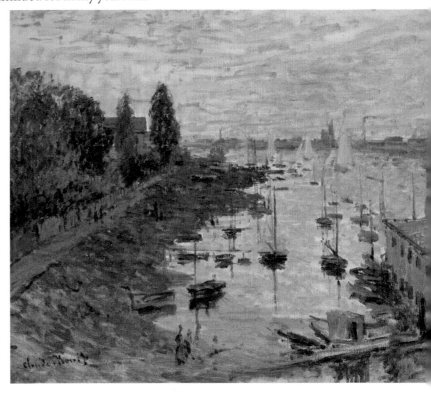

Claude Monet (1840–1926), *The Port of Argenteuil*, 1874. Oil on canvas, 21¾" × 25 ⅞" (55.2 × 65.7 cm). Eskenazi Museum of Art, Indiana University, Bloomington, IN. (Photograph by Kevin Montague)

INSTRUCTIONS

1. Search online for another landscape painting by Claude Monet and one by either T. C. Steele or C. Curry Bohm.
 a. How are these works examples of Impressionist art?
2. Search for a landscape painting that was done in the Impressionist style by an artist of *the region where you live*, during the late nineteenth to early twentieth century.
 a. Download or make a photocopy of the image.
 b. Identify the artist, title of the painting, date of the painting, and the location it describes.

Above, T. C. Steele (1847–1926), *The Bloom of the Grape*, 1893. Oil on canvas, 30 ⅛" × 40 ⅛". Indianapolis Museum of Art, Indianapolis, IN.

Right, Franklin Carmichael (1890–1945), *Autumn Hillside*, 1920. Oil on canvas, 36" × 30 ¹⁵⁄₁₆" (91.4 × 76 cm) (overall). Art Gallery of Ontario, Toronto, ON. (Public domain in Canada and the United States)

3. Write an essay (350–500 words) describing the similarities and differences between Monet, Steele, or Bohm, and the local artist of your region in their attempts to capture impressions of light, their use of brush strokes, and the subject matter of the paintings. Be specific in your answers.

4. Copy the titles of these three paintings and create a colored sketch of each.
 a. The sketches should be on white drawing paper, 9" × 12" in size.
 b. Use colored pencils to create the sketches.

5. Walk around your local community. Find an interesting location with a view of land or water. If you live in an urban area, perhaps you could find a small flower garden or a park with natural features to be the subject of your artwork.

6. Use a viewfinder to select a section of the scene that would make an interesting **composition**. See the section Basics of Creating Works of Art (near the beginning of this book) for instructions for making a viewfinder.

7. Draw or paint the scene using colored pencils on a sheet of 9" × 12" white drawing paper, or using watercolor or tempera paints on a 12" × 18" sheet of watercolor paper.
 a. Use appropriate colors and pencil or brush strokes to describe the scene impressionistically.
 b. Try to capture the light and colors of the moment, and practice working quickly to describe what you see before the light changes.

Materials Needed

white drawing paper, 9" × 12"

watercolor paper, 12" × 18"

drawing pencils with soft and
 hard leads

colored pencils

eraser

watercolor or tempera paints

paintbrushes

water containers

Vocabulary

Avant-Garde

Composition

Impressionism/Impressionist

Plein Air

WHAT TO SUBMIT FOR EVALUATION

- an essay response, as outlined in Instruction #3
- three sketches, one each of a painting by Claude Monet, one of either T. C. Steele or C. Curry Bohm, and one from an artist from your local region
- identification of the artist and title of each painting, its date, and the region it describes, along with a link or citation for the source of each of the three artworks
- an original composition in colored pencils or paints of a site in your local environment, with an indication of the location

TIPS FOR TEACHERS

Students who are exposed only to works of art by internationally famous artists or to historical cultural artifacts that are exhibited in prestigious world museums may fail to notice or appreciate the work of local artists within their regions and communities. Yet great works of art created by artists of diverse local cultures may go unnoticed by curators of international museum collections. Invite students to explore famous artists of the past who were born or worked in your local community or vicinity. This information may be readily available at local historical museums and libraries. Having identified a local artist, encourage students to explore the artworks produced by the artist:

- In what media did the artist work?
- What genres and styles of art did he or she produce?
- How did works by this artist reflect the local natural, man-made, or human environment?

Students also might research the following:

- Who are living artists that currently practice art making in the local community or region?
- What kinds of art do they make?
- Where can you see this art?
- What do these artworks tell you about the location where you live?

Appreciating local culture and art is important to the development of positive self-identities of students. Research has shown that children who are encouraged to appreciate the cultural arts of their local communities are much more likely to contribute to the healthy maintenance of community when they become adults.[5]

Lesson 40: In an Expressionist Style

Expressionism was an art movement of the early twentieth century in which rather than recreating the outer appearances of things, artists tried to capture the subjective expressions of their own or their subjects' inner experiences and emotions. Alexej von Jawlensky's portrait of *The Old Man (Yellow Beard)* is an example of **Expressionist** painting.

Alexej von Jawlensky (1864–1941), *The Old Man (Yellow Beard)*, 1912. Oil on board, 20½" × 19 ⅛" (52.1 × 48.6 cm). Jane and Roger Wolcott Memorial, Gift of Thomas T. Solley, Eskenazi Museum of Art, Indiana University, Bloomington, IN. (Photograph by Kevin Montague)

Look carefully at the image and consider what the artist wants viewers to know about his subject. Which is more immediately noticeable, the old man's physical appearance or the suggestion of his emotional state? What inner emotions are being described by the artist? Do you think this describes the way the artist feels about the old man, or is the artist describing the way the old man feels? Explain your answer and give evidence to support your answer.

INSTRUCTIONS

1. Look into a mirror as you sketch an image of yourself on a sheet of watercolor paper that is either 9" × 12" or 12" × 18" in size.
2. As you draw yourself, think of a strong feeling you have recently experienced and try to capture that in your drawing.

3. Color the drawing using either **oil pastels** or tempera paints. Use colors that emphasize the emotion you are trying to capture.
4. Use lines and shapes that augment the emotion.
5. Write a brief essay (300–400 words) that addresses the following points:
 a. Thoughtfully consider the inner emotion being represented by Jawlensky and the extent to which it reflects the artist's emotion or captures the emotion of the sitter.
 b. Describe your artwork and the feelings you were trying to convey.
 c. Explain how the processes you engaged and choices you made while creating your work reflect the ideals of Expressionism.
 d. Reflect on the extent to which your understanding of Expressionism has been modified by your efforts to create a self-portrait that adheres to those ideals.

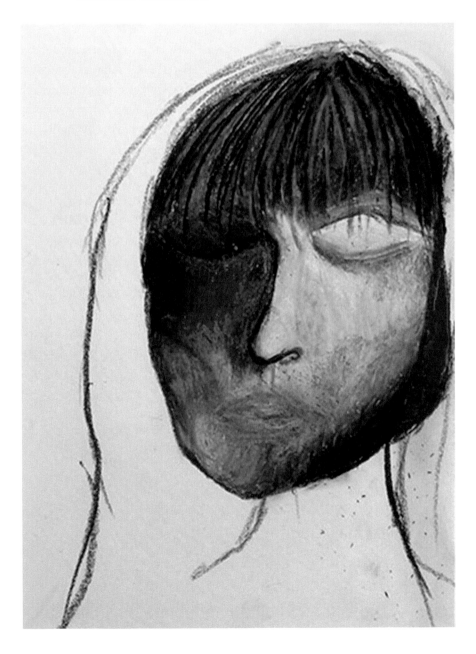

Claire Strohl, *Untitled*, 2015.
Oil pastel on Bristol board, 12" × 9".
(Courtesy of the Artist)

Materials Needed

watercolor paper, 9" × 12" or
 12" × 18"
drawing pencils with soft and
 hard leads

eraser
oil pastels, or tempera paints
bushes with thick and thin bristles
water containers and water

Vocabulary

Expressionism/Expressionist
Oil Pastel

WHAT TO SUBMIT FOR EVALUATION

· a self-portrait in oil pastel or paint that describes a specific emotion and
identifies the intended expression
· a written essay response, as outlined in Instruction #5

LESSON EXTENSION

As a lesson extension, try experimenting with one of the ideas presented above
in the section "Expressing Emotion through Art." For example, you could
explore the relationship between your own feelings by selecting a photograph
of yourself (from the shoulders up) that you believe demonstrates a specific,
identifiable, and describable emotion. Emphasize this emotion by modifying
the photograph in the following way:

· Using a scanner or digital printer, print a 9" × 12" copy of the image.
Make sure the head and shoulders fill most of the page.
· Study the photo of yourself and be sure you can honestly identify and
describe the emotion in a written paragraph.
· Think about colors or patterns that might be appropriate to and further
the emotion being expressed in the photo.
· Using color markers or oil pastels, fill in portions of your photograph
with color and/or visual textures that emphasize the emotion.

TIPS FOR TEACHERS

Seeing Emotion in Art

The word "expressionism" implies that the artist has distorted reality in order to describe or convey an emotional effect. Artists like Edvard Munch, Georges Rouault, and Vincent van Gogh created passionate paintings full of personal angst, but not all Expressionist artists were interested in conveying intense emotions of suffering, fear, or anger. Expressionists like Stuart Davis were inspired by vibrant jazz music. Jackson Pollack expressed himself through vigorous bodily movements as he dripped, splashed, or splattered paint on his canvases.

Artworks created by Franz Marc, a German Expressionist artist, predominantly are of animals painted in brilliant primary colors. For Marc, animals were sacred creatures and the colors with which he painted them held specific meanings. "Blue was used to portray masculinity and spirituality, yellow represented feminine joy, and red encased the sound of violence."[6] Animals thus were presented as metaphors for human emotions, activities, and circumstances. This is evident in Marc's famous work *Tierschicksale* (*Animal Destinies*, or *Fate of the Animals*) (1913), which depicts horses with a violence that seems to predict the impending First World War (WWI) that would soon engulf all of Europe.

Four Foxes also was finished in 1913, but has a very different expressive feel from that of *Tierschicksale*.[7] Invite your students to look carefully at the image of *Four Foxes* shown here. Ask them to consider the following questions:

- How do you think the foxes are feeling, or what are they thinking?
- What is their relationship to one another?
- What feeling does the painting evoke in you?
- What could it be a metaphor for in the outer world?
- What personal experiences or feeling does it remind you of?

Expressing Emotion through Art

If you work with young students, consider the types of emotions children experience and need to express from

Franz Marc (1880–1916), *Four Foxes (Vier Füchse)*, 1913. Watercolor with blue chalk on paper, 17½" × 15¼". (44.5 × 38.7 cm). Jane and Roger Wolcott Memorial, Gift of Thomas T. Solley, Eskenazi Museum of Art, Indiana University, Bloomington, IN. (Photograph by Kevin Montague)

time to time. How could they explore these emotions through art? For example, could students

- dress in costumes and create performance art to express fascination with a favorite character from literature or film?
- paint with watercolors to humorous poetry or finger paint to stimulating music?
- blow bubbles of paint onto a canvas to express appreciation for the random and unexpected?
- release tensions in preparation for or following test-taking by creating puppets and putting on a puppet show that describes their feelings about test-taking?
- calm their inner emotions of frustration or anger by sitting quietly and sorting swatches of color into value scales?

TIPS FOR TEACHERS

Addressing the Problem of Bullying through Art

It has been said that one of the purposes of art is self-expression. By expressing emotions in a visible form, students can see and reflect upon problems and issues from different points of view. In so doing, even if they remain powerless to change an apparently *unfixable* situation that is outside of themselves, it may be possible to change their understanding of or attitude toward the situation and thus change their relationship to it.

An unremitting problem in schools is the prevalence of bullying. Throughout childhood, there is strong probability that an individual will, at one time or another, experience being the victim, bystander, or perpetrator of bullying. Students who find themselves situated in any of these positions in relation to bullying often feel powerless in their abilities to understand why they are so victimized, compelled to act out viciously toward another, or fearful of intervening in the bullying of another. Through projection of feeling, students may come to a greater understanding of the complex factors and circumstances that might render them a victim, motivate them to bully, or deter them from defending a person who is being bullied. Using this lesson as a way of projecting recognition of innermost feelings may be useful in helping students recognize, come to terms with, or even change their own behaviors.

- Begin this project with your students by inviting them to write a story about and create a portrait of a bully. Ask them to contemplate what feelings within the bully might compel the bully to behave cruelly toward another person. Give a backstory explanation of how the bully came to be that way.

- Now suggest that they create a portrait of the bully, using color and line to describe the *internal feelings* of the bully.

- A second drawing could be done of the person who is being bullied. Once again, invite students to consider a backstory for the victim. What circumstances in his or her life led to being vulnerable? How does the victim feel about these circumstances as well as the experience of being bullied? Although the backstory may be written as text, encourage students to use only line and color to convey the *internal emotions* of the victim.

- Hold a critique of the artworks students have made of the bully and the victim. Open the conversation to dialogue about what they see being expressed as the inner emotions of each. What similarities or differences are there in the backstories? What similarities or differences are there in the expressionistic portraits of each?

- Following this class discussion, invite students to create a third portrait of a bystander. While they are to consider why someone would be inclined to stand by rather than confront the bully or come to the defense of the bully's victim, they should also consider how the bystander might be transformed into a peacemaker. What knowledge about bullies and victims might inform the expressivity of a bystander-turned-peacemaker?

- Once again, encourage a class dialogue about resolutions to the problem of bullying, with a focus upon the role of bystander/peacemaker as projected in the students' expressionistic portraits of this character.

Lesson 41: Mood Portraits

With the common use of digital cameras, **selfies** are a contemporary means of recording self-portraits. While self-portraits made in this way may capture a fleeting expression or **mood** of the subject, selfies generally are made for purposes other than as a record of one's mood over time. On the other hand, artists who spend long periods of time studying the features of their faces or who paint series of **self-portraits** might intentionally or inadvertently capture the essence of their own changing moods. In this lesson, you are to create four self-portraits in a sequence of color layers that contribute to the structure of the facial form, while also suggesting changes in mood and feeling.

Student Mikaylah Hershberger created four self portraits in yellow watercolor, added red to three of them, blue to two of these, and completed a final three-color painting with white tempera highlights. Mikaylah Hershberger, *Mood Self-Portraits*, 2014. Watercolor on paper, 12" × 9" each. (Courtesy of the Artist)

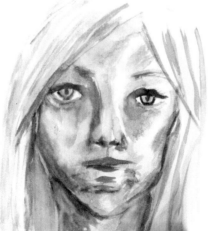

INSTRUCTIONS

1. Sit in front of a mirror with a strong light or lamp placed beside you, so the light casts a shadow on part of your face. Observe your reflection in a mirror.
2. Using only yellow watercolor or tempera paint, paint four self-portraits of your face, one on each of four sheets of 9" × 12" watercolor paper.

You may include your neck, shoulders, and the upper portion of your body, and may alter your physical position and the gesture of your face slightly from image to image if you like, but this is not required.

 a. Paint the image large enough that it fills most of the paper surface. Pay attention to the shapes of shadows and light.
 b. Do *not* use any pencil on this drawing. You are to draw with the yellow paint.
 c. Yellow is used first because any mistakes can be easily adjusted by the overlapping of the next colors.

3. Pick the best of the four drawings and set it aside.

Brandon Ragains, *Step 1: Yellow Mood Portrait.* (Courtesy of the Artist)

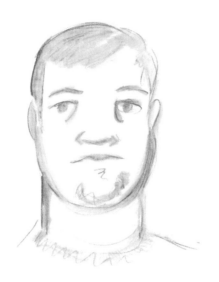

Brandon Ragains, *Step 2: Red Mood Portrait.* (Courtesy of the Artist)

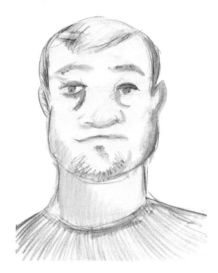

Brandon Ragains, *Step 3: Blue Mood Portrait.* (Courtesy of the Artist)

4. On each of the three remaining paintings, continue to develop the portraits by using only red paint. Subtle shades of orange and pink might be achieved by using a wet brush overlapping the red over the yellow areas.

 a. The red is used to make corrections and to show mid-range values.

5. Pick the best of the three drawings and set it aside.

6. On each of the two remaining paintings, continue to develop the portraits using blue paint. This is where you paint in the darkest of shadows and value on the facial form. By using water and overlapping the previous layers you can achieve light blues, greens, purples, and browns.

7. Put the better of the two drawings aside and develop the weaker (or least-liked portrait) further to find where the darkest shadows fall on your face. Perhaps these are beneath the hair on your neck, along one side of your face or nose. Don't guess or put the dark shades where you *think* they should fall on your face, look at where they really do fall and try to indicate these darker areas with the blue paint.

a. You have been building up the darker values of the facial form, but it is also important to understand where the light falls on your face—on the planes of the face that are facing the light source.

8. The last image is developed using white tempera paint. Using light strokes of a small brush, apply a small amount of paint to those areas of the face where the light is most reflected. This might be along one cheekbone, the side of your nose, or forehead. Don't guess or apply the white haphazardly; look carefully at your reflection in the mirror to see where the light really falls on your face.

9. Write an essay (500–750 words) in response to the following questions:
 a. Describe how you created the first set of yellow paintings. Did you look for light and dark areas of the face, or were you concerned mostly with the outline and features of the face?
 b. At what point did you begin to look for the dark shadows and/or lighter areas of the face?
 c. What were your greatest difficulties in creating these portraits? What surprised you—and/or what did you learn?
 d. What mood is conveyed in each of the pictures?
 e. Does the mood change from portrait to portrait? If so, how do you account for this change? What causes the mood to seem to change?

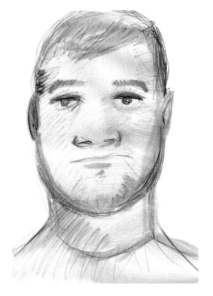

Brandon Ragains, *Final Mood Portrait.* (Courtesy of the Artist)

Materials Needed

a large mirror
a lamp or strong light source
four sheets of heavy watercolor
 paper, 9" × 12"

yellow, red, and blue
 watercolor paints
small and large brushes
white tempera paint
water containers and water

Vocabulary

Mood
Selfie
Self-Portrait

WHAT TO SUBMIT FOR EVALUATION

· four paintings: one in only yellow, one in yellow and red, one in the three primary colors, and one in primary colors with white highlights done in white tempera
· a written essay response, as outlined in Instruction #9

Lesson 42: Inspired by Van Gogh

Vincent van Gogh (1853–1890) lived during a period when artists were turning attention to painting in ways that permitted viewers to see the world through the lens of the artists' feelings and moods. Van Gogh painted with great passion. His paintings are not only beautiful to look at but communicate his strong feelings about people and places of his life. His paintings possess enormous rhythmic power. His brush strokes were repeatedly applied, one next to the other in a rapid manner. Brilliantly lit subjects and bright colors add to the emotional feeling of his paintings. Later artists were influenced by the emotional power expressed through Van Gogh's pictures. His art influenced the works of later artists who worked in twentieth-century **Expressionist** style.

INSTRUCTIONS

Part I

1. Study several works by Vincent van Gogh, until you are familiar with his style of work and the kinds of subjects and themes that appear in his work. You can find information about his life and art online or in books located in the fine arts section of your library.

2. Select two examples of artwork by Van Gogh that you find interesting. Download or make color photocopies of the work and lay them aside to inform your own work.

 a. If you are selecting images from a book, scan each image with a color printer and print it out.

 b. If you download images from the internet, make sure the images are of high resolution and show good color reproduction.

3. Using a compositional arrangement or way of working with color that would be typical of Van Gogh, do two sketches of a place or person you know.

 a. The sketches should be done on white drawing paper, about 9" × 12" in size, with a color medium such as crayons or oil pastels.

 b. You could sketch a picture of your father sitting in a chair in a similar position as a figure in one of Van Gogh's paintings, draw people seated at an outdoor café, a field of mustard, a vase of flowers, or a stack of hay roles from a local farm that reminds you of one of Van Gogh's landscapes.

 c. *Draw from life observation, not memory or imagination.* Indicate the subject and location of your sketches.

Part II

4. Create three or four thumbnail sketches of a subject about which you have strong feelings.

5. Share these thumbnail sketches with peers and your instructor for feedback. Which composition most sensitively or powerfully conveys the feelings you intend to describe? How might use of color or brush stroke enhance or clarify your intentions?

Donnie Cone, *Snowy Evening*, 2006.
Tempera on watercolor paper,
12" × 16½". (Courtesy of the Artist)

6. Based on feedback and your own aesthetic intuitions, select the sketch that you like the best and redraw it on a sheet of watercolor paper that is approximately 12" × 18" in size.
7. Using tempera, paint the larger drawing.
 a. Recognizing that colors appear even brighter when complementary colors are placed side by side in a painting, select colors that describe your feelings about the subject in a way that respects Van Gogh's integration of feeling, color, and brushstroke through painting.

Materials Needed

white drawing paper, 9" × 12"
watercolor paper, 12" × 18"
pencil with soft and hard leads
eraser
crayons or oil pastels
tempera paint

Vocabulary

Complementary Colors
Expressionism/Expressionist

WHAT TO SUBMIT FOR EVALUATION

· two downloaded or photocopied images of works
 by Van Gogh that inspired your artwork
· two sketches of a person or place, drawn from observation,
 done in a style inspired by Van Gogh
· an indication of the subject and location of these sketches

Anonymous student work, *Summer
Stream*, 2004. Acrylic on canvas board,
14" × 11½". (Courtesy of the Artist)

Lessons in Color and Paint 243

- three or four thumbnail sketches of a subject about which you have strong feelings and that informed your finished artwork
- a completed painting, based on one of the thumbnail sketches, that makes use of complementary colors in an expressive way inspired by Van Gogh

TIPS FOR TEACHERS

Complementary Colors, Stasis, and Change

Vincent van Gogh is acknowledged as one of the more passionately expressive artists of the modern era. Powerful feeling is conveyed through his strong brushstrokes and use of brilliant complementary colors placed adjacent to one another in the paintings. Why is it that **complementary color** combinations affect viewers so intensely? Perhaps it is because these are colors that are exact opposites of one another. This sets up an awareness of discord and excites the eye. When exact opposites are in complete balance, we become aware that change is about to occur; exact equilibrium cannot exist for any length of time in the real world, since stasis (i.e., motionlessness, changelessness) is antithetical to life.

An intuitive recognition of change as an essential aspect of life may explain why complementary colors frequently are associated with rituals, ceremonies, and celebrations that mark important changes in human experience and/or cyclical times of the year. For example, Christmas, a Christian and Western cultural holiday that falls near the time of Winter Solstice, is associated with complementary colors red and green. Spring celebrations often feature yellow and pale violet decorations. In late October, Halloween, All Souls' Day, and Day of the Dead celebrations all feature decorative items in orange and indigo or the neutral complements, black and white. Invite your students to notice the complementary colors associated with various holidays and ask them to consider why these colors are identified with the holiday.

The passion in Van Gogh's work, his deep depressions, and profound love of life resonate with viewers even if they may not be able to articulate why his work moves them so. Ayasha Jones, whose work *Backyard Memories* is shown here, explicates her confusion and yet responds by painting her own powerful feelings. Invite your students to respond to an experience, event, or object by painting it in an expressionistic way.

"At first, it was hard for me to make a connection in Van Gogh's work. I didn't understand exactly how drawings of landscapes could show emotions. I later thought about how I might portray happiness or sadness in a painting. My painting is of this very large tree in the backyard of the home that I grew up in. I believed it to be the largest in the neighborhood. I wanted to portray the emotion and passion I felt for that tree in my painting by making the tree purple and the sun that set behind it dark orange." Ayasha Jones, *Backyard Memories*, 2013. Tempera on watercolor paper, 12" × 16". (Courtesy of the Artist)

Lesson 43: Inspired by O'Keeffe

Georgia O'Keeffe (1887–1986) was an American artist who sought to capture the purity and beauty of nature in her works. Her aesthetic ideals were representative of the **Transcendentalist** movement in art. She was famous for stunning combinations of technique and vision that were revealed in **compositions** of brilliant color and simplistic form. Many of her paintings were close-up views of objects like flowers, birds, bones, and other natural shapes within the local environment. In this lesson, you will research the life and work of O'Keeffe and create a painting inspired by her work.

INSTRUCTIONS

1. Research books or online resources for information about the life and work of Georgia O'Keeffe. Consider the following:
 a. Why did O'Keeffe choose to live and paint the desert scenes of the Southwest rather than live and work among the artists of New York City?
 b. What does the term Transcendentalism mean, and what about O'Keeffe's art style might make it appear *transcendental*?
 c. Look at several flower paintings by Georgia O'Keeffe and notice how she **crops** the visible part of an object so that we seem to be looking deep into the flowers. Describe the characteristics of these works by O'Keeffe.
 d. How would you describe the colors she chose to use?
 e. How does she format the paintings, and how does she draw your attention to the subjects of the compositions?
2. Make a photocopy or download images of two different paintings by O'Keeffe. Keep them near you while you work on your own painting. Share these images with your peers and instructor.
3. Find a large flower, shell, or interesting bone and study it carefully. Find a small area of the object that would make an interesting painting if blown up to enormous size.
 a. Take a photograph of the object and keep it near you while you work.
4. Make at least three **contour drawings** of the object. Make the drawings large, on sheets of 12" × 18" white drawing paper.
5. After you draw the contours, select one that you like and crop it down with a ruler so that the background or negative space is reduced.
6. Using a light color of crayon or colored pencil, such as peach, pale blue, or tan, redraw the selected sketch on a 12" × 18" sheet of watercolor paper. Make the shape of the flower much larger than life, filling the whole page with the object's shape. You could even have some areas stick outside the format. Keep the drawn lines light.
7. Using a thin wash of watercolor, begin painting the image from the center outward. Build up layers of color in order to bring out the **transparency** of watercolor. Allow one layer of paint to dry before adding another. You may use a paper towel to dab up excess water.

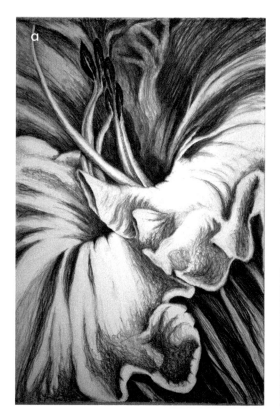 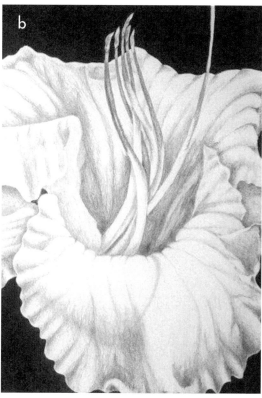

Linda Helmick, (a) *Flower Spirit*, 2015. Graphite on paper, 30" × 20"; (b) *Maestro*, 2014. Graphite on paper, 30" × 20". (Courtesy of the Artist)

8. Write a brief essay (300–400 words) in response to the following:

 a. Describe the characteristics of a Transcendentalist work of art, as demonstrated in the works of Georgia O'Keeffe.

 b. Explain how you created your painting. How is your work similar to one by O'Keeffe?

 c. How is it different?

Materials Needed

large white drawing paper, 12" × 18"
watercolor paper, 12" × 18"
chalk, pastels, or colored pencils in very light colors
colored pencils and/or black drawing pencils in soft and hard leads
eraser

watercolor paints
brushes with thick and thin bristles
water containers and water
mixing tray for paints
a plant, shell, cleaned chicken bone, or other interesting natural object

Vocabulary

Artist's Statement
Composition
Contour Drawing
Crop/Cropping

Transcendentalism/ Transcendentalist
Transparent/Transparency

WHAT TO SUBMIT FOR EVALUATION

- written responses, as outlined in Instructions #1 and #8
- two photocopies or hard copies of O'Keeffe artworks that were used as reference for your artwork
- a photograph of the natural object you selected to draw
- three contour line sketches of that object
- a completed watercolor painting of the object that is inspired by or refers to the Transcendentalist ideals of O'Keeffe

LESSON EXTENSION

Georgia O'Keeffe expressed her understanding of Transcendentalism through painting enlarged images of natural objects in pure, vibrant colors. There are other ways of expressing the philosophical ideals of Transcendentalism. Sara Qurashi, for example, presents us with another way. She creates and manipulates digital photos to arrive at simplified, stunning images that inspire reflection.

- Think about what Transcendentalism means to you and reflect on how that idea might be described in a medium other than paint. Think of the subject matter as well as technique and medium.
- Create an artwork that reflects this notion.
- Did your ideas about Transcendentalism change as you created the work? If so, how and why did your thinking change?
- Write a 250–400 word **artist's statement** of your work and include it with your project.

"Transcendental art is spiritual in nature and appeals to the mind and senses; natural objects are often the subject. I reproduced a photograph and used digital media with several brush, sponge, and water-color techniques to create a digital painting inspired by Transcendentalism. Unlike O'Keeffe's work, my painting has more detail than simple form. The vivid colors of the seahorse and muted colors of a bird suggest Transcendental nature." Sara Qurashi, *Transcendentals: (Digitally Manipulated Photograph-SeaHorse)*, and *(Digitally Manipulated Photograph-Birds)*, 2013.

Lesson 44: Color Shading Rounded Objects

In Lesson 1 of this text, you were invited to explore how light falling on rounded objects creates shading. In this lesson, you will take that information further and consider how color shading occurs. All color is made of visible **electromagnetic waves**. We may see color when light passes through a **prism** or water vapor and is bent into different wavelengths of the **spectrum**. We also see color when light bounces off an object. Therefore, when light is blocked, colors are affected. The less light that falls on a subject, the less color or **hue** we are able to see.

You can create the effect of an object that is in shadow or receiving lessened light by adding black to the hue of the object. However, this dulls the color and may not be the best way of describing the observed shading effects. As you learned in the Lesson 28: Color Studies, colors become neutrals when mixed with a **complementary color**, yet still retain some of their vibrancy. Light bouncing off one object and revealing the hue of another object can cause light to ricochet off the first object to the second one, creating reflections of colors or an effect of color layering. Look at this example of painted fruit by artist Sharon Geels. Notice how a glass bowl captures the lavender-blue color of the tablecloth and casts a reflection onto the edge of the yellow banana. This is a common effect of color reflections caused by bouncing light onto other colored objects or into shadows caused by obstacles to light.

Sharon Geels, *Bananas and Apples*, 2014. Acrylic on canvas, 16" × 20". (Courtesy of the Artist)

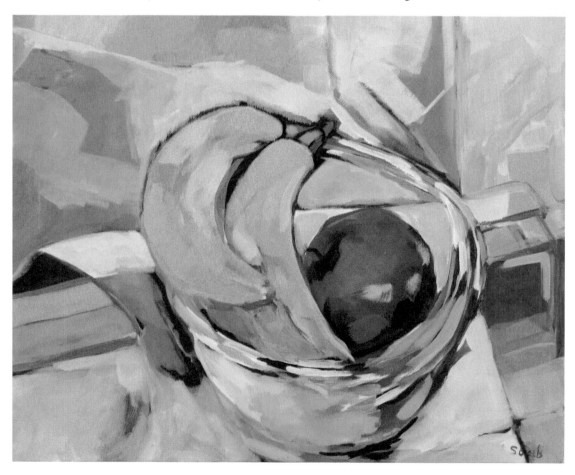

1. Arrange a group of colored curved or round objects into a still life composition in front of you. Some objects should be placed in front of others to overlap.

2. Make sure the light illuminating the objects is from a strong single source, such as a floodlight, flashlight, or reading lamp. It helps to dim other light sources by turning off overhead lights and pulling shades or curtains to block sunlight from windows.

3. On a 9" × 12" sheet of white drawing paper, draw the **contours** of objects in the grouping you have chosen to set up.

 a. Check your drawing for the correct **proportions** of each object to the other.

4. In your drawing, show clearly what happens when rounded objects are lit by a single light source. Use various colored pencils, crayons, oil pastels, or other dry colorants to show gradations of light to dark.

 a. The small section of the rounded object that directly faces (and is therefore closer to) the light source will be lighter/brighter in color than the parts of the object that fall away from this point.

 b. Very few parts will be completely black (no reflected light) or white (maximum reflected light). Most surfaces will reflect some lesser or greater **gradations** of shading.

 c. Use complementary colors layered atop one another to obtain these variations of shading.

5. Pay attention to shadows under the rounded objects and to places where shadows overlap each other. Using **cross-hatching** techniques will help you to build these layers.

Left, Mikaylah Hershberger, *Fruits and Vegetables* (work in progress), 2014. Graphite and watercolor pencils on paper, 9" × 12". (Courtesy of the Artist)

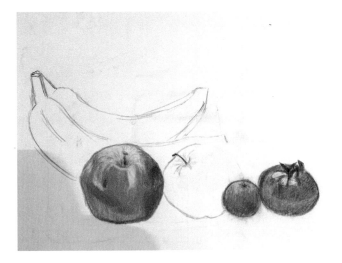

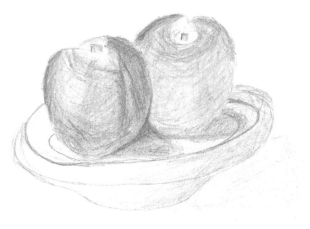

6. Write a brief essay (300–400 words) in response to the following:

 a. Describe what happens when light falls on a colored round surface.

 b. What colors did you layer or blend together to create the illusion of shadows in your work?

Above, Fangqi Li, *Bowl of Fruit in Cross-Hatched Layers,* 2015. Colored pencil on paper, 9" × 12". (Courtesy of the Artist)

c. Explain the differences between using black pencils to draw light falling on a surface and using complementary colors to capture the way light reflects or bounces off rounded color surfaces to create reflection and shadow.

d. What new considerations did you have to take into account, or what did you have to *notice differently* when creating gradations of light and dark in color?

e. Do you think drawing in color changed your perception of three-dimensional form, depth, or balance in this composition compared to how you perceived form, depth, and balance when drawing in black and white? Explain your answer.

f. Describe any difficulties you had creating shadows in this work and explain how your difficulties were resolved.

Materials Needed

heavy white drawing or watercolor paper, 9" × 12"
pencil and eraser
colored pencils, crayons, or oil pastels

Vocabulary

Complementary Colors	Hue
Contour(s)	Prism
Cross-Hatch(ing)	Proportion
Electromagnetic Waves	Spectrum
Gradation	

Example of glue resist still life in color.
(Created by the Author)

WHAT TO SUBMIT FOR EVALUATION

· a drawing of a group of round objects, lit from a single light source, with color shading, shadows, overlapping, and details
· a written essay response, as outlined in Instruction #6

LESSON EXTENSION

As a lesson extension, experiment with new media in creating your work. For example, you could try the following:

· Layer crayon, oil pastels, or transparent washes of watercolor (remembering to let each layer dry before adding a new color wash).
· On a sheet of black construction paper for a background, draw the contour of the objects with a piece of white or yellow chalk or pastel. Add colors with pastels or oil pastels.
· Draw the contour shapes of still life objects with a thin line of white glue on a 12" × 18" sheet of watercolor paper. When the glue dries, paint the colors with black ink or layered washes of watercolor.

Lesson 45: Reflective and Transparent Surfaces

After practicing drawing light and shadows as they fall upon or bounce off solid objects, you will notice that not all the objects we observe are **opaque**. Many objects are **transparent** or translucent, and the surfaces of many objects are shiny or **reflective**. How do artists describe these objects or surfaces in drawings or paintings? It takes considerable practice in observation before one can come to see these objects and surfaces as patterns of light and dark rather than as *things*. In this lesson, you will be challenged to observe and describe the effects of light as it is refracted and reflected by transparent and reflective objects. Your practice should begin with black and white media; later, you can study how colors apply to and are altered by transparency and reflection.

INSTRUCTIONS

Part I: Drawing a Reflective Surface Object

1. Select a single small object that has a reflective surface, such as a watch, brass doorknob, or bracelet.
 a. Set the object on a white cloth or a shiny surface with a bright light focused on it.
 b. Situate your chair or easel in one spot and mark the spot, so if you must leave you can return to the same position to resume your work at a later time.
2. On a 9" × 12" or 12" × 18" sheet of white drawing paper, lightly draw the outline of the object.
3. Look for the darkest areas of the object. This might be a shadowed area where the light does not hit the object at all. Using a soft lead pencil, begin to shade in this area as a layer.
4. Find another area that is less dark and shade it. Continue to look for increasingly lighter areas to be shaded, going back to previous areas to darken them more in comparison to subsequently lighter areas if this is necessary in order to keep the balance of light to dark accurate.
 a. Use soft leaded pencils for the darker areas, medium leads for medium tones, and hard leads for the lightest times.
5. Continue filling in values, while also revisiting earlier sections of dark to make sure the **value relationships** of dark and light are maintained. The lightest areas of the drawing may remain white.
 a. Include the portion of cloth or table upon which the object rests in the drawing.
6. You may notice that as you look for areas of dark or light value, you begin to forget that you are drawing an object and find yourself responding to patterns in relationship to one another. When you reach this state of awareness, you are beginning to draw with an artist's observational eye.

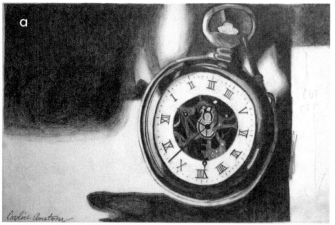

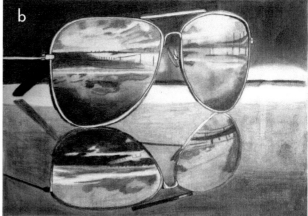

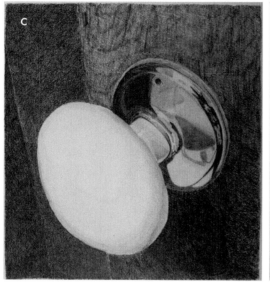

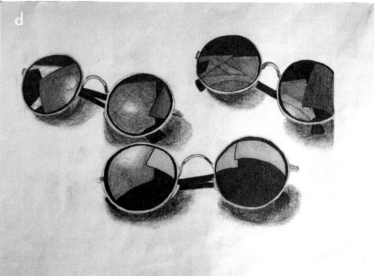

Work by students of Brian Cho:
(a) Caroline Armstrong, (b) Melissa
Horton, (c) Phoebe Horbak, and
(d) Natalia Mendez; 2015.
(Courtesy of the Artists)

a. Write a brief essay (200–300 words) describing the extent to which you experienced seeing and drawing dark patterns rather than thinking of the object as a thing to be drawn.

b. Explain how that altered the process of drawing.

Part II: Drawing Transparency in an Object

7. To set up a very simple still life, select a small glass container and pour some water or lightly colored liquid into the container until it is about one-third full. Set a taller opaque object slightly behind—but not altogether hidden by—the transparent container.

 a. These objects should be set on a white or plain-colored cloth, with a bright light focused on them.

 b. Situate your chair or easel in one spot and mark the spot, so that if you must leave you can return to the same position to resume your work at a later time

8. On a sheet of 9" × 12" or 12" × 18" white drawing paper, lightly draw the outlines of the objects before you, but do not try to add details that would distract you or ensnare you into seeing these as objects. They are merely light and dark surfaces to be studied and focused upon.

9. Begin by finding and placing values in those areas that are darkest. Use a soft leaded pencil to fill these in. Then look for areas that are less dark and begin to layer them in.
 a. Use soft leaded pencils for the darker areas, medium leads for medium tones, and hard leads for the lightest tones. White areas may be left untouched.
10. Continue going back and forth between lighter and darker areas, adjusting the darker areas to become darker if necessary to maintain a balance between dark and light.
 a. Include the portion of cloth or table upon which the still life rests in the drawing.
11. In your transparent objects, you will notice that the water within the container and the object sitting slightly behind the container will seem to change position relative to where you know them to be or where they appear in real space. This is because transparent objects **refract** or bend light; thus, the objects on the other side of a piece of glass appear to change in position.
12. When your work is completed, add to the essay begun in Part I of this lesson.
 a. Describe the experience of seeing values, reflection, and **refraction** in transparencies.
 b. Was it easier or more difficult to see these as patterns when drawing transparent objects?
 c. Why or why not?

Part III

13. Choose one of the two drawings that you completed above and look again at the subject from the point of view of color. Notice how the color of one object may affect the color of another, because light also refracts, bounces, and may ricochet from one object to another. These color anomalies can be described by seeing the still life before you as merely an arrangement of colors and patterns in relationship with one another.
 a. To see examples of the results of this kind of color-pattern seeing, study these works of art by artists Cassidy Young and Kathrine Waste.
 b. Another artist whose work may be studied is Janet Fish, who is a master of **hyperrealistic** paintings of reflected light on transparent surfaces. Her works are available for viewing at the DC Moore Gallery website, http://www.dcmooregallery.com/exhibitions/2012-02-09_janet-fish-recent-paintings, and at http://www.dcmooregallery.com/artists/janet-fish.
14. Study the works of these artists, then go back to your drawing and select a portion of one of the works that could be redone in color. You may

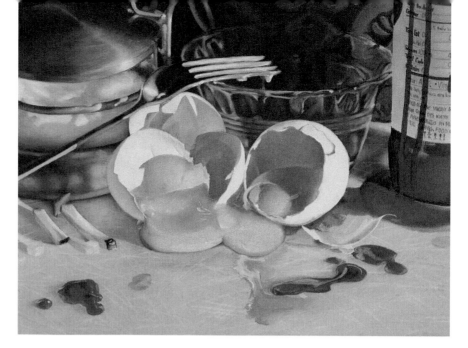

Cassidy Young, *Remains*. Watercolor on paper, 16" × 20". (Courtesy of the Artist)

Kathrine Lemke Waste, *9th Avenue Suite*. Watercolor giclée, 14" × 14". (Courtesy of the Artist)

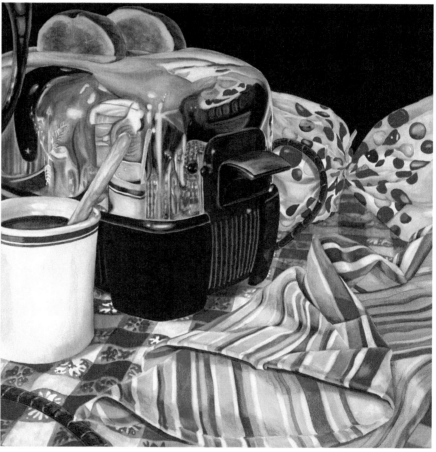

use a viewfinder to help isolate part of the drawing that could be redone in a range of dark and light colors (i.e., tints and shades).

 a. See the section Basics of Creating a Work of Art (near the beginning of this book) for instructions on making and using a viewfinder.

 b. For a tutorial that demonstrates how to draw glass objects with colored pencils, see Matt Fussell, "How to Draw Glass," at http://thevirtualinstructor.com/how-to-draw-glass.html.

15. Using colored pencils, complete finish this color version on a sheet of 9" × 12" drawing paper.

16. When your work is completed, add to the essay written for Parts I and II:
 a. How was seeing dark and light or tints and shades of color different than seeing in black and white?
 b. What did you come to see about color that you were not aware of when drawing the still life in black and white?

Materials Needed

white drawing paper, 9" × 12" or 12" × 18"

colored pencils

drawing pencils with soft and hard leads

eraser

Vocabulary

Hyperrealism/Hyperrealist

Opaque

Reflect/Reflection

Refract/Refraction

Transparent/Transparency

Value Relationship

WHAT TO SUBMIT FOR EVALUATION

· a drawing of an object that has a shiny surface
· a still life drawing that describes transparency of objects
· a still life drawing in color, based on either the shiny surface or transparency drawing
· written responses, as outlined in Instructions #6, #12, and #16

TIPS FOR TEACHERS

Studying reflections and transparencies introduces scientific concepts about how light waves function as they are reflected by concave and convex objects, or are interrupted by passing through transparent objects, prisms, water, or water vapor. Invite students to explore what happens to images that are reflected off curved objects from various distances. For example, look at how the reflection of a person holding a shiny metal spoon could appear upside down in the curved surface of the spoon. Have students research scientific explanations for this phenomenon.

Lesson 46: A Landscape in Inclement Weather

Below left, Albert Bierstadt (1830–1902), *Storm Clouds,* ca. 1880. Oil on fiberboard, 14½" × 19½" (36.8 × 49.5 cm). White House Art Collection, Washington, DC.

Below right, John Constable (1776–1837), *Seascape with Rain Cloud,* 1827. Oil on paper, 8¾" × 12¼" (22.2 × 31.1 cm). Royal Academy of Art, London, UK.

Artists of landscapes capture weather in all its variations. Among the most stunning images are those that describe extreme weather conditions such as fog, violent storms, tornados, and snowstorms or blizzards. Unlike landscapes that describe mild climatic conditions, images of inclement weather do not occur with sufficient frequency to be closely and repeatedly observed and practiced. This makes them challenging to realistically describe. Different cloud structures suggest weather variations. Snow and fog whiten the atmosphere, while thunderstorms tend to darken it. Artists must rely on cues of line, value,

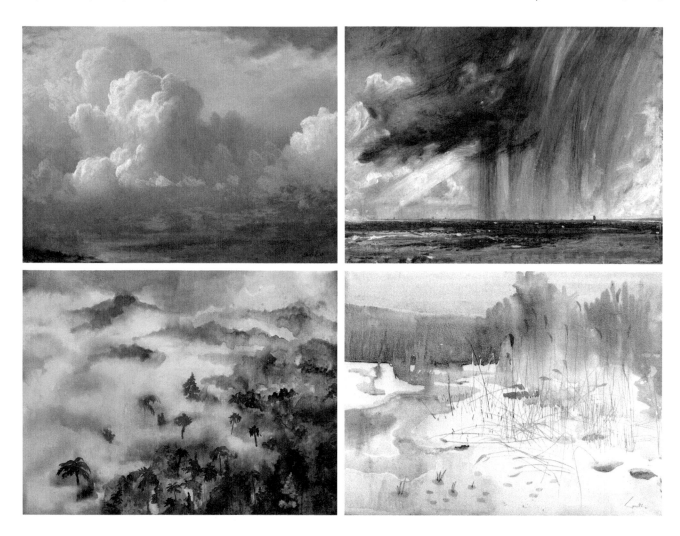

Above left, James Huntley, *Mist Moving through the Mountains,* 2015. Acrylic, watercolor, and pastel on paper, 18" × 24". (Courtesy of the Artist)

Above right, Willard Metcalf (1858–1925), *The Winter's Festival,* 1913. Oil on canvas, 26" × 29" (66 × 73.7 cm). Gift of Mrs. Herbert Fleishhacker, de Young Museum, Fine Arts Museums of San Francisco, CA.

and color to describe phenomena such as blowing winds, wet air, or sudden drops of temperature or the way these weather conditions make you feel.

What visual clues suggest changes of weather to you? What does an approaching storm feel like? How would you visually describe the sensation of a soaking rain or biting cold wind? This lesson challenges you to consider translating these sensory experiences into a work of art.

The optimum time to work on this project is when you are actually experiencing an inclement weather event such as a rain shower or snowstorm, but if necessary, you can create images of the sensations remembered from previous encounters with wild weather.

1. Close your eyes and recall how the atmosphere or clouds looked before, during, and after the event. Write a brief reflective response to the visualization.
 a. How did colors of the environment change?
 b. What happened to the trees, plants, and people as they were engulfed in the event?
 c. What reflections or flashes of light were evident?
2. As you observe or recall these sensations, work quickly on sheets of 9" × 12" or 12" × 18" drawing paper to sketch a minimum of four impressions of inclement weather. Use drawing pencils or another dry color medium.
 a. Try to visualize the experience as you work, include details that you remember, but do not get lost in the overall sensation of the experience by focusing on minute details.
 b. Try to capture the overall essence of features rather than their photorealistic aspects.
3. Share your sketches with your peers and instructor for feedback. Can they recognize the weather event you are describing? Which of the sketches most powerfully conveys what you are trying to describe?
4. Select the most convincing sketch and redraw it in a larger size, on a sheet of 12" × 18" watercolor paper. Make alterations to the work based on the feedback you received. Add color if it seems appropriate to do so.
5. In a brief essay (300–400 words), respond to the following questions:
 a. What sensations did you experience during the real or recalled weather event?
 b. How do the choices you made in drawing the event describe what you experienced?
 c. Are your sketches **nonobjective**, or do they show **realistic** features of landscape, nature, or people? To what extent are these choices important to the description of the weather event?
 d. How well do your choices in sketching a weather event convey the essence of that event to viewers?
 e. How are your choices of medium or color appropriate to the work you created?

Materials Needed

drawing paper, 9" × 12" or 12" × 18"

watercolor paper, 12" × 18"

drawing pencils with soft and
 hard leads

eraser

colored pencils, or another dry
 color medium of your choice

Vocabulary

Nonobjective/Nonobjective Art

Realism/Realistic

WHAT TO SUBMIT FOR EVALUATION

· four sketches of an observed or remembered inclement weather event
· notes on the information provided by your peers and instructor as feedback about your sketches
· a completed artwork of your experiences or impressions of an inclement weather event
· written essay responses, as outlined in Instructions #1 and #5

LESSON EXTENSION

The activities of this lesson focused on capturing the essence of a temporal weather event, such as rain or snow. However, even when the weather is not in a state of change, it can be described through visual imagery. How would you describe an extremely hot and muggy or cold overcast day? Consider the kind of weather day artist James Huntley is describing in the image below. What visual cues does he use to tell you the temperature, quality of wind, or how the day feels overall? As a lesson extension, create an image that clearly describes a very hot, pleasantly balmy, nipping cold, or frigid day. Do so without including people in the composition.

James Huntley, *November Evening*, 2013.
Watercolor on paper, 18" × 14".
(Courtesy of the Artist)

TIPS FOR TEACHERS

Dramatic changes in weather can elicit feelings of awe, excitement or exhilaration, fear, anxiety, or depression. Seasonal changes typically bring particular types of weather conditions, from heat and thunderstorms in summer to cold, blustering snowstorms in winter. Observations of weather conditions provide young students opportunities to study causes of weather, signs of weather changes, and the effects of weather on natural life forms, including effects on human beings. In the work presented here, one child describes her physical and emotional response to an approaching thunderstorm, while another describes the effect of strong wind on a small body. What other weather conditions might elicit emotionally felt or physically experienced responses from young students?

Windy Day. Crayon and oil pastel on manila paper, 9" × 12". (Child Art Collection of Enid Zimmerman)

Lightning Storm Approaching. Oil pastel on manila paper, 9" × 12". (Child Art Collection of Enid Zimmerman)

Lesson 47: Light and Water

Colors are the result of **electromagnetic waves** vibrating at specific frequency ranges within visible light. When light passes through a crystal **prism** or droplets of water, it splits into a sequence of visible light **hues** arranged as a rainbow. Rainbows are generally seen high in the sky, as a result of natural sunlight passing through millions of droplets of rain. However, rainbows may also be seen as a result of artificial light passing through or bouncing off transparencies such glass, water, or the sheen of an oil slick on water.

Eduard Tomek (1912–2001), *Untitled*, 1968. Watercolor on paper, 9 7/16" × 12 5/8" (23 × 32 cm). Private Collection. (Public domain granted by David Tomek, son of Eduard Tomek, CC BY-SA 3.0 US)

What happens when water puddles into large pools on the ground or swirls about in rivers, streams, or oceans and reflects visible light from natural or man-made sources? How does the presence of water affect visible light, especially if light reflects off or passes through water at night? Does light look different when reflected by still water than it does when reflected by moving water, or when water is stirred by movements of waves or splashes of rain? Can we see rainbows at night as a result of reflected light, or does light reflect differently at night than in the day? These are questions that could be posed to scientists or optical engineers, but they also are inquiries that artists explore through observation, as you will do in this lesson.

Capturing the appearance of light reflecting in water requires intense observation. Attempting to photograph such effects is equally difficult and generally unsuccessful, since you would need to set the camera to a very fast speed and then snap the picture at exactly the right instant in order to capture the fleeting effects of light and movement. If you were to use a flash instrument to photograph night scenes of light reflected in water, the flash would distort the image you wish to capture.

Joseph Pennell (1857–1926), *The Shops at Night, Changing Shifts*, 1916. Lithograph. Rosenwald Collection, National Gallery of Art, Washington, DC.

1. For this lesson, you will need to seek out opportunities to observe how lights are reflected in water.
 a. If you live near an ocean or river, you might visit the site at various times of the day and make observational notes and quick sketches of what you see. Work outdoors in **plein air** if possible.
 b. If you do not live near a large body of water, listen for weather reports of times when there might be rain, and set up a painting station in preparation for observing and capturing your impressions of the rain in a watercolor painting.
 c. Be sure to situate yourself in a location indoors or under a protective roof so you can observe the effects of rain falling and pooling on ground surfaces.
 d. If you are working at night or trying to describe reflected light during a time when the ambient light is too low to properly see

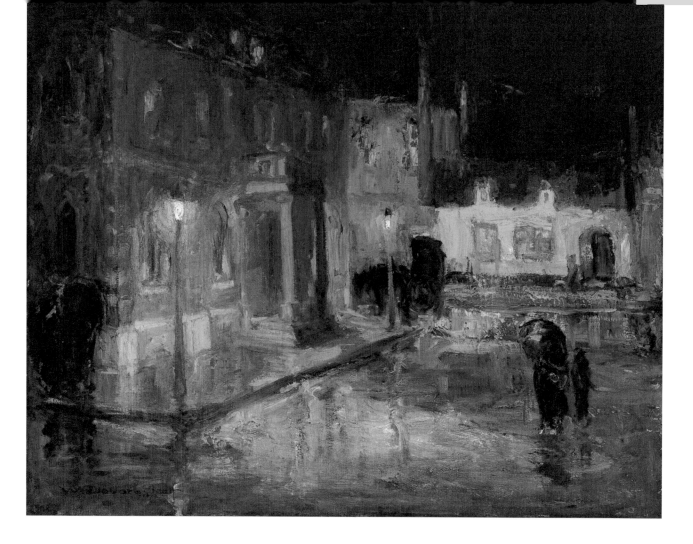

William Edward Scott (1884–1964),
Rainy Night, Etaples, 1912. Oil on canvas,
25½" × 31" (33 × 39¼ cm). Gift of a
Group of African-American Citizens of
Indianapolis, Indianapolis Museum of
Art, Indianapolis, IN.

what you are painting, attach a small book light to your watercolor pad to help you see your work as you observe the scene before you.

2. Set up an easel with a pad of watercolor paper, with watercolors, brushes, and water arranged on a small table beside you.

3. On sheets of 9" × 12" or larger watercolor paper, make a minimum of five watercolor sketches of what you see.

 a. As you sketch with watercolors, remember to begin with the palest colors and move gradually to the darker, more intense ones. Use muted colors and softer focus for shapes and fewer details for objects in the distance. The darkest colors are the least diluted with water and should be added last to describe objects that are closer.

 b. Do not use white paint to create the reflection of light; instead leave parts of your paper unpainted to produce this effect.

 c. Tiny dabs of black may be mixed with color to create darker colors, or try mixing small amounts of complementary colors to arrive at neutral tones for painting.

 d. Emphasize reflected spaces by darkening the areas around them, rather than trying to paint them with light colored paint.

4. Select the best of your sketches and go over it again with additional layers of watercolor until it closely matches what you observed as reflected light on water.

Materials Needed

pad of watercolor paper,
 9" × 12" or larger
watercolor paints
water container with clean water
paint mixing tray

watercolor brushes in several sizes
easel
table set with watercolor supplies
book light with clamp (*optional*)

Vocabulary

Aerial Perspective
Atmospheric Perspective
Electromagnetic Waves

Hue
Plein Air
Prism

WHAT TO SUBMIT FOR EVALUATION

- five watercolor sketches demonstrating light effects on water
- a completed watercolor painting of a scene showing the effects of light with water
- if a photograph was used as a reference for your artwork, submit the photograph along with a link or citation of its source

LESSON EXTENSION

Many painters have been fascinated by the way colors and shapes appear to change as they are viewed in the distance or in conditions of rain, mist, or fog. For centuries, watercolor artists in China and Japan and later in England and America have tried to capture the effects of **aerial** or **atmospheric perspective** in their paintings. In normal weather conditions, darker contrasting colors can be used to describe closer parts of a landscape and lighter, muted colors are applied to describe more distant parts of pictures. In conditions of rain, mist, or fog, this effect is more strongly pronounced. Softer outlines of shapes and less detail are used to describe objects in the distance. Mist or fog can envelop parts of the landscape altogether, creating an impression that objects have been erased or have merged with the white background. You can see this effect in James Huntley's *Mist Moving through the Mountains*, shown in Lesson 46.

As a lesson extension, search online for examples of extreme aerial or atmospheric perspective caused by rain, mist, or fog. Search through photographs and examples of Western and Eastern art. To find images of this effect, try searching online for images of "rain in mountains" or "mist in mountains." You could also search for "sunlight through rain clouds" or "sunlight reflecting off mist."

Download at least two images that appeal to you. On a sheet of 9" × 12" watercolor paper, lightly sketch your favorite of the images, using watercolors to finish the composition.

Lesson 48: Art Resists

Do you remember working with mixed media in elementary art classes? Common projects for elementary students include making crayon leaf **rubbings** and covering them with autumn colors of paint, or drawing underwater scenes with white crayon covered with blue watercolors. It is exciting to see crayon colors **resist** paint and emerge to stand out against translucent colors of paint. This is only one of many mixed media techniques that artists use to create works of art. Each technique depends on the intriguing ways that various materials interact with one another; in other words, the techniques are grounded in simple scientific rules. These rules are observable even though they may not be well understood. For example, we observe that oil and water do not mix, but why is this so? A respondent to *Yahoo Answers* gave this rather complicated explanation of the simple principle:

> Water molecules are dipolar, so they have one end that is partially positively charged (the hydrogen) and one end that is partially negatively charged (the oxygen). When you get a bunch of water molecules together they form a transient network of hydrogen-bonds, short-lived interactions between the oxygen of one water molecule and the hydrogen of a neighboring molecule. . . . Oil is made of long hydrocarbons, which are nonpolar. Nonpolar molecules don't really have much incentive to stick to each other.[8]

The above explanation may be of little help in providing young students with an understanding of how water and oil interact with one another. Yet a practical visual demonstration of oil and water in interaction allows students to observe and make predictions about such actions. In this lesson, you are to explore a variety of mixed media interactions through observing and researching information about interactions of media.

INSTRUCTIONS

1. Below are listed 14 different types of resist techniques. You are to select and reproduce four of the techniques according to the instructions given.
2. Present four examples of completed resist techniques, and answer the following questions about each:
 a. What resist reaction did you observe?
 b. How can this reaction be explained in a simple, yet scientifically accurate way? Cite the source of this explanation.
 c. Describe at least one other resist method that might be combined with each of the four examples you produced.
 d. What would be the anticipated results of this added method? Explain why you think this would be so.

RESIST TECHNIQUES

1. Rubber Cement Resist

- With a pencil, very lightly draw a large design or pattern on a 9" × 12" sheet of watercolor paper.
- With the brush from the rubber cement bottle, apply rubber cement over the drawn lines of the design. *Alternatively, you might skip drawing altogether and simply drip or brush rubber cement on the paper in a random fashion.*
 - Work in a well-ventilated area when using rubber cement. The adhesive is odorless when dry but exudes toxic odors while in use.
 - Don't use good watercolor brushes, as this will ruin them. Small bottles of rubber cement come with applicator brushes attached to the cap.
- Allow the rubber cement to dry entirely.
- Apply paint to the watercolor paper. Here you should use your imagination to decide how many colors you wish to use and how you want to apply them.
- Let the painting dry completely.
- Once dry, rub the rubber cement off with your fingers or a rubber cement eraser.

EXTENSIONS

- Before removing the rubber cement, use a black pen or colored pencils to write poetry or flow-of-consciousness text all over the paper. Do not stop when you come to the rubber cement area even though the writing will come off when the rubber cement is removed.
- Once the painting is dry, use colored pencils or markers to add textures, drawings, or details.
- Draw Zentangles (see Lesson 58) in the white areas left by the rubber cement.
- Combine this technique with Lesson 64: Maori Design—Kowhaiwhai.

2. Crayon Shaving Resist

- Select two or three broken crayons or crayon stubs and cut shavings from them—using a paring knife or old grater (one that you no longer need to use for grating foodstuffs).
- Drop the shavings randomly or in a pattern on top of a 9" × 12" sheet of watercolor paper.
- Place a second sheet of watercolor paper on the crayon covered one.
- Carefully move the crayon "sandwich" to an ironing board or heat resistant surface and with a hot iron, iron the top of the sandwich to melt the crayon shavings between the two sheets of paper.
- While the papers are still hot, open the two and place them *crayon side up* somewhere out of the way to cool.
- Once cooled, apply watercolor over the crayon resist. Use your imagination to decide how many colors you wish to use and where you wish to apply the color.

This technique will result in two crayon-coated sheets.

EXTENSIONS

- Use a salt resist technique when covering one of the crayon coated sheets with watercolor.
- Add highlights, details, or additional designs (such as Zentangles or text) with colored pencils or Sharpie pens.

3. Watercolor and Plastic Wrap

- Cover the surface of a 9" × 12" sheet of watercolor paper with watercolor designs.
- Take a length of plastic wrap and scrunch it up into a loose wad.
- Place the wadded-up plastic wrap on top of the wet watercolor painting.
- Place a cookie tray, large book, or other weighted object on top of the plastic and watercolor painting, and let dry overnight.
- When you remove the weight and plastic in the morning, you should see patterns that resemble huge salt crystals.

- This technique can also be used with bubble wrap, mesh, or plastic doilies, leaves, or flowers. Trying mixing two or more materials together.

4. White Crayon or Oil Pastel Resist

- This technique may be done with either a waxy white crayon or a piece of white oil pastel, or you may combine both in a single resist project and see how they respond differently as water-resisting media.
- Using the white crayon or oil pastel, draw an image or design on a sheet of 9" × 12" watercolor paper. For example, you might draw a Zentangle design or an underwater scene with fish and seaweed. Add any textural effects—such as dots, tiny circles, stripes, or zigzags—that you would like to have left white in the finished picture.
- Press hard with the crayon or oil pastel so that a thick layer of wax or oil is left on the paper.
- Paint over the drawing with colors of watercolor that you prefer. Then let dry.
- Add details to the finished artwork with markers and/or Sharpie pens.

5. Oil Pastel Resist

- Using oil pastels, create a colorful image or design on a sheet of 9" × 12" watercolor paper. Press down to leave a heavy coating of oil-based color.
- Paint over the design with black watercolor, tempera, or ink.

6. Salt and Watercolor

- Cover the surface of a 9" × 12" sheet of watercolor paper with watercolor designs.
- Sprinkle or shake salt in selected areas of the wet colors. Try using differently textured salts (table, sea, and kosher salts) and sprinkling on some areas of the watercolor that are more wet and other areas that are less wet.
- Shake or scrap off the salt when the painting is dry. Notice how the salt acts as a wick, pulling water (and color) toward itself, thus leaving an interestingly textured pattern in the paint.

This technique can be combined with other techniques listed here. However, if used with the Rubber Cement Resist technique, make sure the rubber cement is dry before adding the salt, and shake off all the salt before removing the rubber cement.

- Watercolor and Salt Filigree
- When the salt and watercolor painting is completely dry, revisit the painting by drawing a pattern, design, or image on the surface of the paper with a thin trail of white glue. Do *not* use a pencil. Use the glue bottle cap applicator as a paint brush.
- While the glue is still wet, sprinkle a liberal coating of salt onto the glue until the glue is completely coated with salt.
- Using either a small paintbrush or an eyedropper, touch tiny drops of color paint to the salt-covered glue lines. The salt will act as a wick to absorb the watercolors, leaving a filigree of sparkly salt color atop the original painting.

7. Wax Paper Resist

- Cut off about a 9" length of wax paper from a roll. Fold the wax paper into quarters (or eighths) and carefully cut a snowflake pattern from the wax paper.
- Unfold the snowflake pattern and lay it between two sheets of 9" × 12" watercolor paper.
- Place the wax paper sandwich on an ironing board and apply a hot iron carefully until the wax has melted and transferred to the papers.
- Pull the papers apart. Discard the wax paper and let the papers cool.
- Using watercolors, paint on top of the waxed papers. Use your imagination to determine the colors and places where the colors will be applied.
- When dry, add details, additional designs, or text with colored pencils or thin tipped markers.

8. Oil and Water

For this technique, you will need a shallow pan that is slightly larger than the 9" × 12" sheet of watercolor paper, newspapers to protect the surface of your working area, a small amount (1–2 tablespoons) of cooking oil, a set of food coloring (red, blue, and yellow) and water.

- Fill the pan with about ½" of water and dribble the oil on top of the water. Use a fork to swirl the oil into a design but don't entirely cover the water surface.
- Lay a 9" × 12" sheet of watercolor paper on top of the water and oil (don't submerge) and then remove the wet paper, lay it on a clean surface (cookie sheet or newspapers) with the oil and water side facing up.
- Dribble small amounts of food coloring on the wet surface. Use your imagination to determine the choice and placement of color.
- Allow the artwork to dry on paper towels to absorb the oil.

9. Tempera and India Ink Resist

Tempera paints, brushes, and a bottle of India ink are needed for this technique. Tempera is a water-based paint, while India ink is oil based. For this reason, India ink will stain clothing, hands, and porous work surfaces. Wear old clothing, use rubber gloves, and cover all work surfaces when doing this project.

- On a sheet of 9" × 12" watercolor paper, create a drawing of an object, leaving white spaces around the object. *The idea is to create an image that resembles a stained glass window—with white areas where the lead would be.*
- Using thick tempera paint that is not diluted with water (the paint should be about the consistency of toothpaste), paint all the areas of the "stained glass" except where the lead would be.
- Allow the painting to dry completely.
- Quickly brush India ink over the surface of the painting and allow this also to dry completely.

- Hold the black-covered painting under a running faucet (or take outside, lay the paper on a clean surface such as mown grass or concrete, and use a hose on gentle spray setting) to wash the India ink off the tempera-painted section of the piece.
- Allow the painting to dry overnight.

An example of the ink resist process. (Created by the Author)

10. Puffy Paint

This is not a resist technique, but puffy-paint outlines or designs could be added to images created with resist techniques, and therefore this is included as an explorative technique. Ingredients:

1 cup flour
3 teaspoons baking soda
1 teaspoon salt
food coloring

You will also need small squeeze bottles (called "nancy bottles") that are available in discount or craft stores, or icing squeeze bags with cones.

- Mix together the flour, baking soda, and salt, then add very small amounts of water (a tablespoon at a time) until the mixture is about the consistency of toothpaste.
- Divide the mixture into four to six small bowls and add a different color of food coloring to each.

- Put the mixture into small squeeze bottles or icing cones, and squeeze lines of colored mixture onto a sheet of 9" × 12" watercolor paper.
 - You may work on a sheet of paper that has been covered with colors and patterns from another resist technique, or a clean sheet of watercolor paper on which you have created a design. For example, you might apply the technique to a Maori Design (Lesson 64) or a Papunya Dot Painting (Lesson 65).
- Add details to the work with Q-tips or scratch new lines with a toothpick or fork.

Place the completed painting on a paper towel slide into the microwave to bake for 30–40 seconds.

11. Bubble Paint Prints

You will need a small bowl or shallow pan that is slightly larger than small pieces of pre-cut watercolor paper (about 3" or 4" square or rectangle), newspapers to protect the surface of your working area, straws, and the following ingredients:

2 tablespoons of dish soap (Joy, Palmolive, or Dawn brands work best)
2 tablespoons of liquid tempera paint
1 tablespoon of water

If you wish to use larger pieces of watercolor paper to catch the design, you must increase the ingredients, but keep the proportions of 2 parts dish soap and 2 parts liquid tempera to 1 part water.

- Mix the soap, paint, and water together in a small shallow bowl.
- Place a straw in the mixture and blow until a frothy group of bubbles rise to the surface.
- Place a swatch of watercolor paper on the bubbles to "catch" the pattern.
- Lay this aside to dry, and repeat until you have several bubble pattern swatches.
- Clean out the bowl of bubble paint and mix a second batch in a different color. Use some of the swatches to catch bubbles in this color. Look at what happens when the two colors are layered.
- Allow the bubble-patterned swatches to dry completely again, and repeat (if desired) until three or four layers of color have been added to some of the swatches.

- Show at least four of the swatches as your example of this technique.

12. Texture Rubbing and Watercolor Resist

- Collect several flat but textured objects for the rubbing, such as leaves turned upside down to see the raised veins, small pressed flowers, mesh, fabrics, or wood grain.
- Arrange these in an interesting way on a flat hard surface, such as a kitchen counter.
- Lay a sheet of 9" × 12" watercolor paper on top of the textured objects, and tape the paper securely to keep the objects in place and prevent the paper from shifting while working.
- Using a white or black crayon, rub the side of the crayon over the various objects (you can feel where the objects are located); press hard with the crayon.
- When you are satisfied that you have captured enough rubbed patterns, cover the surface of the paper with watercolor paints. Use your imagination to determine the placement and variety of colors covering the paper.

13. Glue Resists

There are a number of interesting glues that could be used for producing this glue resist technique. White school glue (such as Elmer's brand), gel glue, colored glues, and sparkle glues, which come in small squeeze bottles with applicator tips, are all appropriate although they produce slightly different effects.

- Draw a design or image on a sheet of 9" × 12" watercolor paper.
- Trace the lines of the drawing with a trail of glue.
- Allow the glue to dry overnight.
- Watercolors can be applied over the entire surface of the paper—in which case the glue will resist the paint—or different colors can be applied in various sections of the design, similar to the differently colored sections of the tempera and India ink resist.
- Add textures to various sections of color with colored pencils, crayon, oil pastels, or watercolor and salt resist techniques.

14. Shaving Cream Print and Resist

For this technique you will need an aerosol can of shaving cream, a plastic-covered surface, several 9" × 12" sheets of watercolor paper, and a shallow baking pan filled to ½" depth of water. Set the baking pan and water aside.

- Spray aerosol shaving cream on a baking sheet or a plastic-covered surface and smooth out the shaving cream.
- Dribble a little liquid tempera color on the shaving cream, and swirl the colors about with a toothpick or fork until a pleasing design results.
- Place a 9" × 12" sheet of watercolor paper on top of the colored shaving cream design. Press very gently, remove, and set aside until semi-dry.

- Place a second sheet on the shaving cream and pull a second print. Remove and set aside until semi-dry.
- Using a tongue depressor or other small flat tool, carefully scrape the extra shaving cream off both the shaving cream prints.
- Scrape the shaving cream paint mixture from the plastic-covered surface and place it in the baking pan of water. Swirl the shaving cream around into a pleasing pattern.
- Place a clean sheet of watercolor paper on top of the shaving cream and water.
- Remove and set aside with the other printed sheets.
- Allow all to dry completely. Compare the differences between the three prints. What might account for these differences?

 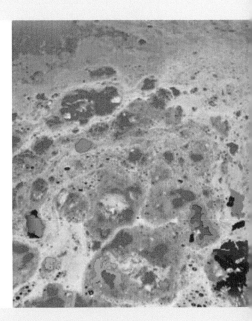

Examples of a shaving cream resist.
(Created by the Author)

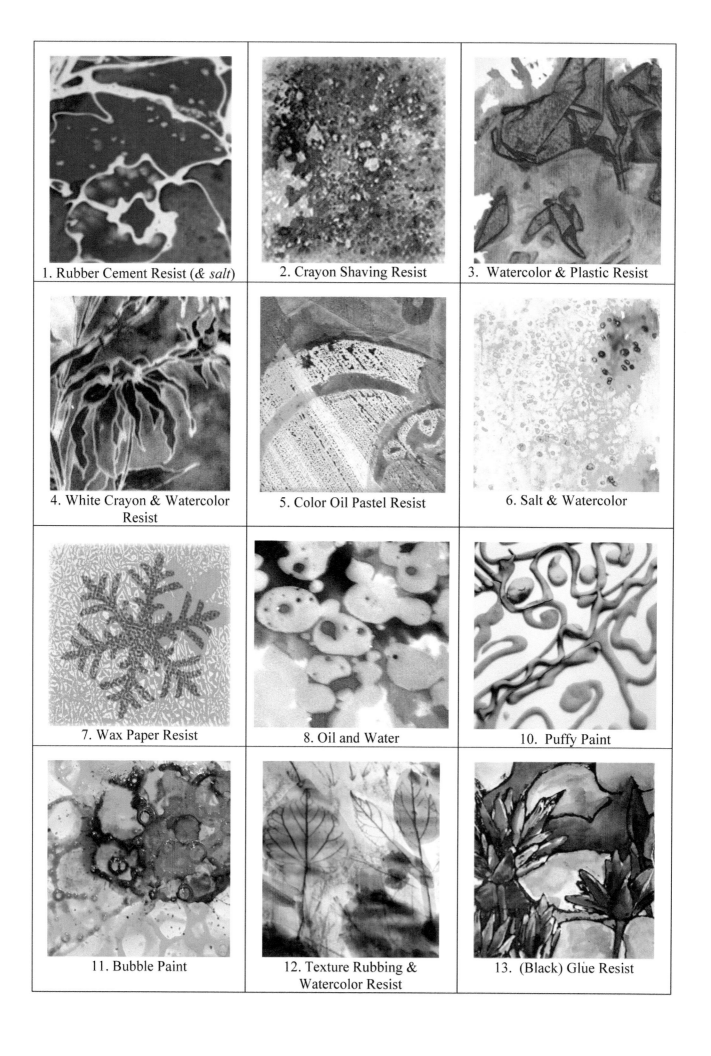

1. Rubber Cement Resist (& *salt*)

2. Crayon Shaving Resist

3. Watercolor & Plastic Resist

4. White Crayon & Watercolor Resist

5. Color Oil Pastel Resist

6. Salt & Watercolor

7. Wax Paper Resist

8. Oil and Water

10. Puffy Paint

11. Bubble Paint

12. Texture Rubbing & Watercolor Resist

13. (Black) Glue Resist

Materials Needed

watercolor paper, 9" × 12"
additional materials as indicated
 in the instructions for the resist
 methods you have chosen

Vocabulary

Resist
Rubbing

WHAT TO SUBMIT FOR EVALUATION

· evidence of having conducted four resist technique experiments, as
 described in this lesson
· written responses, as outlined in Instruction #2

LESSON EXTENSION

To extend this lesson, expand the number of resist techniques explored from
four to eight. From each of the eight technique explorations, cut or trim one
of the best designs to a small size (e.g., 4" × 5") and arrange these on the eight
pages of an accordion fold book (see Lesson 89: Photographic Essay). Include
written scientific information as the text of the book. Use one of the techniques
given in this lesson to decorate the end cover of the book.

Facing, Examples of resist
processes given in this lesson.
(Created by the Author)

Lesson 49: Paint and Imagination

Have you ever looked at clouds floating in the sky and imagined you could see faces in their billowy shapes? Have you ever wanted to capture these illusory images in paint? Perhaps while painting with flowing colors, you have experienced seeing illusions of faces or objects that arose spontaneously out of the paint swirls.

Watercolor as a medium is often difficult to control; because it relies on colors that are applied in a watery state, colors tend to flow, blend, and spread in spontaneous ways, similar to the movements of cloud formations. This makes watercolor an excellent tool for stimulating imagination, since flowing washes of water also might suggest faces or forms. In this lesson, you will permit watercolor shapes to form spontaneously, examine the shapes, and allow them to inspire your imagination. Based on the images you begin to see in the **abstractive** lines and blobs of color, you will elaborate on the imagined forms and bring them to compositional life as a completed painting.

INSTRUCTIONS

1. Using water and watercolor paint, on a watercolor palette or mixing tray mix about 1 teaspoon of a color of your choice.
2. Using an eyedropper, place a nickel-sized drop of the color on a sheet of 12" × 18" watercolor paper. Blow the color around by blowing through a drinking straw, or hold the paper at an angle and allow the paint lines to flow into one another.
3. Repeat this process with two additional colors. Do not be concerned if the colors overlap or merge into one another.
4. Lay the painting aside to dry.
5. When the colors are dry, examine the lines, colors, and shapes of the painting.
6. Stand back from the work in order to see the abstract elements from a new perspective. What do they suggest or call to mind: A desert with shadows of camels falling on the sand? A cloudy sky with kites flying in the air? Seaweed and coral underwater?
7. Once you can *see* a suggestion of some object or event, you will add to the abstractive lines and shapes to develop the suggestive form(s).
8. Using watercolors and brushes, colored markers, and/or colored pencils, begin to draw the forms out of the abstract lines and shapes. Fill in or overlay areas with color, developing these areas into meaningful patterns or objects.
9. Add **visual texture**.
10. Limit the number of colors used in the painting to only those colors used in the original air-blown piece, plus (*optional*) one **complementary color** that can be used in a limited way to develop a point of emphasis.

Paul Vasich, *Trudge and Flow*, 2013.
Watercolor on cream paper, 18" × 12".
(Courtesy of the Artist)

11. Give a title to your finished piece and write a brief essay (300–400 words) that responds to the following questions:
 a. What objects, patterns, or shapes did you see in the air-blown colors?
 b. How did you develop, discover, or enhance these through use of colored pencils or markers?
 c. What figurative shape(s) did they suggest?
 d. How did you develop these in your finished composition?
 e. What were your reasons for choosing the title of the finished painting?

Materials Needed

watercolor paper, 12" × 18"	brushes
watercolor paints	colored pencils or markers
water containers	newspaper or plastic cloth to cover
eyedropper	your work area
drinking straws	

Vocabulary

Abstract/Abstractive
Complementary Colors
Visual Texture

WHAT TO SUBMIT FOR EVALUATION

· a completed painted composition, as described in this lesson
· a written essay response, as outlined in Instruction #11

NOTES

1. C. M. Prudhoe, "Picture Books and the Art of Collage," *Childhood Education* 80, no. 1 (2003): 6.

2. Natalie Deane, personal communication, October 15, 2015.

3. Artist's statement, n.d., http://www.leahevanstextiles.com/.

4. E. K. Rossiter and F. A. Wright, *Authentic Color Schemes for Victorian Houses: Comstock's Modern House* (Mineola, NY: Dover Publications, 1883/2001), 13.

5. See P. Nachtigal, "Place Value: Experiences from the Rural Challenge," in *Coming Home: Developing a Sense of Place in Our Communities and Schools. Proceedings of the 1997 Forum*, ed. M. K. Baldwin (Granby, CO: Annenberg Rural Challenge, ERIC Document: ED421309, 1998), 21–25, http://www.eric.ed.gov/contentdelivery/servlet /ERICServlet?accno=ED421311; and P. Theobald and P. Nachtigal, "Culture, Community, and the Promise of Rural Education," *Phi Delta Kappan* 77, no. 2 (1995): 132–135 (ERIC Document: ED420461).

6. "Franz Marc: Style," *Wikipedia*, https://en.wikipedia.org/wiki/Franz_Marc.

7. To view and read about *Tierschicksale* (*Animal Destinies,* or *Fate of the Animals*), see "Fate of the Animals," *Wikipedia*, https://en.wikipedia.org/wiki/Fate_of_the _Animals.

8. Suzell, "Why Do Oil and Water not Mix?" *Yahoo Answers* (2009), https://answers .yahoo.com/question/index?qid=20090921043147AAJxckQ.

3 · Decorative and Graphic Design

Prior to the invention of printing presses and a subsequent spread of text literacy through all levels of Western society, knowledge was passed from generation to generation orally or through pictures and symbols that represented general ideas. Even decorative designs could be used as forms of identification and communication. Particular body ornamentation and designs painted or woven into fabrics could indicate the wearer was from a particular tribe or group. The overall form of a building, as well as any painted or carved motifs decorating its surfaces, identified its purposes, invoked blessings, or reminded people to interact with civility toward one another in community. Intricately composed images in carved or painted murals, tile mosaics, and glass windows illustrated mythic tales, religious stories, and histories of heroic deeds. These were the books of peoples who had little access to written texts.

Once text-based information became commonplace, the role of the arts in relation to literacy adapted to new purposes. Letter fonts could be seen as elements of artistry as well as symbols of communication. Long narrative passages of books could be enlivened by illustration. In the field of graphic design, text and image were combined in ways that communicated more than either could have done without support of the other. Decorative designs were manipulated to appeal to the senses in ways that elicited desire to own or possess lovely artifacts, achieve idealistic goals, engage attractive ideas, and communicate with and about one another. In contemporary society, text and image as design and media communication are intertwined. One can scarcely be considered truly literate without being able to read both with ease and fluidity. The lessons in this chapter offer opportunities to explore graphic and decorative design through art making.

FEATURED ARTIST: LAURIE GATLIN

Artist Laurie Gatlin has extensive experience teaching visual art to middle and high school students. Although instructing students in a formal school environment might be perceived by some as limiting one's opportunities for personal art making, Gatlin recognized it as an opportunity and inspiration. For her, the space between teaching visual arts and making art has been seamless and symbiotic.

As a professor of art education at California State University, Long Beach, Gatlin invites her students to recognize themselves as both teachers and practicing artists. Using her own work as examples, she demonstrates how ideas can be reflectively addressed through the arts in order to expand human understanding. Through the graphic media of sketchbooks, she investigates "the nature of quality teaching, the influence of community, life outside the classroom,"[1] and how one finds or makes meaning in the world. Her completed works are tracings of the vital roles that creative planning and reflection play in our everyday lives and educational processes.

HERE'S AN ENTRY FROM MY FIELD NOTES (7-13):

"NOW, S— IS KIND OF AMAZING, BECAUSE IN CLASS, S— DOESN'T VOLUNTEER MUCH, HE'S KIND OF QUIET, BUT ONCE HE GOT UP THERE AND STARTED TALKING ABOUT HIS PROCESS — HE REALLY WENT INTO DETAIL AND THAT WAS GREAT— IT ILLUSTRATED THE POINT I HAD MADE EARLIER — THAT SOMETIMES STUDENTS ARE SURPRISINGLY CAPABLE OF TALKING ABOUT THEIR WORK ONCE THERE'S SOMETHING RIGHT IN FRONT OF THEM TO TALK ABOUT. HE TALKED ABOUT HIS PROCESS, HIS STUDENTS— HAVING THAT OPEN BOOK IN FRONT OF HIM — IT MAKES IT EASIER. TAKES THE PRESSURE OFF FEELING LIKE THEY'VE GOT EVERYONE LOOKING AT THEM, EVERYONE IS LOOKING AT THE BOOK. HE TALKED AT LENGTH, AND EVERYONE IS LISTENING AND THEY WANT TO UNDERSTAND HIS PROCESS. AT ONE POINT, I PROMPTED HIM WITH SOMETHING LIKE, "OH- YOU WERE TALKING ABOUT PAINTING AS A SANDWICH PROCESS" WHICH WAS A GREAT METAPHOR, AND SO HE TALKED ABOUT THAT, TOO."

FROM MY FIELD NOTES (7-14)

"WE WERE TALKING— OH, AND B———— DID A WONDERFUL THING TODAY WHEN SHE TALKED ABOUT HER SKETCHBOOK IN THE AFTERNOON— A COMPLETE PERFORMANCE WITH SINGING, ACTING, FUNNY COMMENTS, REALLY ENTERTAINING. I AM GLAD SHE DID THAT— A LOT OF MY HIGH SCHOOL KIDS HAVE DONE THAT KIND OF PERFORMANCE. WHEN SHE WAS DONE, SHE SAID, "WELL, THERE YOU GO, YOU GET AN IDEA OF HOW I TEACH." SHE OFTEN SEEMS KIND OF BLASÉ WHEN SHE TALKS, SO THIS WAS A WONDERFUL EXAMPLE OF AN 'ON STAGE' PERSONALITY."

In this two-page spread from her sketchbook, Laurie Gatlin records her observations of presentations by student teachers during a summer workshop. (Courtesy of the Artist)

Lesson 50: Animal Symbols

Long before written words existed, pictures served as symbols for concepts. The behaviors of particular animals came to be understood as corresponding to similar characteristics, qualities, interactions, or interrelationships of humans to their environments. Thus, people adopted animal names, totems, and heraldry as symbols of themselves and their communal groups. Animal pictograms as symbolic forms communicated important ideas about how humans should behave properly and warned people of the consequences of improper behavior. Among ancient Greeks, for example, who lived near the sea and relied on it as a natural resource, the crab was an important food item. Its association with oceans, tides, and the gravitational interactions of the earth and moon placed the crab in harmonious relationship to the natural rhythms of time. The image of a crab symbolized a creature whose reliable presence, even after the most violent of storms, attested to qualities of character (loyalty or persistence) as well as endurance through long passages of time. According to myth and legend, the ancient gods rewarded the crab's tenacity, determination to survive, and reliability or loyalty by transforming its spirit into a heavenly constellation.

In China, the crab symbolized prosperity and high status in life, because the word for a crab's shell also referred to the highest score one could achieve on the Chinese Imperial Examination, which assured the test-taker of an aristocratic government position. In various Western cultures, the crab was an **anthropomorphic** reference to notions of vulnerability and rebirth, because it uses a shell as protection and may cast off one shell for another. Other cultural references to crabs are based on observations of its peculiar sideways gait; hence, a crab might symbolically refer to someone who takes crooked or unorthodox pathways to his or her goals.

The way animals are depicted tells us a great deal about the cultural contexts of artists who depict them. In this lesson, your task will be to explore how two diverse cultures symbolize the same animal differently and consider the reasons for these differing interpretations. Then you will design a **symbol** that describes how that animal is appreciated or understood in contemporary popular culture.

INSTRUCTIONS

1. Look at books or search online to find artworks that present animals as having anthropomorphic qualities symbolic of human characteristics such as power, wisdom, good, or evil.
2. Choose one animal that appeals to you and search for depictions of it by artists of several different cultures. For example, if you choose an owl as subject of your explorations, you could look at how it was represented by the ancient Romans, artists of ancient China, in folk traditions of Central America, or by twentieth-century Inuit artists of Canada.

a. What do these visual presentations tell us about the qualities members of different cultures associate with the chosen animal?

b. Consider the natural environment, history, social circumstances, and belief system of cultural groups that imagined this symbolic representation. How might these factors have influenced their perceptions of the animal?

c. How might the attitude of a cultural group toward animals that are indigenous in their natural environment be influenced by characteristics of these animals, such as the way they move, stalk their prey, make nests or dens, are colored, or make sounds?

d. Make reference citations to the locations where you found these various images of the animal.

Below, Compare this presentation of an owl as décor of an ancient Chinese ritual wine vessel to the owl costumes worn by revelers of a pre-Lenten Carnival in modern-day Germany. How might the context for an animal image suggest the role or significance of that animal in a particular society? Wine vessel, Late Shang (ca. 1200–1046 BCE). Compton Verney Collection (formerly in Albright-Knox Art Gallery), sold at Sotheby's in 2007. Private Collection.

Above right, Members of Fools Guild Bitzenhofen Oberteuringen, dressed as Gehrenberg mountain owls, participate in a pre-Lenten Alemannic Carnival, 2014. (Photograph by Andreas Praefcke, via Wikimedia Commons)

3. Look for evidence of the animal's meaning in texts as well as imagery.

a. For example, in the Bible the owl is described as an "unclean" creature (Leviticus 11:16; Deuteronomy 14:15) and as signifying ruin and desolation (Isaiah 13:21; Jeremiah 15:39). What characteristics of an owl might have rendered it unclean? What characteristics of owls suggest feelings of desolation? Given these written descriptions, imagine how peoples of ancient Palestine or Israel would have visually depicted an owl.

b. Literary references to animals also appear in classic stories or poems. Again, using the owl as an example, you could compare how it is presented as cranky and devious in Aesop's fable of "The Grasshopper and Owl," as a companion and message carrier in J. K. Rowling's *Harry Potter* book series, or as a silly but romantic partner in Edward Lear's nonsense poem, "The Owl and the Pussy Cat."[2]

4. In an essay (300–500 words), discuss, compare, and contrast your chosen symbolic animal as it appears in two different cultures or periods of time.

 a. Highlight the similarities or differences associated with the animal from culture to culture.

What anthropomorphic personality traits does this presentation of an owl suggest? Edward Julius Detmold (1883–1957), *The Grasshopper and the Owl*. Plate from the 1909 version of *The Fables of Aesop* (Hodder & Stoughton, London).

b. Tell what human-like characteristics are associated with the animal in each cultural reference, and reflect on why these associations may have been made.

c. What characteristics of the animal suggest human traits or behaviors?

5. Draw an example of the chosen animal as it might appear in each of two cultural traditions. Each animal drawing should be on a single sheet of 9" × 12" white drawing paper and should visually articulate how the animal was understood or interpreted. You may copy (but not trace) images of these animal forms.

6. Use contemporary popular culture from literature or the arts as reference for a third drawing of the animal. This drawing should give an indication of how the animal is thought of or appreciated in popular Western culture today. For this drawing, you may refer to visual images and additional media as a reference in composing a symbolic image of the animal, but you are to design an *original symbol* that conveys the essence of the animal.

7. The drawing should be on a sheet of 9" × 12" drawing or watercolor paper. Add color with colored pencils or watercolors if it seems appropriate to do so.

Materials Needed

white drawing paper, 9" × 12"
watercolor paper, 9" × 12"
drawing pencils with soft and
 hard leads
eraser

colored pencils (*optional*)
watercolors, brushes, water
 containers and water, and a
 mixing tray (*optional*)

Vocabulary

Anthropomorphic
Graphic

Motif
Symbol/Symbolic

WHAT TO SUBMIT FOR EVALUATION

· an essay (300–500 words) comparing how the animal you chose to represent was interpreted differently in two separate cultural traditions or time periods, describing these differences and identifying any environmental, historic, social, or philosophic reasons that might explain the differences

· two drawings of symbols (one from each of the two cultures or time periods) of an animal, along with links to sites or citations of where this information and these images were found

· an original drawing of the animal as it might symbolically appear in contemporary popular culture

· a written explanation of why you believe this is an appropriate symbolic representation

1. Having selected an animal that interests you and researched meanings of the animal throughout time and/or in two very different cultures, compare those ideas with the way the animal was presented in children's stories or fairy tales from each of the two cultures. Is there consistency in the fairy tale depiction of the animal and the larger cultural interpretation of the animal?
 · Select one of the stories and create an illustration that describes an event in the story that features the animal.
 · Try to match the visual style of the animal to its characterization in the story.
 · Write a brief explanation of how you matched your illustration to the characterization presented in the story.

2. Select a favorite animal and think about how you might reduce ideas conveyed about the animal into a simple symbolic form or **motif**.
 · Create at least three thumbnail sketches that describe visual ideas about the animal in simpler ways.
 · Eliminate all the other features in your visual presentation except those that clearly describe one important aspect and does so in a simple **graphic** way.
 · Select the sketch that best symbolizes the intended concept. Enlarge the sketch on a sheet of 9" × 12" drawing or watercolor paper.
 · Finish the symbol in pencil, black marker, or cut construction paper.

Amber Cooper, *Otter Reduced to Motif.* (Courtesy of the Artist)

Decorative and Graphic Design

Children have a natural affinity for animals. Researchers tell us that children who are raised to care for pets or animals develop empathy for other creatures.[3] However, the way animals are portrayed in popular media may strengthen, obstruct, or mislead the development of empathy. For example, in the twentieth century, following each release of Disney's animated movie *101 Dalmatians*,[4] many children requested and were given gifts of Dalmatian puppies. When their families discovered Dalmatians to be a dog breed that requires particular strict care and upkeep, animal shelter workers saw sharp increases in the number of Dalmatians being relinquished to them. Likewise, following the release of the movie *Jaws*,[5] which featured a huge man-eating shark, increases occurred in the hunting and killing of many shark species, including species that are harmless to humans and necessary to the ecological balance of marine life and species that are endangered.

1. Individually or in small groups, encourage students to research the traits, needs, and care requirements of a specific breed of pet or domesticated animal. Create posters that educate others about the animal and its proper care. Display these posters around the school or local community.

2. As a class project, invite students to research a creature that has been presented negatively and one that has been portrayed sympathetically in popular media. What role does each play in the ecology of its habitat? Create a chart or visual diagram that illustrates how the roles are similar, different, or complementary to one another.

Lesson 51: Thinking about Advertising Art

Advertising art is all around us on billboards, posters, television screens, internet sites, magazines, and newspapers. Advertising art can be a powerful persuader of public opinion and desire. Advertisers hope to influence what products we buy, where we vacation, how we vote, what we believe, and how we interact with one another. This influence works best when visual images and verbal messages are unified in such a way as to appear matter of fact or as *obvious truths* to the viewer. Advertising art may reflect the wishes of viewers while also influencing their wishes and desires. Images and **text** messages work together to convince the viewer that what is being sold will fulfill his or her needs and desires. In this lesson, you will choose two advertisements and analyze how the designers selected and arranged artistic elements so as to reflect consumer desires and persuade consumers of their real or imagined needs.

INSTRUCTIONS

1. Look at magazines or newspapers and choose two different advertisements that interest you. The advertisements should look very different and convey different messages.

2. Answer the following set of questions for *each* of the two advertisements:
 a. What is the message of the advertisement?
 b. What first attracted you to the advertisement?
 c. How successful is each advertisement in getting the viewer's attention?
 d. What is the overall message of the advertisement?
 e. How is the message conveyed? (For example, through **Elements** and **Principles of Art** that include line, color, visual texture, and shape, the use of **contrast**, placement of image to text, or use of **positive** and **negative space**.)
 f. Why do you think the artist chose the colors used in the advertisement? Would the effect of the ad have been different if other colors had been used? Why or why not? Give examples.
 g. How are other Elements of Art used to convey or emphasize the message?
 h. Why do you think the artist placed the words where he or she did? Would the advertisement's effect have been different if the text had been placed elsewhere? Why or why not? Give examples.
 i. What does the overall message suggest to the viewer (directly or indirectly) about appropriate human relationships and/or roles in society?
 j. What needs, desires, or hopes does the advertisement address? What solutions are offered?

3. Additionally, write a brief (300–400 word) comparison of the similarities and differences between the advertisements you analyzed.

Materials Needed

magazines with advertisements, or online advertisements
writing equipment

Vocabulary

Contrast	Positive Space
Elements of Art	Principles of Art
Negative Space	Text

WHAT TO SUBMIT FOR EVALUATION

- two sets of written answers (one for each advertisement) that address questions outlined under Instruction #2
- conclude with a comparison of the similarities and differences of the advertisements you analyzed, as noted in Instruction #3

LESSON EXTENSION

Revisit the advertisements that you analyzed for this lesson. Did you select them because you were attracted or repelled by them? Having considered the need, wish, or desire each advertisement addresses, and acknowledging that you were drawn to select these images over others, what do you think this might tell you about your subconscious self? Do you embrace or reject the solution or wish fulfillment offered by the advertisement? Why or why not?

- Select the advertisement that least closely matches your needs or desires with a commercial solution.
- Revise the advertisement to present a solution that might be more in harmony with your needs, hopes, wishes, or beliefs.

Lesson 52: Advertising Art as Persuasion

Advertisers try to persuade people to see a movie, buy a particular book, choose a specific brand of shoes, visit a tourist attraction, or join an organization. Artists who do this kind of work select pictures, drawings, and lettering to get their message across and influence the public to respond by seeing, buying, visiting, or joining the advertised site. Advertisements might be glamorous or austere, complex or simple. The only thing that counts is whether or not the design actually persuades people to behave in the matter suggested by the advertisement message. Effective advertisements tend to be excellent in terms of artistry and craftsmanship. In this lesson, you will have the opportunity to design your own persuasive advertisement.

INSTRUCTIONS

1. Choose an object or person that represents a product or event you would like to advertise. For example, you may advertise an article of clothing, a favorite musician, or a point of view about a social issue such as gun ownership or causes of and solutions for global warming. The best choice is always something you know and are enthusiastic about.

2. Make this subject the central focus of your advertisement, although it may be approached directly or indirectly. In advertisements that present messages indirectly, viewers are led to assume the subject is one thing or idea until a punch line of the imagery or text reveals an altogether different subject or idea. For example, in one popular advertisement, the text read like a line from a well-known song: "Drove my Chevy to the levee, but the levee was . . ." The last word of the song lyric "dry" was replaced by the word "gone," and a picture of the destruction caused in 2005 by Hurricane Katrina urged people to support preservation of wetlands as natural barriers to coastal cities.

3. On sheets of 9" × 12" or 12" × 18" drawing paper, make several thumbnail sketches of what an advertisement of your topic might look like.

4. Share your sketches with your peers and instructor for feedback about the clarity and power of your message.

5. Based on feedback and your preferences, select the most effective of your sketches and redraw the sketch on a 12" × 18" sheet of watercolor paper.

6. Using any **two-dimensional** medium of your choice (colored pencils, markers, paint, collage, or digital modification of the scanned drawing) complete a full-sized **rendering** of your advertisement in the most professional looking way possible. You may use one **medium** or any combination of **media** to complete this work.

7. Use only a few words to describe the product.

8. Choose a lettering style or **font** that blends in with or reinforces the idea of the central theme.

9. The words should be easy to read and **contrast** with the **background**.

 a. You may use stencils, or cut and paste letter fonts printed from a computer.

 b. Avoid using too many different colors for the **text**.

 c. Notice the color of background under the text; make sure the text does not become lost in the background color.

10. Consider the blank or **negative spaces** in the background as part of the design. Be sure that lettering and visuals work well together and are well balanced.

11. Write a brief essay (250–400 word) in response to the following:

 a. Explain how your advertisement is designed to persuade people to do or buy something.

 b. Explain how blank background spaces (negative space), text lettering, and visuals work together to create a unified design.

Below and facing, Student-made advertisement for a gym (*below*); and a poster encouraging viewers to resist consumerism (*facing*). (Courtesy of the Artists)

Materials Needed

 watercolor paper
 medium or media of your choice

Vocabulary

 Background
 Contrast
 Font
 Medium/Media
 Negative Space
 Render
 Text
 Two-Dimensional

WHAT TO SUBMIT
FOR EVALUATION

· a full-sized visual advertisement created in a medium or media of your choice
· a written essay response, as outlined in Instruction #11

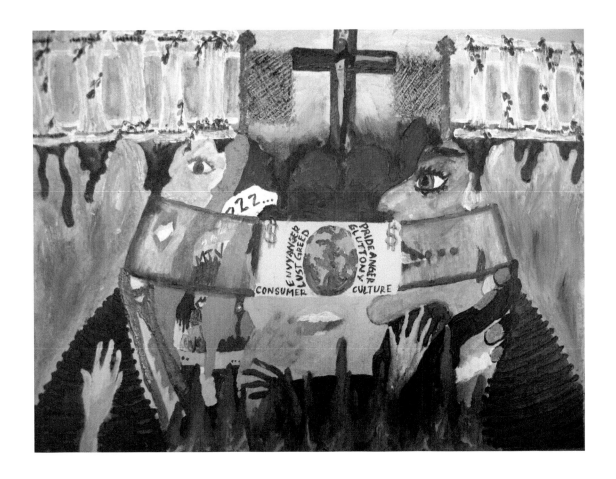

TIPS FOR TEACHERS

Talking to Students about Advertising

Elementary students often have difficulty understanding that the intent of advertisers is to sell something. In fact, producers of commercials attempt to make advertisements more engaging than regular programs. Explain the job of marketers and describe how they play on our desire to possess an exciting new toy, eat delicious food, look more attractive, have more friends, or be successful in some other way. Advertisers want audiences to believe their products will improve our lives and bring us happiness. To reinforce this understanding, you could have students create a poster or storyboard advertisement for a product they acknowledge as having no real value, but that might be presented in a way that would persuade or convince buyers to desire it. Other ideas for teaching students about media messages are available under the Teacher Resources link at Media Smarts: http://mediasmarts.ca/.

Lesson 53: Visual Illusions

Our eyes often play tricks on us, as a result of interference or mediation between the object being viewed and our brains. Visual illusions interfere with our interpretation of what we see; for example, objects viewed through water may appear to bend or move in location. This is because light is **refracted** by glass and water. You also may be familiar with distortions that appear as a result of heat: mirages are commonly seen in deserts as a consequence of light **distortion** when sunlight passes through evaporating moisture. We see objects one way when viewing them only with our eyes, but may see these same objects or portions of these objects differently when we view them through mediating instruments such as microscopes, telescopes, or color filters, or when they are reflected by devices such as warped mirrors.

Sixteenth-century artist Giuseppe Arcimboldo (ca. 1526–1593) used fruits, vegetables, and other objects to create the illusion of faces. The colors and forms of objects were arranged in ways that suggested the colors and forms of his subjects. A notable artist of the twentieth century who used **visual illusions**

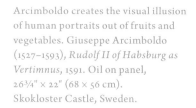

Arcimboldo creates the visual illusion of human portraits out of fruits and vegetables. Giuseppe Arcimboldo (1527–1593), *Rudolf II of Habsburg as Vertimnus*, 1591. Oil on panel, 26¾" × 22" (68 × 56 cm). Skokloster Castle, Sweden.

was Dutch artist M. C. (Maurits Cornelis) Escher (1898–1972), whose tessellating images appear in popular culture on posters, T-shirts, and coffee cups. Contemporary artists also have become fascinated by illusions and optical impossibilities. A few such artists include

Richard Allen (1933–1999)
Richard Anuszkiewicz (1930–)
Liu Bolin (1973–)
Ron Gonsalves (1959–)
Bridget Riley (1931–)
Chris Van Allsburg (1949–)
Victor Vasarely (1906–1997)

In this lesson, you are asked to look at visual illusions and use optical illusions in your own artwork.

Typical optical illusions result from arranging lines or dots to suggest three-dimensional forms. *Abstract Dots*, 2015. (via Wikimedia Commons)

INSTRUCTIONS

1. Begin this project by looking at examples of visual illusions as demonstrated in artworks of the artists listed above. Select three images that you find particularly interesting and download them. Write the name of the artist and title of his or her work on the downloaded picture.

2. Use these images as inspiration for ideas about how you could create an intriguing original visual illusion.
3. Sketch five ideas of impossible shapes or illusions on sheets of 9" × 12" white drawing paper.
4. Share your sketches with your peers and instructor for feedback about which is most convincing and intriguing.
5. Select the best of the sketches and redraw it on a sheet of 9" × 12" or 12" × 18" watercolor paper.
6. Use **visual textures** and **shading** to complete the drawing. Illusions of texture might be created by using **stippling** dots, **cross-hatching**, or **scrumbling** lines.
7. The choice of **medium** used to create this visual illusion may include drawing pencils, color or watercolor pencils, watercolors, tempera paints, or felt tip pens. The decision of which medium will create the desired result is up to you; however, be prepared to explain why this choice is appropriate in creating the illusion.
8. Write a brief essay (300–400 words) explaining the following:
 a. Of the artists whose works you explored, which artists' works most intrigued you, and why?
 b. How did the artist(s) whose work inspired you use illusions and optically impossible shapes?
 c. How did you arrive at ideas for your sketches, and how was the finished product enriched or altered through feedback?
 d. Why did you select the medium you used to complete this artwork?
 e. What visual textures did you create, and how did you created them?

Materials Needed

white drawing paper, 9" × 12"
watercolor paper, 9" × 12" or 12" × 18"

medium of your choice (drawing pencils, watercolors, or tempera, and/or felt tip markers)
eraser

Vocabulary

Cross-Hatch(ing)	Refract/Refraction	Stippling
Distort/Distortion	Scrumbling	Visual Illusion
Medium/Media	Shade/Shading	Visual Texture

WHAT TO SUBMIT FOR EVALUATION

· three downloaded images of optical art, with indications of the artist, title of the work, and link to or citation of its source
· five practice drawings of a visual illusion
· a completed artwork of a visual illusion
· a written essay response, as outlined in Instruction #8

TIPS FOR TEACHERS

Young children are fascinated by challenges to logic such as those provided by visual illusions. Objects and situations that appear magical may compel curiosity and quests to determine how mysterious things work. In *Relativity* (1953), Escher lured viewers by presenting an illogical imagery of people defying laws of gravity as they ascended and descended staircases. Wikipedia describes the effect as resulting from Escher's creation of

> three sources of gravity, each being orthogonal to the two others. Each inhabitant lives in one of the gravity wells where normal physical laws apply.... The apparent confusion ... comes from the fact that the three gravity sources are depicted in the same space.[6]

Giovanni Battista Piranesi's etching of a vast building interior challenges viewers to interpret movement through an unfamiliar maze-like space. Huge stair-step-like structures visually compete with a proportionally accurate staircase that turns to disappear behind a stone arch and confusing collection of structures. When children voluntarily compose images of imaginary buildings or machines with exposed and hidden complexities, their works may reveal similar combinations of logical and illogical or ambiguous spaces. Challenge students to individually or collaboratively create murals of one of the following, with revealed and implied three-dimensional spaces shown:

- an underground ant colony
- an underground city on the planet Mars
- the interior of a castle fortress
- the interior of a submarine, cruise ship, or interstellar spacecraft
- train routes connecting sites on real or imaginary maps
- routes of pipes and vents in a skyscraper building
- routes of circuits in a microchip, with notes about circuit linkage sequences
- hyperlinked boxes compounding interconnections among people or ideas

In planning and creating the mural, students will have opportunities to exercise and stretch their visualization skills.

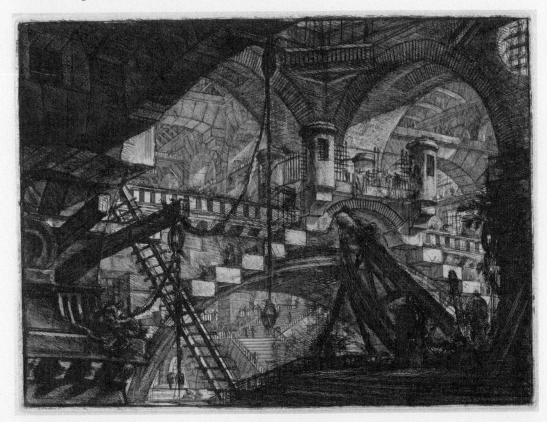

Giovanni Battista Piranesi (1720–1778), *The Arch and a Shell Ornament*, 1800–1809. Etching, engraving, with sulfur tint or open bite, drypoint, 16" × 21 7/16" (40.5 × 54.5 cm). National Gallery of Art, Washington, DC.

TIPS FOR TEACHERS

Integrating Art, Science, and Mathematics

A website of the Art Institute of Chicago introducing the program *Science, Art, and Technology* describes the relationships between these disciplines as naturally overlapping. All are a means of investigation. All involve ideas, theories, and hypotheses that are tested in places where mind and hand come together, the laboratory and studio. Artists, like scientists, study materials, people, culture, history, religion, and mythology, and learn to transform information into something else. In ancient Greece, the word for art was *techne*, from which "technique" and "technology" are derived, terms that aptly apply to both scientific and artistic practices.

Art and math are both grounded by underlying patterns of symmetry, shape or form, space, measurement and proportion, transformation, and generalization. Both rely on signs and symbols to convey processes and meaning. Exploring mathematic principles through visual art may assist students' understanding of abstract concepts, just as knowledge of mathematics can help art students understand rules of good composition, harmony, and unity in art. Resources with information about the natural connections between art, science, and mathematics, with lesson plans and curriculum guides, include the following:

- Art Institute of Chicago. *The Enduring Relationship between Art and Math.* The Art Institute of Chicago, 2003. http://www.artic.edu/aic/education/sciarttech/2a1.html.

Lesson 54: Tessellation Play

Tessellations are interlocking shapes that cover a surface without overlapping, although they may appear to morph from one shape to another. Tessellating patterns often appear to be quite complicated, but because they are created according to a very simple mathematical logic they are relatively easy to make. The simplest form of tessellation is a single geometric shape; it may fit into another shape that is like it, or it may be rotated and fit with other shapes to create a geometric pattern.

INSTRUCTIONS

1. Search in books and online for information about tessellation patterns. Consider:
 a. What kinds of shapes can be used in tessellating designs?
 b. What are some simple ways of creating tessellation patterns? Be able to describe at least two ways a shape may be made to tessellate.
 c. Explore the tessellating artwork of M. C. Escher. Study his work carefully. Try to determine how he makes one shape morph into another. Make a photocopy or download two examples of a tessellating design created by Escher. Keep these with you while you work. Use them for inspiration in creating your own work.

2. Create a tessellating design of your own. Using a pencil, draw three half figures on the inside edges of an equilateral triangle. One of the half figures should be drawn on each of the sides of the triangle.
 a. The figures should be as different from one another as possible. This will allow variety in the finished design.
 b. Each of the three figures should somehow fill as much of the triangle space as possible, so there is very little empty space left over. In fact, the figure halves could touch or overlap one another. For example, the hair on one head might become the fur collar on the next figure when viewed from a different perspective.

3. After the three figures inside one triangle are finished, the lines should be darkened. This makes them easier to trace, and they will copy much better in a copy machine.

4. Flip the triangle upside down and, following the lines that show through from the front side, go over the lines so they are as dark as the lines of the front. *The lines will be easier to retrace if you place the upside*

Tiled marble flooring in the choir, St. Stephen Abbey of Marmoutier (*Revêtement du sol en marbre du chœur*, Abbatiale Saint-Étienne de Marmoutier). While the abbey dates to the 11th century, the choir floor was built in the 18th century. Bas-Rhin, Alsace, France. (Photograph by Kerrmann C. CC BY-SA 3.0 US)

Mosaic floor with geometric pattern, House of the Swastika, 1st–4th century. Conimbriga, Lusitania, Portugal. (Photograph by Carole Raddato. CC BY 2.0)

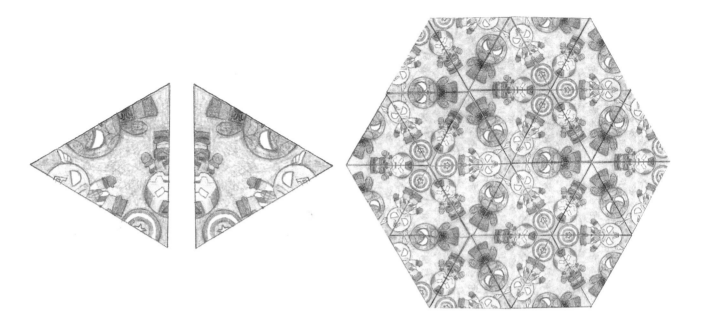

Fangqi Li, Tessellation motif template and the tessellating pattern it creates. (Courtesy of the Artist)

down triangle against a well-lit window. This will result in a reflection image of the front side of the triangle.

 a. When these two triangles, with a half figure drawn on each of their three sides, are fitted together (see above figure), they form the **motif** that will repeat over and over as you create your tessellating design. The tessellating design will appear as the edges of repeated motifs fit together like pieces of a puzzle.

5. Make 12 photocopies of each of these two triangles. You will have a total of 24 triangles, 12 of each version, when you have finished the photocopying.

6. Arrange six shapes into a six-pointed star first. Then the remaining shapes should fit in between the points of the star to create a hexagon.

 a. Practice laying out the design on a poster-board background before gluing the pieces down.

7. Using rubber cement, glue shapes down carefully, making sure the edges match. You may need to adjust shapes or overlap a bit to make everything fit.

 a. Each error in drawing, folding, tracing, copying, or cutting multiplies the problems in getting the final design sections to align.

8. Add colors with colored pencils. To do the color correctly (i.e., to tessellate the colors) use the same color each time a figure or background shape repeats in the design. .

9. Write a very brief essay (250–400 words total) in response to the following:

 a. Explain what you have learned about tessellating patterns. What kinds of shapes can create tessellations? Give at least two examples.

 b. What problems did you experience while creating your project? How did you resolve the problems?

To Make an Equilateral Triangle

· Draw a circle with a **compass**.
· Keeping the compass on the same setting used to make the circle, mark points around the circle at that distance from one another.
· There will be six marks. If you connect every other mark, you will have an equilateral triangle.

Materials Needed

colored pencils
compass
a ruler or straight edge
scissors
rubber cement
rubber cement eraser

a relatively transparent piece of paper, about 4" square
access to a copy machine and copy paper
white poster paper, about 18" × 24"

Vocabulary

Compass
Motif
Tessellate/Tessellation

WHAT TO SUBMIT FOR EVALUATION

· two photocopies or downloaded examples of tessellations
· an original tessellating motif of repeated triangles and drawn faces, as indicated in this lesson
· a completed tessellation created from your pattern
· a very brief essay response, as outlined in Instruction #9

LESSON EXTENSION

Creating a successful result for this lesson requires the original piece and every subsequent piece to be cut with absolute precision. Each imperfectly cut piece will cause an inexact alignment that becomes exaggerated with the addition of each motif. The difficulty of cutting pieces exactly should highlight the skill of artists from past eras when all art was produced by hand, without the benefit of die-cut or digital technologies. Currently we are fortunate to have software programs that can compose and piece together motifs of a tessellation with exactitude. Try reproducing your motif in one of the available tessellation-making software programs and expand the motifs into a large pattern. How different does your finished work look when created digitally rather than by hand? Which pattern is the most visually pleasing to look at? Which could hold your attention longer? Why? Share both of your resulting designs with peers and your instructor, and invite them to discuss which has the greater aesthetic appeal, for which purpose, and why they perceive this as being so.

Lesson 55: Tessellation Design

Tessellations are intricate patterns composed of single **geometric motifs** in repetition. They appear in nature as the scale patterns of certain fish and reptiles, the hard coverings of nuts and fruits, and the structures made by wasps and bees. Tessellating patterns have been used in architecture and as decorative patterns of walls and floors throughout history.

Tessellations also have long been associated with Islamic art and architecture. Examining the geometric patterns that characterize much of Islamic art and architecture provides an introduction to how beliefs may influence aesthetics. In general, Muslim artists do not seek to express *themselves* so much as they strive to produce beautiful patterns that people may use or enjoy while reflecting upon the wonders of Allah's creation. Islamic philosophy is an inseparable part of Islamic daily life and is evidenced in tessellating patterns, which represent the logic and order inherent in an Islamic vision of the universe. The patterns demonstrate how a complex universe was built upon simple precepts and remind Muslims of the structural permanence of Allah.

Below, Akbar's Tomb, 1605–1613. Mughal Architecture. Sikandra, Agra, Uttar Pradesh, India. (Photograph by Antoine Taveneaux, 2011. Creative Commons, Attribution-Share Alike 3.0 Unported)

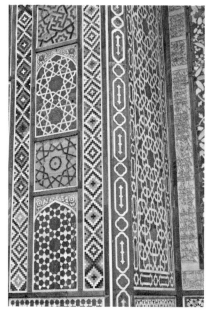

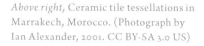

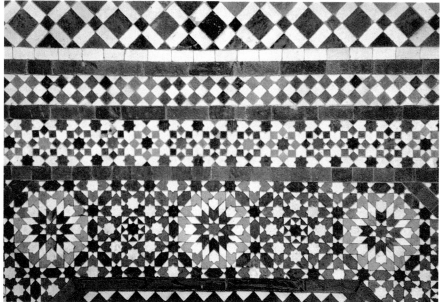

Above right, Ceramic tile tessellations in Marrakech, Morocco. (Photograph by Ian Alexander, 2001. CC BY-SA 3.0 US)

In this lesson you will examine how tessellating patterns are created, develop a tessellating **motif**, and repeat the motif to compose an interesting tessellation design. Before you begin, however, you will need to know the operations of **symmetry** as they apply to the tessellating motif. The theory of creating tessellating patterns is based on the **Principles of Symmetry Operations**. There are four symmetry operations. In other words, a two-dimensional motif can repeat in four different ways:

1. *Translation*, or *glide translation*: The motif moves up or down, left or right, or diagonally while keeping the same orientation.
2. *Reflection*: The motif reverses and reflects, as in a mirror.

3. *Glide reflection*: The motif reverses and also glides, in other words it **translates** and **reflects**.

4. *Rotation*: The motif turns or rotates around a point.

INSTRUCTIONS

1. Search in books and online for examples of tessellating Islamic patterns. Find several interesting patterns and study them to find the small section of the design that is repeated over and over again to make the pattern.

2. Search in books or online for examples of tessellation patterns that have been created by the Symmetry Operations of **rotation**, **reflection**, or **translation**. Compare the Islamic designs to these examples. Determine what method was used to create the Islamic design.

3. Download or make photocopies of two tessellating patterns that you find interesting. Keep these images near you while you work to study and as a stimulus for your ideas.

4. Make your own tessellating pattern based on the Symmetry Operation of **translation**.

5. Translation is a fundamental tessellating technique. It involves redrawing a side of a shape and then translating a copy of that shape directly across the square.

6. Draw a 3" square on a heavy weight piece of graph paper. Make a simple **asymmetric** design by cutting a piece out of the left side and sliding it to the right side of the square. Then cut a shape out of the bottom and slide it to the top of the square. Tape these pieces in place. This will become your repeating motif.

7. Carefully trace this motif in an interlocking design on a piece of poster paper cut to the exact size of either 12" × 12" or 18" × 18".
 a. Cut the poster board on a paper cutter to make sure the dimensions are correct.

8. Complete the design by coloring it in with colored pencils or markers. Try to repeat colors to complement the tessellation pattern.

9. Write a very brief essay (250–400 words total) in response to the following:
 a. Explain how the use of geometric pattern reflects Islamic beliefs.
 b. Describe how you created a motif for your design and indicate to which symmetry operations it adhered.

a) Two examples of translation or glide. (Created by the Author)

b) An example of reflection or flip. (Created by the Author)

c) An example of glide reflection. (Created by the Author)

d) An example of rotation. (Created by the Author)

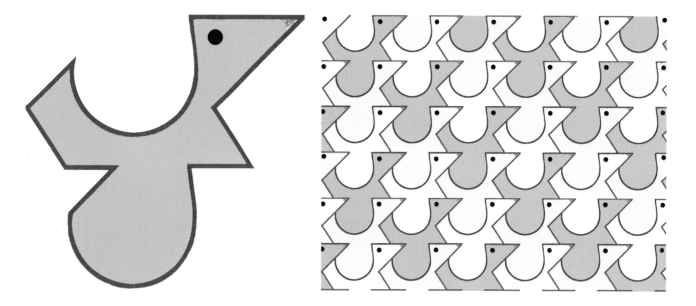

Left, A tessellation motif. (Created by the Author)

Right, A tessellating pattern created from repeating a single motif. (Created by the Author)

Materials Needed

heavy weight graph paper
pencils
black marking pen
scissors and/or paper cutter

poster board cut to 12" × 12" or 18" × 18"
colored pencils or markers

Vocabulary

Asymmetry/Asymmetrical
Geometric Motif
Glide Reflection
Glide Translation
Motif
Principles of Symmetry Operation

Reflection
Rotation
Symmetry/Symmetrical
Tessellate/Tessellation
Translation

WHAT TO SUBMIT FOR EVALUATION

· two photocopied or downloaded images of tessellating patterns
· a copy of the motif you made according to the instructions of this lesson
· a completed tessellating design created from repeating the motif you made
· a very brief essay response, as outlined in Instruction #9

LESSON EXTENSIONS

1. An artist known for his tessellating patterns is M. C. (Maurits Cornelis) Escher (1898–1972), whose ideas have been appropriated and used as tile work on the facade of the building shown here. Explore the tessellating artwork of M. C. Escher. Study his work carefully. Try to determine how he makes one shape morph into another. Make a photocopy or download two examples of a tessellating design created by Escher. Keep these with you while you work. Notice how one side of

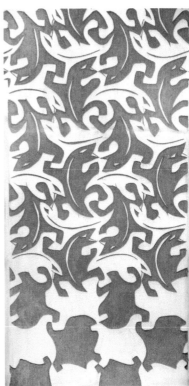

his design changes to fit into the next (slightly altered) pattern. Use the examples as inspiration in creating a tessellating design that gradually changes from one shape to another.

2. Long before Escher made tessellating designs popular to viewers, centuries of artists from a variety of cultures created tessellating patterns in tile, glass, clay, stone, and paint. Having created this assignment with cut-out pieces of paper, you may recognize how difficult it is to keep the motifs even and with all sides matching as the pattern extends over the length and breadth of the repeats. Today, this task can be completed with exact accuracy using digital software or apps. Try recreating your basic motif using a digital tool such as www .amaziograph.com. Compare the results with your handmade project. Given that the digital program can repeat your pattern motif with endless accuracy, which is most pleasing to your aesthetic sensibilities, the precisely repeated pattern or the one that shows the hand and natural errors of the artist?

Try modifying your original pattern or making a variation of it with the digital program and combining it with your original pattern into a single design. What role might variety and emphasis play in producing an intriguing or visually compelling design?

Left, Building facade at 14 Calle del Conde de Romanones, Centro District, Madrid, Spain, with example of M. C. Escher's *Metamorphosis II* as decorative motif. (Photograph by Luis Garcia [Zaqarbal]. CC BY-SA 3.0 US)

Right, Detail of building facade at 14 Calle del Conde de Romanones, Centro District, Madrid, Spain. (Photograph by Luis Garcia [Zaqarbal]. CC BY-SA 3.0 US)

Lesson 56: Complex to Simple

Cubism, a popular art movement of the early twentieth century, was characterized by the reduction of complex three-dimensional forms to arrangements of simplified, flattened **planes**. To arrive at these compositions, Cubist artists practiced a reverse visual engineering. Rather than beginning an artwork by drawing the underlying basic shapes of subjects, then fleshing them out with details, they sought to reduce simple forms to even more simplistic shapes and lines.

 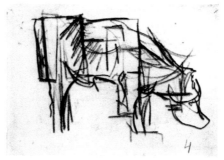

In this series of drawings, artist Theo van Doesburg demonstrates a progressive simplification of the structure of a cow from a realistic representation to a still-recognizable series of interlocking lines, cubes, and geometric forms. Theo van Doesburg (1883–1931), *Cow #1, #4,* and *#7* (from series of 8), 1918. Pencil on paper, 4½" × 6 5/16" (11.5 × 16 cm) each. Museum of Modern Art (MoMA), New York, NY.

Facing top, Liz Grey, *Black Landscape I,* 2005. Charcoal on paper, 12" × 16". (Courtesy of the Artist)

Facing middle, Liz Grey, *Black Landscape II,* 2005. Charcoal on paper, 12" × 16". (Courtesy of the Artist)

Facing bottom, Liz Grey, *Black Landscape III,* 2005. Charcoal on paper, 12" × 16". (Courtesy of the Artist)

Piet Mondrian (1872–1944), for example, studied the trunk and branches of a single tree for several years, painting it again and again in a series of Cubist works that began with clearly recognizable compositions: *Avond (Evening): Red Tree* (1908–1910), *Grey Tree* (1911), and *Flowering Apple Tree* (1912). With *Composition No. XVI: Compositie 1 (Arbres)*, painted in 1912/1913, Mondrian was beginning to move away from Cubism toward the entirely non-representational style of painting, **Neo-Plasticism**, for which he is most known. Mondrian discovered what many Cubist artists had found in deconstructing figures into simpler forms, that studies of this nature can assist one in understanding not only the underlying structures of real objects but also in discovering how shapes, lines, and colors work together to create harmonious visual compositions and designs.

INSTRUCTIONS

1. Begin by exploring how artists Van Doesburg and Mondrian visually reverse-engineered the structural compositions of their subjects. Study the progression of drawings by Theo van Doesburg (1883–1931) provided in this text. Also, search online or in art books for examples of trees from Mondrian's tree series, painted from 1908 to 1915. Scan or download and make photocopies of three examples of tree images by Mondrian that date from this period. Put the images in chronological order of their stages of simplification, and place them to the side as you continue with this lesson.

2. Select a clear picture of an animal, landscape, or *natural* object that has a complex visual structure. (*Do not choose images of man-made objects or buildings, as these are already simplified forms.*) You may select the image

from a magazine, or take a photo with your own photography equipment. The picture or photograph must show the object quite clearly, as a high-resolution image without blurring or other obstructions to a full view of the subject.

3. *Using a black and white medium only* (drawing pencils with soft and hard leads, black watercolor, or pen and ink), sketch the scene on a sheet of 9" × 12" watercolor paper.

4. Simplify the subject or scene by eliminating superfluous details while describing the more significant features of the subject.

5. Lay aside the photograph and, working with your first drawing as a guide, draw a second rendition of the subject. Remove any additional unnecessary details of the subject while seeking to describe the underlying structures of its most significant or outstanding features.

 a. Use only black and white media on a new sheet of 9" × 12" watercolor paper.

6. Refer to the second drawing of this series to inform your final drawing. Using only lines and geometric shapes, reduce the subject to a simplified, cubist-like composition that is still visually readable as the original subject.

 a. Use only black and white media on a new sheet of 9" × 12" watercolor paper.

7. Write a brief essay (300–500 words) describing the experience of reducing a visually complex subject to simple geometric shapes and lines.

 a. Try to imagine that you are living in the early twentieth century. Why might artists of this time have been fascinated with reducing complex forms to simpler geometric planes? Of what do these shapes and lines remind you?

b. What were you trying to *see* as you moved from one drawing to the other?

c. What difficulties in seeing did you encounter? How did you overcome these difficulties?

Material Needed

three sheets of 9" × 12" watercolor paper
drawing pencils in soft and hard leads
black watercolor and brushes, or pen and ink

Vocabulary

Cubism/Cubist
Neo-Plasticism/Neo-Plasticist
Plane

WHAT TO SUBMIT FOR EVALUATION

· three downloaded images from Mondrian's *Tree Series*
· the photograph (or picture) that inspired your artwork
· three progressively simplified black and white sketches of the photograph
· a written essay response, as outlined in Instruction #7

LESSON EXTENSION

The Cubist artists simplified colors as well as forms; or rather, colors were flattened and simplified to enhance the illusion of flattened planes. While light and shade help us visually read three-dimensional volume and form in an image, these were not concerns of the Cubists. Therefore, lights and darks were described as flattened sheets of color. You can see this, for example, in the famous painting *Three Musicians* (1921), by Pablo Picasso (1881–1973), or in *The Round Table* (1929), by Georges Braque (1882–1963). Search online to view these works of art and study the artist's uses of color in each.

· Create a still life of natural forms and rounded or cylindrical objects. Take a color photograph of the still life to share with others when presenting your completed work for this extension.
· Using black and white and color media of your choice, create a Cubist-like composition based on the still life.
· Pay particularly close attention to the role of color in your finished work.

Lesson 57: A Decorative Alphabet

Human communication has evolved to include **visual symbols** for ideas. Just as there are different languages among peoples, there are different kinds of alphabets with which people can communicate. In ancient times, people left messages for one another as **pictographs** on the surfaces of stone walls or clay tablets. Among various cultures these evolved into logographic or syllabaric forms of writing, such as cuneiform and hieroglyphic writing, hanzi and kanji characters, Arabic script, and Cyrillic and Roman alphabets. Additionally, symbols were developed for numbers and mathematical functions, and notions related to chemistry, astronomy, and music, and—most recently—as icons for technological functions and communications. These symbols have one important thing in common: they are **visual modes** of communication. Artists also have been fascinated by writing symbols as abstractive representations of things and have integrated letters, numbers, and words in their artwork.

Left, Psalterium letter, *Psalterium nocturnus* (17th century) from the convent of the Capuchins in Caltanissetta. Library Scarabelli, Caltanissetta, Italy. (Photograph by Oppidum Nissenae. CC BY-SA 3.0 US)

INSTRUCTIONS

1. Cut large pieces of heavy weight drawing or watercolor paper into six 4" × 4" squares.
2. Find a letter and/or number **font** that you like. You can find these by searching online, or from stencils available in craft stores. Enlarge the letters (using scanning or other digital means of enlarging) to approximately 2½" to 3" high. When traced or copied to the 4" × 4" square papers, there should be a border of about ½" to ¾" between the **letterform** and the edge of the paper.

Above, Charles Demuth (1883–1935), *I Saw the Figure 5 in Gold,* 1928. Oil, graphite, ink, and gold leaf on paperboard, 35½" × 30" (90.2 × 76.2 cm). Metropolitan Museum of Art, New York, NY.

3. Be thoughtful in selecting six letters that you wish to use. Trace or copy the outline of one on each of the six pieces of paper. There should be six different letterforms in total.

 a. Each letter should be large and placed within the square in such a way as to leave little dead space between or around individual letters.

4. Decide how you wish to complete the letter designs. For example, you may choose to cover the letters with **Zentangle** designs, make them appear to be three-dimensional by painting them as block letters with shadowing, or weave flower forms in and out of the letter forms.

 a. See the resource list of artists and book illustrations below for ideas of how your work might be decorated.

5. Use pencils, colored pencils, Sharpie pens, tempera paint, or any other color medium of your choice to complete each letter design.

6. Cut an additional six pieces of 4" × 4" square heavy weight drawing or watercolor paper.

7. For each of the six letters and/or numbers you have decorated according to the instructions above, draw an appropriate symbol or simple image. The size of the symbol or image should fit comfortably in the center of the paper—without too much or too little space left over between the object and the border.

8. Decorate these symbols or objects in a fashion that is consistent with the decorated letterform. Be imaginative and go for a surprising solution to this art design problem!

9. Arrange the best four letters and their matching symbolic forms in a square, and rubber cement them on larger heavy weight pieces of white or colored paper, cut to the size of 12" × 12" (or larger).

10. Use rubber cement or a glue stick to attach the squares to the larger paper.

 a. *Do not use white or gel glue!*

11. You may alternate the arrangement with a letter paired with an image, like a checkerboard, or use some other way of formatting the mounted images.

12. Write a brief essay (300–400 words) that explains the following:

 a. Where did you get the inspiration for the design you used to decorate your letters? (List the reference or resource if this is relevant).

 b. Why did you choose these particular letters? What do they mean to you?

 c. Why did you choose this particular imagery as illustration for the letterforms? What does it mean to you?

Katie Voytek, *Letter Sampler*.
Colored markers on paper, 10" × 8".
(Courtesy of the Artist)

Materials Needed

heavy weight watercolor paper,
 cut to 4" × 4"
heavy weight white or colored
 paper, 12" × 12" or larger
18" ruler
scissors or paper cutter

drawing pencils with soft and
 hard leads
eraser
color medium of your choice
rubber cement or glue stick
rubber cement eraser

Vocabulary

Font
Letterform
Pictograph

Visual Modes
Visual Symbols
Zentangle

- a completed and mounted pairing of four letters and their accompanying images
- two additional letters and object images that were not selected for use in the final mounted artwork
- a written essay response, as outlined in Instruction #12

LESSON EXTENSION

Create an entire decorative alphabet. Letters should be of a consistent size and presented in a way that is coherent. Each letterform and its background should work harmoniously with other letters and their background decorations.

Laurie Gatlin, Visual journal with pages of a decorative alphabet, 2013. *Right,* Watercolor and Sharpie marker on paper, 12" × 18"; *below,* Sharpie marker on paper, 18" × 22". (Courtesy of the Artist)

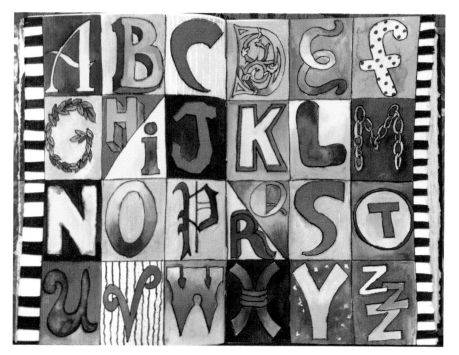

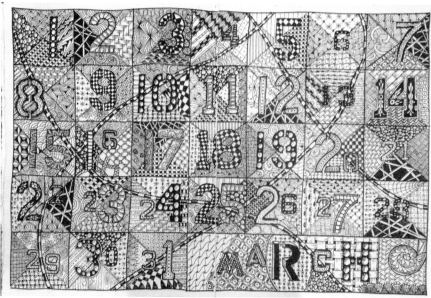

This project lends itself well to student collaboration. You could assign each student a different letter to design and illustrate. Encourage them to look for different ways of illustrating letters that they might find interesting. Consider objects that might be appropriate for the assigned letter. Draw and decorate that object. Then have students line up their letter and corresponding objects with one another to make a huge virtual class quilt.

Assign students to create letter and object images independently or as a collaboration. Rubber cement the letters and their accompanying images back to back so they serve as cards. Have more advanced students use the cards to help younger and less advanced students with letter recognition. Alternatively, collect the letter and number images and arrange them together in book form to be used or displayed in the classroom. Be inspired to create the book from one of the illustrated alphabet and number resources listed below.

Children's Alphabet and Number Books

- Base, G. *Animalia*. New York: Harry N. Abrams, 1993.
- Bataille, M. *ABC3D*. New York: Roaring Book Press, 2008.
- Guery, A., and O. Dussutour. *Alphab'art*. Frances Lincoln Children's Books, 2009.
- Johnson, S. T. *Alphabet City*. New York: Puffin, 1999.
- Johnson, S. T. *City by Numbers*. New York: Puffin, 2003.
- Pelletier, D. *The Graphic Alphabet*. New York: Scholastic, 1996.
- Pomeroy, D. *One Potato: A Counting Book of Potato Prints*. New York: Harcourt, 1996.
- Pomeroy, D. *Wildflower ABC: An Alphabet of Potato Prints*. New York: HMH Books for Young Readers, 2001.
- Seeger, L. V. *The Hidden Alphabet*. New York: Roaring Book Press, 2010.
- Van Allsburg, C. *The Z Was Zapped: A Play in Twenty-Six Acts*. New York: Houghton Mifflin Books for Children, 1987.
- Werner, S., and S. Foss. *Alphabeasties: And Other Amazing Types*. Maplewood, NJ: Blue Apple Books, 2009.
- Woops Studio. *A Zeal of Zebras: An Alphabet of Collective Nouns*. San Francisco: Chronicle Books, 2011.

Media and Techniques for Creating Decorative Letterforms

- Bruce, A. E. *Illuminations: A Lesson in the Art of Illuminated Letters*. http://hrsbstaff.ednet.ns.ca/kmason/images/Illuminations1.pdf.
- *Crayon Resist Illumination*. Incredible Art Department. Website. http://www.incredibleart.org/lessons/high/ken-illumination.htm.
- Fink, J. *Zenspirations*. Design Originals, 2011.

Books about Bookmaking

- Browning, M. *Handcrafted Journals, Albums, Scrapbooks and More*. Edison, NJ: Sterling, 1999.
- Doggett, S. *Bookworks: Books, Memory and Photo Albums and Diaries Made by Hand*. New York: Potter Crafts, 1998.
- LaPlantz, S. *Cover to Cover: Creative Techniques for Making Beautiful Books, Journals and Albums*. New York: Lark Crafts, 1998.
- Thomas, P., and D. Thomas. *More Making Books by Hand: Exploring Miniature Books, Alternative Structures, and Found Objects*. Beverly, MA: Quarry Books, 2004.
- Zamrzla, E. *At Home with Handmade Books: 28 Extraordinary Bookbinding Projects Made from Ordinary and Repurposed Materials*. Boston: Roost Books, 2011.

Lesson 58: Zentangle Delight

Do you ever find yourself doodling? Perhaps when sitting through a boring lecture or during a long phone call, you've absentmindedly scrawled abstract designs along the margins of a textbook, on the back of an envelope, or on scraps of notepaper. Seemingly unconscious doodling has been found to serve an important cognitive purpose. A study done in 2010 found conclusive evidence that doodling helps aid memory[7] and focus mental energies on information that is being received, perhaps by funneling distractive daydreams into imagery. In so doing, doodled insights and imaginative ideas function as symbolic expressions[8] arising from the wells of unconscious mind. Famous doodlers have included presidents, poets, authors,[9] artists, and mathematicians. Leonardo da Vinci doodled mechanical devices that anticipated modern inventions such as helicopter rotors and parachutes. While doodling during a boring mathematics conference lecture, Stanislaw Ulam looked back on his handiwork and realized he had come up with a visualization of prime numbers, which has come to be known as the Ulam Spiral. Young Jim Henson's whimsical doodles evolved into characters of the beloved Muppets of *Sesame Street*.[10]

Recently, doodles have evolved into an art form in their own right. Doodles called **Zentangles** involve the intentional use of repeating patterns in rather semi-random order. Maria Thomas and Rick Roberts are credited with having invented the term Zentangle as an extension of the term "Zen," when Maria noticed that the process of doodling seemed to transport her to "feelings of timelessness, freedom, well-being and complete focus on what she was doing with no thought or worry about anything else."[11] In this lesson, you are encouraged to extend natural doodling inclinations into Zentangles, combining conscious and unconscious energies in a creative decorative art form.

INSTRUCTIONS

1. Select an image of yourself or a loved one that will become the focal point of a Zentangle.
2. Scan the image and enlarge it (or manipulate the size of a digital image) so that when printed out and cut from the background, it will fit comfortably on a 9" × 12" piece of watercolor or heavy drawing paper, with plenty of space around it for the addition of a Zentangle. Lay the image aside
3. On a sheet of 9" × 12" drawing paper that is divided into 9 to 12 rectangles, practice making Zentangle patterns in each rectangle. These can derive purely from your own imagination, or you can search online for a variety of Zentangle patterns.
4. Decide on how you would like to apply the Zentangles to your photograph. Would you like to turn your hair into a Zentangle design, add a costume of Zentangles, or simply create a Zentangle background?
5. Having decided where you wish to add your Zentangle pattern, cut the photographic image from its background and attach it to a 9" × 12" piece

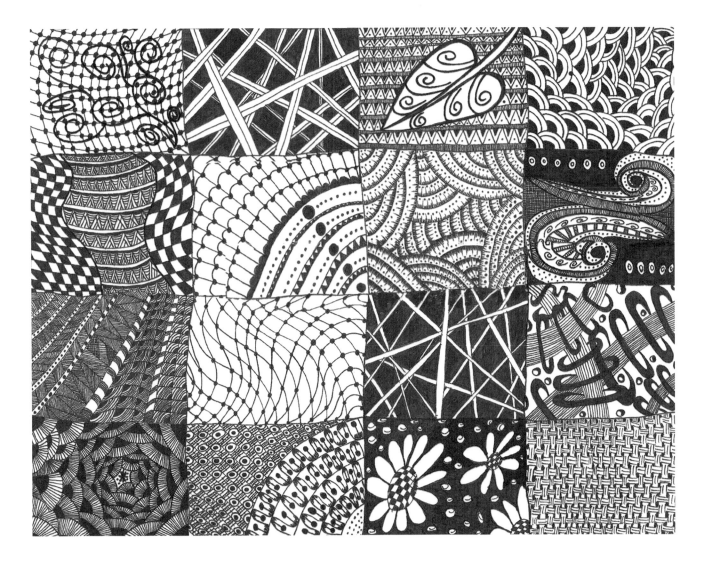

Heather Lund, A sampler of Zentangle patterns created with a Sharpie. (Courtesy of the Artist)

of heavy drawing or watercolor paper with rubber cement or a glue stick, leaving enough room to add the Zentangle. When attached, carefully clean all excess rubber cement residue from the paper.

 a. *Do not use white glue or gel.*

6. In pencil, sketch an outline of spaces where differing Zentangle patterns will be used. Then using colored pencils or a Sharpie pen, begin to add the Zentangles. Let your hand and mind flow freely—if a pattern begins to go in a different direction from the intended pattern, let that happen. If you make a mistake, make something of your mistake!

7. Continue working until all the background space of the image is filled with Zentangle patterns. Remember that a few patches of solid white or black can also be considered part of the Zentangle design.

8. Once finished, stand back from your finished work and reflect on what you see. Give a title to your work, based upon what the image suggests to you.

9. Write an essay (400–650 words) in response to the following:

 a. How did you plan to apply your Zentangle to your photograph? Did the finished work end up as you had planned? Explain.

Decorative and Graphic Design

b. Did you use the patterns that you developed on the practice sheet?

c. Did the designs change as you applied them?

d. Did you have to invent new designs as you were working?

e. Provide a narrative of how the patterns were used or altered, or evolved into something else.

f. Explain the title of your piece.

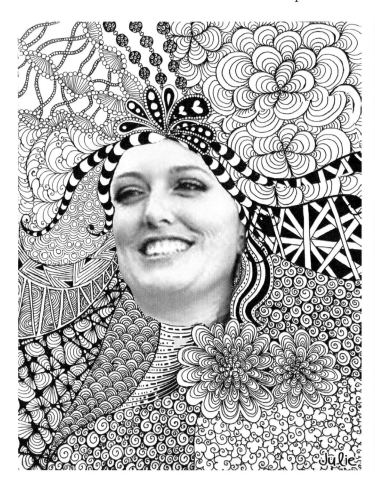

Above, Heather Lund, *Zen Hair.* Mixed media, 14" × 11". (Courtesy of the Artist)

Right, Joan Lancing, *Gypsy Bride.* Collage and digital media, 12" × 7¾". (Courtesy of the Artist)

Materials Needed

scanned or downloaded
 photograph of yourself
 and/or a loved one
drawing paper, 9" × 12"
watercolor paper, 9" × 12"
drawing pencils with soft and
 hard leads

eraser
rubber cement, or glue stick
rubber cement eraser
colored pencils
Sharpie pen

Vocabulary

Zentangle

· a sample sheet of Zentangle patterns
· your completed Zentangle project, as described in this lesson.
· a written essay response, as outlined in Instruction #9

LESSON EXTENSION

1. Using a stop motion camera or a digital camera mounted to a tripod, photograph images of your work frequently while the work is in progress. Be sure to place the drawing in the same spot each time you photograph it. This can be done if you make a tape outline indicating where the paper should be placed each time it is photographed.

2. Load the images into iMovie, MovieMaker, or another movie-making software program and turn them into an animated film. Add music if you like. Make sure you do not move the tripod with camera at any time during this process.

3. An example of a completed project, "Dancing Doodle," may be viewed at http://www.youtube.com/watch?v=Rv5ij0e7rQY&feature =youtu.be.

Alphabetic letters are building blocks of textual literacy in cultures all over the world. Holding a pencil (or a brush, pen, stylus, or piece of chalk) and guiding a line into a letter, then letters into words is an empowering skill. Each person who has learned to draw letters and words through the movement of his or her hand, with or without a writing tool, leaves a unique personal expression in the mark because like fingerprints, no two people will have exactly the same handwriting. Thus, writing allows individualistic expression not only in terms of what is written but also in the marks themselves.

Some educators suggest that with the prevalence of computer technologies, being able to write letters by hand is no longer a necessary skill. They argue that only the abilities to recognize standardized type and push tiny buttons in the correct sequence in order to replicate letters and word order are critical to textual literacy. While children may still be taught to form letters by hand for practical reasons (e.g., in case no word processor is available), the ability to make beautiful letter forms or write in script is seen as neither necessary to twenty-first-century literacy nor worthy of instructional time in the elementary classroom.

On the other hand, educators who argue for the teaching of handwriting in the elementary classroom point to research findings that suggest being able to manipulate lines and shapes into an integrated arrangement of letters or a script is critically important to cognitive development in reading.[12] Handwriting practice awakens parts of the brain that are stimulated by word recognition, encourages metaphoric thinking, and deepens conceptual understanding. Additionally, handwriting is a form of aesthetic self-expression.

Because letters may be modified greatly and yet remain legible, letters lend themselves to being perceived as **imagic** elements or **graphic designs**, as well

Below, Marjorie Cohee Manifold, *Deep Blue Sea,* 1995. Dr. Ph. Martin dyes and watercolor, mounted on gray paper, 9" × 11" overall. (Created by the Author)

Right, Follow the 'Y'ellow Brick Road, a student-made example of an imagic letter. Colored markers on paper, 12" × 9". (Courtesy of the Artist)

as text. They may be manipulated to express something about the characteristics or qualities of an object (or idea) described by the letter sound or a combination of letters. For example, if the idea to be conveyed is that R stands for Rabbit, the notion might be expressed symbolically by allowing a cartoonish image of a rabbit to suggest the letter. Likewise, a saxophone, which is often associated with jazz music, coincidentally has a form resembling the letter J and might stand in for that letter in a word play, while the form of a chameleon might be integrated into the letter C. In the examples provided here, one artist has integrated the image of a fish and the blue colors of the ocean into the letter D as concept cover for a book entitled *The Deep*, in reference to the sea. In a second example, the artist has synthesized the concept of the "yellow brick road" suggested by a popular children's story with the forked Y-shape of a road. In this lesson, you will manipulate alphabetic forms in ways that challenge recognition of the original letter while at the same time adding an additional layer of meaning to the message conveyed.

INSTRUCTIONS

1. Examine a letter of the alphabet whose shape resembles the shape of an object or refers to something that begins with the letter.

2. Look for interesting **letterforms** or **font** types. You could begin this search by looking at the fonts provided by your word processing software. Other interesting fonts can be found on sites such as 1001 Free Fonts, at http://www.1001freefonts.com/new-fonts-5.php.

3. Decide on a letter in that font that suggests an image to you, where the image relates in some way to the letter or the letter's sound. For example, the image may be of a concept or object whose name begins with the letter (e.g., C = calliope or G = gym) or one that alludes to the letter indirectly (e.g., jazz is often played on a saxophone and that instrument is shaped like a J).

4. Enlarge the letter before printing it out or enlarge it on a copier, to be used as a reference for your artwork. On 9" × 12" drawing paper make four thumbnail sketches of an **image-letter synthesis**, that is, as a letter-image graphic design.

5. Share your sketches with your peers and instructor for feedback. Which of the sketches suggests the most powerful, obvious, unusual, or intriguing synthesis?

6. Based on feedback and your own preferences, select the most successful sketch and redraw a large version of it on a sheet of 9" × 12" watercolor paper. Finish the work with a Sharpie pen, markers, colored pencils, or watercolors.

7. Write a brief essay (300–500 words) in response to the following:
 a. Explain how you searched for a font or created a font for your artwork and provide a citation of where it was found.
 b. How did you tackle the project? Did you begin with an object or letterform in mind? Were you inspired by a poem, the lyrics of a song, or a line from a literary work or a movie?

c. What feedback from peers and the instructor did you receive, and how did this influence your decisions about completing the letter-image synthesis?

d. How did you integrate or synthesize the letterform and image?

Materials Needed

drawing paper, 9" × 12"

watercolor paper, 9" × 12"

drawing pencils with soft and hard leads

eraser

Sharpie pens, colored markers, colored pencils, or watercolors

Vocabulary

Calligraphy	Image-Letter	Letterform
Font	Synthesis	Script
Graphic Design	Imagic	

WHAT TO SUBMIT FOR EVALUATION

· a copy of the font that inspired your finished project
· four thumbnail sketches of letter-image synthesis ideas
· a completed image of a letter-image synthesis design
· a written essay response, as outlined in Instruction #7

LESSON EXTENSION

Create an entire alphabet based on a single theme, with each letter associated with an object or idea of the theme. All letters should be of consistent size and be coherent with the theme.

Right, Ashley Langbehn, *Tropical Island Alphabet.* Colored pencil on paper, 12" × 15". (Courtesy of the Artist)

Facing top, A tughra is an Islamic version of a monogram, whereby the letters of an important person's name are worked into a beautiful imagic stamp or seal that is applied to all official documents. *Tughra (Official Signature) of Sultan Süleiman the Magnificent* (r. 1520–1566). Ink, opaque watercolor, and gold on paper, 20½" × 25 ⅜" (52.1 × 64.5 cm). Rogers Fund, 1938. Metropolitan Museum of Art, New York, NY.

Facing bottom, The basmala is a poetic phrase, "bismi-llāhi ar-raḥmāni ar-raḥīmi" (بسم الله الرحمن الرحيم) that can be translated as "In the name of Allah, Most Gracious, Most Compassionate." The basmala begins all but one chapter of the Quran, and is frequently worked into a calligraphic image. Here it is presented in the form of a pear. (via Wikimedia Commons)

Calligraphy, the art of writing beautifully, is a sacred tradition among peoples of many cultures. Children in Eastern nations were once taught to write in ink with flexible brushes, which had to be held at a constant angle to the hand and body. The slightest pressure or release of pressure on the tip of the brush widened or slenderized the stroke of the letter. Writing thus took great concentration and discipline, since the slightest variation of a brush stroke might change the meaning of a word or render the writing entirely illegible. In Islamic cultures, artist-writers developed several alphabetic styles and worked words and passages from sacred text, as well as names of important people, into images.

The ability to write one's own name and express oneself in written text is a joy experienced by all children who are fortunate enough to be schooled. Teaching handwriting to students would also be an excellent time to introduce them to the handwriting cultures of other children around the world. The following children's books are helpful resources:

- Aliki. *Marianthe's Story One: Painted Words; Marianthe's Story Two: Spoken Memories*. New York: Greenwillow, 1998.
- Goldstein, P. *Long Is a Dragon: Chinese Writing for Children*. Berkeley: Pacific View Press, 1991.
- Heide, F. P., and J. H. Gilliland. *The Day of Ahmed's Secret*. New York: HarperCollins Publishers, 1990.
- Louis, C. *Liu and the Bird: A Journey in Chinese Calligraphy*. New York: North-South Books, 2003.
- Louis, C. *My Little Book of Chinese Words*. New York: NorthSouth Books, 2008.
- Milton, J., and C. Micucci. *Hieroglyphs*. New York: Grosset & Dunlap, 2000.
- Olive, G. and Z. He. *My First Book of Chinese Calligraphy*. North Clarendon, VT: Tuttle Publishing, 2010.
- Rumford, J. *Silent Music: A Story of Baghdad*. New York: Roaring Book Press, 2008.

Do you remember learning to write your name? Can you remember how you felt when you recognized your printed name for the first time? If so, as an extension to this lesson, write about the experience of learning to write your name and illustrate your writing. Turn the result into an accordion fold book.

1. To make the accordion book, follow the instruction given in Lesson 89.

2. Write the story in handwritten **script** on three pieces of drawing or watercolor paper cut to the size of 3" × 5". Create three illustrations for the book that visually support the story.

3. If you or a parent has saved an example of your early handwriting, make a photocopy of the early handwriting, adjusting the size to fit onto a page or pages of the accordion book.

4. Arrange the pages of the written story and your illustrations in sequence and rubber cement these onto pages of the book.

5. Design a cover that combines a letter of the alphabet with an idea or object that describes your experience of learning to write.

Lesson 60: A Visual Pun

Synthesis may be defined as the combining of separate elements into a single, unified entity. **Imagic synthesis** is the joining of separate images or symbols into a new idea, or a **graphic design** that transforms the meanings of individual elements of the design. Graphic designers may use this technique in creating clever posters or advertisements that grab and hold viewers' attentions. Often the result is a **visual pun**, a play or joke that is derived from the unexpected interaction of images. The visual pun may result with or without the addition of words.

Left, Charleston Ballet Theatre, *Dracula* poster, 2012. Design and illustration by Gil Shuler Graphic Design, Inc. (http://www.gilshulergraphicdesign.com/), Mount Pleasant, South Carolina. (Courtesy of Gil Shuler)

Right, Shelly Gerber-Sparks, *Light House,* 2015. Mixed media, 9" × 6½". (Courtesy of the Artist)

Below, Kelsey Kilmer, *Eye-Phone,* 2015. Paper collage, 7½" × 11". (Courtesy of the Artist)

Look at the following examples of imagic synthesis. What images are combined and what new meanings are conveyed as a result of their combination? Notice that the symbolic images have been reduced to the most basic forms. Imagic synthesis is easiest to accomplish and tends to be most effective when the images selected are reduced to mere symbol. In this lesson, you are to think of two ideas that might be combined through imagic synthesis to convey a new idea. In order to keep the shapes of the image simple, you will work predominantly in cut papers rather than with pencil or paint.

INSTRUCTIONS

1. Think of a word or phrase such as "bottle-nosed dolphin" or "a bird in the hand," or the name of a musical album, movie, theater production, book, or other phenomenon of popular culture with a double entendre title, such as *Ant Man, Star Wars,* or *Imagine Dragons.* Come up with an idea for an interesting imagic synthesis of two objects or concepts.
2. Find images from magazines or from online sources of the two objects or ideas. Use these as inspiration for sketch ideas.

3. Create a minimum of three sketches on 9" × 12" drawing paper that simplify the objects to their barest possible forms, using no more than three colors plus a background color and combining the colored forms in intriguing ways.
 a. Avoid the use of words; let the images alone tell the story.
 b. Avoid puns that have been overworked conceptually, such as the Greek letter Π (pi) superimposed on an apple or pumpkin, a stick of butter with wings (butterfly), or an egg with horns (a deviled egg).
4. Share your sketches with your peers and instructor for feedback. Discuss technical issues such as proportion and simplification.
5. Based on feedback and your preference, choose one of the sketches that could be redone in cut papers.
6. Redraw the preferred sketch to fill most of a 9" × 12" sheet of drawing paper. This will be used as a template for cutting your colored pieces.
7. Decide what color will be the background color and which colors will be used for the imagic pieces. Your background paper should be approximately 9" × 12" in size. You may use construction paper or scrapbooking papers for the background and imagic forms.
8. Carefully trace the template pieces very lightly with a pencil. Cut them out and place them on corresponding colored papers.
9. Arrange all the pieces on the background and attach with rubber cement. Remove the excess rubber cement with a rubber cement eraser, and remove pencil marks with a pencil eraser.

Materials Needed

drawing paper, 9" × 12"
color paper (construction, scrapbooking, or kraft paper), 9" × 12"
colored pencils

drawing pencils with soft and hard leads
eraser
scissors
rubber cement
rubber cement eraser

Vocabulary

Graphic Design
Imagic Synthesis
Visual Pun

· three sketched variations of an original word-image concept or concepts
· a completed visual pun in collage that demonstrates clever originality

LESSON EXTENSION

· Using Photoshop CS6 or another illustration software, turn the visual pun project into a poster or CD cover.
· Scan your image and upload it into the software program. Add any details needed to clarify or complete the image.
· Add words or a title to reinforce, clarify, or contribute additional meaning to the image.

TIPS FOR TEACHERS

Use visual puns as a playful way of helping young children learn to read and spell words. Create a minimum of 24 colorful playing cards that feature visual puns comprised of commonly used words. Images for the cards can be made of collage or by using a digital art making program. Each image should be printed in color and mounted onto 3" × 4" cards. Create a second set of 48 to 72 cards that feature the words visually represented. Print out each word in a very large font size and rubber cement one word in the center of each 3" × 4" card. Then, using card games such as *Go Fish* or *Rummy* as a model, invite small groups of children to play games that require them to find and match appropriate words to the image cards.

Lesson 61: A Camouflaged Alphabet

There is an innate tendency among human beings to look for patterns in random phenomena. Organizing randomness into meaningful patterns is a way of making sense of the world. **Camouflage** is nature's way of confusing pattern, so the observer is thrown off guard and sees something other than what is there or mistakes one thing for another (see Lesson 129). For example, the mottled pattern of a lost tabby cat's fur allows the animal to blend in with the undergrowth of a hedgerow or patterns of a drapery, so that even if its owner were to look directly at the lost cat, it would remain hidden within its background. An opposite effect is **pareidolia**, a tendency to see meaningful images when they do not exist. A person might see the figure of a cat in the clouds, for example, or in crumpled linens or water stains on a ceiling.

Being able to distinguish patterns in the visual world is an important survival skill. Furthermore, manipulating alphabetic forms may benefit one's ability to discriminate specific patterns amid the background of visual clutter, which is in itself an important form of visual literacy. In this lesson, you are invited to hone your skills of observation and pattern recognition. The lesson requires that you find unintentionally meaningful shapes (pareidolia) in everyday objects.

INSTRUCTIONS

1. Walking around your neighborhood or in your home, explore the objects, shapes, and patterns that you see, including those that are created by effects of shadow and light. Using a digital camera, take close-up snapshots of patterns that resemble alphabetic **letterforms**. Find at least three letterforms, but challenge yourself to find as many as possible. Examine the images after you have taken them to make sure you have captured clear, sharp images.

2. Look online to find additional letterforms in pictures.
 a. Your project may be done in color or black and white.
 b. Letters can be arranged in alphabetical order or randomly.

3. After having collected a minimum of nine interesting letterforms, consider how you might organize them into a mosaic collage, with each image being cropped to a 3" square or a 3" × 4" rectangle.
 a. Use a photocopy machine to enlarge or reduce the photographs so the letters are approximately the same size within the square or rectangle.
 b. If additional images from online sites are added, print out all digital images to the same size as the photographs.

4. Arrange these images on a sheet of 9" × 12" watercolor paper and fasten them down with rubber cement.

5. Write a brief essay (300–400 words) that addresses the following questions:
 a. Where did you look and where did you find images for this project?

b. What were the challenges in finding letters in everyday life? Describe.

c. How did the process of finding letters involve dealing with camouflage and pareidolia?

d. Was one feature more prevalent in this work than the other? Explain.

Materials Needed

a digital camera able to export images for printing or scanning

printer for downloading images from the internet

9" × 12" watercolor paper

scissors

rubber cement

rubber cement eraser

Vocabulary

Camouflage

Letterform

Pareidolia

WHAT TO SUBMIT FOR EVALUATION

· copies of all photographs taken as inspiration or examples of camouflaged letterforms with information about where the images were found

· links to any downloaded images used in the completed collage

· a completed camouflaged alphabet collage using photographs and images of everyday objects or light phenomena that produce illusions of letterforms

· a written essay response, as outlined in Instruction #5

LESSON EXTENSION

An Alphabet Poster

In the lesson above, you were instructed to create a collage of nine letters of the alphabet. As a lesson extension, repeat the lesson but look for *all* the letters of the alphabet. Adjust the size of each image (with a scanner-enlarger or a software program) and print these out (in color or black and white) to about 3" × 5". Arrange the photographed letters on a piece of poster paper in order to fit the alphabet together. You may have to trim some letters to a narrower width and leave some wider in order to fit them onto the poster backing.

Use rubber cement to attach your letter images, and clean the excess rubber cement with a rubber cement eraser. Embellish the letters (with Sharpie pens, colored pencils) in a way that helps the viewer see the letters as seamless parts of the overall whole.

Alternatively, you can arrange the photographed letters digitally in a program such as Photoshop CS6. Have the completed poster printed out in black and white or color on cover weight paper to about 11" × 18." This can be done on a laser printer or by a commercial printing service.

Lesson 62: Machines and Structural Devices

Large tractors and semitrailers are present everywhere. Many are handsome pieces of machinery and have inspired some contemporary artists. Other large moving objects that are visually interesting include giant coal excavators, seagoing freighters, railroad locomotives, road construction machines, army tanks, and aircraft. Suspension bridges, overhead train tracks, cranes, electric transformers, and power lines can be equally dramatic but are less mobile. These large man-made objects can be a source of inspiration for artwork. In this lesson, you are to seek beautiful forms, shapes, or patterns in machines, manufactured objects, or man-made structures of steel and wire.

Laurie Gatlin, Sketches of electric poles from a sketchbook, 2010. Ink wash on paper, 12" × 9" each. (Courtesy of the Artist)

INSTRUCTIONS

1. Seek out examples of large equipment or structural devices that can be found near your home and take a minimum of six photographs of them.
2. Based on your photographs and observations, make multiple sketches of these from differing angles or viewpoints. Fill a minimum of four 9" × 12" sheets of drawing paper or sketchbook pages with examples.
 a. Consider using a **viewfinder** to assist in finding or isolating an interesting arrangement of lines, beams, or other forms to focus on in creating your sketched composition. Use the viewfinder feature

323

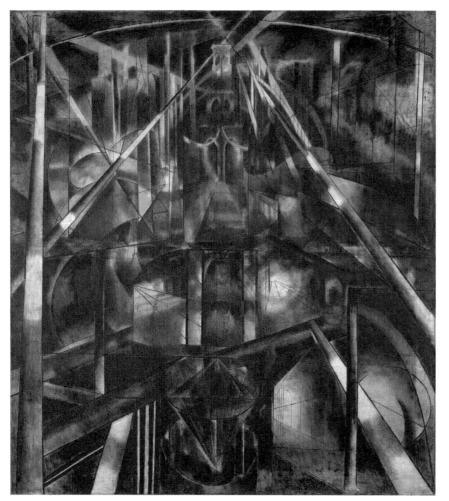

Wires and beam structural supports of the Brooklyn bridge serve as inspiration for a painting by Joseph Stella. Added colors describe a constellation-like mass of automobile lights reflecting against struts of the bridge and the night sky. Joseph Stella (1877–1946), *Brooklyn Bridge*, ca. 1919–1920. Oil on canvas, 84¾" × 76 ⅝" (215.3 × 194.6 cm). Gift of Collection Société Anonyme, Yale University Art Gallery, New Haven, CT. (Photo available from Office for Emergency Management, Office of War Information, Overseas Operations Branch. New York Office, News and Features Bureau (12/17/1942–09/15/1945), National Archives and Records Administration.)

of a digital camera, or make your own viewfinder out of heavy paper or cardboard. (For instructions on creating a viewfinder, see Basics of Creating Works of Art, near the front of this book.)

3. Include notes of where these devices are found and what they do. Make an educated guess if you do not know what function the mechanical device performs.

4. Make a detailed drawing of the object, using your sketches or snapshots for visual reference.

 a. Use black and white media (drawing pencils, black watercolor and brushes, or pen and ink) only.

 b. Make sure proportions, details, shading, and large and small shapes are correctly drawn.

5. Make a second drawing of the object from a different angle or viewpoint.

 a. Once again, make sure proportions, details, shading, and large and small shapes are correctly drawn.

6. Using a medium of your choice, add color to this second drawing.

 a. Many mechanical devices and structures are predominantly black and white in color. If that is true of the subject you selected for this second work, add color based on your imagination and aesthetic tastes.

Materials Needed

digital camera
drawing paper, 9" × 12"
drawing pencils with soft and
 hard leads

eraser
black watercolor and brushes, or
 pen and black ink (*optional*)
color medium of your choice

Vocabulary

Diagram
Viewfinder
Visual Journal

- six photographs of large machines and/or structural device found near your home
- four pages of sketches based on these photographs and your observations
- a completed black and white drawing of one of the subjects that was photographed and sketched
- a completed color drawing of the same subject from a different view-point or angle

LESSON EXTENSIONS

1. On a sheet of 9" × 12" white watercolor paper, create a drawing of a very large machine or machine-like structure. Include people in the composition in order to emphasize the size of the structure in relation to humans.

2. On sheets of watercolor paper cut to a uniform 4" × 5"–4" × 5 ½", create a series of eight to twelve drawings of a machine or structure from many different angles, using a handmade viewfinder or the viewfinder of your camera to isolate a section of the device that suggests an abstractive composition. Use color to enhance some of the drawings. Arrange the images in a visually appealing sequence and create an accordion fold book that features the series as content. (See Lesson 89 for instructions about making an accordion fold book.) Add front and back covers that feature additional images of the subject matter.

Including human figures makes evident the looming size of beams, stairs, and buildings in Gifford Beal's cityscape. Gifford Reynolds Beal (1879–1956), *Elevated, Columbia Avenue*, New York, 1916. Oil on canvas, 36½" × 48½". New Britain Museum of American Art, New Britain, Connecticut. (Photograph by Daderot, via Wikipedia Commons)

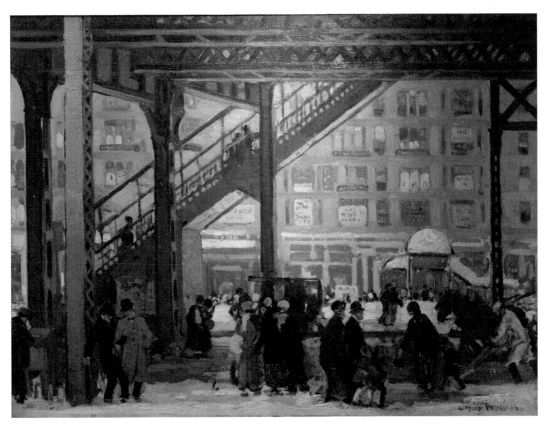

TIPS FOR TEACHERS

Observing Mechanical Functions

Students of science frequently are asked to keep **visual journals** of drawings made from observing nature or natural processes, but scientific illustrations also can be made of mechanical functions. Invite students to observe the work of levers, pulleys, valves, gears, cranes, and other machine parts. After observing these devices, students could draw **diagrams** of imaginary machines or structures that make logical use of specific mechanisms.

Colorful Machines and Structures

Huge machines and man-made structures can be fascinating subjects for child art production. Invite young students to observe and identify geometric shapes in these devices, then apply the shapes they find in creating a large artwork inspired by their observations. Provide large sheets of white or colored paper and oil pastels for students to use. Because the colors presented by many machines and structural devices may be limited, encourage students to use bright imaginary colors in composing their work. Ask students to consider and discuss how different colors change the overwhelming effect of massive machines or structures.

Unconventional Art Making Tools

Create a drawing of a large machine or man-made mechanism or structure using unconventional drawing tools. Use any sturdy paper stock, in white or a color of your choice, as background for the artwork. Select items that, due to their forms or the materials from which they are made, will constrain the types of lines you can make. For example, you could use Lego® bricks, Tinkertoy pieces, Hot Wheels cars, dowel rods, combs, or dinner knives and forks as printing tools or brushes in creating a print or painting of the structure. The resulting image will be determined by the parameters, limitations, or characteristics of the tools used.

Lesson 63: Poetic Weaving

Perhaps you remember learning to **weave** paper mats in primary or elementary school. Weaving presents important cognitive and motor challenges to young children. In this lesson, processes of weaving are combined with metaphor. In a sense, you might say this lesson requires a weaving of explicit image and implicit poetic meaning. For this project, you will combine memories of your life as these are revealed in old photographs with poetry that recalls the memory in mood or feeling, and you will weave these together visually and conceptually. Read the instructions carefully before beginning. This will permit you to preplan the visual elements and their relationship to meaning.

Marjorie Cohee Manifold, *Poetic Weaving of Vintage Photograph*, 2015. (Created by the Author)

INSTRUCTIONS

1. Look through old photographs of you alone or with family or friends, and select an image that brings back strong memories and emotions. Set the image (or images) aside while you move to the next phase of the project.

2. Select a poem that suggests the memory and mood of the photograph you have laid aside. It could be a poem that you composed or one written by another author. The length of the poem selected is not as

important as your internal responsiveness to it. Make sure it calls forth strong emotions and a sense of connection to you and the memory inspired by your photograph.

3. Scan the photograph or enlarge it digitally to a size that would fit comfortably in the center of a 9" × 12" sheet of watercolor paper. If the photo is in color, scan it in black and white, or digitally remove the color.

4. Print out two copies of the photograph on 9" × 12" papers.

 a. Don't worry if the printed images appear somewhat grainy; this could add visual texture to the completed work.

5. Divide a sheet of 9" × 12" watercolor paper into ½" strips. Cut the strips with a paper cutter; or, mark off ½" intervals along the length of the paper at the left and right of the sheet, connect the marks with a ruler and very light pencil lines, and then use scissors to cut the strips.

6. Carefully write one line of the poem on each strip. Use either pencil or ink. You may center the line of poetry as you wish. If the poem is very short, repeat lines so that each of the 18 strips contains at least one line of the poem.

7. Cut one of the photographs into 1" lengthwise strips and the second into 1" strips across the width of the photograph.

8. Lay various strips of the poem on top or beside the photo strips. Weave the strips as a mat or as a freeform arrangement. Move pieces around, change the size of the photo as needed, until you find an arrangement that is pleasing and presents a harmonious pairing of image and poetry.

9. Take a photograph of the arrangement before it is glued down and share the image with your peers and instructor for feedback. Does the composition exhibit evidence of harmony and unity? Is it aesthetically interesting? Does it convey the idea you intend?

10. Only when the composition works as an aesthetically pleasing and meaningful combination of poetry and photograph are you to rubber cement the weaving to a 9" × 12" watercolor paper backing. It is not required that you use all the photograph or poem strips.

11. If there are sections of the work that would be enhanced by color, add with colored pencils.

12. Write a brief explanation (300–400 words) of the poetically woven portrait:

 a. Describe the memory elicited by the photograph.

 b. How does the poem relate to the photograph?

 c. How and to what extent does one element deepen or broaden meaning of the other?

 d. If you used color, explain how it adds or strengthens the overall meaning.

 e. Give a title to your work.

Materials Needed

photograph, scanned or digitally
 enlarged to three sizes in black
 and white
watercolor paper strips, ½"
watercolor paper, 9" × 12"
18" ruler

scissors or paper cutter
pencil or ink pen
rubber cement
rubber cement eraser
colored pencils (*optional*)

Vocabulary

Weave/Weaving

WHAT TO SUBMIT FOR EVALUATION

- a scanned photograph that recalls a memory with strong emotional references
- a copy of a poem that harmonizes with the mood of the image, with a citation or link to its source
- a completed poetic weaving
- a written response, as outlined in Instruction #12

LESSON EXTENSIONS

1. Prepare a black and white photograph as described in the instructions above and cut into 1" strips. Weave the photograph with strips of white drawing paper that also have been cut to 1" widths. When strips of the photograph and drawing paper have been woven together, try one of the following:

 - Use drawing pencils with soft and hard leads to fill in the white squares with a drawing of what you imagine to be hidden behind the white square; match the shading values seen in adjacent squares.
 - Use colored pencils to add realistic or imagined color to all or some of the white squares.
 - Repeat this assignment with a colored photograph and sheet of white drawing paper cut into strips. Use black drawing pencils in soft to hard leads to fill in white squares with values that match the values—but not the colors—in the photograph.
 - Vary the widths of the strips used in weaving the photo and drawing paper, and add any other modifications suggested above.

Lesson 64: Maori Design—Kowhaiwhai

The **Maori** are an indigenous people of New Zealand. Many of their crafted items are decorated with a distinctive pattern known as **kowhaiwhai**. This **curvilinear** pattern builds upon the basic shape of the **koru**—or unfurling fern frond. The beautiful natural form of the koru was worked into many intricate kowhaiwhai patterns that adorn Maori canoes, oars, building supports, clothing, and sacred artifacts. Even the faces and bodies of the Maori people were often adorned with kowhaiwhai tattoos. The Maori favor these patterns, not only because they are graceful and lovely but also because the koru is understood as a metaphor for life that can take many directions and appear with great variety. While a koru symbolizes the beginning of a long and full human life, individual fronds of the koru also suggest the many individuals that make up a community, and the many communities or worlds that make up a universe. In this lesson, you will experiment with creating kowhaiwhai-like patterns that incorporate the koru.

Below, Koru shape of silver fern frond (*Cyathea dealbata*) in Rotorua, New Zealand. (Photograph by J Silver, 2007. CC BY 2.0)

Right, Maori carving showing kowhaiwhai pattern on forehead of a mask. The Treaty Grounds at the Waitangi National Reserve, New Zealand. (Photograph by Sids1, 2009. CC BY 2.0)

INSTRUCTIONS

Look closely at images of the koru or opening fern fronds. Notice how within the larger curved form there are many smaller, tightly curved shapes that resemble shells or circular bundles of seeds. Notice how the form and growth pattern of the koru adheres to the law of **Fibonacci** (see Tips for Teachers in Lesson 33). Imagine how this shape could be a motif that is repeated, intertwined, and turned back on itself in an allover pattern.

1. Practice making patterns that build upon these koru shapes by filling each of two pieces of 9" × 12" drawing paper with pencil drawings of a kowhaiwhai pattern.

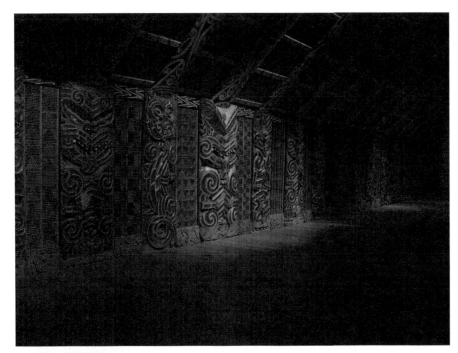

Hotunui carved meetinghouse, built in 1878, used as Auckland War Memorial Museum since 1920. New Zealand. (Photograph by Kahuroa, 2006, via Wikimedia Commons)

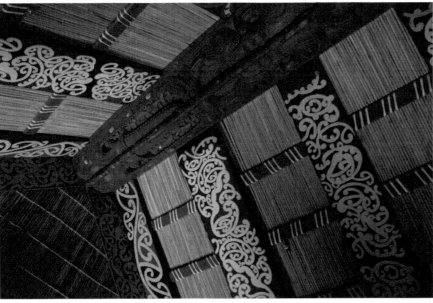

Ceiling of a Maori meeting house, with a carved *tahuhu* or ridgepole, and rafters painted in curvy kowhaiwhai patterns. Te Papa, Wellington, New Zealand. (Photograph by Tara Hunt, 2007. CC BY 2.0)

2. Fill each page with curvilinear lines that form **positive** and **negative shapes**.
3. Use brightly colored oil pastels or gel crayons to draw a kowhaiwhai pattern on a piece of 9" × 12" black construction paper.
4. Decide how you would like to fill in sections of the pattern with **visual texture**, shading, or combinations of colors in order to complete the pattern.

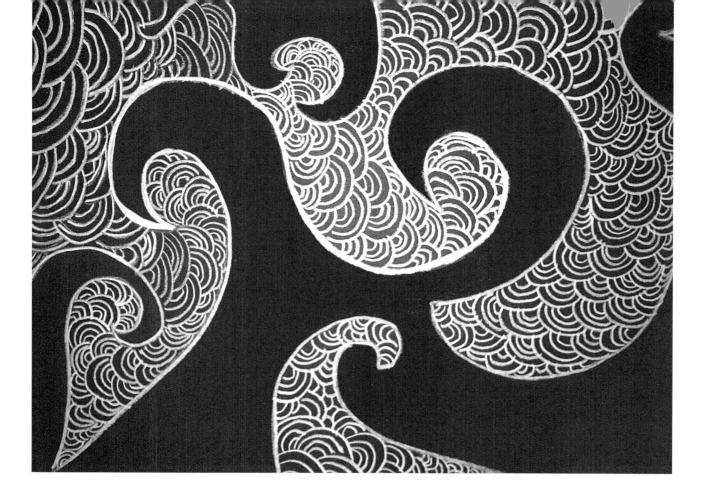

Bethany Herring, *Koru Design*. Oil pastel on construction paper, 12" × 18". (Courtesy of the Artist)

5. Write a brief essay (300–400 words) in response to the following:
 a. Describe the law of Fibonacci.
 b. Explain how your design reflects that law.
 c. Give a title to your design that describes how it is metaphoric of your life.
 d. Explain the metaphor.

Materials Needed

two sheets of white drawing paper, 9" × 12"
one sheet of black construction paper, 12" × 18"
box of oil pastels or gel crayons

Vocabulary

Curvilinear	Kowhaiwhai	Positive Shape
Fibonacci	Maori	Visual Texture
Koru	Negative Shape	

WHAT TO SUBMIT FOR EVALUATION

· two practice pages of curvilinear lines that form positive and negative shapes
· a kowhaiwhai pattern on black construction paper with additions of color, visual texture, or shading
· a written essay response, as outlined in Instruction #5

TIPS FOR TEACHERS

Designs Inspired by Local Environment

Kowhaiwhai designs are inspired by a shape that is familiar to and appropriated by the indigenous (Maori) people who live in New Zealand. Perhaps the plant form appeals to these people because its growth adheres to harmonious law of Fibonacci. The most successful kowhaiwhai designs also reflect this law of nature.

People throughout time and in every culture have been attracted to the natural world around them. Designs often reflect shapes and forms of plants, animals, and geographic features within people's local environments. Designs used to decorate pottery, clothing, and other artifacts help anthropologists and archeologists recognize objects as products of one culture or another. These contribute to the *aesthetic* characteristics of cultures. Invite students to notice differences in designs created by traditional cultures of Native American tribes who dwelt in deserts of the Southwest, Woodland regions, or the Far North. Ask students to speculate why these patterns are so different. What natural forms do they suggest? How are the aesthetic characteristics of clothing, footwear, and baskets or pottery different from one cultural group to another? Here are some helpful resources for studying design differences of these cultural artifacts:

- Appleton, L. H. *American Indian Design and Decoration*. Mineola, NY: Dover Publications, 1971.
- Corbin, G. A. *Native Arts of North America, Africa, and the South Pacific: An Introduction*. Boulder, CO: Westview Press, 1988.
- Starzecka, D. *Maori Art and Culture*. Chicago: Art Media Resources, 1996.
- Wilson, E. *Dover North American Indian Designs for Artists and Craftspeople*. Mineola, NY: Dover Publications, 1987.

Lesson 65: Papunya Dot Paintings

Art is central to Australian Aboriginal life and is linked to religion, serving as a connection between humans and their ancestors, the supernatural spirit world, and between past and present. A distinctive art expression created by the **Aborigines** of Papunya, Australia, describes their notions of the spirit world and aids their recall of places in the real world. In this lesson, you will look at images of these **Papunya** dot paintings and create a work of art that has been inspired by that style.

Lala Eve Rivol (active 1935), *Petroglyph*, 1935/1942. Lithograph on paper, 11 ⅛" × 14 ¹¹/₁₆" (28.3 × 37.3 cm). National Gallery of Art, Washington, DC.

The art of Australia's Aboriginal peoples centers around **Dreaming**. Dreaming is a term used to describe Aboriginal mythology and religion. For the Aborigine it explains the creation of the universe and a time beyond. It describes the creation of the landscape by supernatural beings and creator ancestors. Some Dreamings relate to particular places in the environment. Aboriginal dot paintings serve as maps of the physical world as dreamed by the spirit realm.

Papunya is a community of Aborigines located in a desert environment in central Australia. The Papunya Aborigines produce paintings on flat boards covered with dot designs and **symbolic** shapes. There is no horizon line, because the point of view is not looking across the landscape but from above the landscape, like an **aerial map**. **Concentric circles** may denote a site, waterhole, tree, cave, or fire. Wavy or straight lines may represent a path of water or the path of an ancestor or animal. U-shapes may mean seated figures, rods, or digging sticks. Fields of dots may represent smoke, burnt ground, rain, the feathery down of a bird, or may be read as musical scores for ritual songs.

1. Look in books or online to find many examples of Papunya dot paintings, explanations of these unique artworks, the artists, and the peoples who created them. Consider the following:
 a. What is the purpose of Papunya dot paintings?
 b. What do they tell us about the values and beliefs of the people who live in Papunya?
 c. Make photocopies or download two examples of dot paintings.
 d. Research the meanings and myths relating to the symbols seen in the images you have selected for reproduction.
2. Make a chart of some of the symbols you find in the paintings and write definitions beside each symbol.
3. Add to the chart some symbols that you have created to represent things important to your life experiences but not included in the repertoire of Papunya dot images.

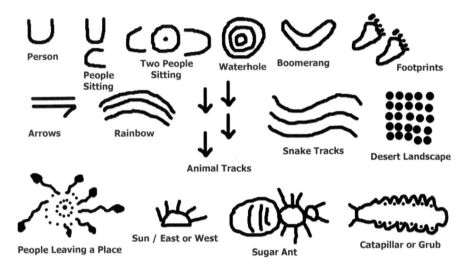

An example of Papunya symbols and their meanings. (Created by the Author)

4. Refer to the chart as you create your work.
 a. Think about a typical day in your life.
 b. Where do you go?
 c. What do you do?
 d. With whom and what do you interact?
 e. How do you feel about specific places and people you encounter during the day?
 f. How might your day look as a Dreaming map?
5. Plan a dot painting based on that day of your life.
6. The painting should appear as an aerial map of a walk or ride through the landscape of your day, and be completed in a style that suggests an Aboriginal Papunya dot painting.
7. You may use traditional symbols as seen in Papunya dot paintings as well as newly invented symbols that represent objects and features of your life landscape.

8. Lightly sketch the dream map on a piece of a brown paper bag or brown **kraft paper** that has been neatly cut to the appropriate size. Limiting the painting to four or five **earth-tone colors**, paint symbols at appropriate places within the composition.

9. Assign one color to show your path through the landscape and assign other colors to each type of object being represented.

10. Paint the rest of the picture, using the tip of the brush to create dots of color. Look at your examples of Aboriginal dot paintings to see how

Alexandria Lake, *Map of My Day*. Tempera on brown butcher paper, 16¼" × 20". (Courtesy of the Artist)

Bethany Herring, *Papunya Inspired Map of My Day*. Acrylic on posterboard, 13" × 16". (Courtesy of the Artist)

spaces inside and around the object symbols should be covered with dots.

11. Continue working until the whole surface of the paper is covered with dots of color.

12. In a brief essay, write responses to questions asked in Instruction #1 above and to the following questions (400–500 words in total):

 a. Explain the meaning or story behind the dot painting examples you copied for study.

 b. Explain the meaning of your own painting and describe the symbols you copied or created to tell your dream story.

 c. Include a chart describing the meanings of your symbols.

Materials Needed

brushes

tempera paint (colors should be
 mixed with white paint to make
 tints of earth-tone colors)

brown paper bag or brown kraft
 paper, cut to 11" × 14" or 12" × 18"

water and water containers

containers for mixed colors

Vocabulary

Aborigine Dreaming Papunya
Aerial Map Earth-Tone Colors Symbol/Symbolic
Concentric Circles Kraft Paper

WHAT TO SUBMIT FOR EVALUATION

· a chart describing meanings of the Papunya dots and invented symbols used in your painting

· a completed dot painting that maps a day in your life

· written responses, as outlined in Instructions #1 and #12

TIPS FOR TEACHERS

Maps as Symbols of Space

Maps are symbolic representations of space. The Aborigines of Australia used dot paintings as sacred representations of spiritual and geographic space. Mariners and travelers throughout history have relied on symbols and patterns in order to read their way through space. Invite students to look at examples of maps from many cultures and historic periods, and seek out the symbols used to designate direction, distance, geographic, and architectural features. How are these like or unlike Papunya dot paintings?

Lesson 66: Adinkra Stamped Cloth

Adinkra symbols are a form of visual communication invented by the Akan, an Ashanti (or Ashante) people of Ghana, West Africa, in the early nineteenth century. According to Ashanti legend, the symbolic forms were invented by a defeated monarch named Adinkra to express his sorrow at being taken captive. Whether or not the legend of the symbols' invention is based in truth, the meaning of the word *dinkra* is farewell, which implies a lasting separation, and mourners at funeral services typically wore draperies of adinkra cloth. Adinkra symbols also were associated with royal and spiritual leaders of the community.

Items decorated with adinkra symbols are not intended to be read as unfolding narratives; nevertheless, the symbols represent concepts, proverbs, or aphorisms. They evoke messages of traditional wisdom based on observations of life and the natural world. Meaning also is conveyed through color. Red, brown, and black denote mourning, while white backgrounds connote joy and celebration.

Examples of adinkra symbols with their names, which are concepts, proverbs, or aphorisms, and meanings of the symbols. (Created by the author)

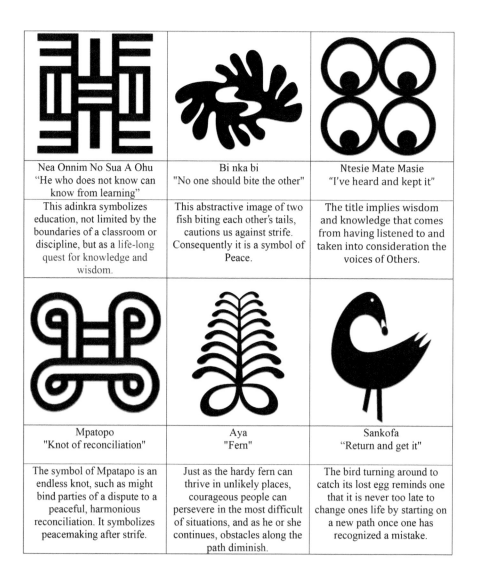

Nea Onnim No Sua A Ohu "He who does not know can know from learning"	Bi nka bi "No one should bite the other"	Ntesie Mate Masie "I've heard and kept it"
This adinkra symbolizes education, not limited by the boundaries of a classroom or discipline, but as a life-long quest for knowledge and wisdom.	This abstractive image of two fish biting each other's tails, cautions us against strife. Consequently it is a symbol of Peace.	The title implies wisdom and knowledge that comes from having listened to and taken into consideration the voices of Others.
Mpatopo "Knot of reconciliation"	Aya "Fern"	Sankofa "Return and get it"
The symbol of Mpatopo is an endless knot, such as might bind parties of a dispute to a peaceful, harmonious reconciliation. It symbolizes peacemaking after strife.	Just as the hardy fern can thrive in unlikely places, courageous people can persevere in the most difficult of situations, and as he or she continues, obstacles along the path diminish.	The bird turning around to catch its lost egg reminds one that it is never too late to change ones life by starting on a new path once one has recognized a mistake.

Traditionally, adinkra cloths were made by placing pieces of handwoven cotton fabric on the ground or on a mat of folded cloth bags, then stretching them tight with pegs.[13] Grid lines were drawn on the cloth to create sections for the stamps, which were made from calabash gourds that had been softened with shea butter for several months. A dye was made by boiling the bark of the Badee tree mixed with iron slag to form a paste called "adinkra medicine" (*adinkra aduru*). The stamp was pressed into the ink, then onto the cloth, and the process repeated until the overall pattern was achieved. One or more stamps could be used to create simple or complex patterns. Bright stitches could be added to emphasize grid sections of the pattern.

In this lesson, you are to print a pattern of adinkra-like symbols on cotton fabric. However, you will use stamps made with commercial materials and fabric paints rather than the bark, handmade fabrics, and dyes used in Ashanti tradition.

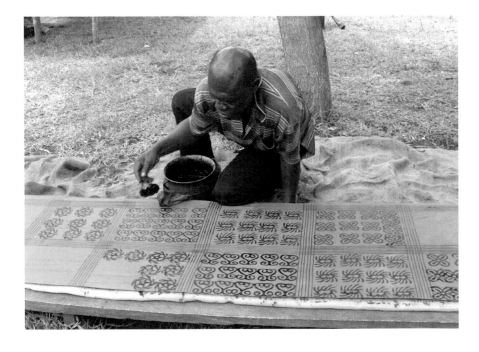

A master craftsman printing traditional adinkra symbols. Village of Ntonso, Ashanti Region, Ghana. (Photograph by ZSM, 2012. CC BY-SA 3.0 US)

INSTRUCTIONS

1. Consider what type of message you want to communicate through adinkra-like symbols. Is it a feeling of love and longing for someone lost to you, admiration for someone who has mentored and advised you, or advice for a peer or a child?
2. Research the meanings of adinkra symbols and find at least two symbols with which you resonate in terms of image and meaning. Make copies or download these and set aside as inspiration for your work.
3. Brainstorm personally meaningful, original adinkra-like symbolic form by sketching six ideas on 9" × 12" drawing paper. These should be original symbols that convey ideas or concepts that are expressive of you and your experiences, hopes, or dreams.

4. Share your original sketches with peers and your instructor; explain what they mean to you. Listen to feedback.

5. Select two of the sketches that would be most appropriate to use in an adinkra-like cloth design and edit the sketches as suggested by the feedback you received.

6. Tape a 12" × 12" piece of pre-washed cotton fabric[14] or unbleached muslin on a hard surface that has been protected by newspaper or a plastic cloth.

7. Use a pencil and ruler to create a 1½" border all around the cloth. Within the 9" × 9" square that is left, mark off 3" × 3" squares. You should end up with nine internal squares.

8. Use rubber erasers or small easy-to-cut printing blocks, such as E-Z Cut, Soft-Kut or Speedball Speedy-Cut Easy blocks, as media for carving three or four adinkra or adinkra-like symbols.
 a. Two of the symbols should be original designs that hold personal meaning for you.
 b. The other one or two should be symbols that have recognized Ashanti meanings.

9. Plan out a pattern using repeats of the stamps.

10. Roll a small amount of printers' ink on an inking plate and smooth out the ink with a brayer. Use a color of ink that reflects the intended mood of the design.

11. Roll the ink across the small printing block and press it onto the cloth.

12. Continue in this manner until all nine sections of the cloth have been printed.

13. Set aside your printed fabric as you clean up your printing materials and work area.

14. Write a brief essay (300–500 words) reflecting on your work.
 a. What were you hoping to say through this project?
 b. Describe the meanings of the traditional adinkra symbols you selected and the ones you created. How do they interrelate?
 c. What decisions did you make about the appropriateness of both traditional and original adinkra symbols in your artwork, and why?

Materials Needed

white drawing paper, 9" × 12"

drawing pencils in soft and hard leads

eraser

18" ruler

masking tape

cotton fabric or unbleached muslin, 12" × 12" (pre-washed)

materials for creating stamps, such as gum erasers, Styrofoam,

Soft-Kut, E-Z or Speedball Speedy-Cut Easy printing blocks, 3" × 3" or 3" × 4½"

fabric printing ink

printing plate

brayer

newspapers or plastic cloth for keeping work area clean

Vocabulary

Adinkra

Fix/Fixed

WHAT TO SUBMIT FOR EVALUATION

· two downloaded images of adinkra symbols
· six or more sketches of personally meaningful, original symbols
· a completed fabric pattern of nine sections that utilizes three or four of
 the selected or created images
· a written essay response, as outlined in Instruction #14

TIPS FOR TEACHERS

Teaching students to make natural dyes from local plants combines social studies and science learning in the classroom. Prior to the invention of synthetic dyes in the late nineteenth century, all dyes were created from natural materials such as nuts, berries, flowers, and tree bark. These materials are eco-friendly, thus reinforcing a practice of living harmoniously with one's environment. Introducing students to dye making requires that they be able to identify various locally available plants and understand chemical processes, such as how dye colors are made permanent or **fixed** by applying salt or vinegar.

Conduct your own research about natural dyes before introducing the topic to students. You will need to know which plants are available in your area and when they may be harvested, which are safe to use, how they are prepared, what materials may be dyed, and how colors are fixed. Resources for teaching about natural dyes and other environmentally friendly art supplies include the following:

· Neddo, N. *The Organic Artist: Make Your Own Paint, Paper, Pigments, Prints and More from Nature*. Gloucester, MA: Quarry Books, 2015.
· Senisi, Ellen B. *Berry Smudges and Leaf Prints: Finding and Making Colors from Nature*. New York: Dutton Juvenile, 2001.

Resources for teaching about adinkra and other African textiles include the following:

· Gillow, J. *African Textiles: Color and Creativity across the Continent*. London: Thames & Hudson, 2009.
· McDermott, G. *Anansi the Spider: A Tale from the Ashanti*. New York: Henry Holt and Company, 1987.
· Mitchell, R. *The Talking Cloth*. New York: Scholastic, 1997.
· Owusu, H. *African Symbols*. Edison, NJ: Sterling, 2007.
· Spring, C. *African Textiles Today*. London: The British Museum Press, 2012.
· Willis, W. B. *The Adinkra Dictionary: A Visual Primer on the Language of Adinkra*. New York: Pyramid Complex, 1998.

Lesson 67: A Design Sketchbook

Where do engineers and designers get ideas for designing working machines, architectural structures, fashions, fabrics, furnishings, crafted objects, and **decorative designs**? Objects in the natural and built environment may serve as imagic resources for **functional** and **applied designs**. Inspiration may be found in observing the architectural structure of objects or the ways light and shadow, water, wind, fire, ice, and aging affect the appearances of objects.

Double-page spreads of sketchbook pages, by students of art teacher Yvette Hughes, The Brooksbank School, UK. (Courtesy of the Artists)

Artists and designers often keep **visual journals** in which they sketch interesting **motifs** and patterns they observe. These sketches may spark ideas for constructional designs or decorating patterns applied to objects and artifacts.

What are some commonplace yet intriguing patterns or designs that you encounter in your daily life, and what applications could be made of these? The structure of a spider web might suggest a way of constructing or linking buildings so they could withstand powerful winds or earthquakes. The arrangement of panes in a cathedral window might conjure ideas for fabric designs or the

An accordion fold book of design, by a student of art teacher Yvette Hughes, The Booksbank School, UK. (Courtesy of Yvette Hughes)

construction of a birdcage. Shadows falling across a bedspread or the flicker of flames from a candle might inspire glaze patterns for a ceramic vase. Even before an artist or designer knows or suspects how an image from everyday life could be usefully applied to a functional artifact, sketching in a visual journal keeps him or her alert and open to imaginative possibilities. In this lesson, you are to prepare and keep a five-day visual journal of patterns found in natural and man-made objects.

For this lesson, you may use a purchased sketchbook or sheets of graph paper, white or colored drawing paper, watercolor or textured papers as foundation for your sketches. As drawing media, you may use drawing pencils with soft and hard leads, colored pencils, colored markers, pen and ink, or watercolors and brushes.

1. On day one: Look around the interior of your home to find three examples of motifs, patterns, or designs in objects, juxtapositions of objects, shadows, or other visual phenomena. Use a viewfinder to isolate a section that presents an appealing pattern or design. Sketch what you see on a paper and in a media of your choice. Make notes indicating where the pattern was seen and what it represents.

2. On day two: Look around the exterior of your home to find three examples of motifs, patterns, or designs in objects, juxtapositions of objects, shadows, or other visual phenomenon. Use a viewfinder to isolate a section that presents an appealing pattern or design. Sketch what you see on a paper and in a media of your choice. Make notes indicating where the pattern was seen and what it represents.

3. On day three: Follow the instruction above in recording three examples of designs found in nature.

4. On day four: Follow the instruction above in visually describing three examples of designs found in architecture within the area around your home or place of work.

5. On day five: Follow the instruction above in sketching three examples of designs from any source of your choice.

6. On day six: Look carefully at all 15 of your sketches, and organize them into a sequence.
 a. The sequence should invite the eye of a viewer to move from one pattern to another by following a visual logic or aesthetic element that you identify.
 b. Set aside three of the least compelling patterns or ones that do not contribute to the visual flow of the sequence of images.

7. Once a sequence of 12 images has been decided upon, use an **accordion fold** technique to create an **accordion fold book** of watercolor paper or another heavy weight paper. (See Lesson 89 for instructions for making the accordion fold book.) Cut each of the 12 selected images of patterns to uniform sizes that will permit them to fit and be displayed on pages of the accordion book.
 a. Be aware that the first and last images of the sequence will become the covers of the accordion book.

8. Rubber cement each of the images to a page of the accordion book. Clean excess rubber cement away with a rubber cement eraser.

9. Look carefully at the results of your work.

 a. Are there lines or spaces that might be enhanced by modifications such as darkening lines with markers or Sharpie pens, creating more intense colors, attaching collage pieces, or painting some sections with watercolor?

 b. Insert notes indicating where the pattern was seen and what it represents as part of the overall design of the pages.

10. Write a brief essay (300–500 words) reflecting on your work:

 a. What were your considerations in selecting papers and media to use in sketching patterns?

 b. What were your considerations in selecting patterns to be sketched? What did you look for? What caught your attention?

 c. Describe the visual elements you discovered or considered in arranging a sequence of designs that connected to one another in a coherent and harmonious way.

 d. If you were to refer to these sketches as inspiration for decorating new objects, to what objects might they be applied?

11. On a sheet of 9" × 12" drawing paper, create three thumbnail sketches illustrating applications of one or more of your patterns to a functional object or as an applied design.

Materials Needed

watercolor paper, 12" × 18"

sketchbook drawing paper, sheets of white or colored drawing paper, graph paper, or textured papers of your choice. Sheets of paper should be large enough to allow them to be cut to fit the pages of an accordion book.

drawing pencils in soft and hard leads

color medium of your choice

eraser

18" metal-edged ruler

scissors or paper cutter

rubber cement

rubber cement eraser

ribbon for book ties (*optional*)

Vocabulary

Accordion Fold

Accordion Fold Book

Applied Design

Decorative Design

Functional Design

Motif

Visual Journal

WHAT TO SUBMIT FOR EVALUATION

· a completed accordion book with 12 pages of design-based prompts, as given in Instructions #1 through #5

· a source list of the 12 used and three unused designs collected according to prompts given in Instructions #1 through #5

· a written essay response, as outlined in Instruction #10

· three thumbnail sketches of design applications, as indicated in Instruction #11

Lesson 68: Carried Away by Design

Vehicles are fascinating devices. Not only do they permit us to transport objects and ourselves over greater distances than would otherwise be possible, they also may serve as symbols of status. Elaborate, sleek, quick, or uniquely designed machines attract admiration and display the good taste and prosperity of the owner. When we are carried by or within a conveyance, that vehicle serves as an extension of the self, and people derive pleasure from adorning this self-extension. Thus, peoples of many cultures throughout history have attended to the decorative design elements as well as to the functionality of transportation vehicles.

Prior to the mass production of automobiles and before the invention of gas-powered engines, transportation devices were designed and made by individual craftsmen who brought their personal design tastes and engineering knowledge to bear in creating one-of-a-kind products. Individual owners might contribute to the uniqueness of their vehicles by embellishing them with painted designs, hanging lanterns, or other decorative features. Since vehicles have come to be mass-produced, many owners still enjoy adding personal design touches to their machines. In Western cultures, this commonly takes the form of decals or stickers on windows and bumpers, painted stripes, or flame details. In some folk societies and non-Western cultures, decorative

Below left, Parade vehicle, Ciyou Temple Mazu Cruise Parade, 2009. Songshan District, Taipei, Taiwan. (via Wikimedia Commons)

Below right, Janis Joplin's 1965 Porsche at the Rock and Roll Hall of Fame, Cleveland, OH. (Photograph by Sam Howzit, 2007. CC BY 2.0)

Bottom left, Custom-painted car found abandoned along Highway 191 in Monticello, UT, 2012. (Photograph by Kool Cats Photography. CC BY 2.0)

Bottom right, 1963 Chevrolet Impala convertible with hydraulics, *Just Klownin' Virginia Car Club,* 4th of July parade. (Photograph by Jarek Tuszynski. CC-BY-SA-3.0)

additions might be quite elaborate and complex. Look at these examples of decorative modifications. Why do you think owners of these vehicles felt compelled to modify them in these ways? Would you enjoy driving or riding in such a vehicle? How might riding in this vehicle feel differently than riding in a vehicle with a standardized appearance?

For this lesson, you are to permit your imagination to expand and flow. What if it were commonplace for people to modify their vehicles as lavish self-expressions? What kind of vehicle would you possess, and how would you decorate it?

INSTRUCTIONS

1. Begin this project by considering the type of vehicle and the exterior (and interior) form of machine you would like to modify. Would you prefer to own and modify a houseboat or a jet plane? Would you look to a classic car of the past, like a 1952 Ferrari, a 1958 Bonneville, or a 1963 Corvette Stingray? Or would you prefer a modern vehicle, like a Hummer or a Sea-Doo Watercraft?

2. Find a vehicle you could imagine owning, and download four to six images of it. These should show the vehicle from multiple angles, including the side, front, and back, and include important details.

3. On sheets of either 9" × 12" or 12" × 18" drawing paper, sketch the car from at least four angles, trying to capture its unique form, and practice adding various **decorative motifs** to the car form. Your sketches should indicate what the vehicle looks like from the front, back, and side, or above. Consider how the design would transition from one section to another.

4. Select the decorative motif that is most interesting and that demonstrates coherence and fluidity as your eyes moves from one section of the car to another.

5. Draw two views of the vehicle on one or two sheets of 12" × 18" watercolor paper.

6. In any medium, decorate the vehicle profusely with motif patterns and designs you have determined to be the most interesting and coherent. Express something of yourself and your personality in the decorations.

7. Write an essay (300–500 words) in response to the following:
 a. Why did you choose these particular decorative motifs? How are they relevant to you?
 b. Imagine yourself traveling in this decorative device. Where would you go (e.g., would it only be used for special occasions or be used every day)?
 c. How might traveling in such a vehicle affect your perceptions of self and the world around you?
 d. What might be the benefits and drawbacks to our contemporary society if it were acceptable for people to decorate transport machines in the exuberantly expressive way you have chosen to

decorate this vehicle? For example, consider whether it might affect the status of a person, depending on the decorations they chose. Might it contribute to traffic jams and accidents if people were to stop and stare at a remarkably decorated car? Might more people be interested in living in house boats if they were decorated? Would planes be easier to spot from a distance if their patterns stood out against the clouds, or could they be camouflaged from above by blending in with patterns of the earth? Would this matter?

Materials Needed

drawing paper, 9" × 12" or 12" × 18"

watercolor paper, 12" × 18"

drawing pencils with soft and
 hard leads

eraser

color medium of your choice

Vocabulary

Decorative Motif

WHAT TO SUBMIT FOR EVALUATION

· four downloaded or photocopied images of a vehicle you would like to modify, showing the vehicle from several angles
· four thumbnails sketches of the vehicle from front, back, and side, with decorative details applied in a coherent way.
· two completed color drawings, informed by your best two sketches that include detailed decorative applications
· a written essay response, as outlined in Instruction #7

Facing top, Oxen yoked to a decorated cart, Costa Rica. (Photograph by Chad Rosenthal. CC BY 2.0)

Facing middle, Traditionally decorated camel against background of the Great Pyramid of Giza (Pyramid of Khufu) and Pyramid of Khafre. Giza, Cairo, Egypt. (Photograph by Mstyslav Chernov. CC-BY-SA-3.0)

Facing bottom, Map of Wadi Hammama from Al-Qusair to Qift. (Courtesy of Kelvin Case. CC BY-SA 3.0)

TIPS FOR TEACHERS

Prior to the invention of gas-powered engines, people relied heavily on beasts of burden to assist them in moving from place to place across land. Just as personal vehicles are cared for and decorated today by the people who own them, domestic beasts of burden were cared for by their owners, who often created elaborately decorated accessories for them. Some of the accessories were aimed at making the difficult work of pulling carts in summer or sleighs in winter more comfortable. Other accessories were protective devices for animals carrying their owners into battle, or celebratory decorations to announce a triumphal event. Domesticated animals that served as beasts of burden or means of transportation included oxen, goats, horses, donkeys, elephants, camels, and llamas. Invite students to explore the animals that have been enlisted as beasts of burden in differing regions of the world. Encourage the students to critically consider the following questions:

· Were all beasts of burden made to wear decorative accessories? If not, which animals would have been decorated and which would not? How might this have defined their roles?

· Which animals and what circumstances encouraged people to create decorative coverings or trappings for an animal?

· What do these practices tell you about how the people of this culture or region felt about their beasts of burden?

Explore more deeply and determine:

· How much weight could one of the animals (described above) comfortably carry?

· Where were they required to carry this weight?

· What routes were the animals obliged to follow?

· How far could an animal carrying this weight travel in a 12-hour period?

· At this rate, calculate how long it would take a camel to carry its load across the northern route from Peking to Palmyra[15] along the Silk Road, or for a horse to carry its owner along the central route from New York City to Los Angeles.[16] What factors, other than distance, might cause delays?

· If a car today was driven at 60 miles per hour for 12 hours a day over the same route, how long would it take to drive the northern route from Peking to Palmyra, or the central route from New York City to Los Angeles?

· Why were particular animals used in specific regions, such as camels in Saudi Arabia, water buffalo in Viet Nam, or horses on the American plains?

· What jobs did they perform for their masters?

· How did their owners typically treat them?

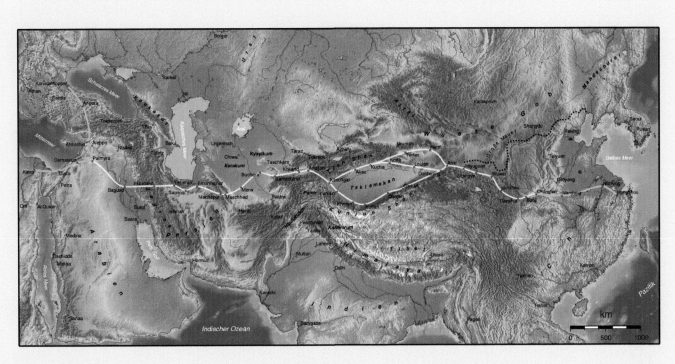

Lesson 69: Futuristic Transportation

Realizing that customers desire vehicles that combine practical considerations of safety, speed, comfort, and utilitarianism with aesthetic qualities, manufacturers work with designers to develop concept automobiles, motorcycles, boats, and planes that will attract buyers. Successful designers combine knowledge of art and engineering with imagination and creative anticipation of what people will want and need in the future. Because putting together a machine that is functionally and aesthetically coherent is a complicated process, teams of designers, who focus on exterior, interior, or decorative elements of the vehicle, often work with technical engineers to develop **concept illustrations** and **prototypes** of new machines.

This work begins with brainstorming sessions, during which necessary attributes of the vehicle are identified. For example, perhaps there is a need for a single-person vehicle that is compact enough to fit into tight spaces and traffic-clogged narrow streets. The vehicle must protect the driver from extreme weather conditions and not become stuck in snow or mud. It should be strong enough to protect the driver in case of accidental impact, yet lightweight and fuel efficient. Will alternative fuels, wind, or solar energy power it? The interior must block extreme noises from the outside without masking the sounds of emergency sirens.

Engineering considerations are also kept in mind. If the machine operates on wheels, how far apart must they be to maintain balance and functionality? Could the vehicle move properly with only two or three wheels rather than four or more? Perhaps there is an alternative to wheels; what other way could the vehicle move? What type of fuel will be used, and where will it be stored? What type of engine is needed, and where will it be located in relation to the driver or passengers? These specifications are kept in mind as designers sketch out ideas.

Early design drafts of the ICE-T front car, 1994. Alexander Neumeister (1941–). (Courtesy of Alexander Neumeister, via Wikimedia Commons)

In this lesson, you are to imagine yourself a designer of a new mode of transportation. Be futuristic in your thinking. What type of vehicle will be needed by the end of this decade or century? What demands made by energy, highway infrastructures, economics, changes of personal lifestyles, and aesthetic tastes might influence your design?

INSTRUCTIONS

1. Begin by brainstorming the required specifications of your design. Indicate the type of vehicle you will design and who will use it (e.g., a single-person, two-person, or family car; a light truck for farming use; a motorcycle, flying military boat, or something else). Other specific considerations should include the following:
 a. power or fuel source
 b. mode(s) of movement (e.g., moving across land, hovering, flying, moving through water)
 c. interior space and comforts
 d. exterior space and features (e.g., light, fuel access, modes of entrance and exit)
 e. accessories such as trunk space, sunroof, racks for luggage or bicycles
2. On 9" × 12" drawing paper, make at least four thumbnail sketches of the exterior appearance of the vehicle.
3. Select the most interesting of the sketches and create six sketches on 9" × 12" drawing paper that show the vehicle from several angles, such as side view, back view, front view, overhead view, and interior space or detailed areas.
4. Add labels to the sketches to indicate specifications indicated in Instruction #1 above, such as solar fuel cells, storage compartment, flip-out wheels, wings or pontoon floats, etc.

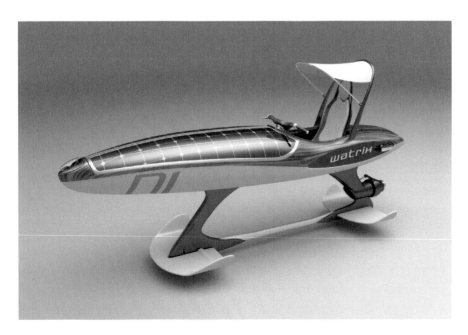

The Watrix hydrofoil (watercraft), 2014. Created by Charles Bombardier (1974–) and designed by Jan Metelka (1973–). (Courtesy of Charles Bombardier, via Wikimedia Commons)

5. Select two views that would impress potential customers. Redraw these on 9" × 12" or 12" × 18" watercolor paper and finish the drawings with a color medium of your choice.

6. In a brief essay (300–500 words), explain the following:

 a. Why and by whom might this vehicle be used in a decade or two from now?

 b. What would life a decade or two from now be like, so as to make this vehicle necessary?

 c. What practical features does this vehicle make use of that would be appropriate to an environmentally sustainable future?

 d. What aesthetic features would make this desirable to the owner and/or user?

 e. Give the vehicle a name.

Materials Needed

white drawing paper, 9" × 12"	eraser
watercolor paper, 9" × 12" or 12" × 18"	18" ruler
	color medium of your choice
drawing pencils with soft and hard leads	

Vocabulary

Concept Artist	Prototype
Concept Illustration	Visual Futurists

WHAT TO SUBMIT FOR EVALUATION

· a brainstormed list of specifications, as indicated in Instruction #1, for a vehicle you will design
· four thumbnails sketches of the overall vehicle design
· six labeled sketches of the machine from differing angles
· two completed color images of the machine from angles that best show off the vehicle
· a written essay response, as outlined in Instruction #6

LESSON EXTENSIONS

Those who design transportation devices for the future may work in teams that include visual futurists or **concept artists** and engineers, such as the six-person Mazda Research and Development Design Team that created the Mazda KAAN,[17] a conceptual race car powered by an electro-conductive polymer. Individual visual futurists do not always work for companies that create vehicles for actual use. Visionary artists conceive many conceptual illustrations of futuristic vehicles for science fiction films and computer games. You can see examples of their work in movies such as *Star Wars*, the *Star Trek* television series, and at expos or exhibitions of futuristic designs. Some examples of conceptual designers and **visual futurists** include

- Émile Delahaye (1843–1905)
- Ettore Bugatti (1881–1947)
- Norman Bel Geddes (1893–1958)
- Syd Mead (1933–)
- Michael Najjar (1966–)
- Mikhail Smolyanov (contemporary)
- Nick Kaloterakis (contemporary)
- Kazim Doku (contemporary)

As an extension of this lesson, look at the work of two artists or teams of artists who design futuristic machines of transportation. Select one artist (or team of artists) from the past who envisioned vehicles for the twenty-first century. Then, select one contemporary artist or team of artists who imagine vehicles for a present and future society. Download an example of a vehicle created by each of the artists (or team of artists). Compare the two ideas and designs and consider the following:

1. How could the work of the earlier artist-designer inform designs of vehicles we actually use today?
 a. Would this design of the past look modern today? Why or why not?
 b. What did the futurist designer accurately predict about life in the early twenty-first century?
 c. What was the earlier artist unable to foresee?
2. Compare the work of the earlier artist with the work of a contemporary visual futurist artist or team of designers.
 a. How does futurist art of the past influence that of the contemporary futurist? Explain.
 b. Do the vehicles rely upon similar fuel sources or energy systems?
 c. Do they address similar life needs?
 d. Are there aesthetic similarities?
 e. What differences in society were not foreseen by earlier artists that are addressed by contemporary visual futurists?
 f. How might these change or be changed by current global events?

Top, Model of Teardrop car, 1933. Designed by Norman Bel Geddes (1893–1958). (Photograph by A.Van Dyke. CC BY SA 3.0)

Middle, Peugot Flux (prototype), 2007. Peugot design concept by Mihai Panaitescu (1986–). (Photograph by LSDSL. CC BY 2.0)

Bottom, Holden Hurricane, 1969. Holden (General Motors), Research and Development section of the Engineering Department at GMH (General Motors-Holden) Technical Centre, Fisherman's Bend, Melbourne, Australia. (Photograph by Sicnag. CC BY 2.0)

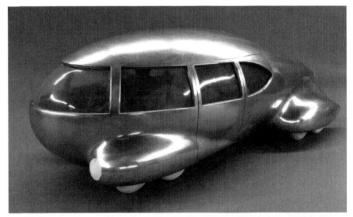

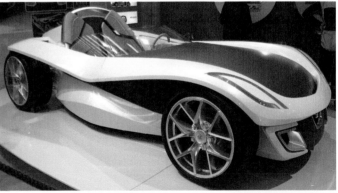

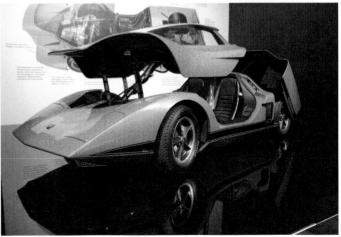

Inviting students to design a vehicle or machine stimulates cognitive problem-solving and design-related thinking skills. Encourage students to work in teams to design the exterior of a vehicle or machine and then build a model of it. Use cardboard from kitchen appliances along with hot glue and packing tape to hold it together. The images below show the progressive development of a DeLorean "Time Travelling Car," designed and constructed by upper elementary students of art teacher Charlotte Neal, in the United Kingdom.

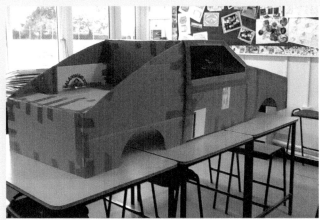
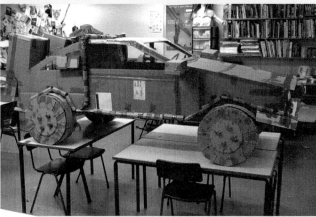
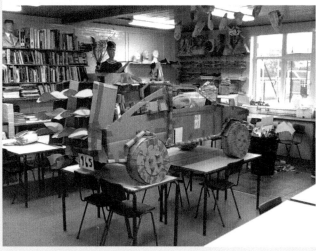
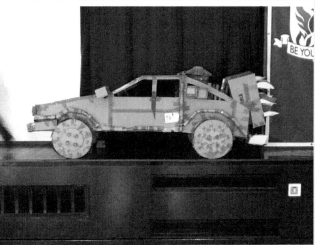

Cardboard Delorean, created by students of art teacher Charlotte Neal, UK. (Courtesy of Charlotte Neal)

Lesson 70: Designing a Logo

A **logo** is a sign or symbol that identities the owner, producer, or manufacturer of a product or company in a way that's easy to recognize. Strong logos communicate important information in a simple way. This simplicity permits them to retain clarity in different contexts and sizes, whether seen on billboards, T-shirts, or letterheads. Additionally, excellent logos will subconsciously connect with a target audience in a positive way.

Although logos must be simple, this does not mean they are easy to design. In fact, coming up with an excellent design is quite challenging. It requires attention to the many **Elements** and **Principles of Art** in the following ways.

- **Color**: Logo designers must consider the meanings of colors and the emotions they convey. Does the color relate to or suggest the product or company in some way? In order to focus the viewer's attention, variations of color should be kept to a minimum. No more than three color hues or color values should be used.
- **Positive and Negative Space**: Do these spatial elements interrelate in a significant way? For example, can negative space be used in such a way as to suggest a missing portion of positive space?
- **Formal Balance**: Whether a logo is symmetrically or asymmetrically designed, it should be formally balanced.
- **Proportion**: If there is more than one item in the logo and one item is to be considered more important than another, the more important element should be proportionally larger than the less important item.
- **Rhythm**: Diagonal lines or a repetition of elements can suggest rhythm or movement. This can be an important factor in logos of products that involve movement in some way.
- **Dominance**: Some logos benefit from applying the principle of dominance, that is, emphasizing a portion of the logo that should first attract the eye.
- **Unity**: All the parts of the logo should interact harmoniously and appear unified.

INSTRUCTIONS

1. Begin by imagining a business or company for which you would like to create a logo. Perhaps this is a business you would like to own. Be as specific as possible in identifying the business, such as a pastry shop, jewelry store, veterinary clinic, or music business.
2. On the side of a sheet of 9" × 12" drawing paper, makes notes about the type of business for which the logo will be designed and indicate some significant symbols that suggest the business. For example, if you are considering a logo for a music business, musical notation or instrument shapes might be logical symbols to incorporate.
3. Brainstorm ideas and create five thumbnail sketches of potential logos.

Franz Marc (1880–1916), *Lizards*, 1912. Woodcut in black on gray-green Japanese paper, 3 ⅜" × 3 ⅜" (8.6 × 8.5 cm). National Gallery of Art, Washington, DC.

Heather Babbin, *Logo*. (Courtesy of the Artist)

355

a. In thinking of these possible designs, refer to the Elements and Principles of Art listed above.

b. Remember to avoid small details, as these will be lost when the logo is reduced to the size of a letterhead or business card.

4. Share your sketches with your instructor or peers and seek feedback about which seems the most compelling, visually pleasing, positively evocative, easy to read, and applies the Elements and Principles of Art in such a way as to clearly communicate the idea of the intended business.

5. Select the sketch that is determined to be the most effective and interesting logo and redraw it large on a 9" × 12" sheet of watercolor paper; center the logo to fill most of the paper.

6. If the logo is to be black and white only, use a black Sharpie pen or marker to complete to logo. If color is used, limit it to a maximum of three colors in a medium of your choice.

a. Alternatively, scan the drawn logo and upload to a software program like Photoshop CS6 or Illustrator. Clean up your drawn lines and fill in colors with tools of the program.

7. Scan (or save) and print out the logo in at least three different sizes, appropriate to a letterhead, brochure cover, and sign, so as to visualize how the logo would work in several contexts.

8. In a brief essay (300–500 words), respond to the following:

a. Identify the product or company for which the logo has been created.

b. Explain how aspects of the logo design relate to or reflect the product or company.

c. Indicate the Elements or Principles of Art that were important considerations and how these are appropriate to the design.

d. Describe problems that had to be resolved during the course of the design process and explain how you addressed these problems.

Hank Powell, *Logo for a Music Production Company.* (Courtesy of the Artist)

Materials Needed

drawing paper, 9" × 12"
watercolor paper, 9" × 12"
drawing pencils with soft and
 hard leads
eraser

black Sharpie pen, or color
 medium of choice
scanner (*optional*)
illustration software such as
 Photoshop CS6 or Illustrator
 (*optional*)

Vocabulary

Color (Hue)	Formal Balance	Principles of Art
Color (Value)	Logo	Proportion
Dominate/	Motif	Rhythm
Dominance	Negative Space	Unity
Elements of Art	Positive Space	

WHAT TO SUBMIT FOR EVALUATION

· five thumbnail sketches of possible logo designs
· a completed logo design in three sizes. The logo must reflect the nature of the intended business, have visual impact, use the Elements and Principles of Art effectively, and convey necessary information in the simplest possible way.
· a written essay response, as outlined in Instruction #8

Anonymous student, logo design.
(Courtesy of the Artist)

LESSON EXTENSION

As an extension, use the logo as a **motif** for an all-over design that would be appropriate for a fabric design or applied design on a product associated with the logo's business. Create the design using a stamp made from a square gum eraser, Styrofoam, or soft printing blocks such as E-Z Cut, Soft-Kut, or Speedball Speedy-Cut Easy blocks (see Lesson 66 for printing instructions), or repeat the motif in a digital program. Consider slight color changes of the motif to add variation to the pattern.

Lesson 71: Package Design

Package design has become a feature of modern industrialized society. An obvious purpose of packaging is to allow customers to recognize a product and its manufacturer, and to be so visually alluring so as to entice customers to purchase the items contained within. Package designers, however, must be conscious of a number of factors beyond visual appeal. Good packaging must

· keep products clean,
· make items easier and less expensive to transport,
· allow for accurate and consistent measurements of contents,
· protect items from unpleasant or unhealthy physical changes (such as oxidation, insect infestation, or being crushed),
· make it easy for marketers to track and inventory items, and
· be visually appealing.

In many cases, packaging also might

· reinforce positive self-identities of the buyers.

Designers will consider how members of the target audience want to think about themselves. For example, the packaging of makeup might reassure a buyer of her youth and beauty, while the presentation of an organic food item might invite buyers to think of themselves as health-conscious and environmentally responsible consumers by assuring them that the materials within are healthy and the packaging biodegradable.

Below, Coulommiers, a soft-ripened cheese made from raw cow's milk and produced in the Seine-et-Marne department of France. (Photograph by Myrabelle, 2010. CC BY-SA 3.0 US)

Right, Apples from Hong Kong, wrapped in Styrofoam net. (Photograph by Hinghungroups. CC BY-SA 3.0 US)

Designers must take into account not only how a product will be presented by its packaging but also the context of the space where the package will be displayed. Will this item be displayed as one of many possible choices of similar products? Will it be displayed at eye level or from a distance? Will it be displayed in a lightly or dimly lit environment? Will shoppers be in a hurry,

or are they more likely to be in an environment where they can shop at leisure? Will they likely shop while being bored, hungry, or engaged in some unrelated activity?

INSTRUCTIONS

Part I

1. Begin this lesson with a bit of preliminary research. First, go to a department store that specializes in small but expensive products, such as beauty products or perfumes, cookware, small electronics, tobacco and cigars, pocketknives, golf balls, or music boxes.

2. In many cases, you will find displays of the actual products outside of their packages. Consider why marketers would display floor samples of the actual products rather than simply display packaged items on a shelf. If the packages containing these items are not also visibly displayed, ask to see them. Make notes about what you see.

3. Write a report in response to the following questions. While no word parameters are given for this report, each question should be answered thoughtfully.

 a. If the product is displayed outside its packaging, why do you think a sample product is made available to customers rather than just as a packaged item? List as many reasons as possible.

 b. Is an image of the product shown on the package, or is there simply a logo or some other marking? Why?

 c. What **Elements of Art** (line, color, shape, etc.) has the designer used to try to make this item stand out from other similar items produced by other manufactures?

 d. Based on the packaging alone, would you be attracted to purchase this item? Why or why not?

 e. How is the product displayed? For example, are items on a shelf or in a bin with other similar products, or displayed on a special stand with accessories to highlight the product? What does this tell you about the actual value of the item or the way the manufacturer wants you to think about its value?

 f. Does the placement or display of this item make it more or less attractive to you? Why?

Bryggkaffe (brew coffee) packaging and product design by Stig Lindberg (1916–1982). (Photograph by Johan Löfgren, 2010. CC BY-SA 3.0 US)

 g. Create a thumbnail sketch of the item and package to attach to this report.

4. Go into a supermarket or grocery store and examine various types of packages on display. Select one package that attracts your attention.

 a. Is an image of the product within the package depicted on the package? If so, answer the following questions:

 Do you think the actual product will look like that image? If not, in what way might the product differ in appearance from its image?

 Does the package include images other than or in addition to the product, such as an image of a celebrity, brand mascot, cartoon, animal, or person? What is the figure shown doing?

 Which image is larger, that of the product or the figure?

 How is the brand name displayed on the package?

 b. What Element(s) of Art has the designer used to try to make this item stand out from other similar items produced by other manufactures?

 c. What considerations of product protection (from crushing, decay, bacteria, etc.) are evident from the packaging?

 d. Where is the product situated in the store? Is it located near the cash registers, in the center of a well-lit area, in a central aisle where people must pass by on the way to someplace else, or at the back of the store?

 Why do you think the product was located here?

 Create a simple map of the store showing the approximate location of the package in relation to major sections of the store and types of items placed therein.

 e. Draw a thumbnail sketch of the item in its package to add to this report.

5. Compare the two packages examined in this section of the Instructions.

 a. Do both provide protection to the products they contain?

 b. Why are they visually different or similar?

 c. What does this tell you about the characteristics of these products, the purposes for which they might be used, and the potential customers of these products?

Part II

6. Brainstorm a type of product for which you might like to design a package. On sheets of 9" × 12" drawing paper, create at least five thumbnail sketches showing what the front and back of the package for this item might look like.

7. Consider the following:

 a. You may design a product for an imaginary or a known company, but aside from the actual brand name, your design must be entirely original.

 b. Will you show the product on the package? Will you add a character? If so, what will the character look like?

8. Select four sketches (two versions of the package front and two of the back) that you find most appealing.

9. Share your sketches with your peers and instructor for feedback about the best front and back package designs. Adjust these two sketches to address their advice or concerns.

10. Redraw the preferred front and back designs on pieces of 9" × 12" drawing paper, making each section as large as possible.

11. Complete the drawing in a medium of your choice. On either the front or back, add important information such as barcode, net weight, company brand logos.

12. Write a brief essay (300–400 words) explaining your package design:
 a. What is the product for which it was designed?
 b. Why did you make these particular aesthetic choices regarding the package?
 c. Which Elements of Art did you consider in making your package appealing to customers?
 d. What other considerations of packaging (e.g., keeping the product clean, being easier and less expensive to transport, providing accurate and consistent measurements of contents, protecting items from unpleasant or unhealthy physical changes) were important to your design?
 e. Where would you advise that your package be displayed? Why?

Materials Needed

drawing paper, 9" × 12"
drawing pencils in soft and hard leads
eraser

Vocabulary

Elements of Art
Green Packaging

WHAT TO SUBMIT FOR EVALUATION

- a written comparison of two packages with responses to questions posed in Part I of Instructions
- five thumbnail sketches showing ideas for the front and back of a package design
- two sketches fleshing out a favorite front and back package thumbnail idea
- completed drawing showing the front and back of a package, with information as indicated in Part II of Instructions
- A brief written essay response, as outlined in Instruction #12 (Part II)

Green Packaging

Environmentalists have criticized the overuse of plastics and other non-recyclable materials in packaging of goods. These find their way to landfills, are discarded on the ground, or pollute rivers, streams, and oceans. Considering ways to safely package consumable goods so they fulfill all the requirements of good packaging while also being environmentally sound is a major problem facing engineers and designers. One way to lessen the problem of packaging pollution is to use recyclable materials. However, recycling addresses only one aspect of the problem. Those who design **green packaging** must also consider ways of making packages with fewer raw materials, using materials that disperse naturally and harmlessly into the environment, and lowering the amount of energy needed to manufacture a product, since the use of heavy equipment and machinery generates thermal pollutants. Invite students to select an item that requires packaging and have them grapple with the problem of designing an environmentally safe and visually appealing package.

NOTES

1. L. Gatlin, "A Living Thing: Towards a Theory of Sketchbooks as Research" (Abstract) (doctoral diss., Indiana University, Bloomington, IN, 2014), ProQuest, UMI Dissertations Publishing, http://search.proquest.com/docview/1287093779.

2. E. Lear, "The Owl and the Pussycat," in *Nonsense Songs, Stories, Botany, and Alphabets* (London: R. J. Bush, 1871).

3. G. F. Melson, *Why the Wild Things Are: Animals in the Lives of Children* (Cambridge, MA: Harvard University Press, 2005).

4. *One Hundred and One Dalmatians* (animated film), directed by C. Geronimi, C. Luske, and W. Reitherman, and produced by W. Disney (Burbank, CA: Walt Disney Productions, 1961; reissued in 1969, 1979, 1985 and 1991).

5. *Jaws* (motion picture film), directed by S. Spielberg and produced by R. D. Zanuck and D. Brown (Universal City, CA: Universal Pictures, 1975).

6. "Relativity (M. C. Escher)," *Wikipedia*, https://en.wikipedia.org/wiki/Relativity_(M._C._Escher).

7. Jackie Andrade, "What Does Doodling Do?" *Applied Cognitive Psychology* 24, no. 1(2010): 100–106, doi:10.1002/acp.1561. March 12, 2009, retrieved June 10, 2011.

8. J. L. Read, "Doodling As a Creative Process" (1997), Enchanted Mind.com, http://www.enchantedmind.com/html/creativity/techniques/art_of_doodling.html, retrieved March 16, 2017.

9. E. H. Gombrich, "Pleasures of Boredom: Four Centuries of Doodles," in E. H. Gombrich, *The Uses of Images* (Phaidon: London 1999), 212–225.

10. See A. Inches, *Designs and Doodles: A Muppet Sketchbook* (New York: Harry N. Abrams, 2004).

11. "History of Zentangle," Ridgewood Centre Wellness Group, http://www.ridgewoodcentrewellness.com/ZentangleHistory.aspx.

12. See Saperstein Associates, *Handwriting in the 21st Century? A Summary of Research Presented at Handwriting in the 21st Century? An Educational Summit* (White Paper, 2012), https://www.hw21summit.com/media/zb/hw21/files/H2948_HW_Summit_White_Paper_eVersion.pdf.

13. Cotton dyed black or brown was used for somber occasions. Otherwise, plain undyed cloth could be used.

14. It is important to pre-wash purchased fabrics in order to assure the *sizing* has been removed. This will permit the ink to soak into and stick to the fibers of the fabric.

15. Approximately 4,594 miles; see Google maps.

16. Approximately 2,904 miles; see Google maps.

17. Members of the research team included Jacque Flynn, Carlos Salaff, Minyong Lee, Greg Less, Tim Brown, and Jordan Meadows. See "Mazda KAAN" at Tuvie.com, http://www.tuvie.com/mazda-kaan-futuristic-electric-car-concept-to-compete-the-e1-races/

4 · Art and Narrative Imagination

Before the invention of writing, drawn images were used to communicate ideas and tell stories about human experiences. Art and narration are natural partners. Pictures can tell stories tacitly, while verbally or textually conveyed stories benefit from the aid of visual illustrations. Images stimulate imagination and may bring ideas to visual reality. In this section, lessons are presented that draw upon, relate, or support communication of real or imagined stories.

FEATURED ARTIST: JAMES HUNTLEY

As an undergraduate student at Indiana University, James Huntley double-majored in fine art and journalism. This combination supported an understanding of images and text as interactive elements of storytelling. After graduation he applied his skills as a computer graphic illustrator and journalist for a news service and Fortune 500 company before leaving the United States to live for six years in Asia. While studying Chinese painting in Taiwan, he developed a love for teaching, and eventually returned to the United States to work as an artist-educator.

James Huntley's artworks are inspired by experiences of travel throughout the world. His work in traditional, digital, and mixed media is influenced by the places he has seen and people he has met along the way. "My ideas are taken from imagination, memories, and observation of journeys both in the mind and the world," he states. Many of his works also are dominated by *fado*, a tacit sense of longing more commonly articulated through a Portuguese form of music that is characterized by distinctively bittersweet tunes and lyrics about life among ordinary folk.

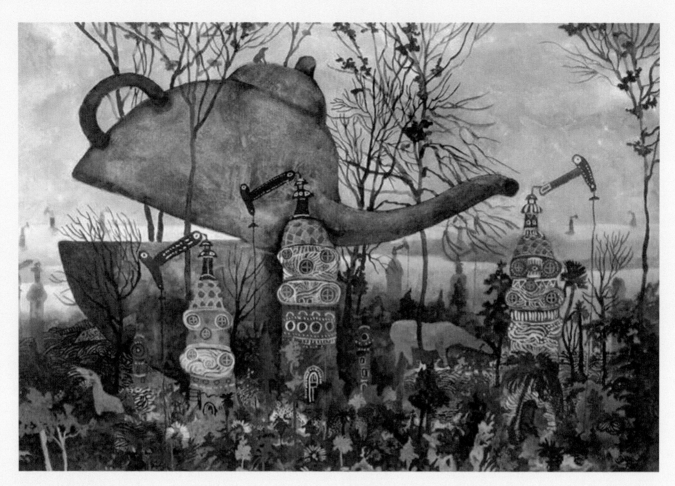

James Huntley, *Under the Teapot Dome,*
2015. Mixed media on paper, 18" × 24".
(Courtesy of the Artist)

Lesson 72: Fantastic Jungle

French artist Henri Rousseau was fascinated by book illustrations of wild animals, the exotic plants he saw in botanical gardens, and the stories told by returning veterans of military expeditions to Mexico. Together, these inspired him to paint scenes of people and animals amid trees, flowers, and tall grasses that he imagined to be jungle-like. How often do we read about unfamiliar places we have not personally experienced or seen, and formed pictures of them in our minds? How would you go about illustrating these untraveled but thoroughly imagined realms? Perhaps like Rousseau, after visiting greenhouses and zoos, by looking at photographic images of flora and fauna indigenous to the specific place, and by reading about how these features interact, we too might compose beautifully fantasized illustrations.

Henri Rousseau (1844–1910), *Tiger in a Tropical Storm (Surprised)*, 1891. Oil on canvas, 51¼" × 63 ¹³⁄₁₆" (130 × 162 cm). National Gallery, London, UK.

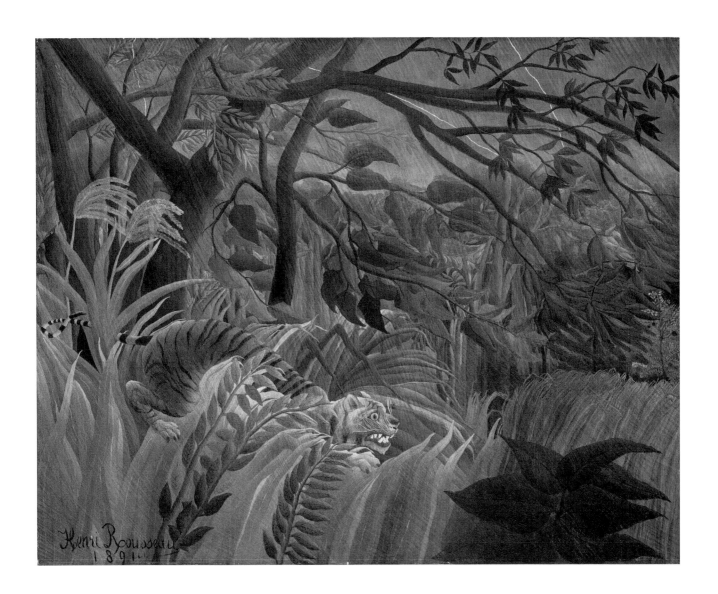

In this lesson, you are to conduct research to determine what creatures, plants, and other natural features are indigenous to jungle areas. What climatic and geographic factors contribute to the growth of jungle plants? How do these features support animals and how do they interact with this environment? Then you are to compose a jungle landscape with animals. Your **composition** will be imaginary, but it must be informed by virtual knowledge of jungle habitats.

The composition is to be finished with wax crayons as art making tools. Children are familiar with wax crayons because they are an inexpensive, safe, and easy-to-handle medium. Professional artists also use wax crayons because of the brilliant colors and interesting textures they produce. Wax crayons can be applied heavily, and one color can be used over another. Heavily crayoned areas can be partially scraped away with a sharp tool, and colors can be deliberately smudged and smeared. This lesson gives you the opportunity to explore using wax crayons in many unique ways to create an imagined jungle scene with fantastic color and **visual texture**.

INSTRUCTIONS

1. Fill three practice sheets of 9" × 12" white drawing paper with pencil sketches of tropical plants and birds. Search through books or online for color pictures of plant life and birds. If possible, visit a zoo or greenhouse for additional information and inspiration.

2. Color three of the pencil sketches in different ways with wax crayons to create visual texture. Apply some colors lightly and others heavily. **Overlap** colors. Apply crayon heavily in an area then scrape away some of the crayon with a sharp flat-edged object. Try blending colors together by laying a lighter color over a darker one, or scratching into heavily applied crayon to create a visual texture.

3. Share your color sketches with your peers and instructor. Explain how you might use these ideas in your final composition. Listen to feedback.

4. Select the most successful sketches or sections of sketches and refer to them as you compose, on a 12" × 18" sheet of heavy white drawing paper or watercolor paper, a picture of an imagined tropical scene.

5. Your finished drawing should demonstrate **asymmetrical** balance. Include many plants and/or animals with bright colors and interesting patterns.

6. Color the finished drawing with crayon or marker. Use some of the techniques you developed and practiced successfully. Repeating a color in several places within the composition may help establish visual **unity**.

7. Colors may be used imaginatively without regard for the real colors of plants or animals. However, make separate notes about the actual colors of plants and animals depicted.

8. Completely fill your composition with color.

9. Write an essay (500–650 words) in response to the following:

a. What plants and animals did you focus on when researching jungle habitats?

- Briefly describe the roles or importance of these various plants and animals.
- Are any of them considered endangered? If so, what are the primary causes of their demise?
- What might be the consequence of their loss to the ecology?
- How might jungle habitats be preserved?

b. Cite the sources of your information about jungle habitats.

c. Describe the ways you used crayon to create color texture in your composition.

d. Tell which parts of the practice sketches you think were most successful and why.

e. Explain why you chose some sections of the practice sketches in the final composition. How do you think these sections work together to create a sense of unity in the work?

Materials Needed

white drawing paper, 9" × 12"	eraser
heavy white drawing paper or	crayons
watercolor paper, 12" × 18"	
drawing pencils with soft and	
hard leads	

Vocabulary

Asymmetry/Asymmetrical
Composition
Overlap
Unity
Visual Texture

WHAT TO SUBMIT FOR EVALUATION

- three practice sheets of sketches of tropical plants and birds, with notes from researching these flora and fauna
- three sketches using crayons in several ways to create brilliant colors and visual texture. If some flora and fauna are presented in unrealistic or fantastic colors, include notations of the actual colors of their features.
- a finished fantastic jungle scene harmoniously composed of elements from your sketches and demonstrating asymmetrical balance
- a written essay, in response to questions outlined in Instruction #9

Fantastic Jungle Scenes by student artists Megan Van Pelt (*top*), Liz Gray (*middle*), and Anna Rademaker (*bottom*). (Courtesy of the Artists)

Art and Narrative Imagination 367

TIPS FOR TEACHERS

Although this lesson addresses habitats from a lighthearted, fantastical perspective, rain forest jungles serve a critical role in the overall ecological balance of the earth. Deserts, plains, wetlands, glacial regions, deciduous forests, savannahs, and the oceans all play profoundly important roles in maintaining life on this fragile planet. Textbook descriptions of global habitats may come to life when students virtually engage with them through observing and manipulating features of these environments as art. After researching a global ecology, invite students to create murals or dioramas with two- or three-dimensional representations of the flora and fauna of a habitat, or combine this lesson with the Tunnel Book lesson (Lesson 86), whereby each page of the tunnel book represents a different layer of ecology. Thus, students could better understand how an environment is both organized and interrelated. Check the library for tunnel books that relate to real and imagined nature, such as the following:

- Sommers, J. *The Coral Reef Tunnel Book: Take a Peek under the Sea!* Tunnel Vision Books, 2007.
- Sommers, J. *Henri Rousseau Tunnel Book: Take a Peek into a Fantastic Jungle!* Tunnel Vision Books, 2006.

Lesson 73: Fantasy Art

All mentally healthy people enjoy a fantasy life. We daydream while awake and dream while asleep. Dreams and daydreams take us to fantastic worlds where the impossible becomes possible. Often reality evolves out of the realms of fantasy. Composers write musical fantasies. Authors and poets weave stories out of their fantasies. Romantic, surreal, idealistic, grotesque, and playful are a few adjectives that can be used to describe visual fantasies. If you look at the works of artists or illustrators who create this type of art, you may find inspiration for creating your own fantasy art.

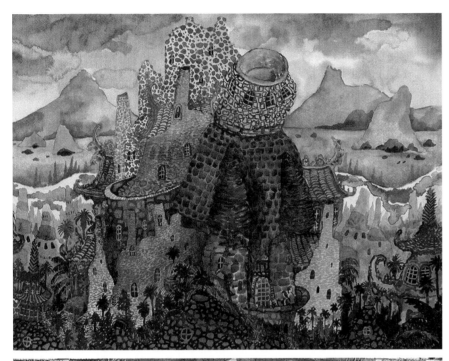

James Huntley, *Kingdom*, 2013. Acrylic, ink, and gouache on paper, 18" × 24" (38.4 × 50.8 cm). (Courtesy of the Artist)

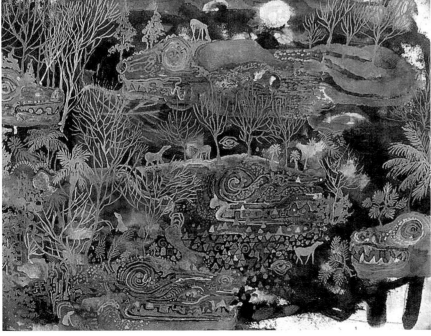

James Huntley, *Midnight Ancients*, 2014. Acrylic, tempera, gouache, and sumi ink on paper, 15" × 22" (38 × 56 cm). (Courtesy of the Artist)

1. Relax and daydream a little. Imagine you are in another time and/or place.
 a. What do the landscape, buildings, and environment look like?
 b. Are there animals or people there?
 c. What do they look like, and how are they dressed?
 d. Are there fantastic creatures or magical beings in this time and space?
 e. Is this a time in the future and in a world of science fiction, or a time and place of the distant past?
2. Make at least two **sketches** of ideas for your fantasy composition. Each sketch should be on 9" × 12" white drawing paper.
3. Share your sketches with your peers and instructor for feedback about the strength of your conceptual ideas and technical considerations regarding the compositions.
4. Based on feedback and your own aesthetic preferences, select a sketch and use it as a basis for creating a finished work of fantasy art. Redraw the sketch on a piece of 12" × 18" watercolor paper. You may adjust parts of the sketch that you wish to improve or elaborate upon while drawing the larger image.
5. Finish the fantasy picture using a color medium or your choice. Suggested media are colored pencils or watercolor pencils, markers, watercolors, or tempera, or you might combine color **media**, such as watercolors and colored pencils.
6. Write a brief essay (300–400 words) in which you address the following:
 a. Describe the scene you have created. If there is an accompanying story that you imagined while creating the scene, briefly relate the relevant part of the story depicted.
 b. Explain your thinking in creating the sketches. What choices did you make in laying out the two compositions? Why did you choose the one **composition** over the other in creating the finished piece?
 c. Explain how the medium you chose is appropriate for the scene you have depicted.

Materials Needed

white drawing paper, 9" × 12"	eraser
watercolor paper, 12" × 18"	color medium of your choice
drawing pencils with soft and hard leads	

Vocabulary

Composition
Medium/Media
Sketch

· two sketches of a possible fantasy scene
· a finished fantasy picture that is based on one of the original sketches and completed with a medium of your choice
· a written essay response, as outlined in Instruction #6

TIPS FOR TEACHERS

Imagination and Literature

Much of children's literature is grounded in fantasy tales that include animals that talk, people with magical powers, or combinations of these in fantastic environments. Invite students to consider how their illustrations might be situated in the context of a story. What happened before the time depicted by the illustration? What will happen afterward?

Move from image to idea by showing students an illustration from a classic or popular children's story. Ask students to imagine this illustration in a story. Afterwards, share the story for which the illustration was made. How do the stories compare? Repeat this activity with an illustration from a culture with which the children are unfamiliar. What clues do students focus upon in developing their stories? How do they interpret unfamiliar or illogical features of the fantasy illustration? What aspects of the image are overlooked? What does this tell you about how children make sense of visual images?

In a French fairy tale, Princess Blondine must prove her loyalty to friends by accepting a tortoise's offer that she make the long journey to their distant castle on his back, without complaint or question. What might viewers who are unfamiliar with the story surmise from this illustration? What different scenarios might it suggest? Virginia Frances Sterrett (1900–1931), *They Were Three Months Passing the Forest*. Illustration for Blondine, Bonne-Biche, and Beau-Minon, in Comtesse de Ségur, *Old French Fairy Tales*, (Philadelphia: The Penn Publishing Company, 1920).

Early in the twentieth century, psychology as a new field of science emerged from the work of Sigmund Freud and that of his student Carl Jung. Both Freud and Jung proposed the idea that a subconscious mind underlies much of the conscious mind and may direct the way we make sense of the world. Jung maintained that although logic often seems suspended during dreams, their strange surreality may contain messages from the subconscious mind.

These ideas were of interest to a group of artists who had been interested in dream-like experiences even before Freud introduced notions of the subconscious mind. Authors like Lewis Carroll, for example, created stories and poetry based on hallucinatory and nonsensical themes. Later artists were inspired to wonder if the creative potential of the mind, which is innately wired to seek patterns in order to make sense of the world, might be released if one were presented with an irrational juxtaposition of images or if ordinary objects were placed in nonsensical situations. A popular art movement known as **Surrealism** evolved from the work of these artists. Surrealist artists created illusory images that compelled viewers to stretch their imaginations in order to make sense of what they saw. The artist's creation of a surrealistic artwork and the viewer's interpretation of it can be described as exercises in imagination.

A collaged illustration by Emmanuel Paletz for an iPad app, composed of images from famous Renaissance-era paintings. Emmanuel Paletz, *A Mad Tea-Party from Alice's Adventures in Wonderland*, The Alice App: Renaissance Art Meets the Alice World, 2014, www.thealiceapp.com. (via Wikimedia Commons, CC BY-SA 3.0 US)

Sammy Slabbinck is a contemporary artist who selects images from old magazines and recomposes them into compelling, often humorous surrealistic compositions. In this lesson, you are to explore a similar technique by creating an artwork from generally unrelated images that have been arranged in a way that challenges a viewer's imagination.

INSTRUCTIONS

1. Search online for examples of surreal collage compositions by Sammy Slabbinck. Download at least two examples that you find inspirational and keep these near you as you work. You are not to copy these images, but use them to stimulate your thinking about how a surreal collage might be composed.

2. Look through magazines, catalogues, or online image sources and select seven items or images based solely on your first instinct. At this point, do not try to make sense of the images or objects that you have selected. You may select all color, all black and white, or a mix of color and black and white images.

3. Cut out the images or items and lay them before you. Try moving the images around, laying one on top of, overlapping, or beside another until you find a composition that uses three to five of the images and is both aesthetically pleasing and intrigues your imagination. Lay the unused images aside.

4. Look over the arrangement and think about what the meaning of the work might be for you. Does it suggest anything from your dreams (or nightmares), or some surprising, confusing, uncomfortable, or ridiculous situation that is real or imagined?

 a. Write these ideas down.

5. Take a photograph or scan the arrangement you have composed and share the image with your peers and instructor for feedback.

 a. Ask them what story they think this arrangement might be about, but do not share your own ideas with others yet. Listen to their suggestions about its possible interpretation.

 b. Does the image present an appealing surreal quality? Does it invoke interest and challenge interpretation?

6. Based on feedback and your own preferences, make final adjustments to the arrangement of images and pieces of the composition.

7. Rubber cement the pieces down on a sheet of 9" × 12" or 12" × 18" watercolor paper and clean off any excess rubber cement.

8. If it seems appropriate to do so, add details to the collaged image with pencils, markers, or a thin-tipped Sharpie pen. The additions should help us see the unrelated parts as relevant to one another.

9. Give the work a title, and add to your earlier writing about your work (300–400 words):

 a. Do the contributions of others suggest something different than what you expected?

b. Did the feedback of others change your opinion and/or ideas about your work? If so, in what way?

c. Write about this experience and give your conclusions about the work.

Materials Needed

magazines and other sources of images for collage

watercolor paper, 9" × 12" or 12" × 18"

scissors

rubber cement

rubber cement eraser

Vocabulary

Surrealism/Surrealist

WHAT TO SUBMIT FOR EVALUATION

· two downloaded or photocopied images of artwork by Sammy Slabbinck that inspired or informed your artwork
· a completed surreal collage that includes three to five magazine images presented in a way that suggests a cohesive story
· written responses as outlined in Instruction #9, with references to Instruction #4 and feedback from your peers and instructor

LESSON EXTENSIONS

As a lesson extension, complete one of the following:

1. Using your collaged image as a model, redo the composition as a pencil drawing—complete with values of light and dark made by using combinations of soft and hard lead pencils. Alter the image if necessary by changing size relationships, repeating some shapes or items, adding a background, or otherwise completing the image to provide richer and/or more complex possibilities of interpretation.

2. Beginning with an abstract painted background, paint over the background with watercolor or tempera to create surrealistic images based on the vague forms that seem to emerge or hide in the abstract background.

3. Create a surrealistic sculptural piece. Collect found materials like broken toys, kitchen utensils, unmatched socks, worn fabrics, old CDs, unusual or interesting objects found at flea markets or garage sales, and think about how these might be joined together into a surrealistic form that invites conversation about their possible meanings. A challenge would be to determine how these items could be joined together. Consult with your instructor about varieties of glues, fasteners, sewing techniques, soldering methods, or other ways of connecting disparate objects together. Give your sculptural piece a title that contributes to the surrealistic intrigue of the work.

Surrealism, an art movement of the late twentieth to mid-twenty-first century, was exemplified by dream-like images. These were occasionally of a nightmarish nature and elicited discomfort from the viewer even as they clearly presented improbable scenes. Examples of Surrealism may be seen in paintings such as Salvador Dali's *Persistence of Memory* (1931) or *Geopoliticus Child Watching the Birth of the New Man* (1943). These artworks presented terrifying subjects with a nonsensical absurdity that bordered on humor. Throughout history there have been examples of artists who, whether intentionally or accidentally, have tempered images of the fearful with humor. For example, the artwork of fifteenth-century artist Hieronymus Bosch entitled *The Garden of Earthly Delights* was intended as a nightmarish representation of imagined torments of hell, but it inspired twenty-first-century authors of a children's books to produce playful poems. "How can I cook for you? How can I bake? When the oven keeps turning itself to a rake?" ask the authors and illustrators of the delightful children's book *Pish, Posh, Said Hieronymous Bosch*.[1]

Some artists of Surrealistic artworks combine horror and humor as a way of easing fear. Illustrators of children's literature may present frightening subjects humorously as a way of reminding readers that some fears can be overcome by perceiving them differently. Artist Brian Cho warns viewers against succumbing to internal monsters of insecurity. Batten's humorous illustration from a book of fairy tales reassures us that getting to know a monster may reveal it to be less daunting than it first seemed. In this lesson, you will explore Surrealism by creating an image that juxtaposes fear and humor, using a common fear as inspiration.

Brian Cho, *March of the Naked Emperor*, 2010. Acrylic on canvas, 40" × 30". A classic children's tale tells how an emperor, who lacked confidence in his worthiness as a leader, and his subjects, who were influenced by peer pressure and mesmerized by the power of authority, were tricked into believing they saw clothing that didn't exist. Cho's illustration reminds us to trust our moral instincts and believe in our own worth, so as to avoid falling prey to inner demons of fear and insecurity that might lead us to vile or stupid conclusions. (Courtesy of the Artist).

INSTRUCTIONS

1. Begin by thinking about a common fear that you have experienced, such as fear of the dark, heights, thunderstorms, mice or bugs, or of being alone.

2. Now think about an opposite, humorous aspect of that fear. To help with this you might think of words that rhyme with the fear, since rhythmic meters have a soothing psychological effect and also may suggest imagery that is both connected by sound but incongruent with the idea, as in visual images of ice, mice, and dice ("mice frozen in icy dice").

3. If this does not bring something to mind, imagine the fearful thing in a ludicrous context. J. K. Rowling used this technique of neutralizing fear by putting a many-legged spider in roller skates and by placing a ridiculous hat on the haughty head of Professor Snape. Likewise, you might envision a terrifying clap of thunder as being produced by a big cloud

ART THEMES

smacking at a naughty little cloud, who responds with an impossibly long and loud roar (thunder).

4. Continue playing word and thought games with the fear word you have selected until you come up with a humorous or pleasant idea of an antidote to the fearful.

5. Now you will combine the fearful and its antidote in a single image. Draw at least three sketches on 9" × 12" drawing paper of possible scenarios.

6. Share your sketches with your peers and instructor for feedback about the effectiveness in producing a contrast of fear and humor.

7. Select the sketch you think conveys the idea of the terrifying-become-humorous clearly and in a compositionally pleasing way. Transfer this into a larger drawing on a sheet of 9" × 12" or 12" × 18" watercolor paper.

8. Use pencils with a variety of soft and hard leads to add details and shading to your drawing.

9. Realize that dramatic lighting can intensify the effect of fear (see Lesson 18: Shadows in a Triptych). Consider whether dramatic lighting, use of light and dark contrasts, or color might contribute to a sense of fun. Play with lighting effects on the sketch and then, if you see that it contributes to the idea you wish to communicate, apply it to the final drawing.

10. You may add color to your work with colored pencils, watercolor pencils, or watercolor paints.

11. Write a brief essay (300–400 words) in response to the following:
 a. What fear did you choose to address?
 b. What were your thought processes as you brainstormed various antidotes to that fear?
 c. What conceptual and visual effects did the use of dramatic lighting, light and dark, or color contribute to the artwork?

Materials Needed

white drawing paper, 9" × 12"	eraser
watercolor paper, 9" × 12" or 12" × 18"	colored pencils, watercolor pencils, or watercolor paints with brushes, water container, and tray for mixing colors.
drawing pencils with soft and hard leads	

Vocabulary

Surrealism/Surrealist

WHAT TO SUBMIT FOR EVALUATION

· three sketches, showing how you visually thought through the idea for an artwork
· a completed artwork of a fear that is tamed by humor, showing evidence of dramatic lighting or light and dark contrast that emphasizes the fear and/or humor of the concept
· a written essay response, as outlined in Instruction #11

TIPS FOR TEACHERS

Using Imagination to Control Irrational Fear

We may think of imagination and creativity idealistically, as outcomes of student learning activities. Yet imagination can be problematic for young children if, for example, they experience irrational fears such as nightmares or exaggerated responses to media reports of locally or globally catastrophic events. When children express anxieties, it is important that adults not belittle them. These fears are very real to children and should be dealt with respectfully if children are to accept their elders as trustworthy. Indeed, fear is justified in regard to dangers about which children should be cautious or instinctively avoid. On the other hand, many of children's fears that may seem irrational to adults are borne of lack of confidence in their abilities to manage natural life challenges. Seeing these fears as controllable and submissive to mind and imagination is important to healthy psychological development. Among favorite children's holidays are Halloween and Day of the Dead, because these permit ridiculing approaches to commonly frightening phenomena. Although the purposes of these celebratory events differ, both feature approaches to figures and themes of death that inspire children's playful imaginations.

Halloween and Day of the Dead celebrations provide children with opportunities to confront fearful images with humor, as can be seen in these examples of children's art. *Halloween* (top), and *Don't Let the Monster Get You!* (bottom). (Child Art Collection of Enid Zimmerman)

Lesson 76: An Image of Catastrophe

Natural and man-made disasters are happening somewhere in the world every day. Fortunate is the person who lives a full life without having been witness to some disastrous event in his or her community. Volcanic eruptions, fires, floods, tsunamis, hurricanes, tornados, droughts and famine, violent human conflicts, and inexplicable accidents may all result in terrible damage or injuries. By irresponsible assault on the environment or lack of consideration and caring for other people, humans may contribute to or initiate catastrophes. Yet those who become victims of these disasters are rarely directly to blame for the misfortune that befalls them. This lesson asks that you consider what a catastrophe might mean to those who experience it, and describe your impressions in a work of art.

INSTRUCTIONS

1. If you have had the experience of observing or being caught in a catastrophic situation, you may choose to visually describe what you experienced. If you have been fortunate enough to have never personally experienced a catastrophe, you may rely on reference materials to suggest ideas for your picture.

2. Create at least three sketches from memory or find and photocopy or download three high-resolution images that can be used to inspire your final work.

3. Refer to the images and your own sketches in composing a visual representation of a catastrophic event on a 12" × 18" sheet of watercolor paper. Organize the parts of the final picture by lightly drawing a sketch of your finished work on the paper. Imagine yourself as actually a part of the catastrophe rather than a distant observer. In this way, your personal feelings about the catastrophe are more likely to show.

4. You may create either a **realistic** or **nonobjective** artwork.

5. As you develop the picture, be sure that one part **dominates** the composition; sharpen that **focal point** through the use of details. You might heighten the message of the picture further by means of **dramatic lighting** or use of color. Refer to Lesson 18: Shadows in a Triptych to find out more about dramatic lighting.

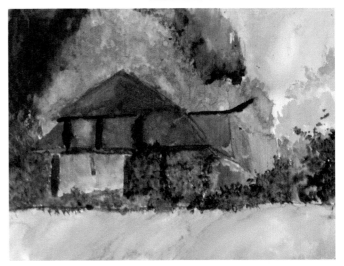

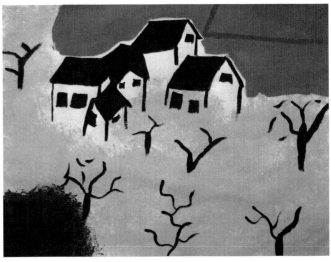

Images of disastrous events include 9/11, by Anna Rademaker (*top*), *Burning House*, by Katherine French (*middle*), and *Flood*, by an anonymous student (*bottom*). (Courtesy of the Artists)

6. Select a suitable painting medium (watercolor, tempera, or acrylic) for the finished work. Paint in colors designed to capture the spirit of the event.

7. Write a brief essay (300–400 words) that addresses the following:

 a. Explain the sources of your sketches or photocopies and downloaded images. What catastrophe inspired this artwork?

 b. How did you conceive of the idea for your finished work?

 c. What elements of the images did you use in composing your final work?

 d. What problems did you encounter when creating your finished work, and how did you resolve these problems?

Materials Needed

watercolor paper, 12" × 18"

drawing pencils with soft and hard leads

eraser

watercolor, tempera, or acrylic paints

brushes

palette and mixing trays

water and water containers

paper towels for clean up

Vocabulary

Dominate/Dominance

Dramatic Lighting

Focal Point

Nonobjective/Nonobjective Art

Realism/Realistic

WHAT TO SUBMIT FOR EVALUATION

· three sketches or photocopies or images collected as sources of visual information about a catastrophic event

· a finished dramatic painting of a catastrophic event, using dramatic lighting and the art principle of dominance

· a written essay response, as outlined in Instruction #7

In television shows, films, and video games, children may be exposed to visual narratives that romanticize disastrous situations as exciting. In fiction, all generally ends well, with peace and happiness being restored. However, some children may observe or experience real life events that do not mirror fiction.

National disasters and world conflicts may concern and affect young children and adolescents as deeply as they do adults; yet students often lack opportunities to express their fears and anxieties with adults. Art and play possess unique powers that permit young people to express, reflect upon, share, and come to terms with difficult emotions. Caring classroom teachers can assist in this process by providing resources and outlets for student expression. Explore these publications for information and resources:

- Delisio, E. R., G. Hopkins, and L. Starr. "Helping Children Cope: Teacher Resources for Talking about Tragedy." *Education World* (2004). http://www.educationworld.com/a_curr/curr369.shtml.
- Manifold, M. C. "The Healing Picture Book: An Aesthetic of Sorrow." *Teacher Librarian* 34, no. 3 (2007): 20–26.
- Manifold, M. C. "Learning from the Inside Out: Using Art to Deal with Difficult Issues in the Classroom." *International Journal of Arts Education* 4, no. 2 (2006): 9–35. http://hdl.handle.net/2022/2557.

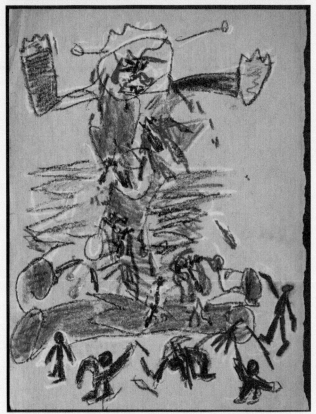

When fire engulfed as apartment building near an elementary school in New York City, children described the frightening event and feelings of fear it elicited through their art. *Apartment Building on Fire* (top), *Burning Building* (middle), and *Fire Monster* (bottom). (Child Art Collection of Enid Zimmerman)

Old age and death are constantly recurring themes in art. We look to elders of our families and communities for their wisdom, guidance, and the unconditional love they shower upon their descendants and children of their communities. We also see that many elders' bodies and minds are cruelly ravaged by time. We aspire to live long lives, yet know realizing that goal brings inevitable frailties. Whether or not we achieve old age, dying happens to everyone sooner or later. Fear, associated with death and dying, has been shown in art across the ages to the present day. If the subject of old age and death inspires you to express your feelings, this lesson offers you an opportunity to do so.

Below, William Lee Hankey (1869–1952), *Etaples Fisher Folk*, 1920. Etching. Gift of Mrs. A. Dean Perry in memory of Mr. and Mrs. Edward Belden Greene, Cleveland Museum of Art, Cleveland, OH.

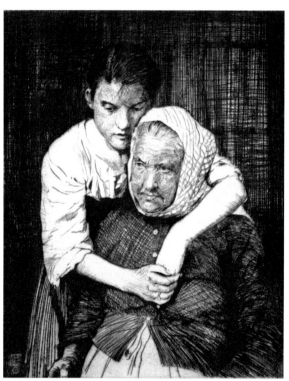

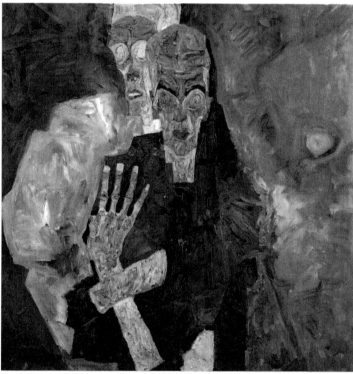

Right, Egon Schiele (1890–1918), *Self Seer, or Death and Man (De Selbstseher oder Tod und Mann)*. Oil on canvas, 31 ⅔" × 31½" (80.5 × 80 cm). Leopold Museum, Vienna, Austria.

INSTRUCTIONS

1. Find a poem or essay that presents old age or death in a way that corresponds to or resonates with your personal feelings. If you prefer, rather than going to other sources, you may write a statement or poem of your own that sums up your feelings about death and dying.

2. Using the written statement as inspiration, create a visual statement on the same theme. The artwork may include parts that are **realistic** or abstractive. Above all, you should seek to express your deepest feelings on this profound topic.

3. On sheets of 9" × 12" drawing paper, make at least three thumbnail sketches that show how you might compose a visual response to the poem or essay.

4. Select the sketch that best describes your feelings and enlarge the sketch on a 12" × 18" sheet of watercolor paper.

5. Complete the image in any two-dimensional (black and white or color) medium of your choice.
6. Write a brief essay (300–400 words) describing how the content of your artwork relates to the poem or statement about old age and death. Explain why you selected this medium or media as appropriate for your idea.

Materials Needed

drawing paper, 9" × 12"
drawing pencils in hard and
 soft leads
eraser

watercolor paper, 12" × 18"
black and white or color medium
 of your choice

Vocabulary

Realism/Realistic

WHAT TO SUBMIT FOR EVALUATION

- a copy of the poem or essay that inspired your work, along with a link to or citation of the source
- a completed artwork in your choice of medium that was inspired by the poem or statement about old age and death
- a written essay response, as outlined in Instruction #6

TIPS FOR TEACHERS

Old Age as a Cycle of Life

Life cycles are part of the biological, psychological, and social aspects of every human's existence. Across cultures, life cycle passages are marked by changes in human bodies, shifting interests and life roles, and through rituals and ceremonies. Artists use motifs and metaphors of life cycles in their creations. Elementary students may explore life cycles in the natural world of plants, animals, ecological systems, and the solar system, but it is important to understand that we as human beings are also subject to these cyclical laws. What changes might one expect to happen over time age? How can changes in one's own life be related to cycles of all living things?

Resources for teaching about the cycles of life include the following:

- Artsedge. *Life Cycles and Processes.* 2014. https://artsedge.kennedy-center.org/themes/life-cycles-processes.
- Rice, D. L., and M. S. Maydak. *Lifetimes.* Nevada City, CA: Dawn Publications, 1997.
- University of Wisconsin-Madison. *I Wonder How the Manducca Life Cycle Compares to the Human Life Cycle.* University of Wisconsin-Madison: Department of Entomology, 2006. http://labs.russell.wisc.edu/manduca/lesson-plans/lesson-14-i-wonder-how-fast-manduca-grows-compared-to-me/.

These units, designed for elementary students, provide lessons for teaching about life cycles in nature and compares them to human experience.

TIPS FOR TEACHERS

Addressing Children's Sorrow

Dealing with the death of a loved one is difficult for all people, but is especially so for children, who may be too young to understand the process or finality of death. Aside from the grief of being severed from the loved one, children experience vague concerns that they can scarcely articulate. Among those fears and anxieties are questions such as: Why has this happened in my life? Did I do something wrong to cause this? What will happen now; who will take care of me? Will I experience this suffering (illness, pain, or death) as well? What happens when someone dies?

It is important that some comfort be given students who experience these difficult emotions for human reasons (we are all connected to one another in joy and sorrow) and practical ones (students cannot concentrate on academic learning while distracted by grief and fear). Children's books that address such issues in ways that open the whole class to conversations provide opportunities for children to support each other through the grieving process. Openness to the sorrows of others develops empathy in all children while soothing the one who suffers.

There are a great number of children's picture books that combine profound text and lyrical images in ways that suggest their usefulness in helping students deal with difficult issues. It is important that you look through various possible texts before choosing ones for classroom use. Select books that address difficult topics in ways that are comfortable to you, for it is important that you have some confidence in your ability to answer the many questions that might result from sharing these ideas with students. Remember that the response "I don't know" is an honest response to many difficult questions about life and death. Children look to adults as knowing individuals, but also need their honesty. The picture books suggested below offer support, visually and narratively, in regards to death of a beloved person or pet. Most address death from the point of view of those left behind, while a few are written to help understand the process as a transition in state of being. Look carefully at a text before choosing it for your students; make sure it is age appropriate and presents a philosophic point of view that you are comfortable with and therefore would be comfortable addressing with your students.

- Brinkloe, J. *Fireflies*. New York: Aladdin Books, 1989.
- Bunting, E., and T. Rand. *The Memory String*. New York: Clarion Books, 2000.
- Clifton, L., and A. Grifalconi. *Everett Anderson's Goodbye*. New York: Square Fish, 1988.
- Holder, H. *Carmine the Crow*. New York: Farrar Straus & Giroux, 1992.

- Kaplan, H., and H. Blondon. *Waiting to Sing*. New York: Dorling Kindersley Publishing, 2000.
- Mellonie, B. *Lifetimes: The Beautiful Way to Explain Death to Children*. New York: Bantam, 1983.
- Notar, S., and D. Paterson. *Abuelita's Paradise*. Morton Grove, IL: Albert Whitman & Company, 1992.
- Rylant, C., and P. Catalanotto. *An Angel for Solomon Singer*. New York: Orchard, 1992.
- Varley, S. *Badger's Parting Gift*. New York: HarperCollins, 1992.
- Viorst, J., and E. Blegvad. *The Tenth Good Thing about Barney*. New York: Atheneum Books for Young Readers, 1987.
- Walker, A., and C. Deeter. *To Hell with Dying*. San Diego: Harcourt Brace & Company, 1988.
- Wallace-Brodeur, R., and K. Mitter. *Goodbye, Mitch*. Morton Grove, IL: Albert Whitman & Company, 1995.
- Warner, S. *The Moon Quilt*. Boston: HMH Book for Young Readers, 2001.
- Wilhelm, H. *I'll Always Love You*. New York: Dragonfly Books, 1988.
- Woodson, J. M., and L. F. Cooper. *Sweet, Sweet Memory*. New York: Hyperion Books.

Elder and Child Friendships

Wisdom is often associated with old age in literature and poetry. Why might this be so? Students can consider this from the point of view of their own families and community. Who are some people who have lived long, adventurous lives? What wisdom about life do these people have to share? Invite students to interview their grandparents or an elder family member about insights into their life experiences, and have students share these findings with one another in class. If there are several children in your classroom whose grandparents or family elders live at a distance, consider pairing each student with an elder member of the community who may be alone or separated from their extended families by virtue of living in an assisted living or nursing home. While this may involve collaborations between school administrators and social services, the rewards for both elder and child could be immeasurable. Plan collaborative activities to engage the pairs. Provide opportunities for them to make art together, work on putting together a puzzle or model, or share photographs and organize them in a scrapbook to tell a story. Take digital videos of interactions as mementos for the elder and student to share and remember.

Lesson 78: Role-Play as Visual Story

Role-playing activities are popular among young children, adolescents, and young adults. In role-play, participants assume traits, dispositions, and roles of imaginary characters and then improvise stories that require them to stay "in character" of the chosen fictive. Participants of **role-play** may become adept at self-expression and reading the visual cues of others' behaviors. If costumes are involved, as in **cosplay** performances, players will observe how visual representations project the moods and internal motivations of characters and of interactive responses among characters. These activities encourage emotional and intellectual development as players come to recognize complexities of **intrapersonal** and interpersonal phenomena that compel action and affect story outcomes.

In order to tell an effective visual story, you must clearly depict explicit and implicit characteristics of the subject. In this lesson, you will visually create two imaginary characters with specific psychological traits, social roles, and physical appearances. Then you will set them in a visually composed interaction that might be read without benefit of text. Your composition will be evaluated on visual coherence of the characters, imaginative integration of character images, and harmonious arrangements of artistic elements like line, color and shape, and balance.

INSTRUCTIONS

1. Character One
 a. The first character of your story should be loosely based on yourself or some aspect of self that you wish to express. To create this character, collect images of things that represent the goals, passions, and experiences of the self you wish to represent. These may include bodily features, clothing, or tools the character might use.
 b. Use these as reference materials when creating three sketches of the character on sheets of 9" × 12" drawing paper. The sketches should incorporate items from your collection in differing ways.
2. Character Two
 a. For the second character, consider a type of individual with whom the fictional "you" might interact. Consider the character's disposition, whether serious, shy, belligerent, gentle, happy-go-lucky, conniving, proud, or a combination of qualities, and brainstorm how the disposition might be portrayed.
 b. What are the life goals and dreams of the character?
 c. What are the great strengths, accomplishments, fears, or weaknesses of the character?
 d. Draw three sketches of the character; present the character in clothing, gestures, and with objects that describe the general disposition of the character.
3. Study your sketches.

Erithe (Erin McChesney), *Priestess: Sweet Black Velvet*, 2008. Bic Pen Photoshop CS3, Wacom Intuos 3. (Courtesy of the Artist. http://erithe.deviantart.com/art/Sweet-Black-Velvet-93703803)

a. Do they suggest the character traits you intend? If not, how can you make your intentions more explicit?

b. How would these two characters interact?

c. How might the two of them be placed in relation to one another compositionally in order to achieve an impactful visual effect?

4. Create three thumbnail sketches of the two characters in a composition.

5. Share your composition with peers and your instructor.

a. Ask how well they can read the work.

John Popchop, *Belmont Preparing for Battle with Zeus* (two frames), 2009. Digital manipulation. (Courtesy of the Artist)

6. On a sheet of drawing paper that is 9" × 12" in size, while looking at your sketches and considering the feedback from your peers and instructor, redraw both characters in a single composition in such a way that either a psychological and/or physical activity interaction is taking place between the two.
 a. How do they feel about and act toward one another?
 b. How could this be shown as a visual gesture or interaction?
7. When you are satisfied with the drawing of your characters, add background elements that could assist in explaining what is going on.
8. To complete the work, you can add color with color or watercolor pencils, or scan your drawing into an illustration software program and color the work digitally.
9. Write a brief essay (300–400 words) summarizing the traits of each character and describe how you have attempted to portray them through your sketches. Explain how the choices you made in drawing these characters relate to the traits you have assigned to them.

Materials Needed

white drawing paper, 9" × 12"
drawing pencils with soft and hard leads
eraser

Vocabulary

Cosplay
Intrapersonal
Role-Play
Storylining

WHAT TO SUBMIT FOR EVALUATION

· nine sketches: three each of two characters, and three of the characters together in a composition
· a completed work that places two characters in a visually interesting way that describes the personalities and physical features of the fictional characters in gesture and details, and shows an interaction of the characters
· a written essay response, as outlined in Instruction #9

Storylining

Storylining is a role-play event that takes place predominantly or exclusively through written text and/or art imagery; it permits the play to be experienced online or from a distance. Storyline play usually begins when children are in upper elementary school, and have learned to read and write with competence. Practices of storylining benefit social understanding while also assisting the development of writing and art making skills. Such practices call upon aesthetic and psychological decision-making, since storyliners must create images that are consistent with the personalities of the fictives and the situations assigned to them or within which they are placed.

Storylining may incorporate role-play, costume play, or **cosplay**, and performance. Performances can be scripted or improvised by imagining how a character that is being played would actually behave or respond in various situations.

When teaching lessons in history, consider having students role-play significant characters from history. Given the circumstances of the time, would the students (acting as these historic figures) respond in the same way as these people from history did, or were there alternatives that might have had different consequences? What might have been the outcome if the players of history had acted differently? How can we know what the "right" way to respond to crisis should be?

Group of cosplay role-players.
AnimeExpo, Anaheim, CA, 2004.
(Photograph by the Author)

Lesson 79: A Bust of a Story Character

What physical features, gestures, and facial expressions help us understand the personality of an individual? As an actor or illustrator of a narrated story, one must understand the subtleties that convey to audiences important information about **protagonists** or **antagonists** of stories. If only the head and shoulders, or **bust**, are visible, how could physical features, gestures, and facial expressions be exaggerated to convey subtleties of personality?

In this lesson, you are to think about actors from a favorite story or series, such as the central characters of L. Frank Baum's *Dorothy and the Wizard in Oz*, Lewis Carroll's *Alice in Wonderland*, or J. K. Rowling's Harry Potter series. Alternatively, think of different personalities or members of a favorite musical group, sports team, or other assemblage of peoples. Select one individual that is a favorite or has a strong personality trait that would lend to exaggerated portrayal. You then will make a **three-dimensional (3-D)** model of the character.

Tattooed Man and Clown, teacher-made sample and student work. Tamzin Ann Harris, art teacher, UK. (Courtesy of Tamzin Ann Harris)

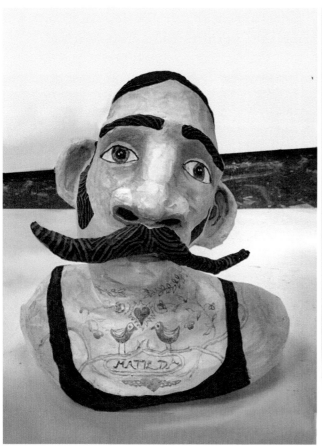
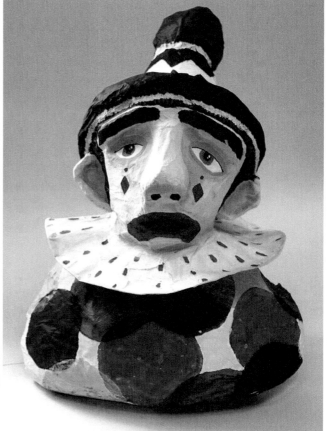

INSTRUCTIONS

1. Having decided upon the character you would like to portray, on the side of a sheet of 9" × 12" drawing paper, make a list of gestures, physical features, and facial expressions that describe the person.

2. On sheets of 9" × 12" drawing paper, sketch four thumbnail images of the character's head and upper shoulders from the front, and four thumbnail sketches of side views. Notice what parts of the face and head would need to be exaggerated. Should the eyes be closer together or wider apart than typical? Will the nose be exaggerated in some way? Will the neck be elongated and thin, or short and wide? How should the mouth, ears, hair, chin, and cheeks be portrayed?

3. Select the most effective front and side view sketches and use these to inform your bust model.

4. To create an **armature** for the bust, you will need a Styrofoam head, like ones used as hat or wig holders. Also, you will need newspapers, small bits of cardboard, and duct tape.

 a. Tape wadded up sheets of newspaper to a cardboard base to form an upper torso with shoulders and neck. Use duct tape to hold the newspaper and cardboard together and in shapes.

 b. Incorporate the Styrofoam head with the molded neck and shoulders, and firmly attach with duct tape.

 c. Use small pieces of lightweight cardboard or wads of newspaper or cotton to form exaggerated features of the head and face, and attach to the foam head with duct tape.

5. When the bust has the desired form, move to a prepared work space. Use layers of newspaper or a plastic cover to protect the work space

6. Choose to use either the **papier-mâché** method or **plaster bandage** method described below to mold the form of your character bust.

Papier-Mâché Method

1. Strips of newspaper dipped in papier-mâché paste may be used to develop the form of your figure.

Left, Styrofoam head covered with papier-mâché. (Created by the Author)

Middle, Building an exaggerated nose feature with papier-mâché. (Created by the Author)

Right, Building an exaggerated mouth feature with papier-mâché. (Created by the Author)

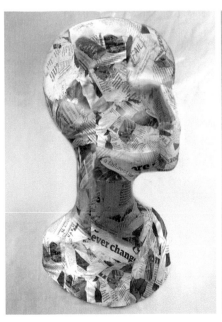
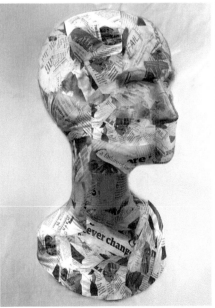
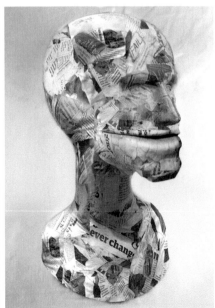

2. Prepare a large stack of newspaper strips in several sizes, from about 2" × 4" to 1" × 2".

3. Prepare papier-mâché paste according to instructions on the box. Mix only as much as you think you will need for one layer at a time, since paste may spoil if allowed to sit unused.

4. Cover the manikin completely (except for the bottom of the base) with two layers of papier-mâché strips, carefully pressing the wet paper into crevices and details of the face and head.

5. Allow the wet form to dry overnight, then add two more layers of papier-mâché strips; mold these into and around details.

6. Discard leftover paste, clean up the work area, and set the model bust aside in a well-ventilated area.

7. Allow the bust to dry again thoroughly overnight.

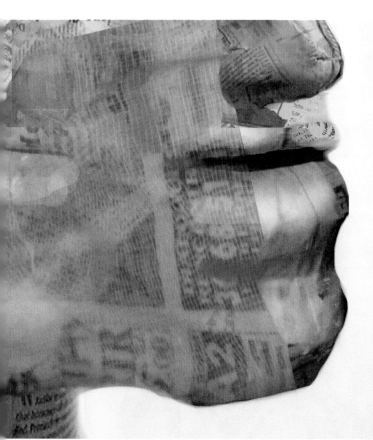

Detail showing the addition of plaster-infused gauze over papier-mâché. (Created by the Author)

Plaster Bandage Method

1. To create a **plaster model**, use instant mold plaster bandages cut in several lengths. Dip bandage pieces one by one in a bowl of warm water, squeeze lightly, and apply to the surface of the manikin. Using your fingers, gently push the plaster bandages into crevices of fine features of the face or head.

2. Continue adding plaster strips until the entire surface of the manikin (except the underside of the base) is covered evenly with one layer of plaster strips. Smooth the seams to remove lap lines.

3. Allow this layer to set, which should take only a few minutes.

4. If additional exaggerations need to be added, attach them with small strips of plaster cloth and allow them to dry.

5. Add a second and then a third layer of plaster strips, permitting each layer to set before adding the next one. Smooth seams and lap lines as you go.

6. Set the plaster-covered bust aside and clean up your work area.

7. Allow the model to thoroughly dry overnight.

Complete the Bust

1. When thoroughly dry, use sandpaper if necessary to smooth any rough edges. (Gently brush off any loose plaster powder.)

2. Take the bust outside to an open area and spray with acrylic seal, like Krylon Crystal Clear. Using a sealant at this point is important to keep the colored paints from soaking into and softening the plaster or papier-mâché.

3. Allow the sealant to dry thoroughly.
4. Using small and large brushes, paint the manikin. Add additional details, such as tattoos, scars, whiskers, or other fine details. Keep mixing trays and water on hand to mix new colors or thin the acrylic to produce transparency effects.
5. Clean all brushes thoroughly with soap and water after use.
6. Give the bust a title and answer the following in an essay (300–400 words):
 a. Who is the character you have represented?
 b. What personality and physical traits are important to the depiction of this character?
 c. What exaggerated features did you add, and why were these selected as a way of emphasizing the personality and physical traits of the character?
 d. What difficulties did you have in constructing the figure and how did you resolve these difficulties?

Materials Needed

foam head (or wig head)—these are available in male, female, or featureless versions
newspaper
heavy and light weight cardboards
duct tape
sandpaper
acrylic paints
acrylic sealant
large and small bristle acrylic brushes
mixing tray and water containers for paints
soap and water to clean brushes
newspaper or plastic covers to keep work area clean

Papier-Mâché Method

newspaper strips
scissors
art paste, rice paste, or wheat paste powder, and water (Mix only the amount of paste you will need and use immediately, as wet papier-mâché paste will spoil if allowed to sit unused.)

Plaster Bandage Method

instant mold plaster bandages
scissors
water

Vocabulary

Antagonist
Armature
Bust
Papier-Mâché
Plaster Bandage
Plaster Model
Protagonist
Three-Dimensional (3-D)

- a list of the gestures, physical features, and facial expressions that describe your character
- eight sketch ideas for a 3-D character: four of the front and four of the side
- a completed 3-D character, using either plaster or papier-mâché strips over a newspaper and foam head and shoulders (bust) that has been molded and painted with exaggerated features and details
- A written essay response, as outlined in Instruction #6 under the section "Complete the Figure"

Vintage Circus Characters, by students of Tamzin Ann Harris, art teacher, UK. Top row, left to right: *The Amazing Lizard Man*, *Ringmaster*, and *Acrobat*. Bottom row, left to right: *Ringmaster 2*, *Westler*, and *Strongman*. (Courtesy of Tamzin Ann Harris)

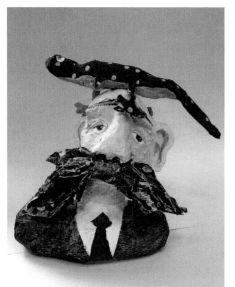 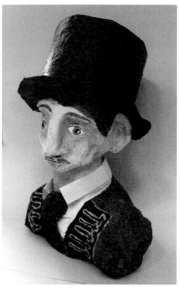 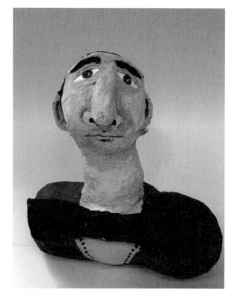

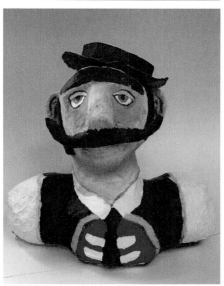 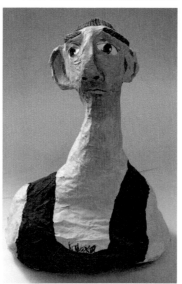

Throughout the history of humankind, people have communicated with one another in stories. Long before people developed systems of writing, narratives were shared through word of mouth and visual images. Among people of every culture, stories evolved as a means of passing instructions from adult to child about how to properly behave toward one another and live in harmony with the natural world. Cultural traditions are preserved through storytelling, and wisdom is conveyed metaphorically through stories. Rules of life are more easily remembered when they are modeled in stories; for example, stories like Beauty and the Beast tell us that kindness and caring for others brings reward, while selfishness and greed results in sorrow, disaster, and loss. Human traits of strength or weakness, generosity or stinginess, kindness or cruelty are presented in the guise of characters, who serve as archetypes for the ways people should act or should be wary of interacting with one another.

Narratives still help us make sense of our lives and the world around us. Stories are relayed orally and visually through informal conversation and gesture, and through formal dramatic performances in theater, movies, and television. Very young children who have not yet mastered the ability to read can learn the great narratives of our culture through picture books. Children and adults of all ages enjoy great literature and appreciate wonderful book illustrations that reinforce or carry the visual meaning of narration. In this lesson, you will read a popular story from another culture and consider how the idea of the story and the culture could be conveyed through illustration.

INSTRUCTIONS

1. Go to the children's section of a local library or bookstore. Look for several artists' versions of one of the following fairy tales:

 Aladdin and the Magic Lamp (Saudi Arabian)

 Brer Rabbit (Gullah–African American)

 Peach Boy (Japanese)

 Cinderella (European)

 You may include one version by the Disney Studio, but do not rely on Disneyesque versions alone. If used at all, the Disney version should be compared and contrasted with other published versions of the story.

2. After looking at various versions of each story, decide which of the stories interests you most and do the following:

 a. Research the cultural origin of the story through online or library sources, and keep a list of the resources that seemed most helpful and informative in answered the following questions:

 · From what culture did this story originate?

 · What cultural ideal(s) does the story convey?

 · What are some of the overarching beliefs and values of the culture? How are these suggested through illustrations of this story?

- What specific symbols, patterns, and motifs are characteristic of the culture from which the story derives?
- What do people of this culture believe to be the proper roles for girls and boys or women and men in society?
- How must people of differing genders, generations, social classes, and/or positions in the family behave toward one another?
- Are there indications of how people should interact with nature or the natural world? If so, explain.

3. Find examples of art from the story's culture of origin. Look at these images from the culture of the selected story. Consider how they reflect the beliefs and ideas of that culture.

4. Select a single event, character, or **motif** from the story that could be illustrated to help the reader imagine the story.

5. Sketch at least three ideas for an illustration that might be appropriate for describing an event or character of the story.

6. Referring to the best of your sketches, illustrate one single event, motif, or character from the story. Use watercolor paper that is either 9" × 12" or 12" × 18" in size and any of the following media:

 cut paper collage

 colored pencils

 watercolor or tempera paints

7. Be careful to use images are respectful of the culture and avoid those that seem stereotypic.

8. In a written report (400–650 words), add to responses given for Instruction #2 above by addressing the following:

Student illustrations for "Aladdin's Lamp," a story from *One Thousand and One Nights*, a collection of Middle Eastern and Southwest Asian folk and fairy tales. (Courtesy of the Artists)

a. What decorative motifs, clothing, or architectural styles did you use in your illustration that are typical of the cultural traditions of the story?

b. How did you respect the overarching beliefs of the culture through your illustrations?

c. Indicate the book illustrators whom you referred to in preparing your own original illustration. Reference the book(s) used.

d. Explain why you think this event or character was important to illustrate and how it helps the reader understand the moral or ethical message of the story.

Materials Needed

watercolor paper, 9" × 12"
drawing pencils with soft and
 hard leads
eraser

pieces of colored paper, scissors,
 and rubber cement, or
colored pencils, or
tempera paint, bushes, water
 containers and mixing tray

Vocabulary

Motif
Symbol/Symbolic

WHAT TO SUBMIT FOR EVALUATION

· an illustration of a significant event or character from the story in either collage, colored pencil, watercolor, or tempera

· a written report, with responses to questions outlined in Instructions #2 and #8

TIPS FOR TEACHERS

Reading Images and Texts

There are differences between the way readers process images that contain all the elements of a story in a single illustration, and the way readers process images in stories that are accompanied by sequences of illustration. In the former, the story must be deciphered and interpreted from visual clues contained within a single frame. These may be actually represented or referenced through **symbolic** metaphor. Paintings or other single artworks that tell stories must use visual conventions to help the reader understand the context of the story being told, such as: What came before? What is happening now? What will or might be the outcome? The reader of the image may decipher the story in any order and at his or her own pace.

In illustrated picture books, artists attempt to hold a reader's attention in the present moment, as if the story were unfolding in real time. The author and artist control the pace of the story, allowing the reader to see only

a portion of the whole until the author/artist is ready to reveal the story climax.

In their everyday lives, children are exposed to a third kind of story reading—the reading of comics or manga. In these visual narratives, text is only one of several story-telling conventions and devices. The story is told neither by words nor by image alone. Each element is dependent upon the other if the reader is to make sense of the story. Illustrating stories and engaging with story illustration are not simply elaborative aspects of children's literacy learning; they do more than make learning fun. They are critical elements of literacy in an increasingly image-saturated world and are necessary to being literate in the twenty-first century.

Artists employ ways of telling stories through symbolic *codes* that are easily understood by those who share the cultural milieu of the artist-storyteller. Imagic conventions might reveal backstories of the protagonists' lives, tell the reader about something going on simultaneously with the event being explicitly described, or inform readers about the world in which the characters of the story live. Images present a real or imaginary worldview, which serves as context for the story. Without knowing the cultural codes of the artist storyteller, it may be difficult to accurately read the tale. However, readers of all cultures use imagination to arrive at personal interpretations of imagic stories. For example, how would you interpret this nineteenth-century Indian image?

Andhra Pradesh, *Krishna Riding a Composite Horse*, ca. 1800. Opaque watercolor on paper, 5½" × 9 ³⁄₁₆" (13.7 × 23.33 cm). Gift of Karen Leonard in memory of Gurucharan Das Saxena of Hyderabad, India, Los Angeles County Museum of Art, Los Angeles, CA.

A powerful story, told as myth or fairy tale, may appear in culturally unique versions throughout the world. These tales are evidences of common experiences had by peoples throughout many parts of the world, told and retold over centuries through the cultural lens of diverse peoples. For example, the Judeo-Christian story of Noah and the Flood occurs in other Eastern European and Middle East cultural traditions as the flood myth of Deucalion or the Epic of Gilgamesh. In Scandinavia, Bergelmir and his family escaped the flood in a boat made from a hollow tree. In India, Manu survived by building an ark and filling it with seeds and animals to repopulate the earth, while the Masai people of Africa credit Tumbainot and his family with accomplishing this feat. During the reign of Emperor Yao (ca. 2356–2255 BCE) in China, a flood engulfed the land for two generations, until it was contained by the heroics of Yu, who thereafter ascended to the throne. Still other flood tales are found

Edward Hicks (1780–1849), *Noah's Ark*, 1846. Oil on canvas, 26 5/6" × 30 3/8" (66.8 × 77.1 cm). Bequest of Lisa Norris Elkins, 1950, Philadelphia Museum of Art, Philadelphia, PA.

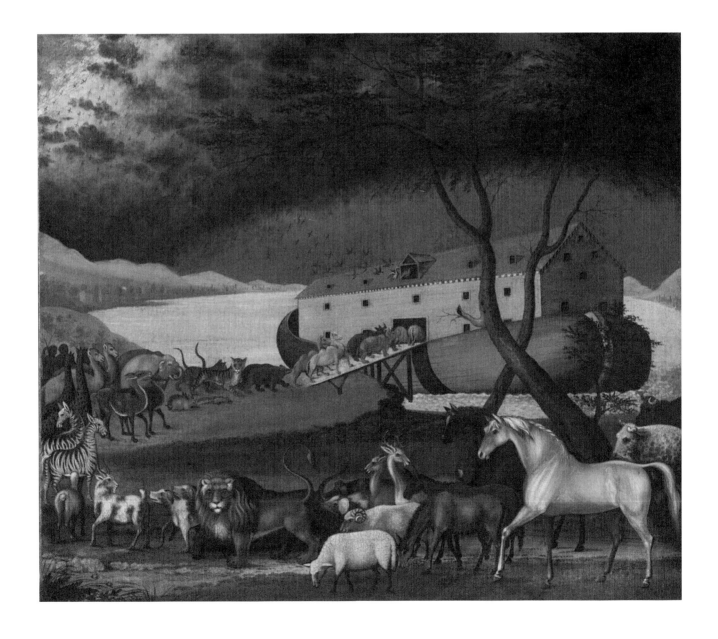

in traditions of people throughout the world, and may refer to a sudden event of melting glaciers at the end of the last great Ice Age.

As a lesson extension, examine a common story theme as it is portrayed in children's books by artists of different cultures. Select a myth or fairy tale that you relate to in a personal way (either positively or negatively). Study at least three different cultural variations or social commentaries of the story. Explain why/how these are different and provide a personal response to them.

Create an illustration that describes an event that is not illustrated but reveals your personal response to or interpretation of the story. Although you may choose any favorite fairy tale or mythic tale, here are two examples of a story theme with widespread cultural variations. **Cinderella** (French), as portrayed from other cultural or social points of view:

- Coburn, J. R., and C. McLennan. *Domitila: A Cinderella Tale from the Mexican Tradition*. New York: Shen's Books, 2014.
- Coburn, J. R., T. C. Lee, and A. S. O'Brien. *Jouanah: A Hmong Cinderella*. New York: Lee & Low, 2014.
- Cole, B. *Prince Cinders*. New York: Puffin Books, 1997.
- Craft, K. Y. *Cinderella*. San Francisco: Chronicle Books, 2000.
- dePaola, T. *Adelita*. New York: Puffin Books, 2004.
- Hickox, R. *The Golden Sandal: A Middle Eastern Cinderella Story*. New York: Holiday House, 1999.
- Jackson, E., and K. O'Malley. *Cinder Edna*. New York: HarperCollins, 1998.
- Jaffe, N., and L. August. *The Way Meat Loves Salt: A Cinderella Tale from Jewish Tradition*. New York: Henry Holt and Co., 1998.
- Louie, A.-L. *Yen-Shen: A Cinderella Story from China*. New York: Puffin Books, 1996.
- Lowell, S. *Cindy Ellen: A Wild Western Cinderella*. New York: HarperCollins, 2001.
- Manna, A., C. Mitakidou, and G. Potter. *The Orphan: A Cinderella Story from Greece*. New York: Schwartz & Wade, 2011.
- Martin, R. *The Rough-Faced Girl*. New York: Puffin Books, 1998.
- Mayer. M., and K. Y. Craft. *Baba Yaga and Vasilisa the Brave*. New York: HarperCollins, 1994.
- Minters, F. *Cinder-Elly*. New York: Puffin Books, 1997.

- Pollack, P., and E. Young. *The Turkey Girl: A Zuni Cinderella Story*. New York: Little Brown Books for Young Readers, 1996.
- San Souci, R. D. *Cendrillon*. New York: Aladdin, 2002.
- San Souci, R. D. *Sootface*. New York: Dragonfly Books, 1997.
- Schroeder, A., and B. Sneed. *Smoky Mountain Rose: An Appalachian Cinderella*. New York: Puffin Books, 2000.
- Shaskan, T. S., and G. Guerlais. *Seriously, Cinderella Is So Annoying: The Story of Cinderella as Told by the Wicked Stepmother*. Mankato, MN: Picture Window Books, 2011.
- Steptoe, J. *Mufaro's Beautiful Daughters*. New York: Puffin Books, 2008.

Little Red Riding Hood (French/European), as portrayed from other cultural or social points of view:

- Artell, M., and J. Harris. *Petite Rouge: A Cajun Red Riding Hood*. New York: Puffin Books, 2003.
- Daly, M. *Pretty Salma: A Little Red Riding Hood Story from Africa*. New York: Clarion Books, 2007.
- Don, L., and C. Chauffrey. *Little Red Riding Hood*. Cambridge, MA: Barefoot Books. 2012.
- Ernst, L. C. *Little Red Riding Hood: A Newfangled Prairie Tale*. New York: Simon & Schuster for Young Readers, 1998.
- Forward, T., and I. Cohen. *The Wolf's Story: What Really Happened to Little Red Riding Hood*. Somerville, MA: Candlewick, 2005.
- Grimm, B., and D. Egneus. *Little Red Riding Hood*. New York: Harper Design, 2011.
- Grimm, B., and B. Watts. *Little Red Riding Hood*. New York: North-South, 2011.
- Grimm, J. L. C., J. Grimm, and L. Zwerger. *Little Red-Cap*. New York: NorthSouth, 2006.
- Hyman, T. S. *Little Red Riding Hood*. New York: Holiday House, 1987.
- Lowell, S., and R. Cecil. *Little Red Cowboy Hat*. New York: Square Fish, 2000.
- Marshall, J., and C. Perrault. *Red Riding Hood*. Retold by James Marshall. New York: Picture Puffins, 1993.
- Pinkney, J. *Little Red Riding Hood*. New York: Little Brown Books for Young Readers, 2007.
- Shaskan, T. S., and G. Guerlais. *Honestly, Red Riding Hood Was Rotten! The Story of Little Red Riding Hood as Told by the Wolf*. Mankato, MN: Picture Window Books, 2011.
- Young, E. *Lon Lon Po: A Red Riding Hood Story from China*. New York: Puffin Books, 1996.

Although it is commonly believed that **Islam** forbids artistic representations of the human form, depictions of figures were never entirely prohibited during the medieval era of Islamic history. From the thirteenth through the sixteenth century, miniature paintings created as one-of-a-kind book illustrations or single works on paper became popular among the rulers and wealthy elite of **Persia**. Artists of these intricately composed images appropriated and incorporated characteristics of Byzantine, **Mughal**, **Arabic**, Central Asian, and Chinese art to produce a distinctive style of representation, unlike that being produced by artists of the European Renaissance.

While European artists were striving to realistically capture what they observed by employing technical tricks such as **chiaroscuro** and **aerial** or **linear perspective**, Persian miniatures were painted in brilliant hues, without the addition of shadows or chiaroscuro. Space was indicated by placing some figures higher on the page with the ground line tilted upward, as if the viewer were suspended in the air above the scene. Figures and natural forms did not diminish in size as they receded into distance spaces. Distant people, objects, and land features were as finely articulated and detailed as nearby objects.

A fondness for patterns also was evident in Persian miniatures. Tent flaps, the tops of buildings, and carpets might be tilted and flattened to appear as screens held parallel to the viewer. Building exteriors and interiors were intricately patterned in rich jewel-tone colors.

In this lesson, you will study compositional characteristics of Persian miniature art, then compare and contrast general conventions of Persian art with art of the late European Renaissance.

INSTRUCTIONS

When looking at artwork from an unfamiliar culture, it may be easier to make sense of the work if it is compared to works that have been created in a more familiar style. The sixteenth-century Persian artist Abd al Samad, for example, worked in a style of book illustration very different from that of Eastern European etcher Wenceslaus Hollar (1607–1677). Abd al Samad's jewel-like colors contrast with Hollar's black and white line work. Their uses of perspective differ; additionally, Hollar focuses on realistic portrayal of human subjects while Abd al Samad's compositions are integrated patterns and designs that incidentally incorporate natural **schemas**. In short, Hollar's work is informed by the European Renaissance era, while Abd al Samad's work reflects traditions of art from the Middle East and Asia.

1. Examine these two works of art and notice how the styles of art differ dramatically. Then identify similarities.
 a. What is the setting of each painting? What is the subject?
 b. Where are you, the viewer, standing in relation to the scene? To determine where you are standing in relation to the subject of the painting, look for the horizon line in the painting.

c. How is space between you and the most distant point of the image defined?

d. Where do you see the most detail? Where is the detail less distinct?

e. What is the role of color in the painting? Does it suggest a mood? Does the mood correspond with what is happening in the image?

Muzaffar Alī (fl. ca. 1540–ca. 1576). Persian miniature illustration for *Haft Awrang (Seven Thrones)*, 1556–1565, by Nur ad-Dīn Abd ar-Rahmān Jāmī (1414–1492), commissioned by Prince Sultan Ibrahim Miza. Freer Gallery of Art, Washington, DC.

Abd al Samad (16th century), *Prince Akbar and Noblemen Hawking*, ca. 1555–1558. Catherine and Ralph Benkaim, Collection Cleveland Museum of Art, Cleveland, OH.

Wenceslaus Hollar (1607–1677), *Hern Hawking*, 17th century. Engraving on paper, 5 5/16" × 4". Wenceslaus Hollar Digital Collection, Thomas Fisher Rare Book Library, University of Toronto, Toronto, ON.

f. In what way might the image be realistic? How might it be abstractive?

2. Search online for another miniature painting by Abd al Samad or by Kamāl ud-Dīn Behzād (ca. 1450–ca. 1535). Decide which of the two contains a section that you might like to copy. Download that image. The overall size of the image (when downloaded) should be at least 6" × 9" and should be of good quality,

3. Create a viewfinder out a piece of Bristol board or water-color paper cut to 6" × 7".

 a. With a ruler and pencil, mark a 1½" border all around.
 b. Fold the paper in half with the borderlines visible.
 c. With scissors, cut out the center. Use the borderlines as a cutting guide.
 d. Open the paper and notice the internal area is a viewfinder opening that is 3" × 4" in size.
 e. Hold the viewfinder over miniature and move it around until you find a section that is composition-ally interesting.
 f. Tape the viewfinder down on the miniature copy at this location.

4. On a sheet of 9" × 12" drawing paper, draw a slightly larger copy of the visible section of the miniature.

5. Use colored or watercolor pencils with a water wash to capture a sense of the color in the original.

6. When you are finished with the illustration, lay it aside and consider.

7. Do you think it is easier or more difficult to draw in this style than to draw in a familiar (Western) style? Why?

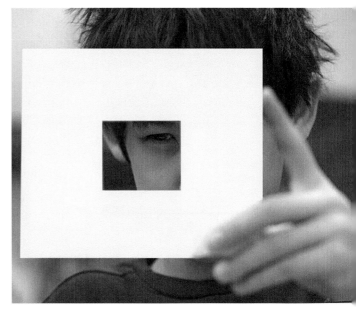

Example of a viewfinder.
(Created by the Author)

Materials Needed

white drawing paper, 9" × 12"	eraser
drawing pencils with soft and hard leads	colored or watercolor pencils with a brush and water

Vocabulary

Aerial Perspective	Linear Perspective
Arabic	Mughal
Chiaroscuro	Persia
Islam	Schema

WHAT TO SUBMIT FOR EVALUATION

· a written response to Instruction #1, in which you compare and contrast artworks by Abd al Samad and Wenceslaus Hollar
· a sketch of a quarter section of a Persian miniature illustration by Abd al Samad or Kamāl ud-Dīn Behzād
· a written response to the question posed in Instruction #7

TIPS FOR TEACHERS

The techniques used by Persian miniaturists to describe space are similar to strategies used by young children, before they have learned to master linear perspective. This does *not* mean the work of Persian miniaturists was simplistic or unsophisticated. However, it does suggest that children might especially enjoy artworks created in the miniaturists' style. Selecting spatial cues that will describe the locations of objects to one another while also reckoning ways to communicate important details about objects that are both near and far requires a great deal of high-level thinking. Children intuit many of these refinements and learn others from observing images made by other children within their social environment. Notice these artworks, which were created by elementary school children. What conventions of space might have been intuited? What conventions might have been copied from others? What conventions might have been taught or reinforced through formal education? Is it possible to tell which was a result of which? What does this suggest about the role of cultural experience in visual literacy?

Examples of children's use of space in art. (Child Art from the Collection of Enid Zimmerman)

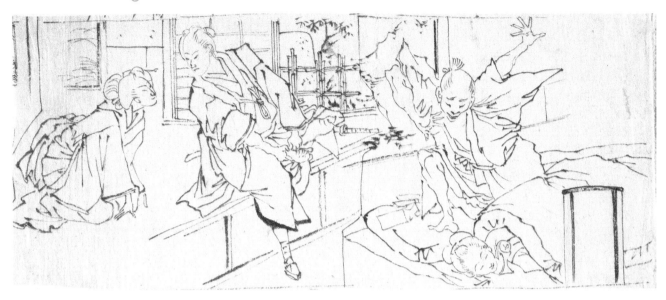

Tsukioka Yoshitoshi (1839–1892), *Figure Studies for an Illustrated Book*, late 19th century. Drawing with ink on paper sheet, 3 ⅝" × 8½" (9.21 × 21.59cm). The Joan Elizabeth Tanney Bequest (M.2006.136.110), Los Angeles County Museum of Art, Los Angeles, CA.

Manga is a popular cultural aesthetic of Japanese origin that has been embraced by youth around the world. The appeal of manga rests not only in the aesthetic beauty of manga forms, but also in its reliance on **stylistic conventions** that serve as multilayered communicative tools. These conventions allow viewers to follow physical actions and interactions of characters and to read various emotions and responses of **protagonists** and **antagonists** within a story. Additionally, the stylistic conventions of manga drawings are easily replicable. This encourages youth to imitate and master drawing images in a manga style. A few of the more obvious **visual codes** of manga include the following:

· Facial expressions, especially of the eyes and mouth, convey important information about what characters are thinking or feeling. Notice the shapes and sizes of the eyes and eyebrows. If the eyes are huge with a white spot of light and the eyebrows curved, the character is feeling one of several positive emotions, which are further explicated by the shape of the white light, such as a simple circle, heart, star, or X-shape. Narrow, straight, or slanted eyes and eyebrows may suggest negative emotions or a cold, evil person.

· Hair color is suggestive of the character's inner nature. White hair may indicate a peaceful or spiritual person, while a black-haired person might be malevolent, somber, or sad.

· **Gestures** are often dramatic and exaggerated to convey a manga character's personality. Conversely, some manga figures are greatly simplified, as in **chibi** style Pokemon characters, in which case straight or zigzag lines, ellipses, or dots may be used to describe the nature of the character. While there are a variety of iterations of the manga styles, including chibi, **shōnen**, and **shōjo**, the overall bodily shape of manga

407

figures is distinctive and might be considered a gestural characteristic of manga.

· The shapes of **word balloons** reiterate the text they contain, the emotions of the person speaking or thinking, or situations of the story environments.

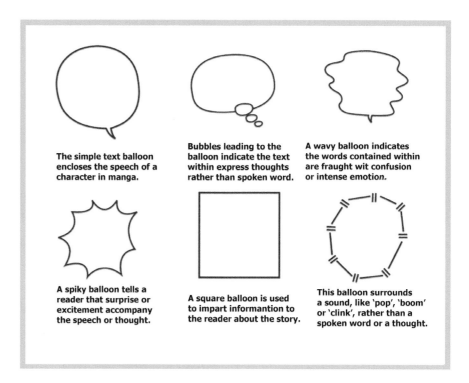

The simple text balloon encloses the speech of a character in manga.

Bubbles leading to the balloon indicate the text within express thoughts rather than spoken word.

A wavy balloon indicates the words contained within are fraught wit confusion or intense emotion.

A spiky balloon tells a reader that surprise or excitement accompany the speech or thought.

A square balloon is used to impart informantion to the reader about the story.

This balloon surrounds a sound, like 'pop', 'boom' or 'clink', rather than a spoken word or a thought.

· Strong contrasts between a character and his or her background, such as a blackened background behind a close-up of a face, may indicate that something shocking has happened or that something has significantly affected the character in an emotional way.

· Manga written and illustrated specifically for girls (shōjo) typically focus on intricacies of character interactions and emotions rather than actions. Often, shōjo illustrations convey the complexities of internal activities through complicated signs and designs. Manga created for boys (shōnen) typically present stories that involve extreme physical activities. These actions, which are described by highly dramatic poses, both mask and reveal intense inner emotions and socially tense interactions of characters.

· The directional readings of text in Western and Eastern cultures are different. In the United States, the direction is from left to right horizontally, while Japanese writing is from top to bottom vertically, or from right to left horizontally. Manga books and magazines produced in the East follow these reading directions, while manga produced in North America and Europe follow the reading directions of Western literacy.

1. Select two **frames** of a favorite manga or manga style that show the same character from two different angles, in two different **poses** or with two different expressions.

2. On 9" × 12" white drawing paper, sketch copies of the two frames, trying to capture the original manga as closely as possible.

3. As you are working, pause from time to time to think about how you tackle the task of reproducing the image.

 a. Where/how do you start the drawing? Do you start with the eyes, then finish the face before moving to the body? Do you sketch out a stick figure of the posture first?

 b. Why do you start in this way? For example, does it just seem natural to you? Do you want to sketch out the overall form so you can be sure to get the entire figure in the frame? Do you find it logical to proceed in this or some other order?

 c. Do you think it is easier to draw manga than realistic drawings? Why or why not?

 d. Do you think manga are more interesting or beautiful that other styles of drawing? Why or why not?

4. When you have finished copying two frames of manga, look at your drawings closely. Consider how you might alter the drawing to transform the character into an **original character**.

 a. What would you change? The pose? The eyes and face or hair? The clothing?

5. On sheets of 9" × 12" drawing paper, create two new manga frames that present an original character. The original character should draw on some elements of the copied figure, but you should also add embellishments or elements that transform that character into something new.

6. Use conventions of manga to help your readers understand the story you are telling in your original frames. Add text boxes if necessary.

Left, Manga drawing by an anonymous student. (Courtesy of the Artist)

Right, Erithe (Erin McChesney), *Spirit Thing: Kyrie,* 2004. Graphite on paper. (Courtesy of the Artist. http://erithe.deviantart.com/art /Spirit-Thing-10575304)

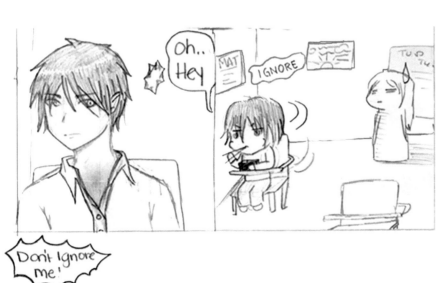

7. If you want to do so, you may complete your drawing with colored pencils, watercolor pencils with water wash, or color markers.
8. Share your work with peers and ask if they can read the story depicted by the frames. Listen to feedback, and make adjustments in your artwork if these changes are necessary to clarify meaning.

Materials Needed

drawing paper, 9" × 12"
drawing pencils in soft and
 hard leads
eraser

colored pencils, markers, or
 watercolor pencils with brushes
 and water for wash (*optional*)

Vocabulary

Antagonist	Manga	Symbol/Symbolic
Archetype	Original Character	Symbolic Iconography
Chibi	Pose	Ukiyo-e
Conventional	Protagonist	Visual Codes
Symbols	Shōjo	Word Balloon
Frame	Shōnen	
Gesture	Stylistic Conventions	

WHAT TO SUBMIT FOR EVALUATION

· sketched copies of two consecutive frames of a favorite manga
· written answers to questions posed in Instruction #3
· sketches of two original manga frames inspired by or adapted from the original manga frames, with clearly readable content

Tracing the evolution of manga as an aesthetic form reveals transcultural influences. Several art historians see roots in **Ukiyo-e** or "Floating World" woodblock prints that became popular between 1600 and 1867 (the Edo Period) in Japan. Among the better-known artists of Ukiyo-e images were Hokusai (1760–1849) and Hiroshige (1797–1858) of the eighteenth and nineteenth centuries. However, Osamu Tezuka (1928–1989), the twentieth-century artist who is recognized as the "father of manga," tells us his early work, *Astro Boy*, was largely influenced by watching Disney cartoons and Takarazuka, a Japanese theater troupe of women who played both male and female roles in lavishly staged Western-style musicals. Through his playful manga images and stories, Tezuka addressed profound universal concepts, presented an expansive worldview of nations, and articulated complex relationships between cultures.

Manga might be used as a resource for teaching about art and culture. Manga relies on **conventional symbols** to convey information about characters and their stories; however, because social mores, histories, mythic **archetypes**, and beliefs will differ considerably from culture to culture, these conventions will be interpreted differently by viewer-readers living in differing nations, cultures, and regions of the world.

> For example, in the United States—a country born of civil rebellion against "unjust" rules and regulations—the heroes of textual and visual literatures often continue this tradition by working outside the law to exact justice. However, in Japanese culture it would not be appropriate for a hero to operate outside the law, regardless of the circumstances.[2]

The popularity of manga and the interest many youth show in learning to read the **symbolic iconography** of manga texts suggests the value of manga as a vehicle for introducing students not only to visual and textual literacies but also to similarities and differences across cultures. Additionally, students might come to a better understanding of their own culture through active comparisons with differing cultures. Understanding the **symbolic** and stylistic conventions of manga is essential for teachers intending to use manga to support cultural teaching and learning. Some questions for students to consider include the following:

1. What does the manga tell us about expected or proper behaviors of characters, individually and in relation to others?
2. What acts are considered heroic?
3. What might motivate a character to act heroically?
4. What would be the consequences of such heroic behaviors for the hero and/or others?
5. How are specific character types (e.g., heroes, villains, parents, children, powerful men and women, gentle men and women, etc.) described differently or similarly in terms of visual details? What does this tell us about how they are culturally perceived?
6. How do visual details of clothing, gesture, and expression help us understand character relationships and roles?
7. How do these collective visual cues describe paradigms and worldviews different from those that are familiar to you?

Lesson 83: Making a Storyboard

When planning the visual progress of a story, animated film, graphic novel, or comic book, artists work with authors in designing **storyboards**. This is a visual chart that sets the key events of the story in sequence. The storyboard serves as an exercise in thinking through a story so as to ensure smooth transitions will move readers and viewers from one idea to the next. The storyboard ensures that viewers will read sequences of images in an orderly and logical way. In this lesson, you are to practice planning and thinking through a **graphic story** by creating a storyboard.

Kawanabe Kyōsai (1831–1889), Plate 3 from *Kyōsai's Sketchbook (Gyōsai suiga)*, vol. 1, 1882. Color woodblock printed book, 7 ³⁄₈" × 4 ¹⁵⁄₁₆" (18.6 × 12.5cm). Herbert R. Cole Collection. Los Angeles County Museum of Art, Los Angeles, CA.

INSTRUCTIONS

1. Invent an original short story or **scenario** from a larger story. The story or scenario can be based on characters from a story with which you are familiar. Your story, however, should be an original version or adaptation of that story.

2. On a piece of paper, provide an outline of the story in seven steps. These are to present important ideas or **plot points** that describe the action of the story from the beginning to end. An outline of the action will be presented in eight squares or **frames** of the storyboard, as follows:

a. Square One: Give the story a title. Put the title of the story and your name (as author/illustrator) in this frame.

 b. Square Two: Introduce the setting.

 c. Square Three: Introduce the character.

 d. Square Four: Introduce the "problem."

 e. Squares Five through Seven: Describe the quest for a solution.

 f. Square Eight: Provides the solution as a conclusion.

3. Create several thumbnail sketches that describe what might take place at each of these plot points.

4. When you are satisfied with your visual ideas for the significant plot points, set your sketches aside and prepare a storyboard chart from a sheet of 12" × 18" paper:

 a. Fold the paper in half the long way so the folded paper is 6" × 18".

 b. Open the paper and with a ruler, divide the length of the paper into four equal-sized (4½") sections. Fold along these lined sections. Your 12" × 18" paper now has been divided into eight equal-sized boxes or frames for story sequencing.

5. Illustrate your story by drawing the action and conversations (which were listed as plot points in your outline) in each sequential frame. Use pencils, or a thin black Sharpie to complete the storyboard.

 a. Use any style of drawing, including realistic or **manga** style drawing.

 b. Look at how-to-draw books or online tutorials to give you ideas for a style you would like to use.

 c. Words may be added in **word balloons** (see Lesson 82).

 d. Use color markers, colored pencils, or watercolor pencils with a brush and water wash to add color if it will contribute to the story.

6. Share your storyboard with your peers and instructor. Are they able to follow the story and understand what is happening in each frame of the sequence of events?

Anonymous student example of a storyboard created with pencils on paper and Photoshop manipulations. (Courtesy of the Artist)

7. If a sequence of frames or an action within a frame is unclear, adjust your images to clarify the meaning.

 a. If you must redo a frame, you may draw the new frame on a piece of 4½" × 4½" drawing paper and rubber cement the new drawing section over the older one.

Materials Needed

white drawing paper, 12" × 18"	eraser
scraps of white drawing paper, 4½" × 4½"	18" Ruler
	color medium of your choice
drawing pencils with soft and hard leads	

Vocabulary

Frame	Scenario
Graphic Story	Storyboard
Manga	Word Balloon
Plot Points	

WHAT TO SUBMIT FOR EVALUATION

· a written seven-step outline of an original story that you have invented
· thumbnail sketches that describe what might take place at each of these plot points
· a completed storyboard with a title frame and seven story frames

LESSON EXTENSION

A natural extension of this lesson would be to create animations or live videos based on the two-dimensional storyboards. Instructions or tutorials for creating animations (from storyboards to finished products) are available in text and as online resources. Suggested resources about storyboarding include the following:

· Canemaker, J. *Paper Dreams: The Art and Artists of Disney Storyboards.* 2nd ed. Glendale, CA: Disney Editions, 2006.
· Cristiano, G. *Storyboard Design Course: Principles, Practice, and Techniques.* Hauppauge, NY: Barron's Educational Series, 2007.
· Simon, Mark A. *Storyboards: Motion in Art.* 3rd ed. Waltham, MA: Focal Press, 2006.

Your local librarian may help you locate additional information about creating storyboards for animated or live videos.

Graphic storytelling has been rooted in world cultures throughout history. Before the invention of writing and widespread textual literacy, the conquests of powerful rulers and noble deeds of legendary heroes were recorded in images. We can still read these stories on ancient Egyptian stelae, the pediment friezes of ancient Greek temples, relief sculptures on Roman columns and arches, mosaics of Byzantine cathedrals, and bas-reliefs of ancient Persia and Southeast Asia.

Trajan's Column: Roman Triumphal Column (showing construction of city), 113 CE. Rome, Italy. (Photograph by Matthias Kabel. CC BY-SA 3.0 US)

The great deeds of peoples, stories of tragedies that befell them, and their explanations of these events also were recorded on perishable materials such as papyrus, parchment, wood, hides, silk, and paper. Many of these have been lost to us through time. We have only a few remnants of **graphic stories** recorded as books or codices. Among these are books or **codices** written by pre-Columbian Aztec peoples. The difficult time-consuming task of telling stories as pictures meant that only narratives of the greatest importance would be recorded. The intent of a **codex** was to remind readers of great deeds performed on their behalf, admonish against inappropriate behaviors that might bring ruin upon them, instruct how to perform religious rituals in ways that would preserve the sanctity of these acts, educate about proper ways of behaving toward one another, and predict or warn about future disasters as consequences of astrologically influenced world cycles.

When printed books and paper pamphlets became readily available and literacy more widespread, people did not lose interest in reading graphic stories, but the types of stories enjoyed came to include less ponderous messages. Newspapers featured illustrations, cartoons, visual parodies, and humorous images that delighted, informed, and persuaded readers. For example,

Benjamin Franklin's 1732 publication, *Poor Richard's Almanac*, presented readers with satirical cartoons that inspired and encouraged colonists toward revolution against England. Serial stories of imaginary heroes became popular in the early twentieth century, and full-length graphic novels were appearing by the mid to late century. Among these were sweeping histories and **social commentaries** that challenged readers to contemplate nuances of good and evil through narratives about the better angels and darker sides of human. These reminded readers to act ethically toward one another and encouraged critical thinking about the subjects being represented.

INSTRUCTIONS

In preparation for this lesson, select at least two of the following graphic novels. Examine the way the story is visually presented. This will require reading portions of the text and looking at the images to see how these relate to and support one another.

- Eisner, W. *A Contract with God Trilogy: Life on Dropsie Avenue*. New York: W. W. Norton, 2005.
- Lewis, J., A. Aydin, and N. Powell. *March*. Trilogy. Marietta, GA: Top Shelf Productions, 2016.
- Long, M., J. Demonakos, and N. Powell. *The Silence of Our Friends*. New York: First Second Books, 2012.
- Sacco, J. *Safe Area Gorazde*. Seattle: Fantagraphics, 2001.
- Sacco, J., and E. W. Said. *Palestine*. Seattle: Fantagraphics, 1996.
- Spiegelman, A. *Maus: A Survivor's Tale*. New York: Pantheon, 1986.
- Torres, A., and S. Choi. *American Widow*. New York: Villard, 2008.
- Vaughn, B., and N. Henrichon. *Pride of Baghdad*. New York: Vertigo, 2008.
- Yang, G. L., and L. Pien. *Boxers and Saints*. New York: First Second, 2013.

1. Write a summary of the story you have read and respond to the following questions:
 a. What style of art illustration was used to tell the story (i.e., manga style, Western superhero comic style, realism, etc.)?
 b. How did the visual presentation of the story support those ideas being presented?
 c. To what extent do you think the visual images helped or hindered you from developing an emotional connection to the story?
2. Select a recent event or a social issue that is of local, national, or global concern. For example, you could identify local problems caused by droughts or flooding, an example of systematic racism nationally, immigrants in search of economic opportunity, or the mass flight of refugees from war-torn regions of the Middle East into Europe.
3. Determine a question about this issue that might spark conversation and debate. Think about how you might present that question as a visual narrative or commentary.

4. On sheets of 9" × 12" or 12 × 18" white drawing paper, make at least four thumbnail sketches of eight-frame **storyboards** (see Lesson 83) that present different options for how the story might be presented.
 a. You may look at how-to-draw books or online tutorials to give you ideas for a style you would like to use.
 b. Words may be added in word balloons (see Lesson 82).
5. Share your favorite sketch ideas with your peers and instructor for feedback regarding the ideas and framed images that clearly convey your intended story and point of view.
 a. Are they able to follow the story and understand what is happening in each **frame** of the sequence of events?
 b. Can they deduce your point of view from the images?
6. Based on your preference and the feedback received, select storyboard sketches that most clearly present your idea and draw these in an eight-frame storyboard.
 a. If the sequence of frames or an action within a frame was deemed to be unclear during feedback, adjust the images to provide clarification of meaning. You may draw the new frames on separate sheets of paper and rubber cement them into the eight-frame storyboard.
7. Use colored or watercolor pencils or markers to add color, if this will contribute to the story.

Materials Needed

white drawing paper, 12" × 18"	drawing pencils with soft and
scraps of white drawing paper,	hard leads
4½" × 4½"	eraser
	18" ruler

Vocabulary

Codex/Codices	Social Commentary
Frame	Storyboard
Graphic Story	

WHAT TO SUBMIT FOR EVALUATION

· a written summary of a graphic story, and answers to the questions outlined in Instruction #1
· four thumbnail sketches of eight-frame storyboards documenting and/or commenting on a social issue
· a completed eight-frame storyboard that clearly articulates, as a graphic story, an important social issue and provides a point of view that might stimulate conversation and debate

Storytellers have been popular members of society since humans began to communicate verbally and gather in groups for social interaction. Telling histories, legends, myths, and fairy tales are ways of communicating culture, beliefs, and social mores to the younger members of a society. Stories also entertain and stimulate the imaginations of listeners. Imaginative storytelling and story creation are features of children's play. Recently, story creation has become a common activity of older youth and adults who engage in **role-playing** games and **fan fiction** writing. In this lesson, you will consider a story you would like to tell, imagine the setting and a character you would like to insert into a **storyline**, and illustrate these. Your character and story may be adapted from a commercial source or may be entirely invented and imagined by you.

When creating a story **illustration**, remember that illustration styles can vary greatly. Well-known illustrators who create in realistic styles include N. C. Wyeth, Norman Rockwell, Arthur Rackham, and Jerry Pinkney. Illustrators who create works that are simplistic, fanciful, or **abstractive** include Mo Willems, Beatrix Potter, David Catrow, and Eric Carl. You do not need to be a realistic artist to create intriguing and beguiling book illustrations. You are to begin this lesson by looking up examples of art created by each of the illustrators listed above. Then you will create a series of sketches that will be combined to tell a story that you have imagined or created.

INSTRUCTIONS

1. Find two artists among those listed above whose work inspires you and download or photocopy two examples of work by each of these two artists. Keep these images beside you as references and models while you work.

2. Imagine a character you would like to place in a story. Create a **concept map** of the character that comprises words and phrases that describe character traits, physical appearances, and behaviors important to the story.

3. Create a minimum of three sketches of the character.

4. Brainstorm an environment appropriate to your character, such as a flower cart on a street in old Quebec, tents near an oasis in a desert, or a fallen log in the forest.

5. Create a minimum of three sketches of the environment.

6. Now imagine an action or interaction the central character might engage in, and sketch a minimum of three examples of the action or interaction.

7. Share your ideas and sketches with your peers and instructor. Ask for feedback about the coherence of the conceptual and technical aspects of the composition.

8. Based on feedback and your preferences, select the most interesting of your various sketches, and on a sheet of 9" × 12" or 12" × 18" watercolor paper, complete a final drawing of the character in an action or interaction within an appropriate environment.

9. Finish the drawing with any color media or **mixed media** of your choice.
10. Write an essay (400–500 words) that addresses the following:
 a. Describe the character and story you have decided to illustrate. Explain why you decided to focus on that character and storyline.
 b. Explain why you chose the medium you used to illustrate the character and story. If you used different media for different aspects of the story, explain why.
 c. Compare your style of art to the styles of the two artists whose work you selected as inspiration for your illustrative style. Which artist's style is most similar to yours? Write a brief explanation of how your styles are similar and different.

Below, Erithe (Erin McChesney), *The Raven's Muse: Modesta,* 2008. Pencils, painted in Photoshop CS3. (Courtesy of the Artist. http://erithe.deviantart.com /art/The-Raven-s-Muse-86163698)

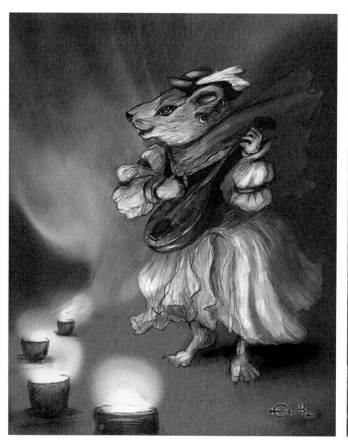

Right, An anthropomorphic castle mourns the absence of its knight owner. Anna Rademaker, *Lonely Castle in Moonlight,* 2012. Crayon on paper, 12" × 9". (Courtesy of the Artist)

Materials Needed

drawing paper, 9" × 12"
watercolor paper, 9" × 12" or
 12" × 18"
drawing pencils with soft and
 hard leads
eraser

recommended color media include crayons, colored pencils, colored markers, watercolor pencils with a blending brush and water, tempera paint, oil pastels, paper collages, mixed media, or a digital illustration program

Vocabulary

Abstract/Abstractive	Mixed Media
Concept Map	Role-Play
Fan Fiction	Storyline
Illustration/Illustrative	

WHAT TO SUBMIT FOR EVALUATION

· two downloaded or photocopied artworks by two of the illustrators listed in this lesson
· a concept map of an invented character that is comprised of words and phrases describing the character's traits, physical appearance, and behavior
· three sketches of the invented character
· three sketches of a background environment appropriate to the character
· three sketches of the character in action or interaction
· a completed illustration placing the character in action or interaction within an appropriate environment
· a written essay response, as outlined in Instruction #10

LESSON EXTENSION

Illustrators still use traditional media to create story illustrations, but many also increasingly are turning to digital media for book or story illustrations and animated stories. If you are familiar with stop motion animation or movie-making software, consider making a short animated story that is between two and three minutes in in length. Include a title screen and credits at the end.

There are a number of resources that would be helpful in working toward this goal, including the following:

· Bancroft, T., G. Keane. *Creating Characters with Personality: For Film, TV, Animation, and Graphic Novels.* New York: Watson Guptill, 2006.
· Beiman, N. *Prepare to Board! Creating Stories and Characters for Animated Features and Shorts.* 2nd ed. Focal Press, 2012.
· Cassidy, J., and N. Berger. *The Klutz Book of Animation: Make Your Own Stop Motion Movies.* Klutz Spiral Edition, 2010.
· Nilsen, S. *How to Create a Short Animated Story.* 2008. http://www .cutoutpro.com/How%20To%20Create%20a%20Short%20Animated %20Story.pdf.

Lesson 86: A Tunnel Book

The invention of motion picture technology in the late nineteenth century spurred a flurry of additional inventions that would assist in making imaginary stories more realistic. One such invention was the multi-plane camera. This permitted photographers to capture a sense of three-dimensional movement through imagined space. Increasingly improved versions of the camera were used in commercial products such as cartoons and feature-length **animations**, including Disney Studio's *Snow White and Seven Dwarfs* (1937), *Fantasia* (1940), *Bambi* (1942), and *Peter Pan* (1953).

Tunnel books make use of the basic multi-plane camera idea. Layers of two-dimensional images are stacked so they may be pulled closer together or apart. When viewed through the lens of a camera, the movement of the plates gives the viewer an illusion of moving through space. With recent accessibility to **laser cutters**, **silhouettes** of complex images may be easily cut, organized in layers, and glued in the bends of **accordion folds**. By peering into the picture plane and moving the accordion in and out, the viewer gets a sense of moving into and out of the scene. In this lesson, you will make a **tunnel book** that allows one to view a scene from a moving perspective.

Examples of a peep-show and stage scene tunnel book. (Created by the Author)

1. Begin the project by searching the children's section of the library and online for examples of tunnel books.

 a. Cite at least three tunnel books that you have discovered and explored.
 b. What are the subjects that are addressed in these books?
 c. Are they organized with a view hole in the front cover through which the action of moving layers can be observed?
 d. Is the book organized like a theatrical stage, with the front area serving as a downstage area, and successive layers beginning to fill space as they move upstage?

2. Think about the topic you would like to address as subject of your tunnel book. For example, you might consider illustrating various layers of flora and fauna that inhabit a rain forest or deciduous forest, a grassland plain, or desert. You might produce a scene from classic literature or media, such as Alice from Lewis Carroll's *Alice in Wonderland* meeting the Cheshire cat, or onlookers watching Superman fly through the air.

3. On sheets of 9" × 12" or 12" × 18" drawing paper, create at least four **thumbnail sketches** of an image you plan to use as subject of a tunnel book.

4. Share your ideas with your peers and instructor for feedback.

5. Based on the feedback and your preference, select the sketched topic that seems to have the most potential as a successful tunnel image.

6. On a larger piece of drawing paper, 12" × 18", begin planning the following layers:

 a. the front cover or scene
 b. four moving layers of the tunnel book
 c. the background scene

The tunnel book may be oriented horizontally or vertically, but all layers must be arranged similarly.

Decide whether your book with be oriented horizontally or vertically. (Created by the Author)

7. The front may be a **peephole** or a layer that will serve as an introductory opening to the book.
8. **Cutout figure layers** will present actions or objects of a scene arranged toward the sides of the paper, leaving the center section of each layer blank.
9. As the layers move back into space, more activity can be shown on the sides and the open center portion can decrease in size.
10. A background sheet should have an interesting scene that fills the page and will remain in view throughout.

The background layer (*above*) will fill the entire page, while other layers (*top*) will include cutouts. (Created by the Author)

11. Once you are satisfied with your sketches of each layer, begin redrawing the front and four layers on separate sheets of 9" × 12" **Bristol board**, cover weight paper, or heavy weight watercolor paper.
12. Fill in details of each layer. Create light and dark values and visual texture to describe various elements of the scene. Add colors as needed.
13. Use an **X-ACTO knife** or a laser cutter to cut away the empty center sections of each layer and the front. *If you use an X-ACTO knife, be sure to protect the cutting surface with a heavy pad of newspaper.*
14. Draw the background scene on a piece of 9" × 12" Bristol board, cover weight paper, or heavy weight watercolor paper. Fill in details of the scene.
15. Add color to all layers as desired, using colored pencils, markers, or any other **dry medium** of your choice.
16. Lay the front, layers, and background aside.

Making the Accordion Folds

1. Cut eight pieces of cover weight or heavy weight watercolor paper. Each should be 4" wide and the length of the sides (9" for **horizontal** or **landscape orientation** and 12" for **vertical** or **portrait orientation**).
2. Mark each piece into 1" segments. Using a ruler, carefully score each piece into three folds.

3. Lay the bottom layer of the book upside down, oriented with the top and bottom of the page in front of you, as shown. Brush a strip of rubber cement on right and left sides of the back.
4. Allow this to dry as you brush the inside edge of two pieces of accordion fold.
5. When the rubber cement is dry, place the glued edges of accordion folds onto the glued sides of the background.

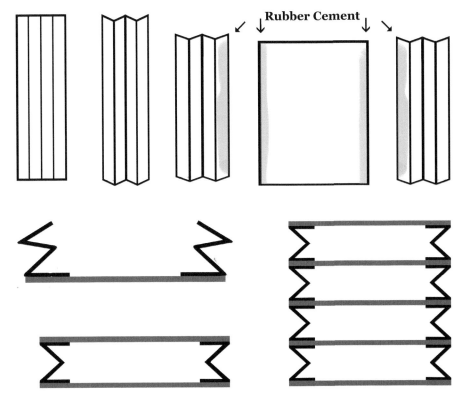

Rubber Cement

6. Flip the background right side up and set aside.
7. Take each layer of the tunnel book, lay upside down and brush rubber cement on the right and left sides of the layer. Rubber cement the inside folds of two accordion strips for each layer and attach as for the bottom layer.
8. Flip all layers right side up and lay aside until the rubber cement is set.
9. Organize the layers and background as shown. Rubber cement the outside edges of adjoining accordion edges. When the rubber cement on all edges is dry, attach the adjoining pieces.
10. When all pieces are attached and set, flip the front layer upside down and brush rubber cement on the right and left sides. Also brush rubber cement on the top edge of the accordion.
11. When the rubber cement is dry or nearly dry, place the top on the folds. Carefully place a weight on the book to hold the various accordion layers together until they are set.

12. Give the book a title, which can be applied to the front with press-on letters or stencils to give a professional appearance to this work.

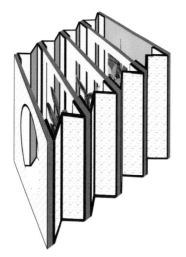

Where's Alice?

Materials Needed

white drawing paper, 9" × 12"
white drawing paper, 12" × 18"
Bristol board, cover weight paper, or heavy watercolor paper, 9" × 12" (six sheets)
Bristol board, cover weight paper, or heavy watercolor paper, cut to 4" × height of the tunnel layers. This will be either 4" × 9" (landscape orientation) or 4" × 12" (portrait orientation), (eight sheets)

drawing pencils with soft and hard leads
colorant (colored pencils or markers, etc.)
eraser
18" ruler
rubber cement
rubber cement eraser
X-ACTO knife and blade, or a laser cutter

Vocabulary

Accordion Fold
Animation
Bristol Board
Cutout Figure Layer
Dry Medium/Media

Horizontal Orientation
Landscape Orientation
Laser Cutter
Peephole

Portrait Orientation
Silhouette
Thumbnail Sketch
Tunnel Book
Vertical Orientation
X-ACTO Knife

WHAT TO SUBMIT FOR EVALUATION

· a written response to Instruction #1, and an explanation of what you selected for the subject of your tunnel book and why
· four thumbnail sketches of a tunnel book addressing this topic
· plans for each layer as sketches on drawing paper
· a completed tunnel book with title

What were the lives of ordinary people like in ancient times? Throughout history, artists have created murals, bas reliefs, sculptures, and paintings of great battles, the deeds of emperors and heroes, mythic tales, and portraits of wealthy elites, but there are fewer scenes depicting the daily lives of ordinary people. This makes sense if we consider who arranged for artworks to be made and the purposes for which art was made. Until the rise of the middle class in seventeenth- and eighteenth-century Europe, it was those with the means to **commission** and pay for the building of cathedrals and monuments, majestic glass windows, intricate tapestries, mosaic walls, or paintings. People of wealth and leisure wanted to see awe-inspiring scenery, beautiful people, and reenactments of noble deeds or tales of sacred wonder. The everyday lives of ordinary people were hardly of concern to these **art patrons**. As wealth became more evenly distributed throughout society, ordinary folk could afford to own pictures of interesting scenes and portraits of their families. Images of everyday life attracted audiences and patrons who longed for the sensual comfort and delight beautiful images provide.

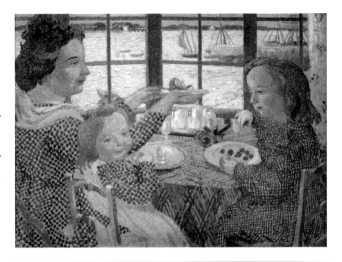

The phenomena of everyday life are readily available subjects for artists to observe and capture in works of art. Without traveling to exotic places one can find subject matter in a bowl of cherries on the kitchen counter, the family dog sleeping on its mat, a man repairing the engine of his car, a girl throwing a baseball, or a toddler learning to walk. Look around you and notice what is happening at this moment. Is someone near you texting a message on a cell phone? Is there a kettle whistling on the stove? Is someone walking her dog down the sidewalk? How can the intimate details of life become subject matter of a work of art? Making the ordinary appear extraordinary will be the challenge of this lesson.

INSTRUCTIONS

1. Keeping your digital camera device with you through an ordinary day, pay attention to familiar situation and scenes.
 a. Become aware of people and pets with whom you share your living space and notice as they go about their daily routines. What events

427

within your home are familiar activities of your life? Perhaps you spend a few minutes each day washing dishes, folding clean laundry, preparing food and wiping the kitchen counters, watching a favorite television show, or filling in a crossword puzzle.

 b. If you spend most of your day at home, observe people in your neighborhood. Does a neighbor mow her lawn or walk his dog? Do children wait each weekday morning for the school bus? Does the mail carrier make his or her morning rounds on foot? Are there cars parked beside a fence?

 c. If you spend most of the day at school or work, notice the people and events that occur at the bus stop, in a coffee shop, in hallways or classrooms.

2. Take as many pictures as possible of these ordinary daily events and scenes.

3. Afterwards, review the photos you took. Select six of the most interesting.

4. Create sketches of these six photos on 9" × 12" drawing paper, using pencils with soft and hard leads.

5. Share your sketches with your peers and instructor. Look for one that presents an ordinary but intriguing subject and pleasing composition.

6. On a 9" × 12" or 12" × 18" sheet of watercolor paper, redraw the most interesting of your sketches. Edit it to remove distracting visual elements if necessary,

7. Use pencils to fill in some details, visual textures, and areas of dark and light in the drawn composition.

8. Complete the work with a black and white or color medium of your choice.

9. Write a brief explanation (300–400 words) of the event that you have chosen to visually describe.

 a. What prompted you to select this image over other photographed events?

 b. What is happening in the image?

 c. Does it have special meaning for you, or did you choose to reproduce this for purely aesthetic reasons?

 d. Explain your answers.

Materials Needed

digital camera	drawing pencils with soft and
white drawing paper, 9" × 12"	hard leads
watercolor paper, 9" × 12" or	eraser
12" × 18"	color medium of your choice

Vocabulary

Art Patron

Commission

· six interesting photographs taken of everyday events as inspiration for this lesson
· six sketches based on the photographs
· a completed artwork of an everyday scene or event
· written responses, as outlined in Instruction #9

LESSON EXTENSION

In the section above you see a work of art, painted in 1901, of a mother and her daughters at breakfast. What does the painting tell us about this family and the nature of their relationships with one another? What can images of how people begin their day, with whom and how they share their first meal tell us about their lives as individuals, families, and in relationship to others of their social communities?

Begin this lesson extension by considering how family experiences of breakfast have changed since the last century. Do members of your family still gather together to eat a prepared meal? If so, who prepares the meal? Do members of your family spend time each morning perusing the newspaper or watching news broadcasts on television? Do family members check latest news and weather reports via some other type of electronic device? What time do you and others of your family eat your first meal, and with whom do you share it? Focus on breakfast as a subject of art, and describe the beginning of your day or your first meal of the day in a work of art.

Left, Gustav Wentzel (1859–1927), *Breakfast II: The Artist's Family*, 1885. Oil on canvas, 55½" × 49 ⅜" (141 × 125.5 cm). National Gallery (Nasjonalgalleriet), Norway.

Right, Carl Larsson (1853–1919), *A Late Riser's Miserable Breakfast*, 1900. Photographer Larssons, Langewiesche Königstein, 2006. Facsimile of the 1902 edition. (via Wikimedia Commons)

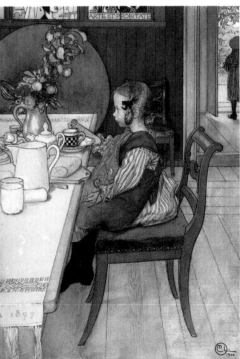

Picture books are among the earliest experiences young children have with literacy. Picture books visually present ideas with minimal or little text; thus children who cannot yet read are able to follow along as a story unfolds. The authority of image over text identifies the picture book as an art object. Art objects and images invite us to metaphorically imagine the world and come to see it in differing ways. For this reason, it is important that the **worldviews** we present to children through picture books do not narrow the perceptions a child might develop about the world. Rather than limiting exposure to one idea of how others experience their lives, several views of others and the contexts of their lives should be presented. This invites children to see people and situations as multifaceted and richly complex. Considering a controversial theme from several different points of view also broadens a child's understanding and empathy for others, while reassuring a child whose own life is touched by challenging situations that life could be different or approached more positively. Thus, the child may be guided to understand that he or she has agency to make sense of the experience on his or her own terms.

For example, look at how these authors have approached concepts of immigration and the migrant child and family from different perspectives. As you look over the following books, notice how the **mood** of each story is revealed through use of **Elements** and **Principles of Art** and the overall **style** of the artwork. Notice how somber the colors in Pérez and Gonzalez's book are compared to the vibrant colors and swirling lines of Herrera's illustrations. Notice how soft and nostalgic the coloration of Altman and Sanchez's work is, compared to the bold lines and colors of Bunting and Diaz's illustrations. Think about how these illustrative effects support and strengthen the viewer's interpretative reading of each text.

- Altman, L. J., and E. O. Sanchez. *Amelia's Road*. New York: Lee & Low Books, 2000.
- Bunting, E., and D. Diaz. *Going Home*. New York: HarperCollins, 1998.
- Herrera, J. F. *Calling the Doves / El canto de las palomas*. New York: Children's Book Press, 2001.
- Pérez, A. I., and M. C. Gonzalez. *My Diary from Here to There / Mi diario de aquí hasta allá*. New York: Children's Book Press, 2013.

Altman and Sanchez present the immigrant child as longing for permanence of place, while Herrera shows the child celebrating freedom to move within a geography and seeing permanence in changes of nature. Pérez and Gonzalez suggest the immigrant child as anxious about relocation to a new place, while the protagonists of Bunting and Diaz's story wonder why anyone would want to return to a former home. To some extent, each of these emotions might be true for the immigrant child. Being invited to see the immigrant experience from a variety of perspectives would help students who are

of migrant or immigrant families to accept emotional ambiguities of their own experiences, while children who have never experienced being migrants or immigrants could realize complexities of experience that defy stereotypic interpretation.

For this lesson, you are to select a theme that is important to you. You might consider, for example, issues inherent in homelessness versus perceptions of the homeless by those who have never experienced it; being teased or bullied from the viewpoint of the bullied and bully or bystander; accepting or being anxious about one's physical appearance; or tensions and celebrations within a family. Choose one topic from among these, or select a topic that is more intimately relevant to you.

INSTRUCTIONS

1. Visit the children's section of your local library to examine the books indicated above. If these books are unavailable, ask the librarian to help you select four picture books that address a single social issue topic from varied viewpoints.

2. Write a very brief essay (250–400 words) addressing the following questions:
 a. How do the uses of Elements and Principle of Art and the illustrative styles of the four books' artists support the mood and interpretation of each book?
 b. How do these approaches help readers see the topic of the book from a particular perspective?
 c. Cite all the books referred to in your essay.

3. Write the topic you will address at the top of a sheet of 9" × 12" or 12" × 18" drawing paper.

4. Do at least four sketches on this and additional sheets of drawing paper, if necessary, that show the topic from differing perspectives.

5. Share your sketches with peers and your instructor for feedback. Are different points of view clearly identifiable? Which sketches are compositionally more powerful?

6. Based on feedback and your own preference, select two sketches that invite differing or oppositional interpretations of the topic, and develop them into complete drawings on sheets of 9" × 12" or 12" × 18" watercolor paper.

7. Consider how the use of line, color, shapes, placement on the page, use of positive and negative space, or other technical decisions affect mood, and apply this knowledge to your work. The intended mood should be clearly conveyed by your artistic decisions.

8. You may add color with colored or watercolor pencils, or a color medium of your choice.

9. Write a brief essay response (250–400 words) to the following questions:
 a. Why was this theme important to you?

b. How did you arrive at two differing points of view about the topic?

c. How did your uses of the Elements and Principles of Art support these differing perspectives?

d. Did imagining this topic from diverse perspectives challenge you to a broader or deeper understanding of the topic? Explain.

Materials Needed

white drawing paper, 9" × 12" or 12" × 18"

white watercolor paper, 9" × 12" or 12" × 18"

drawing pencils with soft and hard leads

eraser

color medium of your choice

Vocabulary

Elements of Art

Mood

Principles of Art

Style

Worldview

WHAT TO SUBMIT FOR EVALUATION

· two written essays, one each in response to Instructions #2 and #9

· four sketches that describe a topic of your choice from differing perspectives

· two completed artworks that describe the topic from two different perspectives

Lesson 89: A Photographic Essay

The invention of the camera permitted photographers to capture, with an "artist's eye," historic events and visual stories about people and society. Among the stories we remember are ones that are told about life during difficult or celebratory times of individuals and the nation. Rarely have efforts been made to photographically record the trials and tribulations of a people as comprehensively as during the era of the **Great Depression**. In 1939, under the auspices of the **Farm Security Administration (FSA)**, photographers were hired to create visual essays about the plight of poor and displaced people, unemployed workers, and destitute farmers across America. Many of the photographs were exhibited in a show, *The First International Photographic Exposition*, at the Grand Central Palace in New York. Our awareness and understanding of ordinary people's lives during that historic period are very much molded by the photographs of that era. In this lesson, you will identify a social issue or concern, record images that relate to your topic, and arrange and compose them into a **photographic essay**.

Left, Migrant Mother: Destitute Pea Pickers in California. Mother of seven children. Age thirty-two. Nipomo, California, 1936. Photograph from nitrate negative, 4" × 5". Farm Security Administration—Office of War Information Photograph Collection, Prints and Photographs Division, Library of Congress, Washington, DC.

INSTRUCTIONS

1. Think about a social issue that concerns you in some way, such as school dropouts, issues related to serving in the military, homelessness in your community, environmental issues, alcohol abuse by college students, drug abuse resulting from over-prescription of painkillers, divisions

Above, Walker Evans (1903–1975), Floyd Burroughs—Sharecropper, 1936. Photographic print, half-length portrait. U.S. Resettlement Administration photographs, Prints and Photographs Division, Library of Congress, Washington, DC.

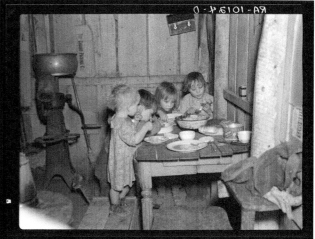

Fold long sheets of paper in half, then fourths, in an accordion fashion. Connect two accordion-fold strips to create more pages. (Created by the Author)

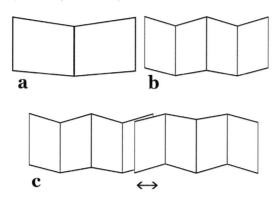

based on political party affiliations, obsessive interests in video gaming, or consumerism.

2. Brainstorm a list of symbols, events, objects, places, or people that could be subjects of photographs that tell a story about this issue. Write the ideas down and refer to them while working on this project.

3. Using a digital camera, seek out opportunities to record images related to your topic.

4. Take a minimum of 20 photographs that tell large and small aspects of the story.

 a. Some images might be **cropped** or sections of them enlarged. This is easy to do with most photograph-editing software.

 b. The photographs may be in color or black and white.

5. Lay the photographs out and study them.

6. Select 12 of the photographs and arrange them into a sequence that tells your story.

7. Print these out and trim them all to the same size: 4" × 5½".

8. Make an outline of the story by giving a title to each photograph in the sequence and noting how it fits in with the photograph that precedes and the one that comes after it.

9. Make an **accordion fold book** as follows:

 a. Using a paper cutter or steel ruler and matte knife, cut a piece of 12" × 18" watercolor paper in half lengthwise to create two 6" × 18" strips of paper.

 b. Fold each strip in half and crease the fold, making two 6" × 9" sections.

 c. Fold each end to meet the centerfold, creasing the folds of the paper, and then reverse the direction of these folds to create a zigzag of four rectangles.

 d. Repeat this with the second strip.

 e. Overlap a front panel from one accordion with a back panel of the second. Using rubber cement, fasten these together. Clean off the excess rubber cement with a rubber cement eraser.

f. You now have an **accordion folded** strip of seven 4½" × 6" sections, or, counting both sides, 14 sections.

g. The two end pieces will serve as covers of the accordion fold book. This leaves 12 sections as pages of the book—counting both the fronts and backs of each page. Arrange your photographs in a sequence in these folds. Mount them in place with rubber cement. Clean off the excess glue with a rubber cement eraser.

h. You may add titles, captions, or written text to the images if these seem appropriate.

10. To create the book covers, rubber cement the two outside pages of the strip to two pieces of heavy mat board that are between 4½" × 6" to 5½" × 7" in size. *You might ask for scraps from a local frame shop or craft store where pictures are framed. Have them cut the pieces for you.*

11. There are many ways the covers may be decorated. Look online or in craft books on how to make handmade books for ideas on designing an interesting set of covers. Look in craft stores for scrapbooking supplies for additional inspiration, ideas, and materials.

12. Use press-on letters, stencils, or a computer-created label to add the title of the essay and your name on the front cover of the accordion book. Try to create as professional a presentation as possible.

13. Consider adding a ribbon or some other means of securing the book in a closed position.

14. Write an essay (400–650 words) in response to the following:

 a. Describe your thought process in selecting a subject for this lesson.

 b. Tell how you determined the photos to include and the sequence of their arrangement.

 c. Did this process and project inspire you to think differently about or clarify your ideas about the social issue you presented? If so, how?

 d. Describe any problems you had in creating the book and explain how you resolved these problems.

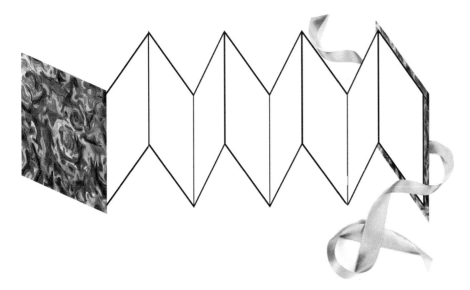

Accordion sheet with covers added and a ribbon for tying the book closed. (Created by the Author)

Materials Needed

digital camera	rubber cement
heavy watercolor paper (or Bristol board or cover weight paper), 12" × 18"	rubber cement eraser
	matte board (two pieces cut to 4½" × 6" or 5½" × 7")
18" metal ruler	press-on letters, stencils, and decorative scrapbooking materials (*optional*)
paper cutter or matte knife	
scissors	

Vocabulary

Accordion Fold	Farm Security Administration (FSA)
Accordion Fold Book	Great Depression
Crop/Cropping	Photographic Essay

SUBMIT FOR EVALUATION

· a list of symbols, events, objects, places, or people that could be subjects of photographs telling a story about a social issue
· a collection of 20 photographs taken for possible use in telling large and small aspects of the socially relevant story
· a written outline of the story, with notes regarding the images selected to illustrate each step of the story
· a completed photographic essay of 12 images, arranged in an attractively presented accordion fold book, with appropriate titles, captions, text, and covers.
· a written essay response, as outlined in Instruction #14

Lesson 90: A Poetic Photo Album

Photographs of people and places capture moments in time visually, but these do not always convey the thoughts and feeling we are experiencing at the time the photograph is taken. **Stream-of-consciousness** writing is a form of writing that can capture elusive emotions and abstract thoughts. Thoughts that tumble out spontaneously often bear characteristics of poetry in language, aesthetic essence, rhythm, and pattern (or meter). In this lesson, you are to combine these elements and create a journal or book that synthesizes imagery with stream-of-consciousness poetics.

INSTRUCTIONS

1. Select a series of six images of yourself (and/or your loved ones) that are important to you. Perhaps these are images that portray you over time, in a relationship, or experiencing mood changes. Be thoughtful in selecting the images. Choose photos that call forth strong personal feelings (either positive or negative). It is crucial that you be able to response to the events, persons, interactions, situations, or internal experiences that are evoked by the photos.

2. Scan the six images or select them from a digital file and crop or otherwise alter them so they are all approximately the same size and then print them out. The printout size should be either 3" × 4" or 4" × 5", depending on the size of the book or journal you are going to create and allowing some space to be left for text.

 a. The images may be in color or in black and white.

 b. If some are color and others are not, think about whether you wish to alter them to be the same, such as all in black and white.

 c. You might modify the images using a digital filter.

3. Arrange images in a logical order that makes sense to you and lay them out before you.

4. At this point you will need to decide if you would prefer to create a different stream-of-consciousness poem for each separate image, or one continuous writing that unites the images. If you decide the latter makes more sense to you, complete the instructions for the **Accordion Fold Book**. Otherwise follow instructions for the Journal Album.

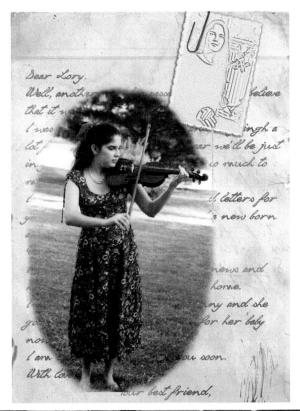

Pina Latuzsek, page of Poetic Photo Album, 2015. Digitally manipulated images with stream of consciousness writing. (Courtesy of the Artist)

Student collection of images to consider for an album. (Courtesy of the Artist)

Accordion Fold Book

1. To create an **accordion fold**, cut a 12" × 18" piece of heavy white water-color paper (or **Bristol board** or cover weight paper) in half lengthwise, creating two strips that are 6" × 18" each.

 a. Using a ruler, mark off the top and bottom lengthwise edges of each strip at 4½", 9", and 13½". Carefully **score** the paper at these points. Using a ruler and a dull object, such as a butter knife, impress a dividing indentation that connects the top and bottom marks. This will allow you to more easily fold the heavy paper at these places.

 b. Fold each strip in half and crease the scored fold (making two 6" × 9" sections).

 c. Fold each end to meet the centerfold, creasing the folds of the paper at the 4½" and 13½" scored locations, and then reverse the direction of the folds to create a zigzag of four rectangles.

 d. Repeat this with the second strip.

 e. Overlap a front panel from one accordion with a back panel of the second. Using rubber cement, fasten these together. For a secure attachment, brush rubber cement on both pieces that will be attached. Allow the rubber cement to dry on both pieces before placing them together.

 f. Use the rubber cement eraser to remove any extra rubber cement.

2. You now have an accordion folded strip of seven 4½" × 6" sections, or, counting both sides, 14 sections.

3. The two end pieces will serve as the covers to the accordion fold book. This leaves each side of the accordion with six sections as pages of the album. Collapse the folds and place a mark on the top and bottom folds to remind you not to write on these pages, as they will be used to create the covers of the book.

4. Open the accordion, and on one side arrange your six photographs in a sequence. Mount them in place with rubber cement. Clean off the excess glue with a rubber cement eraser so rubber cement will not interfere with your writing.

5. Look over the images once again, letting your mind wander over the feelings they evoke.

6. Then, using a pencil or pen and beginning at the top far left-hand side of the paper, write the words "In my life . . ." and let an unbroken stream of thought flow afterward. Do not try to force the words or thoughts in any direction; simply let them emerge from your relaxed mind onto the paper. Allow the words to flow over or around the images as seems natural to you.

7. When you come to the end of the accordion strip, turn the paper any direction you choose (sideways or upside down, or from the beginning again) or flip the accordion fold over, and continue writing. You do not have to write in a straight line. In fact, it is often more interesting if your

line of writing creates hills, valleys, or swirls on the paper, as the words flow from you.

8. Continue this stream-of-consciousness writing until you run out of space.

9. Go back into the strips and add any decorative touches that seem appropriate. These might include **Zentangle** doodles, trinkets, ticket stubs, prayer cards, bits of clip art, pens, buttons, beads, drawings, or more photos.

10. To create the book covers, prepare two end pieces of cardboard or a material that is heavier than the strip used for the album interior. Each should be 4½" × 6½" in size.

11. Rubber cement the covers to the top and bottom pages of the accordion folds.

12. Decorate these covers in a way that is appropriate to the Poetic Photo Album.

13. Add a title to the front cover that follows the theme of the album.
 a. Look at resources below for ideas and how-to tutorials.

Journal Album

If you prefer to create individual pages of your six images in a journal format, look through books or online resources such as Pinterest for suggested journal-making methods and select a preferred technique.

Laurie Gatlin, cover of Poetic Photo Album, 2014. Vintage music pages, paper, ribbon, bookcloth, 6" × 9". (Courtesy of the Artist)

1. Attach images to desired pages of the journal using rubber cement, or construct pieces of the page digitally in an image manipulation program.

2. Create a stream-of-consciousness poem on each page and add other details and items as desired.

3. Add details of drawings, doodles, or Zentangles, collage pieces, or other relevant items to each page.

4. Decorate the front and back of the journal with a composition and materials that fit the theme of the album.

Materials Needed

heavy watercolor paper (or Bristol board or cover weight paper), 12" × 18"
18" ruler
mat knife or large scissors
dull butter knife
rubber cement
rubber cement eraser
pencil or good ink pen

mat board (two pieces cut to 4½" × 6½")
personal photographs, scanned and reduced or enlarged to size
press-on letters, stencils, and decorative scrapbooking materials, and other decorative items (*optional*)

Vocabulary

Accordion Fold

Accordion Fold Book

Bristol Board

Score

Stream of Consciousness/Stream-
of-Consciousness Writing

Zentangle

WHAT TO SUBMIT FOR EVALUATION

· copies of the six original images selected for use in this lesson
· a completed accordion fold album or journal album with stream-of-consciousness writing as a background on each page of the album
· a written essay response (500–650 words) to the following questions:
 · Why did you select these images and/or items for use in your album? What do they mean to you?
 · What thoughts and feelings emerged when you looked over the photos prior to writing your stream-of-consciousness poem(s)?
 · What surprised you about the thoughts and feelings that emerged when you wrote your poem(s)?
 · Why did you select this presentational form (accordion fold album or journal album) as appropriate to your completed project?

TIPS FOR TEACHERS

The following resources may be helpful for learning about or teaching simple bookmaking techniques:

· Browning, M. *Handcrafted Journals, Albums, Scrapbooks and More.* Edison, NJ: Sterling, 1999.
· Doggett, S. *Bookworks: Books, Memory and Photo Albums, Journals, and Diaries Made by Hand.* New York: Potter Crafts, 1998.
· LaPlantz, S. *Cover to Cover: Creative Techniques for Making Beautiful Books, Journals and Albums.* New York: Lark Crafts, 1998.
· Thomas, P., and D. Thomas. *More Making Books by Hand: Exploring Miniature Books, Alternative Structures, and Found Objects.* Minneapolis: Quarry Books, 2004.
· Zamrzla, E. *At Home with Handmade Books: 28 Extraordinary Bookbinding Projects Made from Ordinary and Repurposed Materials.* Boston: Roost Books, 2011.

Lesson 91: A Stab Bound Book

Japanese stab binding is a simple technique for attaching sheets of paper into books. Front and back covers hold pages of the book with decorative stitching at the **spine**. The stitches are created by passing thread through holes along the spine edge of the covers. When thread is passed through the holes a number of times, patterns can be created. The directions below will produce a stab bound book for a use of your choice. The process could be used when putting together collections of photos, postcards, or blank pages to be used as a sketchbook, scrapbook, or journal.

Left, Laurie Gatlin, Monopoly board as book cover. Monopoly board, trinkets, and paper, 6" × 9". (Courtesy of the Artist)

Read through the instructions for this stab bound book carefully before you begin the project. Be sure you understand how the pieces are cut, glued, arranged, and bound together. Decide which method you wish to use for the inner pages, and collect all the materials needed. The sizes for covers and papers, which are given in the instructions below, may be changed to sizes that are more convenient or aesthetically pleasing to you. However, if you alter the dimensions of the book, it is crucial to remember that the cover should be slightly larger than the inner pages, or the pages may stick out from the edges of the cover.

Above, Laurie Gatlin, sheet of music as book cover. Skewers, pearl cotton, paper, cardboard, and vintage music sheets, 9" × 6". (Courtesy of the Artist)

441

Select an already decorated cardboard sheet or decorate your own cover, using the following technique. Decide upon a size for the overall book and its orientation. These instructions suggest that the cover be about 7" × 10" in size and the inside pages be 6" × 9", with the book oriented vertically, so the spine of the book measures 10". If the cover is to be decorated with paper, the decorative paper should be 1" wider all around than the cover cardboard, so the decorative sheet can be glued properly to the inside of the cover. The rough edges of the inside cover will be hidden by an inner lining.

1. Lay a 9" × 12" sheet of decorative paper face down on the work area and evenly apply rubber cement to the backside of one sheet of the decorated cover paper. Smooth the rubber cement with the brush until the glued paper is evenly covered and lays flat.
 a. The cover design or decoration should reflect the purpose for which the blank book will be used. You could create your own decorative cover paper from a collage or drawing.
 b. You may use white craft glue instead of rubber cement. If you choose to use craft glue, smooth the glue out evenly with a wide glue brush. The surfaces do not need to be dry before attaching one part to another.
2. Allow the rubber cement to *almost* dry as you prepare the cover board with rubber cement or glue.
3. Place the sticky side of the 7" × 10" cover board in the middle of the glued covered paper; leave 1" of decorative paper extending beyond the edges of the board.
4. Carefully clip the corners of the decorative cover paper, so the edges will fold smoothly.
5. Flip the cover board over so the decorative paper is on top, and make a **scored groove** near the spine edge of the cardboard.
 a. Mark a line 1" inside the spine edge of the cover pieces. Place a ruler along this line and **score** the length of the mark. Scoring means you press a dull heavy tool, like a butter knife, along the length of the line to crease the cover gently.
 b. Gently score again along this line and bend the cover slightly to allow some ease of the decorative paper.
 c. If possible, do this before the rubber cement is completely dry, being careful not to tear the decorative paper.
 d. This grooved area should be prepared before the decorative paper has been folded over and attached to the inside of the cover.
6. Run an even line of rubber cement along all the inside edges of the cover board. Fold the side edges of the glued cover paper over the board.
7. Tuck in the angled corners of the paper carefully, then fold the top and bottom edges of the paper over the board.

8. Rub down each side of the paper, until the paper lies flat and smooth against the cover board and into the score or groove.

9. Repeat for the back cover.

10. Select two 6½" × 9½" sheets of plain colored paper or white watercolor paper and carefully rubber cement onto the inside of each cover board, covering the raw edges of the folded-over decorated paper.

11. Put covers between clean scrap paper and press with a weight (a few heavy books will do) overnight until the papers and covers are completely dry.

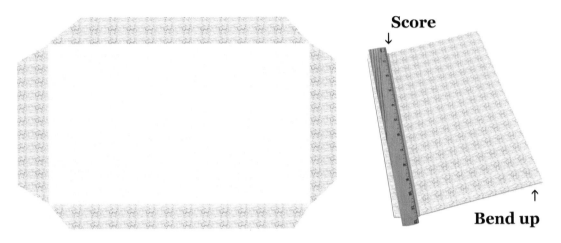

Score

Bend up

12. Prepare a **template** for punching holes for the book. The top and bottom holes should be about ½" from the top and bottom edge and ½" from the spine edge. Seven or eight additional holes should be equally spread out between these two.

 a. If you have access to a laser cutter, use the cutter to create evenly spaced holes that match the front and back covers.

Left, Place a cover board in the center of a sheet of decorative paper. (Created by the Author)

Above, Use a ruler as guide when scoring the cover board. (Created by the Author)

Below, Turn edges of the cover paper to inside of the cover board. (Created by the Author)

Fold paper tabs to underside

Inner Pages

13. There are several materials that can be used as inner pages of the Japanese stab bound book. You may use postcards or other pre-made pieces

Place template along spine edge to mark and cut holes.

Use a template to mark spaces for holes. (Created by the Author)

Assemble covers and sheets of the book. (Created by the Author)

Punch holes through all layers of the book. (Created by the Author)

of paper that are slightly smaller than the size of the covers, or you may make your own blank pages. One method of making your own blank pages involves single-folded pages stacked atop one another, with holes punched at the folded edge. The folded edges are then caught between the covers.

 a. To make single-fold pages, you will need 10 to 15 pieces of paper that are cut to 6" × 18".

 b. Fold each inner sheet of paper in half to 6" × 9" and align the folded edges together. These will be placed at the spine edge.

Continue Assembling the Book

14. Assemble the book: bottom cover, a colored end sheet, the inside pages, another colored end sheet, and the front cover on top. Double-check the page order and orientation of the book.

15. Lay the template as a guide on the spine edge of the book and mark where the holes must be in order for all pieces to match up neatly. Using either a single or multiple **hole punch tool**, a **laser cutter**, or an **awl**, punch holes in the spine edges of the covers and through each page.

 a. If you use an awl, use a pad of newspapers or other protective pad to protect the surface on which you are working.

 b. If using a laser cutter, follow instructions for its safe use.

16. Re-assemble the book in correct order.

17. With a yarn needle and thread, start sewing from the back of the book to the front, wrapping the thread around the top hole first.

18. Leave a tail on either the front or back of the book. This is where the final knot and extra thread will be, and can be used to attach a tassel.

19. Working from the top of the book to the bottom of the book, continue sewing in all the holes. Plan out decorative stitches if you wish to create an unusual look to the binding.

20. Now work from the bottom of the book back up to the top of the book, until a secure and decorate binding has been achieved.

21. When you get to the last hole, where the threads meet, tie a knot and add a drop of white glue to hold the knot securely. You can let long tails remain as tassels that will serve as a bookmarker, or tuck the threads back into the hole and add a drop of white glue to make sure they remain hidden in the hole.

22. You may add additional decorate pieces to the cover, such as buttons or knobs to serve as openers.

23. Write an essay (500–750 words) in response to the following:

 a. Describe ways this book might be used.

 b. Explain why you chose the selected decorative pieces for the cover.

 c. What other materials could be used for a cover or decorative cover paper?

 d. Describe any difficulties you had in creating this book and how you overcame them.

e. In what ways could the instructions be simplified or modified to make it easy to teach this technique to others?

Materials Needed

postcards, precut cards, or 10 to 15 sheets of paper (for the insides of the book), cut to 6" × 18"

two pieces of cardboard, cut to 7" × 10"

two pieces of decorated paper, such as wallpaper, decorative rice papers, or marbled paper, for the covers. These should be cut 1" longer and 1" wider *all around* than the cover board, 9" × 12".

two pieces of plain colored or white watercolor paper for the inside of the covers sheets, cut slightly smaller than the size of the cover board (about 6½" × 9½")

18" metal-edge ruler (preferably with a cork back to keep it from slipping)

dull butter knife

X-ACTO knife and blade (*optional*)

a hole punch machine, laser cutter, awl hand tool, or template made of heavy mat board or illustration board, cut to 10" × 1¼", with holes punched ½" from each end and evenly spaced about 1" apart within these boundaries

tapestry thread, ¼" cloth ribbon, or attractive but sturdy string

yarn needle or needle suitable for the selected thread

rubber cement with a wide glue brush

rubber cement eraser

scissors

newspapers to keep workspace clean and to pad the surface if holes are being punched with an awl

Examples of bindings. (Created by the Author)

Vocabulary

Awl

Groove

Hole Punch Tool

Japanese Stab Binding

Laser Cutter

Score

Scored Groove

Spine

Template

SUBMIT FOR EVALUATION

· a completed, trimmed, and cleaned stab bound book
· a written essay response, as outlined in Instruction #23

Japanese stab bound books might be too complicated for younger children to manage, but older elementary and middle school students could accomplish this if invited to proceed step-by-step along the process. However, it may be helpful to provide students with experiences making accordion fold books (see Lesson 89) or simple multiple-fold books before moving to the more challenging stab book forms.

A simple multiple-fold book can be made to look quite sophisticated by using heavy weight papers, such as construction paper or colored cover weight paper. No hard cover is necessary, as the natural outer "pages" can serve as the front and back. To make multiple-fold pages, you will need several large pieces of paper, 12" × 18".

1. Fold each sheet of paper in half lengthwise. Press the crease to make sure it is flat and tight.
2. Open the page of paper and fold in half widthwise. Press the crease to make sure it is tight.
3. Bring each widthwise edge of the paper to the centerfold and crease again to create eight equal rectangles.
4. If you plan to decorate your pages before the next step, see step "d" of the diagram to understand the orientation of the pages that will result when a multiple-fold book is fully constructed.
5. Open the paper and carefully slice the paper as shown in step "e" of the diagram.
6. Refold the paper and pinch together the outer rectangles to form the shape shown in step "f."
7. Using rubber cement, you may close the pages at either end of the folds, and additional multiple-fold pages can be connected if needed.

Students can decorate the outside pages to serve as covers for the multiple-fold book. Try using collage or overlays of greeting card covers (cut to size), paper doilies, or laser-cut images as decorations for the covers. Decorate the inner pages with commercial or handmade stamps, collage papers or materials, rubbings, drawings, or small paintings that have been allowed to dry thoroughly, one page at a time, before a subsequent page is painted.

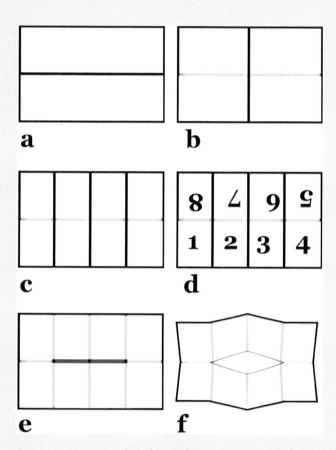

Steps to creating a simple fold book. (Created by the Author)

Lesson 92: Shadow Puppets

Shadow puppet plays have been used to entertain children and adults for over two thousand years. According to an ancient Chinese legend, shadow puppets were invented to ease the sorrow of a grieving emperor. When the favorite wife of Wu, emperor of the Han Dynasty, became ill and died, Wu grew despondent and lost his will to reign. One of Wu's ministers created a puppet in the form of the departed wife and when night fell, he invited the emperor to watch shadows of the puppet cast upon a curtain. The performance brought consolation to the grieving widower, and thus began a tradition of shadow plays.

Shadow puppets were made of very thin **opaque** leather or parchment made **translucent** with oil. These were cut to let a pattern of light shine through holes to define the figure's face, body, and clothing. This form of entertainment is not exclusive to China. For example, in southern Asia and Indonesia, a puppet form called **wayang kulit** is popular. Shadow puppets also were popular throughout Europe, where they were used to tell fairy tales and folk tales, histories, legends, and morality tales to children and adults. In this lesson, you are to select a character from a popular story and create that character in shadow puppet form.

Left, Man (Official), 19th century. Shadow puppet from Shaanxi Province, Lin Lui-Hsin Puppet Theater Museum, Taipei, Taiwan. (Photograph by Hiart, via Wikimedia Commons)

Right, Gathutkaca Wayang. Javanese shadow puppet (wayang kulit) character Gathutkaca. (Photograph by Erwin Sentausa. CC BY-SA 3.0 US)

1. Consider a character from a folk tale, fairy tale, or other fictional literature that might have an interesting or decorative form. Heroes or villains having strong personalities or whose features could be exaggerated make the most distinctive puppet shapes. Think of how the character might be dressed in an exaggerated or exotic way.
 a. Look at images of wayang kulit puppets or shadow puppets from other cultures to get ideas for your design.
 b. Download or copy a design that could be adapted for your selected puppet character.

2. Using the image of the puppet as inspiration, on 9" × 12" sheets of drawing paper create at least three sketches of your favorite character from a folk tale, fairy tale, or other fictional literature.
 a. The face should be done in profile.
 b. Exaggerate the character's distinctive facial or physical features.
 c. Plan how the costume could be decorated with patterns.

3. Share your sketches with peers and your instructor for feedback. Which sketch conveys the clearest information about the character? What technical considerations should be taken into account when transferring the sketched idea to a shadow puppet?

4. Based on feedback and your preference, select the most interesting sketch and redraw it on a 12" × 18" drawing paper as template pieces.
 a. One part will include the head (side view) with torso and two lower legs with feet (or pants or a skirt with feet peeking out).
 b. Cut two arms with hands separately.

5. Carefully trace the template onto flexible foam board or heavy cardboard, and cut out the shapes.

6. Using a hole punch, punch holes at the shoulder joints where the arm pieces will attach to the torso. Leave about ½" to 1" between the hole and edge of the joint.

7. Carefully cut small patterned openings in the clothing and other places where such details might seem appropriate. These can be cut by hand with an X-ACTO knife (be careful to protect the work surface) or with a commercial laser cutter.

8. Attach the arms to the body loosely with brass paper fasteners so the arms move easily.

9. Using clear packing tape and/or craft glue, attach a bamboo skewer or small dowel rods from the head down through the body and off the puppet so you can hold and move the puppet.

10. Two additional bamboo skewers or rods should be attached to the arms so these parts can be moved separately from the torso.

11. Carefully paint the puppet with bright colors of acrylic paints that contribute to a unified overall appearance to the puppet.

12. Write an essay (750–1000 words) in response to the following:

a. Tell what character your puppet represents and explain why you decided to create this character.
b. What other characters would you have to create to produce a puppet play of a story based on this character?
c. Tell about the culture that inspired the design of your puppet, and explain how you adapted this design to make it appropriate for your selected character.
d. Explain how you exaggerated the features of the character.
e. Explain how the patterns of the character's clothing are appropriate to the character and contribute to the unified design of the puppet.

Materials Needed

image of a shadow puppet from a traditional culture, as inspiration for your puppet shape and design

three pieces of 9" × 12" white drawing paper for sketches

at least one 12" × 18" piece of white drawing paper or watercolor paper

large heavy cardboard or flexible foam board (available at craft stores), large enough to cut all the puppet shapes

large scissors

X-ACTO knife and blade, or laser cutter

cardboard or pads of newspaper for protecting the cutting surface

clear packing tape

craft glue

bamboo skewers or very thin (⅛") dowel rods

acrylic paints

brushes

water containers

brass paper fasteners

Vocabulary

Opaque

Translucent

Wayang Kulit

WHAT TO SUBMIT FOR EVALUATION

· a photocopy or downloaded image of a puppet from a traditional culture, as inspiration and reference for your sketches
· three sketches of your favorite fictional character as a shadow puppet
· notes on feedback from peers and the instructor about your sketches for a shadow puppet
· a finished movable shadow puppet of your favorite character
· an essay response, as outlined in Instruction #12

TIPS FOR TEACHERS

Staging a Shadow Play

To conduct a shadow puppet play, you need a screen and very bright light source. Create a screen by hanging a small bed sheet (crib or twin size) between two objects (chairs, sticks, or poles) so that it hangs flat. Tape the cloth in place with duct tape. Place a portable light source behind the screen and facing the audience, so that the light is projected from the back. Move the puppets between the back of the screen and the projected light. Shadows will be cast on the screen for the audience to watch.

Learn more about creating and staging shadow puppet plays from the following resources:

· Artsedge. *The Science of Shadow Puppets*. The Kennedy Center: Artsedge, n.d. http://artsedge .kennedy-center.org/educators/lessons /grade-6-8/Shadows_and_Light.aspx.
· Bryant, J., C. Heard, and L. Watson. *Making Shadow Puppets*. Tonawanda, NY: Kids Can Press, 2002.
· Carreiro, C., and N. J. Martin-Jourdenais. *Make Your Own Puppets and Puppet Theaters*. Carmel, NY: Williamson Books, 2005.

Wayang performance (behind the screen). (Photograph by Michael Gunther, 2014. CC BY-SA 4.0)

Lesson 93: A Full and Empty Composition

Arrangements of positive and negative elements are fundamental to artistic **composition**. In traditional images of Western art, subjects and accompanying objects that appear in an artwork are aspects of positive space. Empty spaces around these are negative compositional spaces. For example, in a portrait of a seated woman, the woman, the chair upon which she sits, and nearby objects such a table or basket of flowers would all be considered **positive** elements of the image, while the space around the woman and between her and other objects would be considered **negative** elements of the portrait. In other words, the positive areas of the composition are filled with things, while negative areas consist of spaces.

An excellent composition includes a **harmonious balance** of positive and negative or full and empty spaces. However, the arrangement of these might vary considerably from one image to another. Most often Western artists will place the main subject of a painting at or near the center of the canvas. However, when cameras came into popular use, imprecisely timed shots of a scene could result in images with figures moving out of a frame, leaving empty space at the center of the composition. Such unintentional images exposed viewers and artists to the idea of empty space as a compositionally interesting and engaging aspect of balance. Artists began to intentionally organize images with **asymmetrical** arrangements of positive shapes and negative space, as in *Street*

Left, Félix Vallotton (1865–1925), *Street Scene in Paris (Coin de rue à Paris)*, 1895. Gouache and oil on cardboard, 14 ⅛" × 11 ⅝" (35.9 × 29.5 cm). Robert Lehman Collection.

Right, Paul Gauguin (1848–1903), *Still Life with Three Puppies (Nature morte avec trois chiens)*, 1888. Oil on panel, 36 ⅛" × 24½" (91.8 × 62.6 cm). Museum of Modern Art (MoMA), New York, NY.

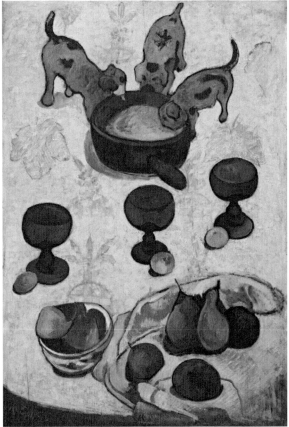

451

Scene in Paris by Félix Vallotton, where the **center of focus** is the dynamically empty space between two women, whose faces are hidden or outside the picture frame. This empty space leads the eye, as if along a path, to the open door of a building at the street corner.

Paul Gauguin complicates our perception of empty and full space by tilting the picture plane upward. In doing so, our perception of empty or negative space is distorted. We become visually disoriented about where objects are in relation to one another. Are the puppies and pan of food on a table along with the tableware and fruit, or are the puppies on the floor and the other items floating in space? The way Gauguin has organized these objects within or against negative space confronts the viewer with ambiguity and inspires intrigue.

Vincent van Gogh also treats negative space as fullness by tilting the picture plane toward us and entirely filling shape and space with color, as if all existed together on a flattened screen. This is accomplished by pushing the women subjects to the edges of the picture frame, outlining them with thick black lines that flatten their three-dimensional form, and allowing bold colors of the background path, grass, and flowers, which would typically be considered

Vincent van Gogh (1853–1890), *Memory of the Garden at Etten (Erinnerrung an den Garten in Etten)*, 1888. Oil on canvas, 29" × 36 ⁷⁄₁₆" (73.5 × 92.5 cm). Hermitage, Leningrad, Russia.

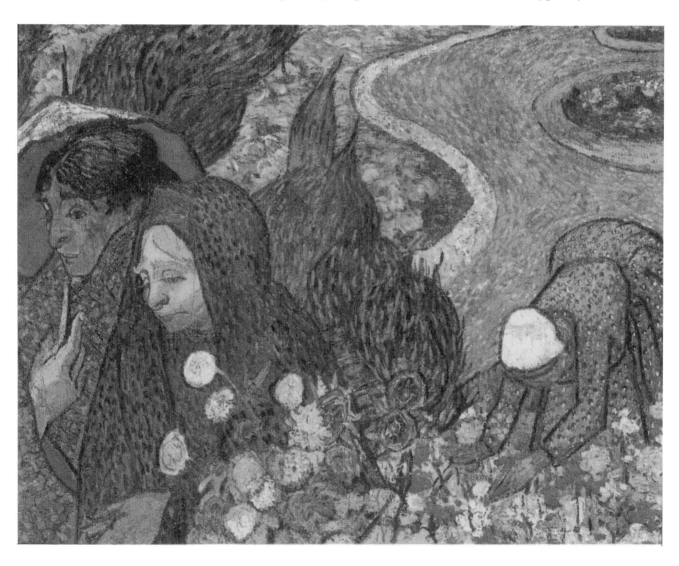

background space or negative compositional elements, to become focal points of the scene. The heavy visual weight of an orange-colored path beyond the blue-clad women creates an equivalent balance between women as things and background as emptiness. Equal amounts of complementary colors, distributed throughout the composition in the women's clothing, flowers, grass, and path, create confusion about which areas are intended as fullness or emptiness.

This lesson provides an opportunity for you to explore and balance arrangements of empty and full or positive and negative space in a composition.

INSTRUCTIONS

1. Look around you for activities or interactions of people or animals in everyday settings, such as shopping at the mall, walking from one class to another, working on the engine of a car, building a snowman, or feeding a pet. Take at least six digital images of various events. Don't worry about capturing all of an event in the shot; close-up images are encouraged.

2. Print out each of the photographs in as large a size as possible on sheets of 9" × 12" printer paper.

3. Using a viewfinder (see Basics of Creating Works of Art for instructions on making a viewfinder), examine each photograph to find a section that presents an interesting combination of full and empty (positive and negative) shapes and spaces.

4. On sheets of 9" × 12" drawing paper, create a minimum of six small sketches based on the photographs.

5. Share the sketches with your peers and instructors. Listen to feedback about which of the sketches presents the most dynamic interactions or ambiguities of full and empty (positive and negative) shape and space. Discuss colors that could be used to enhance the full/empty effect.

6. Select the strongest and most aesthetically intriguing of the sketches and lightly redraw it on a large 9" × 12" or 12" × 18" sheet of watercolor paper.

7. Finish the composition with watercolors or oil pastels, or a combination of both.

8. Write an essay (600–750 words) that includes the following:
 a. An explanation of your thought processes in selecting an image for your composition.
 b. A discussion of how you perceive full and empty (positive and negative) shapes or spaces as working together to create **harmony** in your overall composition.
 · How are full and empty (positive and negative) shapes or spaces organized to create a sense of **harmonious balance** between fullness of things and emptiness of space?
 · Is there more of one than the other?
 · Would you describe the overall balance of the composition as **symmetrical** or **asymmetrical**?

- Which becomes the **center of focus** within the composition, fullness or emptiness?
- How does space hold shapes of things together, or vice versa?

c. Comment on what role, if any, color plays in uniting fullness and emptiness within the composition.

Materials Needed

digital camera	a viewfinder
print-outs of six photos	drawing pencils with soft and
drawing paper, 9" × 12"	hard leads
watercolor paper, 9" × 12" or	eraser
12" × 18"	watercolors or oil pastels

Vocabulary

Asymmetry/Asymmetrical	Harmony
Center of Focus	Negative Space
Composition	Positive Space
Harmonious Balance	Symmetry/Symmetrical

WHAT TO SUBMIT FOR EVALUATION

- six photographs printed out on 9" × 12" printing paper
- six drawn sketches inspired by the photographs
- a completed watercolor painting or oil pastel composition that demonstrates the idea of full and empty or positive and negative shapes and spaces
- an essay response, as outlined in Instruction #8

It is often said that "a picture is worth a thousand words," the implication being that there are so many things to observe in a single image that it would take a lengthy narrative to describe and explicate all that is seen. However, the maxim also implies that a picture presents identifiable faces, places, interactions, or activities that can be verbally interpreted and explained. Would a thousand words be too many or too few if one were trying to read the meaning of an **abstract** image? Perhaps such images cannot be adequately described at all, since the language of sight is not directly translatable into the language of words and speech. Trying to make sense of abstractive images that have no explicit subject matter may involve a nearly impossible task of decoding untranslatable concepts with inadequate clues and insufficient tools.

What if this **scenario** were reversed? Is it possible to translate a word concept into an image? Have you ever looked at an abstract painting and wondered what the artist was trying to say? As you studied the twisted lines or swirls of color, perhaps you began to see emerging forms as feelings, ideas, or concepts rather than "things." Feelings such as isolation or exuberance, or concepts such as peace or ambiguity may have come to mind. Would another person viewing the image see, feel, or deduce these intangible notions as you do? Is it important that the interpretation of the artwork be exact or that diverse viewers read it similarly? In this lesson, you will select words that evoke feelings, ideas, or nonfigurative concepts and try to translate them into images that convey the meanings you intended, while also showing a connective relationship from one image to another.

INSTRUCTIONS

The chart below presents three lists of word or word phrases. The words and phrases in the first section represent possible titles for a work of art. The second section includes words that convey abstract ideas, feelings, or natural processes rather than explicit things. The third section gives a list of non-English terms that do not have exact English translations. Look over the titles, words, and non-English terms carefully.

1. Is there a title that calls out to you as suggesting an emotion, idea, abstractive concept, or ambiguous sensation with which you feel profound connection?
2. Write the title in the center of a piece of a 9" × 12" paper.
3. Select a word from the second section that you feel connects to the title in some way, by explicating or expanding on it. Write this word to the side, above, or beneath the title.
4. Select a non-English term from the last section of the chart that contributes further to the title and word you have chosen. Write this on the paper at a short distance from the previously written concepts.
5. Lay the words in front of you and reflect upon then, then create a **concept map** as follows:

Titles	Abstractive Concepts[1]
Abracadabra (A Hebrew phrase meaning "I create what I speak")	Aborning: *The act of being born*
	Aeolian: *Giving forth a tone as if produced by the wind*
Broken Memento	Antelucan: *Before dawn or daylight*
Ceremonial Wind	Apricity: *The sun feel of the sun's warmth on a cold winter's day*
Delicious	Azimuth: *The arch of the horizon*
Diaphanous Morn	Brabble: *To argue loudly about something insignificant*
Distant Thunder	Collywobbles: *The feeling of butterflies in your stomach*
Earth Time	Cynosure: *That which attracts attention because of its brilliance, interest*
Elysium	Dépaysement: *Being taken out of your own familiar world into a new one*
Faux Pas	Dormiveglia: *The momentary space sleeping and waking*
Fire and Ice	Dulcet: *A sweet and soothing sound*
Gossamer Transformation	Duende: *The mysterious power that a work of art has to deeply move a person*
Halo Effect	
Illusive Dream	Evanish: *To die away or vanish*
Lark Ascending	Gloaming: *The time and colors of twilight or dusk*
Moonlight Landing	Grumpish: *Being sullen or grumpy*
Night Whispering	Hiraeth: *A homesickness for a home to which you can never return*
Offerings	Kismet: *Fate or destiny*
Palimpsest	Lambent: *The glowing, gleaming, or soft radiant flickering of a fire or light*
Path of Sorrows	Lumming: *Heavy rain*
Penumbra	Marah: *A feeling of bitterness*
Quieting Tempest	Meraki: *The soul, creativity, or love put into something*
Rain of Sparrows	Noctiflorous: *Flowering at night*
Reliquary	Ondoyant: *Wavy*
Ripple in the Stone	Paean: *A song of thanksgiving*
Sea of Storms	Quintessence: *An essence, embodiment, or soul*
Sacred Knowledge	Raconteur: *A teller of short stories*
Scorched Memory	Redamancy: *An act of loving in return*
Silent Melody	Sillage: *The trail left in water, impression made in space, or scent that lingers in air after something or someone has been and gone, like the trace of someone's perfume*
Tintinnabulation	
Thrumming Rain	
Urban Birdsong	Snowbroth: *Freshly melted snow*
Victory Cry	Tonitruous: *Thundering or a thunderous sound*
Water Fall	Tremulous: *Trembling or quivering*
Winter Fall	Twitter-light: *A romantic way to refer to twilight or time of the sun going down*
What the Magpie Knows	
Exultation	Usward: *Coming toward us*
Yield to Joy	Vernalagnia: *A romantic feeling brought on by spring*
Zip Lines	Votive: *An offering in fulfillment of a vow*
	Waygone: *Exhausted from a long journey*
	Yonderly: *Mentally or emotionally distant*

1. These terms were adapted from: *The Phrontistery: Obscure Words and Vocabulary Resources. phrontistery.info/index.html*

 a. Allow a stream of consciousness to move your thoughts from one set of words to another.

 b. What memories, sensations, or vague forms come to mind? Add notes, words, or small images that describe these.

 c. What colors, shapes, or forms seem to connect how you feel about these abstractive notions? Add them to the concept map.

6. Begin to make sketches and doodles on the paper, as connective imagery of what is intuited about their meanings.

Words That Do Not Have Exact English Translations

Euneirophrenia (Ancient Greek): *The peace of mind that comes from having pleasant dreams*

Erlebnis or Erlebnisse (pl) (German): *All the experiences, positive or negative, that we feel most deeply; these are not mere experiences that normally occur, but fully Aware Experiences*

Gumuservi (Turkish): *Moonlight gleaming on water*

Hanyauku (Rukwangali): *The act of walking tiptoe to avoid the painful sensation such as that of hot sand on the soles of your feet*

Hygge (Danish): *The pleasant feeling (platonic) of intimate closeness when relaxing with loved ones or good friends, perhaps while enjoying food and drink or a cozy fire*

Ichigi ichie (Japanese): *A significant or transformative encounter that only happens once in a lifetime and reminds you thereafter to treasure every moment as transitory, yet important*

Kintsukurio (Japanese): *To repair with gold; the art of repairing pottery with gold or silver lacquer, thus rendering the pottery more beautiful for having been broken*

Koi No Yokan (Japanese): *The instinctual feeling upon meeting someone for the first time that falling in love with him or her is inevitable*

Komorebi (Japanese): *The beautiful interplay between light and leaves that occurs when sunlight shines through trees*

Mangata (Swedish): *The glimmering, road-like reflection that the moon creates on the water*

Mizpah (Ancient Hebrew/Aramaic): *The deep unbreakable emotional bond between people, especially those separated by distance or death*

Nazlamak (Turkish): *Playing coy or pretending reluctance when you are actually willing*

Pena ajena (Spanish): *The feeling of being embarrassed for another person*

Psithurism Greek): *The sound of leaves rustling in the wind*

Querencia (Spanish): *Place from which one's strength is drawn, where one feels at home, or where you can be your most authentic self*

Resfeber (Swedish): *Tangled emotions of anxious anticipation and excitement that cause one's heart to race before the journey begins*

Saudade (Portuguese): *A homesickness or melancholic longing for a person, place, or thing that is far away from you, regardless of whether or not it refers to home*

Sehnsucht (German): *The inconsolable longing or intense yearning "in the human heart for we know not what"*

Wabi-Sabi (Japanese): *An acceptance of transience, imperfection, incompletion, or modesty and humility as aesthetically beautiful*

Waldeinsamkeit (German): *A feeling as if one is "alone in the woods"; a feeling of solitariness yet connection with nature*

Won (Korean): *A reluctance to let go of an illusion*

Yūgen (Japanese): *A profound sense of wonder at the mysterious beauty of the universe along with deep sadness for human suffering*

7. When you feel as if the well of your imagination has been primed, begin working on three separate pieces of 9" × 12" or 12" × 18" watercolor paper (or a combination of 9" × 12" and 12" × 18" watercolor papers).

 a. Use drawing pencils, watercolor pencils, or watercolors to sketch out a series of three ideas or *feelings* that connect unite the title, word, and non-English term together into a cohesive abstractive whole.

 b. Consider how these will relate to one another visually as well as conceptually.

 c. Will one image flow into another in a color, line, or repeated shape?

 d. Will the images contradict one another or juxtapose competing ideas or emotions?

This lesson asks you to make connections between internally felt sensibilities and the abstract external world. These are not connections that we typically encourage students to make. Educational policymakers, teachers, and parents see a major role of education to be the preparation of children and adolescents to become well-informed adults who are primed to master skills needed in the workplace, and who will behave as contributing citizens of society. If this is so, then arguably the emotional development of children should be as important as intellectual and skill development. Yet the questions we ask of children in the classroom are aimed at determining what they know and whether or not they can connect ideas about things outside of themselves. Rarely are children asked questions that encourage them to think deeply about themselves in relation to the experience of learning, the knowledge they acquire in school, or how their emotions connect with others in the context of the school. One way of addressing this disconnect is to invite students to keep a visual diary of their school experiences. Using a different prompt each day, students could spend a few minutes at the end of each school day recording visual responses (either abstractive or figurative) to a question. The images they create could be accompanied by words if the student is so inclined, and these visual-textual responses would be kept in a small journal. Possible questions include the following:

1. When were you the happiest today?
2. When did you feel like singing today?
3. When did you feel like jumping around or dancing today?
4. What rule was the hardest to follow today? Why?
5. When did you feel most proud of yourself today?
6. Who made you smile today?
7. Describe something kind that you did for someone today.
8. Describe something kind that somebody did for you today.
9. What was the most helpful thing you did for someone else?
10. Who in your class do you think you could be nicer or more helpful to?
11. Describe something new you learned about a friend or classmate today.
12. Describe something that made you laugh today.
13. Who is the funniest person in your class? Why is that person so funny?
14. Who do you want to make friends with but haven't yet? Why not?
15. Who would you like to play with at recess that you've never played with before?
16. Describe one person in your class who is different from you.
 a. How is that person different from you?
 b. Describe how that person is like you.

8. Continue to work on the three images simultaneously, moving back and forth from one image to another, adjusting them so each presents a coherent idea or feeling and the group itself is a cohesive unit of visual ideas, concepts, or expressive emotions.
9. Lay the images in front of you and determine how they should be arranged to tell your story. Write in the corner of the back whether the word should be at the center, or on the left or right side of the **triptych**.
10. Reflect on the experience of engaging with this project, and write an explanation of your work:

17. What is one thing you wish your classmates knew about you?
18. Who of your classmates would you like to know better?
 a. What could you do to get to know that person better?
19. What was the best thing that happened at school today?
20. Describe the worst or saddest thing that happened at school today.
21. Tell one new thing you learned today.
 a. Do you think it is an important thing to know? Why or why not?
 b. When might you use or need that knowledge in the future?
 c. How do you feel about this new knowledge? For example, does it make you more curious about life, or more competent about what you can know or do?
22. Describe something that challenged you today.
 a. Why was it challenging?
 b. Do you think you can master this challenge? Why or why not?
23. When were you bored today?
24. When did you feel like doodling, drawing, or painting today?
25. What do you think you should do or learn more of at school? Why?
26. What do you think you should do or learn less of at school? Why?
27. If you had the chance to be the teacher tomorrow, what would you teach the class?
 a. How would you teach it?
 b. Why do you think it would be important for your classmates to know?
28. If one of your classmates could be the teacher for the day, who would you want it to be? Why?
 a. What about that classmate would make him or her a good teacher?
 b. What knowledge could that classmate teach?
 c. Why would it be important (or interesting) for others in the class to know?
29. What is one thing you wish your teacher knew about you?
30. What is one thing you wish your parent(s) knew about your day at school?

NOTES

1. N. Willard, L. Dillon, D. Dillon, and L. Dillon, *Pish, Posh, Said Hieronymus Bosch* (New York: HMH Books for Young Readers, 1991).
2. M. R. Stoermer, "A Lesson in Character Development," *USSEA Newsletter in Teaching Practices* 29, no. 1 (2006): 10.

 a. Describe the process of allowing a stream of consciousness to bring to mind connections between the various words.
 b. What images or feelings came to mind that startled or surprised you?
 c. How did you articulate these visually in the three artworks?
 d. Was it necessary to change media or alter your original impressions as you worked? If so, explain why.
 e. What insights were triggered or awakened by the experience?

Materials Needed

drawing paper, 9" × 12"

watercolor paper, 9" × 12" or
 12" × 18"

drawing pencils in soft and
 hard leads

eraser

color medium of your choice

Vocabulary

Abstract/Abstractive

Concept Map

Scenario

Triptych

WHAT TO SUBMIT FOR EVALUATION

· a concept map of stream-of-consciousness thinking, colors, words, and images as an evolving sequence of ideas related to a selected title, concept, and word

· three completed images inspired by the concept map, arranged in a triptych to present a cohesive unit of visual ideas, concepts, or expressive emotions

· a written essay, as indicated in Instruction #10, describing the process of creating your triptych of images

LESSON EXTENSIONS

· This lesson lends itself well to digital manipulation. For example, one might scan an abstract watercolor background into Photoshop CS6. Then, using layers, add personal photographs, drawings, or sections of text. Adjusting the opacity or transparency of various items, create photo montages that relate to one another while also alluding to the title, words, or non-English terms.

· This lesson could be envisioned and completed as interconnected sculptural, assemblage, or other three-dimensional pieces made in traditional media like ceramics or wood, or with non-traditional or recycled materials.

5 · Exploring Self and Others through Art

Art making is a self-expressive behavior. Artists must reflect upon their understandings of life in order to effectively interpret these through media. At the same time, artists must constantly explore and become sensitive to the intrinsic qualities of their materials and find personal accord with them. A successful work of art will project deeply personal attributes of its creator through an accommodating medium.

Just as the artist must come to understand the materials of art making in order to be able to mold them into a desired form, and understand her- or himself in order to express the self through art making, the artist may come to understand and empathize with others. In the words of a respected art educator,

> As the child identifies himself with his own work, as he learns to appreciate
> and understand his environment by subordinating the self to it, he grows up
> in a spirit which necessarily will contribute to the understanding of the needs
> of his neighbors. As he creates in the spirit of incorporating the self into the
> problems of others, he learns to use his imagination in such a way that it will not
> be difficult for him to visualize the needs of others as if they were his own.[1]

The lessons in this section are aimed at exploring self and others through a variety of media.

FEATURED ARTIST: STEVE WILLIS

Steve Willis is an artist, a professor of art education at Missouri State University, and a spiritual elder of Hocq'reila. As a teacher, he invites students to look within and without for personal centers of emotional, spiritual, intellectual, and physical understanding. As an artist, he reflects his secular and spiritual understanding of liminal and cosmic universes through his work. Many of these dream-like images come to him through meditative ceremonies. "Creating visual representations is one way for me to grapple with the mystery and subtlety of experiences not easily verbalized," he explains. Additionally, his artworks describe the "multiplicity of identity and cross-cultural relationships . . . [as] relationships of complexity and simplicity developed through color, shape and symbol."[2]

Steve Willis, *Passage Δ*, 2007.
Copperplate, 4" × 6".
(Courtesy of the Artist)

Lesson 95: Mapping Symbols and Legends of Self

In order to read a map accurately, one must understand the layout and recognize the symbols used by the mapmaker or **cartographer**. Although we have become accustomed to seeing maps laid out with the top of the page representing the north, this has not always been the case. In ancient times, map layouts might have been oriented with the top representing the south, east, or west. Various **symbols** and **legends** were used to indicate compass directions, latitude and longitude, mileage, or other measures of distance and elevation. Symbols also indicated whether or not the topography and terrain of an area were known as a result of prior exploration or surmised from incomplete reports and suppositions. Some of the more common symbols and legends included the following:

- **Compass Rose**—This compass symbol, indicating the directions of winds and/or orientation of land and water features of the map, is named after its resemblance to a rose. Originally it was divided into 32 segments, but it is now frequently simplified to indicate eight directions (north, northeast, east, southeast, south, southwest, west, northwest). Metaphorically, roses represent deep emotions of love and longing; when applied to a compass, the metaphor might be extended to suggest "to the ends of the earth."
- **Map Key**—Smaller symbols of the map are explained by a map key. This may explain the uses of color, circles, stars, or broken lines that indicate public monuments, schools, parks, civic centers, bike paths, or minor roadways.
- **Neatlines**—These are the borders of the map, which may be purely decorative or may provide additional information. Neatlines may serve as mileage indicators originating from a fixed point, or indicate what territories lie outside the visible map.
- **Scale**—A small scale indicator at the corner of a map tells the reader how to determine distances in relation to the map's scale. For example, 1" on the map may indicate 10 miles, 100 miles, or 1000 miles, depending on the geographic area depicted within the map layout.
- **Longitude and Latitude**—This grid system has been used by mapmakers for centuries as a way of determining locations in the world. It served as a GPS for pinpointing exact locations on the earth long before there were satellites or digital devices to provide that information.
- **Topography**—These curved lines and ridges, which seem to resemble whorls of a fingerprint, indicate the elevation of land features compared to the level of the ocean.
- The **Four Wind Blowers**—Four basic types of wind were once associated with mythic beings. Zephyrus blew gentle breezes from the west. Boreas blew cold and blustery winds from the north. Warm wet storms were blown by Notus from the south, and gentler warm rains came from

Above, Jacques le Moyne, *Floridae Americae Provinciae (Floridae Americae provinciae Recens & Exactissima Auctore Iacobo le Moyne cui cognomen de Morgues, Qui Laudonnierium),* 1591. Handcolored map, 18" × 14½". Geography and Map Division, Library of Congress, Washington, DC.

Facing top, Joan Matines (1556–1590), *Atlas of Joan Martines* (p. 6), 1587. Ink and colored wash drawing with gold and silver leaf, 22 ¹³⁄₁₆" × 31½" (58 × 80 cm). National Library of Spain, Madrid, Spain.

Facing bottom, Jan Janssonius (1588–1664), *Tabula Anemographica seu Pyxis Nautica Ventorum Nomina Sex Linguis Repraesentans,* ca. 1650. 17½" × 22" (44.5 × 55.9 cm). (Provided to Wikimedia Commons by Geographicus Rare Antique Maps)

Eurus in the east. The presence of one or more faces of the four winds indicated which type of wind was most common in particular areas.

- **Features**—Cartographers have been creative in the ways they have indicated buildings, paths, roads, and waterways. Look at the map key to understand how they are indicated in any particular map.
- **Figures**—In addition to representing actual geographical features, artistic maps may include images of imaginary creatures such as dragons, mermaids or mermen, sirens, religious figures and coats of arm, as well as ships and figural representations of famous buildings, bridges, mountains, rivers, or lakes.

Have you ever thought of the experiences of your life as mappable? If you were to create a map of your life at this point in time, what would be the known and unknown terrains? What compass points make explicit or implicit references to your life experiences? For example, what experiences suggest beginnings (the east) or endings (the west), long nights and days or cold and barren climes and spaces (the north), and relaxed and balmy breezes or the heat of feverish passions (the south). What events seemed huge but in retrospect were

small and insignificant, or seemed small at the time but became important (scale)? What winds of change and circumstances have called to you or blown you off course (Four Wind Blowers)? What paths have you followed or been pulled along, and what obstacles have compelled you to consider detours? What limitations of circumstance or parameters of consciousness keep you in focus and provide guiding measures of your life (neatlines, longitude and latitude)? What interests, concerns, and physical attributes define you as a person (topography) in comparison to the norms of others in your social milieu? Who are the people, places, and things that are important features of your life?

In this lesson, you are to think creatively about how some or all of the features of a map could be adapted to describe some aspect of you or your life, either metaphorically or more literally.

The project suggested in this lesson may be done using traditional collage techniques, or created in a digital software program such as Photoshop CS6 or Illustrator.

INSTRUCTIONS

1. Have a friend help you take a photograph of yourself either standing or sitting erect, in either a full frontal view or a side view.
 a. Think about the clothing or costume you will wear in the photograph.
 b. Include accessories, like a musical instrument you play, evidence of a hobby, or work in which you engage and with which you identify.
2. You can also select images of other people, places, or things that are important to you and perhaps define you in some way.
3. Enlarge the photographs in a scanner or with digital software. Print out one or more copies (in various sizes) of each.
4. Consider what you want to reveal about yourself through these images. Create a **concept map** on a sheet of 12" × 18" drawing paper. Focus on words and ideas that convey your sense of self and the experiences, associations, or resonances that are important to you.
5. Consider what parts, if any, of your self-image you wish to include in your collage. Remove any parts you wish to remain a **terra incognita** (unknown land) by cutting them away, or using a Sharpie marker to carefully black or color out. Then carefully cut out the figures you wish to use and lay them aside.
6. On sheets of 9" × 12" watercolor paper, plan out and create thumbnail sketches of symbols and legends that might orient a viewer about how to read the map that is you and/or your experiences.
7. Select the best examples of these symbols and legends and draw carefully crafted versions of them for use in your map of self.
 a. If you are going to compose your final work in digital software, scan your drawn images and save them as digital files.

Alternatively, you could create the symbols and legends in a software program.

8. Prepare a background piece of 12" × 18" watercolor paper. Cover the surface with drawn doodles, writings of poetry or diary entries, hand-drawn pictures, commercially printed pieces of newsprint, scrapbook paper, or some other imagery that will add visual interest, depth, and meaning to the work.

 a. If you are going to compose your final work in digital software, scan the handmade background and save a digital file.

 b. Arrange the figure(s), symbols, and legends to create a map that underlies or follows the outline of your body, cutting, tearing, or layering the pieces as necessary. Move around various pieces of the composition, looking for visual and conceptual connections among the parts. Be creative and imaginative in the placement of pieces and use of symbols and legends. Don't be afraid to use overlap.

 c. If you are composing this work in a software program, keep figures, symbols, and features of the map on different program layers so these pieces can be manipulated, made more opaque or transparent, and overlapped in interesting ways.

 d. Before fastening the pieces down permanently, share your composition with peers and your instructor for their feedback.

9. When you are satisfied with the composition, glue each piece down with a glue stick or rubber cement. Do not use white glue or gels. If working in digital software, flatten the layers of the composition, save, and print out the results.

10. Use Sharpie markers to add detail lines, text, or other marks to complete the composition, drawing it together visually and contributing additional meaning to the piece.

11. Write a brief essay (400–600 words) that explains the meaning of your map by responding to the following questions:

 a. What images did you select for use, and what is important about these images?

 b. Describe the symbols and legends you created for this project. Explain why you think they are important to the viewer's understanding of the map. Articulate what they mean to you.

 c. Are any places of the map terra incognita? If so, to whom and why?

 d. What does the map tell us about you?

Glen Coutts, *"There be Monsters . . . ,"* 2015. Original digital inkjet print, Somerset 100% cotton, overall size 13¾" × 10¼" (26 × 35 cm). Edition of 15. (Courtesy of the Artist)

e. Have you come to understand yourself better as a result of focusing on this work? Explain.

Materials Needed

photographs of yourself and
 important places, objects, or
 people in your life
scanning device and copier that
 enlarges or reduces image size,
 or a digital software program
 like Photoshop or Illustrator

drawing paper, 9" × 12"
watercolor paper, 12" × 18"
scissors
glue stick, or rubber cement and
 rubber cement eraser
Sharpie pens or color markers

Vocabulary

Cartographer	Four Wind Blowers	Neatlines
Compass Rose	Legend	Scale
Concept Map	Longitude and	Symbol/Symbolic
Features	Latitude	Terra Incognita
Figure	Map Key	Topography

WHAT TO SUBMIT FOR EVALUATION

· the concept map used to plan this piece
· thumbnail sketches of symbols and legends devised to orient a viewer to your map
· a completed map of self in collage or as a digital composition
· a written essay response, as outlined in Instruction #11

LESSON EXTENSION

Rather than producing a map, consider creating a timeline of events and experiences. Arrange images and symbols in a sequence, overlapping sections as necessary to depict a timeline of your life experiences. Print out the timeline and transform it into an accordion book (see Lesson 89: Photographic Essay). Use one of the symbols or legends that you created as a cover image.

Lesson 96: An Identity Map

Human beings are natural wanderers and explorers. We come from a long history of ancestors drawn to searching lands just beyond the known horizon. Maps may speculate upon unfamiliar places. Once new terrains have been explored, new maps are created to describe the explorers' understandings of that space. Yet maps may show more than continents or oceans; maps may describe experiences and events, as metaphors or stories of what has been experienced along a person's life journey.

Maps can also describe routes of human migration or diaspora. What routes did our ancestors take in bringing us to the places where we are today? Could the journeys of Irish people arriving in the Americas to escape the Great Potato Famine of the mid-nineteenth century be mapped? What routes did freed African Americans take, and what cities of the North and Northwestern United States did they settle in after fleeing the lack of opportunity, oppressive poverty, and Jim Crow policies of the South? How could we map the migratory journeys of peoples from Southeast Asia to the West following the Vietnam War of the late twentieth century?

Group maps are helpful in recognizing how the collective experiences of individuals contribute meaning to the whole. For example, family genealogies are maps of interconnections among people of the past that have led to one's life in the present. How have you or others of your family moved through events in space as if these were points on a map? Individual maps may be

Pina Latuszek, *Indiana on My Mind*, 2015. Photographs and map, digitally manipulated. (Courtesy of the Artist)

Sheila Strauss, *James River and Me*, 2013. Photographs, drawings, and map, digitally manipulated. (Courtesy of the Artist)

shared in ways that contribute to a sense of community. Maps of communities ground individuals emotionally and spatially. Recognizing the path one has traveled and the similarities and dissimilarities of one's own experiences to those of others permits empathetic understanding of self and others. Empathetic response is a critical component of emotional and social development and maturation, which also may be mapped.

In a classroom, mapping different knowledge perspectives deepens understanding, encourages positive attitudes toward learning and a willingness to join with and assist in the learning of others. From a multidisciplinary point of view, reading and making maps contributes to awareness of details and nuances within the environment; it can be a form of scientific observation. It

may contribute to students' abilities to make connections between ideas and concepts of geographic space, and envision these connections in ways that organize, categorize, and make sense of them. Additionally, learning to read and create maps increases the ability to visualize spatial relationships, which is important to developing math, engineering, and art making skills.

In this lesson, you will be creating a map of yourself, an aspect of self, or of your life's journey. In doing so, you will be exploring a topic that you know well, and yet in many respects may not know well at all.

INSTRUCTIONS

1. Study some examples of maps that conceptualize space and identity by searching online for "map art" by these artists:

 Matthew Cusick (1970–), United States
 Josh Dorman (1966–), United States
 Ed Fairburn (1989–), United Kingdom
 Nancy Goodman Lawrence (ca. 1950–), United States
 Friedensreich Hundertwasser (1928–2000), Austria
 Elisabeth Lecourt (1972–), France and United Kingdom

2. Find and download two examples of map art by each of two different artists (four examples total) from this list whose work you find appealing. Keep the work with you as possible inspiration for your work.

3. Consider what you want to say about where you come from and the geographic places and events that have influenced your life. Think about visual items that would tell this story.

 a. Find a map of the town where you were born, and additional maps of where you once lived or live now. Scan sections of these or save digital images of them on your computer. Are these greatly different from the places where your parents and grandparents were born and lived? Are you a child or grandchild of immigrants? If so, you could collect maps of the places where your ancestors lived and the routes taken to arrive at your family's current location.

 b. Find or create maps of routes from your home to favorite places, such as the park where you played, the route to a grandparent's house, or a favorite playmate's home.

 c. Collect photos of your early and present home.

 d. Collect several photographs of yourself as a child, teenager, and adult, or celebrating some special event.

 e. Other items of interest might be a photo or floor plan of the school you attended, a ticket to your first prom or football game.

 f. Request mementos from the lives of your parents, grandparents, or other important people in your extended life.

4. On sheets of 12" × 18" drawing paper, sketch a minimum of six scenarios of how your life or some part of your life could be mapped, using the collected materials from your life and lives of the extended family to jog memories or highlight important features along the journey. Consider

whether the map should look like an actual map or more closely resemble a portrait with map-like features.

5. Make notes on the sketch indicating where drawings, photos, or other **two-dimensional (2-D)** materials might be added, or where text might contribute explanatory meaning.

6. On a 12" × 18" sheet of watercolor paper or Bristol board, create an outline (based on previous sketches) of an identity map that tells readers what you would like them to know about the journey of your life and/or the results of others' journeys upon your life.

 a. This will serve as a preliminary sketch for your completed map, but it also may serve as foundation for your finished artwork.

7. Share this layout with peers and your instructor for feedback.

 a. Look for interesting uses of positive and negative spaces.

 b. Consider how various parts of the composition interact with one another in a harmonious way and consider the overall unity of the composition.

 c. Does your map adequately portray what you are intending?

 d. Make edits as suggested.

8. Finish the work in any color medium of your choice.

 a. If your finished work is a collage or includes collaged additions, use rubber cement to attach these details. Remove excess rubber cement with the rubber cement eraser.

 b. If you have created the map in a software program such as Photoshop or Illustrator, flatten layers, save, and print out a copy of the work.

 c. If it would enhance the work, add additional details such as outlines, written text, or visual texture with colored pencils, watercolor pencils, markers, or Sharpie pens.

9. Write an explanation (600–750 words) of the map and its significant features, indicating the following:

 a. Of the suggested map artists, whose work did you find most intriguing and why? Did his or her work inspire your own artwork? Why or why not?

 b. In your own map creation, what experiences were symbolically included?

 c. Does your map primarily represent you, or are the influences of others also represented in some way?

 d. Explain the choices you made in selecting the events (external or internal) and/or people whose influences are alluded to in your map.

 e. How did you decide on the most appropriate images or artifacts to describe important features of the map?

 f. Explain other details of the map.

Materials Needed

white drawing paper, 12" × 18"

watercolor paper or Bristol board,
 12" × 18"

pencils with soft and hard leads

eraser

maps, photos, and mementos of
 self and/or others

color medium of your choice

rubber cement

rubber cement eraser

a software program such as
 Photoshop or Illustrator
 (optional alternative to
 traditional media)

Vocabulary

Two-Dimensional (2-D)

WHAT TO SUBMIT FOR EVALUATION

· four photocopied or downloaded examples of map art, two each by two
 different artists from the suggested list
· six scenarios of who and what experiences might be mapped in your life
· a completed identity map of your life or the effects of others on your life
· a written response, as outlined in Instruction #9

LESSON EXTENSION

Examine some of the mapping works by artist Joyce Kozloff (http://www.
joycekozloff.net/overview/), such as "Los Angeles Becoming Mexico City
Becoming Los Angeles" (1993), "If I Were a Botanist" (2014), and various pan-
els of "The Tempest" (2015). Read her explanations of these works and write
an essay (300–500 words) describing your reaction to one of these examples
or another of her mapping images. In your essay, consider her explanation of
the work.

 To what extent do these works suggest how similarly or differently you
perceive the world and your place within it? Create a map that describes your
perceptions in ways that are reflective or suggestive of the ways Kozloff visu-
ally integrates spaces and places that fascinate and perplex her.

Lesson 97: Mapping Places and Spaces

Being able to find one's way through space and knowing the differences between safe and dangerous spaces are important survival skills, even in an age of **Global Positioning System (GPS)** devices. While we may use GPS devices to help find our way to and through unfamiliar places, memory and experience allow us to maneuver through familiar spaces. For example, you could close your eyes and mentally map your way past the various houses or buildings on the block where you live, or remember the route to school or the grocery store.

Several artists use maps as ways of visualizing and describing familiar and unfamiliar spaces. Their artworks describe how we move through space, what we see or encounter as a result of this movement, and how we mark significant locations within an area. For examples of this kind of work, search online for "map art" by these artists:

- Friedensreich Hundertwasser (1928–2000), Austria
- Valerie S. Goodwin (ca. 1954–), United States
- André Letria (1973–), Portugal
- Nigel Peake (ca. 1970–), Ireland

In this lesson, you will envision a space that is familiar to you and map it in a symbolic way. Additionally, you will visualize your space in relation to the spaces of other people and the built environment or flora and fauna of your known space.

INSTRUCTIONS

1. Search online for examples of map art created by the artists indicated above. Download three examples of map art that you find interesting or inspiring. These should include works created by at least two different artists. Keep these images nearby as inspiration for your work.
2. Search Google Maps or Google Earth for your home address. Examine your home from a satellite and a street view.
3. On a sheet of 9" × 12" watercolor paper, sketch an image of your house from a street view or as seen from across the street. Try to capture the general shape of the house. Complete the drawing with a color medium of your choice.
 a. Alternatively, if you have a large clear photograph of your house, you may enlarge it on a scanner, cut out the scanned image, and lay it aside to use with this project.
4. On a separate sheet of 9" × 12" or 12" × 18" watercolor paper, create a background. There are several ways this can be done.
 a. Download an enlarged overhead (satellite) view of your home that includes some of the surrounding area, then use colored markers to fill in areas of the overhead view. Attach the modified map to a backing paper with rubber cement or glue stick.

b. Cut pieces of scrapbook paper and/or other textured or colored papers, and arrange them to resemble an enlarged street map. Rubber cement these to a backing paper.

c. Create a Zentangle background.

d. Create a drawing of the environmental space around your house. Focus on and enlarge special features that carry emotional appeal, such as a flower garden, a bird or birds that visit your birdfeeder, a favorite cat that roams the neighborhood, or other interesting and/or fondly considered objects or phenomena.

5. Carefully cut out the image of your house and mount on the backing paper, using rubber cement or a glue stick.

6. Plan additional pieces as foreground details, like shrubbery and trees, lawn ornaments, or special furnishings that contribute to meaning as well as compositional harmony.

7. Draw or select these from photos or mementos to be collaged items. Cut the features out and rubber cement them down. Remove excess rubber cement with a cement eraser.

Left, Terry Spencer, *Farm Home,* 2015. Mixed media: photographs, satellite map, and digital manipulation. (Courtesy of the Artist)

8. Write an essay (500–650 words) in response to the following questions:

a. Whose artwork of the artists listed above did you select?

b. What about these images interested you?

c. To what extent did they inform or inspire your own work?

d. How do you explain the choices you made in creating your own artwork?

e. Why did you select and arrange the pieces as you did?

f. What does the work mean to you?

g. What problems did you encounter in the making of this work?

Above, Sheila Strauss, *Great-Grandma's House on the Edge of Town,* 2013. Mixed media. (Courtesy of the Artist)

h. How did you resolve them?

Materials Needed

white watercolor paper, 9" × 12"
 and 12" × 18"

pencils with soft and hard leads

eraser

computer with internet access,
 printer, and copy paper

assorted textured or
 decorated papers

scissors

glue stick, or rubber cement and
 rubber cement eraser

Vocabulary

Global Positioning System (GPS)

WHAT TO SUBMIT FOR EVALUATION

· three examples of map art by at least two of the artists indicated above
· your completed map artwork
· a written essay response, as outlined in Instruction #8

LESSON EXTENSIONS

1. This project could be done on cloth using techniques of embroidery, appliqué, printmaking, or a combination of these. See these examples of map art created by fabric artists:

 Anne Biss: http://www.annebiss.co.uk

 Janet Brown: http://www.janetbrownetextiles.com/index.htm

 Also see examples of 12" × 12" quilted maps created by a group of Australian quilt artists known as Twelve by Twelve. Their website includes images and statements about their works, as well as quilting and stitching tutorials: http://twelveby12.org/maps/index.html. For a book of works by Twelve by Twelve, see:

 Smith, G., and D. Boschert, D. P. Hock, H. L. Conway, N. Wheeler, T. Stegmiller, T. Grant, G. Congdon, K. Rips, K. LaFlamme, F. Jamart, and K. Duncan. *Twelve by Twelve: The International Art Quilt*. New York: Lark Crafts, 2011.

2. In a time when cigarette smoking was acceptable behavior in public places, business owners often imprinted matchbook covers with the logos and addresses of their places of business and made these available to customers as advertisements. Additionally, professional people and business owners shared small business cards with a name, address, and phone number that served as an identifier and contact information for the individual or their business. Today when we wish to locate a specific type of business, we refer to internet search programs or GPS devices. As a result, the way we visualize spaces and places around us and the way we share identification and contact information about ourselves has changed significantly. The use of matchbooks and business cards as advertisements or contact reminders has decreased.

Artist Krista Charles (http://xa.pcmxa.com/) has extended the idea of the matchbook as a business promotional device. Using addresses indicated on matchbooks as locational guides, she draws detailed street view illustrations of buildings associated with these locations on the inside covers of their matchbooks. In this way, she combines the idea of an address as locational information with GPS features of satellite or street view imagery.

Using the work of Charles as a motivator, create a business card for yourself that visually locates you in a specific place. With the exception of your name, do not include text on the card. Consider how it would be possible to locate you through imagery alone. What images would be necessary? What symbols could guide viewers to interpret the imagery?

TIPS FOR TEACHERS

This lesson is adaptable to a collaborative class project. If your students live in relatively close proximity to one another, as for example in the same town, suburb, or city area, you could have them add their personal maps to a collective map. Mount a length of butcher paper or Tyvek® backing to the wall as a mural space.

1. Discuss with your students how their maps relate spatially to one another. Assist them in arranging their images in relationship to each other.
 a. If your students are city dwellers, invite them to add details such as streets, trees, additional buildings, parks, bus stops, or other features that separate the students' places from one another.
 b. If your students live in a rural area, ask them to add things they know about the area, such as places where rabbits live, the creek where they play in the summer, a field of corn, or trees where squirrels can be found.
 c. If the children live in a town or urban area, have them add local stores, the school, or other features that demarcate and hold together the community.
2. The mural can be assembled by having children work alone or in groups to create the additional materials, or you could have children take digital images of the items they wish to add and contribute these to the mural.
3. For excellent resources for using stencils to lay out the streets, buildings, trees, automobiles, and other connective items of the mural, see the following:
 · Parragon. *Vehicles*. Bath, UK: Parragon Plus, 2005.
 · Walton, S., and S. Walton. *Stencil It: Over 100 Step-by-Step Projects*. Sterling Publishing Company, 1993.

Quilt Map

Young children can create a collaborative quilt by decorating uniformly cut pieces of unbleached muslin with fabric paints or natural vegetable dyes. Stencils could be used to create the effect of roads and bridges that interconnect various blocks of fabric. Check your local library for resources that give instructions for using stencils and describe how food dyes might be used as colorants for patched quilt blocks. Suggested resources include the following:

· Amor, J. *Flavor Quilts for Kids to Make: Complete Instructions for Teaching Children to Dye, Decorate, and Sew Quilts*. Paducah, KY: American Quilter's Society, 1991.
· Anderson, A. *Kids Start Quilting with Alex Anderson*. Lafayette, CA: C & T Publishing, 2001.
· Ball, M., and M. Frey. *Creating Quilting with Kids*. Iola, WI: Krause Publications, 2001.

Alternatively, children could simulate quilt blocks with paper:

1. Provide each student a sheet of 9" × 12" brown, tan, or green construction paper and several scraps of construction paper in various additional colors.
2. Have students create a cut-paper collage of their home and the buildings, structures, or natural feature to the immediate east and west or north and south of the house, depending on the orientation of their home. Directions can be roughly determined by thinking about the direction of sunrise or sunset.
3. Arrange the students' works in orientation to one another and add cut paper strips for alleys, fields, or roads.
4. Have students work in groups to negotiate additional features that are important to describe, such as the spaces between the various students' homes. Working in small groups, create these additional items and add them to the collaborative work.

Lesson 98: A Geography of Self

We think of maps as guides for navigating through geographic spaces. Occasionally, maps serve as records of where we have been. However, we can also map internal journeys of self-discovery. A sense of self results from responding to all the external experiences of life, including interactions among family, friends, and strangers, impressions of places and events, and reactions to social and cultural messages communicated through phenomena of everyday life. These influences combine to excite the imagination within. The imagination then serves as an explorer of our internal geography.

INSTRUCTIONS

To begin this lesson, reflect upon your understanding of those experiences that have influenced your sense of self. On a sheet of 12" × 18" drawing or watercolor paper, create a **concept map** that takes into account the following questions:

1. To what extent do you see yourself reflected in visual and digital media, books, or music?
2. To what extent and how do you see yourself reflected in histories and narratives of the nation, community, or classroom?
3. Where do you see yourself in relation to mainstream culture?
 a. Are you part of the mainstream, part of a minority, or an outsider to the dominant society?
 b. Other than members of your family, who else in your immediate environment has a cultural story similar to yours?
 c. What accomplished, famous people share similar cultural backgrounds to yours?
4. Do you feel differently about who you are now compared to how you felt as a child?
 a. Reflect upon your answer and consider why you feel as you do.
5. How is the image you hold of yourself reflected in or by your
 a. education and/or the way you learn,
 b. career choice,
 c. relationships to others,
 d. where you live, and
 e. how you spend your free time?
6. What influences do economics, politics, and religion or spirituality play in your sense of self?
7. How have you been influenced, nurtured, or changed by the places you have been and experiences you have had with local and global friends or strangers?

Use the answers to these questions as a conceptual guide while planning your identity map.

Collage Method

8. Prepare a background approximately 12" × 18" in size, on which collage pieces might be mounted. The background should be of heavy weight watercolor paper or Bristol board.

9. Determine how the background of your geography of self is to appear. It could be left white, or it could include drawings, text, textured papers, or an actual map. If a geographic map is selected for use, consider one that has a strong explicit or metaphorical connection to your sense of self.

10. Select a clear photograph of yourself (either color or black and white) that includes an image of your face and hands. If possible, enlarge the photograph so the face and hands are a good workable size for creating your map. You may want the head to be about 4" high and the hands proportionally sized.

11. Carefully cut out the head and hands, and lay them aside to be collaged later, once you have selected other pieces for your composition.

12. Arrange pieces of maps, text, small tokens, and visual items as compositional elements, cutting or tearing the pieces as needed. Tack these pieces into places with tiny dabs of a glue stick, but do not firmly attach.

13. Share the arrangement with peers and your instructor and ask for feedback.

14. Once you have edited your arrangement based on the feedback you receive, fasten pieces down securely with a glue stick or rubber cement. *Do not use white glue or gels, as these will cause the papers to wrinkle.*

15. Use Sharpie markers to complete your work with detail lines or drawn additions that pull the parts together visually while also contributing meaning to the composition.

Digital Method

16. Follow steps described for the Collage Method above, but scan and arrange the parts of your image as layers in a software program such as Photoshop or Illustrator.
 a. Some layers can be made more opaque or transparent to soften an effect or increase dominance of a visual item.
 b. You could use filters to alter the appearance of compositional pieces.

17. Share the in-progress composition with your peers and instructor before flattening the layers.

18. Save, print out and, embellish with drawn details if these would contribute to the piece.

Materials Needed

drawing or watercolor paper,
 12" × 18"
drawing pencils with soft and
 hard leads

Collage Method

heavy weight watercolor paper or
 Bristol board, 12" × 18"
rubber cement

Digital Method

image-making software program
 and computer

eraser
maps, photos, and small personal
 images or objects

rubber cement eraser
scissors
Sharpie markers

printer and printing paper
Sharpie markers

James Huntley, *Baby Blues*, 2013. Digital,
16" × 20". (Courtesy of the Artist)

Vocabulary

Concept Map

WHAT TO SUBMIT FOR EVALUATION

· a concept map that takes into consideration questions given in Instruc-
tions #1 through #6
· a completed geography of self artwork on watercolor or poster paper, or
created in a digital imaging software program

Exploring Self and Others through Art 481

TIPS FOR TEACHERS

Media Variations

Young students could explore geography of self through self-portraiture in paint or clay. Even more challenging would be to develop a self-portrait without using or creating actual images of themselves. Adapt the instructions to fit the needs of your students while encouraging them to think about those aspects of self that exist beyond mere physical appearance.

Interdisciplinary Variations

Extend this lesson by turning from exploration of self-geography to an exploration of another culture. Create a visual geography of the culture as a historic timeline or map. Read stories about everyday life written by authors from diverse cultures and compare similarities and differences of common experiences. Research and organize data about the cultural group and then quantitatively analyze it, using digital as well as traditional media for this exploration. The following resources suggest other ways of applying self-geography and cultural learning across disciplines of math, history, literature, social studies, and science:

- "Beautiful Maps." Pinterest. http://pinterest.com/drmanifold/beautiful-maps/.
- Berry, J. K. *Personal Geographies: Explorations in Mixed-Media Mapmaking*. Cincinnati: North Light Books, 2011. See also www.CreateMixedMedia.com.
- Conlin, K., ed. *Mixed Media Storytelling Workshop: Art Journaling Inspiration, Words, and Prompts*. Cincinnati: North Light Books, 2013.

- "Global Maps." NASA Earth Observatory. http://earthobservatory.nasa.gov/GlobalMaps/.
- Harmon, K. *The Map as Art: Contemporary Artists Explore Cartography*. New York: Princeton Architectural Press, 2010.
- Harmon, K. *You Are Here: Personal Geographies and Other Maps of the Imagination*. New York: Princeton Architectural Press, 2003.
- Harzinski, K. *From Here to There: A Curious Collection from the Hand Drawn Map Association*. New York: Princeton Architectural Press, 2010.
- Jacobs, F. *Strange Maps: An Atlas of Cartographic Curiosities*. New York: Viking Studio, 2009.
- Scher, P. *Paula Scher: MAPS*. New York: Princeton Architectural Press, 2011.
- Turchi, P. *Maps of the Imagination: The Writer as Cartographer*. San Antonio: Trinity University Press, 2007.

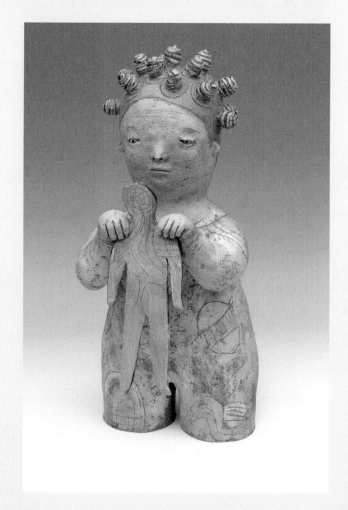

Sara Swink, *Self Study*, 2013. Ceramic, 19" × 8" × 9½". (Courtesy of the Artist. http://saraswink.com/artwork/3293910-Self-Study.html)

Lesson 99: A Postcard Travelogue of My Day

How conscious are you of the ordinary events of your daily life? Between a first cup of coffee in the morning to lying down for a night of sleep, many events of daily life make only fleeting impressions upon one's consciousness. In this lesson, you are to practice attentiveness to the small details of experiences throughout a day. In creating a **postcard travelogue**, you will intentionally focus on sights, sounds, tastes, and little things that have become so familiar they fade into the background of your thoughts. By reintroducing them to conscious awareness you may come to see your daily experiences from an enlightened point of view.

INSTRUCTIONS

For this lesson, you will need a package of 4" × 6" or 5" × 7" white unruled index cards, or you can make your own cards by cutting a sheet of watercolor paper into cards of this size. Prepare a little folder or packet that you can carry with you throughout the day, containing the cards, three or four drawing pencils in hard and soft leads, and a small package of colored pencils. Think of this preparation as packing for a trip, during which you will be using these materials to keep a travelogue of your journey.

1. Beginning early in the morning, right after you get up or as you are eating breakfast, begin recording small impressions of events, experiences, things, and people you engage with as you travel through your day. Using the cards as postcards, record drawings of these encounters.
 a. For example, on one side of a card, draw the cup you used for morning coffee or tea, noticing its color, the shape of the handle, the warmth of the cup as you held it. Notice the aroma and taste of the drink.
 b. Add details, such as text, that describe the warmth, aroma, taste, and/or your impression of the experience.
 c. If time and opportunity permit, color in the image with colored pencils or a medium of your choice. If there is no opportunity for immediate addition of color, this detail can be added at the end of the day.
2. On the reverse of the card indicate the time of day (approximate) of the experience, and write a bit about how you felt or what you were thinking at the time this event was taking place.
3. Continue to capture moments of experience throughout your day. For example:
 a. Notice who was standing near you as you waited for the bus to class, and how they stood (patiently or impatiently)—perhaps huddling beneath umbrellas to keep dry during a rain storm, hunching their shoulders to keep warm on a crisp winter morning, or standing with unbuttoned jackets to enjoy the warmth of a spring morning.

b. Notice the color of the cat walking across the road before the bus arrived, or the dog walking on a leash beside its owner.

c. Notice whether or not the bus was late or on time, full of people or nearly empty.

d. Notice who first greeted you when you arrived at your destination and how you felt in response to that greeting.

4. In spare moments throughout the day, record these events on your individual postcards.

a. If your day is very busy and you do not have time or opportunities to draw on the postcards, you may take a snapshot with a digital camera and jot down notes on a postcard about your impressions of the captured image. Later, you could match the image to the notes as you download the snapshot, trim it, and rubber cement it to the front of the postcard.

b. Alternatively, if you are unable to capture 12 events in a single day, you might extend this lesson to cover a second or third day, for up to a 72-hour period but no longer.

5. Collect a minimum of 12 cards during one 24-hour period (or maximum 72-hour period), although you may collect many more than 12 if you are inspired to do so.

6. Go over your work at the end of this period and select 12 images that are descriptive of your experiences, adding embellished details of color or drawn details that are consistent with the feelings you remember or describe on the back of the card.

7. When you have collected at least 12 cards throughout the allotted time period, prepare one final card. On the front, draw an overall impression or composite impression of all the experiences.

a. The image may include small sketches from some of the other cards, or it could be an entirely original drawing from your imagination that describes your moods and general feelings about the day.

8. On the reverse, write a reflection of your overall impression of general feelings about the experience of having made *the familiar unfamiliar*.

9. Use a ribbon or twine tied around the cards to keep them together, or keep them in a small box.

Left, Pola Switz, *Monday Morning Train,* 2015. Photograph modified with ink, white tempera, and Photoshop CS6. (Courtesy of the Artist)

Middle, Pola Switz, *Wake Up Call,* 2015. Photograph modified with ink, white tempera, and Photoshop CS6. (Courtesy of the Artist)

Right, Pola Switz, *Guitar Lesson,* 2015. Charcoal on watercolor paper with Photoshop CS6. (Courtesy of the Artist)

ART THEMES

Materials Needed

package of 4" × 6" or 5" × 7" white
 unruled index cards, or sheets
 of watercolor paper cut to
 this size
drawing pencils with soft and
 hard leads

eraser
colored pencils or color media of
 your choice
container for holding these
 materials
ribbon or twine

Vocabulary

Postcard
Travelogue

WHAT TO SUBMIT FOR EVALUATION

· 12 postcards (visual images with accompanying text) of daily encounters
 that have become so routine you scarcely notice them
· a final (13th) card with a visual and written description of how you felt
 about or were enlightened by the experience of paying attention to the
 familiarities of your day

LESSON EXTENSION

A natural extension of this lesson would be to use this technique for record-
ing new encounters or unfamiliar experiences during a vacation or weekend
road trip. Collect postcards from places you visit or create your own postcards
(as suggested above) from unruled index cards. You could include photos.
Download these from your camera and attach them to index cards with rubber
cement. Then send yourself one or several postcards every day from wherever
you are; write about what you did that day. When you return home, make or
decorate a box for the cards or bind them in a book (see Lesson 91: A Stab
Bound Book). The result will be a journal of your trip, complete with images
of sights, sketches, photos, stamps, and a record of each day's events.

TIPS FOR TEACHERS

Often a parent's question to a child, "What did you
do in school today?" is met with the casual response,
"Nothing." Strategies of noticing suggested by this les-
son may help students become aware of the events of
their day in a way that could prompt them to articulate
and convey this information to parents. Have students
make postcard travelogues of a day or week in school.
Mail them home or present them to parents during
Open House. For examples of questions that could be
asked, see Tips for Teachers in Lesson 94: A Triptych
of Abstract Word Images.

Lesson 100: Metaphors of Self

In creating self-expressive artworks, an artist selects **motifs** that have uniquely personal **symbolic** meanings. These artworks are drawn from the singular physical, intellectual, and spiritual experiences of an artist and are couched in that artist's specific culture, time, and place. Yet viewers can experience an aesthetic response to the artist's work if they perceive metaphoric connections between the artwork and phenomena in their own lives. In this two-part lesson, you are to explore the metaphoric connection between a work of art by another artist and your own life, then respond to that connection with a work of your own.

INSTRUCTIONS

Part I

In this lesson, you are to seek an artwork and artist with whom you feel a personal connection.

1. Visit a museum or gallery or search online to find a work of art with which you feel an immediate resonance. You may be attracted to the work or repelled by it. In either case, you are to select a work with which you feel a strong but inexplicable reaction.

Steve Willis, *Truth*. Acrylic on canvas, 36" × 48". (Courtesy of the Artist)

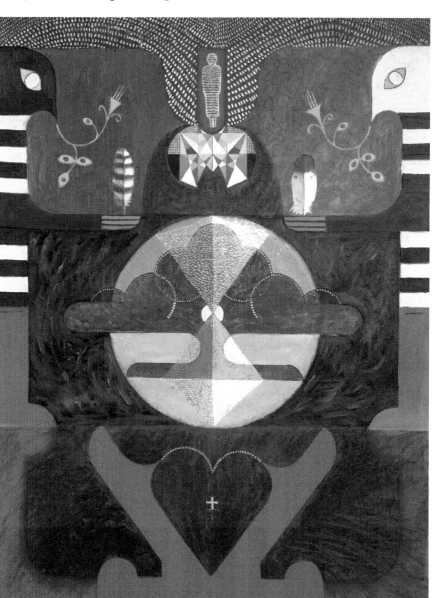

486

2. Use library and internet resources to research the selected artwork and its artist. Read about the artist's life, what he or she has to say about this work, and look at examples of other artworks created by the artist.
3. Reflect deeply about your feelings of resonance with the artwork you have selected and its correspondence with your own personal experiences and feelings.
4. In a written paper (approximately 1500–2000 words):
 a. Describe the work in terms of the mood it conveys and/or its visual-narrative content and the materials and processes of its creation.
 b. Draw **metaphoric** connections between you, your life, and relevant aspects of the artwork and artist.

Part II: Artistic Activity
5. Reflect upon the metaphoric connections you have described in your paper. Create at least four sketches, on sheets of 9" × 12" drawing paper, that visually describe connections between your feelings, life experiences, the artwork, and its artist.
 a. The sketches are to be self-reflective.
 b. You may add color in a medium of your choice.
6. Add notes to these sketches that answer the following:
 a. Which metaphoric meaning-making activity (writing or art making) elicited the deepest insights and/or emotions?
 b. Why do you think this was so?

Materials Needed

access to a computer with word processing program

white drawing paper, 9" × 12"

drawing pencils with soft and hard leads

eraser

Vocabulary

Metaphor/Metaphoric
Motif
Symbol/Symbolic

WHAT TO SUBMIT FOR EVALUATION

· a paper (approximately 1500–2000 words) describing how aspects of your feelings and life experiences resonate metaphorically with a work of art and the artist (or cultural context) of its creation
· four sketches that visually describe this connection, with reflective notes about the connections, as indicated in Instruction #6

Lesson 101: Yin and Yang

In Chinese philosophy, the two principles of **yin** and **yang** describe how opposite or contrary forces are actually complementary, interconnected, and interdependent in the natural world, and how they give rise to each other as they interrelate. These two forces, yin (the dark, moist, feminine) and yang (the bright, dry, masculine), interact to preserve balance among creatures and things. In this way, harmony is maintained in the universe.

Below, Gutzon Borglum and Lincoln Borglum *The Mount Rushmore National Memorial*, 1925. (Photograph by Clément Bardot. CC BY-SA 4.0)

Right, Jin-Shiow Chen, *The Tension of Site Energy*, 2000. Wire mesh and bread dough. Installation at Chia Yi Railroad Alternative Space, Chia Yi City, Taiwan. (Courtesy of the Artist)

In art, yin is evident as lyrical organic lines, softly muted or shaded colors, and the negative space around and between objects. Yang is visually described as bold geometricized lines, bright pure colors, and the objects or subjects of the composition. The positions of yin and yang may seem to change when, for example, the space around an object becomes the subject and forms an artistically relevant shape. Balancing aspects of yin and yang are easily found in nature, with yin experienced through new life, pliant trees and plants, gentle breezes, rolling hills, fog and mists, soft rain and flowing water; yang appears in stone boulders and mountains, sturdy plants, bright sunlight or raging storms, arid deserts and death. Environmental artists attend to these yin and yang forces when modifying natural elements into works of art. However, artists of many media consider complementary effects in compositions and sculptural works. In this lesson, you will pay attention to the balancing principles of yin and yang in creating a work of art.

INSTRUCTIONS

Part I

1. Research the principles of yin and yang to determine the range of qualities attributed to each.
2. Create a list that includes a minimum of 20 complementary characteristics that could be attributed to yin and yang. For example: moon/sun, submissive/aggressive, etc.

488

3. Use the natural environment as a model for conceptualizing yin/yang interactions. Go outdoors and notice how these complements interact on any given day. For example:
 a. In spring, observe shoots of new growth (yin) pushing up through melting snow (yin) and the deadened brown (yang) of last year's grass and foliage.
 b. On a bright summer day, study the different greens of trees and grass, or the dappled effects of light and shade as sunlight filters through foliage.
 c. In autumn, watch how brilliant colors of leaves are softened by morning fog or misty rain.
 d. In winter, notice the contrasts of softly falling snow compared to crunchy hard snow that has been crystalized by sunlight.
 e. Take crayons and paper on a hike and capture the textures of bark, stones, leaves, or twigs.
 f. Take a hike in a natural area and find places where yin and yang exist in harmony with one another, as when a waterfall wears grooves into stone, or new twigs emerge out of a broken tree limb.
4. In a brief essay (300–400 words), describe what you observed and experienced.
 a. What did you observe as yin, and what did you identify as yang?
 b. How did you perceive yin and yang interacting?
 c. Give specific examples.
 d. How might these forces be metaphoric of or meaningful to your life?

Part II
5. Gather together a selection of *natural* materials. Depending upon the season of the year and in your local environment, these could include the following:
 a. Acorns, bamboo stalks, bark, beans (with or without pods), beetles or beetle shells, bones, buckeye husks, broken sticks, damp and dry soils, driftwood, feathers, flowers, fossils, fungi, fur, grasses, leaves, milkweed filaments, moss, mushrooms, pinecones, reeds, root vegetables (beets, onions, potatoes, turnips, yams, etc.), sand, sea glass, seashells, seaweed, seeds/seed pods, snakeskins, starfish, sticks, stones/rocks, turtle shells, twigs, vines, wool (spun or raw), woody plant stalks.
 b. Be sensitive to the environment when foraging for these materials. Collect only natural materials, and in a way that does not harm the environment. Do not endanger plants or creatures. Ask permission if necessary.
6. Sort your gathered materials into those that suggest yin qualities and those that suggest yang qualities.
7. Select and arrange the items into a circular or **mandala** form that balances yin equally with yang. The assembled work should be rich in texture and form.

8. Take several photographs of the construction.
 a. Take photographs of the mandala at various stages of its assemblage.
 b. If creating the mandala indoors, you can use smaller objects and arrange them on a large plate or platter.
 c. If the mandala has been created outdoors, the mandala can be of a larger size in a place where it could be left to deteriorate naturally. Take photographs of it immediately after its creation and as it succumbs to natural processes.
 d. Be original in your mandala making; avoid using the traditional yin/yang symbolic form.
 e. Print out six of the most interesting photographs to as large a size as possible on 9" × 12" printing paper.
9. Share your photographs with your peers and instructor for feedback. Consider which images present an equal balance of yin/yang. If one dominates the other, consider how slight revisions in choice of materials, their placement in relation to one another, or use of color might remedy the imbalance.
10. Using the photographs as guides, and keeping your peers' and instructor's feedback in mind, lightly draw the mandala on a 12" × 18" sheet of watercolor paper.
11. Add light and dark values and color to the drawing in a medium or mixed media of your choice.
12. Using any drawing or color medium of your choice, or using visual modification software such as Photoshop, build up the drawing in the following ways:
 a. Emphasize yang qualities of the objects in terms of strong textures, crisp lines, and bright colors.
 b. Focus on yin qualities in softened lines or textures and dark colors of the background.
 c. Or emphasize the *objects* as yin and *background* as yang.

Materials Needed

watercolor paper, 12" × 18"
printing paper, 9" × 12"
digital camera
drawing pencils with soft and hard leads
eraser

color medium or digital image modification software of your choice
natural objects collected from your environment

Vocabulary

Mandala
Yin/Yang

Jin-Shiow Chen, *Tree of Hope*, and Paul Y. Lin, *Bird Heaven* (Sculptures in Honor of a Fallen Tree), 2005. Wood and paper. Outdoor Sculpture Garden, Taiwan. (Courtesy of the Artists)

WHAT TO SUBMIT FOR EVALUATION

- a list of 20 complementary qualities categorized as yin or yang
- an essay response, as outlined in Instruction #4
- six photographs of your constructed mandala
- a drawn and altered or enhanced version of the photographed mandala

LESSON EXTENSION

Research the soft stone sculptures of Spanish artist José Manuel Castro López. Notice how he creates yin-like sculptures of stone (yang). Download at least three examples of his artwork. Then, respond to the following questions:

- How do López's sculptures remind us of how natural yin/yang forces actually work?
- How might natural forces employ yin to modify yang substances, or vice versa?
- Make a list of at least three examples of yin forces modifying yang.
- Make a list of at least three examples of yang forces modifying yin.
- Find three examples of environmental art by others artists that celebrate yin.
- Find three examples of environment art by other artists that celebrate yang.
- Download images of these artworks and write a brief essay in which you identify the art and artists, and explain how principles of yin and/or yang are used in the artworks.
- Do you find balancing effects of both elements in the artworks? Explain.

Lesson 102: A Woven Portrait

Photographic portraits capture and freeze a subject in a fleeting moment of time. Because photographic portraits are two-dimensional, the image is flattened; we cannot move around and see the portrayed subject from other angles, and figures in the picture cannot move as they do in motion pictures. Artist David Samuel Stern, however, has devised a method of presenting photographic images of people in ways that give them ghostly holograph-like characteristics. Our brains are programmed to recognize the symmetry of faces; when that symmetry is challenged, the result can be mesmerizing. By taking two photographs of a subject, each from slightly different angles, cutting each into thin strips (one vertically and one horizontally), and weaving these together, Stern creates a spectral illusion of movement. The resulting image triggers a kind of visual dissonance that suggests something more than a physical visage. It is as if, in an elusive, ambiguous space, something of the inner personality is being revealed that a traditional photographic portrait could not capture.

Photographic transfer or **photo transfer** is another intriguing technique for modifying images. Transferring a photograph from its original form to another invites the element of chance. Portions of the photograph could become distorted or be lost altogether. The image is softened and given an ethereal quality. Combining processes of photographic transfer with weaving complicates the effects of each. As a result, illusions of movement and otherworldliness

Pola Switz, *Two Men*, 2015. Photographs on paper, digital image manipulation. (Courtesy of the Artist)

may be layered and enhanced. In this lesson, you are to explore the possibilities inherent in combining photo transfer with portrait weaving.

INSTRUCTIONS

1. Begin this lesson by searching for woven photographic portraits by David Samuel Stern, and download two images of his work.
 a. Study the positions of the subjects in the pre-woven photographs and notice how Stern weaves the two images together.
 b. Set the downloaded images beside you while you work, and refer to them for inspiration and guidance in your work.
2. Your weaving can be created as a self-portrait or a portrait of a friend or loved one. If this is to be a self-portrait, begin by having a friend take several photographs of you. If it is to be of another person, take several portraits of the friend or loved one.
 a. The subject should be shown from the shoulders up (a **bust** portrait),
 b. Mount the camera and do not move the camera between shots.
 c. Mark a spot on the floor or ground where you or the subject of the portrait will stand or sit while the photograph is taken.
 d. Photographs should include frontal, side, and three-quarter views from the left and right.
3. Think ahead about whether you want to focus on gesture, position, or expression, and whether you want additional effects incorporated into the woven portrait.
 a. If you are interesting in exploring differing expressions or gestures of the person, take photographs of the person smiling, frowning, looking surprised, tilting the head one way or another, or otherwise expressively gesturing from photo to photo.
 b. The photographs can be taken in color or black and white, or (by switching the camera or the film) a combination of both.
 c. The same or different backgrounds could be used for the images.
 d. Be aware that the transfers will come out backwards, so avoid taking photographs that include words on clothing or in the background.
4. Look over the photographs carefully and select two that you visualize as relating to each other in a *subtle* but interesting way.
5. Make a **laser print** or **photocopy** of each.
 a. Each print should be printed in the same size, approximately 8" × 10".
 b. Each should be photocopied with a **laser printer**, not an **inkjet printer**. This may require that you have the photographs commercially photocopied rather than printed out on your home inkjet printer.

Coat surface with acrylic medium.
(Created by the Author)

6. Transfer the photographic images to two sheets of 12" × 18" *heavy* watercolor paper by using a photo transfer method. Lay sheets of watercolor paper in front of you and on a surface that has been prepared with newspaper or a plastic cloth to protect your work area.

7. Quickly brush a thick layer of gloss or matte **acrylic gel medium** on a sheet of watercolor paper with a 1" wide acrylic brush. Make sure the entire surface is covered with gel medium.

8. Center and place one of the photographs on the acrylic gel–covered sheet of watercolor paper, with the image side down.

9. Press gently and evenly, so the photocopy print lays flat with no bubbles of air between it and the watercolor paper, *but do not rub.* You can use a rolling pin to assist in this process.

10. Repeat this process with the second photograph and sheet of watercolor paper.

Place photocopy upside down on the damp acrylic medium and press down with a sponge. (Created by the Author)

11. Leave the work to dry in this position for at least 24 hours.

12. Immediately after finishing this procedure, thoroughly clean your paintbrush with soap and water.

13. When the work has dried for a minimum of 24 hours, carefully remove the paper photocopies by gently rubbing the photocopy paper with a damp sponge.

 a. Make sure all excess water has been wrung from the sponge so the photo image is not removed along with the paper backing.

 b. Alternatively, you can spritz the paper with a light layer of water mist and assist the removal of the dampened paper by gently rubbing the copy paper surface with your fingers.

14. As pieces of print paper start coming off, the image will be revealed.

 a. This process takes time and may be messy. Have a waste can near-by and brush excess scraps of paper into the container frequently to keep your work surface cleaned.

 b. Dampen the photocopy paper if it begins to dry out, and work slowly so as not to tear the watercolor paper.

15. Continue working until all or most of the excess print paper has been removed and the portrait images are visible.

 a. You will notice that some of the print transfers are imperfect, with sections of the image missing or faint. This is acceptable and can be incorporated into the completed artwork.

16. Lay the print-covered sheets of watercolor paper aside to once again dry overnight.

Day 3

17. Cut one photo-transferred sheet of watercolor paper vertically into 1" strips. There should then be twelve 1" × 18" strips for the **warp** of your weaving.

18. Cut the second sheet of watercolor paper horizontally in 1" strips. There should be eighteen 1" × 12" strips for the **weft** of the weaving.

19. Weave the strips together.

 a. If you like, you may add additional materials such as ribbon, reeds, pieces of twine, or strips of decorative papers to either the warp or weft of the work.

20. When the piece has been woven in a way that pleases you, use tiny dabs of white glue to the end strips of the weaving to hold the work together.

21. Write an essay (500–650 words) that provides an explanation of the woven photograph:

 a. Who is (or are) the subject(s), and why did you select this person or these people to include in your work?

 b. What factors did you consider when selecting the specific pose or expressions shown in the two photographs?

c. What difficulties did you have with this process, and how did you resolve the difficulties?

d. How do the two images interact with one another or contribute meaning to one another as a result of their being woven together?

e. If you embellished the finished work with writing, painting, or additional imagery, explain why these were added. What additional or extended meaning did they contribute?

f. What metaphoric ideas are suggested by the completed work?

Materials Needed

watercolor paper, 12" × 18" (two sheets)

two laser-printed self-portraits, about 8" × 10"

acrylic gel medium (gloss or matte)

acrylic paint brush with 1" wide bristles

white glue

Sharpies or other permanent ink pens or markers; watercolor pens and markers will not adhere to acrylic surfaces. Use permanent marking

instruments such as Sharpie Paint Pens (these come in various point sizes, down to fine and very fine), Faber-Castell Pitt Artist Pens (Fineliners, Big Brush), or Sakura Pigma Micron pens.

acrylic paints and brushes

water containers, water, and mixing trays

newspaper or plastic cloth to protect work space

soap for cleaning brushes

Vocabulary

Acrylic Gel Medium

Bust

Inkjet Printer/Inkjet Print

Laser Printer/Laser Print

Photographic Transfer/ Photo Transfer

Photocopy

Warp

Weft

WHAT TO SUBMIT FOR EVALUATION

· two photo-transfer images of a self-portrait or portrait of a friend or loved one woven together, with or without added embellishments

· a written essay response, as outlined in Instruction #21

LESSON EXTENSION

While this lesson asks that you combine two processes, variations of the lesson could be imagined using only one of these processes. Photographic transfer can be used as a process of modifying straightforward images or transferring them to paper montages, pieced patchwork fabrics, or as decorations on wood. Woven images alone might present whimsical or powerful messages about the subjects being combined. Woven photographs of different animals could suggest imaginary (bestiary) creatures. Photographs of landscapes taken before and after droughts, floods, or other natural or man-made disasters might spark

insight regarding changes in the environment over time. Likewise, photographs of a single person taken at different ages would produce eerie allusions to the aging process. Additionally, a photograph could be woven with other materials, such as scrapbook papers, ribbon, string, fabrics, or cellophane.

Connie Cody, *Woven Portrait*, 2015. Photographs on paper, pencil, digital manipulation. (Courtesy of the Artist)

The instructions direct you to use two images of the same person, posed in slightly different positions. The resulting effect should be of a ghostly movement. However, you could also weave a portrait of two different people. For example, you could choose an image of your father and your mother, two sisters, yourself and a loved one, or two people related in some other significant way. In putting together photographs of two people, think ahead about how you want them to interact in the completed image. Rather than taking pictures of them posed in a marked location, with a mounted camera, have each stand in a slightly different location, either to the right or left of a marked (center) location.

Pose them in ways that allow them to turn toward one another or gesture in some way that is interactive. Use your imagination in posing the subjects and shooting individual images in order to arrive at a completed weaving that is both planned and surprising in its result.

Lesson 103: Cataloguing an Inner World

A **catalogue** is an organizing system that is useful when trying to keep track of large amounts of data, analyzing how items relate to one another, or distinguishing between somewhat similar objects. Generally, we think of catalogued items as *things*; rarely do we think of experiences, thoughts, and feelings as phenomena that are suited to being catalogued. Yet organizing important internal and external features of our lives may open us to new ways of *seeing* how our behaviors have been influenced. As a result, we may be empowered to reorganize our responses to these influences and redirect our thoughts and actions in ever more positive directions. In this lesson, you will catalogue important thoughts, feelings, or responses to experiences as visual artifacts for reflection and possibly re-envisioning.

Anonymous student, *A Day I Regret: She'd made an apple pie for me, but I'd forgotten it was her birthday. I wish I'd hugged her*, 2014. (Courtesy of the Artist)

INSTRUCTIONS

1. Using an 18" ruler and pencil, create a 1½" border all around a sheet of 12" × 18" watercolor paper. Then divide the internal space into nine sections. Each section will be 3" × 5" in size.
2. With the paper and sections oriented either vertically (portrait style) or horizontally (landscape style), number each of the sections in sequence, from left to right.
3. Look over the Visual Prompts chart and out of the twelve sections presented, select *one* question that interests you from *nine* of the sections (nine questions in total).

4. In each 3" × 5" section of your catalogue, create an image as a visual response to one of the nine questions selected from the Visual Prompts chart.

5. On a separate sheet of 9" × 12" drawing paper, in numerical order, write down the questions you visually responded to within each section of the grid.

6. You may use a medium of your choice or combine media, either within a section or from section to another.

 a. For example, you could combine drawing and text in one section, photographic transfer with Sharpie pen in the second section, and collage with drawing in a third section.

 b. As you work, connect the visual elements from one section to the next with line, color, visual texture, or some other Element or Principle of Art, so as to produce a harmoniously unified overall effect.

7. View your completed work from across the room to determine if the nine sections hold together as a unified composition. If not, add additional lines, texture, text, or other elements to pull the various parts together into harmony.

8. Write a brief essay (300–400 words) describing how the process of cataloguing your responses to these questions affected you:

 a. Did the results encourage reflection, new understanding, and perhaps a re-ordering of responses? If so, how?

 b. How do you perceive the sections of your work as being unified?

 c. To what extent does unification of the image reflect a harmonious resolution of your responses to the questions?

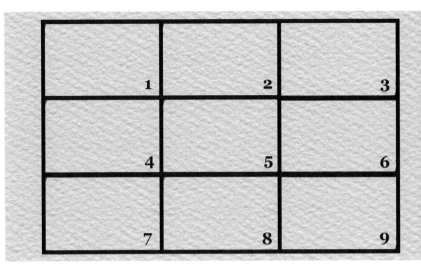

Watercolor paper divided into nine sections.

Materials Needed

sheet of watercolor paper, 12" × 18"
18" ruler
drawing pencils with soft and hard leads

eraser
color medium or media of your choice

Vocabulary

Catalogue

WHAT TO SUBMIT FOR EVALUATION

· a completed project of nine imagic responses to selected questions
· on a separate sheet, a list of the questions you visually responded to within each section of the grid
· an essay response, as outlined in Instruction #8

Section	Visual Prompts: Select one of the questions listed for each day, and respond to it by creating a visual image. You may create the image(s) in any medium of your choice.
1	1. How many siblings do you have and how has the order of your birth influenced your life? 2. What's the most memorable class you've ever taken or subject you've ever studied? 3. What is your hidden talent?
2	4. What is the strangest or oddest thing you believed as a child? 5. What strange occurrence have you experienced for which you have no explanation? 6. Have you ever wished on a shooting star? For what did you wish? Did your wish come true?
3	7. What is typically your first thought when waking up in the morning and your last thought before you go to bed at night? 8. What is the best compliment you have ever received? 9. Who/what makes you laugh?
4	10. In what area of your life are you immature? 11. How do you vent your anger? 12. When was the last time you cried?
5	13. What are you afraid of? Why? 14. If you could eliminate one weakness or limitation in your life, what would it be? 15. If you could have a super power, what would it be?
6	16. Do you have a collection of anything? What do you collect? 17. When are you most likely to want to listen to music? Why? What kind of music? 18. What is one thing you wish scientists would invent?
7	19. What is one guilty pleasure you enjoy too much to give up? 20. What sort of conversational topics get you excited when you talk? 21. If you could change anything about yourself, what would you change?
8	22. Who do you trust and to what extent do you trust that person? Explain 23. Who are your mentors in life? (formal or informal)? How has that mentorship helped you? 24. What do you want your friends to think about you?
9	25. Who is/are the most important person(s) to you in the world. What kinds of things should you do with that person more often? 26. What is your ideal life partner like? Where can you find him/her? How can you get to know him/her? 27. What qualities do you naturally express that might make you a good friend?
10	28. If you could go back in time to one point in your life, where would you go? Why? 29. If you could go back and change one day, what would it be? 30. Is there anything that you have done that you regret? How have you been changed by that experience?
11	31. What traumatic global event do you recall as making a strong impression on you? Explain. 32. Do you hold any convictions for which you would be willing to die? What are they and why? 33. Is there a motto or saying that describes how you try to live your life?
12	34. When do you find yourself singing? 35. Have you ever danced in the rain? When and why? 36. Are you happy with the life you have? Why or why not?

Visual Prompts

Lesson 104: Collaborative Images

During the Modernist era of the Western art tradition, artists were seen as independent agents who created artworks based on their unique perceptions of the world. As we move into the twenty-first century, we are seeing that art making is rarely an individualistic experience, but one that relies heavily upon feedback and support from groups of friends and peers. Often art making is a **collaborative** experience. In this lesson, you are to reflect upon how collaborative art making influences your perception of art media, processes, products, and reasons why art might be made.

Left, Community members working together to create a portable mural in preparation for a local celebration, 2010. (Photograph by the Author)

The lesson calls for **collaboration** between you and three to seven other people. This group may include people of varying ages or art developmental levels. You and others of the participating group are to work together to determine a theme for an artwork. After agreeing on the thematic subject, each person is to create an image of the subject on a small card. Each artwork should be oriented in the same way and should be done privately, without observing one another's process or progress. Each artist should create a work that represents his or her preferences, personality, and (insofar as possible) cultural background. Realize that even among people with a similar cultural background there are preferences of artistic style, media, materials and processes of art making, and individual expressivity that will show through as the images are created. When the different images are **collated**, a mosaic of diversity will become apparent.

Above, Teachers learning to sew from a local seamstress, 2010. (Photograph by the Author)

INSTRUCTIONS

Together with the other participants, decide on a topic that is of mutual interest. Possible topics could be "a portrait of mother," "playful cats," "detail of a car engine," or "close-up view of birds." Aside from creating a work based on the agreed-upon subject, other requirements are that each image be completed

on a 3" × 4" card with similar directional orientation, and that the subject fill up most of the space of each card. Any two-dimensional color medium is permitted.

1. Prepare four to eight cards of uniform 3" × 4" size by cutting 9" × 12" or 12" × 18" watercolor paper with a paper cutter, or use an 18" ruler and mat knife to make the cuts.

2. Provide each of three to seven participants with a 3" × 4" card of heavy watercolor paper. If a participant does not have painting art supplies, discuss ways of completing the project with cut paper and rubber cement (*do not* use white or gel glues), crayons, colored pencils, or markers.

 a. All artworks should be created in private, without directly referring to one another's work.

 b. Indicate a deadline for when the card artworks are to be completed, and collect the cards at that time.

3. Arrange the cards on a colored or neutral background of heavy weight paperboard that has been cut to 9" × 12" or 12" × 18", depending on the number of participants in the project.

4. Show the arrangement to your collaborators for their feedback regarding how the images relate to one another visually. Move the cards around until the overall arrangement has a harmonious appearance.

5. Rubber cement the cards down with a small bit of space (about ¼") showing between each card and a large enough space (about 1") beneath each card for each participant to write a **legend** or title for the card.

 a. Clean off any excess rubber cement.

 b. Ask your participants to carefully write the title legend beneath his or her project with pencil (see Instruction #5). Each title should include the participant's name; for example, "Dorothy, Beth's Mother," or "Goldie, Juan's Cat."

6. Make color scans of the collaborative composition and give each participant a copy of the final product.

7. Study the completed composition and write a brief essay (300–400 words) that addresses the following questions:

 a. How did you and your collaborators decide upon a topic for this artwork?

 b. To what extent are different personalities, developmental levels, stylistic preferences, and cultural backgrounds apparent in the choice of subject matter? Explain.

 c. What decisions went into the arrangement of the different cards on the final backing?

 d. How do the images relate to one another visually? (Think of line, color, visual texture, shape, and other **Elements** and **Principles of Art**.)

 e. How do the images relate to one another conceptually?

Materials Needed

four to eight sheets of white
 watercolor paper, cut to a
 uniform size of 3" × 4"
white or colored cover weight
 backing (Bristol board of poster
 board), 9" × 12" to 12" × 18"

paper cutter, or 18" ruler and
 mat knife
color medium of choice
rubber cement
rubber cement eraser
pencil

Vocabulary

Collaborative/Collaboration
Collate
Elements of Art

Principles of Art
Legend

WHAT TO SUBMIT FOR EVALUATION

· a completed project resulting from a collaboration with three to seven
 peers, creating small images of an agreed upon theme, with individual
 artworks arranged together in a visually harmonious grouping
· a written essay response, as outlined in Instruction #7

TIPS FOR TEACHERS

It is a common practice of art teachers to display collections of student artwork that address a similar topic. In most cases, however, the decision to display images together is made after the artworks are completed. Students working on themed artwork in the classroom can see one another's drawings or paintings as these are being created. Thus, there is a tendency for them to adjust their work technically and stylistically to resemble the artwork of a neighbor, or to copy the acknowledged "best artist" in the room. This project asks students to create their image in private, using a color medium of their choice, while they consider how the artwork might reflect something of their own artistic personality. The following resources that may help students understand the notion of stylistic and cultural differences:

· Goldberg, D. *On My Block: Stories and Paintings by Fifteen Artists.* Children's Book Press, 2007.

· Rohmer, H. *Honoring Our Ancestors.* San Francisco: Children's Book Press, 2013.
· Rohmer, H. *Just Like Me.* San Francisco: Children's Book Press, 2013.

Artworks created by students of your class could be shared across geographic communities. Contact teachers in other parts of the state, country, or world,[3] and collaborate on an exchange of small artworks based on a similar theme. For example, students in different locations could create images of "favorite foods," "things I like to do in winter," "games we play during recess," or "what I want to be when I grow up."

Exchange actual cards through the post office or digitally through an online sharing site such as Voice-Thread. Encourage students to explore and discuss similarities and differences in the content of the shared images as well as in their stylistic approaches.

Lesson 105: A Spirit Doll

Dolls, as small figural representations of humans or animals, may serve many purposes. Commonly used in the pretend play of children, dolls also are appreciated by adults as decorative or symbolic figures. Katsina (or Kachina) dolls of Hopi Pueblo cultures serve as anthropomorphic representations for abstract concepts of nature, creativity, healing, or power. Tiny Guatamalan worry dolls are intended to deflect emotions. These little dolls are placed under one's pillow at night to symbolically carry fears or worries away. Other dolls may focus the attentions and energies of community members through ritual, or serve as symbolic gifts. For example, among the Ndebele people of southern Africa, colorfully beaded dolls may be given by a suitor to a young woman he hopes to marry, or by a grandmother to her newlywed granddaughter as a reminder of traditions to be passed down into new generations. Women in parts of Africa and the Caribbean Islands also create dolls as material reminders of spiritual supplications. Ancient and modern peoples of India, Egypt, Greece, and Mexico have all used elaborate sculptured and adorned figures as ways of depicting history, conveying cultural ideas, and soothing minds and spirits.

Small sculptural dolls such as these could be referred to as **spirit dolls**, because through their form and decorative features they encapsulate and project something about the artist's needs or intentions. A doll of this sort might reflect the traditions of a people as well as the individuality of its maker. It provides its user an opportunity to reflect upon qualities that are (consciously or unconsciously) projected outward.

In this lesson, you are to explore a doll-like sculptural form as an expression of some significant or playful expression of self or personal culture. The following instructions suggest **polymer clay** as a medium for molding the doll's head and limbs. However, for a more eco-friendly medium, you can substitute homemade salt dough for polymer clay. (A recipe for making salt dough is given in Lesson 115.) If you don't want white-colored head and limb pieces, you could use colored polymer clays or mix food coloring with the salt dough. Use bright primary or secondary colors if you prefer, or natural light-tan to dark-brown skin tones. If making your own clay, various skin tones can be made by mixing equal amounts of blue and orange or green and red food coloring into the dough. The more food coloring added, the deeper the tone will be. Bake the salt dough head and limbs to harden and strengthen them. Once hardened, salt dough may be painted with acrylic paints.

Another obvious medium that lends itself to doll making is cloth, but you should not limit yourself to making a doll of stuffed fabric. Consider using natural materials such as wooden branches or leather. Body forms also could be made of **papier-mâché** or salt dough. A template and instructions for creating a fabric body are given here, but this is only a suggestion. You may substitute the instructions for an all-fabric doll body given in Lesson 106, search online or in books for a different body template with instructions, or invent an entirely original process of doll making that is more interesting to you and challenges your skills without overtaxing them.

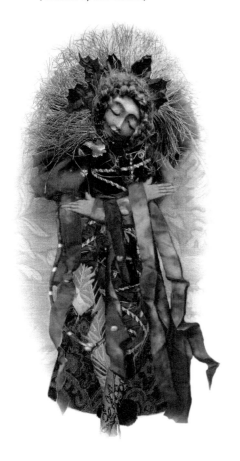

Digital sketch of spirit doll. (Created by the Author)

1. Begin by thinking about the purpose or idea you would like to address through your spirit doll. On pieces of white drawing paper, make at least five sketches of how you would like the doll to look.
2. Show the sketches to your peers and instructor for feedback about your concept and advice about how to manage the technical aspects of construction.
3. Select one of the sketches you think comes closest to the vision and purpose you have for the doll.
4. Make lists of the kinds of materials needed to create the doll.
5. Begin gathering these materials.

Head with shoulder plate and holes for attaching to body. (Created by the Author)

There are many media and methods that are be appropriate for creating a spirit doll. If you choose to work with polymer clay in creating the head, hands, and feet of a doll and want to use stuffed fabric for its torso, these instructions may be helpful.

Polymer Clay Head, Hands, and Feet

1. On sheets of white drawing paper, 12" × 18", plan out the overall size and proportions of various parts of the doll.
2. Draw sketches of what the head and limbs might look like.
3. Using polymer clay[4] (or homemade salt dough), form a head that is approximately 2" high from chin to neck and proportionally wide. Leave an equal amount of polymer to form a neck and shoulder ridge that is about 2" wide and ¾" thick. Hollow the underside of the ridge slightly and, using a large yarn needle, poke several evenly spaced holes along the bottom of the shoulder ridge, as show in the figure below. Take care not to make the holes too close to the clay edge.
4. Polymer clays come in a variety of colors. If a single color is used, paint the head as desired.
5. Create two hands with arms that are consistent in size with the proportions planned for the whole doll. Flatten the end of the upper arm and with a large yarn needle, poke a hole through the flattened area. Be careful not to place the hole too close to the edge.
6. Create two feet (with shoes if desired) and legs. Flatten the top edge of the legs and poke a hole through the center of the flattened piece, again being careful not to place the hole too close to an edge.
7. Bake or allow the clay piece to harden according to directions.
8. Meanwhile, cut two identical pieces of fabric in a somewhat triangular shape, folding the fabric in half with the right sides together before cutting.
 a. Enlarge the body pattern given here to the desired size onto a large piece of paper or brown paper cut from a large paper bag. Flip the pattern vertically to make a full body template. Use the resulting template for cutting two body pieces.

Above, Example of arms. (Created by the Author)

Below, Example of legs. (Created by the Author)

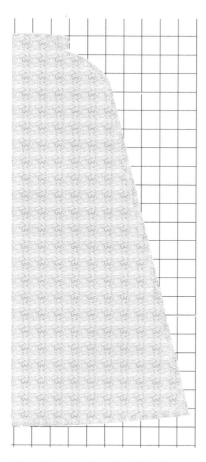

Above, Suggested template for body.
(Created by the Author)

Below, Sew three sides of the body.
(Created by the Author)

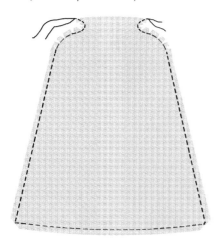

Right, Sew shoulder plate to the body.
(Created by the Author)

b. If your head is about 2" high, the triangle should be about 12" to 14" long, 8" to 10" wide at the widest point, and 3" wide at the flattened or curved apex of the triangle.

9. Consider where the head and limbs will be added to the body,[5] and mark these on the cloth with tailor's chalk.

Attaching Polymer Clay Pieces to the Body

1. Lay the two fabric pieces with right sides together. Sew a ½" to ⅝" **seam** all around three sides of the triangle, leaving open the flat apex. This is where the body will be stuffed and the neckpiece tucked into the opening.

2. Clip the corners at the two bottom corners.

3. Turn the piece right side out. Using clean, recycled hose stockings, or cotton **batting**, stuff the body to fullness, leaving the apex/neck area open with space for inserting the shoulder plate of the head.

4. Fold the neck opening in toward the inner body and tuck the neckpiece inside. Use a curved needle and thread to tack the shoulder plate to the body.

 a. Alternatively, *before* turning the sewn fabric right side out and stuffing the body, fold over the edge of the neck opening (the apex of the triangle) and using tiny hand stitches or a sewing machine, sew a hem about ½" from the top of the fold. Leave about 1" of the hem unsewn at the end. There should be enough space between the fold and sewn hem to allow a small safety pin with a cord to be pulled through the tunnel.

 b. Attach a safety pin to a small cord, and run the cord through this tunnel space. Leave tails of about 6" on either side of the tunnel.

 c. Now turn the piece right side out and stuff the body to fullness, leaving the neck area open with space for adding the shoulder plate of the head.

 d. Carefully tuck the shoulder plate into the body cavity at the neck. Gently pull the cord ends together to tighten them around the neck, until the shoulder piece is thoroughly embedded in the body.

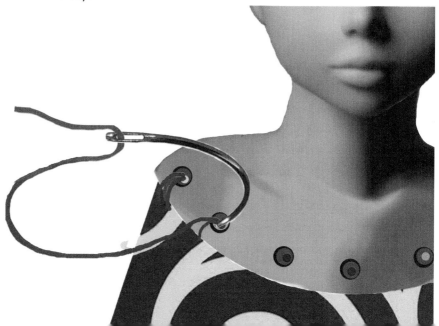

e. Tie the cord tightly around the neck. Trim off the cord ends to about 4" to 6" on either side. Later, these cords can become part of the doll decorations.

Left, Sew channel in neck. (Created by the Author)

Right, Attach body to neck with cord. (Created by the Author)

5. Pin the arm in place on one side of the triangular body and position a button or bead on either side of the limb and cloth, to allow movement of the limb with causing too much tension to the fabric.

6. Sew the arm to the body by passing the needle all the way through the fabric from front to back and catching the buttons or beads. Repeat until the limb is firmly attached to the body and buttons (or beads).

7. Attach the remaining arm and the legs in a similar manner.

8. Embellish the doll as desired. Be as creative as you like by adding beads, feathers, glitter glue, additional fabric, paint, or small mementos to the figure. Sew these features on or use hot glue or craft glue to attach them securely.

9. Write responses (300–400 word) to the following:
 a. Provide an **artist's statement**.
 b. Explain your reasons for creating your spirit doll.
 c. What difficulties did you overcome in creating it?
 d. What meaning does the doll have for you? (i.e., what is your personal connection with the doll)?

Materials Needed

paper for pattern or template making	straight needles and threads
pencil	buttons, cording
eraser	beads and other accessories for embellishment.
cloth	fabric or acrylic paints, brushes,
cotton batting	water, water containers and
scissors	mixing trays
tape measure	craft glue and/or hot glue
tailor's chalk	polymer clay, papier-mâché, or salt
curved (upholstery) needle	dough medium and supplies

Vocabulary

Artist's Statement	Polymer Clay
Batting	Seam
Papier-Mâché	Spirit Doll

WHAT TO SUBMIT FOR EVALUATION

- five sketched ideas for your spirit doll
- sketches and planning diagrams, with notes about suggestions given by your peers and instructor for creating the doll
- a completed spirit doll in media of your choice
- a written response, as outlined in Instruction #10

TIPS FOR TEACHERS

After directing students to explore microscopic images of cell structures and simple biological forms, art teacher Debbie Hepplestone invited her students to consider how a few elemental structures can result in enormous diversity. Photographs were taken of facial features, skin surfaces, and hair. These were combined with textiles and other materials to create doll forms that students called "Gene Genies."

Integrate art making with the study of biologic diversities within a single species; minor changes in a genetic sequence will result in diverse individual characteristics. Cotton fabric cut to precise patterns and sewn to create similar bodies may be compared to genetic codes for basic structural aspects of human bodies. Cotton fabrics, however, come in an enormous array of colors and printed designs. Decorative additions of clips from magazines or photographs, buttons, ribbons, and small mementos added to the basic forms contribute originality and individualism to the creations.

Cut two pieces of printed cotton fabric according to a similar pattern. Stitch the pieces with right sides together, leaving an opening for turning the fabric. Clip curved sections of seams before turning the body inside out and filling it with stuffing.

Features can be created by cutting images from magazines or photographs and transferring the images to

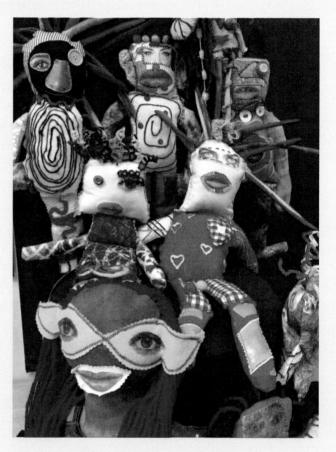

"Gene Genie" dolls by students of Debbie Hepplestone, art teacher, UK. (Courtesy of Debbie Hepplestone)

pieces of unbleached muslin, using the photographic transfer technique described in Lesson 102 for transferring a photograph to heavy watercolor paper. Cut photo-transferred fabric sections and attach them to the doll's body with hot glue, or sew them on using decorative stitches such as those described in Lesson 133. Add beads, ribbons, or other adornments as desired.

Invite students to observe how these dolls are greatly different from one another, even when they have been created from the same basic "genes" of cotton cloth, stuffing, and photographic features. Recognition of how similar structural elements of biology can result in basically similar yet vastly different forms provides a natural transition to exploring differences that result from the nurturance of culture.

Dolls in Cultural Learning

Dolls can be used to teach social skills and explore cultural traditions. Doll making art lessons appropriate for teaching young children about cultures include the following:

- Bodhidharma/Daruma Doll Lesson Plan— Darumas are technically doll "heads" rather than whole dolls, but present excellent cultural teaching tools. See Arts of Asia in Reach, http://www.oberlin.edu/amam/asia/daruma/.
- Ndebele Dolls—These are doll tokens given to members of the Ndebele community at turning points in their lives, such as the onset of puberty and becoming a woman or a man, at weddings, or giving birth to a child. Crizmac (http://www.crizmac.com) offers small authentic dolls for sale, as well as lesson plans for making and using them in the classroom. An excellent elementary-level lesson also is provided at We Heart Art, http://ourartlately.blogspot.com/2010/10/ndebele-dolls.html.
- Sculpey Dolls—This site offers links to tutorials for creating dolls of Sculpey (oven-baked) clays. See Incredible Art Department, http://www.incredibleart.org/files/dolls.htm.

- Whimsical Dolls—Amaco offers a lesson in clay-made dolls that are humorously appealing to boys and girls. See http://www.amaco.com/lesson_plans/148.

ADDITIONAL RESOURCES

- Catherall, V. *Folk Art—Dolls*. Utah Museum of Fine Arts, 2008. centralpt.com/upload/417/9999_DollFolkArtLessonssm.pdf. This resource provides information and instructions for making Pioneer Handkerchief Dolls, Russian Nesting Dolls, Pueblo Storytelling Dolls, and Guatemalan Worry Dolls with young children.
- Corbett, S. *What a Doll!* San Francisco: Children's Book Press, 1996. Beautiful color images of dolls from many cultures. Very little textual information.
- Garran, D., and J. Payne. *A Listening Doll: Create Traditional Native American Storyteller Dolls*. Washington, DC: Kennedy Center, 2013. http://artsedge.kennedy-center.org/educators/lessons/grade-3-4/Listening_Doll.
- "How to Make Cornhusk Dolls." Teachers First. www.teachersfirst.com/lessons/nativecrafts/cornhusk.cfm.
- Lenz, M. J., and C. S. Kidwell. *Small Spirits: Native American Dolls from the National Museum of the American Indian*. Washington, DC: National Museum of the American Indian, 2013.
- Malone, R. *Ultimate Robot*. London: DK Adult, 2014. Robots can be dolls, too. This text includes excellent images of robotic toys, with emphasis on the robotic figure as popular culture. The resource provides a different take on dolls.
- Markell, M. *Cornhusk, Silk, and Wishbones: A Book of Dolls from Around the World*. New York: HMH Books for Young Readers, 2000.
- Simons, S., and D. I. H. Mendez. *Trouble Dolls: A Guatemalan Legend*. Vancouver: Apple Publishing, 2000.
- Smithsonian Institution. *Smithsonian in the Classroom: Native American Dolls*. New York: Smithsonian Institution, 2004.

Lesson 106: Doll Making Inspired by Ringgold

Faith Ringgold is an artist who incorporates fabric arts in many of her expressive artworks. Ringgold makes images on quilts and sculpts her works as dolls, masks, or **sewn** costumes. She defies the idea that serious artists should stay away from anything too closely associated with women's work. Her exquisite quilts and dolls help to dismantle the hierarchy that places fine arts above crafts. Ringgold's subject matter includes her personal family history, the historic experiences of African Americans in the United States, and the history of social activism and feminism in the art world. Ringgold wants her artifacts to reflect who she is. In seeking to express her individuality and artistic style, she has experimented with the media of soft sculpture dolls inspired by strong African American women. In this lesson, you are to look at images of Ringgold's work, especially of her sculpted dolls, then create a soft sculpture doll that has been inspired by her work.

INSTRUCTIONS

1. Search in books or online for information about the artist Faith Ringgold. Try to find examples of her artwork, and especially of her doll art. Consider:
 a. Why does Ringgold create these artworks? What do they mean to her?
 b. How does she decorate them?
 c. What do these decorations symbolically represent?
2. Now search in books or online for information about soft sculpted dolls that are created by two other women artists, or artists of two other cultures.
 a. How do these dolls differ from those created by Ringgold?
 b. What meaning do they hold for the artists who create them and the people who use them?

Above, Head, arm, and torso pattern. (Created by the Author)

Below, Leg pattern. (Created by the Author)

Make photocopied reproductions or download examples of one doll created by Ringgold and two dolls created by an artist or artists of another culture. You should have a total of three reproduced images. Keep these images near you while you work on creating your own soft sculpture doll.

Basic Rag Doll Pattern

3. Select the color of the cotton fabric to represent the doll's skin tone. This may be any shade of pale peach through black, or it may be a color that is totally unrelated to true human skin colors.
4. Enlarge the two pattern pieces to a 1" square grid. One pattern piece is needed for the doll's head, torso, and arms. The second piece will be used for the legs.
5. Fold the piece fabric in half so that the *back* or *reverse* side of the fabric is facing up.
6. Fold the fabric again so there are four thicknesses of fabric. Smooth the fabric so all four layers are lying flat and even.

510

7. Place the head and body pattern on the fold line of the fabric and pin it to the fabric so the pins go through all four thickness of the fabric.

8. Cut out around the pattern, making sure to cut through all four thicknesses simultaneously.
 a. *Do not* cut the fold line; this will be the center of the doll's body.
 b. There should be two body pieces when you have finished cutting.

9. Place the two pieces of fabric with the front sides together, so the back or reverse side appears on the outside. Set this aside.

10. Fold the remaining fabric again so there are four layers of fabric. Pin the leg pattern to the fabric, making sure to attach it to all four layers.
 a. Cut around the pattern, making sure to cut through all four layers simultaneously.
 b. There should be four leg pieces of fabric.

11. Using a ⅜" **seam allowance**, **stitch** the two body pieces of the doll together from the bottom edge toward the arms and continuing around the body form to the bottom edge of the other side.
 a. *Do not* sew along the bottom edge. This should be left open so the body may be stuffed and the legs attached.
 b. You may stitch the pieces together by hand or machine, although the pieces will tolerate stuffing much better if they are sewn by machine.

Left, Sew around the chest, arm, and head, but leave the bottom of the torso open. Clip at extreme curves. (Created by the Author)

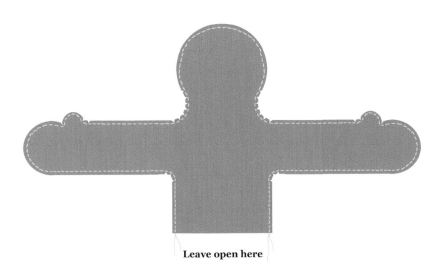

Leave open here

Above, Do not sew across the upper thigh. (Created by the Author)

12. Sew together two leg pieces at a time. Make sure the right sides are together. Using a ⅜" seam allowance, join two leg pieces from the top of the thigh toward the foot and continuing around the foot to the top of the thigh again.
 a. *Do not* sew across the thigh. This should be left open so the leg may be stuffed and attached to the body.

13. Repeat this instruction with the second leg.

14. After stitching the body and both leg pieces, carefully clip the **seams** at the extreme curves of the neck and arms, being careful *not to cut into* the stitches.

Left, Clip inner curves.
(Created by the Author)

Right, Clip outer curves.
(Created by the Author)

15. Turn each piece right side out, using a pencil or knitting needle to push out the fabric of the arms and legs.
16. Stuff the doll with polyester fiberfill or a similar **stuffing** material, inserting it through the opening at the bottom of the doll and the top of each leg.
 a. Use small amounts of filling at a time, and push the material into the arms and legs with a pencil or knitting needle.
 b. Do not stuff the pieces too tightly or the seam may pop.
17. Leaving a ½" seam allowance, **baste** the top of the legs closed.
 a. If you want the legs to turn forward on the finished doll, pin the lengthwise seams of each leg together and baste across the leg opening so the seams match up in the center of the closed seam line.

Right, Baste into place.
(Created by the Author)

Below, Stitch at the meeting of arm and torso. (Created by the Author)

Stitch legs to inside back.

18. Turn about ½" of the fabric in at the bottom of the body. Pin the two legs to the back of the body piece and baste each in place.
19. Then baste the bottom edge closed with the leg pieces caught in the closure.
20. Secure the legs in place and close the body by sewing through all layers of fabric.
21. When the body and legs have been attached, stitch a line through each arm where the arm meets the body, so the doll can move.
22. You may then begin decorating the body of the doll. Consider what idea you want to convey through the doll.
 a. Will this doll suggest something of your own history and life experience?

512

 b. Will it represent someone who is close to you, such as your mother or grandmother?

 c. Will it represent someone or something that inspires you?

23. Decide if you want to create a face on the doll or leave the face blank.

 a. If you wish to create a face, will you use fabric paint, buttons, or embroidery to make the face?

24. Will you dress the doll or decorate the body in some other way?

25. You may use embroidery or sewing techniques to add interesting details to the doll. Carefully select objects such as shells, coins, beads, cloth, feathers, or trinkets that you could use to decorate the doll.

 a. Objects can be attached by sewing, using craft or fabric glue, or using a glue gun with wax glue.

26. Think about what these objects might represent and how they fit in to the theme of your creation.

27. Write a brief essay (300–400 words) that answers the following questions:

 a. How did you create your doll sculpture? Did you follow the instructions in this lesson, follow instructions provided from some other source, or design and create an entirely original doll? Provide links or citations for any tutorials, instructional books, or other resources used to complete this project.

 b. What problems did you encounter while creating your doll, and how did you resolve them?

 c. Explain why you chose the items you used for decoration. What do these mean to you? What does the doll represent for you?

Materials Needed

1 yard of cotton fabric	polyester fiberfill, or	items of your
drawing paper	similar stuffing	choice
pencils	material	craft or fabric glue (or
sharp scissors	buttons, yarn, beads,	a hot glue gun and
straight pins	scraps of felt and	wax glue)
sewing needles and	fabric, embroidery	
thread	floss, and/or small	

Vocabulary

Baste	Seam Allowance	Stitch
Seam	Sew	Stuffing

WHAT TO SUBMIT FOR EVALUATION

· three photocopied examples of dolls: one by Faith Ringgold and two by other artists or cultural groups

· a soft sculpture doll that is inspired by the work of Faith Ringgold and other individual or cultural artists, and that has personal meaning for you

· a written response (300–400 words), addressing questions in Instruction #27

TIPS FOR TEACHERS

Faith Ringgold is also known as an author and illustrator of children's books. Books by Ringgold and books about her work include the following:

- Cameron, D., ed. *Dancing at the Louvre: Faith Ringgold's French Collection and Other Story Quilts*. Oakland: University of California Press, 1998.
- Farrington, L. E., D. C. Driskell, and F. Ringgold. *Faith Ringgold*. The David C. Driskell Series of African American Art 3, vol. 3. Portland, OR: Pomegranate, 2004.
- Ringgold, F. *Aunt Harriet's Underground Railroad in the Sky*. New York: Dragonfly Books, 1995.
- Ringgold, F. *Cassie's Word Quilt*. New York: Dragonfly Books, 2004.
- Ringgold, F. *Dinner at Aunt Connie's House*. New York: Hyperion, 1993.
- Ringgold, F. *Harlem Renaissance Party*. New York: Amistad, 2015.
- Ringgold, F. *Henry Ossawa Tanner: His Boyhood Dream Comes True*. Piermont, NH: Bunker Hill Publishing, 2011.
- Ringgold, F. *If a Bus Could Talk: The Story of Rosa Parks*. New York: Aladdin, 2003.
- Ringgold, F. *The Invisible Princess*. New York: Dragonfly Books, 2001.
- Ringgold, F. *Tar Beach*. New York: Dragonfly Books, 1996.
- Ringgold, F., L. Freeman, and N. Roucher. *Talking to Faith Ringgold*. New York: Crown Books for Young Readers, 1996.
- Ringgold, F., and C. R. Holton. *Faith Ringgold: A View from the Studio*. Piermont, NH: Bunker Hill Publishing, 2005.
- Venezia, M. *Faith Ringgold*. Danbury, CT: Children's Press, 2008.

Books as Resources: Dolls in Stories

Because dolls are ubiquitous to the lives of children throughout the world, dolls and doll making can be resources for teaching young students concepts of tolerance, caring, and appreciation of cultures. Students could be encouraged to design and assisted in creating a doll that illustrates a character from popular children's literature.

Some excellent literary resources for teaching about self-identity, tolerance, cultural customs, and beliefs through dolls and doll making include the following:

- Gruelle, J. *Raggedy Andy Stories: Introducing the Little Rag Brother of Raggedy Ann*. Reissue. New York: Simon & Schuster Books for Young Readers, 1993.
- Gruelle, J. *Raggedy Ann Stories*. Reissue. New York: Simon & Schuster Books for Young Readers, 1993.
- Medearis, M., S. Medearis, and L. Johnson. *Daisy and the Doll*. Lebanon, NH: University Press of New England, 2008.
- Polacco, P. *Betty Doll*. New York: Philomel, 2001.
- Pomerantz, C., and F. Lessac. *The Chalk Doll*. New York: HarperTrophy, 1993.
- Stuve-Bodeen, S., and C. Hale. *Elizabeti's Doll*. New York: Lee & Low Books, 2002.

Lesson 107: The Arts and Crafts of the Local Community

Only a few artists or craftspeople achieve national and international recognition during their lifetimes, but many enjoy a local and regional popularity. Local artists and craftspeople are more likely to be appreciated by others of the community if they create works that reflect the specific cultural ideas and ideals of their local communities. These are important to sustaining the creative energies and cultural lives of communities. Unfortunately, the skills, creative visions, and sustaining dynamism of local artists and craftspeople can easily be overlooked by the community, because they and their artistic products are so familiar that they are taken for granted. Furthermore, their artistic identities may be disguised by more obvious everyday roles: mail carriers, retired business owners, nurses, or teachers who create during leisure time in the privacy of their homes or workshops and share their creations with only a few intimate friends. In this lesson, you'll explore makers of arts and crafts in your community and begin to see them as *artists*.

Above, Opanek—Traditional Crafts, 2014. (Photograph by Mila Milosavljec. CC BY-SA 4.0)

Below, A Carpenter, 2011. (Photograph by Werner 100359. CC BY-SA 4.0)

INSTRUCTIONS

1. For this lesson, you are to identify someone in your local community who creates art or a craft. The person could be a quilt maker, doll maker, someone who creates books of pressed flowers, a violin maker, a carver, a basket maker, or a painter of local landscapes. Many individuals who could be considered artists or craftspeople work in unconventional materials. For example, those who decorate cakes, arrange flowers, or build models of planes from scratch could also be considered art makers. To identify these creative people, attend a local craft festival, ask among those who display their art or craft in shops, or ask members of your family or friends whom they know who does creative work.

2. Once you have identified a local artist or a craftsperson, contact the person and ask permission to interview him or her. Among the questions you might ask are:

 a. When and how did you become interested in creating this art/or craft?

 b. How did you learn the skills necessary to create in this way?

 c. What does making art (or a craft) mean to you? Why do you create it, and how do you feel before, during, and after you create a work of art?

 d. You may be inspired to ask other questions by comments that the artist or craftsperson makes as they answer your initial questions.

3. Take notes, or use an audio recorder (with permission) to capture the interviewee's answers to your questions. Afterwards, transcribe the interview responses into text.

4. If possible (i.e., with permission), take a digital photograph of the artist or craftsperson and two or three photographs of his or her art or craftwork.

5. Prepare an essay (1000–2000 words) that describes the artist/craftsperson and his or her work, and sums up what this person told you during your interview (see Instructions #2). Also address the following questions:

 a. Were you surprised to find that there were local artists/craftspeople? Why or why not?

 b. Has your idea about local artists and craftspeople changed as a result of this lesson?

 c. How or in what way?

Materials Needed

computer and word processing program
note paper and pen, or audio recording device
camera

Vocabulary

Alebrije

WHAT TO SUBMIT FOR EVALUATION

· an essay (1000–2000 words) describing an artist/craftsperson and his or her work, as outlined in Instructions #2 and #5

· photographs, if these were permitted

LESSON EXTENSION

As an extension, create a drawing or painting of a craftsperson/craftspeople or artist/artists at work.

Right, Édouard Vuillard (1868–1940), *Les Courtières*, 1890. Oil on canvas, 18 11/16" × 22 10/16" (47.5 × 57.5 cm). Private Collection.

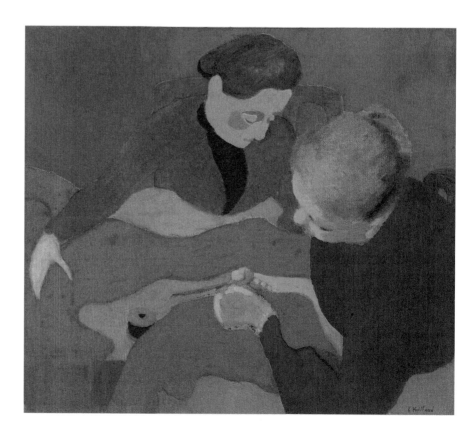

Facing, Providing a "Safety Net" for Syrian women immigrants living in Lebanon, 2013. (Photograph by Russell Watkins, UK Department for International Development. CC BY 2.0)

TIPS FOR TEACHERS

Throughout history, people of agrarian cultures often cultivated craft making as a practical skill. Knowing how to make things was necessary to the life of the farmer. The ability to create useful items from accessible resources within the local environment has also benefited people living in times or circumstances of economic stress. Adding ornamental or decorative elements to these items may attract buyers who admire the works for their beauty, in addition to or in spite of the item's utilitarian purpose. Thus, members of some societies have turned to art making as a way of sustaining life; for example, the Pueblo potters of the North American Southwest and Oaxacan wood carvers of Mexico have developed crafts of great beauty from local clay and wood. Their pottery and wooden crafted items are highly sought after by tourists and art collectors, thus providing an income to artists and other members of economically impoverished communities.

To help students understand the relationship of craft making and local resources to economic development, you could have them trace the histories of Pueblo pottery makers or Oaxacan carvers of **alebrijes**. Then invite students to consider how resources in particular geographic regions have attracted immigrants or artists with skills to take advantage of those resources. For example, consider how stone workers and carvers from Germany and Italy were attracted to southern Indiana to work in limestone quarries, how early filmmakers were attracted to southern California so as to take advantage of the wide variety of landscapes and year-round sun needed for shooting outdoor scenes, or how immigrants from the coastal regions of Syria were able to apply skills of weaving and knowledge of fishing to the work of fishnet mending in Lebanon. Ask students: What local resources could be paired with art or craft making skills to provide economic support for people of their community?

Lesson 108: Looking at Sculpture in Your Community

Sculpture is art that occupies real **space**; it is **three-dimensional**. A piece of sculpture will be seen from every angle and in different light throughout the day and year. It will be seen as a whole and in detail, far away and up close. Public sculpture is often made to honor local heroes, provide pleasurable aesthetic experiences for local citizens, celebrate the ideals or unique attributes of the community, or remind local citizens of civic responsibilities and social issues. In this lesson, you are asked to explore sculptures in your local community. Answering nine sets of questions about a selected sculpture will help you look at public sculpture from a critical perspective and notice its special features.

Alexander Phimister Proctor, *Dumbarton Bridge Buffalo*, 1914/1915. Washington, DC. The bridge as a whole is listed on the National Register of Historic Places. (Photograph by Ricardo Martins. CC BY 2.0)

INSTRUCTIONS

Look around your local community to see where public sculptures are displayed. The courthouse square, in municipal or state parks, in front of public libraries, or near civic centers or plazas are places where you could begin your search.

518

1. Find a piece of public sculpture that appeals to you, and write down answers to the following questions:
 a. Where is the piece located?
 b. What is it titled?
 c. Who created it?
 d. When was it created?

This information is usually provided on a plaque or stand located near or on the sculpture.

 If a plaque with information about the sculpture is mounted nearby, read this information carefully. Dates and titles suggest historic periods, and this may help put the sculptural piece in context, even when other factual information is missing.

2. Look carefully at the sculpture.
 a. What do you think this sculpture is about?
 b. How does the form of the sculptural piece support this meaning?

3. The processes a sculptor may use to create a sculptural piece include **additive method** processes, whereby the sculptor unites pieces together to create the sculpture, and **subtractive method** processes, whereby the sculptor removes something to made the sculpture. An assemblage or constructed sculpture is made using additive processes; a carving requires a subtractive technique.
 a. Determine which of these techniques was used to create the sculpture you have selected to study.
 b. Explain how you know this was the technique used.

4. A sculpture is not only surrounded by empty space, it occupies space. Nevertheless, a sculpture need not be totally solid. There can be open spaces or openings through the sculpture.
 a. Describe how open and closed spaces are used in the sculpture.
 b. The surfaces of a sculpture have textures that can be rough or smooth, hard or soft, deep or shallow, etc. Describe the texture(s) of this piece.

5. A sculpture can be one or several colors. Sometimes a sculpture piece is left in the original color of the medium used in its creation. Other times the surface may be painted, polished, or otherwise modified to include variations of color.
 a. Describe the color of the sculpture you have selected to study.

6. Consider the *subject* of the piece you have selected to study.
 a. What is the sculpture about?
 b. Is this subject matter presented in a **realistic** or **abstract** style?

7. Consider how the location of the sculpture may be related to its meaning and purpose.
 a. How does the place where the public sculpture is located help support or suggest the meaning of the sculpture? Consider, for example, why a sculpture of a soldier on the courthouse square

might be more appropriate in this location than on a children's playground.

8. What important issues and information should a sculptor have before beginning to create a sculptural piece for a specific public location?

9. Who do you think should be responsible for commissioning the making of a public sculpture, and who should be responsible for paying for it?

 a. Should only those paying for a sculpture have a say in the work and how it is used, or should all those whose environment is affected by a piece of public art have a say in the final work?

 b. If possible, find out
 · who commissioned the work you have selected,
 · to what extent the community was involved in its design and placement, and
 · who paid for the artwork to be made and installed.

10. As accurately as possible, draw the public sculptural piece you have selected. Include shading and details. The drawing should be on a 9" × 12" sheet of white drawing paper. Use a variety of soft and hard lead pencils and an eraser to help you create effective light and shade in the drawing.

Materials Needed

white drawing paper, 9" × 12"
drawing pencils in soft and hard leads
eraser

Vocabulary

Abstract/Abstractive	Space
Additive/Additive Method	Subtractive Method
Realism/Realistic	Three-Dimensional

WHAT TO SUBMIT FOR EVALUATION

· identification of a piece of sculpture in your community
· thoughtfully written responses to the questions in Instructions #1 through #9
· a drawing of the sculpture that includes shading in the drawing

Lesson 109: Women as Artists

Can you name five famous artists who are women? If you pick up an art history book that was written before the twenty-first century, you will find very few women artists mentioned. This gives the impression that nearly all the great artists of the past were men. This is a clear misconception. It is true that during certain periods of history men made types of art, such as heroic paintings, that women typically were excluded or hindered from making. Women who worked in these genres may have had their work attributed to male artists who were their relatives or associates. Other types of art typically produced by women, such as woven or embroidered tapestries, quilts, and botanical or miniature paintings, may have been dismissed as unworthy of even being considered as art.

Left, Anne Pratt, *Six Flowering Plants, including bladderseed (Physospermum), chervil (Anthriscus cereifolium) and cow-parsley (Anthriscus sylvestris),* 1855. Chromolithograph by W. Dickes & Co. Wellcome Library, London, UK.

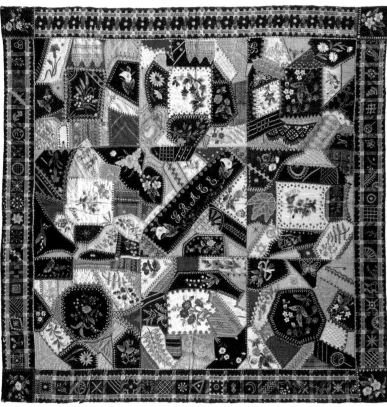

Today, women artists work in a wide variety of genres, techniques, and media that are recognized and respected by both men and women as legitimate art forms. Professional roles for women artists include that of architect, sculptor, ceramicist, painter, installation artist, textile artist, metal smith, photographer, and cinematographer. Nevertheless, many women who create artistic works still do not think of themselves as artists, and may not recognize themselves as artistic. For example, women who create crafts like woven baskets, scrapbooks, or sewing projects may not identify themselves or be acknowledged by art professionals as artists, although they might be considered and appreciated as crafters. In other cases, the creative efforts of women are considered neither art

Above, Tamar Horton Harris North (1833–1905), *Quilt (or decorative throw), Crazy Pattern,* 1877. Silk, silk velvet, cotton, and cotton lace, 54½" × 55". Made in North's Landing, IN. Gift of Mr. and Mrs. John S. Cooper, 1983, Metropolitan Museum of Art, New York, NY.

nor craft. Women who are excellent cooks and prepare attractively presented meals, decorate cakes and pastries, plant and nurture beautiful gardens, or create beautiful flower arrangements may not be recognized as artists. Yet all these accomplishments are dependent upon aesthetic sensibilities that lift ordinary experience into the realm of art.

INSTRUCTIONS

Part 1

1. Go to your local library or search online to find information about women artists of the past and present. Seek out artists with whom you are unfamiliar.
 a. Women artists born prior to the twentieth century include
 Rosa Bonheur (1822–1899)
 Mary Cassatt (1844–1926)
 Käthe Kollwitz (1867–1945)
 Dorothea Lange (1895–1965)
 Élisabeth Louise Vigée Le Brun (1755–1842)
 Edmonia Lewis (1844–1907)
 Beatrix Potter (1866–1943)
 b. Women artists who have been born since the beginning of the twentieth century include
 Deborah Butterfield (1949–)
 Janet Fish (1938–)
 Taraneh Hemami (1960–)
 Maya Lin (1959–)
 Faith Ringgold (1930–)
 Betye Saar (1926–)
 Miriam Shapiro (1923–2015)
 Melanie Yazzie (1966–)
2. Become familiar with five women artists.
 a. At least two must have been born prior to the twentieth century. Others are to have been born in the twentieth century.
 b. Give the name of each artist, her date of birth, and nationality.
 c. Indicate the genre, style of art or media used, and the subject matter of each artist's work.
3. Download or make small photocopies of a work of art by each of the five artists.
4. Choose one of the artists and write a paper (500–750 words) about her and her work that addresses the following questions:
 a. What formative influences motivated the artist, and what kind of work is associated with her? Focus on the things that may have prompted her to create this kind of art; for example, "She liked playing with her father's carpentry tools and this inspired her to create huge wooden carved sculptures." Avoid providing mere statistical information, such as what school she attended.

 b. What is the artist trying to say through her artwork? (e.g., does she focus upon biblical stories, animals in nature, reflective surfaces, social issues, or expressive emotions?)

 c. What attracted you to this artist as a subject for your paper?

5. Make two photocopies of two additional works by this artist. How do you think these artworks represent the overall work of this artist?

6. Include a reference list of at least three resources (online and in books) for this information.

Part II

7. Identify a woman in your family or community who creates some form of art or craft, and ask her to speak with you about her work. With her permission, take careful notes or an audio recording of the interview.

 a. What kinds of art does she make?

 b. What inspired her to begin creating this work?

 c. How did she learn the processes of making this work?

 d. With whom does she share her work?

 e. Does she consider herself to be an artist? Why or why not?

 f. Do other people recognize her as an artist? Why or why not?

 g. With her permission, take at least three photographs of her work.

8. Prepare a typed transcript of the interview and submit it along with the three images of her work.

Materials Needed

computer and word processing program
audio recording device
camera or digital camera

Vocabulary

Make Special/Making Special

WHAT TO SUBMIT FOR EVALUATION

· photocopied or downloaded images of artwork by five women artists from the list above, along with brief descriptions of who they are, when they lived, and what kind of art they made

· a written paper (500–750 words) about one of the artists you identified, answering the questions outlined in Instruction #4, along with

 · two additional photocopies or downloaded images of art by the selected artist, with explanations of how these accurately represent her overall work

 · a reference list of three resources from which information about the artist was gathered

· a transcript of a conversation with an artist from your family or community about her work

 · three photographs of her work (if permitted)

Recent theories suggest that art is always made in expressive response to a need to project ourselves into the world, make our environment special, or to "**make special**" in the world.[6] As an extension of this lesson, write about your own experiences as an artist, art maker, or artistic person. Consider the following: What activities have you engaged in (or engage in now) that could be described as *making something special* in the world? That is, what artistic activities have you engaged in privately or with others? For example, consider these activities: model making, building with Lego® bricks, creating scrapbooks or posters, coordinating clothing and accessories, arranging furniture or decorating rooms, displaying collectibles, creating fan art, making graffiti, tagging, tattooing, painting designs on cars, making jewelry, engaging in cosplay or in role-play performances. Expanding the definitions of art or craft to include activities of pleasurable self-expression and/or alteration of the environment to make it more beautiful or special opens us to recognize that human beings are by nature artists.

Lesson 110: Visiting a Museum

Art museums house artistic works and artifacts of many kinds, but the types of artwork immediately associated with art museums are paintings. We expect to see paintings when visiting art museums and may be surprised or disappointed when we do not. Of course, art museums are not the only places where paintings may be viewed. Art galleries typically feature paintings of contemporary artists or artists who are locally famous but perhaps not well known enough to have been accepted into museums. Works of art by local artists also may be exhibited in restaurants or at community festivals. After all, emerging artists must gain exposure somewhere, and this exposure may begin in the artist's hometown or local community before local acclaim invites the attention of an art **critic** or museum **curator**.

In this lesson, you are to play the role of an art curator and critic by visiting a nearby museum or art gallery with the specific purpose of seeking out paintings that you find extraordinary or intriguing. Then, you are to report on what you see. In the museum, you may see paintings that you are familiar with from books, television, or popular culture, and be astonished at how different they are from what you imagined through photographs. You may see works with which you are unfamiliar but recognize as remarkable, and want to bring to the attention of others.

Having experienced these works as a visitor to a museum or art gallery, you are to answer questions about the paintings that you found most interesting, appealing, or unusual. The questions of this lesson are intended to guide your attention to specific features of paintings that inform understanding of them. If you live in a rural area without access to a museum or gallery, you may not be

European Night of Museums in Vinnytsia Oblast Art Museum, 2012. Vinnytsia, Ukraine. (Photograph by Milena Chrona. CC BY-SA 4.0)

able to find paintings that fit all the criteria indicated by the questions below, but you should try to find as many as possible in places such as local fairs or festivals. Give explanations for why you could not locate others.

Read the following directions and try to find paintings that match the criteria in the directions. Keep your statements brief. For each painting you discuss, give the title, artist's name, and date the painting was created.

1. A painter can apply pigment (paint) in different ways. Paint that is very thin and looks watery creates a **wash**. Paint that is applied to create a thick texture is called **impasto**.
 a. Describe a painting that the artist created by using a wash technique.
 b. Describe a painting that was created by using an impasto technique.

2. A **medium** is any material used for creating art. For example, paint, beads, embroidery thread, and wood can all be **media**. Find a work of art that is made with a medium other than paint.
 a. Describe the artwork and how the medium is used.

3. Sometimes you can tell from the way a painting appears what tools the artist used to apply the paint to the painting surface.
 a. Describe the surface of a painting where the paint was applied by a small brush.
 b. Describe a painting that looks as if the paint was applied by a large brush or with some other tool.

4. You will notice that colors in some paintings are so bright they almost hurt your eyes. We call these colors **intense**. Colors in other paintings appear less intense and may even be dull or soft and pastel.
 a. Describe a painting that includes predominantly dull or pastel colors.
 b. Describe a painting with intense colors.
 c. Describe one in which both dull and intense colors are present, thus creating **contrast**.

5. Some artists use colors realistically while others do not concern themselves with depicting color this way.
 a. Describe how color is used realistically in a specific painting.
 b. Describe how colors that do not appear true to life are used in another painting.

6. Some artists use recognizable people, objects, and scenes in their paintings. Some of these paintings tell a story. These paintings are said to be **representational** or **realistic** artworks.
 a. Describe a painting in detail that has subject matter depicting an event or displaying a particular mood.

7. **Nonobjective** paintings are composed of Elements of Art such as color, line shape, and texture, but do not portray recognizable objects.

a. Describe a painting that does not contain any recognizable objects or story. How are the **Elements** and **Principles of Art** used to make this an interesting artwork?

8. Find one work that seems particularly interesting, and about which you would like to know more and think others might also enjoy knowing more about.

 a. Who is the artist? Is he or she still living? If not, when did he or she live?

 b. Describe the painting and explain what it seems to be about.

 c. Conduct a bit of research on the artist and painting. You may be able to find information about the artist and painting online, in books, from gallery brochures, or from the gallery owner. If you attend a gallery opening or festival where the artist is present, you could ask the artist directly to help you answer these questions:

 · What does the artist say the painting is about? Does that match what you assumed it to be about?

 · What motivated its creation?

 · Many contemporary artists will includes an **artist's statement** with their works. If there is an artist's statement, summarize it and indicate how you see (or do not see) the artist's intent being expressed by the painting.

 · What do you find most interesting about this painting? Describe this, and explain why you think the painting should (or should not be) included in a museum collection.

 · Make a sketch of the painting, to be included with this report.

9. Indicate the museum or gallery you visited in order to complete this assignment. If you visited neither, explain where you saw the paintings you describe and why they were observed here rather than in a museum or gallery.

Materials Needed

pencil and notepaper (*pens are not allowed in museums*)

Vocabulary

Artist's Statement	Impasto	Principles of Art
Contrast	Intense	Realism/Realistic
Critic	Medium/Media	Representational
Curator	Nonobjective/	Wash
Elements of Art	Nonobjective Art	

WHAT TO SUBMIT FOR EVALUATION

· written responses, as outlined in Instructions #1 through #9
 identification of the title, artist, and date for each painting you refer to
 in your responses

· a sketch of the painting you selected as most intriguing

TIPS FOR TEACHERS

Tips for Visiting Museums with Elementary Students

Museums can serve as wonderful enrichment resources and extensions of classroom teaching and learning. Yet just as you would never walk into the classroom without a lesson plan, never walk into a museum without a plan. Determine ahead of time which galleries or collections will be open during the time of your visit. Consider what exhibition would be the most interesting to your students and/or how the works in a particular collection would inform other disciplines your students are studying at this time.

Museum education curators are experienced at tailoring museum tours to the needs of specific thematic units or lessons. Discuss your ideas and goals with staff members before you schedule your field trip, and limit the students' visit to the specific section, exhibit, or group of exhibits recommended. Arrange to have an experienced docent take your students on the museum tour, but be prepared with plans for before and after visits as well as for how you would like the docent to conduct the tour.

To prepare pre- and post-visit activities, visit the museum's teacher resource center and/or website for planning tips and suggested activities. Many museums provide lesson plans or activity guides that include helpful teaching and learning materials. These are often available free of charge or for a minimal fee. Make use of these resources. Then follow these tips to ensure a successful visit.

Before the Visit

1. Go over museum rules with students before the visit (store coats or bags, no touching, running, roughhousing, etc.). If at all possible, invite a few parents to serve as chaperones to help watch over students' behavior and attend to their unexpected needs.
2. Find out in advance or upon arrival about practical things: location of restrooms, gift shops, or dining facilities, etc. Try to arrive early so students have an opportunity to visit the restrooms before the tour begins.

Children with the School Age Care center aboard Marine Corps Air Station Iwakuni, Japan, view models of different vehicles inside the Transportation Museum in Hiroshima, Dec. 23, 2014. SAC took the children to the Transportation Museum to learn about all the different types of transportation used throughout history. (Photograph by Pfc. Carlos Cruz Jr., via Wikimedia Commons)

At the Museum

1. Labels provide basic information about works being exhibited, but should not be relied upon exclusively for information. The title of an object, the artist, the year it was made, and what it is made of contribute to exploratory looking. However, encourage students to discuss the objects and exhibits they see rather than what the text says about a work.

2. Invite students to look for recognizable or familiar things. Being able to identify things in a painting can be informative and pleasurable. Ask, for example, how the people are dressed, what the people appear to be doing, or how are they interacting with one another. Ask students what colors and shapes they see, or what their eyes are drawn to first.

3. After the students have made a long list of what they have seen, guide them to consider how these things work together. Use open-ended questions and try to get to the how and the why of things. For example, at a science exhibit of dinosaur illustrations, you could ask, "How do you think they ate? How might they have found protection from other dinosaurs? Where did they sleep?"

4. Relate what is seen to what the student may already know. For example, a knight's suit of armor might serve the same purpose as a padded football uniform and helmet. Then move students to consider differences between what is known and what is speculated. How are the purposes of a knight's suit and a football uniform different?

5. Guide students to seek out visual clues that uncover meaning. Prompt them to consider what clues indicate the time of day, season, or social status of the subjects. What visual clues brought them to these conclusions? What other clues might help to surmise the meaning of a picture?

6. Invite children's active imaginations to come to life by prompting them to make up a story for a picture. Using visual clues to determine what is happening in the painting, ask, What do you think just happened and what makes you think that? What will happen next? Encourage students to place themselves in the painting and explore. What sounds, smells, or feelings would they experience? Imagining the painting as a three-dimensional world without an audience, what would they see looking out toward where the audience now stands?

7. Use art to help students notice features of art by inviting them to make drawings based on their observations.

After the Visit

1. Ask the students to share their viewing experiences by describing the object or artwork they most liked. Have them explain why this was a favorite.

2. If they could take one object or artwork from the museum to keep in their homes or in the classroom, what would it be and why?

3. What was an artwork they did not like and why?

4. Invite the students to draw or paint from memory a remarkable work of art that appealed to them. If you have a catalogue of the museum exhibits and can compare the students' work with a photograph of the actual artwork, invite them to compare their drawings from memory with the photograph. What was remembered and what was forgotten? Why might this be?

5. Encourage students to start a classroom collection of objects that build upon the theme and experience of their museum visit, or invite them to become curators and select personal items for an exhibition that addresses a new theme of their choosing.

Lesson 111: Native American Artists

For many, the idea of **Native American** art brings to mind stereotyped images of teepees, feathered headdresses, moccasins, and other beaded leather garments worn by members of various tribes during the nineteenth century. Yet Native Americans have made continuous contributions to world art traditions up to and including the present day. The works of contemporary Native American artists may reflect influences from their tribal traditions combined with influences of modern mainstream culture and the global art world. Research into the art created by Native American artists of the twentieth century helps us see how specific tribal backgrounds or regional geographies inform their work.

There is not and never was a singular style or visual characteristic universal to all Native American arts. Visual expressions by the artists listed below are unique to each artist. At the same time, elements of their work reflect long traditions and conditions of their tribal history. In this lesson, you are to research works by two of the artists listed below and attempt to tease out distinctions between influences derived from their traditional and mainstream affiliations.

INSTRUCTIONS

Do an online search of these artists and their works. Select and research two of those listed, with attention to his or her life and work. Download or photocopy an example of an artwork by each that you find particularly intriguing.

- Kenojuak (Ashevak) (1927–2013), Inuit
- F. Blackbear Bosin (1921–1980), Comanche/Kiowa
- T. C. Cannon (1946–1978), Kiowa/Caddo
- Helen Cordero (1915–1994), Cochiti Pueblo
- R. C. Gorman (1932–2005), Navaho
- Allan Houser (1914–1949), Chiricahua/Apache
- Michael Kabotie (1942–2009), Hopi
- Maria Antonia Montoya (1887–1980), Tewa
- Jaune Quick-to-See Smith (1940–), Salish/Cree/Shoshone
- Bill Reid (1920–1998), Haida
- Fritz Scholder (1937–2005), Luiseño
- Charlene Teters (1952–), Spokane Tribe of the Spokane Reservation

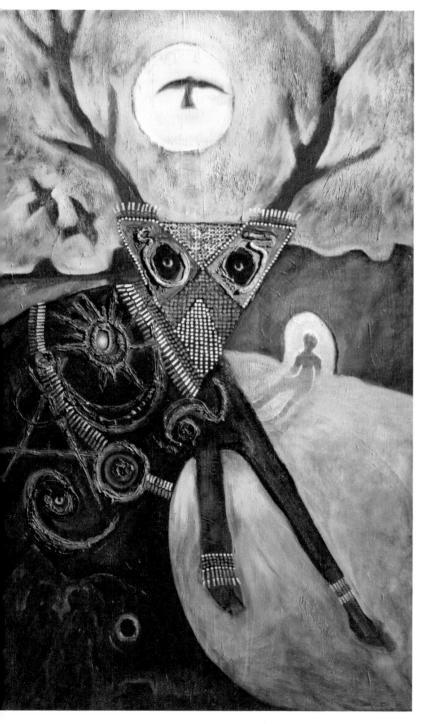

Steve Willis, *Clown Deer Medicine*, 2005. Oil on canvas, 36" × 60". (Courtesy of the Artist)

1. For each artist of the two artists selected, write a short essay (400–550 words) summarizing the cultural influences in the artist's life. Focus on the ideas that inspire his or her work. (*There are to be two essays: one for each artist.*)

 a. Does the artist create images based on myths of his or her tribal group?

 b. Does he or she refer to spiritual beliefs, or focus on ideas from everyday life?

 c. What aspect of the artist's work is reminiscent of a tribal heritage?

 d. What aspects are clearly influenced by or attributable to mainstream non-Native culture?

 e. In what ways, if any, are the works intended to create bridges between the need to sustain or maintain cultural identity and the social realities of life in the twentieth or twenty-first century?

 f. Do the artist's works serve as social comments about the injustices meted out on Native American peoples?

 g. Are the works created as commodities to be sold to tourists in order to support the economic well-being of an individual or group?

2. Write an additional essay (250–400 words):

 a. Describe a specific painting, sculpture, or other artwork done by *each* of the two artists whose lives and works you explored.

 b. Compare and contrasts the two works, and explain why you were drawn to these artworks.

3. Give personal interpretations of each of the artworks by creating a pencil sketch of each work on separate sheets of white drawing paper that measures 9" × 12". Color the sketch with colored pencils.

Steve Willis, *Ootah Red Figure at Barrier,* 2010. Oil on canvas, 18" × 24". (Courtesy of the Artist)

Materials Needed

computer with internet and word processing program	pencils with soft and hard leads
	eraser
white drawing paper, 9" × 12"	colored pencils

Vocabulary

Native American

WHAT TO SUBMIT FOR EVALUATION

· two essays (400–500 words *each*), each summarizing the cultural influences in the life of one of the two artists selected from the list presented in this lesson, and describing how these influences are integrated in the artist's imagery

· a third essay (250–400 words), comparing and contrasting a specific work by each of these two artists, explaining why you are drawn to these artworks and giving your personal interpretations of them

· colored sketches of each of the two artworks

Lesson 112: Visual Poetry in Myth

Throughout human history, rich narratives comprised of visual symbols and motifs have been easily read by members of the cultures that created them. Prior to the late nineteenth and twentieth centuries, among **First Peoples** of Canada and **Native American** peoples of the United States, myths, legends, and cultural lore were conveyed through song, dance, and image-embellished material artifacts. These imagic phenomena represented a type of visual poetry insofar as they combined abstract ideas and symbolic forms into an eloquently expressed literature or narrative of the experiences, imaginations, and beliefs of a people.

Native cultural practices and products are not only phenomena of the past. People of today make sense of traditional symbols and motifs differently than they did historically, for their experiences today are vastly different from those of their ancestors. Interpreting myths and symbols of the past through contemporary media mixed with references to mainstream cultural histories creates forms of visual poetry. These poetics are a result of juxtaposing ancient and modern cultural texts and images.

In this lesson, you will look at and study the aesthetic ideas and artworks of two Native American (First Peoples) artists, Bill Reid and Robert Davidson. Then you will compare and contrast referents of their traditional cultures with contemporary influences as elements of visual poetry.

BILL REID

William (Bill) Reid, Jr. (1920–1998) was born in British Columbia, Canada, to the Raven/Wolf Clan of the **Haida** people. At an early age he was inspired to learn about the material art of his culture from his grandfather, who had learned art making skills from Charles Edenshaw, a famous Haida **totem** artist and wood-carver of the nineteenth and early twentieth century. Reid was especially fascinated by the symbolic meanings of traditional Haida artifacts. Many meanings were being forgotten or lost due to Native assimilation into Euro-American culture. He began working in modern 3-D media (gold and bronze metals), and with traditional red and yellow cedar woods to transform the ancient myths and folk stories of his people into contemporary forms.

Among Bill Reid's beautiful creations is a wooden sculpture, *The Raven and First Man*, showing a raven standing on a huge cockleshell from which human beings are emerging like infants from a womb. The sculpture visually relates how Raven dug a cockleshell from the sea and released the First Men who had been living in the shell. In Haida mythology, Raven is recognized as an archetypal **trickster**, who gifted the earth and all mankind by freeing the sun from dark imprisonment and setting the stars and moon in place. Raven's mischievous obstructiveness forces us to rearrange and reorganize the world in ways that are ultimately beneficial; his behaviors reveal truths about our own imperfections of character. Reid tells us about the cultural role of Raven in a visually poetic way.

Although Bill Reid is credited as the artist author of *The Raven and First Man*, he did not carve it alone.[7] It is a **collaborative** creation, made with the assistance of other First Nation sculptors. The notion of artistic **collaboration** is consistent with cultural ideals of the Haida people.

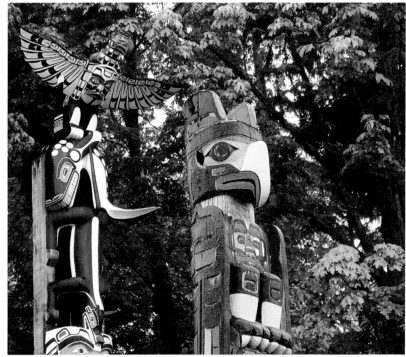

ROBERT DAVIDSON (1946–)

While the Raven is considered a Trickster who delivers messages to humans from the Great Spirit, the Eagle is recognized as having the ability to carry human messages to the Great Spirit creator. As the bird soars high into the sky, a connection is made between the physical and spiritual realms. Reid's works

tells the Haida myth of trickster Raven who is a messenger from the Creator (heaven); Davidson's work incorporates the image of the Eagle, a cultural reference to the conveyance of messages (prayers) up to heaven.

Gyaana is a totem pole designed by Haida artist Robert Charles Davidson and carved with the help of others, with Eagle as a significant feature of the work. Totem poles are structural forms that may serve functional as well as communicative purposes. They were used as columns supporting the walls and roofs of buildings, as welcome signs for visitors to a village, or as memory devices. Carvings on the poles may narrate myths, legends, or histories, or they may symbolically indicate ancestral lineages. Accurately interpreting the purposes and meanings of a totem pole requires familiarity with the culture from which they derive.

INSTRUCTIONS

After having read about the work of Reid and Davidson in this lesson, continue your exploration of the lives and artworks of these artists and the cultural influences that inspired them.

1. Search for two more examples of work, one from each of the two artists, in books or online. Make photocopies or download the images and keep them beside you for reference.
2. Write an essay (750–1000 words) in response to the following questions:
 a. How and to what extent do works by Reid and Davidson convey stories in ways that might be understood by people outside the Haida culture?
 b. What do the works and the processes of their creation tell us about the cultural lives of artists in the context of their Native communities?
 c. How do these works demonstrate integration with contemporary mainstream society?
 d. How might the collaborative processes of carving Reid's sculpture and Davidson's totem pole evidence a kind of cultural poetry? Give an explicit example.
 e. How do myths of a cultural group give insight into the fundamental beliefs of a people?
 f. How could the myths presented in works by Reid and Davidson instruct people in today's mainstream society? Give an explicit example.
3. Consider a common myth from your cultural experiences as a work of visual poetry.
 a. Using colored pencils on a sheet of 9" × 12" drawing paper, create a sketch of the myth in a visually compelling way.
 b. Give a brief synopsis of the myth and the culture from which it derives.

c. What symbols did you use that would be immediately recognized and understood by others of your cultural community?

d. Explain how your drawn image presents the myth in a visually poetic way.

Materials Needed

drawing paper, 9" × 12"
colored pencils
eraser

Vocabulary

Collaborative/Collaboration	Native American
First Peoples	Totem
Haida	Trickster

WHAT TO SUBMIT FOR EVALUATION

· two photocopied or downloaded images of works, one each by Bill Reid and Robert Davidson.

· a thoughtfully written essay (750–1000 words), in response to Instruction #2

· a sketched illustration of a myth from your cultural background, with information about the visual poem, as requested in Instruction #3

TIPS FOR TEACHERS

Resources for Students and Teachers

· Budd, R., and R. H. Vickers. *Raven Steals the Light: A Northwest Coast Legend*. Medeira Park, BC: Harbour Publishing, 2013.

· Davidson, R., and I. M. Thom. *Robert Davidson: Eagle of the Dawn*. Seattle: University of Washington Press, 1993.

· Levine, M. *The Ojibwe*. Minneapolis: Lerner Classroom, 2007.

· Lourie, P. *The Lost World of the Anasazi: Exploring the Mysteries of Chaco Canyon*. Honesdale, PA: Boyds Mills Press, 2007.

· McDermott, G. *Raven: A Trickster Tale from the Pacific Northwest*. Logan, IA: Perfection Learning, 2001.

· McNair, P., D. Augaitis, and M. Jones. *Raven Travelling: Two Centuries of Haida Art*. Seattle: University of Washington Press, 2008.

· McNair, P., and J. Stewart, eds. *Listening to Our Ancestors: The Art of Native Life along the Pacific Northwest Coast*. Washington, DC: National Geographic, 2005.

· Peacock, T., and M. Wisuri. *The Good Path: Ojibwe Learning and Activity Book for Kids*. Minneapolis: Minnesota Historical Society Press, 2009.

· Tippett, M. *Bill Reid: The Making of an Indian*. Toronto: Vintage Canada, 2011.

· Wyatt, G. *Mythic Beings: Spirit Art of the Northwest Coast*. Seattle: University of Washington Press, 1999.

Lesson 113: Wind Horses—Tibetan Prayer Flags

If you were to take a stroll along a footpath in the Himalayan Mountains, you might see a row of brightly colored cloth panels, strung on a rope stretched between high rocks or ridges and fluttering in the wind. These would be **Lung-Ta** or Wind Horses, sets of rectangular flags connected to one another horizontally and arranged in order from left to right: blue, white, red, green, and yellow. The colors are symbolic of the five elements: sky or space (blue), wind and air (white), fire (red), water (green), and earth (yellow). In Tibetan Buddhist culture, they represent a harmonious balancing of nature, with resulting health, prosperity, and peace.

Because there is no exact translation for the concept of Wind Horses in Western languages, these brightly colored panels have come to be called **prayer flags**. However, the flags do not carry prayers for individual concerns. Rather they are hung as blessings or compassionate wishes of goodwill sent out, like seeds in the wind, to all peoples of the world. In return, these blessings are believed to fall back upon the person who hangs the flag.

Typically, Wind Horses feature a block-printed image of a flying horse bearing three wish-fulfilling jewels. Around the horse, printed texts invoke

Prayer Flags at Potala Palace, 2006. Lhasa, Tibet. (Photograph by Dennis Jarvis. CC BY 2.0)

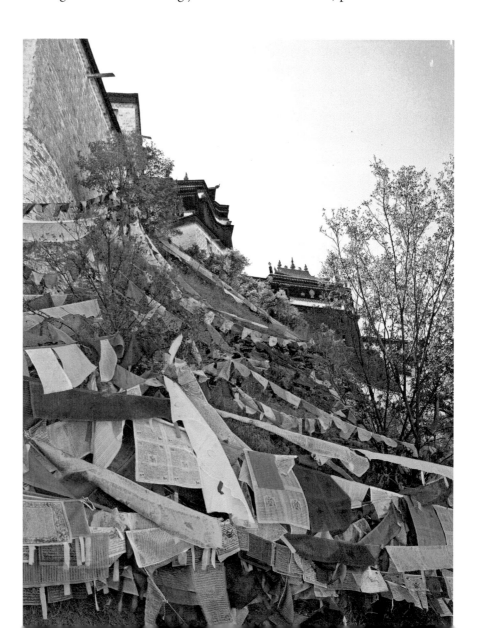

messages of happiness, prosperity, wisdom, or peace. As flags flutter in the breeze, the Wind Horse symbolically carries these messages around the world and into space. In corners of the flag appear visual representations of four animals that symbolize elemental energies or the cardinal directions, and assist in transporting universal goodwill. These are a powerful yet benefic thunder dragon, a **Garuda** or anthropomorphic bird of wisdom, a white tiger as symbol of confidence, and a celestial snow lion that represents joy and fearlessness.

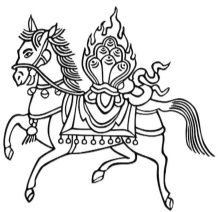

Left, Lung-Ta or Windhorse. Drawing based on an element from an old Bhutanese xylograph for printing prayer flags. (©Christopher Flynn / Wikipedia Commons. CC BY-SA 4.0)

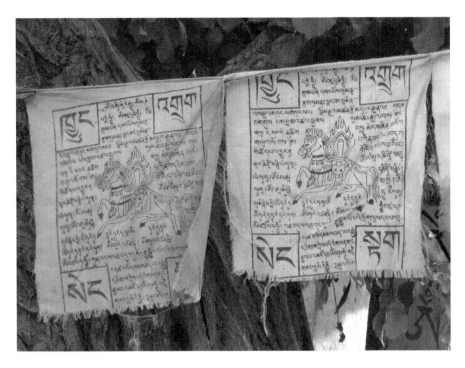

Above, Close-up of Lung-Ta style prayer flags, Ladakh, Kashmir, India. (Photograph by Redtigerxyz. CC BY-SA 3.0 US)

In this lesson, you are to think about how the conceptual ideas of a Lung-Ta might be translated into an original work of art. The projects asks that you combine the recognizable form of a flag, familiar symbols of Western traditions, and personal sensibilities regarding care and compassion for others and/or earth stewardship with the less familiar Tibetan tradition.

INSTRUCTIONS

1. Your work should begin with considerations of what you want to say through the production of a prayer flag. Brainstorm the message, design, processes, and materials of your design and write notes in response.
 a. What concerns are near and dear to your heart?
 · Do you hope for more attention to preserving a healthy earth environment, more consideration of others, a softening of intolerance among diverse groups of peoples, or a cure for diseases that plague humankind?
 b. What symbols could metaphorically suggest the outcome for which you hope?

c. What color of fabric would be appropriate for a background of your work, and why would this be most appropriate?

d. What words, aphorisms, poetry, words of wisdom, or verse from a sacred or favorite text reinforce the solution you seek?

e. What application process would be appropriate to create your flag?

 · Options include printmaking techniques like block printing or monoprinting, **photographic transfer**, patchwork, appliqué, embroidery, or combinations of these techniques.

 · Search for "Prayer Flag Project" online to find images and tutorials that offer ideas and processes for creating a basic prayer flag. Cite any sources used.

f. What other materials might be useful in creating your work?

g. Will you leave the final product unfinished and in a way that will permit it to deteriorate naturally, or will you finish the work in a way that will permit it to be displayed as a reminder that draws attention to a cause over time?

2. On sheets of 9" × 12" drawing paper, make four to six sketches of ideas for a flag based on your responses to the questions in Instruction #1.

3. Share your ideas, notes, and sketches with peers and your instructor, and listen to feedback.

4. Based on feedback and your own aesthetic sensibilities, select the best of your sketched ideas and redraw the sketch on a sheet of 9" × 12" or 12" × 18" drawing paper. Add notes about colors, symbols, text, and medium that will be used to complete the work. Lay this drawing aside to use as a guide as you proceed.

5. Select a piece of cotton fabric in a color or your choice, cut to either 12" × 12" or 12" × 18". This will be the background of your work.

6. If your flag will be constructed in a printmaking medium, search online for a process you would like to try, or follow instructions given in other sections of this text for printmaking processes.

a. To create a block print, you will need a printing block such as an E-Z Cut, Soft-Kut, or Speedball Speedy-Cut Easy block, in a size of your choice. Follow instructions given for block printing in Lesson 126 or Lesson 128.

b. To create a monoprint, follow the instructions given in Lesson 125.

c. Lesson 102 gives instructions for creating a photographic transfer onto a heavy sheet of watercolor paper. A similar process could be done on unbleached muslin.

7. If you plan to use a stitchery technique in creating your work, explore instructions given in Lesson 131 for appliqué, Lesson 133 for stitchery, or Lesson 134 for patchwork.

8. Combinations of two or more techniques may be applied.

9. If desirable, sew beads, buttons, tassels, twigs, or other decorative pieces to your work.

10. If your flag is to be hung indoors, turn the raw edges under ¼" all around and crease or **baste** in place. Then turn the edge over once more by ½" on all sides except the top. Hand **slipstitch** this **hem**.

11. Prepare the flag for hanging by turning the top edge down again ¾" and use straight pins to hold in place while sewing with a slipstitch hem. Leave an opening at each end so a string can be run through to hang the work.

12. If you intend to hang the flag outdoors in the wind, where it might deteriorate or dissolve over time, there is no need to finish the raw edges. However, you will need to turn the top edge down ¾" and stitch it down, leaving openings at each end for a string to be run through as a hanger.

13. For outdoor hanging, find two trees or porch posts where the wind blows freely and hang the prayer flag between them with string.

14. Prepare a written explanation (300–400 words) of your flag, as follows:
 a. What message is represented in your prayer flag?
 b. What symbols and colors did you choose to use? How do these convey your message?
 c. What processes did you use in preparing the flag?
 d. Describe any difficulties you encountered in creating the flag and tell how you resolved them.

Materials Needed

drawing paper, 9" × 12" or 12" × 18"

drawing pencils with soft and hard leads

eraser

cotton cloth in a color of your choice, cut to 12" × 12" or 12" × 18"

materials for medium of your choice

needle

thread

string of a size appropriate for hanging

Vocabulary

Baste

Garuda

Hem

Lung-Ta

Photographic Transfer/Photo Transfer

Prayer Flag

Slipstitch

WHAT TO SUBMIT FOR EVALUATION

· notes and sketches addressing questions in Instruction #1
· citations of any sources of inspiration, instruction, and tutorials that were references or resources informing your work
· a completed prayer flag
· a written response, as outlined in Instruction #14

Lesson 114: A Papier-Mâché Alebrije

Papier-mâché is a French term for a medium of paste and paper. **Alebrijes** is the name given by the Mexican artist Pedro Linares (1906–1992) to the elaborately decorated imaginary animals and creatures he crafted of papier-mâché. Combining a French medium and Mexican tradition, Linares began his artistic career by making piñatas, carnival masks, and figures for local fiestas in and around his home in Mexico City, Mexico. Then at the age of 30, Linares became very ill and in a feverish dream, he imagined the brightly colored, fanciful creatures that would inspire his art making for the remainder of his life. Eventually, Linares's alebrijes were discovered by the owner of an art gallery in Cuernavaca, Mexico, who made Linares's work known to the world. Today Linares's sons and grandsons carry on the tradition of creating papier-mâché alebrijes and have become famous artists in their own right. In this lesson, you will examine images of alebrijes by the Linares family and practice the process of papier-mâché in creating an imaginary figure in the style and tradition of Linares alebrijes.

Below, Mario Castellanos Gonzalez (1973–), *Armadillo Alebrije*. La Zoología en el Arte Mexicano exhibit, Museo de Arte Popular, Mexico City, Mexico. (Photograph by Alejandro Linares Garcia. 2015. CC BY-SA 4.0)

Bottom, Alebrijes made of cardboard and paper-mâché for sale at the Anahuacalli Museum in Coyoacan, Mexico City, Mexico. (Photograph by Alejandro Linares Garcia, 2010. CC BY-SA 4.0)

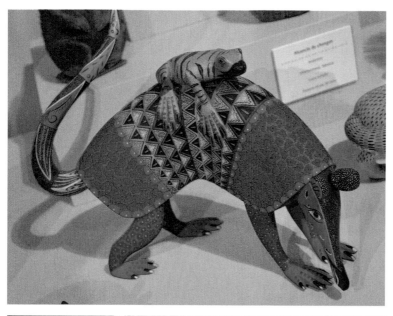

INSTRUCTIONS

1. Search online or in books to find example of works by Pedro Linares, his sons, or his grandsons. Examine the kinds of whimsical creature they have created and notice the colors and patterns used to decorate these works of art.
2. Download two examples (in color) of alebrijes that you find particularly interesting in terms of the animal form and/or the colors and patterns used in their decoration. Keep these beside you for reference and inspiration as you work.
3. Make two sketches on 9" × 12" sheets of white drawing paper of original alebrijes that you might create and that are inspired by the images you selected.
4. Share these sketches with your peers and instructor for feedback.
5. Make adjustments to the sketches based on feedback and set the sketches aside in a clean dry space, so that you can refer to them as you work.

6. Set up a space to work on your papier-mâché project by placing a plastic tablecloth or several layers of newspaper on the surface of the work area. Mix a small amount of wheat paste, rice paste, or art paste in a plastic mixing bowl (follow instructions on the box).

7. Tear many pieces of newsprint and/or folded paper towels from commercial paper towel dispensers into long 1"–2" strips. Set these and the paste aside.

8. Create an **armature** for your creature by twisting and/or wadding up pieces of newspaper and taping them with strips of masking tape. Continue adding wads of paper and tape until the armature is sturdy and resembles the form of the animal you wish to make.

9. You may add wires and/or cardboard for wings or appendages. Make sure the armature is stable and able to stand before you begin adding the papier-mâché strips.

Illuminated metal, plastic, and cloth alebrije in progress at the Escuela de Artesanías in Colonia Transito, Mexico City, Mexico. (Photograph by Alejandro Linares Garcia, 2015. CC BY-SA 4.0)

10. Dip strips of newspaper or paper towel in the paste, run each strip between two fingers to wipe off the excess paste, and lay one strip at a time over the armature. Smooth it down to remove air bubbles. Cover the armature with two to three layers. Allow these layers to dry for about 48 hours, then add another two or three layers. Repeat this again if desired,

allowing all previous layers to dry before adding new ones. Don't put too many layers on at once or the armature will get soggy and sag.

11. Set the papier-mâché armature in a dry undisturbed place for two or three days until all layers are completely dry, before finishing with paint.

12. Refer to your drawings and the images of alebrijes by Linares and/or his sons to get ideas for the painting of your whimsical animal. (Hint: complementary colors placed side by side create dazzling effects.)

13. Paint the armature with acrylic paints. Use large brushes to apply the base color and small brushes to add decorative patterns and textures.

14. Prepare a brief (300–400 word) essay explaining the following:

 a. Which images of Linares alebrijes interested you, and why did they appeal to you?

 b. What new form did you create, and why did you choose this for your personal alebrije?

 c. Explain how you arrived at your color and pattern scheme.

 d. What difficulties did you encountered when making this artwork, and how did you resolve the problems?

Materials Needed

wheat paste, rice paste, or
 art paste powder and water
plastic bucket to hold paste
strips of newspaper
strips of paper towels
masking tape

small sections of wire to
 strengthen or stabilize
 armature
newspaper for armature
plastic tablecloth or newspapers to
 protect your workspace

Vocabulary

Alebrije
Armature
Papier-Mâché

WHAT TO SUBMIT FOR EVALUATION

· two downloaded or photocopied images of alebrijes that you find interesting in terms of the animal form and/or the colors and patterns used in their decoration
· two sketches of an original alebrije with notes of adjustments suggested through feedback
· an original alebrije created with papier-mâché
· a written essay response, as outlined in Instruction #14

LESSON EXTENSION

Although you will be making a small portable alebrije during this lesson, those designed for festivals are often made in very large sizes that require sturdy steel armatures. Artists may engineer these larger alebrijes to feature special lighting effects or to move with the aid of digitally controlled mechanical devices. Here you can see how an artist encased the metal feet of a figure with plastic

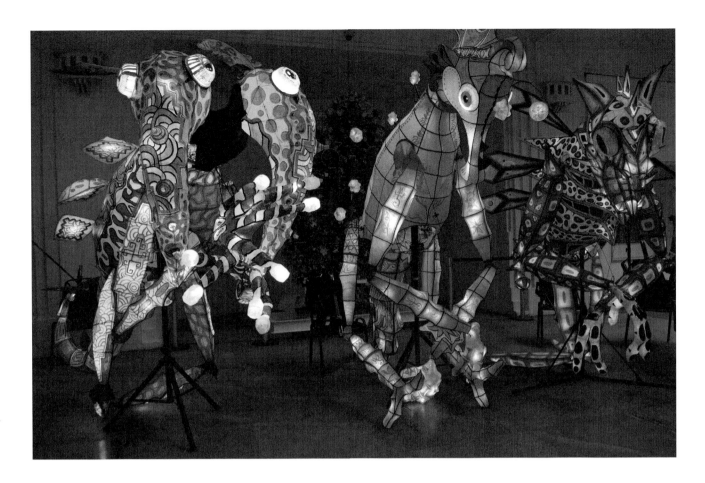

soda bottles; small LED lights controlled by switches were then inserted into the plastic bottles before the figure was covered with papier-mâché and spray paint.

Above, Iluminated alebrijes at a press conference for the 2015 Monumental Alebrije Parade, Museo de Arte Popular, Mexico City, Mexico. (Photograph by Alejandro Linares Garcia, 2015. CC BY-SA 4.0)

Left, Foot of an illuminated alebrije being made of clear plastic drink bottles at the Escuela de Artesanías, Mexico City, Mexico. (Photograph by Alejandro Linares Garcia, 2015. CC BY-SA 4.0)

As a lesson extension, plan a small alebrije that could be equipped with special effects, such as movement or LED lights.

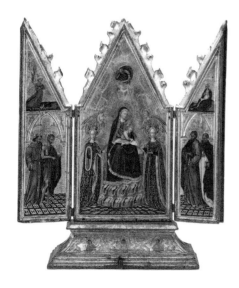

Lesson 115: A Retablo

Retablos, or small boxes containing precious objects or figures composing a scene, are a folk art form from the Andes mountain region of South America, with historic roots that stretch back to medieval Europe. During the era of the crusades, Spanish knights would carry little boxes with religious images or relics as portable altars for prayer and worship. The concept was carried by the Conquistadors to the Americas, where indigenous peoples of the Andes added scenes celebrating Native beliefs or protesting colonialist oppression in the guise of themes of everyday life.

Retablo boxes carried by crusading knights during the Middle Ages likely were made of wood or metals, with some elaborate renditions including applications of gold leaf or adornments of precious gems. Indigenous peoples of South and Central America used readily available media such as clay, light wood covered with a **gesso** of gypsum or a paste made of boiling potato and gypsum powder, sometimes mixed with clay.

The aesthetic form of the retablo spread to Mexico and the Southwestern United States, where, for example, small boxes containing elaborately decorated skulls and flowers made of spun sugar may be seen as celebratory decorations for El Dia de Los Muertos (Day of the Dead), and painted tin, paper, and various other media may be used to create retablo images of Our Lady of Guadalupe for personal meditation or sale to tourists. Shadowboxes, which resemble the form of retablo boxes, can be used by artists as aesthetic forms containing mementos or pleasant little **vignettes** in paper, wood, or china. In this lesson, you will make a retablo box of a salt and flour dough that also can be used to make some of the figures you decide to add to the box.

INSTRUCTIONS

Part I

1. Begin this lesson by examining the retablo art of Andean artist Nicario Jiménez Quispe (1957–) and comparing his work to the work of another artist who creates retablo art, such as Catherine Robles Shaw, Alejandro Chavez of Peru, or Claudio Jimenez. Find two images by Nicario Jiménez Quispe and one image by another artist of your choice whose retablo work you find appealing. Examine and compare the works of

Top, Fritz Boehmer (active 1935), Ornamental Shadow Box, ca. 1939. Watercolor, gouache, and graphite on paper, 11" × 9 1/16" (28 × 23 cm). Index of American Design, National Gallery of Art, Washington, DC.

Middle, Anonymous, Retablo, 1935/1942. Watercolor, gouache, colored pencil, and graphite on paperboard, 14 5/8" × 11 7/16" (37.1 × 29 cm). Index of American Design, National Gallery of Art, Washington, DC.

Bottom, Master of the Richardson Triptych, *The Virgin and Child Enthroned with Angels and Saints, the Redeemer, and the Annunciation,* ca. 1370–1415. Tempera on panel, 30 1/2" × 22 9/16" (77.5 × 57.4 cm), open. Siena, Italy. (via Wikimedia Commons)

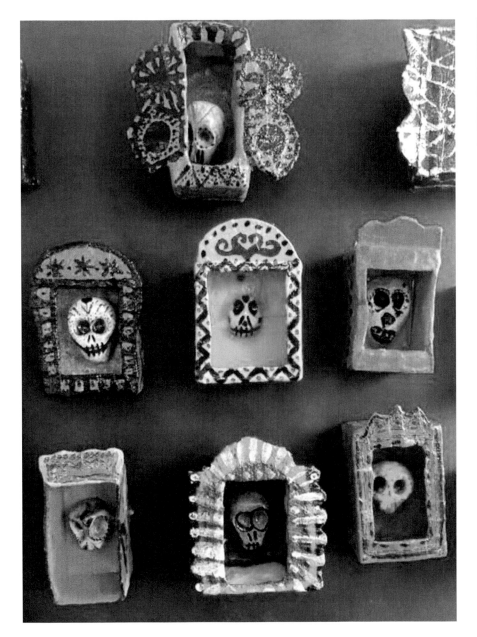

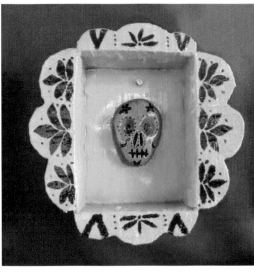

Above, Day of the Dead Retablo, by a student of Sarah Freeman. (Courtesy of Sarah Freeman)

Left, Display of *Day of the Dead Retablos*, by students of Sarah Freeman. (Courtesy of Sarah Freeman)

these artists, and then respond in an essay (750–1000 words) to the following questions:

a. What are the cultural backgrounds of the artists? Are these backgrounds evident in the aesthetic characteristics of these differing works?

b. What subjects are presented in the works of these two artists?

c. For what purpose(s) are their artworks used?

d. What media do they use to create their works?

e. How are the works similar and different? What accounts for these similarities and differences?

- You may find examples of artifacts interchangeably called retablos or **láminas**. Describe the difference between a retablo and lámina.

 f. How do the subjects of these works relate to you, your experiences, or beliefs?

2. Download two retablo images by each of the two artists, and lay the images aside to inspire and inform your work.

3. When planning your retablo, consider the following:

 a. What idea or story would you like to portray in a retablo you create?

 b. Will the story relate to you or serve as a reminder of something that is important to you?

 c. Will others be able to read or interpret the story, or will it be personal only to you?

 d. What pieces will you need to tell the story or make the scene?

4. On sheets of 9" × 12" drawing paper, sketch at least six thumbnail sketch examples of a retablo scene you would like to create. Consider the size of box needed in order to include all the necessary parts of the scene.

5. Show your sketches to your peers and instructor for feedback about your ideas. During feedback, consider the following:

 a. What size would the retablo need to be in order to fit all the parts of your scene in place? What would be the proportional relationship between the box and character(s)?

 b. What story would the scenes tell?

 c. Have you included all the pieces or characters that are needed to tell your story?

 d. What could be eliminated while still allowing the scene to fully convey the story you wish to tell?

6. Select the most effective and visually interesting of your sketches and redraw it to a larger size on a sheet of 9" × 12" drawing paper. Adjust the drawing with more details and notes about color uses.

Part II

7. As medium for the retablo box, you will be using a salt and flour dough. The recipe for the dough is as follows:

 2 cups all-purpose flour
 1 cup fine salt
 1 tablespoon wallpaper (wheat, rice, or art) paste
 ½–¾ cup water
 food coloring (*optional*)

8. Place 2 cups of flour and 1 cup of fine-grained table salt and 1 tablespoon of wallpaper paste in a large mixing bowl with ½ cup of water. Mix these together with a spatula and then with your hands to form the dough into a ball. If the dough feels dry or hard, slowly add up to another ¼ cup of water, kneading the dough as the water is added, until the dough is pliable but not sticky. If it becomes sticky, add a bit more flour and salt.

9. Once the dough is firm but pliable, divide the dough in half. Place one half in a resealable plastic bag and seal the bag to keep the dough moist while you work with the other half of the dough. Begin forming your pieces as suggested in the following instructions. Any unused or leftover salt dough placed in a plastic resealable bag will keep for several weeks in a refrigerator, but you may need to add a little water if it becomes dry during storage.

Part III

10. To make the retablo box you will need a small cardboard or plastic box as a mold. Small boxes from 4" × 6" to 5" × 8" in size, such as those used to hold costume jewelry, cell phones, or other small electronic devices are ideal. Very small plastic food storage boxes could also serve this purpose. Cover the *entire* outside of the box with a thin coating of petroleum jelly and lay it aside while you work the dough into shape.

11. Using half the dough mixture, roll it around in your hands until you have formed it into a ball. Holding the ball of dough with your non-dominant hand, press the center of the ball with the thumb of your dominant hand to make an indentation in the ball. Slowly widen the indentation by pushing down with your thumb and pinching the sides of the ball with your flattened fingers to form a walled pinch pot. Continue working the ball of dough in this way, keeping the walls an *even thickness* of about ½" to ¼" all around and at the bottom, until the opening is slightly wider than the width of your box mold.

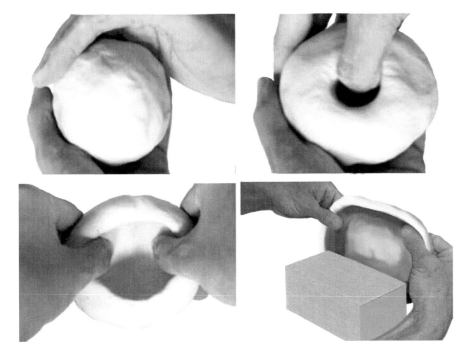

Fitting salt dough over a box as a mold for the retablo. (Courtesy of the Artist)

12. Gently, using your thumb and fingers as you did when creating the pinch pot shape, begin to modify the shape of the dough to a shape

similar to that of the box, checking as you work to see if the dough will fit over the box mold. As soon as it large enough and of a shape suitable to fit over the mold, gently drop the dough onto the mold and work it into place until the mold is covered by dough to an even thickness of about ¼" to ½" all over. Excess dough that splays out on the table beyond the box may be trimmed, worked into, or cut to a frame-like shape. Lay the box aside to air-dry for one or two days. When it is nearly dry, gently slip the salt dough form off the box mold, place it right side up on a baking sheet, and place in a warm oven at 200°F (93°C) for about half an hour to make sure it is hard and strong.

13. After you have completed making the retablo box and have set it aside to dry, use the remaining ball of dough to create pieces that will be displayed within the box. Keep in mind the proportion of these small pieces to the box. For very small pieces, you may need to use tools such as toothpicks, the tip of a chopstick, a small knife, or tweezers to sculpt forms. It's a good idea to create more pieces than you think you will need, and create them in two or three slightly different sizes to be sure of having what you need to construct the retablo.

14. When finished, you may want to bake these pieces for a quarter to half an hour until hardened all the way through, or if you prefer, you can place all the pieces aside to air-dry for one or two days, and then bake them together with the retablo box.

15. When all pieces are dry and hard, paint the finished pieces with acrylic paints, using appropriately sized brushes for the objects being painted. Allow the paint to dry thoroughly before assembling the pieces and attaching them with craft glue or a small glue gun. Ornaments such small mementos, beads, or sequins also can be added at this time.

16. Write a very brief essay (250–400 words) to be added to the longer essay outlined in Instruction #1:
 a. What mementos were selected for inclusion in your work, and why were they chosen?
 b. What is the overall meaning of your retablo for you?
 c. Describe any difficulties you had in creating the retablo and how you resolved these difficulties.

Materials Needed

small bag (2 cups or more) of flour	petroleum jelly
box of salt	plastic resealable bags
wheat paste, rice paste, or art paste powder	small plastic or cardboard box as mold form
food coloring	assorted mementos or decorative pieces
water	
wooden spatula or spoon	glue gun with glue sticks or craft glue
measuring cups and spoons	
mixing bowl	acrylic paints

paint brushes in several sizes
mixing tray and water containers

plastic tablecloth or newspaper for
protecting work surface

Vocabulary

Gesso

Lámina

Retablo

Vignette

WHAT TO SUBMIT FOR EVALUATION

· six sketches of ideas for retablos
· notes from feedback received from sharing your sketches
· a final sketch idea for a retablo
· a completed retablo project
· an essay response, as outlined in Instructions #1 and #16

LESSON EXTENSION

The concept of the retablo can be carried over into a twenty-first-century context by thinking about how technology has transformed our world in positive and negative ways. While the traditions of retablos are rooted in their use as mementos of cultural or devotional histories, the retablo form has also been used to communicate messages of satire and protest against social injustice. As a secular object, the form has been appropriated for use as a decorative object or to express interest in popular culture. If this contemporary interpretation of the traditional retablo interests you, a lesson extension could be to create a small portable box containing an object, scene, or figure that expresses an idea that is meaningful to you and communicates to viewers. An example is presented here of the work of Laurie Gatlin, who has used recycled materials as satirical commentary of contemporary society.

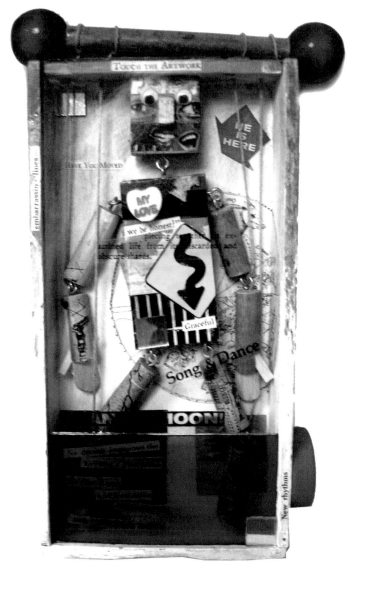

Laurie Gatlin, Retablo of art assemblage, 2015. Found object materials, 8" × 4" × 1¾". (Courtesy of the Artist)

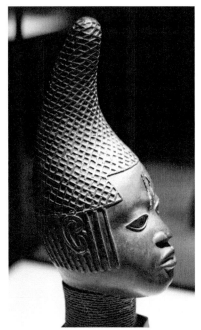

Lesson 116: Out of Africa

The various regions of the African continent feature different artistic practices and styles. There is no one style or form that can be called "African art." The arts of Egypt, Libya, and Morocco, for example, exhibit Islamic influences along with the earlier influences of tribal ideals and ancient contacts with Greece, Rome, and the high culture of Egypt. The art of East Africa is historically and culturally different from the art traditions of West Africa, and there are thousands of tribal or **cultural groups** throughout the continent whose **artistic traditions** differ from one another. In recent years, the work of many African artists has been strongly influenced by European, American, and world traditions. For this lesson, you will identify and visit a museum where many art pieces and artifacts from ancient and contemporary African cultures are housed. Museums that feature major collections of African arts are listed on the Smithsonian Libraries website, at http://library.si.edu/libraries/african-art/african-art-collections.

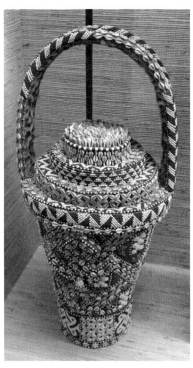

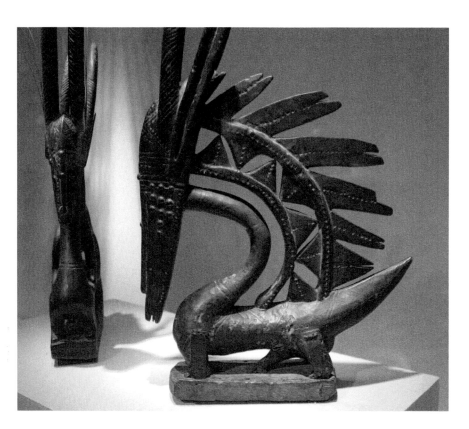

Top, Head of a Queen Mother Joyba, Nigeria, Kingdom of Benin, early 16th century. Gun bronze, 20" (50.8 cm) height. Theodor Francke Collection, acquired in 1901, Africa Department, Ethnological Museum, Berlin, Germany. (Photograph by Bin im Garten, 2011. CC BY-SA 3.0 US)

Above, Basket with Beads and Cowrie Shells. Exhibit in the Royal Museum for Central Africa, Tervuren, Belgium. (Photograph by Daderot, via Wikimedia Commons)

INSTRUCTIONS

1. Visit an art or cultural museum and ask directions to exhibits of artifacts created by various African peoples.
2. As you look at examples of African art, you may find the art from a particular region more appealing than art from other parts. Also, you may prefer looking at the art of carved wood figures rather than masks, or baskets and textiles rather than carved drums.

3. After examining the art objects presented from a variety of different regions and tribes of Africa, decide upon an art form you find intriguing.

4. Make a 9" × 12" freehand drawing of this artwork on white drawing paper. Record the cultural group from which the artifact originated. Be able to locate where in Africa members of this cultural group live. Explain what the object was used for. Labels near the exhibited artifact usually provide this information.

5. Do a search on the internet or in library books to find out more about the tribe or region from which the artifact came.

6. Write a brief essay (400–500 words) on the following points:
 a. Identify the artist who created this work or the cultural group of its origin.
 b. Describe the beliefs inherent in or reflected by this object or artwork.
 c. Describe the group from which the object came, and explain how the environment, lifestyle, and beliefs of that particular group are reflected in this specific object.

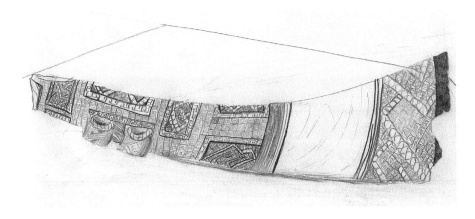

Materials Needed

white drawing paper, 9" × 12"
drawing pencils in soft and hard leads
eraser

Vocabulary

Artistic Tradition
Cultural Group

WHAT TO SUBMIT FOR EVALUATION

· a drawing of an African artwork or artifact from a museum collection
· identification of the region, cultural group, or tribe from which the artwork or artifact came
· a written essay, as outlined in Instruction #6

Left, Valarie Herron, *Drawing of the Ivory Trumpet.* Afro-Portuguese/Loango, Democratic Republic of the Congo/Angola, 17th century. Eskenazi Museum of Art, Indiana University, Bloomington, IN. (Courtesy of the Artist)

Facing, During a ritual celebration of the Bamana (Bambara) people of southern Mali, masqueraders wear Ci Wara or "farming beast" headdresses to encourage farmers to plant and tend their crops with care. Each headdress combines a zoomorphic suggestion of the grace, strength, and boundless energy of an antelope's body with the head of an anteater, who burrows into the earth with its snout. Worn by male and female partners, the headdresses remind others that maintaining a healthy and vital community requires cooperation. *Two Bambara Chiwara Headpieces* (masks), female (left) and male (right), mid-19th to early 20th century. Wood, metal, brass tacks, and grasses. Left: 38¾" × 16 ⅛" × 4¼" (98.4 × 40.9 × 10.8 cm); right: 31¼" × 12½" × 3" (79.4 × 31.8 × 7.6 cm). Art Institute of Chicago, Chicago, IL. (Photograph by Helen Cook, 2006. CC BY 2.0)

Lesson 117: A Mardi Gras Mask

Carnival is a modern celebration with deep roots in antiquity. In Neolithic times, winters were long and food sources would grow increasingly scarce for hunter gathers. Hoping to encourage and influence a return of spring, members of prehistoric tribal groups may have joined together to perform rituals of symbolically driving out winter's cold and welcoming spring's warmth. By the Roman era, this awakening of benefic nature spirits was celebrated as Lupercalia. In this raucous event, young men dressed in the skins of sacrificed animals ran through paths lined with eager young married women, who hoped the men might lash them with strips of animal hide to assure a year of fertility. Eventually, Lupercalia evolved into a holiday whereby the old established order was symbolically swept away through mockery, parody, and general disorder.

As Christianity swept over Europe, ancient customs such as Lupercalia were absorbed into the liturgical calendar and given renewed significance. In commemoration of the 40 days Jesus spent fasting in the desert and in anticipation of his death and resurrection on Easter Sunday, Christians were to refrain for six weeks from partying or eating rich foods. This was the Lenten season. On the eve of Lent, however, members of the parish were encouraged to finish off stores of meat, fats, sweets, and other foodstuffs that would otherwise perish if left uneaten during Lent. The day before Lent became known as **Mardi Gras**, or Fat Tuesday. Its timing fell near to that of the earlier pagan revelries, and so these traditions were blended.

Mardi Gras costumes may have evolved from the wearing of animal hides by male participants of rituals such as Lupercalia; however, the desire to temporarily abandon one's everyday identity and take on another persona seems to be a universal phenomena that matches the nature of season-changing rituals. Role reversals metaphorically suggest the switch from wintry death to reborn spring; mockery of the established order also served as a safety valve for release of social stresses from too-rigid hierarchies. Cold weather added to the necessity for costumes that covered and protected the bodies of revelers, while masks guarded the celebrants' identities and permitted anonymity in riotous or outrageous behaviors.

French explorers brought Mardi Gras to New Orleans in the late seventeenth century. However, the celebration as it is known today was not established until the mid- to late nineteenth century. Central features of contemporary Mardi Gras celebration are the **Rex** or King of Mardi Gras, and an elaborate parade with costumed revelers and decorated vehicles or **floats**. These are created by members of special societies or **krewes**, who identify with mythological archetypes and compete with other krewes for recognition as having the most beautiful costumes or flamboyant parade floats.

In this lesson, you are to research the history and customs of a particular historic feature of the New Orleans Mardi Gras, then create a mask that could be worn in a Carnival celebration.

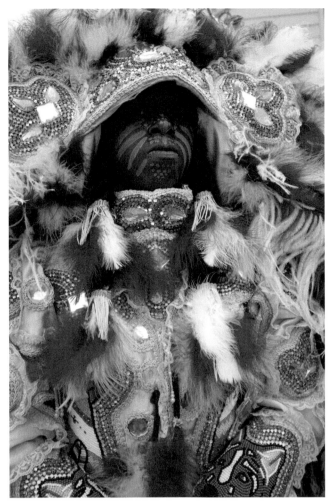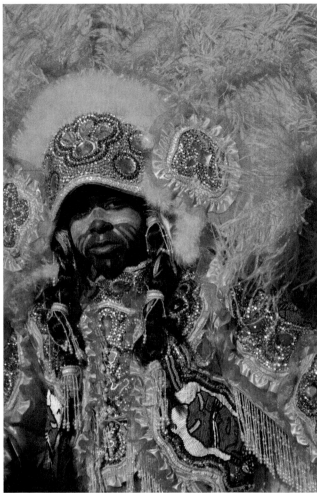

INSTRUCTIONS

Part I: Mardi Gras Indians

The evolution of **Mardi Gras Indians** is unique to the history of Mardi Gras in New Orleans. During the antebellum era, slaves were excluded from participation in Mardi Gras festivities. Cultural separation continued through the nineteenth and well into the twentieth century. Undeterred by their exclusion from the official celebrations, members of Black neighborhoods developed their own Mardi Gras traditions. Participants of these celebrations call themselves Indians in honor of Native Americans who often aided their escaped slave ancestors by accepting them into Native communities.

1. Begin this lesson by researching the history and traditions of the Mardi Gras Indians. In an essay (750–1000 words), respond to the following:

 a. To what extent did vengeance and violence play a role in the early history of the Mardi Gras Indians?

 b. Who paved the way for an end to violence, and how did disputes come to be resolved among krewes of Mardi Gras Indians?

 c. Describe the roles of each of the following participants:
 The Spy Boy
 Flag Bearers

Second Liners
A Wild Man
The Big Chief
Women (Big Queens) and children

 d. Identify stylistic differences between decorations of Uptown versus Downtown krewes.

 e. Identify some references to other cultural traditions, such as African foot stomping, Aztec and Native American costume decorations, and Day of the Dead festivals.

2. Download four images of Mardi Gras Indian costumes or masks that can be used as inspiration for your mask creation.

Part II: Create a Mardi Gras Mask

3. It would be helpful to use a pre-made papier-mâché or plastic face mold as a base for your constructed mask. If you use a plastic mold, it may be necessary to give the surface a light brushing with steel wool or to cover the top with a coat of gritty acrylic gesso to create a surface rough enough to hold glues or pastes in place.

4. Lay the mold aside as you plan out the design for your mask.

5. On sheets of 9" × 12" drawing paper, create three sketches of possible mask designs.

6. Along with visual designs, consider how parts of the design could be attached to the mold.

 a. Your mask may consist of a full headpiece that fits over the head, a face mask, or a masquerade mask that hides the eyes but leaves the nose and mouth free.

7. Consider the attached pieces:

 a. What pieces will be needed?

 b. How will they be attached?

8. How can the physical weight of various parts be balanced in such a way as to positively affect the wearability of the mask?

9. Share your sketches with peers and your instructor. Take notes about suggestions for attaching extensions and balancing the visual and physical weight of the mask to assure its wearability.

10. Select the best design for your mask, set your sketch aside, and begin collecting materials needed to create the mask.

11. Lay the face mold in the center of a very large sheet of drawing paper, or brown **kraft paper**.

12. Draw a template design around the face mold. This will give some idea of the size needed for various pieces of the mask.

13. Cut cardboard pieces needed to create the form of your mask. Use masking tape to attach these to the face mold. Make sure that the tape covers all joining areas front and back.

Tape extensions to face template. (Created by the Author)

14. Using strips of newspaper dipped in papier-mâché paste that has the consistency of yogurt, begin covering the entire surface of the mold and extensions.

15. Press down into details with your fingers, a blunt-edged butter knife, or other modeling tool.

16. Cover the mask with two or three layers of newspaper strips of various lengths that have been dipped in the paste. Allow these to dry for 24 to 48 hours. Then add another two or three layers of paste-coated newspaper strips. The mask should have between four and six layers by the time it is completed.

17. See the instructions given in Lesson 79 for making a papier-mâché bust. Use as a guide for coating the entire surface of your Mardi Gras mask and adding details.

18. Allow the mask to dry thoroughly (which may take up to a week) before adding coloration and surface details.

19. Use acrylic paint colors.

20. Glitter or sequins can be added by brushing a light coating of gloss acrylic medium on top of dried paint and sprinkling the glitter or sequins over the tacky medium.

21. Feathers or other embellishments can be attached with hot glue, using a glue gun.

Left, Marcela J., *Mask,* 2015. Student of Kelliann Meserole. (Courtesy of Kelliann Meserole)

Right, Chloe S., *Mask,* 2015. Student of Kelliann Meserole. (Courtesy of Kelliann Meserole)

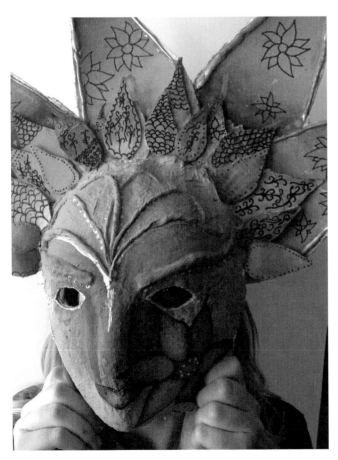
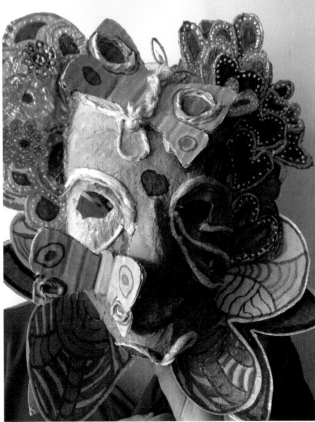

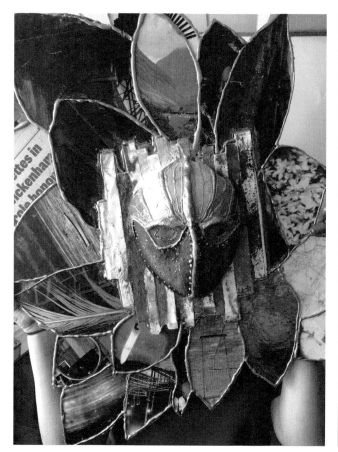

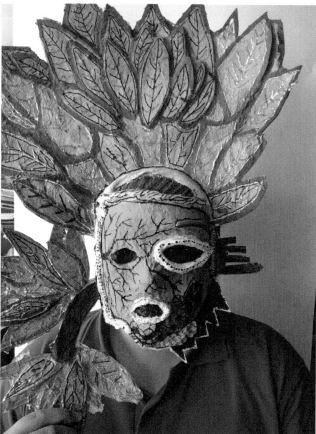

Above, Lydia W. *Mask,* 2015.
Student of Kelliann Meserole.
(Courtesy of Kelliann Meserole)

Right, Samuel F. *Mask,* 2015.
Student of Kelliann Meserole.
(Courtesy of Kelliann Meserole)

Part III: Wearing the Mask

22. **Masquerade** eye masks can be attached to a slender dowel rod, about 12″ long. Lay the end of the rod along the inside of the mask and attach to the mask with hot glue from a glue gun. Decorate the exposed part of the rod.

23. A face mask can be attached to the head with sturdy grosgrain ribbons that have been fastened with staples or hot glue to either side of the face on the inside of the mask. Fit the mask to your head and ask a friend to help mark the spot where ribbons should be affixed. Use staples, hot glue, or poke holes in the sides of the mask and tie the ribbon tightly to the mask.

24. Full-headed masks tend to be heavy. It is useful to create sturdy ties such as grosgrain ribbons, attached to the mask with a hot glue gun and staples, to hold the mask tightly to the head. However, this may not be enough to keep the mask from slipping down while worn. Therefore, it may be necessary to create a headdress in order to keep the mask in place. For a headdress, you can use an old baseball cap. Choose an adjustable cap that is slight larger than your head size but may be adjusted to fit your head snuggly.

 a. Clip the bill off of the cap, being careful do not cut too close to the cap or you will destroy the cap's structure. (Cut into the bill, *not* the stitching or headband.) Reinforce the rim with duct tape

after altering the bill. Place the cap on your head and fit the mask against the cap. Adjust the cap to a comfortable position that also balances the weight of the mask and holds it in place.

b. Then, using hot glue, attach the cap to the inside of the mask. Once the mask is in place, adjust the cap to fit snuggly on your head.

Materials Needed

face mask mold

newspaper

heavy and light weight cardboards

heavy duty scissors

duct tape

baseball cap (*optional*)

sandpaper

acrylic paints

acrylic sealant

large and small bristle
 acrylic brushes

mixing tray and water containers
 for paints

soap and water to clean brushes

feathers, glitter, or other
 ornamental decorations

hot glue gun and hot glue, or
 heavy-duty stapler with staples

hole punch

grosgrain ribbon (1"), 1½ yards

kraft paper

newspaper or plastic covers to
 keep work area clean

Plaster Method

instant mold plaster bandages

scissors

water

Papier-Mâché Method

newspaper strips

scissors

art paste, rice paste, or wheat paste
 powder and water (Mix only

the amount of paste you will
 need and use immediately, as
 wet papier-mâché paste will
 spoil if allowed to sit unused.)

Vocabulary

Carnival

Float

Kraft Paper

Krewe

Mardi Gras

Mardi Gras Indians

Masquerade

Rex

WHAT TO SUBMIT FOR EVALUATION

· an essay (750–1000 words) that provides researched responses to Instruction #1
· four downloaded images of Mardi Gras Indian costumes for inspiration of your mask design
· three sketches for a mask design
· notes from peer feedback and your reflections about how the mask might be balanced aesthetically and physically
· a completed mask that has been created and decorated as described in the instructions

Lesson 118: Art of Ancient Egypt

Ancient Egyptians told stories of the lives and accomplishments of their leaders in stone carvings on public monuments, temples, palaces, or buildings where affairs of state were conducted. Paintings and carvings in the tombs of deceased royalty and other important people related the life deeds of the deceased and described what Egyptians believed souls of the dead would experience in the afterworld. Because the intent of images and statues seen in public places was to instill a sense of patriotism among Egyptian citizens and intimidate Egypt's enemies, and because tomb paintings were intended as guidebooks for souls of the dead, these artworks were presented with symbolic formality. The purpose was not to convey photographically realistic images of people, places, or events, but to unmistakably affirm power and immortality. This explains certain stylized conventions in the representation of people.

Ancient Egyptian artists intentionally presented the human head and body from two simultaneous points of view: the front and side. This is impossible in real life. We cannot see people from both the side and front at the same time. However, showing the human body in this way served two important purposes: it made drawing people easier, since each part of the body is drawn from the viewpoint that is easiest to capture; and more importantly, the resultant human figure seems frozen in an immovable position. This conveys an idea of greatness, strength, and a kind of "truth" that reflected ancient belief.

This drawing of a wall painting seen in the tenth tomb at Gourna, Thebes, was made during an expedition to Egypt organized by Robert Hay between 1826 and 1838. It depicts a procession where homage is being paid to a blue-faced pharaoh, symbolizing Amon, who as creator of the world spiritually rules over crops and fertility. Egypt Wall Painting, Procession of Figures with Offerings (whole drawing), from *Egyptian Collections*, Vol. XI (originally published/produced in Egypt, 1826–1838). British Library, London, UK.

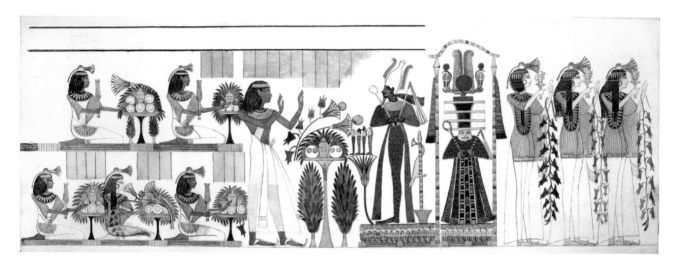

In this lesson, you will practice drawing a human body in the **stylized** manner employed by ancient Egyptian artists. By focusing on how Egyptian representation differs from the way human bodies are realistically constructed and move fluidly through space, you may also recognize how human figures might be more realistically rendered.

1. To draw the human body as was done by ancient Egyptian artists, take two photographs of the same person.

2. One photograph must show the person from the front, standing with arms down, feet flat on the floor, and looking straight ahead with no particular expression on his or her face.

3. The second photograph should show the same person in the same pose, but from the side.

4. On a sheet of 9" × 12" or 12" × 18" watercolor paper, and using the two photographs as references, begin drawing the person as follows:
 a. Draw the head and the neck of the person from the side view.
 b. Draw the shoulders and chest as if you're looking at the person from the front, and draw the arms hanging straight down from the shoulders, with hands clenched into fists or with fingers down. The hands may be facing the same way (i.e., as if both were right hands or both were left hands).
 c. Draw hips, legs, and feet from the side view.

5. You now may add clothing. Men wore short skirts that flared out just above the knees, and women wore straight dresses, which were held in place by two straps and fell to just above the feet.

6. Now go back to the head and draw the lips from the side view
 a. Add an ear as it would be seen from the side.
 b. Draw an outline of a wig that includes bangs and is cut straight below the shoulders.
 c. Add one eye as it would look from the front and outline the eye in black, with the outside edge of the eyelid drawn out a little past the eye.
 d. Add a curved and black eyebrow.

Example of Egyptian figure. (Created by the Author)

7. When the drawing is completed, finish it with colored pencils or carefully paint with tempera (poster) colors.
 a. The skin of a male should be colored (or painted) dark tan; women were shown in a slightly lighter shade of tan.
 b. Clothes can be white, blue, or striped, with brightly colored straps or belts.
 c. Add a large, brightly colored jeweled collar and arm bracelets to both male and female figures.
 d. A pharaoh would have a circlet around the head, with a side view of the raised head of a cobra at the forehead.

8. Research images from ancient Egypt for ideas about adding background details such as reeds, boats, or palm trees.

9. *Optional*: research how to write **hieroglyphs** and add hieroglyphic writing to the finished piece.

Materials Needed

two full-length photographs of the same person, from front and side

watercolor paper, 9" × 12" or 12" × 18"

drawing pencils with soft and hard leads

colored pencils or tempera paint with brushes, water container and water

Vocabulary

Hieroglyphs

Stylized

WHAT TO SUBMIT FOR EVALUATION

· two full-length photographs of the same person, one showing a front view and the other showing the side
· a completed portrait drawing of the photographed person, done in the stylized Egyptian way

TIPS FOR TEACHERS

Students should be reminded that contemporary Egyptian artists do not create the same types of art today as their ancestors created. Have students look at artworks by contemporary Egyptian artists and compare them with images from ancient Egypt. Search online for information about these Egyptian artists:

· Alaa Awad (1981–)
· Khaled Hafez (1963–)
· Hamed Owais (1919–2011)

Introduce these artists and their work to your students and ask, based on these images, what can be surmised about differences in the lives and beliefs of Egyptians today versus the lives and beliefs of their ancestors.

TIPS FOR TEACHERS

The drawings of older elementary students frequently feature side views of subjects. In many respects these side-view images will resemble the conventional body views demonstrated by ancient Egyptian paintings. Looking at Egyptian art and realizing the way two viewpoints are confused (front with side view) can help students see their errors in attempting to create realistic side views.

Once the errors are recognized, students may want to correct their figures to present a consistent body perspective. Be prepared to help students when they ask how to draw from a consistent angle. There are a number of how-to-draw books that can assist students in this regard. Look at these resources and consider which ones may be useful to your students:

- Hammond, L. *Draw Real people!* Cincinnati: North Light Books, 1996.
- Hart, C. *Figure It Out! The Beginner's Guide to Drawing People.* New York: Chris Hart Books, 2009.
- Levin, F. *1–2–3 Draw People.* Columbus, NC: Peel, 2007.
- Levy, B. S. *How to Draw Princesses and Other Fairy Tale Pictures.* Mineola, NY: Dover Books, 2008.
- Reinagle, D. *Draw Sports Figures.* Columbus, NC: Peel, 2000.

Top, Egyptian Portrait, 1989. Oil pastel on manila paper, 12" × 9". (Child Art Collection of Marjorie Manifold)

Bottom, Egyptian Portrait, 1989. Oil pastel on manila paper, 12" × 9". (Child Art Collection of Marjorie Manifold)

Lesson 119: A Culture Fusion Mandala

Cultures are not static. Exposing students to the artifacts of a past or ancient culture can provide them with historical information about a group, but should be balanced with contemporary cultural images and artifacts that convey how people of that cultural background experience life today. Students should be aware, for example, that Native peoples no longer live in wigwams or teepees, hunt with handmade bows and arrows, or wear clothing made of buckskin. In fact, many Native Americans are so well integrated into the milieu of modern society that we would not recognize them as culturally different from the mainstream.

Nevertheless, while people of many cultures share common aspects of twenty-first-century life, such as using cellphones, eating pizza, or watching favorite football teams, they also may carry with them aesthetic tendencies and preferences of their ancestors. This may appear in their artwork in symbolic, stylistic, or conceptual ways. Look at artworks by Steve Willis (Lesson 111), an artist of Irish and Cherokee heritages. Search online for examples of ancient **petroglyphs** made thousands of years ago by Native peoples in the eastern and western regions of North America, and compare Willis's work to the petroglyphs. What visual commonalities and differences do you see? Can we make assumptions about or know with certainty what the artists' intentions were? Why or why not?

Left, Ando Utagawa Hiroshige (1797–1858), *Plum Garden, Kameido,* 1857. Woodblock print, 8 ¹⁴/₁₆" × 13½". Iris and B. Gerald Cantor Center for Visual Arts, Stanford University, Stanford, CA.

Right, Vincent van Gogh (1853–1890), *Flowering Plum Tree (after Hiroshige),* 1887. Oil on canvas, 21 ⅝" × 18 ⅛" (55 × 46 cm). Van Gogh Museum, Amsterdam, the Netherlands.

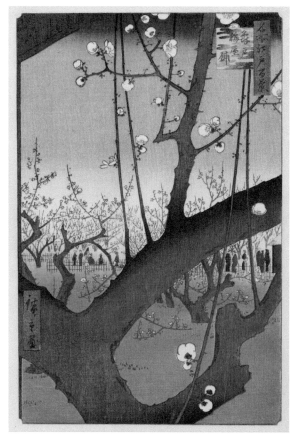

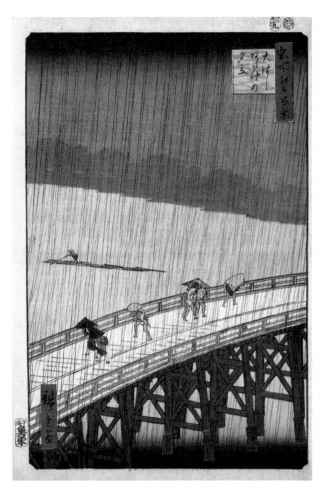

In the past few hundred years, ordinary people have become increasingly aware of the artistic expressions of global cultures, and artists have come to be influenced or inspired by the aesthetic expressions of ancient and modern peoples from many cultures. In the mid-nineteenth century, Western artists attending a world exposition in Europe were inspired by the beautiful Japanese **woodcuts** or **ukiyo-e** prints they saw exhibited. Vincent van Gogh, a Dutch born artist living in France, was impressed by the work of Japanese master artist Hiroshige, and painted copies of two Hiroshige artworks: *Japonaiserie: Plum Tree in Bloom*, and *Japonaiserie: Bridge in the Rain*. While obvious copies, these works show unmistakable characteristics of Van Gogh's style, which transforms his versions into something different from the Hiroshige images. In what ways are they similar? How are they different?

This lesson challenges you to consider a symbolic form that has been present since antiquity and reinterpret it as a fusion of your current life experiences and symbolic representations of your cultural past. As format for the artwork, you will work with a mandala shape.

ABOUT MANDALAS

The circle is among the more common motifs found in patterns, designs, and sacred symbols of diverse cultures in antiquity and the present day. In fact,

Left, Ando Utagawa Hiroshige (1797–1858), *Ohashi Atake no Yudachi (Sudden Shower over Shin-Ōhashi Bridge and Atake).* Ukiyo-e print showing pedestrians crossing the great bridge at Atake during a rain storm. No. 52 in the series *Meisho Yedo Hiakkei (One Hundred Famous Views of Edo),* 1857. Woodblock print, 14½" × 9 13/16" (37 × 25 cm). Prints and Photographs Division, Library of Congress, Washington, DC.

Right, Vincent van Gogh (1853–1890), *Bridge in the Rain (after Hiroshige),* 1887. Oil on canvas, 28¾" × 21¼" (73 × 54 cm). Van Gogh Museum, Amsterdam, the Netherlands.

circle symbols may be universal, appearing in all cultures throughout time. Because a circle is defined by a line that has no beginning or end, circle symbols have represented infinity, eternity, wholeness, or endless cycles. The meaning of the **mandala** among different cultures may be similar but not exactly the same. In some Native American cultures, for example, it may represent protection and healing. Tibetan, Hindu, and Buddhist mandala forms represent a unity of the visible and invisible worlds; mandala symbols may be used by worshippers as aids to meditation or to induce trance states. Rose windows in medieval cathedrals presented stories in glass as existing within a sacred space. Earth, femininity, and the sun are other meanings assigned to the circle by diverse cultural groups. In contemporary society, we gather in circles as signs of unity and community, while a red circle with a single line drawn diagonally across its diameter is a universal admonishment that whatever is shown within the circular shape is forbidden.

INSTRUCTIONS

1. In a brief essay (300–400 words) address the following:
 a. Describe how the work of Steve Willis is similar to and different from ancient Native America petroglyphs.
 b. Describe how Hiroshige's work and Van Gogh's appropriation of it are similar and different.
2. Consider some of the experiences that define you as a person. Think of interests, activities, and characteristics that are visible evidence of your lifestyle. Also think of important internal qualities (bravery, perseverance, curiosity about cultural differences, being passionate about gardening, etc.) that describe who you are as a unique individual. How would you indicate these symbolically?
3. Make at least six thumbnail sketches of symbols that describe visible evidence of self, and six that describe internal aspects of you as a person (12 sketches in total).
4. Reflect upon attributes of your life that may be evidence of family or community traditions. For example, what holidays do you and others of your family celebrate, and how are these celebrated? What foods, sayings, heirloom artifacts, or other traditional phenomena might be specific to your family or community experiences?
5. Create a least six thumbnail sketches that symbolically present these traditional influences. Arrange these into three possible mandala compositions.
6. Share your sketches with your peers and instructor for feedback about the compositional unity and harmony of various elements and how they relate visually to one another.
7. Using a large dinner plate as a template, place the plate upside down on a sheet of watercolor paper. Center the plate on the paper and carefully trace around it with a pencil to create a circular outline for your mandala.

8. Based on feedback from your peers and your own aesthetic sensibilities, integrate variously sketched symbols into a unified a mandala that represents you. You may add lines, decorative designs, or shapes (such as Zentangles) to hold the symbolic elements together in a cohesive and pleasing **radial** composition, that is, a composition arranged in a mandala or circular form.
9. Carefully draw your integrative design in pencil and finish it with watercolors. Choose colors that are relevant to the symbols.
10. In a brief essay (300–400 words), explain the symbols used in your design:
 a. What do the symbols represent for you?
 b. What technical and aesthetic choices went into the design?
 c. What difficulties did you encounter in composing the design, and how did you resolve those issues?

TIPS FOR TEACHERS

Symbols in Culture

Children can learn about symbols and cultures by selecting a common motif and noticing how it appears in various cultures. Symbols may be geometric shapes such as squares, pyramids, five- or six-pointed stars, or natural motifs such as four-leaf clovers, oak trees, roses, lions, cats, or foxes. Many symbols originate in local geographic features. Teaching symbols assists students in understanding abstract concepts and metaphoric relationships. Resources for teaching these concepts include the following children's books of myths that feature similar themes from around the world:

- Braman, A. N. *Kids around the World Create!: The Best Crafts and Activities from Many Lands*. Hoboken, NJ: Jossey-Bass, 1999.
- Mendia-Landa, P. "Universal Myths and Symbols: Animal Creatures and Creation." Curriculum Unit 98.02.05. Yale-New Haven Teachers Institute, 1998. http://www.yale.edu/ynhti/curriculum/units/1998/2/98.02.05.x.html.
- Moehn, H. *World Holidays: A Watts Guide for Children*. London: Franklin Watts, 2000.
- Philip, N., and N. Mistry. *Illustrated Book of Myths*. New York: DK Children, 1995.

Materials Needed

several sheets of drawing paper

one sheet of 9" × 12" watercolor paper

pencils with soft and hard leads

a dinner plate

colored pencils, or watercolor paints

Vocabulary

Mandala

Petroglyphs

Radial Symmetry

Ukiyo-e

Woodcut

Facing top left, Parthenon, 447–438 BCE. Athenian Acropolis, Athens, Greece. (Photograph by Mstyslav Chernov, 2009. CC BY-SA 3.0 US)

Facing top right, Henry Bacon, architect (1866–1924), *Lincoln Memorial,* 1914–1922. Washington, DC. (Photograph by Christoph Radtke. CC BY-SA 3.0 US)

Facing bottom left, Attributed to Apollodorus of Damascus (2nd century CE), *Pantheon (Dome Interior).* Originally erected by Marcus Vipsanius Agrippa in 27 BCE; reconstructed by Hadrian in 125 CE. Rome, Italy. (Photograph by Szilas, 2013, via Wikimedia Commons)

Facing bottom right, United States Capitol Rotunda. Dome designed by Thomas U. Walter (1804–1887) and built 1850–1863; restored in 1960. Photograph by William D. Moss, 2006. (Family members, dignitaries, and members of the U.S. Senate and House of Representatives honor former President Gerald R. Ford during a memorial service in the U.S. Capitol Rotunda in Washington, DC., Dec. 30, 2006.)

WHAT TO SUBMIT FOR EVALUATION

· eighteen thumbnail sketches, including six that describe your visible appearance, six that describe character traits or internal qualities of the self, and six that describe influences of your family culture or traditions
· three sketches that suggest arrangements of these thumbnails into a unified mandala composition
· a completed mandala artwork that integrates elements into a radial composition in a harmonious way
· two written essays, one each in response to Instructions #1 and #10

Lesson 120: Architecture Influenced by Classical Greece and Rome

Citizens of the United States can trace much of the American governmental system, philosophical ideals, foundations of science and education, and architectural style to ancient or **Classical** Greece and Rome. Just as the pragmatic ideas developed by peoples of these ancient civilizations continue to influence our civil lives, the arts of Classical Greek and Roman artists, sculptors, and architects provide a foundation of realism that influences our aesthetic

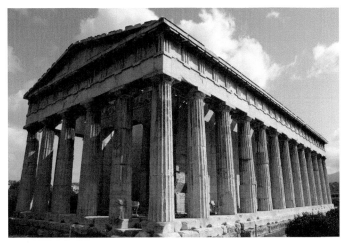

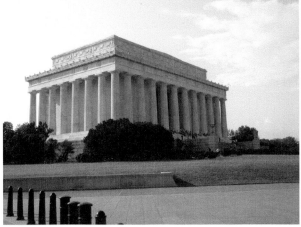

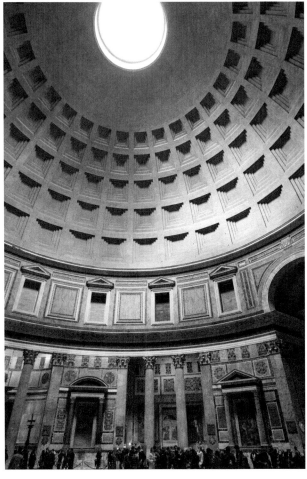

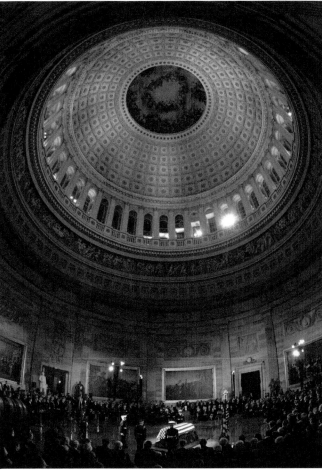

Left, Pont du Gard Aquaduct, 40–60 CE. Vers-Pont-du-Gard, Gard, France. (Photograph by Les Portes du Temps. CC BY-SA 3.0 US)

Right, Arches Detail on South Face of Ahwahnee Bridge, 1991 (spanning Merced River on a service road). Yosemite Village, Mariposa County, CA. Photograph by Brian C. Grogan. Part of Yosemite National Park Roads and Bridges Recording Project, 1991. Prints and Photographs Division, Library of Congress, Washington, DC.

preferences today. For example, compare the styles of these ancient Greek and Roman structures to features we are familiar with from contemporary buildings and structures. What ideals of order do they invoke? Why do you think this is so?

INSTRUCTIONS

1. Study the pictures of Classical Greek and Roman architecture provided in this lesson, and then take a walk around the community where you live, looking for examples of architecture that seem to have been inspired by Classical Greek or Roman builders.
2. Look for buildings that have **columns**, **arches**, **domes**, **friezes** or **pediments**.
3. Make careful drawings of at least two different buildings that show some influence from Classical Greek or Roman architecture. Fill two sheets of 9" × 12" white drawing paper with the drawings. Include **shading**, **details**, and correct **proportions** of the buildings as they appear in the surrounding environment.
4. Write a brief essay (300–400 words) addressing the following points:
 a. Identify the buildings you drew and tell where they are located.
 b. Explain how the buildings that you found in your community demonstrate elements of Classical Greek and/or Roman architecture. Accurately identify columns, arches, domes, and pediments, or other elements that reflect ancient Greek and/or Roman architecture.
 c. Describe how you used shading, details, and proportion to make your drawing look realistic and fit into its surroundings.

Materials Needed

white drawing paper, 9" × 12"
drawing pencils with various grades of soft and hard leads
eraser

Vocabulary

Arch	Cornice	Proportion
Bas-Relief	Detail	Shade/Shading
Capital	Dome	Terra Cotta
Classical	Frieze	
Column	Pediment	

WHAT TO SUBMIT FOR EVALUATION

· two pencil drawings of buildings in your local community that imitate elements of Classical Greek and/or Roman architecture, demonstrating correct shading, details, and proportion in your drawings

· an essay, as indicated in Instruction #4

LESSON EXTENSION

In addition to the basic structure of a building, many public buildings also are embellished with carvings or **terra cotta** reliefs that include symbols meant to elicit feelings of patriotism, remind us of our highest civic ideals such as justice, or inspire us to be good citizens. Make two drawings of some specific feature of a building such as a **cornice**, pediment, column, or **capital** that reflects not only architectural features of Classical Greek or Roman architecture but also suggests something about our contemporary civic ideals. For example, are there carvings of national or state birds or patriotic symbols? Is there a **bas-relief** of some national hero or exemplary citizen? Add to your essay your ideas of what these features might be intended to convey. What civic behaviors do they extol or inspire? How do they reinforce the aesthetic notions suggested by the overall architecture?

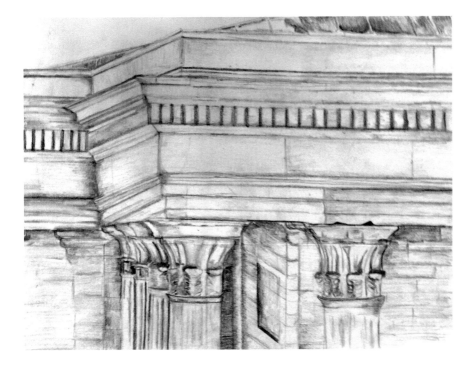

Katie Voytek, *Arch 3: Detail drawing of corner of Monroe County Court House, Bloomington, IN.* (Courtesy of the Artist)

NOTES

1. V. Lowenfeld, *Creative and Mental Growth*, 3rd ed. (New York: Macmillan, 1957), 36.

2. Steve Willis, "Influences from Native American Experiences," http://stevewillis.org/na-influences.html; and "Identity: Mixed Media Installation," http://stevewillis.org/identity-images.html.

3. To find teachers willing to collaborate with you and your students on this project, contact USSEA (United States Society for Education through Art) at http://ussea.net/, or InSEA (International Society for Education through Art) at http://www.insea.org/.

4. Fimo® or Sculpey® are preferred polymer clays.

5. If desired, the limbs and legs can be omitted.

6. E. Dissanayake, *Homo aestheticus: Where Art Comes from and Why* (Seattle: University of Washington Press, 1995).

7. See "The Raven and the First Men," Bill Reid Foundation, http://www.billreidfoundation.ca/banknote/raven.htm.

What materials can be used to create works of art? Traditional notions of visual arts are of paintings on canvas or paper, sculptures of wood and stone, and sometimes ceramic objects. Creative arts produced by women and ordinary folk to celebrate and beautify artifacts of everyday life have less frequently been recognized with the reverence given to painted canvases or sculptures. Perceptions of what art might be and who might make authentic works of art have changed greatly in the past few decades. Contemporary artists explore a wide range of materials, from fibers to photographs and recyclable objects to foodstuffs. This section presents lessons that encourage experimentation with a wide variety of materials and processes.

FEATURED ARTIST: JIN-SHIOW CHEN

Jin-Shiow Chen is an installation artist who is inspired to work in materials that stimulate the senses of smell, touch, and taste as well as sight. She aims to engage viewers with empty or unseen spaces between visible elements. Materials she has used in her creations include yeast, flour, dough, chocolate, eggroll wrappings and other foodstuffs, natural dyes and plant fabrics, wool, wood, and growing plants. Due to the natural characteristics of media selected by Chen, her works feature processes of growth, ripening, and decay. The invisible elements she experiments with include bacteria, moisture, dust, temperature, acids, and time. These she describes as the feminine (yin) aspects of nature. Many of Chen's recent installation works are done in collaboration with her husband, Paul Yann Lin, whose bold works in wood, glass, and metal serve as a masculine (yang) foil to her yin-inspired creations. Together they challenge us to consider how we might treat the environment more kindly and live in balance with nature.

Jin-Shiow Chen's works explore issues of
the yin or feminine elemental forces of
the environment through use of atypical
art media. She uses materials such as raw
fiber, flour, yeast, dough, mold, fungus,
and plants or foodstuff to draw personal,
visceral responses from viewers. Here
she sews together spring roll wrappers
in strips that will be hung as part of an
installation. (Courtesy of the Artist)

Lesson 121: Designing an Imaginary House

There is certain delight in imagining and creating personal spaces and outfitting them with dreams. Young children may envision and create private spaces, castles, or spaceship homes of cardboard boxes or bed blankets; they may build forts of snow, sand, or sticks; or fantasize living on a houseboat or in a tree house. The imagined home space serves as a metaphor for private hopes and dreams. In this lesson, you will give free rein to your wildest fantasies in designing a place of refuge and play.

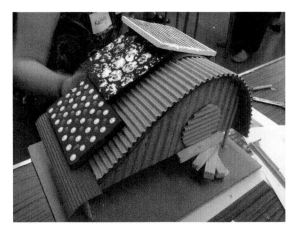

INSTRUCTIONS

Part I

1. Stretch your imagination and let it go. On sheets of 9" × 12" drawing paper, create at least six sketches of fantastic houses that could be created out of totally unconventional materials.

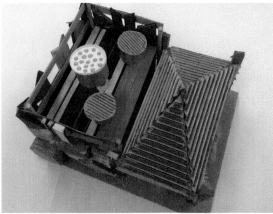

2. Makes notes on your sketches about the materials that could be used to build the house. Remember that these should be unconventional materials. For example, a house might be constructed entirely of doors recycled from demolitions of old abandoned houses. It might be made of plastic bottles filled with sand or glass beads and cemented into place. It might be remodeled from a shipping crate or an old school bus.

3. Consider how you will enter the house, and how light will be allowed in.

4. Remember to keep the features of the house in proportion to one another and to any person who might live in the house.

5. Show your plans to your peers and instructor for feedback about house proportions and materials appropriate to creating a small model of the house. Discuss various constructional considerations.

6. Decide on the best house sketch or sketches, and add notes and additional touches to the sketches that will be used to inform the model you will make.

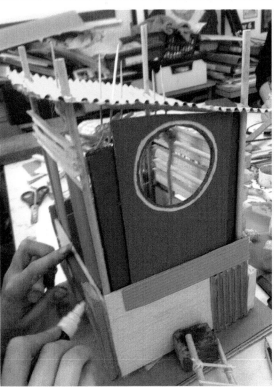

Part II

Transform your sketch into a **model** of the structure.

7. Use a sturdy foundation for the house. This could be a heavy piece of cardboard, foam core, or a piece of Plexiglas or Masonite, depending on the weight and nature of the materials you will use to construct the house.

Imagined Houses, elementary students of Natalie Deane, UK. (Courtesy of Natalie Deane)

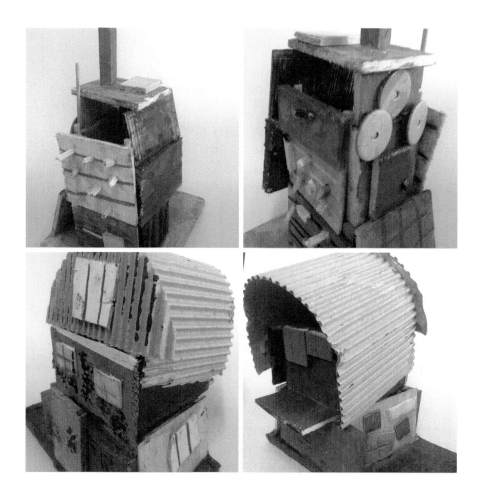

8. Collect materials to create a model of your house. Suitable materials for creating the model structure include **corrugated cardboard**, **foam core**, and/or **balsa wood**.

9. Plan how you will construct and attach parts of the house. For example, you might use white glue on wooden sticks or cardboard, epoxy on plastic, or strings to bind parts together.

 a. Add decorative pieces made from carved popsicle sticks, toothpicks, cardboard, or other materials.

 b. Use appropriate glues to construct the model.

10. Plan how you will finish the house. Will you cover parts with plaster gauze, papier-mâché, or paint?

11. Finish the model as accurately as possible with as many details as you like.

 a. You may want to include balconies, windows, steps, and doors, or add on features such as glued trinkets, cloth for awnings or wall covers or window coverings.

 b. You may add paint to finish the piece—although you are not specifically required to paint the model.

12. Clean off excess glue that would detract from the appearance of the final piece.

13. Write a brief essay (400–550 words) in response to the following:

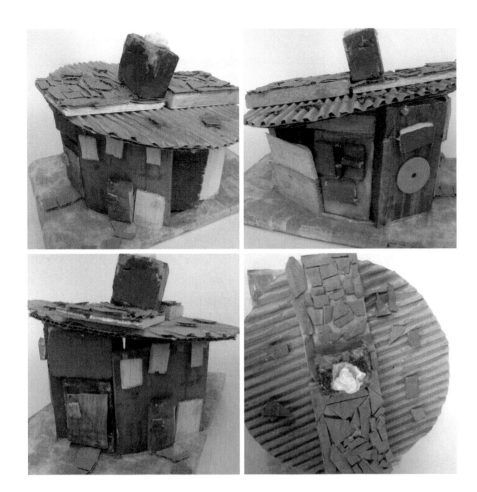

a. Explain what ideas inspired your sketch of an original building.
b. Tell how your drawing was developed into a finished model.
c. What could or could not be recreated in the model?
d. Explain what problems you encountered in creating the model and how you resolved these issues.

Materials Needed

white drawing paper, 12" × 18"
drawing pencils with soft and
 hard leads
colored markers
eraser
18" ruler with metal edge
foam core, balsa wood, or
 corrugated cardboard
X-ACTO or mat knife and blade

heavy-duty shears
white glue, wood glue, craft glue,
 and/or glue gun and wax
protective materials for cutting
 surfaces and painting areas
tempera or acrylic paint
brushes in several sizes
water containers, mixing trays,
 and water

Vocabulary

Balsa Wood
Corrugated Cardboard
Foam Core
Model

- six sketches of imaginary building designs, with notes about possible materials
- a final drawing of a building design, with added sketches and/or notes from feedback
- a finished model of an imaginary building
- a written essay response, as outlined in Instruction #13

LESSON EXTENSION

The best part of imagining something is not having to limit one's fantasies to the here and now. Imaginary houses can exist in any time or place. One can actually imagine an "old woman who lived in a shoe," or a house made of gingerbread. A house might be suspended in the air or nestled in a tree. A house might float on the water or be transported from place to place on wheels. In fact, creative individuals have designed houses of packing crates, railroad cars, and tin cans. Houses have been built into the ground or made of bamboo and paper. There are houses built in trees, on boats, and as movable trailers or wagons. As a lesson extension, stretch your ideas of what a house could be and create a small model of a fantasy house that

- travels through the air, across land, or through water; or
- resembles something entirely different than a house, as for example, a shoe or mushroom.

Laurie Gatlin, *Caboose House*. Balsa wood and cardboard, 7½" × 8" × 10". (Courtesy of the Artist)

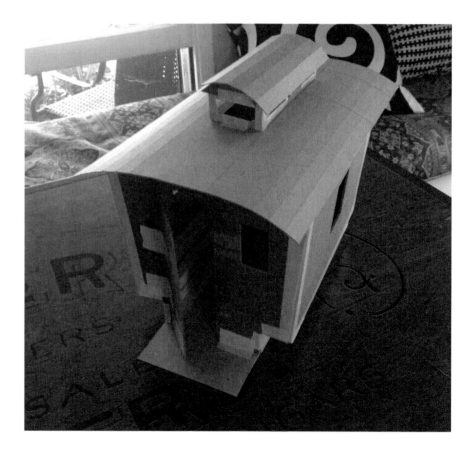

As a child, did you ever collaborate with friends to build a tree house or make-believe fort? Perhaps you built an igloo out of snow, lashed together fallen tree limbs into a teepee, transformed an upturned chair into a barricade, or turned a discarded refrigerator box into a secret clubhouse. Building spaces is a natural form of child's play, but some people do not outgrow the need to transform found or natural materials into special structures. Patrick Dougherty is one such artist.

As a young man, Patrick Dougherty (1945–) purchased a few acres of wooded land and began building his handmade home of "old barn timber, fallen trees and rocks that he dug from the ground."[1] The experience not only resulted in a livable dwelling but also affirmed his love of sculpting with natural materials. Dougherty prefers to work with red maple tree saplings, because they are flexible yet sturdy. These he lashes into groves of nest-like shapes or lairs. Often, he enlists the aid of volunteers to assist in constructions that he calls "Stick Works." Their interactions recall the collaborative (and sometimes contentious) play of children constructing fantastic spaces together. Other than the home he has built, however, Dougherty's sculptural works are not meant to be permanent. Rather, like all items of the natural world, they break down after a few years and dissolve back into the earth.

Andy Goldsworthy (1956–) is another artist who uses natural materials as media for his ephemeral creations. Goldsworthy has worked with sheets of ice, twigs, leaves, stones, and water in producing imaginative structures whose delicacy seem to defy earth temperature, wind, tides, and natural processes of decay. Many of these sculptures and constructions are constructed in remote, out-of-the-way, or uninhabited places and take hours or days to produce. Because they may last only a few moments once completed, Goldsworthy captures them in photographic images, which are exhibited in museums for viewers to contemplate and enjoy at leisure. Yet he declares that it is only after elements of time and nature have absorbed his works back into the earth that they are truly complete.

The **environmental art** of Stan Herd (1950–) is intended to change over the time of a planting season. He enlists the aid of farmers to produce his designs by sowing crops or grain, flowers, or herbs according to a design he lays out for them. As the plants grow and mature over the season, a massive image is revealed. Herd's works cannot be fully appreciated by viewers standing on the earth. They can only be truly enjoyed when seen from overhead, while flying in a plane or floating in a balloon.

Like Herd's **crop art**, the **beach art** of Andres Amador (1971–) is best viewed from overhead. Working when tides are low, he creates elaborate designs by raking beach sand, only to have incoming tides wash over his painstaking work and smooth over the images.

In this lesson, you are to explore the ideas and works by Dougherty, Goldsworthy, Herd, and Amador. After considering their ideas about the

relationship between the artist and nature, create a work of art of natural materials that expresses your own ideas about the natural world as art.

INSTRUCTIONS

1. Begin the lesson by looking up artists Dougherty, Goldsworthy, Herd, and Amador, along with their artworks. Below are suggested resources and links to sites featuring works by these artists; you also may seek other sites for information.
2. Download at least one example of work by each artist.
3. Consider the following questions, and prepare a written essay (1000–1500 words) that addresses them:
 a. Why do you think these artists would put so much time and effort into images that will disappear over time?
 b. What does this say about what each artist perceives his art and its relationship to the world to be?
 c. What do their efforts tell us about the relationship of human beings, man-made artifacts, and the earth?
 d. What knowledge of the natural world is required to create these various artworks?
 e. What knowledge of engineering is required in order to complete the various creations?
4. Think about natural materials to which you have access in your local environment. How could these be imagined as media for art making that is temporal and will fade over time (as in the work of Amador), unfold and become evident with time (as in Herd's crop art), or make use of natural processes in another way?
5. Sketch ideas for a sculptural piece that would involve natural materials. Make notes about the various materials you will need in this construction. How will materials be held together using all-natural connective devices? What tools will be needed to dig, carve, gouge, plant, or otherwise modify natural media?
6. Gather all the materials that you have determined you need, and create a sculptural piece using any natural materials (and in any scale).
7. Document the making process and the completed work in video and/or photography.

Resources and Links to Artists

1. Andres Amador

 Andres Amador Arts. http://www.andresamadorarts.com.
 Straus, R. R. "Tide Waits for No Man." *Mail Online*, March 12, 2012.
 http://www.dailymail.co.uk/news/article-2113843/The-amazing
 -beach-artist-Andres-Amador-starts-day-new-canvas.html.
 http://www.youtube.com/watch?v=mPoO4YuokYE.
 http://www.youtube.com/watch?v=T_tIG5mo1DM.
2. Patrick Dougherty

Dougherty, P. *Stickwork*. New York: Princeton Architectural Press, 2010.

Ferris, A., and L. Muehlig. *Patrick Dougherty: Natural Magic.* Sheboygan, WI: John Michael Kohler Art, 2010.

Green, P. "Building with Sticks and Stones." R. Wright, and R. Harris. "A Log Home in Chapel Hill" (slide show). Home and Garden section. *New York Times* (online edition), October 6, 2010. http://www.nytimes.com/slideshow/2010/10/06/garden/20101007-TWIG-3.html.

Patrick Dougherty. http://www.stickwork.net.

3. Andy Goldsworthy

Andy Goldsworthy: Rivers and Tides. Directed by Thomas Riedelsheimer. Produced by A. von Donop, L. Hills, and T. Davies. Docudrama. DVD-BluRay. Mediopolis Film- und Fernsehproduktion, 2001.

Goldsworthy, A. *A Collaboration with Nature.* New York: Harry N. Abrams, 1990.

Goldsworthy, A., and T. Friedman. *Hand to Earth.* New York: Harry N. Abrams, 2004.

Goldsworthy, A., and J. L. Thompson. *Wall.* New York: Harry N. Abrams, 2011.

Morning Earth: Artist/Naturalist Pages. http://www.morning-earth.org/ARTISTNATURALISTS/AN_Goldsworthy.html.

4. Stan Herd

Herd Arts. http://www.stanherdarts.com.

Herd, S. *Crop Art and Other Earthworks.* New York: Harry N. Abrams, 1994.

Miller Meiers. http://www.millermeiers.com/stanherd/.

Materials Needed

found natural materials	Beach Art
a digital camera	Crop Art
Vocabulary	Environmental Art

WHAT TO SUBMIT FOR EVALUATION

· a downloaded image of work by each of the four artists indicated above
· an essay (1000–1500 words) that addresses questions asked in Instruction #3
· evidence of planning an environmental art piece, with sketches and notes about needed materials
· an environmental art piece that is also documented in video and/or photography

Musicians as well as visual artists respond to the natural world as media, or allow nature to be a collaborator in music making. These musicians may call upon the temporal, accidental elements of nature to produce musical works. Watch these videos of environmental music:

· http://www.youtube.com/watch/?v=C_CDLBTJD4M
· http://www.pinterest.com/pin/124974958384345970/

How are these conceptually different (in terms of time and nature) or similar to works by the visual artists mentioned above? As an extension, consider how music that is responsive to, inspired by, or otherwise integrative with the environment could be added to or incorporated in your environmental art project. Add the music and resubmit your video with an explanation of how you came to include music in this way.

TIPS FOR TEACHERS

When visiting art museums, visitors are accustomed to being warned against touching precious works of art. Artworks made to interact with time, however, invite and may be dependent upon processes of change, including changes that result from human interactions with these works. Consider providing experiences for students to interact with nature as if natural forms were art. For example, set up a sand table and invite students to rake the sand smooth, then create images in the sand, or encourage students to rake a pile of leaves into a mound and then dance in the dried leaves. Interactions with nature are calming to children who have become weary of sitting at study desks, and may instruct them in processes of the natural world.

Facing, In the installation piece *Breezes in May*, Chen hung long skeins of wool as permeable walls crisscrossing the site space. Flour blown over the wool caught in its fibers or sprinkled down to the floor. These visible organic materials attracted visitors and invited interaction. Here, school children play in flour dust that sprinkled down from the strung woolen strands of the *Breezes in May* installation. Jin-Shiow Chen, *Breezes in May*, at the Flow of Irrational Elements Exhibition, 2003/5. Gallery of the Cultural Affairs Bureau of Chiayi County, Chiayi County, Taiwan. (Courtesy of the Artist)

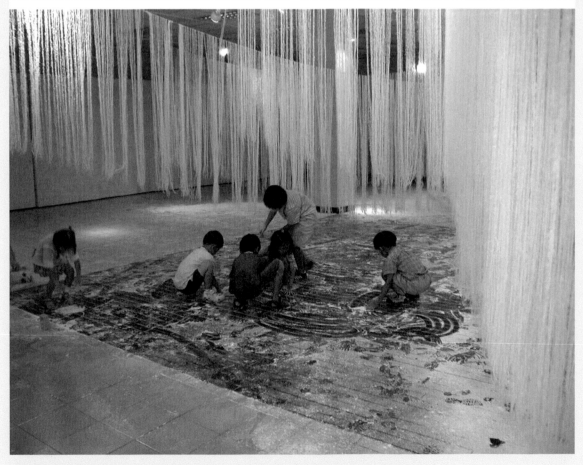

There is a mistaken notion that artists are able to accurately reproduce whatever they envision in their heads entirely and exactly, without reference to real life objects. This is not always, or even usually, true. Artists must *observe* objects to draw them with convincing realism. Also, they must refer to real life, even when creating abstractive or cartoon-like images. Not only must artists observe an object or event as it appears in a moment of time; to understand the natural world, artists must observe nature as it changes over time and as it appears in differing conditions. In the following series of images, we see how artist Joseph Turner observed and sketched sunsets as they appeared in differing weather conditions, from the same position on earth.

What natural processes can you observe in your environment? Are there subtle seasonal changes, such as ripening grain or melting snow, that can be observed as changing dramatically over the course of a week? In this lesson, you are to keep a sketchbook as a **botanical journal** of changes that you observe in nature.

INSTRUCTIONS

Part I

1. Prepare a small drawing pad as a journal for keeping sketches of natural forms that you encounter and notice over the course of one week. The sketchpad journal may be any size you are comfortable carrying on your person. Keep a pencil nearby or attach it to the drawing pad, so you will have it at the ready when needed.

2. As you go about conducting the routine activities of the week, look about you and notice natural forms that you encounter. Perhaps you will become aware of a clump of flowers blooming beside the bus stop, an icicle that forms on an eave and grows longer and then smaller each day as it begins to melt, or a bunch of bananas on the kitchen counter with a few uneaten bananas growing overripe during the passage of days.

3. Make quick thumbnail sketches of at least 12 different natural forms that you observe during the early days of the week. Make notes of *where* and *when* these were observed.

4. Revisit at least six of the items during midweek and make thumbnail sketches of how they look now. Notate the amount of time since this form was previously observed.

5. Revisit at least three of the items at the end of the week and make thumbnail sketches of how they look with this passage of time. Make notes of how the object has changed.

Part II

6. Select a natural form that changes states within a matter of hours or days. For example, an ice cube set on the counter at room temperature will melt into a puddle of water within an hour; a cut rose will open its petals fully, then wilt and die within a week.

7. Place the selected object or natural form in a place where you can observe it undisturbed as it changes its state.

8. On sheets of 9" × 12" drawing or watercolor paper, draw three large squares or rectangles of equal size (approximately 5" × 5").

9. Using soft and hard pencils on three separate sheets of paper, in each of the squares produce a careful, detailed sketch of the subject in each of three states.

10. Mount the drawings like an arrangement of **specimens** on a piece of black or grey construction paper (or other cover weight paper). Leave a small border between each drawing. Cut the backing to an even border around the three drawings.

11. You may add color with colored pencils if you like (this is not required).

Facing, Joseph Mallord William Turner (1775–1851). Four pages from *The Channel Sketchbook*, 1845. Graphite and watercolor on medium, slightly textured, white wove paper, 3¾" × 6¼" (9.9 × 15.9 cm). Paul Mellon Collection, Yale Center for British Art, New Haven, CT.

Below left, Robert Bruce Horsfall (1869–1948), *Chickadee.* Colored illustration opposite p. 372 in *Bird-Lore,* vol. 14 (New York: National Associations of Audubon Societies, 1912). American Museum of Natural History Library, New York, NY.

Below right, Laurie Gatlin, *A Robin "Making Special,"* page from sketchbook journal, 2010. Acrylic and ink on paper, 9" × 6". (Courtesy of the Artist)

12. Write a brief essay (500–650 words) addressing the following questions:
 a. Did the conscious search for natural objects to focus on as subjects of your observational sketches make you more aware of things in your natural-physical environment?
 b. Did you become aware of forms that have been present in your environment for some time but had previously gone unnoticed? Describe how it made you feel to "discover" these forms.
 c. What was the most difficult part of fulfilling Part I of this assignment? Did it become less difficult over the course of the week? Why or why not?
 d. What object did you choose to draw in three states for Part II of the assignment? What appealed to you about this object as a specimen of study?
 e. How did the object change over time, and what was the most difficult state to describe in a drawing?

Materials Needed

a sketchbook
drawing pencils in soft and
 hard leads

eraser
colored pencils (or a color
 medium of choice)

Vocabulary

Botanical Journal
Specimen

WHAT TO SUBMIT FOR EVALUATION

· pages of your sketchbook with accompanying notes
· a completed and mounted three-specimen sketch for evaluation
· a written essay response, as outlined in Instruction #12

TIPS FOR TEACHERS

Creating learning sketchbooks or journals of observations from the environment increases the likelihood that young students will notice and remember important facts about the natural world. The activity may inspire students' interest in researching to discover more about the world around them.

Seahorse (above left), *Starfish* (above right), and *The Kraken* (left); pages from Oceans and Seas Learning Journal, 2015. Students of Felicity Bland, UK. (Courtesy of Felicity Bland)

Lesson 124: Cataloguing an Outer World

Scientists observe the world around them closely so that when they see curious, unexpected, or inexplicable phenomena in the environment, questions come to mind. Why, for example, are there differing layers of colored soil revealed on the side of a cliff, or why do water and oil resist one another? Besides observing and questioning, scientists must also use their imaginations in mentally testing possible reasons for the incongruencies they perceive. Use of imagination helps hone in on areas that might be tested to determine most likely theories explaining a phenomenon. Artists play with observation and imagination is similar ways. In fact, well into the Renaissance, artists and scientists were perceived by and functioned in society similarly, and were often the same person. Science and art are essentially related.

In this lesson, you are to practice skills of observation, visual description, and imagination in tandem. You are to look closely at a small natural or man-made object of your choice and after considering the object from various intellectual perspectives, record your observed, imagined, and concluding responses in a series of drawings. Alternatively, you may draw connections between the carefully observed object and experiences in your life for which the natural form might serve as metaphor. The result will be the categorization of an object's features in a way that may trigger insightful postulations of its origins and possibilities.

INSTRUCTIONS

Part I

1. Take a single object: a piece of fruit, an antique wooden spool, a small shell, or a fossil. Look at the object closely. Turn it over and around, examining its texture, warmth or coolness, color, and form. Ruminate about the object by considering the questions outlined in Instruction #2.

2. In a sketchbook or on sheets of 9" × 12" drawing paper, write brief responses to the following:

 a. Describe the object. Look at it closely and describe what you see.
 - Color: Is it one color or are there variations of shade, tint, hue?
 - Shape: Is it a complex shape or simple one? Are there subtleties to the simple/complex shape? Describe them.
 - Size: Is it smaller or larger than others of its type? How large or small are different aspects of the object in proportion to itself (e.g., the stem to the veins, etc.)?

 b. Compare it.
 - How are the various parts different from yet related to one another?
 - What is it similar to?
 - What is it different from?

 c. Associate it.

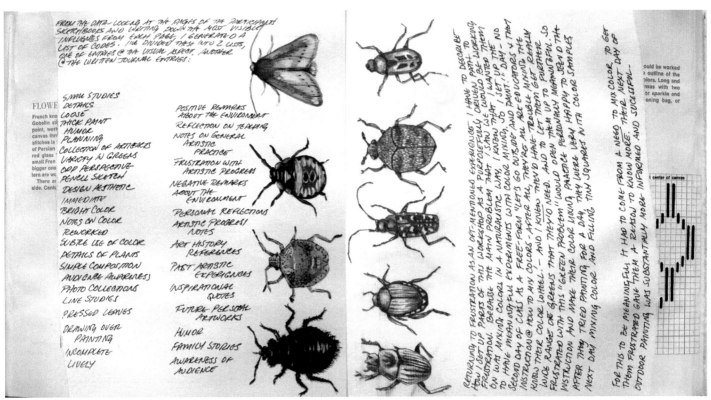

FROM THE DATA - LOOKING AT THE PAGES OF THE PARTICIPANTS SKETCHBOOKS AND WRITING DOWN THE MOST VISIBLE INFLUENCES FROM EACH PAGE, I GENERATED A LIST OF CODES. I'VE DIVIDED THAT INTO 2 LISTS, ONE OF ENTRIES @ THE VISUAL ASPECT, ANOTHER @ THE WRITTEN JOURNAL ENTRIES:

SMALL STUDIES
DETAILS
LOOSE
THICK PAINT
HUMOR
PLANNING
COLLECTION OF ARTIFACTS
VARIETY IN GREENS
ODD PERSPECTIVE
PENCIL SKETCH
DESIGN AESTHETIC
IMMEDIATE
BRIGHT COLOR
NOTES ON COLOR
REWORKED
SUBTLE USE OF COLOR
DETAILS OF PLANTS
SIMPLE COMPOSITION
AUDIENCE AWARENESS
PHOTO COLLECTIONS
LINE STUDIES
PRESSED LEAVES
DRAWING OVER PAINTING
INCOMPLETE
LIVELY

POSITIVE REMARKS ABOUT THE ENVIRONMENT
REFLECTION ON TEACHING
NOTES ON GENERAL ARTISTIC PRACTICE
FRUSTRATION WITH ARTISTIC PROGRESS
NEGATIVE REMARKS ABOUT THE ENVIRONMENT
PERSONAL REFLECTIONS
ARTISTIC PROGRESS NOTES
ART HISTORY REFERENCES
PAST ARTISTIC EXPERIENCES
INSPIRATIONAL QUOTES
FUTURE PERSONAL ARTWORKS
HUMOR
FAMILY STORIES
AWARENESS OF AUDIENCE

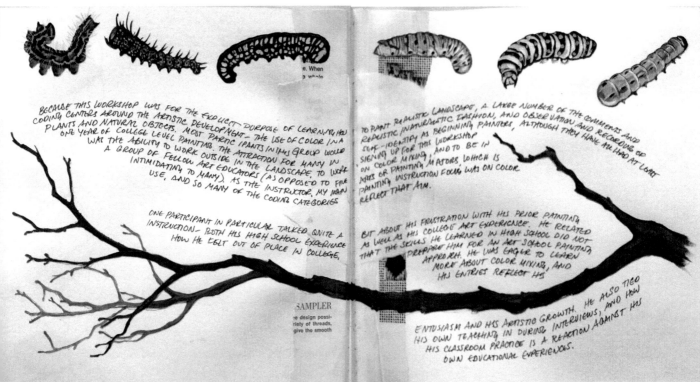

BECAUSE THIS WORKSHOP WAS FOR THE EXPLICIT PURPOSE OF LEARNING HOW CODING CENTERS AROUND THE ARTISTIC DEVELOPMENT - THE USE OF COLOR IN A PLANTS AND NATURAL OBJECTS, MOST PARTICIPANTS IN THIS GROUP WOULD ONE YEAR OF COLLEGE LEVEL PAINTING. THE ATTRACTION FOR MANY IN WAS THE ABILITY TO WORK OUTSIDE IN THE LANDSCAPE, TO WORK A GROUP OF FELLOW ART EDUCATORS (AS OPPOSED TO FIVE INTIMIDATING TO MANY). AS THE INSTRUCTOR, MY MAIN USE, AND SO MANY OF THE CODING CATEGORIES

ONE PARTICIPANT IN PARTICULAR TALKED QUITE A INSTRUCTION - BOTH HIS HIGH SCHOOL EXPERIENCE HOW HE FELT OUT OF PLACE IN COLLEGE.

TO PAINT REALISTIC LANDSCAPE, A LARGE NUMBER OF THE COMMENTS AND REALISTIC/NATURALISTIC FASHION, AND OBSERVATION AND RECORDING OF SELF-IDENTIFY AS BEGINNING PAINTERS, ALTHOUGH THEY HAVE ALL HAD AT LEAST SIGNING UP FOR THIS WORKSHOP ON COLOR MIXING, AND TO BE IN ARTS OR PAINTING MAJORS, WHICH IS PAINTING INSTRUCTION FOCUS WAS ON COLOR REFLECT THAT AIM.

BIT ABOUT HIS FRUSTRATION WITH HIS PRIOR PAINTING AS WELL AS HIS COLLEGE ART EXPERIENCE. HE RELATED THAT THE SKILLS HE LEARNED IN HIGH SCHOOL DID NOT PREPARE HIM FOR AN ART SCHOOL PAINTING APPROACH. HE WAS EAGER TO LEARN MORE ABOUT COLOR MIXING, AND HIS ENTRIES REFLECT HIS

ENTHUSIASM AND HIS ARTISTIC GROWTH. HE ALSO TIED HIS OWN TEACHING IN DURING INTERVIEWS, AND HOW HIS CLASSROOM PRACTICE IS A REACTION AGAINST HIS OWN EDUCATIONAL EXPERIENCES.

· What does it make you think of?
· What comes into your mind?
· These associations can be similarities, or you can think of different objects, times, places, or people. Just let your mind go and see what associations you have for this object.

d. Analyze it.
- Where did it come from?
- Is it man-made or natural?
- If man-made, who made it and why?
- Tell how it is made.
- If it is naturally made, what processes were involved in its making?
- If you do not know, speculate and visualize the possibilities.

e. Apply it.
- Tell what the object's purpose is/was, or what it is/was used for.
- How else might it be used?

f. Imagine it.
- Make up a story about it.
- Imagine it as playing a role or having significance in the world. This might be a realistic or fantasized role in the overall scheme of things.

g. Think of three other things.
- Extend your thinking past this object to three other things that might relate to it, have influence over it, or upon which it might have impact and influence.
- Describe these things.
- Delineate their relationship, influence, or interaction with the original object.

Part II

3. Now look over your observational responses to questions in Part I.
 a. Was there a response that seemed surprising or aroused further curiosity?
 b. Was there a response that revealed something you had not noticed before?
 c. Was there a response that stretched or challenged your imagination?

4. Closely study the object again in light of each of these surprising, revealing, or imagination-challenging responses.

5. In your sketchbook or on sheets of 9" × 12" drawing paper, write a **stream-of-consciousness** extension to each of these responses. Spend about three minutes on each stream-of-consciousness extension. Allow your thoughts to flow freely as you write. In this way, allow at least three new revelations to come *through* observation of the object.

Part III

6. Prepare a large sheet of drawing paper as a chart for images. Using an 18" ruler and pencil, divide a sheet of 9" × 12" watercolor paper into four sections.

 a. Each section will be 4½" × 6" in size.

7. In each of the sections, draw the selected object in a way that both physically describes the object and takes into account an intentional observation (Part I) or intuited stream-of-consciousness revelation (Part II) about it.

 a. Each drawing should be based on the observed actual appearance of the object, and *either* your response to a question from Part I *or* your flow-of-consciousness response to it from Part II

 b. Thus, a drawing might have elements of realism and/or abstraction.

8. Referring to your writing as a guide, make notes around or beside each drawing that address the observed or revealed discoveries.

Materials Needed

an interesting small object	18" ruler	color medium or media of your
drawing paper, 9" × 12"	drawing pencils with soft and hard leads	choice
watercolor paper, 9" × 12"	eraser	

Vocabulary

Stream-of-Consciousness/Stream-of-Consciousness Writing

WHAT TO SUBMIT FOR EVALUATION

· written responses, as outlined in Instruction #2
· written stream-of-consciousness responses, as outlined in Instruction #5
· a category chart of four drawings with written comments of a small object, in which each drawing physically describes the object and takes into account an intentional observation (Part I) or an intuited stream-of-consciousness revelation (Part II) about the object

Lesson 125: Monoprinting

Monoprinting is a process that combines features of printmaking with painterly techniques. Because only one print can be pulled at a time, repeated copies of the same image cannot be made. This, and the way paints are applied to a printing plate, means the finished monoprint may closely resemble a one-of-a-kind painting. In this lesson, you will experiment with a monoprint technique.

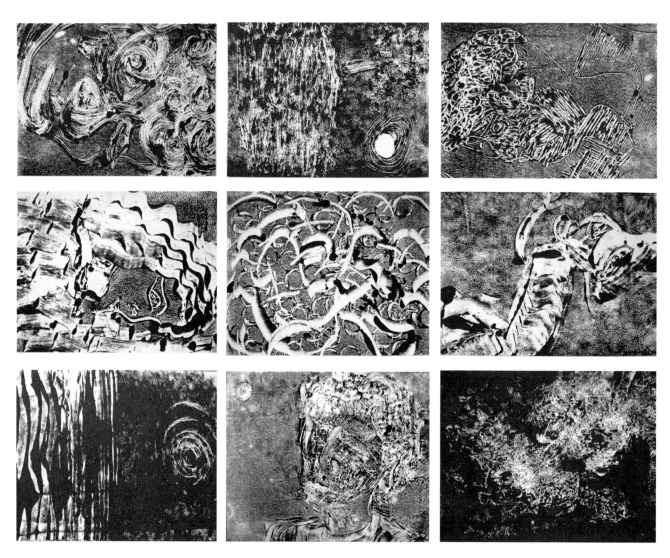

Adam Clark, *Monoprint Sampler*, 2004. (Courtesy of the Artist)

INSTRUCTIONS

Part I

1. Prepare six pieces of watercolor paper, cut to about 4" × 4" or 4" × 6" each, and dampen the papers. This can be done by blotting both sides of each piece of watercolor paper with a damp sponge.
2. Lay the watercolor papers aside. If necessary, you can cover them in plastic wrap to keep them moist while you work.
3. Create some samples of monoprint textures and lines by placing a small amount of printer's ink in the center of a sheet of Plexiglas and

smoothing the ink out with a **brayer**. (You can find Plexiglas at a craft store or hardware supply store. Choose a size that is the same as or slightly larger than a sheet of 9" × 12" drawing paper.)

4. Once the ink smoothly coats the central section of the Plexiglas, with no blank spaces or lumps of ink, use a tool of your choice, such as a dried-up ink pen, butter knife, toothpicks, or a rough sponge to create lines and textures in the ink.

5. Lay a sheet of the dampened watercolor paper on top of the inked texture and press gently so as to transfer ink to the paper.

6. Repeat Instructions #4 though #5 with each prepared sheet (six times altogether), creating a new visual texture with each new monoprint.

Part II

7. Consider an image that you would like to create using the monoprint technique. Look at artwork by a favorite artist, sketch a local landscape scene, or set up an interesting still life to draw in the ink.

8. Sketch the image on a piece of 9" × 12" white drawing paper. Fill the entire paper with the drawing.

9. Share the drawing with your peers and instructor for feedback on balance in terms of positive and negative spaces, inclusion of interesting visual textures, and overall compositional harmony.

10. Adjust the drawing to address critiques and suggestions.

11. Lay the drawing in the center of a pad of newspaper. Lay a sheet of Plexiglas beside the drawing.

12. Take two sheets of 9" × 12" watercolor paper and dampen them. This can be done by blotting both sides with a damp sponge.

13. Lay these damp papers aside. Cover them with a piece of plastic wrap if there is a chance they might dry out before you complete the next few steps.

14. Using water-based printing ink, smooth the ink onto the Plexiglas surface with a brayer. (It is important that you work quickly so the paint does not dry too quickly).

15. Using the drawing that is placed beside the Plexiglas as a guide, reproduce the drawing as a monoprint painting by scraping or marking into the smoothed ink on the Plexiglas with tools such as those described in Instruction #4.

16. Place the dampened watercolor paper on top of the Plexiglas. Apply gentle pressure to the paper, either with your hand (press lightly but do not rub) or a pad of cloth.

17. Gently lift the watercolor paper from the printing plate and lay the print aside to dry.

18. Clean and dry the Plexiglas, then lay it near your drawing again and repeat the process described above.

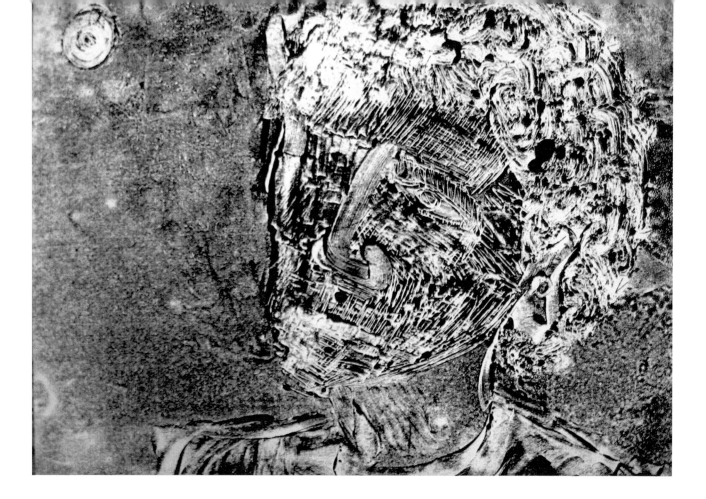

Adam Clark, *Self-Portrait with the Moon,*
2004. (Courtesy of the Artist)

19. Select the monoprint that you like the least. Add details and **visual texture** to this image using acrylic paint, tempera paint, colored markers, or ballpoint pens.

Materials Needed

drawing paper, 9" × 12"
drawing pencils with soft and
 hard leads
eraser
brayer (about 4" size)
sheet of Plexiglas, 9" × 12"
water-based printing ink in a
 color of your choice

watercolor paper or other printing
 papers (e.g., construction paper,
 drawing paper, rice paper, or
 scrapbook paper)
newspaper for keeping the work
 space clean

Vocabulary

Brayer
Monoprint
Visual Texture

WHAT TO SUBMIT FOR EVALUATION

· six monoprints texture samples
· one planned monoprint image
· a second monoprint with added details and visual texture in another medium

Lesson 126: Easy Printmaking

Printmaking generally involves processes that require one to *think in reverse*. This is an excellent mental exercise. However, printmaking in the classical sense can also be a messy process that requires the use of special and often expensive equipment. Therefore, it has been a process that classroom teachers have generally avoided and only the most dedicated hobbyists embraced. In recent years, new materials and imaginative people have presented us with simple printmaking techniques. A practical reason for using printmaking as a medium for art is that many copies can be made. If mistakes are made in one print, they can be corrected in a second. Each copy can be made intentionally the same or be altered so a series of slightly different prints result. With a bit of ingenuity, the possibilities for artistic expression are astonishing. In this lesson, you will create a **printing plate** out of a piece of Styrofoam and make a series of prints from the printing plate.

INSTRUCTIONS

Part I

Before beginning any printmaking project, you will want to think clearly about the subject matter of the print. Consider a form that is both interesting and relatively simple in terms of the outer form, but may have interesting or complex textural details. Perhaps you would like to make a charming print of a favorite bird or pet, a still life, or flowers in a garden.

- There should be at least one large object in the composition that can be overlaid with a second color.
- Once you have decided upon the subject of the print, consider how the composition could be arranged as a two-color image of contrasting colors on a third colored background.
- Be imaginative in selecting a printing paper. Consider using white drawing paper, rice paper, newsprint, decorative scrapbook paper, kraft or construction paper.

1. Make five small sketches of your idea on a piece or pieces of 9" × 12" drawing paper.
2. Share the drawings with your peers and instructor for feedback regarding which might make the most interesting composition in a repeated print.
3. Based on feedback, select the sketch you think most fits your aesthetic tastes and needs. Use this sketch to inform your print.
4. Carefully cut a square from the smooth side of a Styrofoam take-out box or use a commercially made foam printing material. This will be used as a **printing plate**. Make sure there are no embossed markings on the square. (If there are markings, these should be turned to the backside of the plate.)

5. Use a printing tool such as a dulled pencil or ballpoint pen to carefully **impress** your selected sketch image into the foam plate. Remember as you draw that the impressed lines will be the same color as the paper on which the image will be printed.

 a. Any area that is not an impressed line or area will accept ink and appear as the ink color when printed onto the paper. This will result in strong contrasts that can be softened by visual texture rather than by gradations of dark and light.

 b. Because of this mirror image reversal, it is wise *not* to use words or letters in your print.

6. Place some newspaper or other protective surface over the area where you will be working to keep the space clean.

7. Squeeze a small amount of the first color of printing ink onto a Plexiglas **inking plate**, and roll a **brayer** over the ink until the ink on the plate is evenly and smoothly distributed without lumps, and also covers the surface of the brayer evenly.

 a. Don't over-roll the ink, as it will become too dry and not transfer to the Styrofoam printing plate evenly. A good rule of thumb is to "listen" to the ink. When it makes a "snap-crackle-pop" sound and the brayer is coated evenly with ink, it's time to print the plate.

Below, Rolling ink onto Plexiglas with a brayer and pulling a first print. Students of Kelliann Meserole. (Courtesy of Kelliann Meserole)

Bottom, Printing an internal shape in second color. Students of Kelliann Meserole. (Courtesy of Kelliann Meserole)

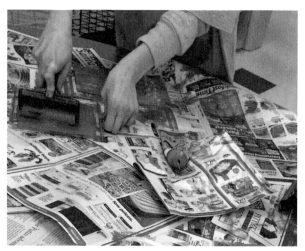
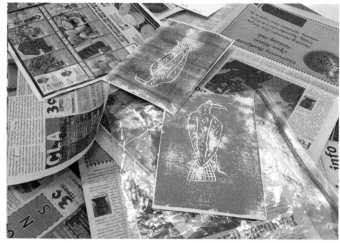

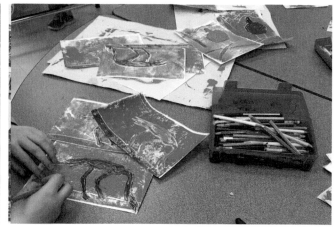

8. With the brayer, roll paint over the Styrofoam printing plate until there is an even coat of ink on the surface. Don't over-roll, as the ink will dry before it is printed.

9. Place a clean piece of printing paper on top of the inked drawing and gently rub over the surface to make sure each part of the inked surface makes firm contact with the drawing paper.

10. Gently remove the paper from the plate, and lay the paper ink-side up to dry.

11. Repeat these steps until you have made four good copies of the print on the same or different-colored backgrounds.

Part II

12. Clean and dry the printing plate and carefully cut the shape of the main or chosen object from the background.

13. Clean and dry the inking plate.

14. Roll a second color of printers ink on the inking plate and, with a brayer, transfer ink to the Styrofoam shape.

15. Place the inked shape over the shape as it appears in the original print.

16. Lay the prints aside to dry.

Four two-color prints.
Student of Kelliann Meserole.
(Courtesy of the Artists)

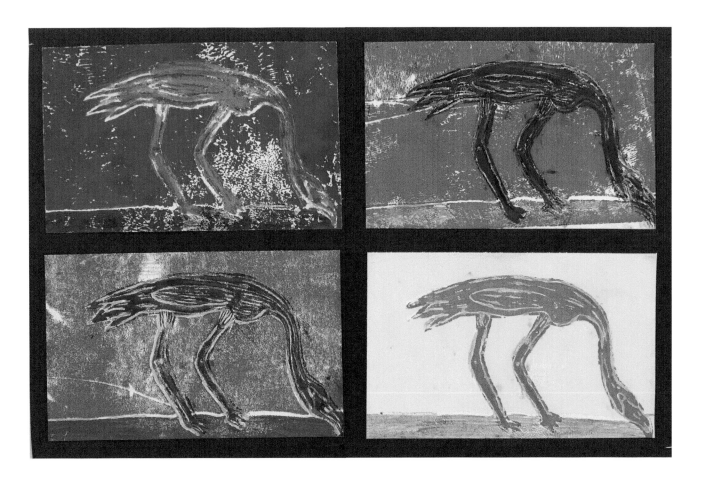

17. Once the print is dry, you can add letters or words with stencils. (*This is an optional step.*)
 a. Place the stenciled letters where you wish them to be and use markers, crayons, oil pastels, or paint (dab tiny amounts of paint with a small sponge) to fill in the letters.
18. Arrange the four completed prints on a large background of construction paper or poster board and rubber cement them in place.
19. Write a brief essay (200–300 words) in response to the following:
 a. What influenced you to choose this subject matter for your work?
 b. Describe any difficulties you had with the printing process. How did you resolve these issues, or how might you do so in the future?
 c. Give a title to the completed composition.

ART THEMES

Top, Eric Doyle, Printing plate and print modified, with text added in Photoshop. (Courtesy of the Artist)

Above, Brandon Ragains, *Anti-War Poster*. Styrofoam print, 17" × 16". (Courtesy of the Artist)

Materials Needed

large-size Styrofoam take-out box (such as are available from restaurants)or a commercially made foam printing block[2]

tool for impressing the image (such as a dull pencil or ballpoint pen with dried-up ink)

two colors of water-based printing ink (tubes)

brayer (about 4" size)

Plexiglas inking plate, 9" × 12"

several sheets of printing papers (construction paper, drawing paper, decorative scrapbook papers) in a variety of colors

newspaper or plastic picnic tablecloth to protect the area where you are working

Vocabulary

Brayer

Impress

Ink/Inking Plate

Kraft Paper

Printing Plate/Block

WHAT TO SUBMIT FOR EVALUATION

· five idea sketches for a print, with feedback notes from the critique of peers and the instructor

· completed project of four two-color prints arranged on a background

· an essay response, as outlined in Instruction #19

LESSON EXTENSIONS

1. Using two inking plates, prepare a different color on each of the plates. Quickly roll different colors of ink on the Styrofoam plate and print the plate as a multi-colored image.

2. Consider a purpose for which your print may be made. Perhaps you would like to make a political or civic statement and print several copies to be posted in public places on campus or around your community. Create a series of different printing plates and arrange them into a poster.

TIPS FOR TEACHERS

Printmaking is an excellent medium for creating multiple posters. You could encourage children to create posters about care of pets, healthy habits, or social issues of relevance to them. Then display these posters around the school or community.

The technique also lends itself to collaborative learning projects. For example, on a long sheet of **kraft paper**, have students work together to paint a natural habitat such as a prairie, desert, or woodland. Then invite students to create images of animals that live in this particular habitat. Transfer the drawings to small Styrofoam printing plates. Print the animal images in positions where they would live within the habitat. An animal could be located beside a tree, in an underground tunnel, or near a pond.

Lesson 127: A Color Collagraph

Collagraphy is a relatively new printmaking technique; the name refers to prints made from a plate of collaged items. It is an experimental or playful way of creating images that are **abstractive** or design-like. The technique involves gluing objects to a hard surface such as cardboard, then covering the printing block with ink, laying a sheet of paper on top and running the block and paper through a printing press. Materials selected for construction of the printing plate must be very thin. Appropriate materials include paper doilies, pressed leaves, and textured papers or fabrics like sandpaper, mesh, woven tweeds, or string. However, because the items used to construct the printing plates may be delicate, the very act of rolling an inked brayer over the surface of the printing block can destroy some of the items to be printed. Therefore, after items are attached to the printing plate, the entire surface may be covered with a protective covering, like varnish or foil. This not only protects the surface of the collagraph printing plate but also allows more than one print to be pulled from the block.

Properly preserved collagraph printing plates may be printed multiple times. When layers of color are printed on top of one another, ghostlike images may result, with new colors appearing where overlapped colors blend. For this reason, it is important to consider the colors that will be used for various layers of the print. For example, covering blue ink with yellow might allow some faint shades of green to seep through. Collagraph artists consider this an intriguing and desirable effect. In this lesson, you will experiment with the effects of layering differing colors in collagraph prints.

Left, Mari French, *Harvest Moon 2*, 2011 Collagraph. (Courtesy of the Artist. http://marifrenchblog.com/category /laurie-rudling)

Right, Mari French, *Arches*, 2011. Collagraph. (Courtesy of the Artist. http://marifrenchblog.com/category /laurie-rudling)

Part I

1. It is helpful to have a theme in mind before planning your cardboard plate. For example, you could create a collagraph of a science fiction subject, such as a robot or alien monster, or you could plan an interesting design.

2. Create at least four sketches on 9" × 12" drawing paper of possible subject matter.

 a. If you plan to use words or letters, they must be placed in reverse on the cardboard printing block in order to appear in correct orientation on the print.

 b. Think about the colors you will use in the process. Which color will you use first, second, and third? Why is this order of colors appropriate?

 c. Will all of the block be covered with each color, or will colors be rolled over only parts of the plate?

3. Share your sketches and ideas about printing with your peers and instructor. Explain the types of materials you plan to use as textures. Remember that these should be thin, yet thick enough to make a textural impression. Also describe the colors you plan to use and how these will applied.

4. Select the most interesting of the sketches for your cardboard block, taking into account feedback from your peers and instructor. Use this sketch to inform the layout of materials on your cardboard collagraph printing plate.

5. Carefully cut and arrange materials to construct your printing plate. Attach these pieces with tiny dabs of white glue or craft glue. In some instances, you might use small beads or lines of glue to add texture or definition lines to the plate.

6. Let the glue and block dry thoroughly before proceeding to the next step.

7. Tear a sheet of aluminum foil from the roll. The sheet should be larger than the surface of your printing block, so as to wrap the edges around to the back of the board.

8. Cover the entire surface of the printing block with a thin layer of rubber cement, and while still slightly tacky but not wet, lay the tin foil (shiny side down) on top of the rubber cement–covered block.

Collagraph plate prepared for printing: two layers of cardboard, sandpaper, yarn, and glue embellishments, covered with acrylic medium. (Created by the Author)

9. Carefully press the tin foil into the materials, so each texture and shape is clearly visible.
10. When the foil has been pushed into every area of the collagraph block, wrap the loose ends around the back of the plate and smooth them down. They can be fastened with masking tape if necessary.

Part II

Printing the Collagraph Plate

11. To keep your workspace clean, place some newspaper or other protective materials over the work area.
12. Select the three colors of water-based printing ink you will use for the colored collagraph print.
13. Squeeze about a ½ teaspoon of the first color you wish to use onto the inking plate and roll it out with a **brayer**. Continue to roll the color until the ink is evenly distributed, with no globs or uneven splotches of ink. Listen for a smooth rhythmic "snap-crackle-pop" sound; this should let you know the ink is ready to be rolled onto the collagraph block.
14. Roll the ink onto the collagraph block, making sure the ink evenly covers those areas that are to be printed. Anything *not* covered with ink will end up being the color of the paper on which the print is made.
15. Place a clean piece of printing paper on top of the painted cardboard and gently rub over the surface to make sure the inked surface makes firm contact with the drawing paper.
16. Gently remove the paper from the block, and lay ink-side up to dry.
17. Repeat this with a second and third piece of printing paper.
18. Clean the ink plate and brayer with soap and water and pat dry with paper towels.
19. When the printed papers are dry or nearly dry, squeeze the second color of ink onto the ink plate, roll it out with a brayer, and roll the color onto the collagraph block. Cover only those areas that you want to print out in this new color.
 a. Because the surface of the collagraph block is covered with foil, you can use a damp cloth or sponge the wipe off sections of ink that you do not want to print onto to printing paper.
20. Place the already printed sheet on a heavy board or cardboard. Mark the corners of the paper onto the board, so any new sheets can be laid down in the same space. Then mark where you would like the new colored plate to fall (see figure on page 602). These will be your **registration** marks.
 a. Register the print by lining up the top edge of the collagraph block with the top edge of the already printed paper. This is more easily done if you lay the block on top of the printed paper. Carefully flip the block and paper over, and gently rub the paper into the ink.

b. It is unlikely that the block will align exactly with the previous print. This is acceptable and often desirable, since **off-registration** adds to the abstractive quality of the final prints.

c. To make the prints even more abstractive, you may intentionally change the position of the plate when printing new layers.

21. Press evenly on the back of the cardboard to transfer the ink to the print paper.

a. To make sure the color has transferred evenly, you might flip the printing block, with paper stuck to it by the stickiness of the ink, and rub the back side of the paper gently and firmly against the ink-covered printing plate.

Registering a collagraph plate.
(Created by the Author)

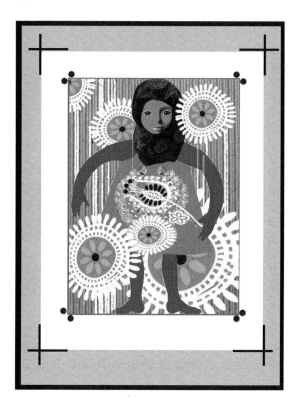

22. Repeat this with the second and third print, adding more ink to the collagraph block as needed.

23. Once again, lay these printed pages aside while you clean off the ink plate and brayer in preparation for the third and last color of ink.

24. When the ink plate and brayer are clean and the printed pages dry or nearly dry, add your third color to the ink plate, roll out the ink, and cover the sections of the collagraph block that you wish to have appear in this color.

25. Repeat until all three pages have been printed in three colors.

26. Clean your work surface, the ink plate, and brayer while the last color is drying on the printed pages.

27. Examine the printed pages, noticing how each is different. Which is the most interesting to you?

28. Give this page a title and write the title in pencil beneath the bottom left edge of the print. Write your name in pencil beneath the bottom right edge of the print.

29. Write a brief essay (400–550 words) explaining the theme of your print and why the materials used to create the collagraph block were appropriate to the theme.

 a. Explain your decisions about the choice of colors and order of their application.

 b. Describe any difficulties you had with this process. How did you resolve these issues, or how might you do so in the future?

 c. Why did you title the work as you did? What is the meaning of the title?

 d. Would the other two prints of this series be titled similarly or differently? Why?

Materials Needed

large board or heavy cardboard, at least 2" larger than your collagraph plate, to use as a registration board

large piece of sturdy cardboard, about 9" × 12" or no larger than 12" × 12" in size, for a collagraph plate; this could be cut from a clean pizza box—try not to gouge holes or impress dents into the cardboard.

several small flat textured materials to be added to the cardboard plate; these could include scraps of textured or smooth papers or fabrics, paper doilies, mesh, leaves, stencils, sandpapers or string

white or craft glue

heavy scissors

rubber cement

tin foil sheet, larger than the size of the printing plate

water-based printing ink in three colors

soft brayer (about 4" size)

inking plate (Plexiglas is recommended), 9" × 12"

several sheets of printing paper slightly larger in size than the cardboard collagraph plate; these could be kraft paper or cut paper bags, scrapbooking paper, white drawing paper, construction paper, or newspaper

newspapers or a plastic picnic tablecloth to cover the area where you are working

Vocabulary

Abstract/Abstractive

Brayer

Collagraph/Collagraphy

Off-Registration

Register/Registration

WHAT TO SUBMIT FOR EVALUATION

· four sketches for this project

· one completed print that has been titled

· a written essay response, as outlined in Instruction #29

Focus on texture rather than color. Compose four small 4½" × 6" cardboard printing blocks, each being covered with two or three differently textured items. Cover the blocks with foil as instructed above. Print each block with only one color of printing ink. Print the blocks alternately on two very large (unfolded) sheets of newspaper, 18" × 24" or larger, to create an overall pattern of rectangular-shaped textures. Create different patterns on the two sheets by alternating the direction or order of the collagraph blocks.

TIPS FOR TEACHERS

Collagraphy as a printmaking technique can lend itself to collaborative projects, and especially so when integrating science with art. For example, in science lessons, students learn that animals and insects use camouflage to help them survive in their natural environment. A collagraph could comprise an animal or insects arranged with leaves in a camouflaging environment. Students could think about how texture or patterns contribute to camouflage and try to replicate this in the materials arranged on the cardboard plate. Collectively, these collagraphs could be arranged as a classroom display to initiate discussions about animals and insects in the environment.

Lesson 128: Multicolor Block Printing

Prior to the innovation of easy and inexpensive color reproduction tools like inkjet and laser printers, artists who wanted to produce duplicate copies of an original work would have used **printmaking** media. One **printing** technique involved cutting a design into a **printing block** of linoleum or wood, covering the surface with ink, laying the inked side down on paper and running the block and paper through a press. If another color were to be added to the image, the block would be cleaned and more areas of the block design would be cut away. A new color of ink was then added to the block, which would be printed again onto the first paper image. This process might be repeated many times to produce several copies of an image.

Printing multicolored images in this way required a considerable amount of planning on the part of the artist. He or she had to be aware of which layers of the image were to be printed first, and the order of additional layers to be added. Each layer required the removal of more of the block's surface, and the application of **opaque** ink that would cover portions of the previous color. Gustave Baumann (1881–1971) was skilled at planning **woodblock** prints in up to seven colors. In his work *Aspen Red River* (1924), he seems to have printed the background first using a very dark hue. On top of this he has added blue, green, dark red, then yellow. In *My Garden* (1924), the lighter colors may have been laid down first, with progressively darker colors added in subsequent layers. In other works by Baumann, the woodblock layers might alternate from dark to light and back again to dark.

Baumann's woodblock prints required a **subtractive** method of work. Each layer is created by cutting away portions of the previously printed block. Because each new layer of color means more and more portions of the woodblock have been cut away, the woodblock will be destroyed in the process of printing. Therefore, the printer makes several copies of each layer. A challenge encountered by artists of multicolored woodblock prints is the need to **register** each layer accurately on top of the previous layer. Sometimes special frames are used to lock the print paper and woodblock into place, so that each time a block is printed it will fall onto the paper in exactly the same position as the previous layer. But prints with a **registration** that is slightly off, demonstrating **off-registration**, are also appreciated by some collectors because they result in interesting abstractive images that make them unique and therefore desirable.

If printmakers are successful in their work, they might be able to **pull** a hundred or more good prints of the same image. You can often tell how many good prints were made from a block by looking for the **impression number**. This is a handwritten number (written to look like a fraction) below the printed area. For example, 23/50 would indicate that the image you are looking at is the 23rd print out of an **edition** of 50 prints made. Printmakers also may add the title and sign the print in pencil.

In this lesson, you are to practice visualizing and planning out how layers of color must be applied in an appropriate sequence for building a color image up in an intended fashion. Special printmaking tools will be needed to create

Gustave Baumann (1881–1971), *Aspen Red River* 20/100, 1924. Color woodcut, 9¹⁄₂" × 11". New Mexico Museum of Art, Sante Fe, NM.

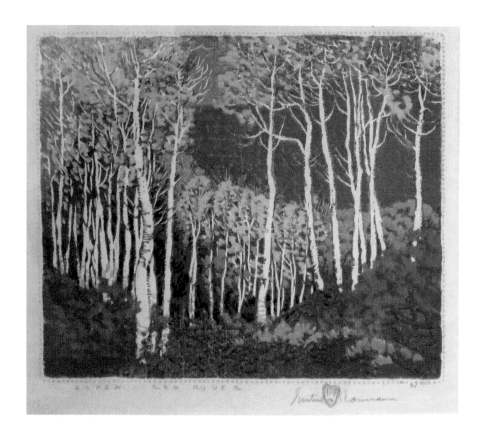

the print, so read about these, collect the necessary tools and materials, and read through the instructions before you begin.

INSTRUCTIONS

1. Search online or in books for images of color prints by Gustave Baumann. Find one that appears to have been printed with the darkest layer laid down first as a background, and one that appears to have a light layer in the background. Study these two images and consider:
 a. What is the subject matter of Baumann's print?
 b. Counting the background as a color, how many layers of color appear to have been added to make this print?
 c. Name the color layers that you see, beginning with the first layer or background and ending with the top layer.
 d. Lay the prints aside as references for considering the process of your own printmaking.
2. On sheets of 9" × 12" drawing paper, sketch four ideas for a multicolored prints. Include notes about the major areas of color that will need to be considered when composing the print. Your print may be of anything you choose, although the subject should be drawn large enough to be easily cut and printed. Good choices of subject matter could be a simple still life arrangement or objects from nature, such as a sprig of leaves or flowers, a seashell with interesting details, or a bird or small animal.
3. Share these sketches and notes with your peers and instructor for feedback.

4. Based on feedback, make a full sketch on a sheet of 9" × 12" paper.

5. Make notes directly on the paper about the intended colors for each area of the image. And plan the sequence of the layers of color that are to be laid down. This will determine the order of cuts you will need to make for each layer you print. Lay this sheet aside to use as a reference while you work.

6. Prepare eight 7½" × 9" sheets of paper on which you will print your images. The **printing paper** may be white or another color of your choice. The background color will constitute the fourth color of your print. It should be a relatively smooth but not shiny piece of paper, so it will grab the ink from the printing block easily and without smearing or resisting the ink. Construction paper is a good choice, but other papers can also work, such as some scrapbooking papers, kraft papers, a brown paper bag or newspaper cut to 7½" × 9". Use a paper cutter to cut larger sheets of paper to this size, or mark the size with a ruler and pencil, then carefully cut the paper with sharp scissors.

7. Lay the paper on a working surface that has been covered with newspapers or a vinyl cloth to keep it clean.

8. Using a ruler and pencil, lay out the spaces for your prints. Mark off a 1½" border around all the edges of the paper, so the internal area of the paper will measure 4½" × 6", which is the size of the block you will be using. To make sure the corners of the border are easy to read, you might place masking take at the corners is such a way as to allow the printable area to be outlined by the tape. This border will permit registration of the prints.

Illustration of preparing paper and × alignment. (Created by the Author)

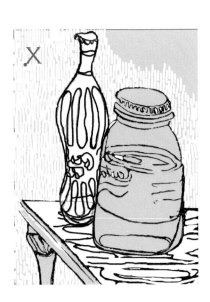

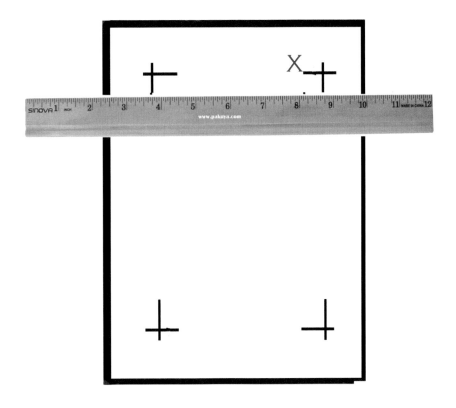

9. If the print block is a size other than 4½" × 6", adjust the size of the printing paper accordingly. Leave a clearly marked border of at least 1½" all around the section that will be printed.

10. Two sheets of 9" × 12" paper will be used as test sheets or practice prints. You will test each layer of print on this paper and make adjustments if needed before printing on the smaller papers. Test prints are called **artist's proofs**.

11. To make the block for printing, using a permanent marker or Sharpie pen, mark an × on the upper right hand back of a 4½" × 6" E-Z-Cut, Soft-Kut, or Speedball Speedy-Cut Easy printing block.

 a. When printing your block, always make sure the × appears in the upper right-hand corner when pulling a layer of color, as this will keep you from making the mistake of printing the block upside down.

12. Flip the printing block right side up and with a permanent marker or Sharpie pen, draw your image onto the block.

13. If any areas are to be the background color of the printing paper, remove these areas with your **lino cutter**.

 a. Select a cutting blade that is appropriate to the area you wish to remove in order to allow the background color to remain. Use a wide U-shaped blade to remove large areas and a small V-shaped blade to cut thin lines.

 b. Hold the cutter at a slight angle, and remove only a thin layer of the plate at a time.

 c. Be very careful to cut away from yourself, so as not to slip and cut yourself.

Illustration of cutting with cutting tool. (Photograph by Ivo Kruusamägi, Kose Art School, Japan, 2006. CC BY 2.5)

ART THEMES

14. In the center of a Plexiglas **ink plate**, squeeze or spoon out about a tea-spoon of the first ink color needed for your print.

15. Use a small **brayer** to roll out the color until the entire surface of ink is even, with no globs of uneven ink on the ink plate or brayer. Listen for a "snap-crackle-pop" sound that will let you know the ink is ready to be rolled onto the ink plate.

16. Roll the ink onto the printing block, making sure the ink evenly covers the entire surface of those areas that are to be printed.

17. Place the print upside down into one section of the test print paper.

 a. This will give you a chance to practice registration of your print. This means lining up the printing block with the edges of the bor-der on the printing paper. Try to line up the plate evenly with the top line of each marked or taped off corner.

 b. Press down steadily and evenly to make sure the ink transfers to the print paper. You may need to flip the paper and plate over care-fully, and rub the back surface of the paper with a wooden spoon to make sure all the ink transfers to the test paper.

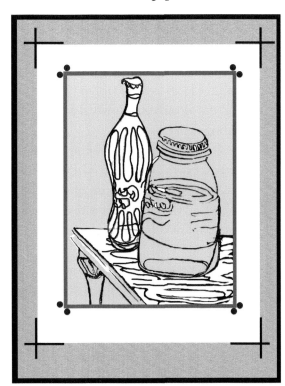

Example of registration.
(Created by the Author)

18. Check the results. If adjustments need to be made, such as additional removal of a cut line or portion of the printing block, clean off the block and make the adjustments. Then test on the second section of the test page, making further adjustments if necessary.

19. When the printing block is as you want it to be, roll out more ink on the ink plate and smooth it with the brayer. Roll an even layer of ink on the printing block and carefully place the block ink-side down onto a section of each printing paper, making sure the block aligns with the

registration borders and corners. Press down steadily and evenly to make sure the ink transfers to the paper.

20. If necessary, carefully flip the block and paper over and, using the convex surface of a wooden spoon, rub gently and evenly over the paper to make sure the ink has transferred to the paper.

21. Repeat this seven more times until you have made eight prints with this layer of ink.

22. Clean off the surfaces of the printing block, ink plate, and brayer, and wipe them dry.

23. Decide what areas now need to be removed in order to print the next layer of color. Carefully remove any areas of the printing block that you intend to have remain the layer of color previously laid down.

24. Check the already printed images to make sure they are dry. New colors should be placed on top of dry colors if you want crisp and sharp color layers.

25. When the first layer of ink is dry and you are ready to print the next of color, place a dab of this color onto the ink plate and smooth out the ink with the brayer as before.

26. Using the brayer, roll ink onto the printing block and test this layer on the test sheet. Make adjustments in the block if needed, as directed above, and test the layer again.

27. When the block is as you intend it to be, print eight copies of it on top of the ink already laid down. Add more ink to the printing block before printing each new copy.

28. Register the new colors by lining the plate up with the top line and corners of each border, as you did when printing the previous color. Realize, however, that each time you add a new layer of color, your registration (i.e., the alignment with the previous color) will be "off" a little. Some printmakers don't mind this, since it makes each print unique and interesting.

29. Repeat this process in cutting and printing the top layer of color.

30. Check your final prints. You will want to submit your best two prints for evaluation.

31. Write a brief essay (300–400 word) response to the following:
 a. Explain why you chose the subject matter of your prints.
 b. What technical considerations went into the choice of subject matter?
 c. What were some difficulties you encountered when creating these prints? How did you resolve the problems?
 d. Give a title to the prints and explain why this is an appropriate title.
 e. In pencil, write the title on left-hand side beneath the image. After the title, write the impression number as a fraction ($\frac{1}{8}$, $\frac{2}{8}$, $\frac{3}{8}$, or $\frac{4}{8}$, etc.). Write your name on the right-hand side beneath each print.

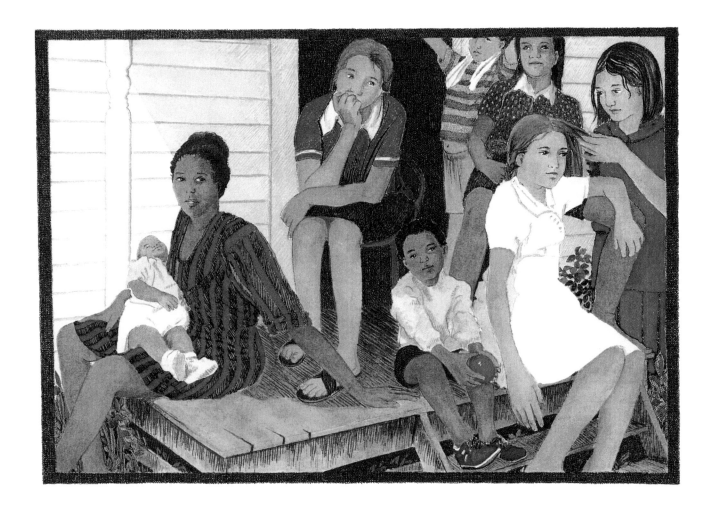

MATERIALS NEEDED

brayer (brayers come in various sizes; recommended size for this project is 3"– 4" wide)

drawing pencils with soft and hard leads

eraser

E-Z-Cut, Soft-Kut, or Speedball Speedy-Cut Easy printing block or plate, 4½" × 6". These blocks come in variable sizes, usually in packs of two or more. They are made of a soft material that is easily cut and flexible; some types may be used on the both sides. *Do not use linoleum or wood, as these materials are too difficult for novice printmakers to cut.*

ink plate (Plexiglas is recommended), 9" × 12"

lino cutter (handle with box of five changeable blades)

printing papers. Adjust the size of the printing paper to the size of the printing block, so that your paper has a border of at least 1½" all around the printing block. This will be the background of your print, and may be white or any color of your choice. The paper should be smooth, but not glossy. Some suggested papers include construction paper (although construction paper colors fade over time), colored kraft paper, scrapbooking paper, a brown

paper bag or newspaper cut to
7½" × 9"
Sharpie pen or thin-nib
permanent marker
water-based printing inks in three
colors

white drawing paper, 9" × 12"
newspaper or plastic cloth to keep
your work space clean
water, sponge, and paper towels
for cleanup

Vocabulary

Artist's Proof	Off-Registration	Pull
Brayer	Opaque	Register/Registration
Edition	Print	Subtractive Method
Impression Number	Printing Paper	Woodblock
Ink/Inking Plate	Printing Plate/Block	
Lino Cutter	Printmaking	

WHAT TO SUBMIT FOR EVALUATION

· two images of prints by Gustave Baumann, along with responses to
 questions outlined in Instruction #1
· sketches of possible prints, with notes of color layers
· a final sketch for a print, with plans for layers of color
· two practice four-color prints and eight finished four-color prints
· a written essay response, as outlined in Instruction #31

In the natural world, **camouflage** is a means by which living creatures develop colorations that permit them to blend into their natural environments. It is a survivalist adaptation that allows them to hide from prey or from being preyed upon. Here are some basic forms of camouflage:

- **Concealing Coloration**—This indicates that a creature with fur, feathers, scales, or skin has a similar color or pattern to the background of its habitat. For example, the white fur of the polar bear blends with the white of Artic snow and ice, while the dark fur of a brown bear conceals it among the tree trunks, dead leaves, and forest undergrowth of its natural habitat.

- **Disruptive Coloration**—This is somewhat similar to concealing coloration in that the color of the creature allows it to blend into the background. However, this is possible because the coloration of the animal is mottled, striped, spotted, or otherwise broken up in a way that disrupts its outline against the background, preventing a predator from identifying it. Animals like raccoons, tigers, zebras, rat snakes, and peppered moths have developed this type of camouflage.

- **Disguise**—Creatures that rely upon disguise as a form of camouflage use more than color to mask their appearance, they use shape and texture as well. In this form of camouflage, the creature not only shares the color of its surroundings but also looks like another object in its environment. Examples include underwater creatures such as Leafy Sea Dragons and insects commonly known as "walking sticks" and "leaf insects." For these creatures, the colors and shapes of their bodies serve as costumes, allowing them to hide from predators.

- **Mimicry**—A harmless or defenseless creature using mimicry will imitate another creature that is poisonous, dangerous, or generally unpalatable to predators. Thus, predators are deterred from attempting to prey upon the harmless creature out of evolutionary concern for self-preservation. Some creatures imitate others whom they wish to avoid to their own advantage. Examples of mimicry are seen in the recently discovered Lygodium Spider Moth, whose wings are patterned to imitate the spider that would otherwise be its predator, and the Death's Head Hawkmoth, whose patterning resembles a honey bee, thus allowing it to steal honey from a bee hive without being recognized as an intruder and stung to death.

- **Transparency**—In this less common form of camouflage, creatures develop transparent body parts, which allows them to blend into their habitat backgrounds. Jellyfish and the Transparent Goby fish employ this as a camouflage strategy, as do Glasswing butterflies.

Above left, Leaf Insect, at Pakke Tiger Reserve, India. (Photograph by Nandini Velho, 2010. CC BY-SA 3.0 US)

Above right, Leafy Seadragon, native of the Southern Ocean off Australia. (Photograph taken at Monterey Bay Aquarium by Joseph C. Boone. CC BY-SA 3.0 US

INSTRUCTIONS

Do an online search for fishes, mammals, reptiles, or insects that use the various forms of camouflage described above (concealing coloration, disruptive coloration, disguise, mimicry, or transparency).

1. Download five examples and make sketches of these examples.
2. Select the best of these sketches and redraw it on a 9" × 12" piece of watercolor paper.
 a. Do a careful line drawing of the creature that includes its background habitat.

Franz Marc (1880–1916), *Siberian Dogs in the Snow,* 1909/1910. Oil on canvas, 31 ¹¹/₁₆" × 44 ⅞" (80.5 × 114 cm). Gift of Mr. and Mrs. Stephen M. Kellen, National Gallery of Art, Washington, DC.

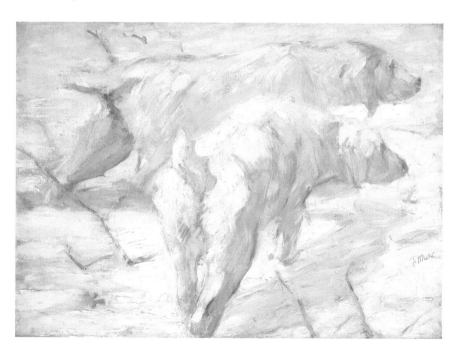

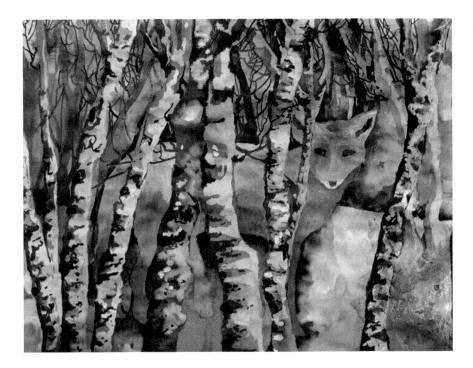

James Huntley, *Coyote* (Fado Fable Series), 2014. Acrylic, gouache, and tempera on canvas, 15" × 22". (Courtesy of the Artist)

3. Using colored pencils or watercolors, add camouflage coloration to both the creature and its habitat.

4. Identify the type of camouflage used and how it works in this particular instance.

Materials Needed

colored pencils
drawing pencils with soft and hard leads
watercolor paper, 9" × 12"

Vocabulary

Camouflage Mimicry
Concealing Coloration Pareidolia
Disguise Transparent/Transparency
Disruptive Coloration

WHAT TO SUBMIT FOR EVALUATION

· five downloaded images of various forms of camouflage
· five sketches of camouflage in nature, as presented in your downloaded images
· a completed color artwork of a creature camouflaged within a background
· an identification of the type of camouflage used by the creature and an explanation of how the camouflage works in this particular case

Human beings have a need to make sense of their cluttered visual environments, thus there is a natural inclination to seek patterns that might help organize and categorize things as familiar or unfamiliar. This can result in identifying patterns and shapes of things even when no such patterns or forms are intended, such as seeing the face of a favorite celebrity in a piece of toast or in a water stain on the ceiling. The tendency of the human brain to make sense of images by likening abstract forms to familiar objects is called **pareidolia**.

1. Find another flower or fauna form that unintentionally or intentionally (i.e., through camouflage of disguise or mimicry, or as a result of pareidolia) resembles some other natural form. Research the item, determine whether or not the resemblance is intentional, indicate that which you discover to be the case, and explain why this resemblance may occur.
 a. On a 9" × 12" sheet of drawing paper, draw an image of the flower or animal you found. Use colored pencils to complete the drawing.
2. Create an image of a habitat that is teeming with life. Include several life forms and at least one kind of camouflage within the image.

Left, The Moth Orchid is so called because it seems to resemble a moth in flight. Moth Orchid (*Phalaenopsis*), Munich, Germany. (Photograph by Diego Delso. CC BY-SA 3.0)

Middle, Some see resemblance to a swaddled baby in this tiny orchid. *Anguloa uniflora* in Gothenburg Botanical Garden, 2015. Plant id: 1990-V0330 p G. Gothenburg, Sweden. (Photograph by Gustav Svensson. CC BY-SA 3.0 US)

Right, Monkey Face Orchid (Dracula simian). In C. Luer and A. Sijm, *Monographs in Systematic Botany from the Missouri Botanical Garden.* (St. Louis: Missouri Botanical Gardens Press, 2006). (Photograph by Orchi. CC BY-SA 3.0 US)

Lesson 130: Camouflage in Art

In times of war, artists have been called upon to assist military operations by use of camouflage. You may be familiar with uniforms made of fabrics designed to **camouflage** military personnel. Fabric designers have developed different patterns to provide protection for men and women in various combat terrains, from urban to jungle or watery environments. During World War II, artists provided protective camouflage for the Allied Forces. British and Russian artists painted the roofs of buildings, roads, and runways to confuse Nazi bombers, who relied upon visual landmarks during bombing raids. American GI artists, whose unit, the 23rd Headquarters Special Troops, was dubbed the "Ghost Army," created illusions of convoys, phantom tanks, and military headquarters to deceive the enemy into believing they were outnumbered in military might.[3]

However, camouflage as an artistic effect is certainly not limited to protection or deception during times of conflict. It is also used playfully, to delight the eye and engage curiosity. Illustrators like Martin Handford, author-illustrator of the *Where's Waldo* books, and artist Beverly Doolittle[4] playfully hide objects in plain sight, and then invite readers to search for them amid visual clutter.

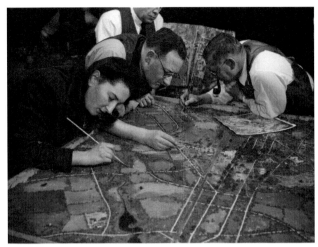

INSTRUCTIONS

Part I

1. Look up examples of artwork by Beverly Doolittle. Download two examples for reference.
2. Search for two examples of military craft or vehicles (airplanes, ships, trucks, tanks, etc.) that are camouflaged to blend in with a terrain, water, or air environment. Download these images.
3. Lay all four images out in front of you and study them, comparing and contrasting them for similarities or differences.
4. Write an essay (500–650 words) in response to the following:
 a. Do the artists employ similar or different forms of camouflage in each of the examples? Describe the similarities and differences.
 b. Refer to Lesson 129 for a description of the various types of camouflage found in nature. What types of camouflage are used in these images?
 c. Do you see a type of camouflage being used that is not described by those found in nature? If so, describe the characteristics of the camouflage.

Top, A student who is preparing for work in the military or industry makes corrections to the photograph of a camouflaged defense plant model. Marjory Collins, *Camouflage Class in New York University,* 1943. Farm Security Administration—Office of War Information Color Photographs, Prints and Photographs Division, Library of Congress, Washington, DC.

Bottom, Arthur Lismer (1885–1969), *Olympic with Returning Soldiers,* 1919. Oil on canvas, 48 7/16" × 64 5/16" (123 × 163.3 cm). Beaverbrook Collection of War Art, Canadian War Museum, Ottawa, ON.

Part II

5. Select a satellite image of an **aerial map** showing an urban area. Zoom in to view an area of approximately ¼ square mile or less, and print this map out as large as possible on a regular-sized (8½" × 11") piece of printing paper.

6. Select several satellite images of a rural or unpopulated area that is geographically near the urban area. If the geographic places chosen are located in a temperate climate zone, download images of the nearby unpopulated terrain as the area would look in the summer and as it would look during winter.

7. If the geographic places selected are located in a warm wet climate, select satellite images that show the nearby rural terrain during wet and dry seasons, and/or during early morning and late evening.

8. Both the urban and rural areas selected for use should encompass an area of the same size (about ¼ square mile).

ART THEMES

9. Print each of the map sections out as large as possible on regular-sized (8" × 11") sheets of printing paper. These will serve as references for creating a camouflaged image of the urban terrain.

10. Using a scanner, make two black and white copies of the urban satellite image.

11. Study all the satellite maps carefully, with special attention to the coloration, light effects, and geographic features of the unpopulated terrain under different conditions.

12. Carefully plan out how the urban image might be camouflaged by coloring or distorted lighting to resemble the unpopulated landscape in these situations. (*Remember, you can think of camouflage as hiding objects so they disappear into a background, appearing to be something else, or suggesting that objects are present when they are not.*)

13. Using colored pencils or markers, color the two urban aerial copies to closely resemble the unpopulated areas of the similar (nearby) geography, as the unpopulated terrain might appear during each of two different conditions (i.e., either summer or winter, wet or dry, or morning or evening).

Materials Needed

downloaded hard copies of aerial maps
printer paper, 8" × 11"
colored pencils

Vocabulary

Aerial Map
Camouflage

WHAT TO SUBMIT FOR EVALUATION

· four downloaded examples of art, as indicated in Instructions #1 and #2
· A written essay response, as outlined in Instruction #4
· two camouflaged images of an urban map along with the original (untouched) images and aerial maps of the nearly rural environment in various conditions

Lesson 131: An Appliqué Wall Hanging

A **wall hanging** is typically a decorated textile that is suspended on a wall as decorative art. Some people prefer to display wall hangings rather than paintings or drawings. One popular way of making a wall hanging is to use **appliqué** techniques. Appliqué involves cloth pieces of various kinds that are stitched to a cloth background. The technique is used as a means of decorating quilts or blankets, clothing, and other functional textile artifacts. In this lesson, you may try your hand at creating an appliqué wall hanging.

Left, Wallhanging: Cotton and Linen Appliqué. Adapted from a Vietnamese costume displayed at the Vietnamese Women's Museum, Hanoi, Vietnam. (Photograph by the Author)

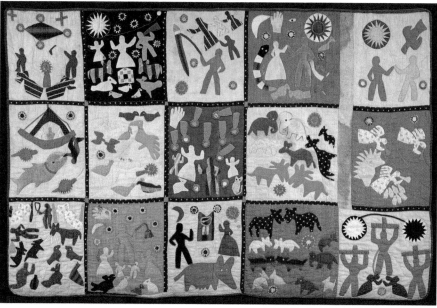

Right, Harriet Powers (1837–1910), *Pictorial Quilt,* 1895–1898. Cotton pieced, appliqué, and embroidery, 68 ¹⁴/₁₆" × 105" (1750 × 2667 mm). Bequest of Maxim Karolik, Museum of Fine Arts, Boston, MA.

INSTRUCTIONS

1. Arrange pieces of cut colored paper to make a design plan that will be enlarged to a size between 12" × 16" and 20" × 32" when replicated in cloth.
 a. The pieces may be cut to resemble **organic shapes** such as flowers, trees, leaves, or waves. They may also be **geometric shapes** that are arranged to create patterns or to resemble man-made objects such as houses, robots, or cars.
 b. When creating your plan for the design, pay attention to the **silhouettes** of the shapes you have chosen.
 c. Plan how you will repeat shapes, colors, and textures to achieve **unity** in the design.
2. Collect pieces of cloth of varied colors, shapes, and textures that complement the image in your plan. Cut them into shapes based on your plan and place them on a fabric background, which may be any size from 14" × 18" to 24" × 36".
3. Since the cloth pieces are silhouettes, your design will divide the background cloth into new spaces.
 a. The silhouettes are the **positive spaces**.
 b. The new spaces are called **negative spaces**.

c. Arrange the pieces of cloth so that the negative spaces contribute to the interesting overall design. Remember to use repeated shapes, colors, and textures to achieve unity in your appliqué design.

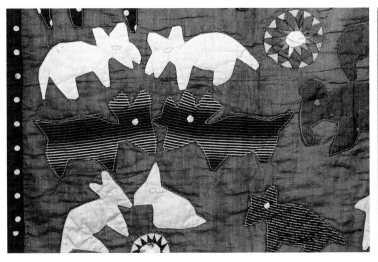

Left, Harriet Powers (1837–1919), detail of *Pictorial Quilt,* 1895–1898. Bequest of Maxim Karolik, Museum of Fine Arts, Boston, MA.

4. As a test of your sensitivity to the background (negative) spaces, make a sketch that shows the background spaces. If some background spaces seem awkward to you, move the added silhouette pieces (or positive spaces) to improve the overall design.

5. The pieces of cloth should now be neatly stitched to the background. You may use an **embroidery hoop** to keep the background taut while you loosely **baste** stitch the cloth pieces to the background.

6. The edges of the silhouette pieces can be tucked under and stitched down with **blind stitches**, or the raw edges can be covered with **decorative stitches**. The stitches that decorate the edges of the cloth should be planned as integral parts of the appliqué design. Stitches can also be used to add decorations to other parts of the cloth pieces or background. (See Lesson 133 for various types of stitches.)

7. When the design is finished, roll or fold the bottom and side edges, and stitch these down to create a **hem**.

8. Fold and stitch the top edge down to leave a 1" tunnel, through which you slip a curtain rod or **dowel rod** that is 4" longer than the width of the wall hanging. If using a curtain rod, select a type that includes screw-on ball end hardware, and attach the ball end once the rod has been run through the tunnel. If using a dowel rod, attach a ribbon or cord to either end of the rod to create a hanger.

9. In a very brief essay (200–250 words), respond to the following:
 a. Define appliqué with reference to wall hangings.
 b. Describe how the paper design and sketch of the background are related to your finished appliqué design. How did you arrive at this design?
 c. Did you use organic or geometric shapes to create the silhouettes of the design?
 d. Identify the positive shapes and negative shapes of the design.

Right, Detail of appliquéd and embroidered costume of Hao Lo people. Vietnamese Women's History Museum, Hanoi, Vietnam. (Photograph by Daderot, via Wikimedia Commons)

An appliqué technique involves attaching smaller pieces to a backing. Turn the hem of the piece to be added under and baste stitch cloth piece to a backing. (Created by the Author)

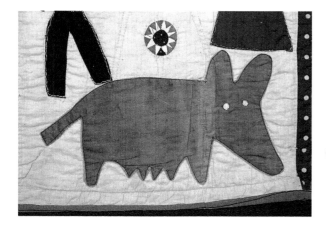

Left, Harriet Powers (1837–1919), detail of *Pictorial Quilt*, 1895–1898. Bequest of Maxim Karolik. Museum of Fine Arts, Boston, MA.

Right, Sewing a cloth tunnel and inserting a hanging rod. (Created by the Author)

Materials Needed

several pieces of cut paper
needles
threads, embroidery flosses, and/
 or tapestry yarns
pieces of fabric
scissors

embroidery hoop
curtain rod with ball end
 hardware, or dowel rod cut 4"
 wider that the wall hanging
ribbon or cord for a hanger (for
 dowel rod hanger)

Vocabulary

Appliqué	Embroidery Hoop	Positive Space
Baste	Geometric Shape	Silhouette
Blind Stitch	Hem	Unity
Decorative Stitch	Negative Space	Wall Hanging
Dowel Rod	Organic Shape	

WHAT TO SUBMIT FOR EVALUATION

· the colored paper design created as a plan for the appliqué wall hanging
· a completed appliqué wall hanging, 14" × 18" to 24" × 36", based on a cut paper plan
· an essay response, as outlined in Instruction #9

Lesson 132: Stitching with Yarn

In Western culture, working with needle and thread traditionally has been thought of as women's work. Over time, in and across various social and cultural contexts, stitching with yarn has come to be recognized as a gender-neutral medium for making art. In this lesson, you will use yarn to create a stitchery design.

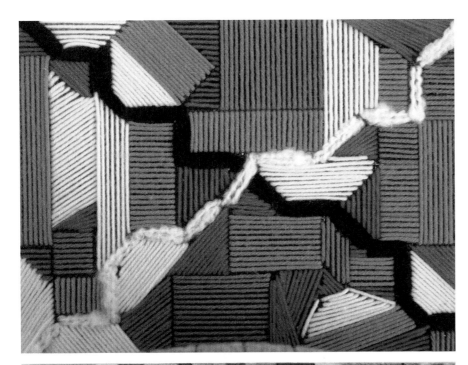

Anonymous students, yarn stitchery projects, 2004. (Courtesy of the Artists)

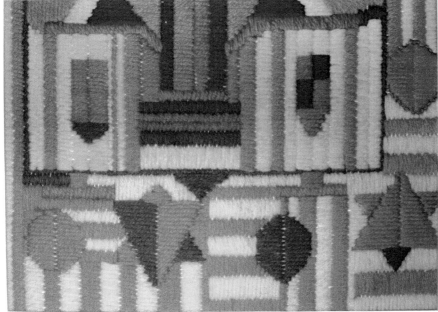

1. On four sheets of 9" × 12" white drawing paper, plan a design that will be executed in yarn stitchery.
 a. The design may include geometric, **organic**, or a combination of geometric and organic shapes.
 b. The design may be **symmetrical** or **asymmetrical**. But you must be able to tell your instructor whether it is symmetrical or asymmetrical and what makes it so.
 c. Plan the colors you will use to create the design.
2. Take a piece of **plastic mesh** or **needlepoint screen** (available at a fabric, needlepoint, or craft store) that is cut about the same size of your plan.
3. Tape the sharp ends of the edges of the screen or mesh with masking tape; this creates a border and helps keep the yarn from snagging on the screen.
4. Transfer the design to the mesh using a permanent, waterproof marking pen. Be sure the ink is completely dry before stitching the design onto the screen or mesh.
5. Thread a **yarn needle** with yarn.
 a. Knot one end to prevent it from pulling through the screen.
6. Hold the needle on the underside (back side) of the mesh and place the needle in the mesh with the sharp end pointed toward the top or front of the mesh. Pull the yarn from the back of the mesh to the front.
 a. On the front of the mesh, point the needle in at a place where you want the yarn to disappear from view. Pull the needle and yarn through to the back of the mesh.
 b. Repeat this process with different yarns and threads until you have a pleasing stitchery design.
7. Finish the edges of the mesh with a blanket stitch.

Example of scrim and stitches. (Created by the Author)

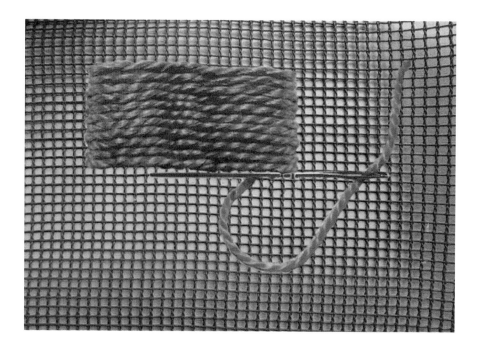

ART THEMES

Materials Needed

white drawing paper, 9" × 12"
drawing pencils with soft and
 hard leads
eraser
masking tape

needlepoint screen or plastic
 needlework mesh
yarns
yarn needle

Vocabulary

Asymmetry/Asymmetrical
Needlepoint Screen
Organic/Organic Shape
Plastic Mesh

Scrim
Symmetry/Symmetrical
Yarn Needle

WHAT TO SUBMIT FOR EVALUATION

- four drawn stitchery designs
- the final finished and well-crafted stitchery

LESSON EXTENSION

Scrim is a sturdy yet flexible material that lends itself to many practical uses. Consider having students create two stitchery pieces on scrim that could be used as the covers of a class journal or the back and front of a folder.

- Give each student two pieces of scrim cut to the same size—from 5" × 7" to 11" × 12½", depending on the size of the book or folder you wish them to make.
- Design a pattern for each piece and finish the pattern with yarn stitchery.
 - One design should incorporate the student's name.
- Finish all the edges of both pieces with blanket or staggered blanket stitches. The covers can be fastened together on three sides to make a folder, or along one edge (with pages in between) to create a journal or book.

For thousands of years, women and sometimes men have created beautiful works of art with needles and threads on fabric. In this lesson, you will practice using the medium of stitched yarn as a way of creating an artistic image.

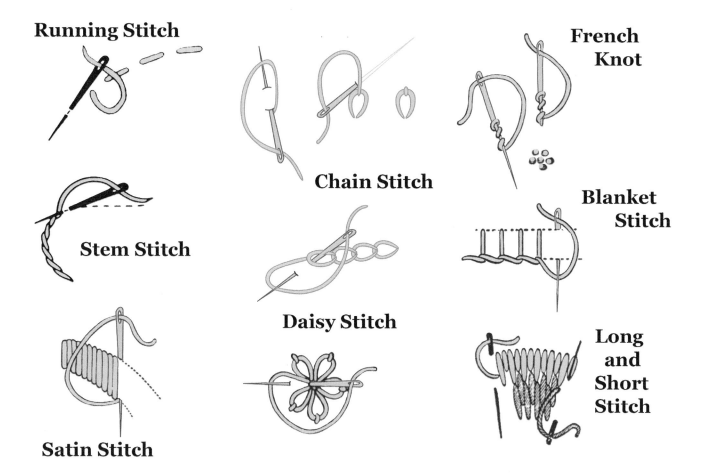

Running Stitch

Stem Stitch

Satin Stitch

Chain Stitch

Daisy Stitch

French Knot

Blanket Stitch

Long and Short Stitch

Sample of stitches.
(Created by the Author)

INSTRUCTIONS

1. Placing a large scrap of material between sections of an **embroidery hoop** to keep the fabric taut as you work, practice making the nine sample **stitches** illustrated in this lesson.
2. When you feel that you can make these stitches, draw a simple line design on a 9" × 12" sheet of white drawing paper. This is to be the basis of your **stitchery** "painting." Your design may be **abstract**, **geometric**, or **organic**. You may look at stitchery designs from different sources to get ideas for your design.
 a. Do not use commercial kits or designs, although you may get *ideas* from stitchery design books.
3. Share your sketched idea with your peers and instructor for feedback about the overall unity of the composition. Discuss the types of embroidery stitches that could be used to create the image.

Eliza M. Kandle (1822–1892), *Stitchery Sampler*, 1839. Samples of stitches; linen plain weave with wool embroidery in cross, chain, and rococo stitches, and with silk embroidery cross stitch, 22½" × 22¾" (57.2 × 57.84 cm). Philadelphia Museum of Art, Philadelphia, PA.

4. Using this feedback as a guide, make alterations to the sketch, then transfer the drawing onto a cloth that will serve as a background color. The fabric may be cut to any size between 9" square to 14" square.

5. Use a pencil or fabric marker to draw on the cloth.

6. Stretch the cloth in an embroidery hoop to keep the fabric taut as you work.

7. Using a combination of any of the stitches you practiced, and a variety of threads, yarns, or **embroidery floss**, recreate the drawn image in colored stitchery.

8. Most shapes can be edged with **outline**, **running**, or **backstitches**. **Satin** and **chain stitches** are good fill-in stitches for larger areas.

9. Search online for additional stitches, such as **fly**, **cross**, or **seed** stitches that will provide a variety of textures to your work. Combinations of these can create unusual effects.

10. Fill in most of the shapes of your design with stitchery.

11. You may add decorative materials such as buttons, sequins, feathers, and beads, although this is optional.

12. Prepare a brief essay (400–550 words):

 a. Describe how you created each of the sample stitches. Identify the difficulties you may have had. Which are the easiest, and which are the most difficult to create?

 b. Explain how you went about developing a design to be done in stitchery.

 c. Where did you get your ideas?

 d. What were the important considerations in determining an appropriate design?

 e. What combinations of stitches did you use, and why were these appropriate stitch choices?

 f. Identify any difficulties you encountered in completing this work.

Materials Needed

white drawing paper, 9" × 12"

drawing pencils

a variety of yarns, embroidery floss, twines, or tapestry threads

yarn needle and embroidery needle

embroidery hoop

backing material (burlap, poplin, linen, or other sturdy fabric, cut to any size from 9" square to 14" square)

textural decorations (buttons, sequins, feathers, beads, etc.)

Vocabulary

Abstract Shapes

Embroidery Floss

Embroidery Hoop

Embroidery Stitches: Backstitch, Chain, Cross, Daisy, Fly, Long

and Short, Outline, Running, Satin, Seed, Stem

Geometric Shape

Organic/Organic Shape

Stitchery

WHAT TO SUBMIT FOR EVALUATION

· a practice fabric with examples of eight stitches
· a line design with notes from your peers and the instructor's critiques
· a finished stitchery project
· an essay response, as outlined in Instruction #12

Pieced **patchwork** patterns have been used to decorate the tops of quilts and comforters for hundreds of years. Patchwork quilts have a special place in the history of America. Early settlers had to create their own cloths from spun and woven wool, cotton, or linen, and sew these into clothing. Because this was a difficult and time-consuming task, every scrap of fabric was considered precious and not to be wasted. Pieces of fabric left over from newly made clothing or recycled from old or outgrown clothing were shaped into pieces and arranged into patterns to create **quilt tops** or **comforters**.

Patchwork tops were not only popular because they conserved resources, they were also imbued with social significance. For example, as pioneer families began moving West across the continent, they may have looked forward to the new adventure, but they would also have felt remorse at having to leave friends and loved ones behind. To ease this separation, friendship quilts were sometimes made for the woman who were leaving for westward lands. Each patchwork pattern was created by a different friend, then all the pieces were put together to create a single quilt top, serving as a remembrance of dear ones left behind.

Pioneer women also created pieced quilt tops as they traveled westward. Often the patterns they created were named after the sights or experiences of their trip. Thus, common patterns had names such as Log Cabin, Broken Dishes, Wagon Wheel, Lone Star, or Flying Geese. Of course, we know these quilts served a practical purpose in keeping people warm during the night, but they served other purposes as well. A folded quilt offered a little padding on the wagon seat for the person riding over the long rough trail. When winds spread dust across the plains, blankets, quilts, and comforters were used to cover openings that would otherwise allow choking dust inside the wagon. When a loved one died upon the journey, wrapping him or her in a quilt for burial gave family members comfort, knowing that something symbolizing their love enfolded the dear one left in that lonely grave along the trail.

Pieced patchwork quilt tops also hold a special place in the history of the African-American people of early America. There are intriguing stories of how quilting patterns were used to help the slaves escape through the Underground Railroad. A Log Cabin quilt hanging in a window with a black center for the chimney hole was said to indicate a safe house. Other pieced patchwork patterns, displayed on quilts hung on clotheslines or draped over fence rows, were said to give clues to the safe path to freedom.

As the people of various Native American tribes interacted with or were subjugated by European settlers, their cultural practices were inevitably influenced. Many of the traditional patterns of various tribes began to be translated into pieced patterns of quilt tops or into clothing. An example of this can be seen in the strip pattern designs of Seminole quilts, the Morning Star pattern of Plains tribal quilts, and Pineapple designs of Hawaiian quilts. In this lesson, you will make a simple pieced motif and repeat it to create an interesting pieced pattern of cloth.

A quilt block pattern can have very different results, depending on how you arrange the direction of individual pieces and the fabrics in the basic block. The pattern below, for example, which is one of the most basic cuts, can be organized and repeated to create many different looks.

Above, A quilt block comprised of one large and two small triangles. (Created by the Author)

Right, Cut 12 large triangles of color **A** with the large template. Make sure there is about ¼" of fabric extending all around the template. Cut 12 small triangles of color **B** and 12 small triangles of color **C**, again making sure ¼" of fabric extends around each template. (Created by the Author)

1. A pattern **template** may be easily cut from a square piece of cover weight paper or poster board. Use a ruler and X-ACTO knife or a paper cutter to cut the pieces to exact sizes with straight edges. Depending on the size you wish your individual blocks and finished quilt top to be, start with either a 4" × 4" or 6" × 6" square template.
 a. Cut the square diagonally in half.
 b. Cut one of the resultant triangles in half again. You will have one large triangle template and two small triangle templates.
2. Next, take three different colors (A, B, and C) or patterns of cotton fabric and cut each into squares that are 1" larger than the template square (i.e., 5" × 5" or 7" × 7"). You will need six large squares of color A and three large pieces of fabric for each of colors B and C.
3. Stack the six fabric squares to be used for large triangles in color A. Lay the template on top so that ¼" of the cloth extends beyond the template edges (see below). Cut along the long edge.

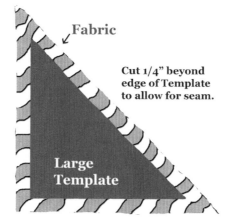

Fabric

Cut 1/4" beyond edge of Template to allow for seam.

Large Template

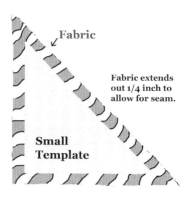

Fabric

Fabric extends out 1/4 inch to allow for seam.

Small Template

4. Stack three fabric squares to be used for smaller triangle pieces of color B.
 a. Cut the squares in half diagonally. Then lay the small template on the fabric triangles in such a way that ¼" of fabric extends beyond the edges. Cut the fabric along the short edge.
5. Repeat Instruction #4 for small triangle pieces in color C.
6. Arrange three pieces (one of A, B, and C) together and sew them together using a ¼" seam. Press the seams open so they lay flat. This reassembled block will be a **pattern motif** or **pattern block**.
7. Make nine or 12 pattern motifs.
8. Try arranging the nine or 12 pattern motifs in a number of combinations until you find an arrangement that you like.

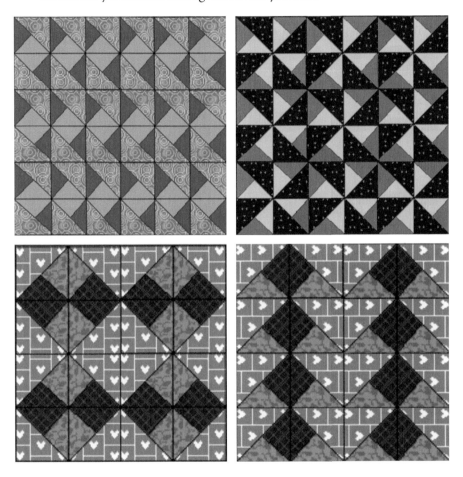

Arranging the motifs in differing ways produces a variety of patterns. (Created by the Author)

9. When you are satisfied with an arrangement, sew the nine or 12 motifs together. You will find this easier to do if you sew three together to make a strip of three pattern motifs. Repeat this three or four more times. Then sew the strips together to create a square or rectangle.
10. You have now created a quilt pattern top. To turn this into a quilt, you must now layer this patterned top with **batting** and a **backing**. For batting, you can use an old blanket or purchased fiberfill batting. For backing, use a plain or patterned piece of cotton fabric. Cut the batting and backing to the same size as the quilt pattern top and layer the three parts together, as seen here.

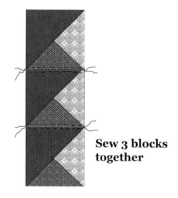

Sew 3 blocks together

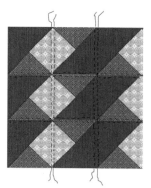

Sew 3 strips together

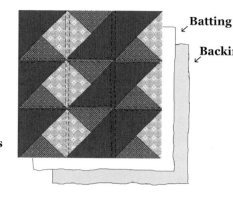

Batting

Backing

Above left and middle, Sew three pattern blocks together, and then sew the three-block strips together. (Created by the Author)

Above right, Stack layers together with pattern blocks on top of batting and backing. (Created by the Author)

11. **Tack** the three pieces together with yarn stitches in the corners of each of the pattern motif or pattern block. Carefully smooth out all layers of fabric while you work so there are no wrinkles. When all tacks are in place, **baste** the edges of the work closed.

12. Finish the edges with quilt **bias tape**, machine stitching it in place. Use quilt-size bias tape to finish the edges of the work. Follow the directions given below or on the package of bias tape to finish your work.

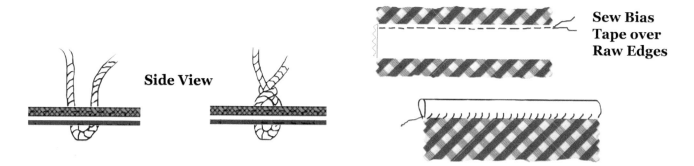

Side View

Sew Bias Tape over Raw Edges

Fabric layers are tacked together by a single stitch running from top to bottom and back again, catching all three layer of fabric. Loose ends of the thread are tied in a knot. Sew bias tape about ½" from the raw edge of fabric. Fold the tape over the raw edge of fabric and hand sew it down on the backside of the fabric. (Created by the Author)

Tacking

13. With a large-eyed needle threaded with yarn, take a single stitch through all three layers of fabric, going from front through the back and returning with the yarn to the front side, as shown in Figure 6. Cut the yarn ends to 6" and tie the ends with a knot, pulling the knot tight to the top fabric.

Finishing Raw Edges with Bias Tape

14. Open one edge of the tape and lay it along the raw edge of the layered fabrics. Baste the tape along the edge, catching all three layers of fabric. Then go over the seam with a machine or with small hand stitches.

15. Flip the bias tape over the raw edge of the fabric and fasten it down using overcast stitches, as shown above.

poster board or cover weight paper

ruler and X-ACTO knife or
paper cutter

½ yard each of three patterned
cotton fabrics

½ yard of cotton fabric for backing

½ yard of batting material (an old
blanket or fiberfill)

sharp scissors for fabric cutting

needle and quilting thread

sewing machine (*optional but
preferred*)

yarn and large-eyed needle
for tacking

1 package of quilting-size bias tape

Vocabulary

Backing

Baste

Batting

Bias Tape

Comforter

Patchwork

Pattern Block

Pattern Motif

Quilt Top

Tacking

Template

Autumn Mitchell, Quilt Front and Back,
2012. (Courtesy of the Artist)

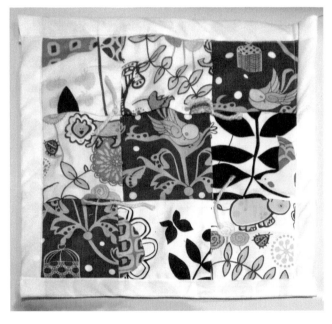 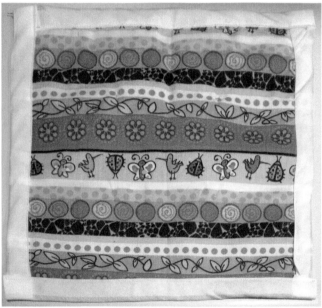

WHAT TO SUBMIT FOR EVALUATION

· a completed patchwork quilt top of three different cotton fabrics,
consisting of nine or 12 pattern blocks, assembled with three layers
(patchwork top, batting, and backing) and finished with bias tape

Lesson 135: A Mola

Molas are works of art created by the women of the Central American Kuna (or Cuna) tribe, of the San Blas Islands in Panama. Molas are made using an **appliqué** process referred to as **reverse appliqué**. Several layers of cloth, varying in color, are loosely stitched together. Fine-tipped scissors are used to cut the design of each top layer larger than the one beneath it. The cut edges are folded back and stitched to the layer below. Mola means "blouse" in Dulegaya, the language of the Kuna people. Although the mola now is considered part of traditional woman's dress, its production is believed to date only as far back as the nineteenth century, when colonialists brought cotton fabrics as trade goods to Panama.

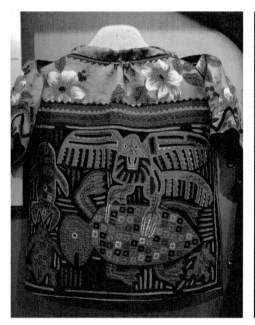

Left, San Blas Islands, *Panama Mola,* 20th century. Displayed in the Fernbank Museum of Natural History, Atlanta, GA. (Photograph by Daderot, via Wikimedia Commons)

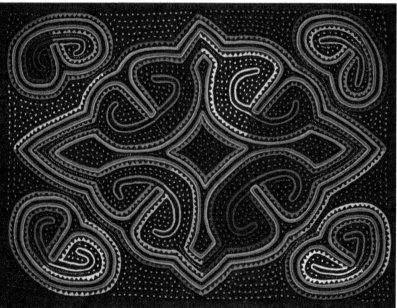

Right, Venancio Restrepo, *Mola.* San Blas Islands, Pananma. (Photograph by SV Moonrise. CC BY-SA 3.0 US)

Originally, mola **motifs** were derived from observing nature in everyday jungle and village life. Traditional motifs included birds, animals, sea life, plants, and flowers. In the late twentieth century, mola panels made for sale to tourists began to show abstract designs, images of consumer products, and icons from popular culture such as soda cans, cell phones, or cartoon characters.

A panel can have two to seven layers of cloth. To make the mola, a design is sketched with pencil on the top layer of cloth. Then fabric is snipped away, closely following the design, to reveal the lower layers of fabric. The cut is made through one or more layers to reveal the selected accent color. The large patterns are usually cut from the bottom piece, and progressively larger patterns are cut from successive layers placed atop this. The layers of fabric, cut in squares or rectangles, are then basted together. The fabric most often selected for use in making a mola is cotton. Red, black, and orange are the dominant colors; however, every color imaginable can be found in the accent fabrics.

INSTRUCTIONS

1. Look online to find examples of molas created by Kuna (Cuna) women of the San Blas Islands. Consider:
 a. What kinds of objects are represented in the mola designs?
 b. How has modern life affected the choice of objects that are represented in mola appliqué?
2. Make photocopies or download two examples of molas made by women of the Kuna tribe.
3. Draw at least six small sketches of simple objects that could make interesting mola designs.
4. Share the sketches with your peers and instructor for feedback about the quality of aesthetic appeal and important technical aspects to be considered.
5. Based on feedback and your own preferences, choose one of the designs and redraw the outline of that design in the very center of a lightweight piece of cotton fabric.
6. Draw concentric rings of the design, each larger than the previous shape, paying attention to the proportion of the design to the cloth. There should not be too much or too little space left around the design.
7. Place four layers of fabric together with the drawn design on the top piece and loosely **baste** two edges of the fabrics together so they do not slip around while you are completing the next three steps. Leave other edges free, so you can slip one hand under various layers to facilitate cutting.

Layering the fabric.
(Photograph by the Author)

8. Using very sharp fabric sheers, carefully snip the largest drawn shape out of the center of the top layer of fabric.

9. Use a pencil to trace a ½" smaller version of the shape made by the hole that was cut from the first piece of fabric, onto the second layer of color. With fabric sheers, carefully snip the shape out of the second layer of fabric.

10. Repeat the previous step on the third layer of fabric.

Left, Cutting first layer.
(Created by the Author)

Right, Cutting the next layer.
(Created by the Author)

11. Use a variety of **embroidery** stitches to cover the raw edges of the designs, while at the same time firmly attaching each to the piece below. Refer to Lesson 133 for examples of embroidery stitches.

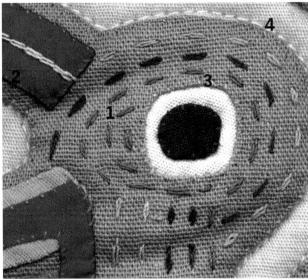

12. Use scraps cut from the design areas to further decorate cut and uncut areas of the mola.

13. In a brief essay (200–250 words), explain why you chose to create this pattern in your mola. Describe any difficulties you encountered when making the mola, and explain how you resolved the difficulty.

Materials Needed

four pieces of 12" × 12" lightweight cotton fabrics in different bright colors
sewing thread
embroidery floss
sewing and embroidery needles

sharp scissors for cutting fabric
pencil
thimble

Vocabulary

Appliqué
Baste
Embroidery

Mola
Motif
Reverse Appliqué

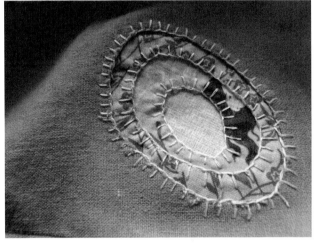

Top left, Finish the mola by adding pieces. (Created by the Author)

Top right, Add embroidery and decorative stitches. (Photograph by the Author)

Bottom right, Reverse appliqué on linen. (Photograph by Kelly Hogaboom. CC BY 2.0)

WHAT TO SUBMIT FOR EVALUATION

· two downloaded images of molas, with responses to Instruction #1
· six sketches for a mola, with feedback notes from peers and instructor
· a four-color mola panel using techniques of fabric cutting, sewing, and embroidery
· an essay response, as outlined in Instruction #13

Lesson 136: Clothing or Costume Design

The clothing people wear project stories about them. We can imagine the world as a stage and the people we see every day as wearing costumes that indicate their roles in the play of life. When given a choice of costumes, people tend to select clothing that projects the way they want to be seen or known by others in the world. Clothing manufacturers and marketers realize this, and display items for sale that will appeal to a potential customer's sense of real or desired self-image.

Left, Window Display, in Bergdorf Goodman Fifth Avenue, 2008. New York, NY. (Photograph by David Shankbone. CC BY-SA 3.0 US)

Right, Thierry Mugler (1948–), *Evening Dress*, 2010. Indianapolis Museum of Art, Indianapolis, IN. (Photograph by ellenm1. CC BY 2.0)

Throughout history, styles of clothes and the materials used to make them have reflected the geographic location, climate, culture, social status, gender, age, and historic period of the wearer. Practical considerations of clothing dictate that it protect and/or conceal parts of the body without restricting movement. Aesthetic features of clothing permit all manner of playful adornments, unconventional materials, and imaginative forms. **Avant-garde** fashions are experimental, often impractical or outlandish clothes created by designers to inspire futuristic possibilities in materials and design. In this lesson, you are to design a unique or avant-garde costume, made from a material not typically used for clothing and in a style that describes a specific persona or role.

INSTRUCTIONS

1. Begin this lesson by searching online for ideas of materials that could be used to create a costume.
 a. Search online for examples of costumes made from unusual materials, such as woven wires and plastic, laser light, newspaper, trash bags, or feathers.

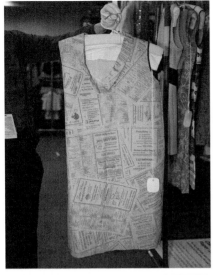

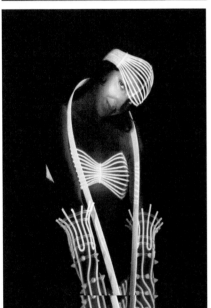

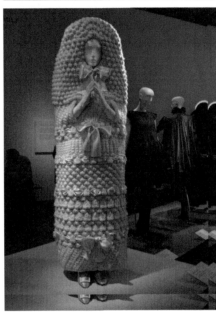

 b. Download at least five examples of clothing made from unconventional materials, and lay the images aside for inspiration as you work.

2. Scavenge materials that could be used to create unusual clothing items. These might include old clothing items from thrift stores or rummage sales, plastic bags, newspapers or magazines, soda can tabs, electric wire, ribbons, cardboard, tin foil, bubble wrap, or natural materials such as young bamboo shoots or reeds.

3. When you have collected a large range of items, begin brainstorming about a character you could dress with a costume made of one or several of these materials.

 a. Consider possibilities such as a rock star, debutante, car salesman, lawyer, ballroom dancer, athlete, gardener, or Victorian nanny.

4. On 9" × 12" sheets of paper, make sketches of at least six costume designs that could be created from some of the materials you have collected and

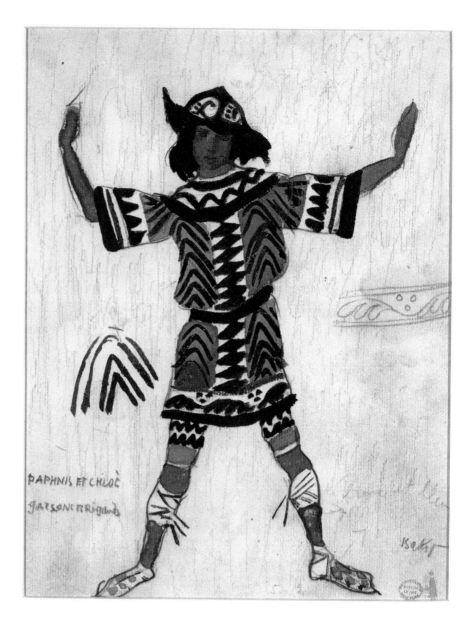

Léon Bakst (1866–1924). *Costume Design of Brigand Boy in Daphnis and Chloe,* 1912. Watercolor and lead pencil, 10 ²/₃" × 8 ¹/₃" (27 × 21 cm). Gift of Albert Gallatin, 1922, Metropolitan Museum of Art, New York, NY.

are appropriate to being worn by a specific character type. Consider both practical and aesthetic factors.

a. Practical Considerations:
- Can the body move while wearing the outfit?
- How will the wearer get into and out of the costume?
- All private body parts should be concealed or protected.
- What climate conditions should be taken into account (rain, cold, sun)?

b. Aesthetic Considerations:

Silhouette
- Overall balance (neither too top heavy or bottom heavy)
- Movement with the body or as a result of external elements
- Interesting and pleasing use of color and/or texture
- Harmony of various parts together

- Unity of design
- Added decorations or embellishments

5. Make notes about how the materials might be assembled or put together (e.g., weaving, sewing, draped and tied, glued, applied with hot glue, etc.)

6. Share your sketches and ideas with your peers and instructor for feedback about the feasibility of constructing the garment and the aesthetic aspects of your design.

7. Add feedback notes to your own sketches and notes.

8. Select a costume design that would be most interesting in terms of artistic and structural design, and redraw the sketch as a plan to follow in creating your costume.

9. Construct your costume on a dress form, manikin, or clothes hanger.
 a. You may ask a friend to serve as a model upon which to construct the design; however, take care not to cause any harm when pinning, cutting, or otherwise constructing and fitting the costume to your friend.

10. Take at least four digital photographs of the costume in the process of being constructed.

11. In a very brief essay (500–650 words), respond to the following:
 a. Describe the character for whom this costume was made and explain why this costume would be appropriate.
 b. How did the images you downloaded inspire or inform your design?
 c. Describe how you constructed the costume.
 d. What difficulties did you encounter, and how did you overcome them?

Materials Needed

dress form, manikin, or hanger upon which to build a costume

drawing paper, 9" × 12"

drawing pencils in soft and hard leads

colored pencils (or color medium of choice)

erasers

found items and crafting materials (e.g., old clothing, plastic bags, newspapers or magazines, soda can tabs, electric wire, ribbons, tissue paper, cardboard, tin

foil, bubble wrap, or natural materials such as young bamboo shoots or reeds)

pins

sewing machine and thread, or needle and thread for hand sewing if fabric is used

zippers, buttons as needed

adhesives (e.g., glues, self-adhering seam binding, wax and hot glue gun, etc.) as needed

digital camera

Vocabulary

Avant-Garde

Silhouette (Fashion)

WHAT TO SUBMIT FOR EVALUATION

- five downloaded images of fashions or costumes made from unconventional materials
- six sketches with notes of costumes that might be created of the materials you collected for a specific character you have identified
- a final sketch with notes regarding the construction of a costume from unusual and/or unconventional materials
- four digital photographs of the costume in the process of being constructed
- a created costume of unusual and/or unconventional materials
- an essay response, as outlined in Instruction #11

LESSON EXTENSION

Using cardboard and papier-mâché or found objects, design a pair of avant-garde shoes. The shoe might be made entirely by hand, using wire, cardboard, or found objects as the internal structure of the new shoe, or the new shoe might be formed over old tennis shoes, flip-flops, flats, or high heel shoes. Paint the completed papier-mâché form and add embellishments if you wish to do so.

Shoe sculptures by students of Craig Longmuir, UK. (Courtesy of Craig Longmuir)

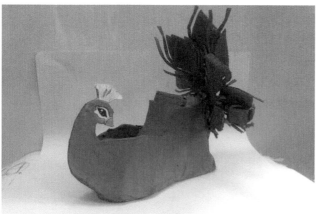
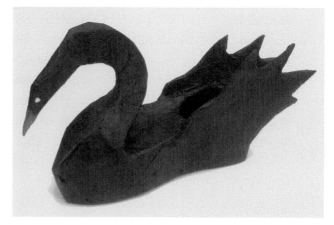

Costume design activities can be integrated with learning in social students, literature, or the arts to increase student interest and understanding of both subjects. Some activities appropriate to elementary grades include the following:

1. *Historic Costume Designs:* Invite students to research costumes worn by people during a particular cultural or historic period. Using a preprinted template of male and female figures (adult or child), invite students to draw, paint, or create collage costumes for the figures on separate pieces of watercolor paper. Add tabs at appropriate locations on the clothing and cut out the clothing designs (being sure to keep the tabs intact). Attach the students' clothing pieces to the templates using the clothing tags, as if adding outfits to paper dolls.

2. *Costume Design and Literary Character:* Choose a character from a favorite work of literature. Working in small groups, make a chart of important details about the story and the character. Perhaps the character is a cowboy who works on a ranch in Saskatchewan, Canada. How would the weather, geography, and the nature of a cowboy's work affect his clothing style? Or perhaps the character is a fairy from Shakespeare's *Midsummer Night's Dream.* How would the movement, lifestyle, and fantastic geography of a fairy influence clothing possibilities?

3. *Costume Design and Science:* Encourage students to study and draw examples of insects (e.g., dragonflies, butterflies, and moths) or flowers or birds of various species. Notice the differences in patterning, texture, color, and forms of these fauna or flora. Use observational drawings as inspiration for designing sketches of a fabric and costume that reflect the visual elements inherent in the insect, flower, or bird. On 9" × 12" paper, draw an idea for an outfit that presents these natural details in a unique way. Transfer the sketches to digital illustration software and overlay actual clips of insect or bird colorations, textures, and patterns onto the sketched fashion designs.

4. *Art and Costume Design*: Collect small swatches of many different types and designs of fabric, such as pinstripe wool, woven plaids, cotton prints, silk chiffon, velvet, leather, or burlap. Invite students to brainstorm a list of character traits of individuals who would wear a costume made of each type of fabric. In small groups, have students work together to plan a story or scenario in which three differently clad characters would interact (e.g., an individual dressed in pinstripe, one in buckskin, and one in burlap). Assign each student to illustrate one of the characters on a sheet of 9" × 12" drawing paper. Cut the figures out and arrange them in a group mural that describes the story. Ask each group to share with the others why the pairing of fabric and character was appropriate and explain how the characters relate to one another.

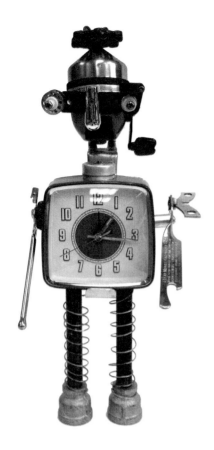

Lesson 137: An Assemblage—Anthropomorphic Transformation

Traditionally, sculptures were defined as carved objects of stone or wood. Contemporary sculptures, however, also may be constructed or *assembled* out of all manner of objects or materials: metal, glass, cloth, plastic, or natural and found objects. Sculptors may transform objects intended for one specific purpose into something altogether different. For example, looking at the front of a car, one might imagine the grill as a mouth and the car lights as eyes. Sculptors can take advantage of these unintentional effects by emphasizing them in their creations, or artists can create entirely intended illusions by arranging found or discarded objects into **assemblages** that suggest unexpected phenomena. Especially popular are constructed sculptures with **anthropomorphic** features that suggest human or animal forms. A toy car might be turned into the head of a baboon, a tricycle seat might become the form of a human head, a clock might become the body of a chubby child.

In this lesson, you will create a **found object** sculpture. In order to challenge your thinking about objects that could be used as found sculpture, you will be restricted in terms of what may *not* be used in the sculpture, yet unrestricted in terms of what materials (other than these) may be used. You may *not* use paper, Styrofoam, or plastic materials such as plates, cups, meat trays, or plastic bottles, because although these items may be unconventional art media, they can be commercially recycled into new plastic or paper items. Additionally, do not use pipe cleaners or other commercially produced crafting materials, since these are not *found* objects. Instead, think of how materials that are not generally considered as recyclable could be media for art making purposes. Your final product should have anthropomorphic characteristics that are derived from the use of found objects.

INSTRUCTIONS

1. Gather a collection of objects that are no longer needed or wanted for their original purposes but might be useful as pieces of a found object sculpture. For example, items could include a doll with a missing arm,

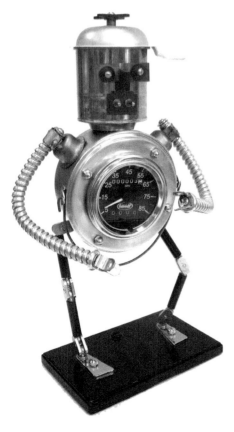

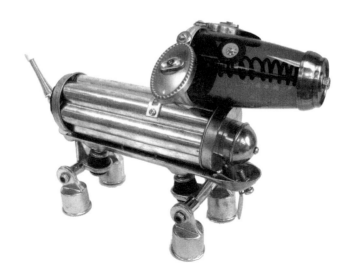

a chipped teacup, an empty cigar box, leftover electric wire, worn out gears or faucet fixtures, a frayed electric cord, a hubcap, or an old license plate.

2. Brainstorm arrangements of these pieces into an interesting assembled sculpture. Sketch out, on sheets of 9" × 12" drawing paper, at least five possible arrangements.

 a. Think about the relationship of one object to another when placing parts together. What is suggested when you set a teddy bear with a missing eye beside a chipped teacup and attach them to a box of marbles and small balls, or what is suggested when you use nuts and bolts to create the appearance of eyes, a screwdriver to create a nose, and then mount these on an oil can?

 b. Think about how you might alter some of the items by cutting, wiring, hammering, adding nails, or otherwise adding or subtracting from them.

 c. What anthropomorphic features could be suggested or highlighted?

 d. Think about how objects could be attached to one another.

 · Besides suggesting new and intriguing meanings, the found object sculpture should show an inventive method of construction. Small and large objects may be repeated or incorporated in the overall sculpture. The entire piece should be sturdily constructed and show evidence of an appropriate method of attaching materials.

 · Check out various adhesives in the hardware store. White glues, glue sticks, and tacky glues are *not* appropriate for attaching metal or plastic. Metal, ceramic, and plastic require adhesives such as wiring, nailing, welding, or hot wax to get these materials to stick and hold. Some forms of adhesives, like epoxy, can melt plastics. If you are in doubt about an appropriate adhesive substance, ask an expert at your local hardware or craft store. Do not use tape except for holding pieces together while an adhesive dries.

3. Share your sketches and ideas with your peers and instructor for feedback about the construction feasibility, aesthetic qualities, and anthropomorphic attributes of your plans.

4. Using your plans and feedback from peers and the instructor as a guide, begin assembling your project.

5. Give your completed found sculptural piece a title, and write an **artist's statement** (600–750 words):

 a. What inspired you to place one piece with another?

 b. Did you have an idea in mind before beginning the work, or did you simply go with the flow and allow ideas to arise as you manipulated parts of the whole?

 c. Explain the thought processes that went into making the piece.

 d. Describe the choices you made in selecting found objects for your sculpture. Why did you choose these objects? What new meaning does this arrangement suggest?

Facing top, Laurie Gatlin, *Untitled 1,* 2015. Found objects (clock, pipes, fishing reel, can opener, sprinkler handle), 14½" × 8" × 5". (Courtesy of the Artist)

Facing bottom left, Laurie Gatlin, *Untitled 2,* 2015. Found objects (camping pot, electrical conduit, sifter, gauge, lamp base), 13" × 8" × 6". (Courtesy of the Artist)

Facing bottom right, Laurie Gatlin, *Untitled Dog,* 2015. Found objects (drink shaker, fence caps, bread baking mold, door spring), 10" × 16" × 7". (Courtesy of the Artist)

e. Describe the methods you used to construct your sculpture.
f. What difficulties of construction did you encounter, and how did you overcome them?
g. Explain the ways your sculpture is successful. What could be improved?

Materials Needed

found objects, such as toys, jewelry, discarded CDs, cardboard, wire, tin cans or canisters (*Do not use paper, Styrofoam, or plastic plates, cups, trays or bottles, or pipe cleaners.*)

appropriate adhesives for use with the porous and/or non-porous materials you will use, such as craft glue, wood glue, a glue gun and wax, solder and welding tools, wire, duct tape, epoxy, super glue, nails (*Do not use tape.*)

Vocabulary

Additive/Additive Method
Anthropomorphic
Artist's Statement

Assemblage
Found Objects

WHAT TO SUBMIT FOR EVALUATION

· five sketches of an assemblage, with feedback notes
· a completed assemblage with anthropomorphic characteristics
· an artist's statement, as outlined in Instruction #5

LESSON EXTENSION

Assembling sculptures from found objects is an **additive method** of sculpture. This means that rather than carving materials away from wood or stone to create a form, pieces are added together to construct the form. Many contemporary artists use additive forms of sculpture to construct artworks from found objects. Three such artists are

· Deborah Butterfield
· Matthew Hollett
· Jud Turner

After examining artworks made by these artists, answer the following questions:

1. What types of materials do these artists use?
2. How do the types of materials they use relate to the natural environments or spaces where they live?
3. To what extent does their work inform viewers about conservational practices?
4. How practical is it to re-use materials in this way?

Sketch a plan for a recycled project that would inform others about how one might respect the environment through conservational practices. If possible, create a small model of the project.

TIPS FOR TEACHERS

Recycling Natural and Man-Made Materials

Using recycled materials to create works of art fits into the larger theme of teaching about ecologically sound practices. In the past, people who subsisted on agricultural or hunter-based economies often had to make do with they had. New items were expensive and often difficult to obtain. Many of the art forms associated with rural communities are a direct or indirect result of the need to recycle materials. Historically, Native American peoples made use of every part of the game they hunted. Parts of animals that were not consumed were used for clothing, decorative materials, utensils, and in rituals or religious ceremonies. This can be understood as a form of recycling elements of the natural world. In rural agrarian communities, women recycled old clothing into quilts and comforters to keep their families warm at night. This too can be understood as a form of recycling. To what extent or in what ways do we recycle today? Can natural materials be recycled, or do we think only of man-made materials as recyclable?

Your students may rightfully surmise that only a very, very small percentage of man-made materials are recycled into art, having a negligible effect on preserving the environment. You can point out, however, that in many countries or regions where people have little access to new consumer goods, recycling in a way of life. People under circumstances of limited resources learn how to repair items and use them again and again, or make things they want and need from items discarded by more affluent people. For example, in the Caribbean, people found they could make musical drums from unsightly discarded oil barrels left lying about by oil company workers. In the slums of South America, where no electricity is available for lighting, people learned to light their windowless shanty homes by inserting water-filled plastic bottles in their ceilings. The water captures light from the sun and filters it into home interiors. Research other ways that people have come to use recycled materials to their benefit.

As a class project, have students collaboratively create an artwork that instructs viewers about the benefits of recycling. Use found objects in creating the piece.

Helpful Resources

Increasingly, book publishers recognize the need for children to learn about and engage with practices of recycling. A few book resources that incorporate natural or recycled materials in art and craft lessons include the following:

· Carlson, L. *Ecoart! Earth-Friendly Art and Craft Experiences for 3- to 9-Year-Olds*. Carmel, NY: Williamson Publishing, 1992.
· Martin, L. C. *Recycled Crafts Box*. North Adams, MA: Storey Publishing, 2004.
· Martin, L. C., and D. Cain. *Nature's Art Box: From T-Shirts to Twig Baskets, 65 Cool Projects for Crafty Kids to Make with Natural Materials You Can Find Anywhere*. North Adams, MA: Storey Publishing, 2003.
· Needham, B. *Ecology Crafts for Kids: 50 Great Ways to Make Friends with Planet Earth*. New York, NY: Sterling, 1998.

Lesson 138: A Steampunk Assemblage

Steampunk is a term used to describe an **aesthetic** genre of new media (art, literature, music, theater, and film) that incorporates elements of science fiction and fantasy. Visually, steampunk combines **Victorian** style aesthetic elements with references to fantastic steam-powered technologies, such as those described in the **sci-fi** fantasies of Jules Verne and H. G. Wells. Materials used in steampunk artifacts include brass, wood, glass, leather, velvets and satin fabrics, gears, wires, tubes, and layer upon layer of details. Steampunk artists imagine and transform simple everyday object into elaborately detailed gadgets. In this lesson, you are to redefine an everyday object in a steampunk style.

INSTRUCTIONS

1. Begin this lesson by conducting visual research about the steampunk aesthetic. Search online to find ten different examples of steampunk-style objects. These should include steampunk fashions and/or accessories, household objects, vehicles, or machines.
 a. Download all ten images and refer to them as you work.
2. Make a list of at least ten visual characteristics of steampunk, as evidenced in the downloaded images.
3. Make a list of at least ten different materials that are used to create steampunk-looking items, as evidenced in the downloaded images.
4. Now go on a treasure hunt for an interesting **found object** from a garage sale, flea market, auction, second-hand store, or your own attic, closet, or garage for an item that could be re-envisioned as a steampunk object.
 a. Possible objects include old toys, such as a baby doll with a missing limb, a teddy bear with a missing eye, a little pony, or an airplane. Household objects also might be considered for re-envisioning. Items such as wind-up clocks, an old-fashioned radio, hand mixer, a world globe, rotary dial telephone, skateboard, birdhouse, or candelabra could be transformed into a steampunk version.
 b. Also look for items that could be affixed to the found object to create a steampunk aesthetic.
 c. You may have to take apart or dismantle old mechanisms to find items such as washers, gears, springs, tubes, wires, Plexiglas forms, circuit boards, a compass, leather scraps, or pieces of flexible metal.
 d. Look for interesting add-on items that can be found in the hardware section of a retail or discount store.
 e. *Do not use paper, plastic, or Styrofoam plates or cups, plastic bottles, or pipe cleaners.*
5. Lay out the objects and manipulate them as you study the various pieces to discover possible arrangements that suggest a working gadget or an object with a function more complex than it originally had.

Facing, Steampunk Assemblages by secondary students of Paula Dearringer. (Courtesy of Paula Dearringer)

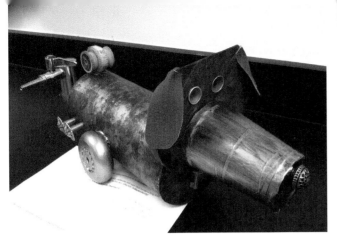

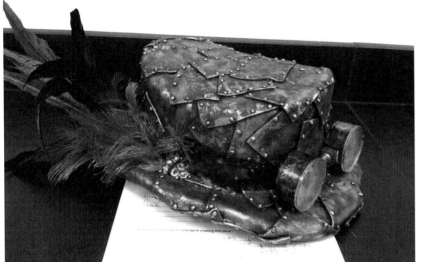

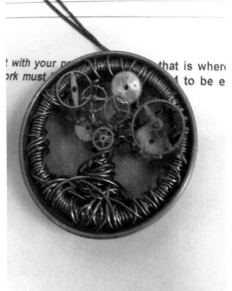

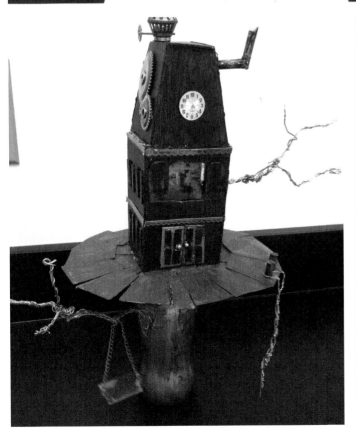

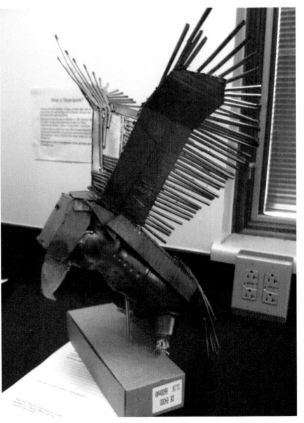

6. Make five sketches of possible arrangements of materials into innovative steampunk devices or objects. Make notes about how various items will be added or attached. Also make notes about how these parts could be painted or modified to achieve the look of steampunk.

7. Share your sketches with your peers and instructor for feedback and suggestions for additional changes or modification to produce a steampunk device or object that is structurally feasible and aesthetically appealing.

8. Taking into account feedback from your peers and instructor, select the best of your sketched ideas and redraw it in detail. Use this as a diagram of how you will construct your project.

 a. Make notes on the diagram about materials to be used, how they will be attached, and how they will be finished (e.g., painted, polished, or textured) to produce the steampunk aesthetic.

9. Select the necessary materials from those you have gathered and obtain any additional materials that are needed.

 a. These might include adhesive materials, tools, copper- or metallic-colored acrylic paints.

 b. Remember that when attaching **non-porous** materials to one another, you must use an appropriate type of glue. Craft glues, wax glue guns, epoxy, or nails, welding materials, clamps, and screws with washers can be used for adhering **porous** materials to one another.

10. Construct your steampunk item.

 a. If you are using wire, nails, welding, or other dangerous materials or processes, use safety goggles and/or protective gloves.

11. Write an artist's statement (600–750 words) about your creation:

 a. What inspired you to select this particular object for a steampunk design?

 b. Describe the choices you made in selecting found objects for your finished project:

 > Why did you choose these objects?
 > How do they convey a steampunk aesthetic?

 c. Did you have an idea in mind before beginning the work, or did you simply go with the flow and allow ideas to arise as you manipulated various items?

 d. What would your project do if it actually functioned in a world of steam-powered devices?

 e. Describe the methods you used to construct your sculpture.

 f. What difficulties of construction did you encounter, and how did you overcome them?

 g. Explain how you completed the piece with paints or other materials to create the final steampunk look.

 h. Give your work a title.

Materials Needed

everyday found objects, such as an old toy, kitchen appliance, mechanical device, old clothing, glasses, watch or clock, telephone, lamp, etc., that can be re-envisioned in a steampunk style

add-on devices, such as gears, washers, plastic tubing, dryer tubes, compass, watch face, springs, leather straps, buckles, thermos bottle parts (*Do not use plastic, Styrofoam or plastic plates, cups or pipe cleaners.*)

appropriate adhesives for use with the porous and/or non-porous materials you select to use, such as craft glue, wood glue, a glue gun and wax, solder and welding tools, wire, duct tape, epoxy, super glue, nails, etc.

(*Do not use tape. Rubber cement, paste, and white glues are only appropriate for attaching porous materials like paper and cloth to one another. They do* not *work well on glass, metal, plastics, or other non-porous materials. For other adhesive methods and materials, consult your instructor or an expert at your local hardware or craft store.*)

tools for construction— depending on your project, these might include a hammer, pliers, laser cutter, or sewing machine

finishing materials, such as metallic acrylic paints

safety goggles

plastic or workman's gloves (if appropriate)

Vocabulary

Aesthetic/Aesthetics
Found Objects
Non-Porous
Porous

Sci-Fi
Steampunk
Victorian

WHAT TO SUBMIT FOR EVALUATION

- · ten downloaded images of steampunk items from categories that include fashions and/or accessories, household objects, vehicles, and machines
- · a list of ten visual characteristics of steampunk, as evidenced in the downloaded images
- · a list of at least ten different materials that are used to create steampunk-looking items, as evidenced in the downloaded images
- · five sketches of possible arrangements of materials into innovative steampunk devices or objects
- · a final sketch, based on feedback from your peers and instructor, with notes indicating how your project is to be constructed and the materials and tools needed for its completion
- · a finished steampunk project
- · an artist's statement about your creation, as outlined in Instruction #11

Lesson 139: Wire Sculpture Manikin

Soft wire is both a malleable and challenging medium for art making. Wire can be modeled into an **armature** or foundational form for additive sculptures. Plaster, cloth, clay, or papier-mâché can be built into fantastic forms over a base of wire. Yet wire sculptures can be beautiful and interesting in themselves, without any additional applications. Artists who work in wire include Elizabeth Berrien, Rudy Kehkla, Steve Lohman, and Deborah Butterfield. Search online for examples of works by these artists to get ideas and inspiration for this lesson.

BEFORE YOU BEGIN

This is one time that working with sketches may not be productive. Wire responds to the manipulation of the hand much better if you allow yourself to *feel through* the form and react to what wire can do naturally. Attempting to force wire into a preconceived form, as indicated by a drawing, may be frustrating or non-productive. Therefore, for this lesson, begin by manipulating the wire into **freeform** shapes and let the form that begins to emerge suggest a human, animal, or object that could be developed into a sculptural piece.

Samantha Whitfield, *Wire Figures*, 2004. (Courtesy of the Artist)

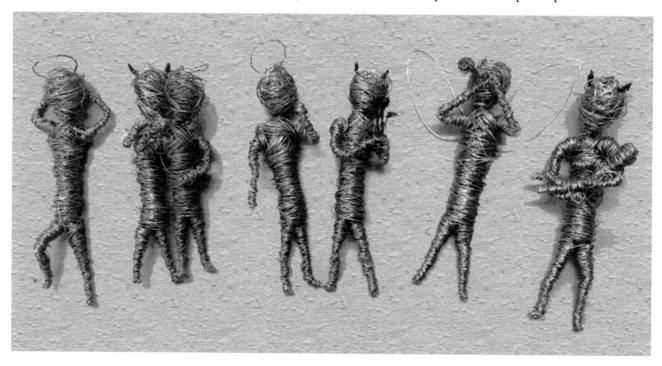

Important! Wire can be a dangerous material to work with; loose ends of wire could accidentally scratch your eyes. Therefore, in order to work safely with wire, you should

· wear protective safety goggles and gloves;
· use very soft wire, such as brightly colored telephone wire or soft copper wire;

- cut several pieces in 12" to 18" lengths, as working with short pieces is less dangerous than working with excessively long pieces.

INSTRUCTIONS

1. Begin by working with three short lengths of wire (about 18" long). Work with the wire by looping, twisting, wrapping, or bending the wire—letting your fingers and the wire make the decisions about what form to take, until the form suggests something interesting to you. Don't be hesitant to take the work apart and rework sections or add new pieces of wire, pipe cleaners, or other materials to the form as you handle the wire.

2. Once you have determined an interesting form suggested by the wire, continue to work the wire, adding more of it until the details of the form, features, and gesture are developed.

3. When you are satisfied with the form, decide how to best display it. You could make a small stand for it out of wood and mount or attach the wire structure with nails to the stand (precut wooden blocks are available at craft stores). Alternatively, you might create a hanger for the form, or allow the wire form to stand on its own without any additional support.

4. Write a brief essay (250–400 words) about the experience of creating this work:

 a. Describe how working with wire was a different process than working with other media in terms of planning and thinking through the creation process. How did this process feel to you?

 b. Describe some problems you encountered while creating the sculpture and explain how you resolved them.

 c. Explain your decision to create a stand or hanger, or to leave the wire unmounted.

 d. Give the wire sculpture a title.

Materials Needed

soft wires, such as floral wire, paddle wire, copper wires from craft stores, or telephone wire from hardware stores

optional wires, such as coat hanger wire for stands or hangers, and

pipe cleaners for decorative touches

pliers and wire cutter

safety goggles

wood block or hanger (*optional*)

nails and hammer, epoxy (*optional tools*)

Vocabulary

Armature

Freeform

- a well-crafted wire sculpture
- an essay response, as outlined in Instruction #4, explaining the experience of working in wire sculpture

LESSON EXTENSION

A wire armature that has been molded into the form of an animal or person could serve as a base for a papier-mâché or clay-covered figure. As an extension of this lesson, create figural forms of wire that suggest characters from a favorite story or movie. Nail the wire armature to a wooden base, and then cover the wire with papier-mâché or self-drying clay. When dried, paint the resultant figure and add any necessary accessories to complete your work.

Standing figures by students of Charli Neal, art teacher, UK. (Courtesy of Charlotte Neal)

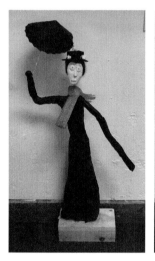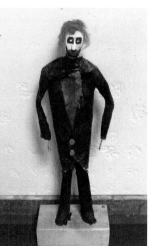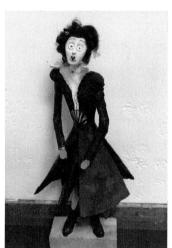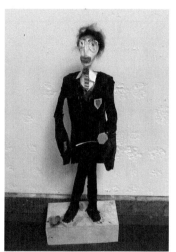

TIPS FOR TEACHERS

Obtaining Supplies for Art Making

Commercially made art making supplies are expensive, while budgets for classroom supplies are generally low. Look around the local community for supplies that could be donated. This project, for example, requires easily manipulatable wire such as telephone or florist wire. Try asking local telephone companies or florists for donations of these materials. Explore other sources for art supplies, like wallpaper sample books, scraps of fabric, cardboards and papers, foam meat trays (for printmaking), and other items that may be available and donated by local retailers and manufacturers. Most local companies are happy to contribute support toward the education of the community's children. Work out an exchange—offer to have students provide posters or artworks to decorate sponsoring stores, factories, or restaurants. This provides an opportunity to involve the community in your classroom teaching and learning, while also involving students in the community.

Lesson 140: Kinetic Sculpture

Sculptures that move are called **kinetic sculptures**. The movement may be initiated by wind, water, heat, sound vibrations, or as a result of batteries or machines. Materials used to create kinetic sculptures range from natural materials to plastics, papers, and metals. Early forms of kinetic sculptures were **mobiles** created by Alexander Calder. These delicately balanced works featured appendages that hung from braces and moved or spun with the gentlest breeze. Calder also created **stabiles**, supported by posts or stands that rested on the ground. Here again, a stabile responds to slight vibrations with swaying movements. Kinetic sculptures also can be made to move like robots, clocks, or devices that turn, bobble, or walk, with or without the assistance of handles, knobs, gears or springs, batteries, small motors, or electric circuits.

Left, A kinetic sculpture can be made to move in response to moving air currents or air, initiated by wind or human activity. Lyman Whitaker, *Whirligig,* 2006. Public Library, O'Fallon, IL. (Photograph by Robert Lawton. CC BY 2.5).

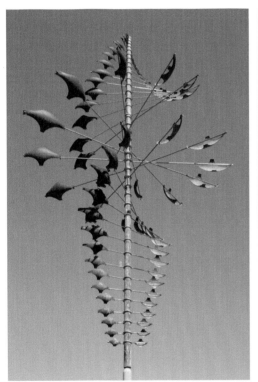

INSTRUCTIONS

1. Begin this lesson by doing a search online for kinetic sculptures to get some sense of how artists use materials, the means by which motion is initiated, and the types of movement that can be expected. Here are some places to start:
 a. Find examples of mobile and stabile art by Alexander Calder and read about the types of materials he used and how he constructed these works. What important considerations of weight, balance, and support were crucial to the success of Calder's works?

Above, Jesús Rafael Soto (1923–2005), *Soto Sphere (Esfera Concorde),* 1996. Jesús Soto Museum of Arts for Modern Sculptures, Caracas, Venezuela. (Photograph by Guillermo Ramos Flamerich. CC BY-SA 3.0 US)

Water and gravity work together to create movement. Burren & Keen, Architects and Town Planning Consultants, *Bucket Fountain*, 1969. Cuba Mall, Wellington, New Zealand. (Photograph by Matt Boulton, 2012. CC BY 2.0)

b. Look at how papers can be folded and glued together to create movement ("Kinetic Paper Sculpture," WN.com, http://wn.com /kinetic_paper_sculpture).

c. Explore sculptures created by Pete Beeman (http://www.pete beeman.com/) or McConnell Studios that move in the wind or as a result of touch or vibrations (http://www.mattmcconnell.com /#/momentum/).

d. Examine movement created by water in artworks like the Bucket Fountain, created by Burren and Keen in New Zealand ("The Bucket Fountain," *Wikipedia*, https://en.wikipedia.org/wiki /The_Bucket_Fountain).

e. Explore sculpture that moves as a result of gravity or Newton's laws of motion.

2. Download five examples of kinetic art that move as a result of differing conditions or mechanisms.

a. Download three instances from the examples suggested in Instruction #1. Lay the images aside as ideas that might inspire your work.

b. Include two additional examples that you find online. Lay the images aside as ideas that might inspire your own work.

3. On sheets of 9" × 11" or 12" × 18" drawing paper, create three sketches for an original work of art that you could create, which moves as a result of some condition or mechanical device. Make notes on your sketches that indicate you have considered the following questions:

a. What kind of movement will this sculptural piece make? What parts of it will move?

b. Under what conditions will it move, and what conditions or mechanism will initiate and/or sustain the movement?

c. How big will it be, and where will it be situated (outdoors or indoors)?

d. What materials and tools will be needed to produce this piece?

e. How will it be constructed?

4. Share your sketches and plans with your peers and instructor for feedback. What constraints to this work should be considered? Is the work interesting aesthetically as well as mechanically (i.e., in terms of movement)?

5. Following feedback, complete a new sketch that takes the feedback into consideration and include notes that will guide the construction of your work.

6. Collect materials and tools needed to create the work and begin construction.

a. Objects that could be used include batteries and circuits, cardboard, fabrics, **found objects**, gears, paper, plastic, rubber bands, small motors, springs, string, and wheels, widgets, wire, and woods.

7. If you encounter difficulties constructing your kinetic sculpture, seek advice from your instructor or from online tutorials.

8. Take several photographs of your work in progress and once it is completed. Take photos from several angles. You should end up with a minimum of 12 photographs from all stages and angles of the work.

9. Write an essay (500–650 words) in response to the following questions:

a. What inspired the ideas for your kinetic sculpture?

b. How is it intended to move and what initiates the movement?

c. What aesthetic consideration of beauty (form, harmony, and balance) went into the creation of this sculpture?

d. What difficulties did you encounter while creating this work, and how did you resolve them?

e. What works and what doesn't work, and how might the unsuccessful parts be made to work in the future?

Materials Needed

The list of materials that can be used to create kinetic sculptures is endless, but most commonly useful items include found objects, rubber bands, gears, wheels, batteries and circuits, springs, gears and widgets, string, wire, cardboard, woods, plastics and fabrics.

a glue gun with glue sticks or other appropriate adhesives
acrylic paint (spray or brush on), a brush and clean-up supplies
tools such as hammers, wire cutters, pliers, clamps, saws or Dremel tools, as needed

Vocabulary

Found Objects Mobile

Kinetic Sculpture Stabile

WHAT TO SUBMIT FOR EVALUATION

· five downloaded examples of kinetic sculpture, three from artists or sites indicated in Instruction #1, and two from sites you have identified
· three sketched ideas for an original kinetic sculpture that you might create
· personally considered ideas and feedback notes about the original kinetic sculpture you might create, as indicated in Instructions #3 and #5
· a completed kinetic sculpture
· an essay reflecting on your work, as outlined in Instruction #9

LESSON EXTENSION

As an extension of this lesson, search online for examples of sculptural works that include sound or music as an integral component of the work.

· Download visual examples of a minimum of three examples such works, and lay them aside as inspiration for an original work that you might create.
· Create a minimum of three sketches with notes about how your project could be constructed.
· Collect all materials and tools needed for this work, and create a sculpture that incorporates sound or music.
· Share the results of the finished sculpture with others.

NOTES

1. Quoted in R. Wright and R. Harris, "A Log Home in Chapel Hill," slide 3 of slide show accompanying P. Green, "At Home with Patrick Dougherty: Building with Sticks and Stones," Home and Garden section, *New York Times* (online edition), October 6, 2010, http://www.nytimes.com/slideshow/2010/10/06/garden/20101007-TWIG-3 .html.

2. Foam printing plates also are available for purchase from craft and art supply stores. These may be sold, for example, as Scratch-Foam or Printfoam.

3. See R. Beyer, director and writer, *The Ghost Army,* DVD (Boston: Plate of Peas Productions, 2013).

4. See B. Doolittle and E. MacLay, *The Forest Has Eyes* (Seymour, CT: Greenwich Workshop Press, 1998); and E. MacLay and B. Doolittle, *The Art of Bev Doolittle* (Seymour, CT: Greenwich Workshop Press, 2001).

Aborigine The indigenous people of Australia.

Abstract/Abstractive A thought or idea that is visually expressed without reference to a specific object or concrete physicality.

Abstract Shapes Random shapes that bear no reference to natural, man-made, or geometric objects.

Accordion Fold A way of folding something repeatedly, first to the right and then to the left, in such a way as to resemble a concertina or the bellows of an accordion.

Accordion Fold Book A book or booklet that opens like the bellows of an accordion or fan. Pages of the book are arranged in such a way that the reader may flip the book over to read both sides of the accordion.

Acrylic Gel Medium A milky polymer paint that has bonding properties and dries clear and hard.

Additive/Additive Method A process of adhering or uniting materials to a foundation or armature to build a three-dimensional or sculptural work.

Adinkra A symbolic form of visual communication invented by the Akan, an Ashanti (or Ashante) people living in Ghana, West Africa, during the early nineteenth century.

Aerial Map A view of the earth's surface as seen from above.

Aerial Perspective A term used to describe how air and water molecules or particulate matter in the atmosphere cause distant features of a landscape to appear lighter and bluer in color or grayer in tone.

Aesthetic/Aesthetics The underlying philosophy or worldview that informs an artistic or cultural style of expression and belief about beauty.

Alebrije A fanciful animal art form invented by Pedro Linares.

American Realism/American Realist An art movement of the early twentieth century distinguished by attention to the social realities and experiences of everyday life among ordinary people in various settings or circumstances.

Angle A space defined by two or more lines that diverge from a common point.

Animation A film created with drawings, puppets, or models rather than with live or photographic images.

Animé An art form originating in Japan characterized by highly stylized, symbol-laden figures in animation narratives.

Antagonist The adversary or villain in a narrative.

Anthropomorphic A non-human object or form having human-like characteristics.

Applied Design The application of decoration to functional objects, toys, or materials to make them more beautiful or interesting.

Appliqué A textile pattern or image created by sewing small pieces of fabric to a backing with decorative stitches.

Arabesque A decorative feature characterized by flowing scrolls and intertwining lines that reference motifs used in Arabic or Moorish art and architecture.

Arabic The language and culture of a Semitic people originating from nomadic groups in North Africa and the Middle East.

Arch A symmetrically curved structure that spans two supporting posts or walls of an architectural structure.

Archetype A character, behavior, or action that describes a universal model of human behavior.

Architectural Style Visual or structural features of a building or construction that are typical of a particular historic period and/or cultural tradition.

Architecture The design and construction of built environments.

Armature A framework of wood, wire, metal, or other sturdy material over which a sculpture of clay, plaster, or papier-mâché is molded.

Art Patron A person who provides support, especially financial support, and encouragement to an artist or artists.

Art World A term referring to all the people involved in the creation, criticism, commissioning, exhibition, preservation, promotion, support, purchase, and appreciation of art.

Artistic Tradition The aesthetic beliefs, forms, styles, and processes of art making created and appreciated by a group and passed down through its history.

Artist's Proof (Printmaking) A first impression of a print, made by the artist to test the quality of the overall design and inking process.

Artist's Statement An artist's written description of his or her work that provides an understanding of the foundational belief, theory, or philosophy that served as inspiration for the work.

Assemblage A three-dimensional construction made from a variety of materials.

Asymmetry/Asymmetrical Irregular, not straight or symmetrically balanced; for example, the letters F, G, J, P, Q, and R are all asymmetrically shaped letters of the alphabet.

Atmospheric Perspective *See* Aerial Perspective.

Avant-Garde An original, innovative, and unusual artistic creation that pushes the boundaries of what is considered stylish or fashionable (from French, meaning "advance guard").

Awl A pointed tool used to pierce holes in cardboard, leather, or similar materials.

Background The space or scenery behind the focal objects of a visual scene or composition.

Backing (Quilt) The under layer or backside of a quilt.

Balsa Wood A very lightweight and slightly flexible wood produced by a fast-growing tree species indigenous to tropical zones.

Bas-Relief A carved image that may be viewed from the front and sides, but remains attached to a solid background material.

Baste The temporary sewing together of fabrics with wide, loose, stitches made by hand or with a sewing machine.

Batting (Quilt) A cotton wadding used as filling between the upper and lower layers of a comforter or quilt.

Beach Art A form of environmental art constructed on a beach with sand as a primary medium, and swept away over time by the natural actions of waves or wind.

Bestiary A compendium of imagined or mythical creatures, each of which may combine visual characteristics of several known animals.

Bias Tape A long narrow strip of material that has been cut on the bias to ensure flexibility and evenly folded lengthwise twice or more to give it strength.

Blind Stitch A sewn stitch that is run through a folded hem is such a way as to be visible from one side only.

Botanical Journal A visual sketchbook or written journal that documents examples of natural plant forms that have been observed by the artist or journal keeper.

Brayer A roller with a handle used to smooth out ink and apply it to a printing plate.

Bristol Board A smooth-surfaced cardboard used as a base for drawings and illustrations.

Bust A drawn or sculpted portrait that includes only the head, shoulders, and chest of the subject.

Calligraphy The art of beautiful handwritten letter forms or scripts.

Camouflage The hiding of a person, animal, or object in such as way as to make it difficult to accurately identify or distinguish the subject from its surroundings.

Capital (Architecture) The top portion of a column, which has aesthetic features that mark where it meets with an upper layer of the structure.

Carnival A festival held during the week before Lent begins (in Catholic societies), characterized by costumed revelers and parades.

Cartographer A person who creates or draws maps.

Catalogue An organized list of items.

Center of Focus An emphasized area of a composition that draws the eye's attention.

Chiaroscuro A technique employed in the visual arts to represent extreme light and shadow as they define three-dimensional objects (from Italian *chiaro*, "light," and *scuro*, "dark").

Chibi (Animé/Manga) A stylized drawing of the human figure characterized by highly simplified child-like forms and features.

Cityscape An image that portrays an urban scene or city landscape.

Classical Referring to ancient Greek or Roman art, architecture, literature, philosophy, and culture.

Codex/Codices An ancient text in a folded book-like form, such as the codices of pre-Columbian peoples.

Collaborative/Collaboration The process of working together on a project that shows evidence of mutual cooperation in the design and construction of the work.

Collage Artwork created by adhering pieces of paper, fabric, photographs, and other thin materials to a backing.

Collagraph/Collagraphy A printmaking process whereby materials are attached, in a collage-like way, to a backing and then coated with ink for printing.

Collate To collect and arrange items in a proper set or order.

Color 1. (Hue) Visually perceived wavelengths of the light spectrum, from red to violet. 2. (Value) The gradation of visible light or hues from extreme light (tint) to dark (shade).

Color Medium/Media A type of colored material or materials, such as crayons or paints, used to create art.

Color Scheme An arrangement of colors that describes and categorizes colors in relationship to one another.

Color Wheel The visual spectrum from red to violet, arranged in a circle.

Column (Architecture) A pillar or post, sometimes carved or decorated, that bears the compressive weight of the upper levels of a structure.

Comforter A warm blanket made with new or re-used scraps of fabric, with a top that is often made of a sewn patchwork design, an inner layer for warmth, and a smooth lower layer. A comforter differs from a quilt in that a quilt is finished with finely sewn quilting stitches that bind the layers together, while the layers of a comforter usually are bound together with tacking stitches.

Commission To request the creation of an artwork in exchange for money or traded goods.

Compass A tool used to draw exact circles, by allowing a flexible arm with an attached pencil to rotate around a fixed point.

Compass Rose A circular symbol with text or illustrations showing the principal directions on a map.

Complementary Colors Two colors that are situated opposite to one another on the color wheel.

Composition The placement or arrangement of Elements and Principles of Art in such as way as to produce a coherent work of art.

Concave A visual or sculptural inward curve or surface, as if looking into a hollow form.

Concealing Coloration A form of camouflage in nature, whereby the coloration of a living species has evolved to blend into or match the colors of its natural habitat.

Concentric Circles One circle inside of another.

Concept Artist An artist who creates images of imaginary scenes, often related to narratives or digital games, or images of futuristic devices or environments.

Concept Illustration Illustrations of devices or environments that do not exist in reality but might exist in some future or theoretical world.

Concept Map The visual representation of an idea or a graphically presented plan showing how ideas or abstractive phenomena are connected.

Construction The process of building a large object, structure, or architectural form.

Contour(s) The visual outline of a shape or form.

Contour Drawing The line-drawn outline of a shape or form.

Contrast Strikingly different values, colors, lines, shapes, textures, or other visual/sensual elements within a composition or sculpture.

Conventional Symbols (Animé/Manga) Standardized visual motifs that serve communicative functions, such as eye shapes or types of word balloons.

Convex An outwardly curved shape or form, like that of the exterior of a globe.

Cool Colors Colors that suggest feelings or things we experience or describe as cool or cold; these include hues, tints, and shades of blues, greens, and violets.

Cornice (Architecture) A decorative molding that crowns and embellishes the top of a building.

Corrugated Cardboard Layers of very heavy kraft paper with a center of kraft paper that has been shaped into alternate ridges and grooves.

Cosplay A costume play and performance in the character of a favorite fictional person, especially of a narrative fictive from animé, manga, comics, or popular literature (a portmanteau of "costume" and "play").

Critic An expert in the arts who makes judgments about the objective characteristics, subjective qualities, and value of artworks.

Critique A critical analysis, discussion, and evaluation of a work of art by peers and experts.

Crop/Cropping To cut a large image or composition so as to focus on a small section or detail of the work.

Crop Art A form of environmental art created by planting various garden plants or field crops to create a design or image, or by cutting into ripe or growing crops to create a maze or image best seen from the sky.

Cross-Hatch(ing) Shading created by laying a series of parallel lines on top of and at an angle to another series of parallel lines.

Cubism/Cubist An art movement begun by European artists of the early twentieth century, characterized by the reduction of objects to flat, abstract, and often geometric planes.

Cultural Group A group of people who identify with one another based on a common ancestry and history, or who share traditions, interests, or social circumstances.

Curator A person charged with the collection and care of art or artifacts in a gallery or museum.

Curvilinear A line or lines characterized by a curve or curves.

Cutout Figure Layer (Tunnel Books) A layer of cutout silhouettes that are important focal points or scenic features of a tunnel book.

Cylindrical Having the shape of a cylinder.

Decorative Design A design added to functional or ornamental objects to produce a pleasant decorative effect.

Decorative Motif A repeated motif that is applied as decoration to an artifact, utilitarian object, or structure.

Decorative Stitch A hand- or machine-sewn stitch characterized by stitches placed in such a way as to resemble drawn patterns.

Design An intentional plan or visual model used to guide the creation of a building, functional object, or ornamental artifact.

Detail A small section of a larger work that focuses attention on a specific feature of the work.

Diagram A schematic plan or simplified sketch or drawing.

Diameter A straight line drawn through the center of a shape or form—especially of a circle—used as a linear measurement of that distance.

Disguise (Camouflage) Having a natural appearance that resembles the physical features of another flora or fauna in a creature's habitat, either as a means of intimidating predators or misdirecting the attention of predators.

Disruptive Coloration A form of camouflage coloration in nature that is broken and splotched in such a way as to blend in with the light and dark variations in the creature's natural habitat, such as the coloration of a tiger or zebra.

Distort/Distortion An alteration of the original shape or realistic representation, to appear abstract or to highlight a mood, emotion, or idea.

Dome (Architecture) A rounded vault ceiling or roof of a building.

Dominate/Dominance A Principle of Art whereby one art element or grouping of elements assumes more importance than others in a composition or sculptural work.

Dowel Rod A solid rod of a fixed size, made of wood or other hard material, used in construction of built objects.

Dramatic Lighting Strong contrasts between light and dark created by a strong, directed beam of light falling on objects in a darkened space.

Dreaming (Aborigine) An Aboriginal myth of the spiritual realm.

Dry Medium/Media Materials such as graphite, charcoal, crayon, color pencils, or pastels that are used to create artworks without the addition of liquids.

Earth-Tone Colors Colors ranging from neutral to rich hues that are created by the addition of slight amounts of brown or the color's complement hue in order to resemble muted colors that appear in nature.

Edition (Printing) A set of prints from the same printing plate, or a group of prints from a thematic series of printing plates.

Electromagnetic Waves A wave of energy within the electromagnetic spectrum, including radio, infrared, and visible light, ultraviolet, and X-ray waves.

Elements of Art The basic visual alphabet of art whereby features of line, shape, form, space, texture, value, and color are arranged to create compositions or sculptural works.

Ellipse/Elliptical A regular oval shape.

Elongate To make something longer and slimmer than it is or appears to be in real life.

Embroidery The use of decorative stitches or thick threads to create an image on a cloth or on a fabric or plastic mesh.

Embroidery Floss A thread traditionally used for embroidery, usually made of six loosely twisted strands of soft cotton thread, but can also be made of silk or other fibers.

Embroidery Hoop An instrument consisting two hoops of nearly the same size, equipped with tightening screws or springs. A piece of fabric is stretched and held taut between the hoop pieces.

Embroidery Stitches These include many types of stitches, such as Backstitch, Chain, Cross, Daisy, Fly, Long and Short, Outline, Running, Satin, Seed, and Stem stitches, that are used to complete an embroidered composition.

Emphasis A Principle of Art, whereby special significance is given to a feature of the composition.

Environmental Art Artworks that use natural land formations or features of the natural world as materials of art making.

Equilateral Triangle A geometric term for a triangle that has three equal sides.

Exaggerated (Features) Facial or bodily gestures that are overstated or overblown beyond what might be naturally expected, for example, grimaces rather than grins or stomping gestures rather than natural stepping motions.

Expressionism/Expressionist A style of art that places importance on the abstractive expression of emotional experiences rather than on realism.

Facade (Architecture) The front, external surface or outward appearance of a building.

Facial Proportions The classical proportions of a human face, which are dependent upon universal relationships of facial features such as the width and placement of the eye in relation to the overall width and height of the head.

Fan Art Artworks created by fans of celebrities or popular visual narratives such as comics, manga, films, video games. Fan artists copy, appropriate, or create new images in homage to their favorite person or story character.

Fan Fiction Written stories or scenarios inspired by favorite stories or characters from popular culture.

Farm Security Administration (FSA) A federal agency created in 1935 as part of the New Deal, aimed at combating poverty in rural America.

Features The visual representation of objects or phenomena in a composition, artifact, sculpture, or map.

Fibonacci (Law of) A series of numbers identified by Leonardo de Pisa of twelfth-century Italy, who attributed the discovery to East Indian mathematicians, that describes growth patterns and proportions of natural phenomena. The sequence is derived by adding together the two previous numbers in the list 0, 1, 1, 2, 3, 5, 8, 13, 21, 34, etc.

Figurative Images within a composition that are recognizably derived from the natural world and human life.

Figure The visual shape or form of a person, object, or phenomenon.

First Peoples The indigenous people of a nation, especially of peoples living in Canada.

Fix/Fixed 1. The dye process of rendering a color stable or permanent so it will neither wash out nor bleed onto other fabrics during laundering. 2. A process of stabilizing the surface of a drawing or painting with a spray, varnish, or other fixative material that will prevent smearing, fading, and deterioration.

Float (Mardi Gras) A movable platform, powered by a mechanical engine, that carries a lavishly decorated tableau in a parade.

Foam Core A lightweight layered material composed of an inner layer of polystyrene foam, covered on either side by a clay-coated or kraft paper.

Focal Point A significant feature or point in a composition that draws the viewer's eye and serves as the center of attention.

Font A letter type style used in mechanical or computerized printing.

Foreground The part of a visual composition that appears to be nearest to the viewer.

Foreshorten/Foreshortening An illusion of perspective, whereby an object extending toward and at eye level to the viewer appears much shorter than it actually is.

Form One of the Elements of Art, form refers to the outlined volume of three-dimensional figures.

Formal Balance A symmetrically balanced composition in that there is a visual equivalence or balance between both sides of the composition, even though the sides may not be mirror images.

Found Objects Objects that are commonly found and used in everyday life, including items or materials typically discarded after their intended use and not normally used as art materials.

Four Wind Blowers A symbolic figure inserted on maps, indicating typical wind patterns in geographic regions of the earth.

Fractal The shape or characteristics of a small part of a natural organic or geometric form that are statistically similar to the characteristics of the whole of that form. Fractals appear in otherwise seemingly random natural processes, such as the formation of snowflakes, erosions of soil, wind turbulence, and the formation of universes.

Frame 1. (Animé/Manga) A shape that contains a segment of action in a visual story or graphic narrative. The shape, which is frequently confined by an outline, may be altered to indicate internal thoughts and feelings, physical actions, or events in time. 2. (Storyboard) A unit of the story contained in an drawn or implied box or frame of a storyboard.

Freeform A shape, form, or structure that is created by stream-of-consciousness expression, is irregular and unintentionally created, or only loosely resembles the empirical object it attempts to represent.

Frieze (Architecture) A painted or sculpted band of decoration near the ceiling of a room or upper portion of a wall or building.

Functional Design The intentionally planned appearance and working features of an artifact, tool, or device that performs a specific function or serves a useful purpose.

Garuda A mythical eagle-like creature or humanoid bird of Hindu and Buddhist lore.

Genre A category of artistic product characterized by similarity in form, style, or subject matter.

Geometric Motif A section of a pattern that consists of geometric shapes, such as parallel lines, triangular shapes, or circles.

Geometric Shape Shapes that adhere to curvilinear or angular laws of geometry, such as circles, ovals, squares, triangles, etc.

Gesso A liquid plaster-like substance applied on a board or canvas as a ground for a painting.

Gesture The essence of an action or thought expressed in the pose or movement of a body. A gesture drawing attempts to capture a human or animal form, pose, or movement in quick, loose, expressive lines.

Gingerbread (Architecture) A particular style of highly decorative and elaborately detailed lattice-work and columns or ornaments adorning eaves and/or openings of buildings, popular among architects of late twentieth-century homes.

Glide Reflections (Tessellation) A glide reflection copies and flips a plane, then reflects it across a mirror parallel to the plane.

Glide Translation (Tessellation) A glide translation moves the reflected plane forward or backward in parallel to the line of reflection.

Global Positioning System (GPS) A navigational system whereby a device captures signals from space-based satellites and translates that information into readable real-time maps.

Golden Numbers/Golden Ratio A special number system found in nature that is derived by dividing a line into two parts in such a way that the longer part divided by the smaller part is also equal to the whole length divided by the longer part. When arranged as a geometric form, a predictably expanding spiral results. The ratio is evident in the proportions of the human body as well as in animal and plant forms. *See also* Fibonacci.

Gradation An even and gradual transition of one hue to another, from lightest value or tone to darkest, or from smoothest texture to roughest.

Graphic A visual composition that relies on values or tones of light and dark, lines, textures, and sometimes texts to create two-dimensional images or designs.

Graphic Design Designs created by arranging texts or blending texts and images together to create posters, magazines, books, or other visual/textual materials.

Graphic Story A narrative work produced through imagery with or without use of text to assist meaning.

Gravity Well A conceptual model or visual representation of the gravitational field surrounding an object in space. The more massive the object, the deeper the gravity well will be.

Gray Scale A gradual and evenly sequenced gradation of neutral hues from light to dark. *See also* Gradation.

Great Depression A period of history, beginning in 1933 in the United States and ending worldwide with World War II, marked by severe economic decline, mass unemployment, and extreme poverty among the general population.

Green Packaging Packaging materials that require minimal energy in their manufacture and will dissipate naturally and harmlessly into the environment after use.

Grid A framework of lines arranged in evenly distributed parallels to one another, set at a 90° angle to a second set of similarly distributed parallel lines.

Grillwork (Architecture) Lines or bars of metal or wood set at parallels or angles to one another, and used as decorative motifs of windows, screens, walls, or other architectural or mechanical details.

Groove (Book) A depression or impressed line that is applied to cardboard to weaken the surface tension of the cardboard sufficiently to allow it to be folded along the depressed area.

Ground Line An implied or drawn line upon which figures stand or are arranged in a composition.

Haida The culture, language, and tribal identity of a Native American people whose traditional territory is coastal British Columbia and southern Alaska.

Hatching Parallel lines drawn to indicate light to dark tones or values.

Harmonious Balance One portion of a composition is sensually balanced with another, although the visual characteristics that produce sense of balance may be varied; for example, a dense visual texture in one portion of a composition may harmoniously balance against a large solid space in another portion of the composition.

Harmony A Principle of Art, whereby the various Elements of Art function in a pleasing accord within a composition or work of art.

Hem The edge of a sewn textile item that is turned under one or more times to conceal the rough edge of fabric, then sewn in place.

Hieroglyphs A form of written language used by ancient Egyptians. Highly simplified or stylized pictures or symbols object represented words, sounds, or syllables of the language.

Highlights Contrasts of a very light value that mark where light falls directly on an object.

Hole Punch Tool A sharply pointed hand tool, much like a ice pick, used to pierce holes in leather, cardboard, and other stiff materials.

Horizon Line The visual illusion of a place in the distance where the sky meets the earth.

Horizontal/Horizontally A line, usually at eye level, that is parallel to the top and bottom of a drawing paper or surface.

Horizontal Orientation A rectangular shaped object, drawing, or pictorial image that is placed in such a position as to be wider than it is tall.

Hue A color in its pure state.

Hyperrealism/Hyperrealist An exaggerated realistic appearance, so as to seem more real than reality could be.

Illuminated Manuscript A book, manuscript, or text that has been enhanced with hand-painted decorative initials or introductory letters or words to a chapter, and may include borders or pages illustrated with miniature scenes.

Illustration/Illustrative Images created to visually communicate the narrative of a book or text.

Image-Letter Synthesis A composition that combines an image and word or images and words into a single integrated and unified whole.

Imagic Related to pictures or images.

Imagic Synthesis A combination of images into a single cohesive visual form.

Impasto The technique of applying paint very thickly.

Impress To press into a soft material, such as Styrofoam or cardboard, with a thin, rounded point.

Impression Number When pulling several prints from a single printing plate, the impression number indicates the order of this print out of all those that have been or will be pulled in the print run. The impression number is written as a fraction beneath the printed image.

Impressionism/Impressionist An art movement of the late nineteenth century that began in Paris. Impressionist artworks were usually created in plein air and described the temporal effects of light and movement in natural and everyday life.

Ink/Inking Plate The sheet of plastic, glass, or metal on which ink is placed in order to be rolled out with a brayer for transfer to the printing plate.

Inkjet Printer/Inkjet Print A computer-linked printing process that involves shooting droplets of ink onto paper, plastic, or other materials.

Intense 1. Demonstrating strong feelings or emotions in a work of art. 2. A highly saturated color or hue.

Intermediate Color *See* Tertiary Color/Hue.

Intrapersonal The internal thoughts, emotions, and subliminal aspects of a person.

Islam A monotheistic faith rooted in Abrahamic traditions that was revealed by the prophet Mohammed to the Arabian people during the seventh century.

Japanese Stab Binding A covering for a book or booklet that is characterized by cordage woven through holes punched along the spine edge of the cover and pages.

Kinetic Sculpture A three-dimensional construction, assemblage, or sculpture characterized by moving pieces that are major features or functions of the overall work.

Koru An unfurled fern frond.

Kowhaiwhai A distinctive Maori pattern characterized by organic scroll-like patterns.

Kraft Paper A strong heavy paper commonly used for parcel wrappings, grocery bags, and crafts.

Krewe (Mardi Gras) A club of like-interested people who sponsor costumed performers or parade floats and participate in Mardi Gras celebrations.

Lámina A small devotional painting on a flat surface of clay, plaster, wood, or metal.

Landscape An aesthetic image of a countryside or rural environment.

Landscape Orientation *See* Horizontal Orientation.

Laser Cutter A computer-linked technological device used to cut patterns out of wood, metal, or other stiff materials.

Laser Printer/Laser Print A computer-linked printer that produces good-quality images by using a laser to form a pattern of electrostatically charged dots on a light-sensitive drum. The dots attract toner (dry ink powder) that is transferred to the printing paper and fixed by heat.

Law of Fibonacci *See* Fibonacci.

Layout The arrangement of text and images to create a poster, magazine, or newspaper spread or other composite of texts and/or images.

Legend An inscription or explanation in the form of a diagram, chart, or image that is inserted in a map or published text.

Letterform The aesthetic form of a letter or letters of the alphabet.

Light and Dark Values Gradations of white to black or of tinted to shaded tones in a visual composition.

Linear Perspective A technique used by artists to create the illusion of depth in space by aligning objects with drawn lines than converge at a single point on the horizon. *See also* Perspective.

Lino Cutter A small hand tool that consists of either a U-shaped, V-shaped, or straight blade attached to a handle. Lino cutters are used to cut into linoleum or easy-cut plates in preparing an image for printing.

Logo A sign or symbol that identifies a company, or the owner, producer, or manufacturer of a product in an easy-to-recognize way.

Longitude and Latitude Geographic coordinates as parallel lines circumventing the globe from east to west (latitude) and lines converging at the north and south poles (longitude).

Lung-Ta A Tibetan aesthetic form whose name translates roughly as "wind horse" or "prayer flag." Lung-Ta are rectangular pieces of cloth arranged from left to right in order of blue, white, red, green, and yellow. The colors symbolize five natural elements sky or space (blue), wind and air (white), fire (red), water (green), and earth (yellow).

Lung-Ta allegorically represent goodwill blessings sent out into the world.

Macroscopic Visible to the naked eye without benefit of a microscope.

Make Special/Making Special A theory of philosophic aesthetics proposed by Ellen Dissanayake that human inclinations to make art evolved and continue to function as a way of remembering, celebrating, demonstrating care or appreciation for another, or sharing social experiences.

Mandala A circular shape symbolizing the universe, often with an interior design that conveys deep personal, ritualistic, or spiritual meaning.

Manga A style of Japanese comic illustration, characterized by highly stylized graphic conventions.

Maori An indigenous people of New Zealand.

Map Key A list of symbols or notations used on a map, with a word or phrases explaining their meanings. The list typically appears in a box placed in a corner of the map.

Mardi Gras A celebration held in New Orleans, Louisiana, on Shrove Tuesday, the day before Lent.

Mardi Gras Indians Members of African-American communities (wards) of New Orleans, Louisiana, who developed and practice a unique cultural expression of costume masquerade performance.

Masquerade A elaborate costumed dress or performance that masks one's true identity.

Medieval Referring to the Middle Ages as a historic period (fifth through fifteenth centuries) in Europe, or to the cultural arts, fashions, and traditions of life during the Middle Ages.

Medium/Media The material or materials an artist uses to create his or her work of art.

Metaphor/Metaphoric A figure of speech or image of a thing, action, or event that alludes to or symbolizes an entirely different and typically abstract phenomenon.

Microscopic So small as to be invisible to the human eye, yet able to be clearly seen through a microscope.

Middle Ground The perception of a space between the background and foreground in a painting or photograph.

Mimicry A feature of camouflage whereby a creature of one species resembles that of another species as a means of discouraging predators.

Mixed Media The use of a variety of materials (media) to create a single work of art.

Mobile A three-dimensional work of art that is intended to be hung from a ceiling or brace.

Model A figure or object used as a three-dimensional example or guide to be followed in creating a full-scale work.

Mola A traditional textile decoration of the San Blas people of Panama, whereby layers of colored fabric are stacked, then cut into patterns that are concentrically smaller from the top to the next-to-last layer, and finished with decorative stitches.

Monochromatic Color/Hue A single color along with its tints and shades.

Monoprint A form of printmaking that destroys the printing plate in the process of making a print. Thus, only one print can be drawn from each printed plate.

Monotone *See* Monochromatic Color/Hue.

Mood Suggesting a particular feeling or temporary state of mind.

Motif A shape, color, texture, or pattern that is repeated in a design.

Mughal A sixteenth- to eighteenth-century era of Middle Eastern and East Asian art, architecture, and culture, characterized by fusions of Southeast Indian, Persian, and Islamic aesthetic influences.

Multiple Ground Lines Several drawn lines upon which figures or objects rest, as a way of indicating deep space in a composition.

Native American A direct descendant and member of one of the indigenous tribes or groups of the Americas.

Neatlines The outline of a map that frequently features notations of latitude and longitude, or other geographical indications.

Needlepoint Screen A fabric of coarsely but evenly woven natural or synthetic threads that serve as a background for cross-stitch and other forms of needlepoint art.

Negative Shape *See* Negative Space.

Negative Space The perception of space around objects in a composition.

Neo-Plasticism/Neo-Plasticist An abstract style of art characterized by vertical and horizontal lines, rectangular shapes, black and white values, and primary colors.

Neutral/Neutral Color Color that is created by mixing together two complementary colors, such as red and green, and the tints or shades of these mixed colors.

Nonobjective/Nonobjective Art Art images or artifacts that contain abstractive content without reference to literal objects or figures.

Non-Porous A material that does not permit passage of air or water through it, such as plastic or metal.

Off-Registration Overlaps of colors in a print that are not perfectly aligned.

Oil Pastel A dry color medium that combines characteristics of soft chalk pastels and wax crayons with an oily binder.

One-Point Perspective A type of linear perspective with objects receding toward a single point on the horizon.

Opaque A surface that lacks transparency and cannot be seen through.

Operations of Symmetry *See* Principles of Symmetry Operation.

Organic/Organic Shape An irregular shape that resembles natural, non-geometric objects.

Original Character A fictional character that is not directly based on a pre-existing character from a published graphic or textual literature, movie, video game, or popular culture.

Orthagonal Linear perspective lines that lead to a vanishing point, or right angles and perpendiculars that recede toward a vanishing point.

Outline Lines that enclose a space in such a way as to identify a shape in a drawing or sketch.

Oval A rounded shape that is elongated as an ellipse.

Overlap A perception of depth created by placing one or more objects in front of others in a composition.

Painted Lady (Architecture) A Victorian-style house or mansion that is painted in three or more colors, according to a stylistically conventional color scheme, so as to highlight decorative and structural features of the building's exterior.

Papier-Mâché A malleable mixture of water, paste, and paper or paper pulp that may be draped or molded when wet but becomes stiff and hard when dry.

Papunya (pa-pun-ya) A small settlement of Aboriginal peoples living in the western desert of Australia.

Parallel Lines Two lines going a similar direction that remain equidistant for the duration of their length and do not meet at any point.

Pareidolia A psychological phenomenon whereby the mind perceives random visual data as resembling something familiar, even though the perceived image does not intentionally or actually exist, as when one imagines one sees a human face in a cloud formation.

Pastel 1. A powdered color pigment that has been mixed with a chemical gum binder and pressed into sticks or rolled into pencils for use in creating colored drawings. 2. A very light tint or color.

Patchwork (Quilt) A quilt top that is created by stitching together small pieces of fabric into a design.

Pattern Block (Patchwork) An arrangement of geometrically cut pieces of fabric into a pattern

segment or motif that will be repeated to create a patchwork design.

Pattern Motif A shape, color, texture, or group of shapes, colors, and textures that are repeated to create a pattern.

Pediment (Architecture) The triangle-shaped portion of a building, often supported by columns, that rests above the front opening of a classical-style building.

Peephole (Tunnel Books) A small hole that may be looked through to give an impression of depth or a panoramic view to an interior space.

Persia A powerful ancient empire and the former name of that geographic area of the Middle East now called Iran.

Perspective The perception of space created by drawing objects in such a way as to suggest the objects' accurate heights, widths, depths, and positions in relation to each other and the viewer.

Petroglyphs Symbolic pictographic forms and images created by prehistoric peoples by carving or incising into rock.

Photocopy A photographic copy of an image created by an electronic process involving light bouncing off the original image onto a specially prepared inked plate.

Photographic Essay A story, generally of a documentary nature, told in photographs.

Photographic Transfer/Photo Transfer A photographic image transferred in reverse from its original form to another surface by use of an adhesive or gum-like substance.

Photorealism (Super-Realism) A style of painting presenting everyday subject matter in such detail that it looks like a photograph, and is often larger than life.

Photoshop CS6 A popular software program for editing or creating visual images.

Pictograph Symbols and shapes that communicate an idea to others within a broad cultural or social group. Pictographs have been a known form of conveying information since the Neolithic era.

Picture Books Illustrated stories with few words, often created for young children who are not yet text literate.

Pixel/Pixelate A tiny fragment of the entire picture; to break down a large picture into tiny particles.

Plane A flat, two-dimensional surface that would theoretically extend in all directions into infinity, if not interrupted by juxtaposition with another plane.

Plane of Vision All objects and phenomena that appear on the same plane as the viewer's eye and within the eye's range of vision.

Plaster Bandage A strip of gauze impregnated with plaster of Paris, used to make plaster casts or molds.

Plaster Model An example or prototype for a work of art, or a finished work of art created out of a mixture of lime, gypsum, sand, and water, or out of gauze bandages dipped in such a mixture and draped over an armature. The plaster then hardens to a smooth white surface.

Plastic Media Any art medium that is malleable when being used to create art, as for example clay, plaster, or papier-mâché.

Plastic Mesh A material made of a network of woven plastic fibers.

Plein Air A painting or drawing entirely done outside in the open air rather than in a studio.

Plot Lines The events, internal and external dialogue, and character interactions that make up the course of a story or narrative.

Plot Points Significant places within a narrative that reveal important character motivations, plot twists, or other significant features that move the story to its conclusion.

Polymer Clay A synthetic modeling material that contains no natural clay minerals but hardens under conditions of heat.

Porous A material characterized by microscopic holes through which air or liquid may pass or be absorbed.

Portrait Orientation A painting surface oriented vertically with the shortest edges at the top and bottom of the page. *See also* Vertical Orientation.

Pose An assumed position of a body when being drawn, painted, or photographed by an artist.

Positive Shape *See* Positive Space.

Positive Space The area of a visual composition occupied by recognizable objects.

Postcard A small card, usually about 4" × 6" in size, that bears an image on one side and a space on the reverse for a message and an address, so the card may be sent to someone through the mail.

Prayer Flag A section of cloth or fiber upon which a prayer is painted or printed, as a text or as symbolic imagery.

Primary Color/Hue The group of three colors (red, yellow, and blue) from which all other colors may be obtained by mixing.

Principles of Art The ways that Elements of Art are combined in order to achieve visually compelling works of art or design. These Principles are balance, emphasis, harmony, movement, pattern, proportion, rhythm, unity, and variety.

Principles of Symmetry Operation An intrinsic property of an object that causes it to remain unchanged even after certain classes of transformations, such as rotations or reflections, have occurred.

Print To copy multiples of a single image through a process that transfers an original image from a block or plate to another surface.

Printing Paper 1. A lightweight paper used in creating digital copies of text materials. 2. A paper chosen as a ground for printmaking.

Printing Plate/Block A wood, metal, plastic, stone, or cardboard surface on which an image is carved, impressed, or incised, and then coated with an ink so the image may be transferred to another surface.

Printmaking The process of making finished works of art by transferring an image from a printing plate or screen to another surface.

Prism A glass or crystal instrument, in the form of a triangular tube or angular form, that refracts light in a way that separates light waves into the color spectrum, from red to violet.

Proportion The size, weight, color, texture, or other sensual qualities of a visual object or phenomenon in relation to all its other parts.

Protagonist The leading character or hero/heroine of a narrative.

Prototype A first model or example of a device or vehicle that is created to test the viability of the item before it is produced for use by the general public.

Pull (Printmaking) To make a print through a printmaking method.

Queen Anne (Architecture) A variation of Victorian-style architecture, popular during the late nineteenth and early twentieth centuries, that is distinguished by asymmetry, spindled columns, side towers or turrets, and extreme ornamentation of external details such as textured surfaces and gingerbread moldings.

Quilt Top The decorative top layer of a quilt.

Quilting The finely sewn stitches that create patterns while holding layers of a quilt together.

Radial Symmetry Symmetry radiating evenly from a fixed central point, usually in the shape of a circle, as in the spokes of a wheel.

Ratio The quantitative relationship of one fixed amount to another that shows the number of times one quantity is contained within the other, as in the ratio of the height of an adult human head to the height of the adult human body.

Realism/Realistic The representation of objects and relationships among objects in a visually accurate or perceptually true-to-life way.

Reflect/Reflection The image of something that appears mirrored or reflected in another object.

Reflection (Tessellation) A reflection flips all the points in the plane over a line, which is called the mirror.

Refract/Refraction The bending of light due to interference from a transparent object or surface such as glass or water.

Register/Registration A method of aligning differently colored printing blocks so that subsequent layers of colors fall exactly in line with previous layers.

Renaissance A period of time in Europe, beginning in the fourteenth century and ending in the seventeenth, that marks the transition from medieval to modern history. The Renaissance (from French *renaistre*, "to be born again") was an era of increased learning, revival of the arts and literature, and scientific discovery.

Render To copy or draw the representation of an object or idea.

Repetition The repeating of a line, shape, color, or texture over and over in a regular or rhythmic way to create a pattern, suggestion of visual movement, or harmonious connection of one aspect of a composition to another.

Representational Denoting the physical appearance or essence of an event, object, or idea.

Resist A process of art making that involves applying a wet medium over an oil-based medium or other material that resists water.

Retablo A small devotional or personal image or artifact displayed in a three-dimensional frame or box.

Reverse Appliqué Rather than adding small layers of fabric to create an appliqué, reverse appliqué involves removing layers of fabric that have been basted together. Shapes are cut from the top to the next-to-last layers, in progressively smaller sizes. Raw edges of the cut fabric are then finished with decorative stitches.

Rex (Mardi Gras) The king or central figure who "rules" over a Mardi Gras celebration.

Rhythm A repeated pattern of line, color, shape, or texture, that creates an illusion of movement in a work of visual art.

Role-Play An informal game or performance in which a person or people assume the roles, characteristics, and (sometimes) costumes of fictional or imaginary characters in an invented narrative.

Rotation (Tessellation) A rotation turns all the points in the plane around one point, which is called the center of rotation.

Rubbing To place a sheet of paper or fabric over a textured item and rub across the paper or fabric with a drawing or painting tool in such a way as to capture the visual texture of the underlying object.

Scale 1. The ratio of two lengths, areas, or mathematic portions to one another. 2. The act of increasing or decreasing the size of an object in proportional relation to the original size.

Scenario A written, performed, or visual representation of a segment of a narrative or storied plot.

Scene 1. A visual representation of an event from everyday life. 2. The visual presentation of a segment from a larger visual narrative.

Schema An arrangement or framework, or small underlying elements or structures that serve as model, plan, or diagram for a larger composition, organization, or structure.

Sci-Fi A short term for science fiction.

Score Using a dulled pointer to press an indentation along a line, which permits a semi-rigid material such as cardboard or foam core to be neatly bent.

Scored Groove The indentation or groove that is made in the act of scoring.

Scratchboard A cardboard or Bristol board covered with two layers of wax medium. The lower layer is of one color, and the top layer of a second (usually black) color. Images are drawn by scratching away parts of the top layer to make the second layer visible.

Scrim A coarse fabric, commonly made of plastic or nylon screen, with large regular grid-like openings.

Script The written text of a performance, play, movie, or fictional story narrative.

Scrumbling A thin layer of dry or wet media, applied by dabbing or scribbling to create a soft

impressionistic value, color, or texture to a visual composition.

Seam The edge or line along which two pieces of fabric are joined together by sewn stitches.

Seam Allowance The space between the raw edge of two pieces of fabric and the sewn stitches that hold the pieces together.

Seascape A drawn, painted, or photographed image of an expanse of the sea.

Secondary Color/Hue The colors orange, green, and violet that result from mixing equal parts of two primary colors together.

Selfie A photograph of oneself, taken with a hand-held camera.

Self-Portrait A drawn, painted, or photographed image by an artist of her- or himself.

Sew To join pieces of fabric together with a threaded needle, either by hand or by machine stitching.

Shade (Color) A shade is a dark color created by mixing black with a pure color, or by mixing two complementary colors together.

Shade/Shading (Value) A darkened area that results when a solid object obstructs the fall of light upon a part of itself or upon another object. Shade adds the illusion of depth, volume, contrast, character, and mood to an image.

Shape An Element of Art referring to the outlined area of two-dimensional objects.

Shōjo (Animé/Manga) A style of manga art and narrative originally aimed at girls and women, characterized by emphasis on emotional situations or romantic relationships.

Shōnen (Animé/Manga) A style of manga art and stories originally aimed at adolescent boys and men, characterized by plots based on friendships and heroic actions.

Silhouette (Fashion) The shape or outline of a figure, often visibly emphasized against a contrasting background.

Sketch A loose, unfinished, preliminary drawing as a plan for a more detailed and finely finished drawing or painting.

Slipstitch A loosely sewn stitch with a long hidden stitch and short stitch that catches the fabric securely. The result is a long-short-long-short stitch pattern.

Social Commentary A rhetorical means, through spoken work, text, image, or performance, of commenting on issues in a society, often with the goal of initiating change by inspiring the audience with a sense of justice.

Space An Element of Art that describes the apparent area of or around an object in a two-dimensional work of art.

Specimen An individual animal, person, plant, or object that stands as an example of all others of its category.

Spectrum The band of light separated by wavelength into colors organized like those in a rainbow.

Spine (Book) The column-like part of a book to which its pages are attached.

Spirit Doll A figure or figurine that focuses the attention of its maker or user on a need or desire toward a goal of psychological healing and self-empowerment, or a figure that carries spiritual petitions and prayers to the universe.

Stabile A sculptural work or assemblage that stands upright.

Steampunk A popular aesthetic style of the twenty-first century that references nineteenth-century works of science fiction such as those of Jules Verne and H. G. Welles, and is characterized by idealization of Victorian fashions and re-imagined scientific inventions of the Industrial Revolution, such as elaborately detailed devices of copper, polished wood, leather, and glass.

Still Life A work of art that focuses on arrangements of flowers, food, or other inanimate, everyday objects as subject matter.

Stippling The use of small dots to produce an illustration or the effect of shading and volume in a visual composition.

Stitch (Sewing or Embroidery) A connecting loop of thread (yarn or filament) that is created by passing a threaded needle back and forth through a fabric or layer of fabrics.

Stitchery A process of art or craft making that involves sewing or stitching with needles and threads, yarns, or flosses.

Stop Motion In stop motion cinematography, a figure or scene is posed and a photograph taken, then the figure or objects in the scene are moved slightly and another photograph taken. This activity is repeated until continuous sets of motions are captured. When these are shown in rapid sequence, the effect is that of a motion picture.

Storyboard A sequence of sketches that visually describes the plotline of a graphic story, such as an animated film, movie, or comic.

Storyline The plot of a story, play, movie, or other narrative form.

Storylining A form of imaginative play, especially popular among adolescents, characterized by the creation of fictional characters that project their creators' real or wished-for traits, set in collaboratively written stories.

Stream of Consciousness/Stream-of-Consciousness Writing An internal monologue of thoughts and feelings that are projected outward into writing, without the intention of consciously organizing or focusing them in a particular direction.

Stuffing A soft, fluffy, absorbent material used to fill a pillow or fabric toy, or as a padding layer of a quilt or comforter.

Style The distinctive or unique aesthetic characteristics of an artist, or the overall visual expressions of a group during a historic period.

Stylistic Conventions A set of visual symbols or stylized motifs that are used in particular genres of graphic literature and are commonly understood by aficionados of that artistic genre, such as stylistic representations of eyes in shōnen manga.

Stylized An image or artifact that has been presented in a highly mannered or unrealistic way.

Subtractive/Subtractive Method A method of removing portions of a printing block in order to obtain a print, or of removing excess stone, wood, or plaster from a block in order to create a sculpture.

Super-Realism *See* Photorealism.

Surrealism/Surrealist An art movement of the early twentieth century, inspired by the emerging field of psychology. Surrealist artworks focus on the subconscious mind and dreamed images as sources for art content.

Symbol/Symbolic A visual representation or motif that alludes to a non-literal object or that communicates a specific idea.

Symbolic Iconography An interpretation of images that include symbols alluding to deep underlying ideas, motivations, and mysteries.

Symmetry/Symmetrical 1. The balancing of a composition or artwork in such a way that when divided in half, each half is a mirror image of or similarly balanced with the other. 2. (Tessellation) A figure that looks the same under a transformation is said to be symmetrical under that transformation. For example, the letter A is symmetrical under a reflection around a vertical mirror through its center. This sort of symmetry is called bilateral symmetry. Other letters that are symmetrical include M, O, T, U, V, and X.

Synthesis (Art) The uniting of diverse ideas, symbols, and aesthetic forms into an interrelated, integrated artistic whole.

Tacking In sewing, a tack is a created by inserting a yarn-threaded needle from front to back through several layers of material, taking a short stitch, and then bringing the needle back up to the front. Long ends of the thread are tied together in a knot and cut to a tassel. This is repeated at regular intervals in order to securely hold the layers together.

Taper A long rectangular strip or form with one end gradually decreasing in width to create a slender point.

Tempera A paint made of water-soluble pigment mixed with a glutinous binder. Tempera paints typically are the consistency of heavy cream but may be thinned with water to create transparent washes of color, or applied thickly to create impasto-like effects.

Template A piece of cardboard, plastic, or other hard material that has been cut to a desired shape and used as a pattern for processes such as cutting, painting, or stenciling.

Terra Cotta A reddish brown, unglazed earthenware ceramic that is extremely hard and durable and often used as architectural decoration.

Terra Incognita Latin for "unknown land," this is an inscription on a map that indicates an area that has not yet been explored.

Tertiary Color/Hue A color made by mixing a primary color with one of the secondary colors that lies next to it on the color wheel. For example, teal is the tertiary color that results from mixing primary blue with secondary green, while chartreuse is the tertiary of primary yellow mixed with secondary green.

Tessellate/Tessellation A pattern composed of identical shapes that fit into one another without any gaps, like pieces of a puzzle.

Text Words, messages, or literatures written in an alphabetic form.

Three-Dimensional (3-D) Having volume and form, that is, having height, length, and depth in space.

Three-Point Perspective A form of linear perspective whereby an object seen in an illustration appears to have three visible sides, two of which recede toward vanishing points to the right and left along the horizon, and the third recedes either upward or downward from the position of the viewer.

Thumbnail Sketch A small rough drawing as a plan for a more finely finished drawing or painting.

Tint (Color) Any color to which white has been added to make it lighter is a tint of the original hue.

Tone A light or dark value of color.

Topography A map that describes the elevation of various features in relation to sea level.

Tortillon A stump-like stick made of tightly packed and twisted paper, for use in smudging or smearing pencil, charcoal, or pastel drawings.

Totem An animal or natural object that is believed to have spiritual significance and may be seen as a spiritual ancestor or guardian of members of a particular cultural community.

Transcendentalism/Transcendentalist An art movement rooted in the philosophical belief that the true essence of things is revealed more through intuition than through physical substance or empirical experience.

Translation (Tessellation) A translation slides all the points in the plane the same distance in the same direction.

Translucent Having the quality of allowing light to pass through.

Transparent/Transparency Materials having the ability to allow light to pass through so that objects behind them may be seen.

Travelogue Written or visually recorded evidence in the form of diaries, journals, drawings, photographs, or films about the places one has visited, events that occurred during a journey, and the emotions and thoughts experienced during traveling.

Trickster A mythic archetype that appears in all cultures of a character who deceives, misbehaves, and generally disrupts social norms as a means of revealing truths and deep knowledge.

Triptych A set of three associated artistic images arranged on three panels, typically hung side by side on a screen or attached with hinges and set in a standing position.

Tunnel Book A concertina-like book with cutout pages that permit the viewer to see through several

pages, and when extended or opened gives an actual depth of space to images.

Turret (Architecture) A small tower atop a larger tower, usually located in the corner of a building that was constructed in earlier times, from the medieval era through the early twentieth century.

Two-Dimensional (2-D) A flat surface that has height and length but no depth.

Two-Point Perspective A form of linear perspective whereby objects seen at an angle appear to recede from the viewer toward two vanishing points on the horizon, one vanishing point to the left and one to the right of the viewer.

Ukiyo-e A style of Japanese art prevalent during the sixteenth and seventeenth centuries, characterized by scenes of everyday life.

Unity A Principle of Art that is demonstrated when all elements of a composition hold together in a harmonious way.

Value (Color) *See* Color 2. (Value).

Value(s) An Element of Art referring to the gradation of light in a composition, from lightest (tint or white) to darkest (shade or black).

Value Relationship The contrasts, similarities, or other relationship between the various values of light and dark in a composition.

Vanishing Point A point within a composition or an implied point beyond the frame of a composition where the receding lines of perspective seem to converge.

Vertical/Vertically Being at a right angle to the horizon, as if pointing up and down.

Vertical Orientation A rectangular-shaped surface or object placed in such a way as to be taller than it is wide.

Victorian 1. (Architecture) The several styles of architecture that flourished during the long nineteenth-century reign of Queen Victoria of England, and are characterized by domes, towers, ornate decorative motifs, and references to Middle Eastern and Asian structures and motifs. 2. (Culture) Aesthetic expressions of the middle class during the nineteenth-century reign of England's Queen Victoria, characterized by interests in scientific discovery, colonial expansionism, and economic prosperity that resulted in vibrant growth of the middle class.

Viewfinder A handheld device that permits a viewer to focus on a cropped section of a scene or image.

Vignette A brief scene or illustration of a larger event or experience.

Visual Codes Motifs or arrangements of Elements and Principles of Art that are understood by viewers or readers as symbols of ideas in popular culture or graphic narratives.

Visual Futurists Artists or illustrators who envision the appearance of future machines, architectures, and environments through their art.

Visual Illusion The distorted or deceptive perception of an image or artifact, or the arrangement of elements such as size, space, or color in such a way that the eye is fooled into imagining a visual presentation other than it is.

Visual Journal A sketchbook with text explanations or diary-like entries accompanying images, used to record impressions of one's observations and experiences.

Visual Modes A way of communicating meaning through imagery.

Visual Pun An image that conveys the message of a pun.

Visual Symbols Abbreviated visual forms that convey meanings, such as stick figures that represent people or astrological symbols that represent planets.

Visual Texture A two-dimensional image that gives the visual perception of three-dimensional texture.

Visual Weight A perceptual phenomenon whereby white or light values and tones of a composition give an illusion of having less physical weight than dark values or saturated areas of color.

Vitruvian Man A drawing by Leonardo da Vinci that demonstrates the canonical proportions of a classical European male body.

Wall Hanging A large decorative fabric construction that is intended to be displayed by being hung on a wall or as a room divider.

Warm Colors Hues, tints, and shades of reds, yellows, and oranges. These colors suggest warmth and refer to things we perceive or experience as warm.

Warp (Weaving) Thread fibers or filaments that are held in tension by attachment to a loom for weaving. Weft threads are then worked over and under warp threads.

Wash Painting a very thin layer of paint or ink that has been diluted with water or a thinner to create a transparent effect.

Wayang Kulit A shadow puppet performance that is popular in Javanese and Balinese culture.

Weave/Weaving The uniting of fibers or filaments by passing horizontal strands of one set of fibers (weft) over and under the vertical strands (warp) of another set of fibers.

Weft (Weaving) The fibers, filaments, or threads that are placed at a right angle to the warp and passed over and under the warp threads in weaving.

Wet Medium/Media Art materials that involve moisture, such as paints and liquid glues.

Woodblock A thin block of wood into which an image is carved; the block is then coated with ink for printing.

Woodcut A print made by cutting into a plate or plates of wood, inking the plate(s) and impressing the ink onto paper.

Word Balloon An outlined shape in a cartoon, manga, comic, or graphic story that contains the texts of speech or thoughts of a character in the visual narrative.

Worldview A deeply inculcated or accepted philosophical belief about the meaning of life, how life should be lived, how society should function, and what is to be valued in the world.

X-ACTO Knife A utility knife with a sturdy handle and retractable, razor-like blade.

Yarn Needle A long thin needle of plastic or metal that has a sharp point at one end and an opening or eye large enough to accommodate a yarn-sized thread on the other.

Yin/Yang Two complementary forces in the universe. Yin is passive, yielding, and associated with the feminine, while Yang is active, oppositional, and associated with male energies.

Zentangle The intentional creation of elaborately drawn or inked patterns or designs as visual texture or ornamentation of an illustration. The name "Zentangle" was trademarked by Maria Thomas and Rick Roberts of Zentangle, Inc., in reference to 102 specific drawn or inked patterns.

MARJORIE COHEE MANIFOLD

is Associate Professor in Art Education at Indiana University Bloomington. She is editor (with Steve Willis and Enid Zimmerman) of *Culturally Sensitive Art Education in a Global World: A Guidebook for Teachers.*

DIRECTOR	*Gary Dunham*
ASSISTANT ACQUISITIONS EDITOR	*Peggy Solic*
PROJECT MANAGER	*Rachel Rosolina*
BOOK & COVER DESIGNER	*Pamela Rude*
COMPOSITION COORDINATOR & LAYOUT	*Tony Brewer*
TYPEFACES	*Arno & Futura*